THE ARTS
OF MANKIND

EDITED BY ANDRÉ MALRAUX
AND ANDRÉ PARROT

CAROLINGIAN ART

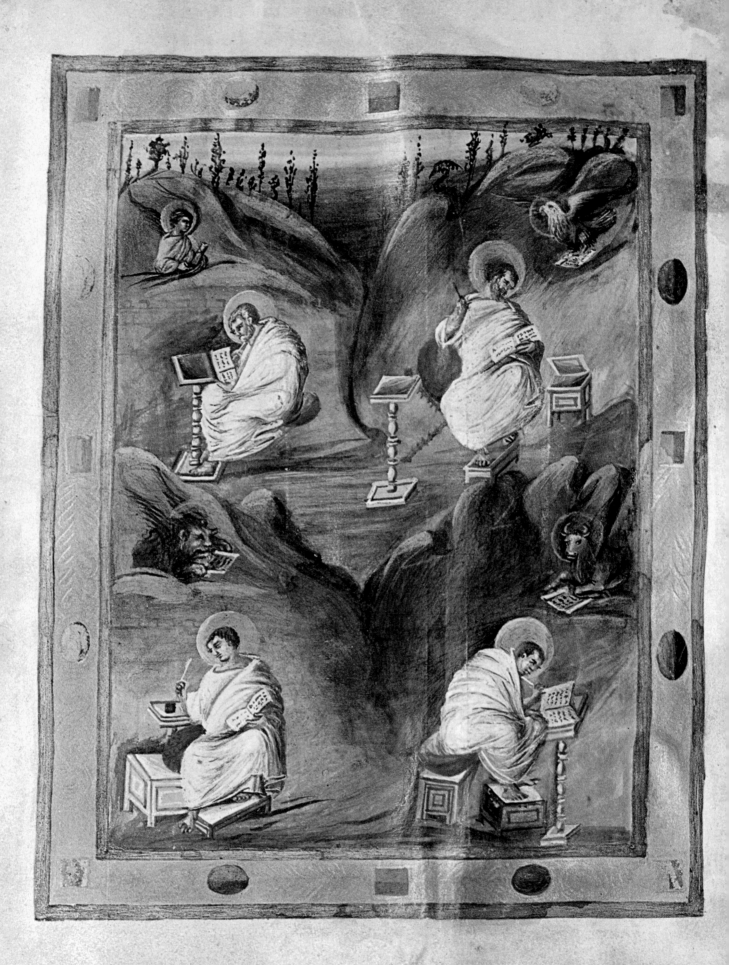

J. HUBERT J. PORCHER W. F. VOLBACH

CAROLINGIAN ART

THAMES AND HUDSON

Translated from the French
L'Empire Carolingien

Parts One and Four by James Emmons
Part Two by Stuart Gilbert
Part Three by Robert Allen

Published in Great Britain in 1970 by
Thames and Hudson ltd, London

English translation © 1970 by Thames and Hudson Ltd, London
and George Braziller, Inc., New York

© 1968 Editions Gallimard, Paris

Printed in France

500 03012 X

Contents

A LAST FAREWELL TO JEAN PORCHER

Now that The Carolingian Renaissance *is going to press, we cannot but evoke anew, with gratitude and admiration, the memory of our colleague Jean Porcher. On this volume, as on its predecessor,* Europe of the Invasions, *he collaborated heart and soul. Manuscript painting was one of the domains of art history in which he felt supremely at ease and took a special delight. And it was, naturally, to him that the chapter dealing with Carolingian painting was assigned.*

Rereading this chapter signed by Jean Porcher, we seem to hear the very voice of the man we knew so well; full of enthusiasm for the subject he knew and loved most of all. We could almost believe that he had lived in some previous form in the entourage of Charlemagne, Louis the Pious and Charles the Bald (of whom we are told, despite the sobriquet, that he had a thick shock of hair, a fact confirmed by one of the earliest portraits of the king), so convincingly does he bring to life the milieu over which these kings presided. After reading Jean Porcher, we can no longer doubt that the ornamentation of Carolingian Gospel Books and Bibles reflected a court art. Lavish patronage was needed to make such works feasible and it is clear that the art centres of Rheims, Metz and Paris were strongly influenced by Aachen and took their lead from it. This is evident when we compare the work emanating from these centres with the 'marginal' productions from St Gall, Salzburg and Fulda.

At the end of the litanies in a Sacramentary entirely written in gold and dating to the reign of Charles the Bald, we find an inscription: 'Hic calamus facto Liuthardi fine quievit' ('here, its task accomplished, Liuthard's pen has come to rest'). If called on to choose his epitaph, Jean Porcher might well have made these words his own; with his contribution to this volume his pen, too, has come to rest. Too soon, alas; far too soon. Fortunately, so far as The Arts of Mankind *series is concerned, his work was done, and the pages by him in this volume are, indeed, his last will and testament.*

ANDRÉ PARROT
October 1967

Introduction

IN OUR preceding volume, *Europe of the Invasions* (or, as it was published in Great Britain, *Europe in the Dark Ages*), we drew attention to the long survival of the art of the Late Roman Empire. We also pointed out that from the sixth to the eighth century attempts were often made to imitate the Roman buildings which formed the setting of daily life in the Merovingian period. But these praiseworthy efforts had only a very limited scope. There was as yet no set purpose to further progress by drawing inspiration from the past. This was to be the task of Charlemagne and his associates.

During the first part of the early Middle Ages any effective progress of the arts had been hindered by the chaotic conditions then prevailing in almost all parts of the Frankish kingdom. Fortunately the monastic institution was soon to establish itself as a powerful instrument of order, counteracting the excesses of cruel kings and a bellicose nobility. Once the monks abandoned the eremitical state and took to residing in groups, first in 'lauras,' then in organized monasteries, it was easier for them to devote themselves to study and to take an interest in the arts. Towards the beginning of the eighth century the first monasteries built on a regular plan made their appearance in the West. As a result of the reforms introduced about 754 by Chrodegang, bishop of Metz, a new way of life, resembling that of the monks, was enjoined on the cathedral clergy. Thus the order which already reigned in Benedictine monasteries was extended to a large section of the clergy. Charlemagne was instrumental in this change. One of his chief ambitions was to give to the theocratic society on which his heart was set an ambiance worthy of it. Thus the layout of many cathedral towns was profoundly modified.

Charlemagne did not himself supervise the changes made in the monastic establishment, nor did he initiate the creation of cathedral chapters, but it was he who gave these reforms a wider, almost a universal application. The same applies to the reform of the liturgy. Pepin, crowned king at Saint-Denis in 754 by Pope Stephen II, was the first to prescribe in Gaul the imitation of the usages of the churches of Rome for the singing and celebration of divine service. The church books had to be changed, and cathedrals and monastery churches were even made to face west, like the pontifical church of St John Lateran and St Peter's in Rome.

◀ 1 – AACHEN, PALATINE CHAPEL. BRONZE DOOR, DETAIL.

An exact imitation was achieved at Fulda, and there were others, less literal, in the form of churches with two sanctuaries, one at each end. Though these drastic changes took effect only after Charlemagne's rise to power, we must not forget that it was Pepin, his father, who inaugurated them. Nor must we overlook the fact that the flourishing state of architecture, as evidenced in the late eighth century by Saint-Riquier, Aachen and Germigny-des-Prés, was clearly the fruit of previous endeavours. The advance of architecture preceded that of literature; it was not till 787 that Charlemagne enjoined that schools should be established in every diocese. All the same we are bound to recognize that but for Charlemagne's personal initiative and the enormous resources at his disposal no great building programme could have been carried out. It is important today to emphasize the complexity of the 'Carolingian renaissance,' for rather too simplified a picture of it has gained currency. The genius of Charlemagne is great enough not to suffer by being given its proper place in history. Provided we leave eighth-century architecture out of account, there is every justification for speaking of a Carolingian 'miracle' when we observe the sudden appearance in the early ninth century of illuminated manuscripts, goldwork and enamelling, ivory carving and gem engraving—diverse arts practised with a perfection that in some cases has never been surpassed.

Charlemagne died in 814. The renascence of the arts continued in the reigns of his successors, Louis the Pious (died 840) and Charles the Bald (died 877). Soon, however, many workshops in Gaul were compelled to close down. Internecine conflicts within the empire put an end to the patronage of the arts and the Norse invasions (recorded in the Chronological Table, Part Four) dispersed the craftsmen or forced them to take refuge in outlying regions unoccupied by the invaders. Such unusual works as the abbey church of Saint-Michel de Cuxa and the statue of St Foy at Conques are not original tenth-century creations but rustic versions of forms invented by the best Carolingian ateliers of the second half of the ninth century. To this time, too, belongs the magnificent Gospel Book of Saint-Martial of Limoges, dated to about the year 1000 until the excellent study of it recently made by Mme Danielle Gaborit-Chopin. The high qualities of Carolingian works were maintained and even improved on at the court of the Ottonian emperors, where patronage of the arts was on almost the same scale as at the court of Charlemagne.

By the end of the reign of Charles the Bald, the Carolingian renaissance had lost its initial impetus. It was thus of short duration, but it played a decisive role, shining out like a beacon in the surrounding darkness. It bore fruit in a large part of Europe and lay at the origin of medieval humanism. To it, indeed, modern times owe something of their own humanism; our writing, for example, is based on the calligraphic script of those magnificent illuminated ninth-century manuscripts, which scholars of the sixteenth century had taken for antique works.

Jean Hubert

PART ONE

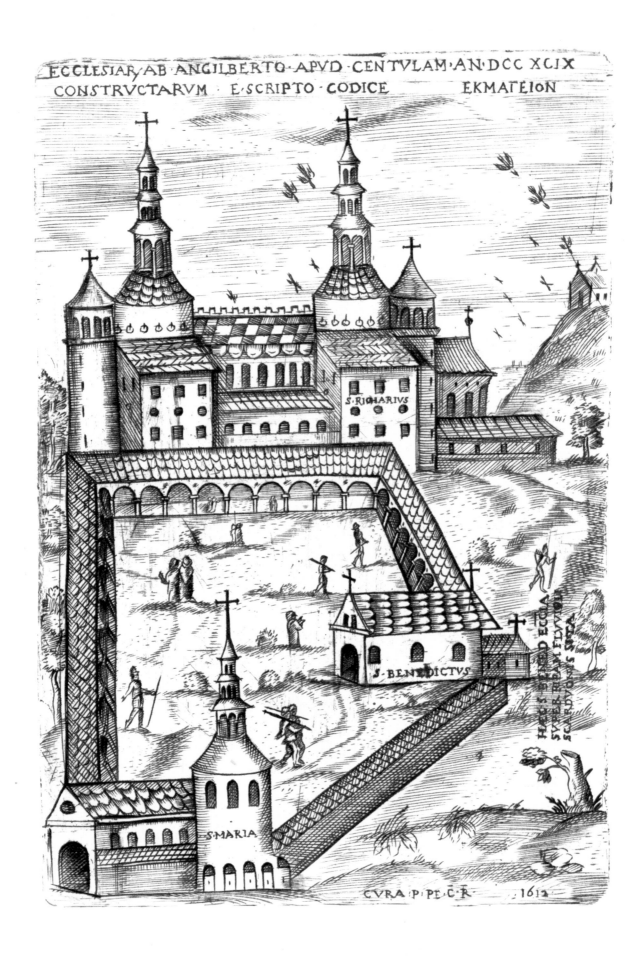

ECCLESIAR AB ANGILBERTO APVD CENTVLAM AN DCC XCIX
CONSTRVCTARVM E SCRIPTO CODICE EKMATEION

S. RICHARIVS

S. BENEDICTVS

S. MARIA

CVRA P PE C R 1612

Architecture and Its Decoration

To my wife

T̶HE STORY of the monastery of Centula (present-day Saint-Riquier), of its construction and its downfall, is the very symbol of all that was brilliant and transitory in the civilization of the Carolingian renaissance.

Saint-Riquier is a small market town in northern France (Somme department), about thirty miles north of Amiens. Its population today is 1,130. It stands on the site of what in Carolingian times was a city, one which, according to extant records, had a population of about 7,000, and which stood at the gates of an abbey whose resident community numbered 300 monks, 100 novices and a large staff of servants. Town and abbey together formed a sort of holy city, whose sacred character appeared to promise it a long and peaceful future. But in the year 881 the Northmen devastated the region, the abbey was burnt down and everything destroyed. In the Middle Ages the monastery was rebuilt on a much smaller scale. The present church of Saint-Riquier—a fine building of the thirteenth and fourteenth centuries, measuring over 250 feet in length—is the only remaining monument which gives some idea of the size and extent of the abbey buildings in the time of Charlemagne.

Were it not for the fact that there has survived a view of the Saint-Riquier monastery, whose features, though very schematically represented, can be filled out on the basis of textual records and a study of local topography, one would hesitate to believe that the Carolingian Centula covered an area as great as that of Cluny in the twelfth century (and Cluny was the largest monastic establishment of medieval Christendom). My conjectures as to the size of Centula have been confirmed by the recent discovery of vestiges of the round church of Notre-Dame, in the course of excavations carried out by Honoré Bernard.

Centula and Cluny each had a community of 300 monks. This is about the only point of resemblance between the two abbeys, which existed three centuries apart. In all other respects they differed conspicuously. Cluny was a house of prayer; though it accepted gifts from laymen for the construction of its churches and the support of its monks, it was quite independent of secular authority. Centula,

◄ 2 – SAINT-RIQUIER, ABBEY. FROM A PRINT OF 1612. BIBLIOTHÈQUE NATIONALE, PARIS.

1

on the other hand, was a state-supported institution. The construction of the monastery was completed in 799. It had been carried out in less than ten years, the bulk of the funds having been supplied by Charlemagne, who, due to his conquests, was already disposing of immense resources. The founder-abbot, Angilbert, had a son by one of Charlemagne's daughters. Angilbert distinguished himself as a poet and scholar; the nickname Homer was bestowed on him by his fellow members of the Palace Academy. He also became one of the highest dignitaries of the court. Between 792 and 794 Charlemagne sent him on three missions as imperial legate to the pope. At Centula Angilbert acted both as abbot of the monastery and as mayor of the holy city outside it. He had his private residence in a villa built outside the walls of the abbey, but he held audience in a hall near the main gate.

The monastery was dedicated to the 'holy and indivisible Trinity,' symbolized by the number 3 and the form of a triangle given to the layout of the monastic buildings. Although the symbolism of numbers had been taken over by Christianity from ancient Greece, rarely was it given so concrete an application as here. The main church was placed under the triple patronage of the Saviour, the Virgin and St Richarius. There were two other churches, one dedicated to the Virgin and the Apostles, the other to St Benedict. These three churches stood at the three extremities of a vast triangle bounded by porticoes and walls, forming not an inner courtyard like that of the monastic cloisters of the later Middle Ages but a triangular area nearly 1,000 feet long on each side in which the various monastic buildings stood. The porticoes visible in the old view of the monastery form a covered walk, abutting the enclosure wall, which the monks could use in inclement weather for their morning and evening processions from the abbey church to the two other sanctuaries.

The church of Notre-Dame was a large rotunda to which was attached a rectangular part that has just been cleared in the current excavations. We know from documents that in the centre of the rotunda, beneath a gold-plated ciborium, stood the altar dedicated to the Virgin. Round the periphery stood twelve altars dedicated to the Apostles. The dome overhead was decorated with mosaics or paintings.

If the old view of the abbey gives a trustworthy picture of the main church, dedicated to the Saviour, the Virgin and St Richarius, then this great monument too was very different in design from French Romanesque churches. The main altar was at the west end of the church and stood over a crypt housing the most precious relics of the monastery. Like the other altar at the east end, it was surmounted by a 'tower' whose outward aspect resembled that of the top of the rotunda of Notre-Dame. These towers, as in the Palatine Chapel at Aachen, were flanked by turrets with spiral staircases. At each end of the church was an atrium; that at the west end formed the main entrance of the monastery. The gates were surmounted by three oratories dedicated to the guardian angels.

As for the interior of the church of St Richarius, it too was of a very unusual design. For the divine service the 300 monks were divided into three choirs, one in the centre of the nave and one at each of the two sanctuaries at opposite ends of the church, so that their alternating chants resounded throughout the vast edifice. At certain hours the service was broken by processions whose itinerary and stations

were carefully regulated. Devotions were performed at twelve altars. Three main altars, dedicated to the Saviour, the Virgin and St Richarius, were entirely faced with gold, silver and precious stones. Six 'bronze images' representing 'animals, birds and men' surmounted the columns which closed off the altar under the east 'tower.'

In addition to the twelve altars, there were four commemorative monuments inside the church, one at each of the four cardinal points; these were the principal stations at which the daily processions of the monks halted for prayer. Their decoration was no doubt similar to that of the crosses which, in the British Isles at the same period, marked the stations of the liturgical processions. But these British crosses stood outdoors and were carved in stone, while the monuments inside the church of St Richarius were made of stucco. Each of these monuments offered a representation of the scene it commemorated: at the west end was the 'Nativity,' at the east end in front of the choir, the 'Holy Passion'; on the north side of the nave was the 'Resurrection,' on the south side the 'Ascension.' They were stucco reliefs, as a text tells us, of 'admirable workmanship,' enhanced with gold, precious stones and sumptuous colours. As in Britain, there was then in Gaul a flourishing school of figural sculpture, although such imagery had been banned over a large part of Christendom at that very time by the triumph of Iconoclasm in the Eastern Church.

A remarkable feature of Centula was the town that adjoined the abbey and formed with it an imposing holy city—larger and more populous than most of the cathedral towns of Gaul at that time. The houses were built with light materials (like those shown on the plan of St Gall), so that they were probably all destroyed in the fire of 881. But texts of the early Carolingian period leave no room for doubt as to the town's size and the well-ordered layout of its streets; it must have been more like an ancient city than a straggling medieval town. According to a census taken in the year 831, it had 2,500 houses and five churches, divided into several *vici* (streets or wards), each reserved for a particular category of inhabitants. The *vicus militum* was the residence of 110 knights with a church of their own, the 'chapel of the nobles.' Of these, one hundred held benefices, while all of them owed military service to the abbey. In the other *vici* lived people of various crafts and trades, who owed the monastery services in kind corresponding to their profession. There were also merchants who had their forum or marketplace.

The holy city was surrounded by suburbs. Seven villages within a radius of four miles played a part in the liturgical life of Centula similar to that of the seven processional stations of Rome. On certain feast days the villages were visited by processions of monks and townsfolk. On other days the villagers came into town to take part in the processions held at Centula. As in Rome, all these processions kept to a strict pattern. The number 7 symbolized the seven gifts of the Holy Spirit. There were accordingly seven processional crosses, seven reliquaries, seven deacons, seven subdeacons, seven acolytes. The monks and townfolk followed seven abreast, and the hundred novices of the monastery brought up the rear carrying seven standards. Every detail was regulated, even the route taken by those on horseback.

We are fortunate in having this precise and detailed information about Centula, set down in written records. The monastery and its holy city were organized and

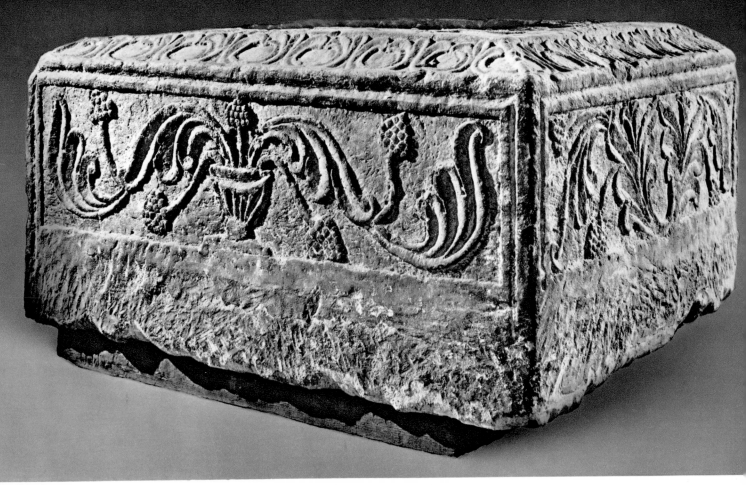

3 – SAINT-DENIS, ABBEY. COLUMN BASE. MUSÉE LAPIDAIRE, SAINT-DENIS.

their way of life regulated by their founder, Angilbert, who was appointed abbot in 790. The buildings were therefore only a few years earlier in date than the Royal Palace and the Palatine Chapel of Aachen. Centula and Aachen were virtually contemporary institutions, founded by Charlemagne or his councillors, and each sheds light on the other. For Aachen no written records remain, but the essential part of the buildings still stands. Antedating the revival of letters, eighth-century architecture, whose fine workmanship is exemplified by the column base from the abbey church of Saint-Denis consecrated in 754 by Pope Stephen II, is for us the visible link connecting the Carolingian civilization with a past that is still obscure. In the history of Centula, however, one is struck by an entirely new feature. The texts show that, alongside a nascent feudalism, there was a very strict organization of civil and religious activities, so strict as to smack of military discipline. The same observation has been made regarding the monastic institutions established by Benedict of Aniane. The civilizing achievements of the Carolingian dynasty cannot obscure the fact that its power rested on its prowess in war; it lost that power when it ceased to be capable of answering violence with violence. We have no very clear idea how, in the early years of the ninth century, the Carolingians assembled the talent required to set up ateliers of calligraphers, painters, ivory carvers and goldsmiths who at once produced masterpieces. Strict discipline was probably a significant factor.

CHARACTERISTICS AND SOURCES
OF CAROLINGIAN ARCHITECTURE

The buildings of Centula and Aachen prove that, during the long interval separating antiquity from the Middle Ages, there was a brief period of time—about three centuries after the fall of the Roman Empire, and about three centuries before the first Gothic cathedrals rose into the sky—when Gaul produced a well-ordered architecture, capable of covering wide spans with vaulting and designed on a scale that aspired to give men the taste for grandeur. At no other stage in the formation of Europe was architecture so directly and forcibly the expression of a political ideal.

In the Merovingian period there had indeed been an architecture worthy of the name, but there had been no distinct art form styled to reflect the aspirations of the Merovingian dynasty. Now, on the contrary, there appeared under Charlemagne a specifically Carolingian architecture, a court art whose full development took place after the publication of the *Libri carolini* shortly after 790, and which continued into the reigns of Louis the Pious and Charles the Bald. This court art soon spread far and wide, for the prelates and palatines of the Emperor's entourage imitated it in the buildings which they themselves sponsored. The workshops, being few in number, moved from place to place as the need arose; this is proved by characteristic similarities of design and decoration at Aachen, Saint-Médard of Soissons, Ingelheim, Regensburg and Germigny-des-Prés. The heavy labour was done by local workmen, and the bishops did not fail to complain when, as occasionally happened, too much was asked of their diocesans. These similarities among widely distant monuments provide some valuable clues to an art that has become much better known due to excavations carried out since World War II. Very few Carolingian monuments have survived in their entirety, but the remaining vestiges often enable us to reconstruct the ground plan or even in part the elevation of a vanished building. Many of these buildings can be accurately dated, and sometimes the purpose and circumstances of their construction are known thanks to an abundance of documents which make the history of the Carolingian period easier to write than that of the early Capetians.

Wall Painting

Before considering in detail the different elements of Carolingian architecture as shown by the monuments themselves, something must be said about one of its highly original features. We can still admire the church books of the ninth century with their magnificent illuminations and beautiful handwriting. All evidence seems to indicate that churches and palaces were also painted in bright colours skilfully

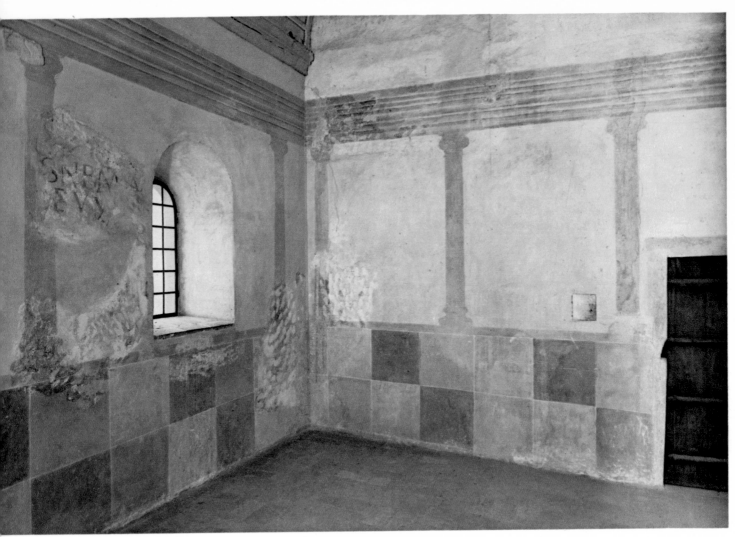

4 – LORSCH, ABBEY GATEWAY. PAINTED DECORATION, UPPER HALL.

combined in decorative patterns or narrative scenes. Such paintings were described by the poet Ermoldus Nigellus in his *Life of Louis the Pious*. He vaunted not so much the palace itself, which had been built and decorated for this ruler at Ingelheim near Mainz, as the paintings that covered its walls. The large frescoes in the Imperial Hall depicted the epic and legendary history of the Franks from antiquity to the conquests of Charlemagne. The nave of the palace church was decorated, symbolically, on one side with Old Testament scenes, on the other with Gospel scenes. (The religious iconography of the Carolingian period was at once stricter and more varied than that which we see in later Romanesque frescoes.) For the Ingelheim frescoes Alcuin, Theodulf and Florus of Lyons composed painted inscriptions which in some cases show an impressive elevation of thought. Were the paintings themselves, to which the inscriptions refer, informed by anything like the same grandeur? For a long time this seemed hard to believe, but today, in the light of the magnificent sets of paintings discovered at Lorsch, Saint-Germain of Auxerre, San Satiro of Milan and St Maximin of Trier, it can no longer be doubted.

5 – AUXERRE, SAINT-GERMAIN, CRYPTS. VAULT DECORATIONS. ▶

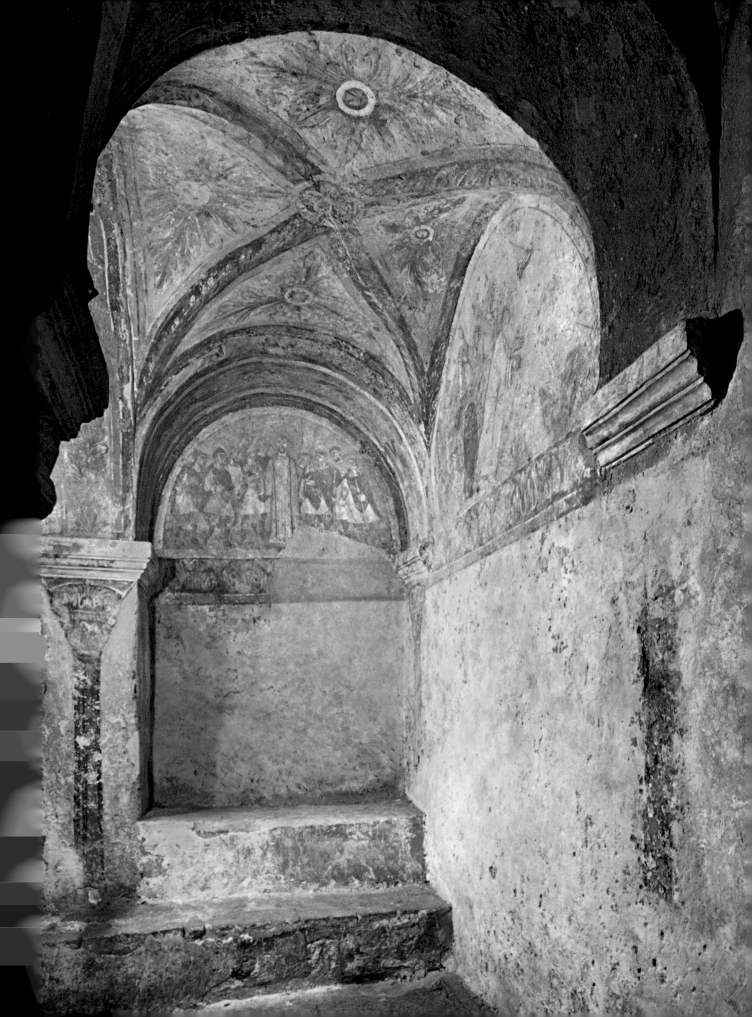

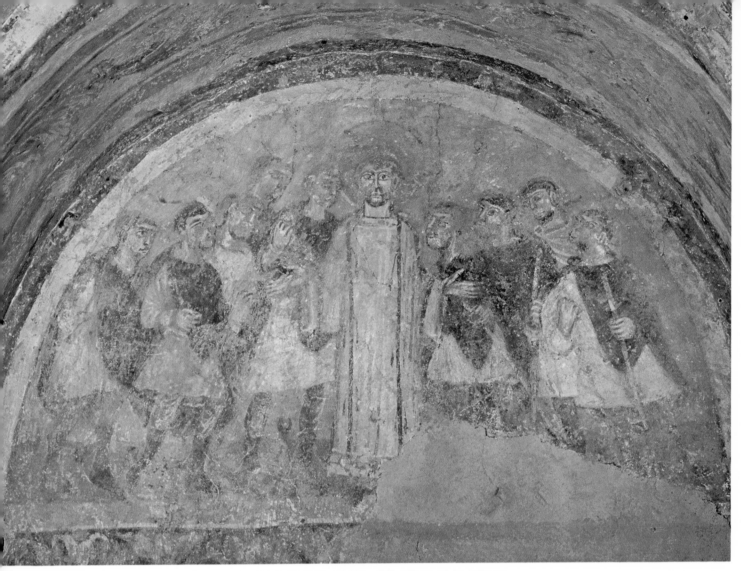

6 – AUXERRE, SAINT-GERMAIN, CRYPTS. THE ARREST OF ST STEPHEN.

The gateway of the monastery of Lorsch, which the Germans call the *Torhalle* and which appears to date from the early ninth century, is designed in imitation of a Roman triumphal arch with three archways. It stands alone on the west side of the vast atrium in front of the monastic church, as the antique triumphal arch stood at the entrance of a forum. This complex falls short of the perfection achieved by the Romans in the first centuries of our era, but it aspired to the same ideal of grandeur.

On the upper floor of the gateway is a large hall thirty-three feet long and twenty-three feet wide. Its exact purpose is not known. It may have served as a reception hall when the emperor, exercising his privilege as the founder, came to stay at the abbey, for kings often had living quarters of their own at the entrance of monasteries. It may also have served as audience hall for the abbot, as did that at Saint-Riquier. This would have been in keeping with an old tradition, for we know that at Reims in the seventh century the bishop lived over one of the town gates. In any case the paintings in this hall, discovered underneath some medieval frescoes at the beginning of this century, evoke most impressively the majestic forms of ancient palaces.

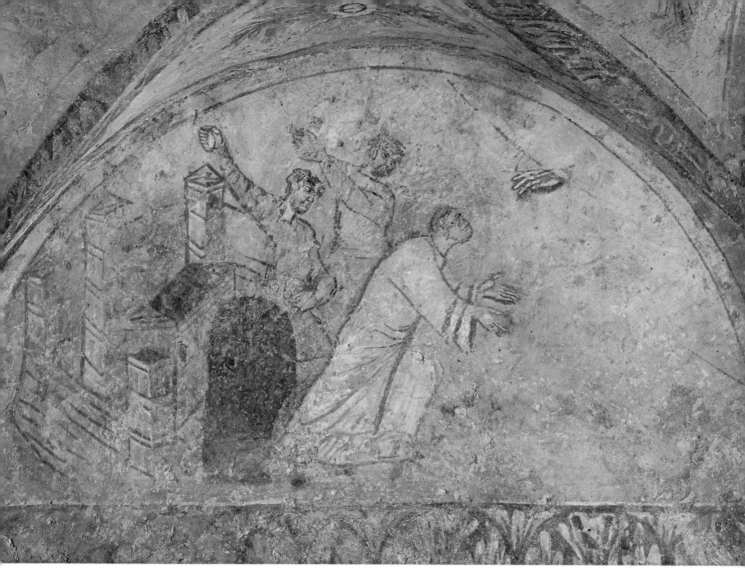

7 – AUXERRE, SAINT-GERMAIN, CRYPTS. THE STONING OF ST STEPHEN AT THE GATES OF JERUSALEM.

Probably nowhere else do we get so vivid an idea of the setting of palace life in Carolingian times, for these remarkably well-preserved wall paintings are like a stage momentarily deserted by the actors. They are illusionistic paintings, in the manner of so many ancient Roman frescoes. They show a delicately moulded architrave carried by marble columns resting on a low wall. Squares of two colours form a chequer pattern on the wall. The same chequerwork appears on the ground floor of the eleventh-century narthex at Tournus, and subsequently in many decorative paintings of the Middle Ages. There is unfortunately no way of telling whether the Lorsch paintings represent a survival or a deliberate renaissance of antique art.

At Auxerre, however, the wall paintings in the crypt of Saint-Germain have an unmistakable originality. These remarkable scenes, brought to light by René Louis in 1927, were painted expressly for the 'admirable series of crypts' (in the words of a contemporary chronicler) which were consecrated in 865. They are not the work of one painter or one workshop. The latest of them appear to be the figures of several bishops of Auxerre painted life-size on the outer wall of the *confessio* contain-

9

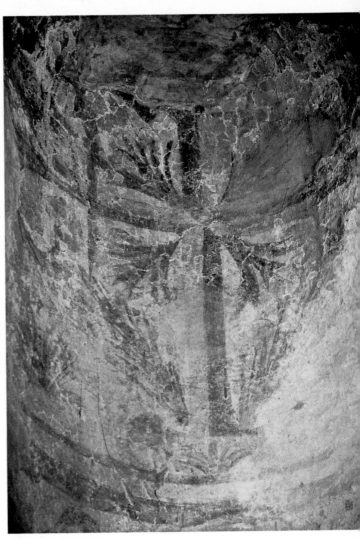

8 – AUXERRE, SAINT-GERMAIN, CRYPTS. DECORATIVE PAINTING.

9 – MILAN, SAN SATIRO, PIETÀ CHAPEL. DECORATIVE PAINTING.

ing the body of St Germanus—silent guardians, as it were, of their own tombs hidden from view under the pavement of the crypt and around the saintly remains of the holiest of their predecessors. The three episodes from the life of St Stephen painted in the north ambulatory may well be prior to 857, the year Bishop Heribald died. For this prelate is known to have donated a silver altar, dedicated to the patron saint of his cathedral and placed under the fresco representing the arrest of St Stephen. This piece of information is all the more valuable since the same bishop is said by a contemporary chronicler to have had his cathedral adorned with 'most beautiful paintings.' The Carolingian cathedral of Auxerre dedicated to St Stephen no longer exists, but the Saint-Germain frescoes show that the mural painters of this period could surpass the illuminators in skill and imagination. Some analogies have been rightly drawn between these frescoes and manuscript paintings from the scriptorium of Saint-Denis. But in the ninth century, and later as well, mural painters must have specialized, since they had their own techniques and conventions. Significant in this respect is the scene of the stoning of St Stephen. All the most

10

emphatic lines, both in the figures and in the architectural elements evoking Jerusalem, run parallel to the oblique lines of a grid easily reconstituted on the basis of the half-square in which the circumference of the arch is inscribed. The beauty of the two figural scenes reproduced here is so evident to the visitor that they scarcely call for comment. Another scene represents St Stephen being questioned by the judge: this, in my opinion, is the most moving of the three. Unfortunately it is all but effaced. As in the other two scenes, one is struck by the variety of expression given to the faces. On this score the Auxerre paintings are superior to the best frescoes of the twelfth century. The realism of this Carolingian figural painting had its origin in the practice of portrait painting which had been maintained in Italy and possibly Gaul as well since late antiquity. (Many of the admirable ruler-portraits in Carolingian manuscripts seem to have been painted from life.) The Auxerre painter's evident sincerity and directness did not, however, exclude convention, since he did not scruple to paint a simulated capital under a real abacus of stone. This feature of the Auxerre paintings is very much in the spirit of those in the Lorsch gateway. Another of their features—the decorative arabesques setting off the architecture of the vaulting—links them with the frescoes in San Satiro, Milan, which are only slightly later in date.

The crypt paintings in St Maximin of Trier, which were probably executed soon after the Norse invasion of 883 and certainly before the partial collapse of the church in 943, may be likened to Romanesque frescoes in their uniformity of facial expression, but the Crucifixion scene still retains much of the Carolingian vigour in its composition and colour scheme.

By this time, the end of the ninth century, the best workshops had moved for safety far away from the river valleys most exposed to Norse raiders, as Mme Gaborit-Chopin has recently shown conclusively redating to the last quarter of the ninth century the very fine Gospel Book of Saint-Martial of Limoges, which hitherto had been attributed to a painter of around the year 1000.

Mosaics

Wall mosaics, more dazzling than frescoes, were used in church architecture from Early Christian times to the ninth century, both in Italy and in Gaul. It is not known, however, whence came the mosaicists who were employed by Charlemagne to decorate the dome of the Palatine Chapel at Aachen and by the councillor Theodulf to decorate the apsidal vault and some of the walls in the oratory of his country residence at Germigny-des-Prés. Unfortunately the large Aachen mosaic, showing an over-life-size figure of God enthroned opposite the imperial loggia and surrounded by the twenty-four elders of the Apocalypse, is known to us now only from a print by Ciampini, a seventeenth-century sketch by Peiresc and a few short descriptions. Its iconography was traditional in Italy, but the mosaicist's colours

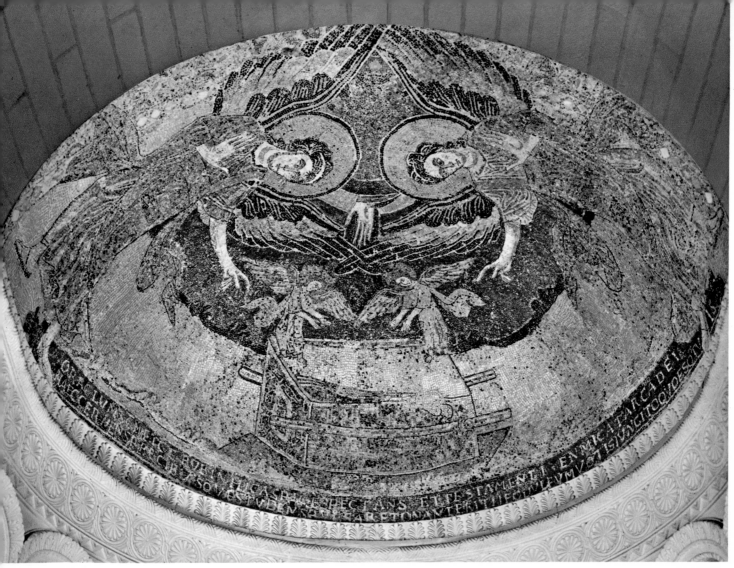

10 – GERMIGNY-DES-PRÉS, CHURCH. APSE MOSAIC.

seem to have been richer and more numerous than those of contemporary mosaics in Rome. At Germigny-des-Prés all that remains after many restorations and the reconstruction of the oratory is the main apse mosaic, but some years ago I published some early copies which give us an accurate picture of the lost mosaics.

It is instructive to compare the Germigny-des-Prés mosaics, finished about 806, with those in the church of Santa Prassede in Rome, commissioned by Pope Pascal I (817–824); these are the finest of ninth-century Roman mosaics. The two works differ in technique, and their only iconographic feature in common is the representation on the intrados of the vaults of worshipping cherubim, each with a double pair of outspread wings. The two works are very different, and each has its particular merits. The inspirer of the Germigny-des-Prés mosaics—undoubtedly the poet Theodulf himself—must be credited with having sought to convey in them a philosophy of his own, one that was not without affinities with contemporary aniconic theories. This point has been well brought out by André Grabar. The general theme was an evocation of the Paradise promised to man, with its flowers, trees and angels, from

11 – GERMIGNY-DES-PRÉS, CHURCH. APSE MOSAIC, DETAIL. ▶

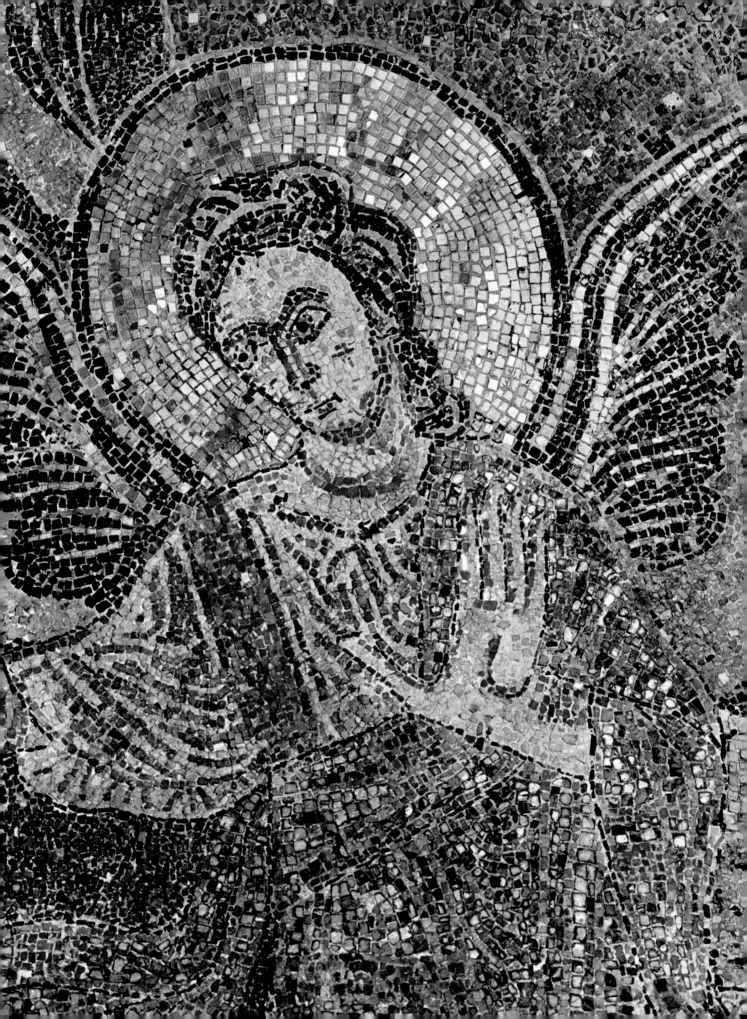

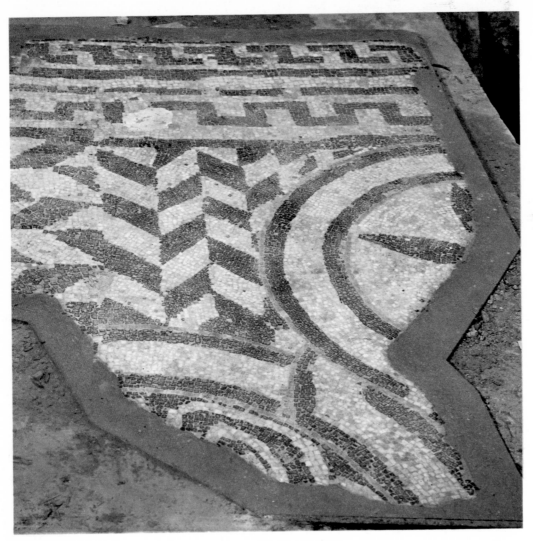

12 – SAINT-QUENTIN, COLLEGIATE CHURCH, CRYPT. MOSAIC PAVEMENT.

the time when God (represented by the divine hand issuing from a cloud) gave the Israelites the Ark of the Covenant guarded by two angels. The divine hand and the Ark figured in the apse mosaic, Paradise in the wall mosaics around the altar.

This outstanding work shows no trace of Byzantine or Roman influence, and its subtle iconography had no effect on any subsequent work. It must be remembered that the Germigny-des-Prés church was not designed for crowds of worshippers. It was the private oratory of the most cultivated member of Charlemagne's entourage. Judging by the poems he wrote, Theodulf was a genuine lover of art, a dilettante who knew, for example, how to interpret in choice and scholarly terms the representation of the Earth and the World which he had had painted on the walls of his villa. Although it is clear from his description of this painting that it was based on antique models, there were other sources of inspiration as well. In the main apse of the oratory there was a blind arcade, each arch of which was decorated in mosaic with a large-petalled, highly stylized flower which has been designated as the 'Sassanian palmette.' True, this motif occurs in Iranian art from very early times. But it passed

into the decorative repertory of the Arabs, and it must have reached Germigny-des-Prés by way of Moorish Spain. Theodulf as a child had lived further south, close to Spain. He was a native of Septimania and his parents were Goths. Several Carolingian manuscripts of the ninth century, in particular the Gospel Book of Lothair, contain pictures of pointed arches, multifoils and characteristic ornaments undoubtedly deriving from Umayyad art; by what channels these alien forms were transmitted to Gaul it is impossible to say.

From the British Isles, Septimania, Italy and Rome, Charlemagne summoned clerics of high repute to become his collaborators. It was as if he were trying to regain control of the driving energies of the lands that had once formed the Roman Empire. What has been said above about wall paintings and mosaics shows the variety of sources on which Carolingian art drew, but also the freedom with which the chief men of the kingdom handled art forms and shaped them to suit their purposes. It must not be supposed, from the high quality of these works, that the Carolingians ever practised 'art for art's sake.' On the contrary, it would appear that everything was made to answer to a religious or political purpose.

Of the mosaic pavements in Carolingian churches and palaces, there remain only a few vestiges. Those that have come to light at Saint-Quentin and Aachen testify to the survival or revival of antique practices.

EXAMPLES AND MODELS FROM NORTH ITALY

In the previous volume of this series, in dealing with the 'crypt' in the church of Saint-Laurent at Grenoble, I pointed out how much this late eighth-century monument has to tell us about the origins of Carolingian architecture. The superimposed orders of engaged columns and colonnettes, the wall ribs (formerets) and the stucco decorations reappear at Germigny-des-Prés. Now, these elements of early medieval architecture came not from the North but from Lombardy. The same is true of the triapsidal choir. This type of chevet existed at Parenzo as early as the sixth century; by the eighth it had spread to Italy, Switzerland and Gaul. The main road taken at that time by travellers from northern Gaul to Italy ran through Switzerland. It is on this road that we find the main evidence for the extension northwards of forms already established along the Mediterranean and the Adriatic.

Many factors favoured this northward migration of forms, beginning in the eighth century with the reigns of Pepin and Charlemagne. The introduction of the Roman liturgy into Gaul was one episode in a political undertaking which, carried out with remarkable foresight and consistency, cemented a close alliance between the early Carolingians and the papacy. Continual embassies and journeyings to and fro established almost unbroken relations between Rome, Saint-Denis and Aachen. Further exchanges arose from the founding of many monasteries by Franks in Italy in the late eighth and ninth centuries. To give an idea of the level reached by the

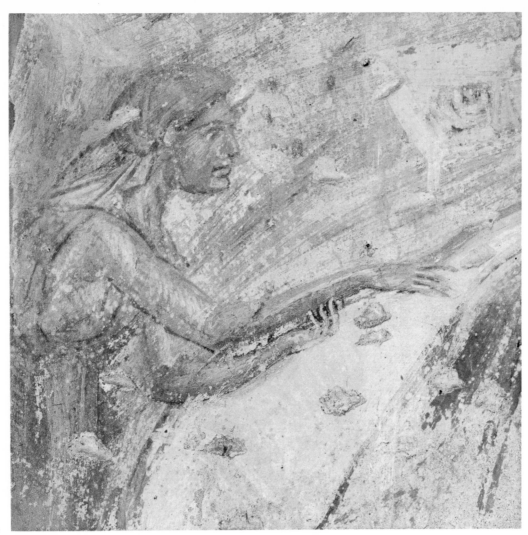

13 – CASTELSEPRIO, SANTA MARIA FORIS PORTAS. NATIVITY, DETAIL.

arts in Italy at that time, it is enough to cite the discoveries of wall paintings made in recent years in Santa Maria Foris Portas of Castelseprio, San Salvatore of Brescia, San Benedetto of Malles and the Johanneskirche of Müstair: all are highly significant.

As related in our previous volume, the choir frescoes in the church of Santa Maria Foris Portas at Castelseprio in Lombardy were discovered by chance in 1944. This remote country town was once the summer residence of the archbishops of Milan. The Castelseprio frescoes are among the pinnacles of Christian art but cannot be dated with precision: they may have been painted at any time between the early eighth and the late ninth century. The technique bears the obvious mark of Byzantine training, but the mistakes made in the lettering of a Greek inscription indicate that the artist must have been a Latin. Two other features conform to Western usage: certain iconographic details in the scenes of Christ's childhood and the arrangement of the scenes in superimposed registers, like the Müstair paintings and the later frescoes of the Ottonian school.

14 – CASTELSEPRIO, SANTA MARIA FORIS PORTAS. ADORATION OF THE MAGI. ▶

16

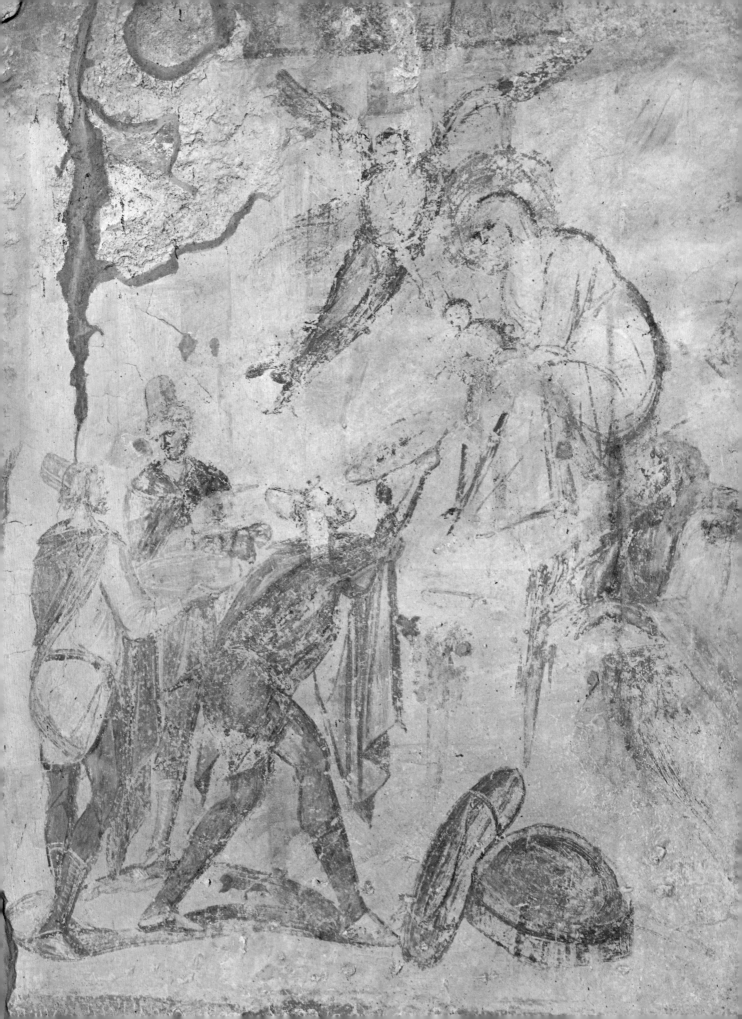

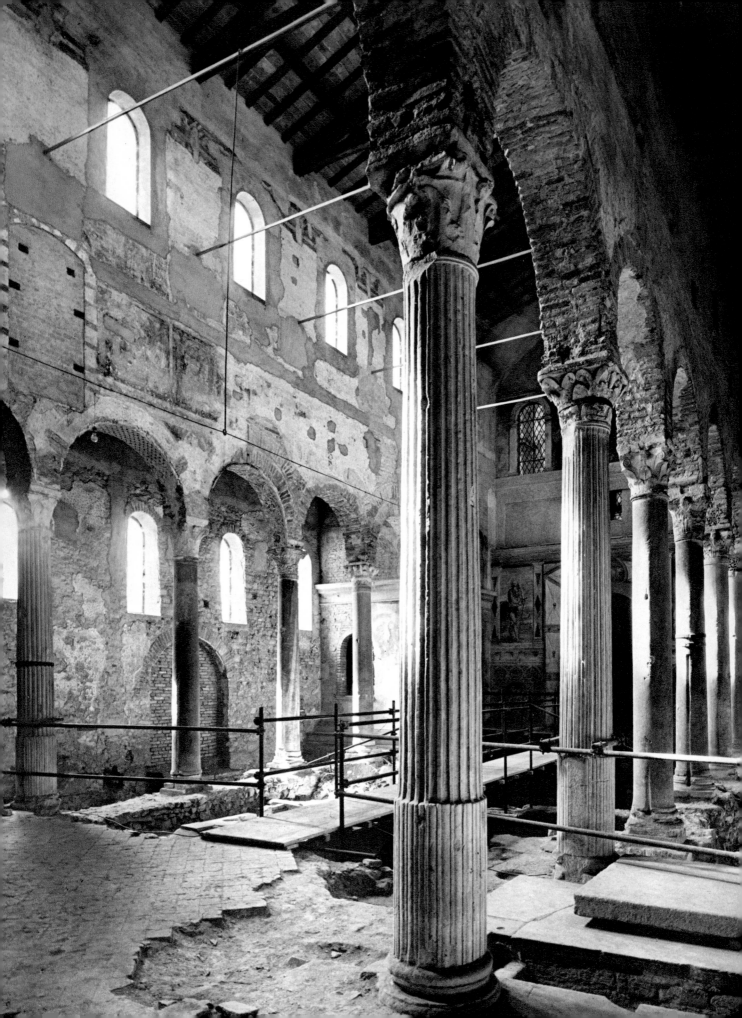

There can be little doubt today that southern Italy, steeped as it was in the Byzantine civilization, played a very important part in transmitting a knowledge of Byzantine art to the workshops of north Italy and Gaul. It seems to me that the stuccoes and frescoes of Santa Maria della Valle of Cividale tell the same story. In Constantinople the Iconoclast controversy had thrown many artists out of work, and some of them must have taken refuge in Italy. This influx of foreign masters gave new life and vigour to Western art. The Adoration of the Magi at Castelseprio, a work of sovereign grandeur, remains in our memory as the symbol of this upsurge of Western painting, of which Carolingian book painting represents another aspect.

A few years ago a series of wall paintings and stuccoes was methodically cleared in the church of San Salvatore at Brescia, which was part of a monastery founded in the eighth century and rebuilt in the ninth, probably in the reign of Louis the Pious. The church is a basilica of grandiose proportions. The nave and side aisles are covered with a timber roof. The nave arcading consists of semicircular arches supported by fluted columns, some of which, together with nearly all the capitals, were taken over from ancient monuments.

The church was decorated with both paintings and stuccoes, the latter of remarkable workmanship. They adorn the intrados of the semicircular arches in the nave, in accordance with a long-standing tradition of which the most famous examples are at Ravenna and date from the sixth century. The patterns obtained by modelling the stucco are astonishingly varied, ranging from woven designs to stars. Some patterns recall in more rustic form the stuccoes in Santa Maria della Valle of Cividale. Whatever may be the date of the Brescia stuccoes, it is impossible to attribute them to artists hailing from Gaul. Nor are they related to any known Roman works. They must have been made by one of the many local workshops active at that time in northern Italy, where religious architecture was then enjoying a vigorous revival.

The same remarks apply to the Brescia paintings, which were brought to light in the nave above the arcading. Like many Early Christian churches, the basilica of San Salvatore was expressly designed so as to leave plenty of room for wall paintings between the nave arcading and the upper windows. The fine drawing and vivid colouring of these frescoes can be seen from the ones that have come down to us in a good state of preservation.

At Malles, in the Italian Tyrol, a few of the wall paintings decorating the oratory of the monastery of San Benedetto have survived. Its closure slabs and some of the strange and precious stuccoes in high relief, which adorned the east wall, are now preserved in the Bolzano museum. The oratory consists of a single rectangular hall with a timber roof. In one feature, however, its plan is highly original. Recessed into the west wall are three tall niches forming apses and housing three altars. In so small an oratory one altar would have sufficed. Clearly then, at the time of its construction in the early ninth century (the dating suggested by the carving of the closure slabs), a special point was made of placing three altars side by side, and even giving this arrangement an architectural setting: the altars were enclosed by stucco columns carrying elaborately decorated arches. This monumental ensemble marks,

◀ 15 – BRESCIA, SAN SALVATORE. INTERIOR.

19

16 – BRESCIA, SAN SALVATORE. FRESCO, SOUTH WALL.

as it were, the first step in the direction of the great altarpieces of the later Middle Ages.

This piece of stuccowork is of particular interest, for it may possibly represent a replica in popular style of the great altar enclosures with marble columns and bronze figures which, as we know from documents, could once be seen at Saint-Riquier and other monastery churches of the ninth century. The columns at Malles, some with flutings, others with interlace patterns, are accompanied by crouching quadrupeds (lions and panthers); on the upper parts are spirited caryatid figures. The Malles oratory stands on what once was a busy highroad over the Alps; the fact that this route later was used infrequently saved these priceless decorations from destruction. They were executed by a highly skilled workshop which must have produced many others. The art of stucco carving was a legacy of late antiquity. Being easy to practise, it may not have led to the creation of masterpieces, but it did play a key part in transmitting the traditions of ancient sculpture and high relief carving. The almost complete destruction of these fragile works is a great loss for archaeology.

17 – BRESCIA, SAN SALVATORE. FRESCO, FRAGMENT. MUSEO CRISTIANO, BRESCIA.

All these stuccoes were painted. At Malles, as at Cividale, polychrome stucco-work alternated with paintings of figures or scenes. A large figure of Christ was painted over the main altar. He is represented standing, holding an open book and flanked by two angels. Above the side altars the figures of St Stephen and St Gregory can be made out. In the space between the main altar and the two secondary altars, two standing figures are represented. One is a churchman, his head set off by a square nimbus; the other is a bare-headed warrior, holding with both hands a heavy sword sheathed in its scabbard. It has been assumed, no doubt rightly, that this churchman and knight were two donors, or rather—since the former is shown holding a model of the church—the founders of the Malles monastery, which provided accommodations for travellers making their way over what was then the main road between Switzerland and northern Italy.

The faces of these two figures give the impression of being portraits, and the painting, full of subtle gradations, gives the illusion of life. No such pictures of living people appear on the walls of Romanesque churches, for by then the art of portrai-

21

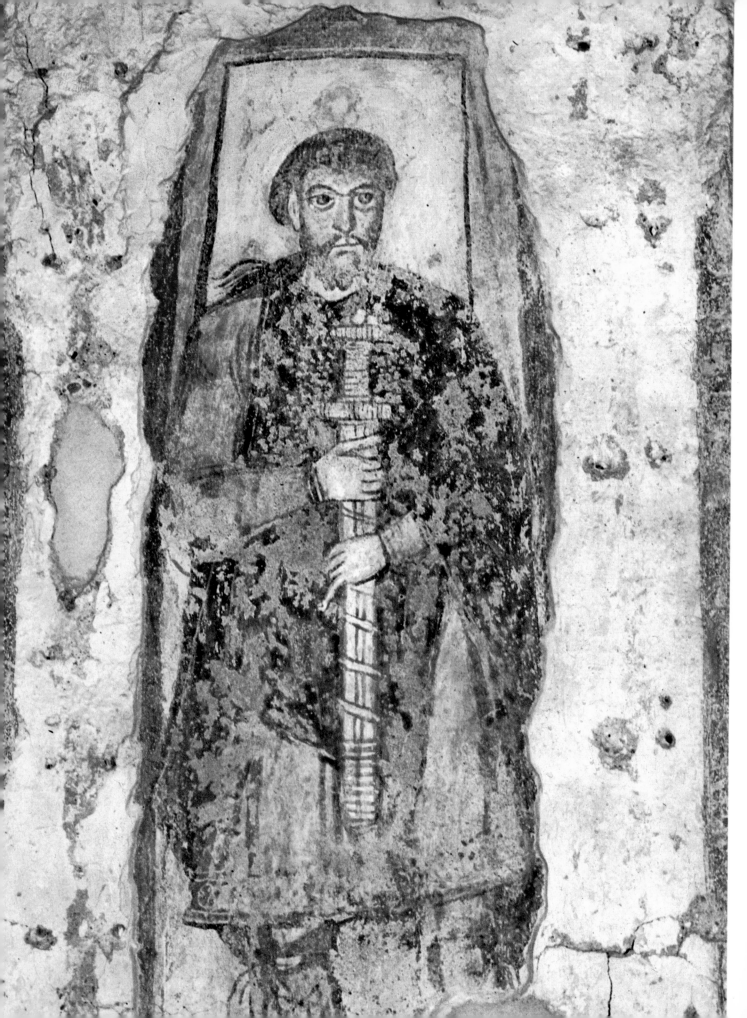

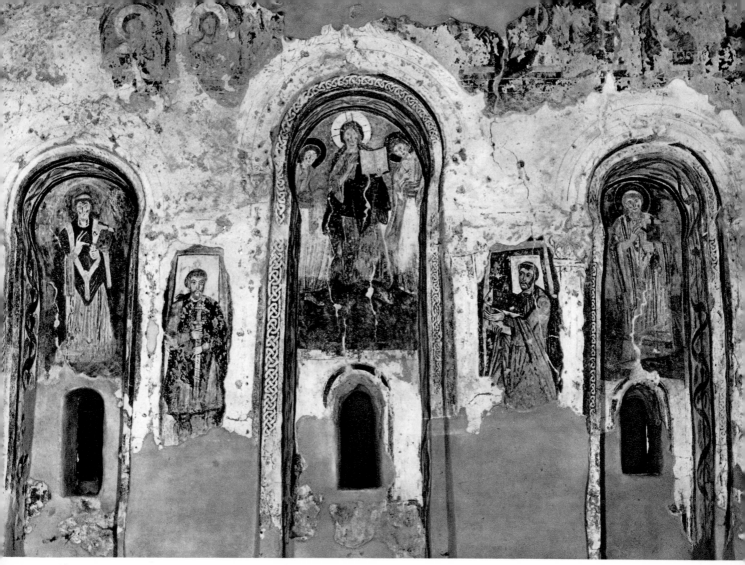

19 – MALLES, SAN BENEDETTO, EAST WALL.　NICHES FORMING APSES.

ture had been lost, not to be revived in France until the early fourteenth century.

A short distance to the west of San Benedetto of Malles stands the Johanneskirche, the abbey church of St John, at Müstair in the Grisons. Founded in the early years of the ninth century, it was patronized by Charlemagne himself. Even so, both architecture and decoration are characteristic of this part of Switzerland bordering on upper Italy, which still preserves precious vestiges of its early medieval art at Disentis, Chur and Schänis. Another church in the Grisons, at Müstail, picturesquely situated on a mountainside, does not go back beyond the early Middle Ages; its apse is so close an imitation of that of the Johanneskirche at Müstair, built two centuries earlier, that we are justified in regarding this as the standard type of church in the architecture of this region.

The Johanneskirche reproduces the very simple plan of San Benedetto of Malles, but on a scale of uncommon size. In the fifteenth century the building was divided into nave and side aisles by two rows of columns, these being installed to support the cross-ribbed vaulting which then replaced the timber roof. Originally the church

◀ 18 – MALLES, SAN BENEDETTO, EAST WALL.　A DONOR.

20 – MÜSTAIR, JOHANNESKIRCHE. FRESCOES, NORTH WALL.

was a very large rectangular hall church, nearly sixty feet in width and correspond-
ingly high. This large hall ended on the east side in three apses of equal depth,
which projected outside beyond the hall itself. As at San Benedetto of Malles,
the apses rise to such a height above ground level that they are more like the niches
of ancient monuments than the apses of Romanesque churches. Crowning them is a
lofty semidome obviously intended from the start to contain a vast fresco whose
every detail should be clearly visible throughout the church. The side walls were
pierced with rather narrow windows, so that a considerable surface area remained
for the wall paintings. These were arranged in a long series of rectangular panels,
extending from the floor to roof level. This type of hall church was clearly designed
with a view to making the most rational use of wall painting. In what remains of the
Carolingian construction, there is no trace of any stone carvings or mouldings.
It is possible, however, that before the extensive interior alterations of the fifteenth
century there were stucco decorations on the east wall similar to those in San Bene-
detto of Malles. (In one of the former abbey churches at Disentis, also in the Grisons,

21 – MÜSTAIR, JOHANNESKIRCHE. FRESCOES, NORTH APSE. ▶

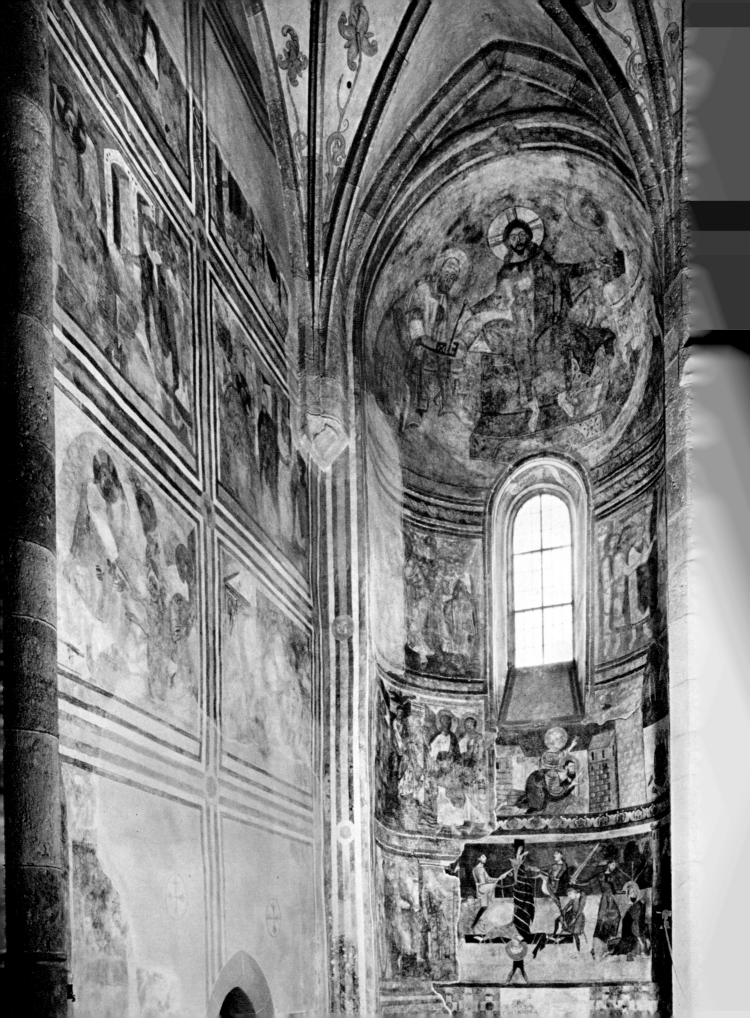

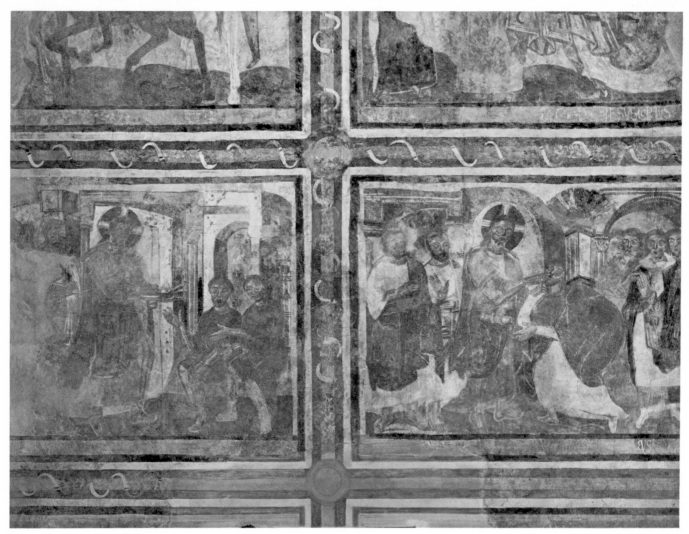

22 – MÜSTAIR, JOHANNESKIRCHE, NORTH WALL. SCENES OF THE LIFE OF CHRIST, DETAIL.

about one hundred miles distant from Malles and Müstair, various stucco fragments have been found, some from friezes, some representing the heads of figures; they were undoubtedly part of the church decorations. Of rather uncouth workmanship, they still show touches of bright colour.)

The square tower standing on the south side of the chevet of the Johanneskirche is a twelfth-century addition. The two galleries, however, which ran along the north and south side walls were of early medieval construction. They represented a belated form of the side porches of early basilicas; such porches were a common feature of the churches of Gaul in Merovingian times, as shown in the church plans grouped together in our previous volume. Here the open gallery became an oratory, while no doubt retaining its funerary character.

Ninth-century paintings were brought to light in the Johanneskirche under the medieval frescoes which had been painted over them. They would have been of inestimable value to us, were it not that in all too many places they have been over-restored, to an extent that has completely changed their character. But the overall

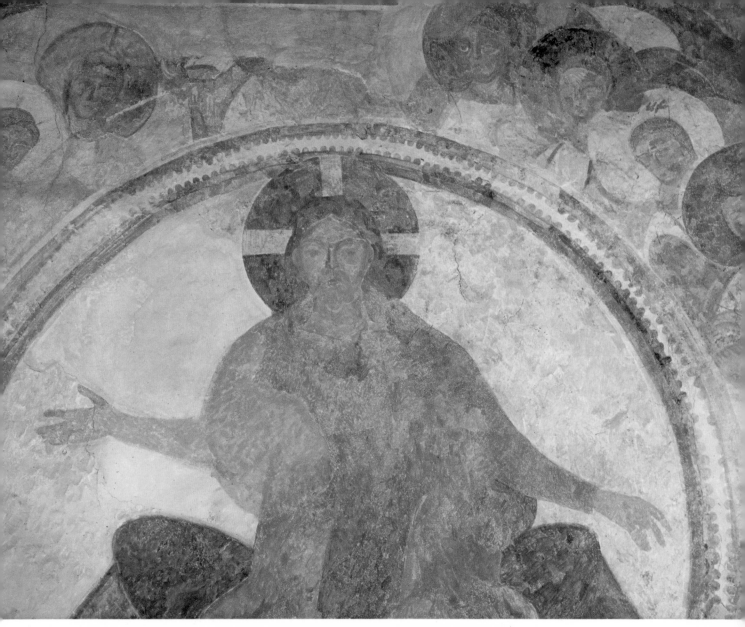

23 – MÜSTAIR, JOHANNESKIRCHE, WEST WALL. THE LAST JUDGMENT, DETAIL.

effect remains, and it is impressive. By the early ninth century wall painting had become a means of edification and instruction comparable to the book. The pictures painted in the nave of Old St Peter's in the time of Constantine the Great or the large fifth-century mosaics decorating Santa Maria Maggiore in Rome had none of this imposing and insistent continuity.

The arrangement of the Müstair paintings in a long series of rectangular panels perpetuated the compositional principle which had already been adopted at Santa Maria Foris Portas of Castelseprio and anticipated that of the Ottonian paintings in churches of the Lake Constance region. The side walls represent scenes from the Old and New Testaments; among them are also a few scenes from saints' lives. The west wall is covered with a huge composition representing various episodes of the Last Judgment: above, the return of the Son of Man, the angel sounding the

trumpet and the dead rising from their graves; lower down, Christ the Judge, enclosed in a circular glory and accompanied by the Apostles. It is difficult to give a fair appraisal of these paintings, which are much less proficient than those in San Benedetto of Malles and which yet leave the impression of a grandiose work. The colours, in which browns and ochres predominate, are lustreless. Faces are rough and churlish. Yet this rather uncouth art has a grandeur of its own, due to the skilful design of the composition as a whole and its architectural character. The influence of northern Italy can also be seen—indeed it predominates—in the stone carvings of the sanctuaries.

The sanctuary round the altar, where the priest officiated, was separated from the worshippers in the nave by chancel parapets or closure slabs. Such partitions became a prominent feature of monastery churches and cathedrals; they marked the limit of the 'choir' of monks or canons assembled for the divine service or the sacred chants. These screens, consisting of upright slabs fitted together and held in place by grooves and tenons, were an ideal medium for ornamental carvings. So was the ambo, the stone pulpit facing the congregation assembled in the nave; so too was the ciborium, the canopy placed over the altar, which was sometimes made of metal but usually of stone. Since the most venerated object in the whole church was the altar, it was often covered in the Carolingian period, like the shrines containing saints' relics, with sheets of gold or silver with elaborate repoussé work; such was the altar given to Saint-Denis by Charles the Bald, whose beauty and richness can be seen from a fifteenth-century painting in which it is represented (see p. 251). It is known from written records that the choir of Saint-Denis was decorated with bronzes and ivory carvings; of these splendid fittings nothing remains.

What has survived however, over a large part of Europe (Italy, Switzerland, Germany, France), is a number of carved closure slabs from eighth- and ninth-century churches. Their patterns of interlaces, spirals and vine scrolls, though often fascinating in their virtuosity, are in sharp contrast to the still classical elegance of the marble slabs of the sixth-century churches in Ravenna. The carving of interlace patterns is not, as was long supposed, a creation of the Carolingian renaissance. It has now been established beyond doubt that the Carolingians borrowed this design from northern Italy and gave it a prominent place in the art of Gaul by using it for the adornment of their renovated or newly founded churches.

The only closure slab whose design—and a most remarkable one it is—can be attributed to the Carolingian renaissance, or at least to the ingenious activity of the workshops in or around Metz in the late eighth century, is the one from the former monastery church of Saint-Pierre-en-Citadelle at Metz. Its style is so directly inspired by themes of Early Christian art that archaeologists used to date it to the seventh century. That this dating was erroneous has been shown by the recent discovery of some slabs carved by the same workshop; they come from the church of a monastery founded in 783 in the royal villa of Cheminot, quite close to Metz.

Several hundred closure slabs carved with interlaces or braid designs are now known to exist. Many of them had been reused as paving slabs, with the carved

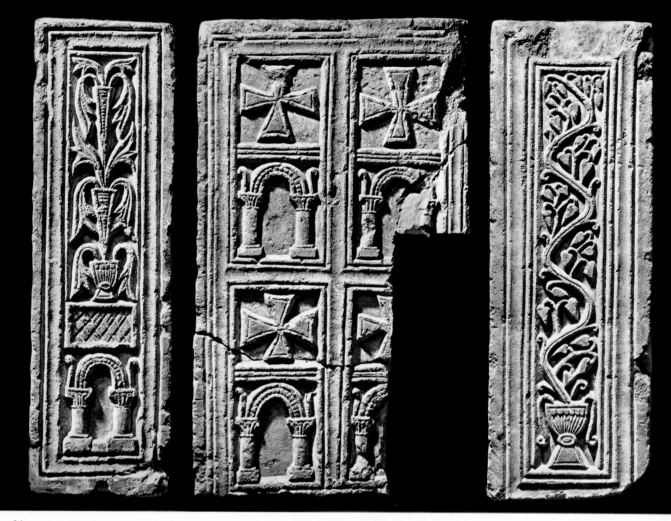

24 – METZ, SAINT-PIERRE-EN-CITADELLE. CLOSURE SLABS. MUSÉE CENTRAL, METZ.

side turned face down and thus preserved intact. The same decorative patterns occur in many different places and countries, sometimes at a great distance from each other. How is this to be explained? Research work has been carried far enough for a plausible hypothesis to be put forward.

By pinpointing on a map all the places where these carvings have been preserved, we find that they extend over an area including northern and central Italy, Switzerland, Gaul, Istria, Austria and southern Germany. The densest concentration lies in the vicinity of the famous quarries (still being worked today) at the meeting point of the present frontiers of Italy, Switzerland and Austria. The earliest stone carvers must have set up their workshops here, near the quarries, and exported their products far and wide, by land and sea, following the economic practice of antiquity. The exported carvings were copied locally, and these copies were imitated in turn by other workshops. This would explain the wide uniformity of a decorative design formerly attributed to the genius of the barbarian artists of northern Europe. The investigations of Raffaele Cattaneo, Maurice Prou and Nils Åberg have thrown light

26 - AIX-EN-PROVENCE. CLOSURE SLAB. MUSÉE GRANET, AIX-EN-PROVENCE.

on the origin of this design: it stems from the rustic imitation of models provided by Syria and Byzantium, and transmitted by way of Istria to the northern Adriatic.

The chronology of these carved closure slabs can now be established with sufficient accuracy to show the slow evolution of this craft industry, which has to its credit such fine works as the Aix-en-Provence slab.

The oldest known carving of this type served in the decoration of the tomb of St Pontius (Pons) at Cimiez near Nice. An inscription records that the tomb was restored at Charlemagne's behest some time after the year 775. The same carvers decorated the wall-niche tombs installed at that period in the baptistery at Albenga.

Several other works can be dated with certainty to the first quarter of the ninth century. First of all, there are the closure slabs which in our time have been employed to adorn the altar of the crypt at Schänis in eastern Switzerland; they stood originally in the abbey founded here shortly after 800. One of the Schänis slabs is very similar to that of San Benedetto of Malles, which is now in the Museo dell'Alto Adige at Bolzano. Then, further south in Italy, the ciborium in Sant'Apollinare in Classe,

◀ 25 – MALLES, SAN BENEDETTO. CLOSURE SLAB. MUSEO DELL'ALTO ADIGE, BOLZANO.

27 – SCHÄNIS, CHURCH, CRYPT. CLOSURE SLABS RE-USED AS AN ALTAR FRONTAL.

Ravenna, and the Budrio cross in Emilia are dated by inscriptions to 810 and 827 respectively. Finally, in the church at Saint-Geosmes (Haute-Marne), there is a large closure slab which undoubtedly comes from the church consecrated in 886. The interlace patterns of this late Carolingian work at Saint-Geosmes are so neatly and accurately carved that they almost become monotonous. Many similar closure slabs date from this later period, with the result that in numerous regions the interlace became a stock theme of early Romanesque sculpture.

One point must be emphasized. Closure slabs with Lombard designs had become common in Gaul by the first half of the ninth century, for they have been preserved, or fragments have come to light, in many different places: Marseilles, Aix-en-Provence, Les Arcs (Var), Fréjus, Apt, Avignon, Carpentras, Vienne, Lyons, Bordeaux, Bayon, Reims. Investigations recently undertaken will reveal others. These works provide us with valuable clues. Of course Charlemagne's contemporaries, Einhard in particular, duly credited the emperor with the large buildings which he himself sponsored (the Palatine Chapel and palace of Aachen, the Ingelheim palace) and

28 – MILAN, SANT'AMBROGIO, CHAPEL OF SAN VITTORE. CLOSURE SLAB RE-USED AS AN ALTAR FRONTAL.

the projects which he initiated (like the large stone bridge over the Rhine, which remained unbuilt); but he was praised even more for the care he personally took, through ordinances and the intermediary of his *missi dominici*, to see to the restoration of any churches in his kingdom that were too poor or too decrepit to serve as worthy places for the celebration of the divine service. The carving and setting up of new closure slabs undoubtedly formed part of this vast programme of church renovation. As the marble carvers of Aquitaine had ceased all activity since the Arab incursions and the wars of Aquitaine, the field was free over a large part of Gaul for the diffusion of the interlace design from northern Italy.

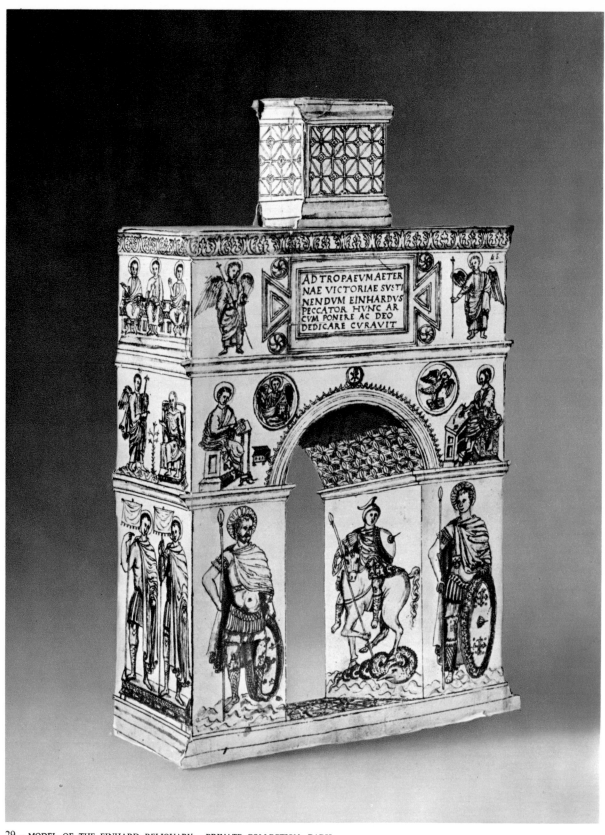

29 – MODEL OF THE EINHARD RELIQUARY. PRIVATE COLLECTION, PARIS.

THE IMITATION OF ANTIQUITY

Writing to his 'very dear son' Vussin, Einhard advised him that, if he wanted to understand certain architectural terms used by Vitruvius, he should carefully examine a reliquary adorned with ivory colonnettes which had been made by the artist Eigil 'in imitation of ancient models.' Some modern scholars have been reluctant to attach much importance to this remark—quite wrongly, for Count Blaise de Montesquiou-Fezensac has found in a manuscript in the Bibliothèque Nationale a picture of another reliquary: presented by Einhard to his abbey at Maastricht, it had the form of a Roman triumphal arch. It was made of wood plated with chased silver. On the pediment, enclosed in a clipeus, was an inscription in the antique manner recording the donor's name. This small triumphal arch carried an allover decoration. The ground area of each of its two main sides formed a perfect square, and the registers of the composition corresponded to the regular divisions of this square. While the geometry of antique models, based on the equilateral triangle, was more subtle, the decoration of the reliquary's cradle vault faithfully reproduced that of Roman triumphal arches. As Count de Montesquiou-Fezensac rightly says: 'Everything considered, what has been termed the Carolingian renaissance expressed itself not so much by the revival of this or that motif of classical antiquity or the Late Empire, which may never have quite died out in Gaul, as by a better understanding of these motifs and a renewed aptitude for reproducing them directly.'

As early as the late sixth century we find imitations of the antique, such as the reliquary cippus of Saint-Marcel-de-Careiret and the marble sarcophagus with hunting reliefs in the Toulouse museum. The eighth-century inscription on the tomb of Theodechilde at Jouarre is based on Roman lettering. But what in the Merovingian period was only a chance for the artist to enrich his means of expression by imitation, became in the Carolingian period a deliberate return to antiquity. Political ideas certainly had their share in this return, for the new institutions were modelled on those of the West Roman Empire. In its form (though not in the details of its execution), the bronze chair of Saint-Denis closely enough resembles a Roman curule chair for it to have been regarded at one time as an ancient work. The equestrian statue of Charlemagne has the same 'antique' character as the coins bearing his effigy (see p. 224). The return to the sources, moreover, had the same didactic value in the arts as in letters. It was no more unusual then to study works four or five centuries old than it is now for a French child to learn a fable by La Fontaine. For the contemporaries of Charlemagne the majestic remains of the ancient world were as familiar and suggestive a part of daily life as a seventeenth-century château is for a present-day Frenchman. So in all this there was nothing strictly comparable to the sentiments that inspired the sixteenth-century Renaissance theorists.

One thing is true of Carolingian sculpture which is not true of that of any later period: the artists were capable of reproducing with the strictest accuracy a capital or a frieze of classical antiquity, as is shown in the Palatine Chapel at Aachen

30 – AACHEN, PALATINE CHAPEL, TRIBUNE. BRONZE PARAPET, DETAIL.

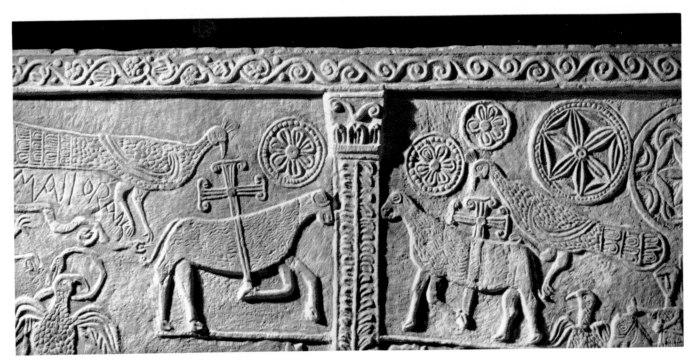

31 – CARVED SLAB, DETAIL. SANTA MARIA VECCHIA, GUSSAGO.

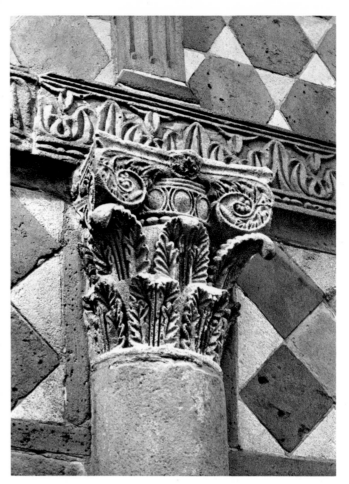

32 – NIMES, MAISON CARRÉE. ENTABLATURE, DETAIL.　　33 – LORSCH, ABBEY GATEWAY. WEST FAÇADE, DETAIL.

by a stucco capital standing next to its ancient model, and by the admirable parapets of the chapel's tribune. Carolingian copies of fifth-century ivories are so perfect that archaeologists have been fooled by them. Although this extraordinary mastery must be attributed rather to the skill of the Carolingian artist than his sensibility and imagination, it entitles him to a special place in the history of the psychology of art. After him, for a span of several centuries, no one in the West seemed capable of copying a model correctly. The crisis of the invasions in the tenth century put an end to the practices bequeathed by antiquity. The medieval artist had lost the knack of copying. Villard de Honnecourt proved incapable of reproducing in his sketch-book the rose windows of the cathedrals at Basel and Chartres. Medieval man had an imperfect vision of the outside world; a vision which in some ways is more revealing than a straightforward record of reality, but which for the period extending from the late ninth to the early fourteenth century has deprived us of an essential document—the portrait. In Carolingian times the art of the portrait was not so much a revival as simply the continuance of an age-old practice. Pope Gregory the Great, (died 604), had commissioned a pair of stucco medallions of his mother and himself. In the next century, the stucco figures in Santa Maria of Cividale have such telling expressions that one feels they must have represented real people.

37

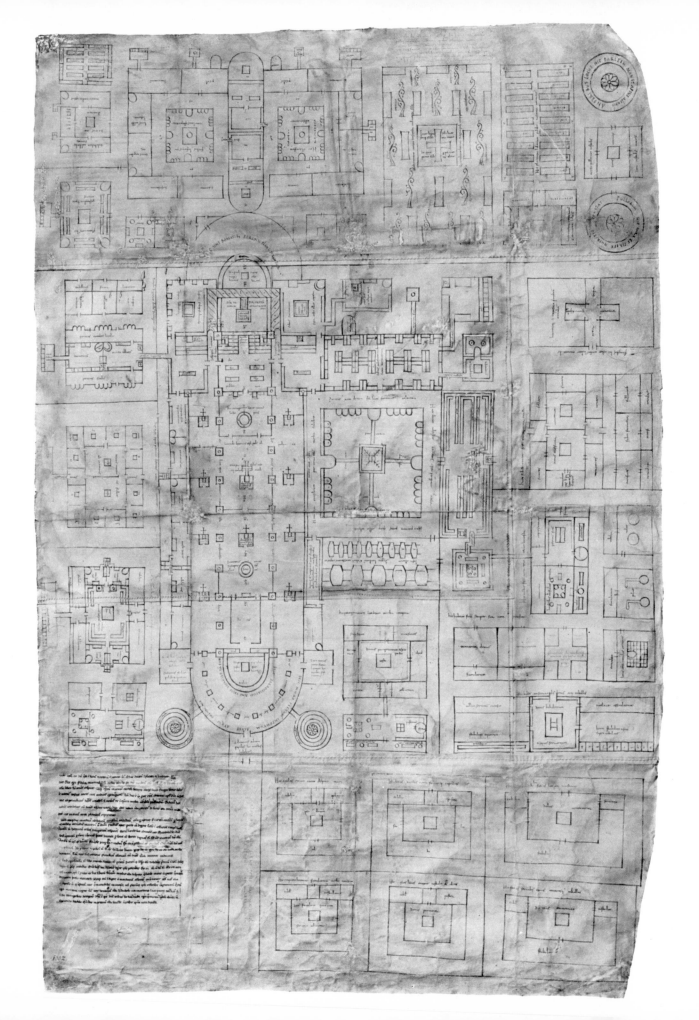

A NEW URBAN DEVELOPMENT:
TOWNS, MONASTERIES AND PALACES

Although the Carolingian dynasty lasted into the tenth century, the period of large-scale building was short-lived. It began at the end of the eighth century and ceased about the year 845, when the settled life of towns and monasteries was disrupted by the Norse invasions. Urban development in the Carolingian period may be summed up as an enterprise boldly conceived and initiated but soon discontinued.

In the early years of the ninth century the Frankish empire extended into the heart of Germania and to the south of Italy. A long age of peace seemed to lie ahead. So the opportunity was taken for demolishing the town walls of Reims, Langres, Melun, Frankfurt, Regensburg and possibly Beauvais. This at last did away with the cramping inconvenience of the high defensive walls with which so many towns in Gaul had been girdled in the late third century. The dismantling of the old walls, carried out by the bishops with the emperor's approval, indicates that it was intended to enlarge the towns. For new arrangements had been made necessary by the reform of the clergy in the cathedral churches—one of the salient features of the Carolingian period—and by the organization of community services (hostels, poor relief, etc.) in imitation of those which had long existed in the monasteries. These great undertakings were broken off after about 850, when the towns had again to be walled and fortified to withstand the Norse invaders (see the Chronological Table in Part Four).

Chrodegang, bishop of Metz, drew up in about 754 a rule imposing on the clergy of his cathedral a mode of life similar to that of the monks. Between 755 and 815 Chrodegang's Rule was adopted in many churches and spread throughout the empire. For the canons of each church to live and pray in common, provision of a 'chapter' comprising a meeting hall, a refectory, a dormitory and oratories, was necessary. An old plan shows the arrangement of the chapter at Metz as it was in the eighteenth century. This group of buildings must have undergone many changes in the course of time, but its 'inorganic' aspect, as we would call it today, strongly suggests that the general layout was a very old one. What is especially remarkable is the chapter's size: over 320 feet long and 230 feet wide.

Charlemagne himself chose the bishops of his kingdom and he chose them well. Leidrad, appointed in 798 to the see of Lyons, was a former *missus dominicus*. A cleric from Metz helped him to reform his cathedral in accordance with Chrodegang's Rule. Beside the old cathedral of St Stephen, which was only sixty-five feet long, Leidrad built a church three times as large, whose foundations were discovered in 1935. He did the same at Vienne a few years later. There, beside the new chapter, he erected the church of Saint-Sauveur whose vestiges, recently identified, show it to have been comparable in size to the new cathedral of Lyons. So at both Lyons

◀ 34 – ST GALL. PLAN FOR A PROJECTED RECONSTRUCTION OF THE ABBEY. STIFTSBIBLIOTHEK, ST GALL.

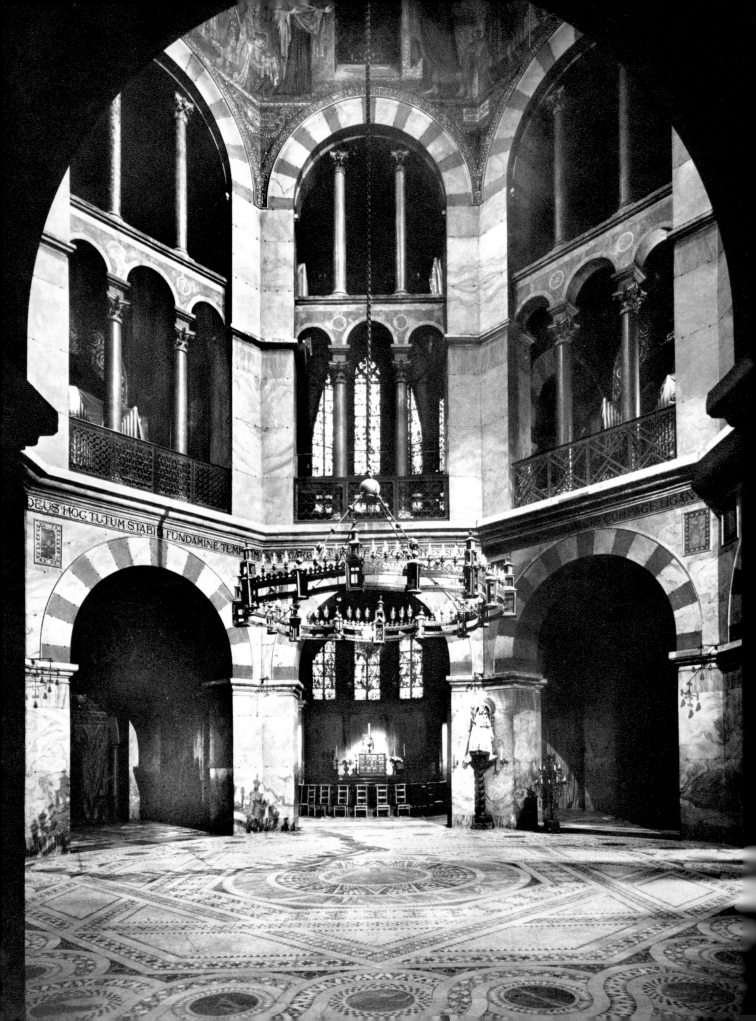

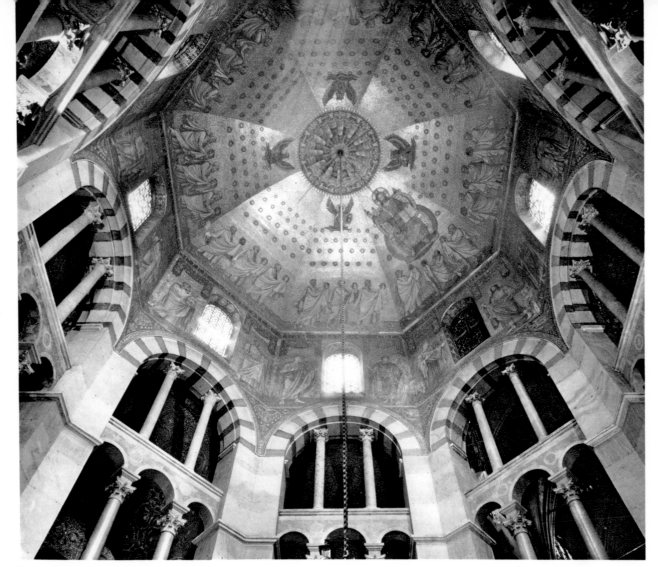

36 – AACHEN, PALATINE CHAPEL. DOME

and Vienne a church was built for the canons. Elsewhere, as a rule, the canons had to be content with the use of one of the two churches forming the cathedral group.

Aldric, a former canon of Metz, was appointed bishop of Le Mans in 832. He at once rebuilt the cathedrals of Saint-Étienne and Notre-Dame, adding a cloister for the new canons. Notre-Dame, consecrated in 834 under the dual patronage of the Saviour and the Virgin, was fitted with fourteen altars, five of which were in the tribunes, an arrangement recalling that of the palatine chapels. At Metz it had seemed enough to establish separate oratories in order to multiply the altars required by a large clergy. At Le Mans the new Rule gave rise to a new architecture, apparently comparable in its perfection to that of Aachen.

The same thing happened in other cities. The cathedral complexes of the Merovingian period gradually gave way to majestic groups of buildings occupying the major parts of what had been Late Roman towns. The canonical reform spread rapidly, as one church set the example for another, and triumphed everywhere in the

◄ 35 – AACHEN, PALATINE CHAPEL. INTERIOR.

41

eleventh century. It was thanks to the initiatives taken in the Carolingian period that the towns later had at their disposal the surface area needed for the Romanesque and Gothic cathedrals that so radically changed their skyline and aspect.

It was not till the eleventh century that the Gallo-Roman type of villa was superseded by the castle and the village. Ninth-century records refer to country settlements and houses without describing them. Much more is known about the monasteries and palaces of this period. Their layout and internal arrangements have much to tell us about the new character of living accommodations and the evolution of architecture. We have already referred to the grandiose plan of the Saint-Riquier monastery whose main outline formed a triangle, symbolizing the Trinity. In the early ninth century the abbeys of Fulda and Lorsch were each preceded by a vast atrium recalling that of Old St Peter's in Rome. The other abbeys built at that time had more rational plans, designed to fit them, to serve at once as a place of prayer, a farming community and a reception centre.

A priceless document of this period is preserved in the St Gall library. It is a complete plan for a monastery, drawn in ink on five sheets of parchment sewn together and sent before 829 to Abbot Gozbert of St Gall to help him rebuild his monastery. With its detailed inscriptions, this thousand-year-old plan is as clear as a blueprint from a present-day architect's office. The area covered by the projected buildings forms a vast rectangle over 700 feet long. The regularity of the layout, which recalls the *insulae* of Roman cities of the early Empire, may exemplify the chequer pattern of the new cities projected by the Carolingians. All the buildings are arranged round the place of prayer, the church. On the south side are the dormitory, the refectory and the cellar, disposed round a square arcaded court. On the north are the abbot's house and the school. On the west, on either side of the monumental colonnade in front of the church, are guest houses for men of rank and for the poor. On the periphery, from east to south, are the infirmary and the novitiate, the doctor's house and a blood-letting ward, then orchard, cemetery, kitchen garden, workshops, mill, bakery, servants' quarters, stables and farm buildings.

Plan and inscriptions show that the standard of comfort was high. The buildings were connected by covered walks. Rooms were spacious and heated by stoves and fireplaces. The furniture consisted of tables, beds, wardrobes, benches and chairs. There were four bathrooms, reserved for the abbot, the monks, the novices, and the sick in the infirmary. The abbot's lodge was a two-storey house. On the ground floor were a reception hall with chairs and two fountains, and a room with eight beds; on the upper floor, a two-room apartment; kitchen and bath were in an outhouse. Each room in the guest house had a fireplace. In the stables were feeding troughs for the livestock. The infirmary included a separate ward for contagious diseases. The windows of the doctor's house overlooked a garden of medicinal herbs. Eighteen kinds of vegetables were grown in the kitchen garden, and fourteen varieties of fruit in the orchard. Chickens and geese were raised in circular pens. Nevertheless, that there was nothing exceptional for the time in the projected buildings of the St Gall plan is proved by a chronicle referring to comparable buildings erected by Ansegisus, abbot of Fontenelle from 823 to 833.

37 – AACHEN, PALATINE CHAPEL. AMBULATORY. ▶

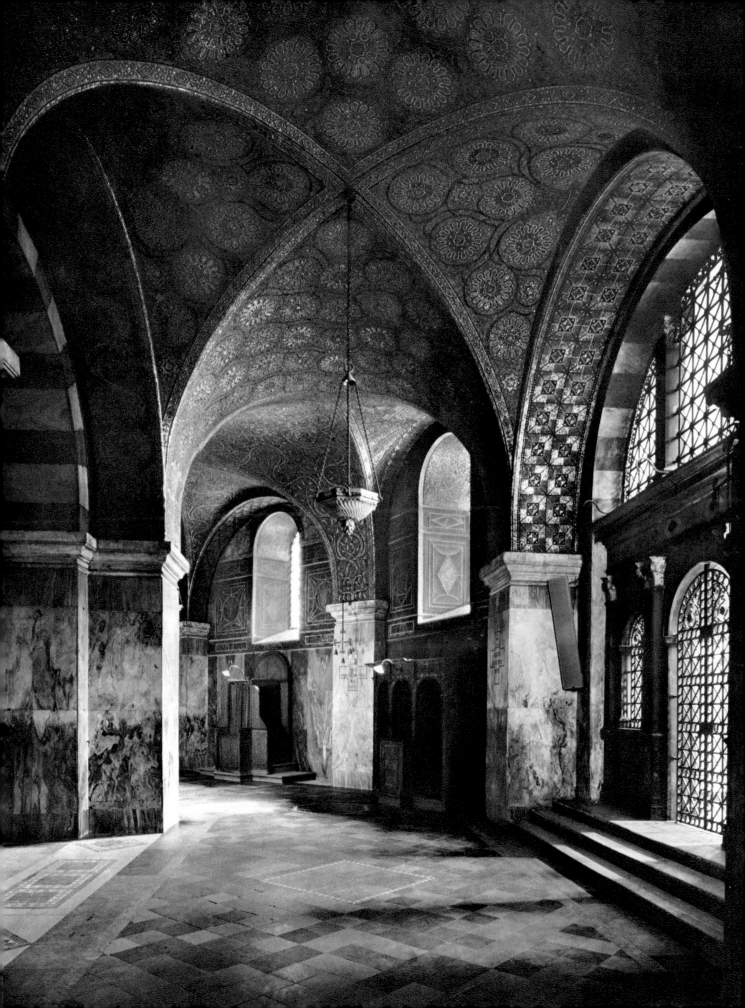

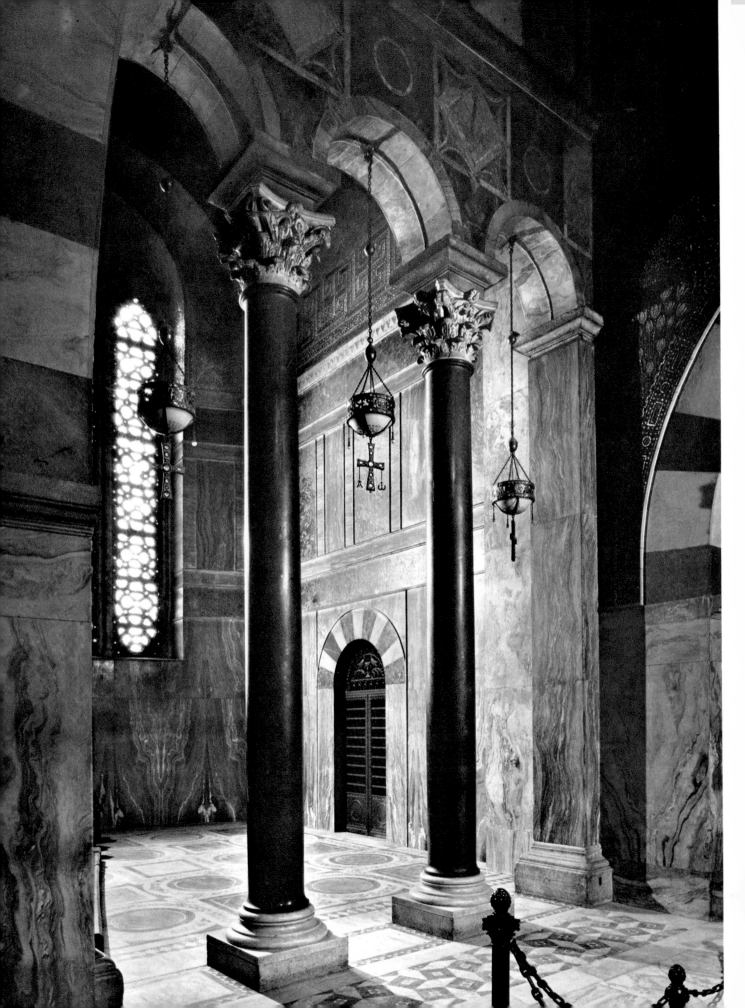

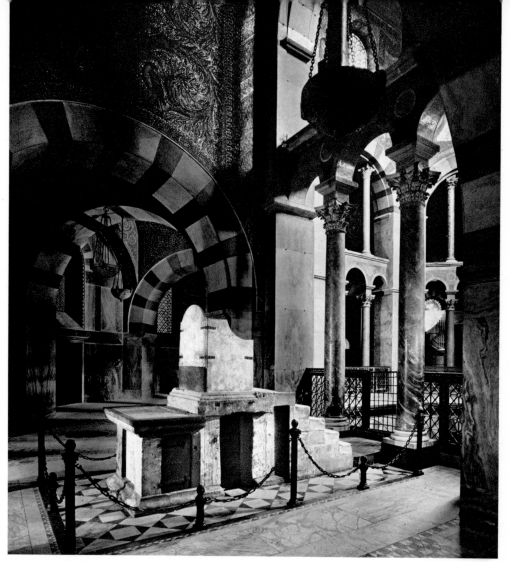

39 – AACHEN, PALATINE CHAPEL, TRIBUNE. IMPERIAL THRONE.

Work on the palace buildings at Aachen began prior to 798 and had not quite reached completion when Charlemagne died in 814. These buildings are justly famous. The Palatine Chapel or minster, which has come down to us almost in its entirety, is an exceptionally fine monument. But, in the age which saw the construction of Centula and the planning of the St Gall monastery, there was nothing unusual about it.

The main features of Charlemagne's palace have been ascertained by excavations. Chapel and palace stood at opposite ends of a large courtyard over 650 feet in length. In studying the plan revealed by excavations, the French architect and archaeologist Robert Vassas has made some important observations, which with his permission are published here for the first time. The area covered by the chapel atrium corresponds to two squares, whose sides each measure fifty-eight feet. This basic unit of measurement governs the proportions of the whole plan; by means of a grid it was possible to lay out the buildings correctly on the terrain. However, as in ancient times, the grid plan had a nobler role, that of imposing symmetrical and harmonious

◀ 38 – AACHEN, PALATINE CHAPEL. TRIBUNE.

45

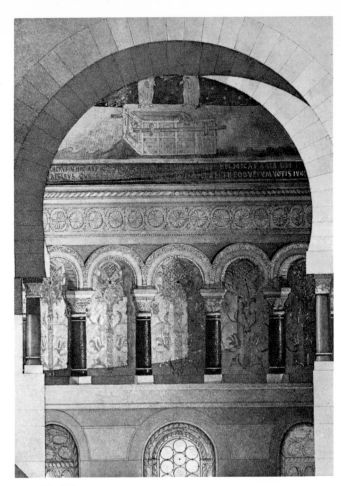

40-41 – GERMIGNY-DES-PRÉS, CHURCH BEFORE RECONSTRUCTION — ARCADING IN THE APSE.

proportions on the component parts of a whole. (In this respect, the grid plan of the crypts at Saint-Germain of Auxerre and Saint-Médard of Soissons is less revealing than that of Germigny-des-Prés, which was applied to all the main units of the building, both in the ground plan and the elevation.)

The palace of Charlemagne was only half the size of that of the Byzantine emperors in Constantinople, but it was larger than the largest known Gallo-Roman villas. It owed nothing to the royal Merovingian palace which it replaced, for excavations have shown that its orientation was different. The imperial throne hall was much larger than the reception halls in the Lateran palace. Probably Charlemagne was deliberately imitating the most impressive Roman monument in that region, the *aula palatina* of Trier, the 'basilica' that can still be seen there.

The imitation of Trier is still more evident in the Ingelheim palace near Mainz, begun by Charlemagne about 777, completed by Louis the Pious, then entirely rebuilt by the Ottonian emperors, who kept, however (or so it would seem), to the main lines of the original plan. Here the throne hall, exactly half the size of the Constantinian *aula* and its apse at Trier, is reproduced again, as at Aachen. A courtyard again separates the great hall from the palace church. The palace buildings

46

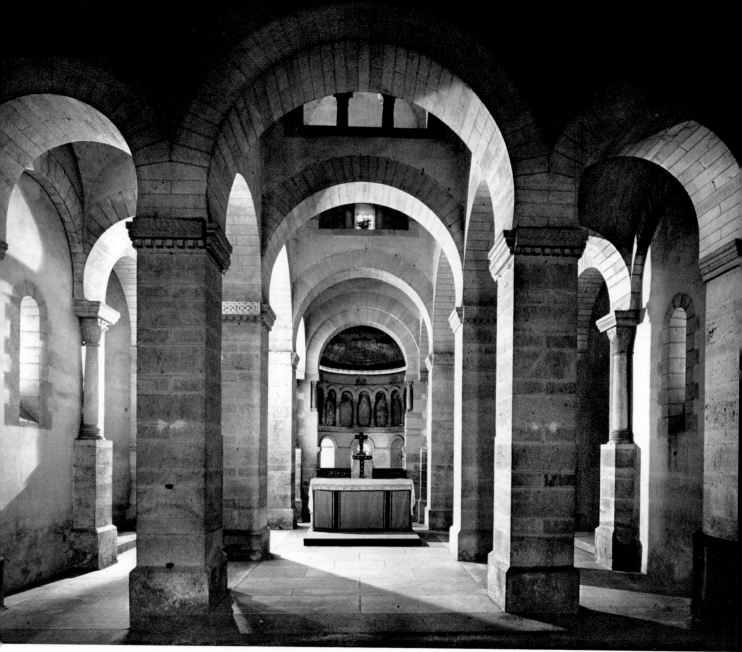

at Ingelheim stand within a square, about 330 feet long on each side, which is pro-
longed on the east by a monumental semicircular entrance. A Carolingian villa
in Geneva, whose foundations were discovered in 1953, closely reproduces, but on
a scale only half as large, the arrangement of the Ingelheim palace.

The palaces of Aachen, Ingelheim and Geneva, though built to three different
scales, were designed according to the same architectural principles as the great
monasteries of Carolingian Gaul. Aachen surpassed the others not only in the
perfect design and execution of its chapel but also in its sheer size. In architecture
the secret of grandeur is to combine vast spaces with simple forms. Aachen, the
Escorial and Versailles illustrate this principle at three different periods of history.

47

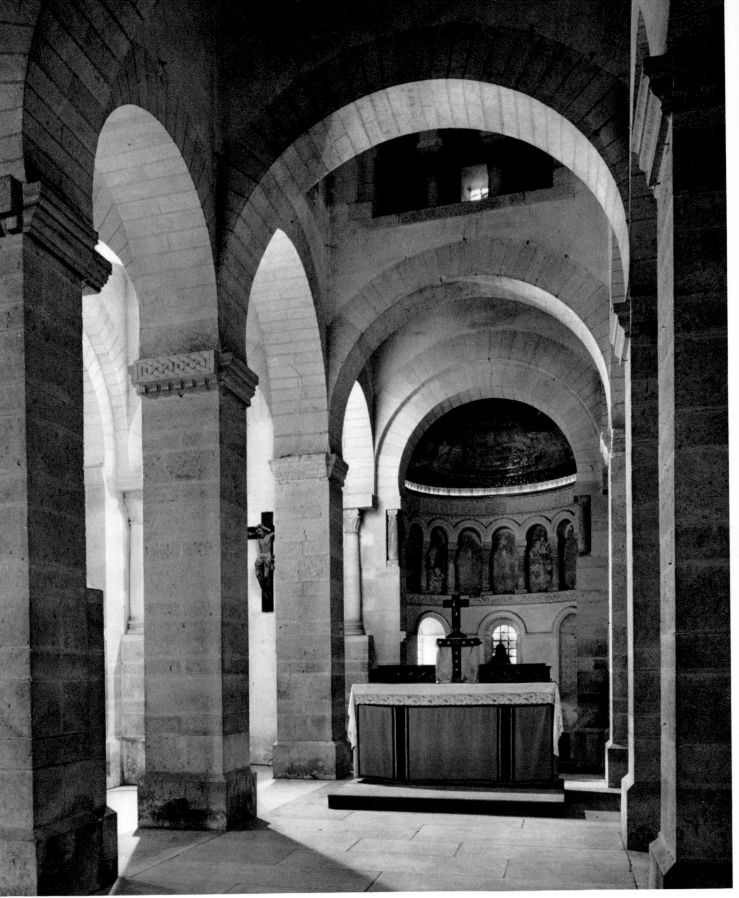

43 – GERMIGNY-DES-PRÉS, CHURCH AFTER RECONSTRUCTION. INTERIOR, VIEW FROM THE WEST.

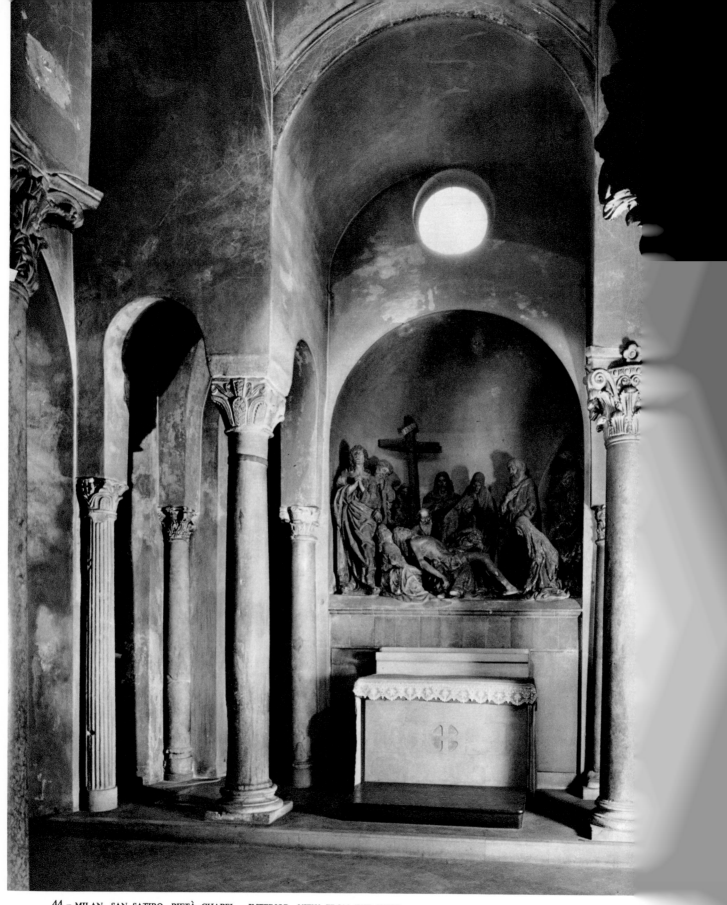

44 – MILAN, SAN SATIRO, PIETÀ CHAPEL. INTERIOR, VIEW FROM THE WEST.

A NEW CHURCH DESIGN

An entirely new ground plan, internal arrangement and outward aspect were given to the monastery church and the cathedral by the makers of the Carolingian renaissance.

It is only in recent years that this fact has been realized. For a long time Carolingian architecture was hardly touched on at all in textbooks on archaeology—and no wonder. Not a single piece of Carolingian architecture, not even the most famous, Charlemagne's Palatine Chapel at Aachen, has come down to us intact. All that remains here and there are parts or even mere fragments of buildings, left standing as if by a miracle amid sweeping reconstructions. These remnants are scattered over the whole extent of the former Carolingian empire and separated by vast distances: crypts, like those of Saint-Médard of Soissons and Saint-Germain of Auxerre; partially vaulted choirs, like that of Saint-Philbert-de-Grand-Lieu; an immense westwork of several storeys, like that of Corvey; the abbey gateway at Lorsch and Notre-Dame de la Basse-Œuvre at Beauvais. These speak for the variety given to the outward aspect of the buildings of this great period.

These buildings are illustrated on the following pages. Only thus assembling the surviving parts of each will give one some idea of what these great churches were like when still intact. We shall try to show how they came into existence. Their background and origins constitute an important problem for the historian, inasmuch as church architecture passed through only three main phases between antiquity and the Middle Ages: the timber-roofed basilica of the ancient Roman world; the late antique and early Byzantine domed church; and lastly the Carolingian church, which was soundly and skilfully vaulted at each end, and which prepared the way for the medieval church with its overall vaulting.

The various elements that went to make up the Carolingian church existed singly in ancient architecture and in the early churches of Rome and Italy, but the bringing together and the calculated combination of these elements represented a genuine architectural achievement. How did this come about? There was a time when it was thought that reasons of prestige or aesthetic motives were sufficient explanation. Although both certainly contributed to the fine effect of this architecture, the new building programmes were initiated, early in the ninth century, in response to the growing cult of relics and the reform of the liturgy imposed by Pepin and Charlemagne in their desire to imitate the church usages of Rome. The Chronological Table and comparative plans in Part Four of this book provide, we believe, arguments in favour of this opinion, but much remains to be discovered in a field and period in which it is still impossible to determine with certainty the actual sequence of forms.

A few years ago an important discovery was made by Louis Blondel at Saint-Maurice d'Agaune (canton of the Valais, Switzerland). His excavations there revealed that the basilica founded in 515 by King Sigismund had been largely rebuilt in the time of Charlemagne. The original aisled nave with a timber roof had been left standing, but to this had been added a two-storey apse at each end, the larger of the

45 – SOISSONS, ABBEY CHURCH OF SAINT-MÉDARD, CRYPTS. INTERIOR, VIEW FROM THE NORTH. ▶

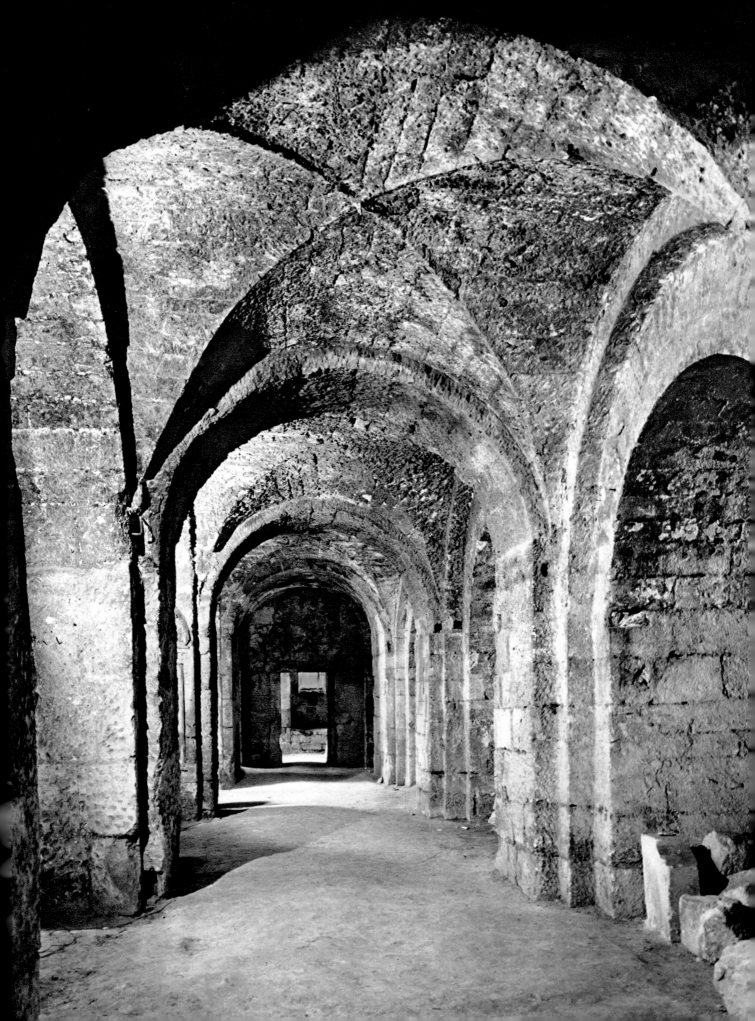

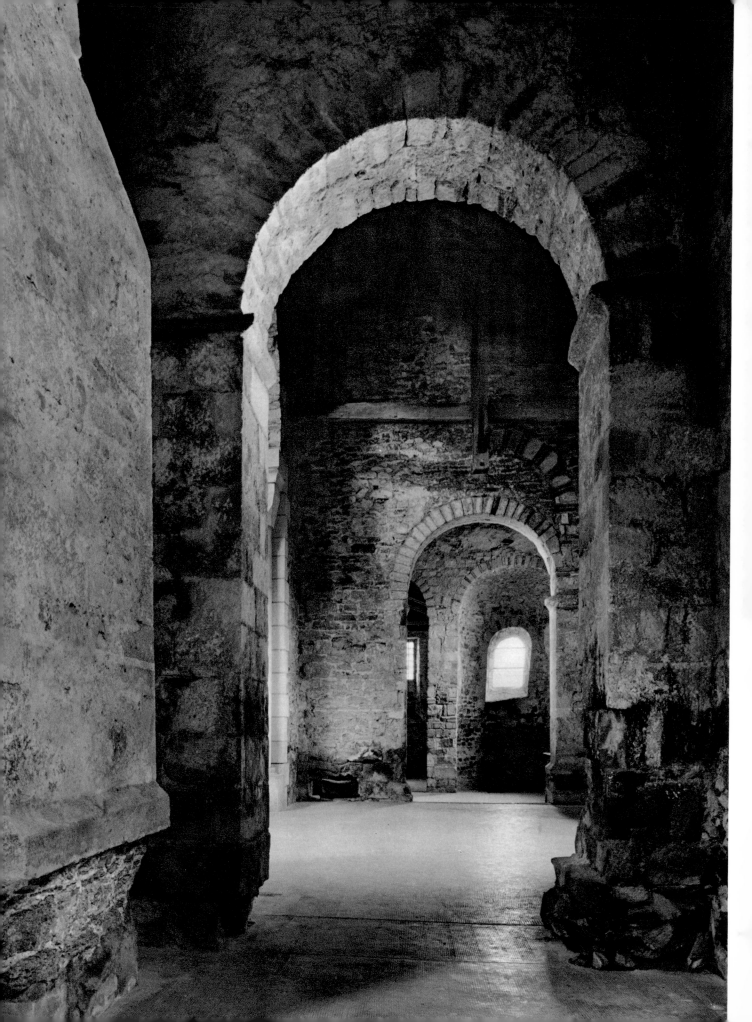

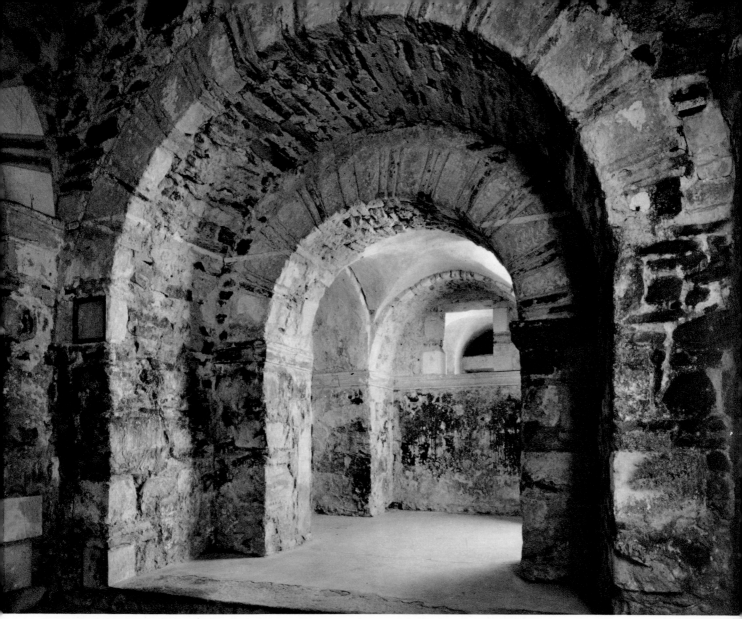

47 – SAINT-PHILBERT-DE-GRAND-LIEU, ABBEY CHURCH, CRYPTS. CHAPEL OF THE HOLY SAVIOUR, FROM THE EAST.

two being on the west. The ground floor of each apse was occupied by a *confessio* with a semicircular corridor communicating on the same level with the nave. This *confessio* plan originated in Rome where it appeared towards the end of the seventh century. By then, with Rome under continual attack by the barbarians, the bodies of martyrs were too much exposed to desecration in the cemeteries *extra muros;* so, in spite of the graveyards' immemorial usage, the bodies were transferred to churches within the city walls. In these churches a *confessio* was dug under the floor of the sanctuary—a room hardly bigger than the martyr's sarcophagus which it housed, and round which led a narrow semicircular corridor enabling the faithful to come and pray at the foot of the saint's tomb under the altar. This arrangement was carried out in over five Roman churches, notably San Crisogono, in the time of Pope Gregory III (731–741).

◄ 46 – SAINT-PHILBERT-DE-GRAND-LIEU, ABBEY CHURCH. CRYPTS.

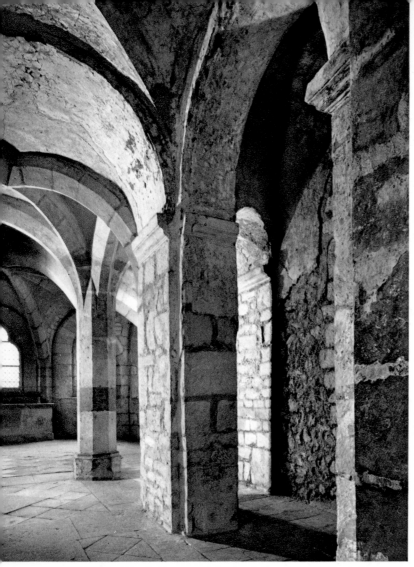
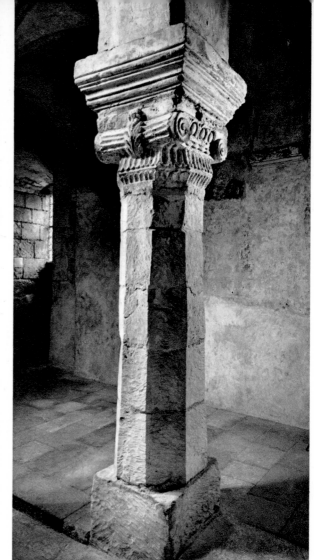

48-49 – AUXERRE, CHURCH OF SAINT-GERMAIN. EAST SIDE OF THE CRYPTS — PILLAR AT THE ENTRANCE OF THE AMBULATORY.

As the dangers of this lawless period grew, Christians placed their hopes of safety in the intercession of the saints and the power of their relics to avert evil. In 765 Pope Paul I had a large number of catacomb tombs opened and the bodies distributed among the churches of Rome. Shortly afterwards began the exodus of these relics, both secretly and with special permits, towards the rest of Europe, chiefly Gaul. Along with the relics, the Roman type of *confessio* spread northwards in the course of the eighth and ninth centuries. It appears in northen Italy in two churches at Ravenna, Sant'Apollinare in Classe and Sant'Apollinare Nuovo; in Switzerland at Saint-Maurice d'Agaune, in the St Gall plan and in two churches at Chur in the Grisons; in Germany at Seligenstadt; in Belgium at Nivelles; in Gaul at Saint-Denis in the basilica consecrated in 754 by Pope Stephen II.

The two crypts of the Saint-Maurice d'Agaune basilica kept to the plan of the Roman type of *confessio*. This plan is the only feature connecting Saint-Maurice with Italy. The elevation is different: in Rome the *confessio* is an underground chamber reached by two stairways, while the Saint-Maurice crypts are almost on a

50 – AUXERRE, CHURCH OF SAINT-GERMAIN, CRYPTS. THE CONFESSIO SEEN FROM THE WEST.

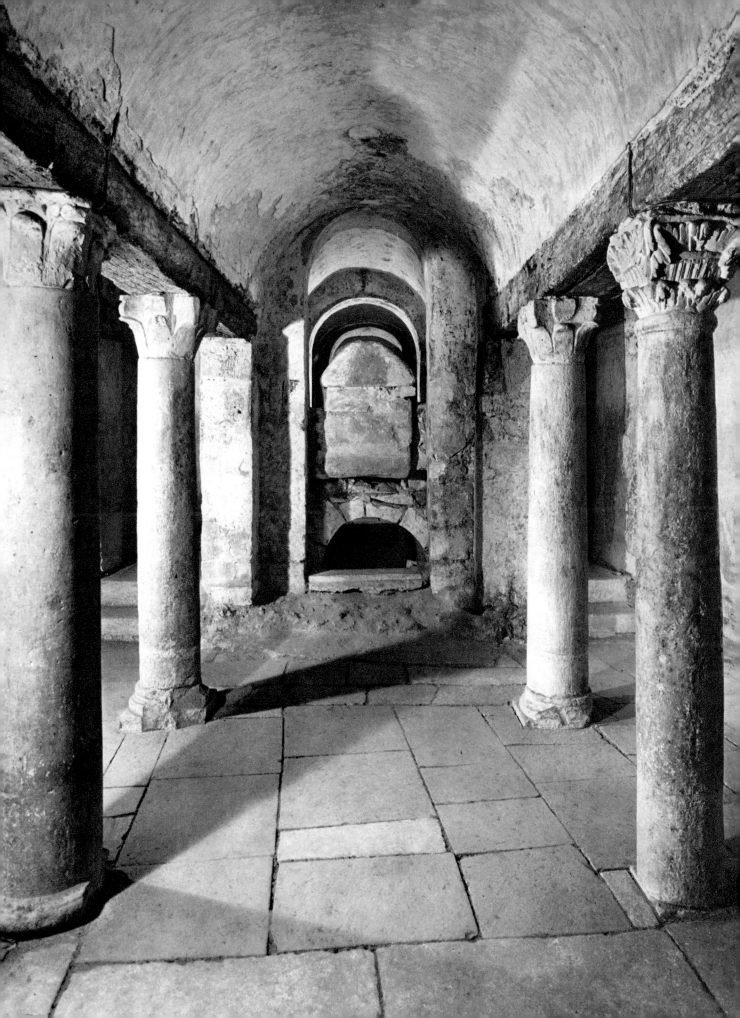

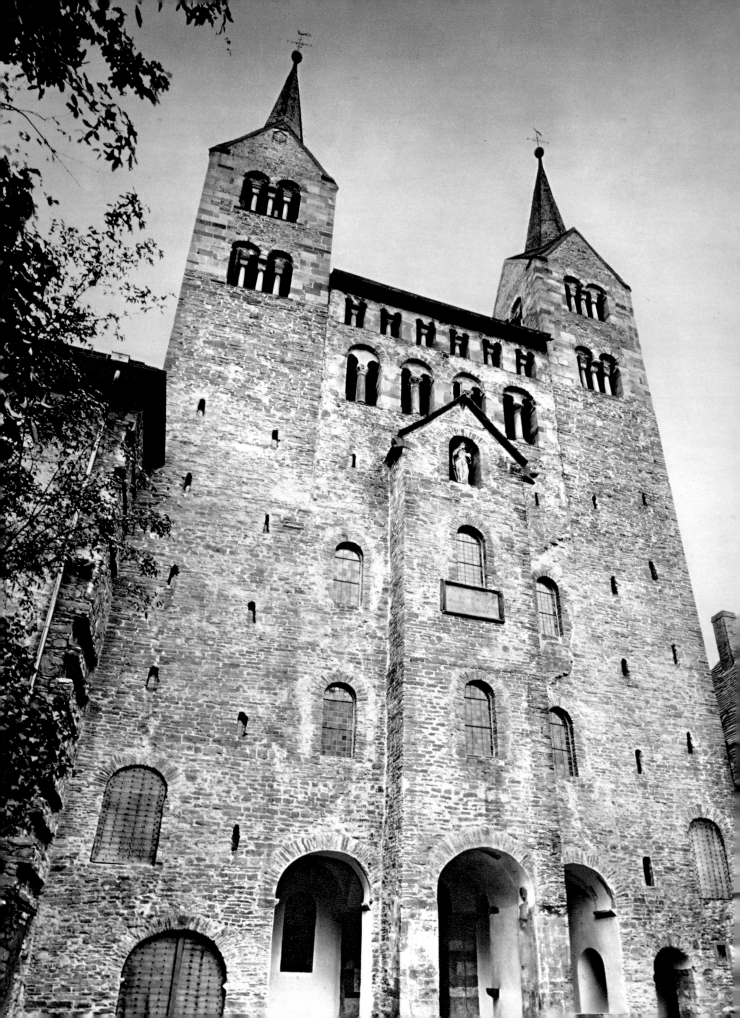

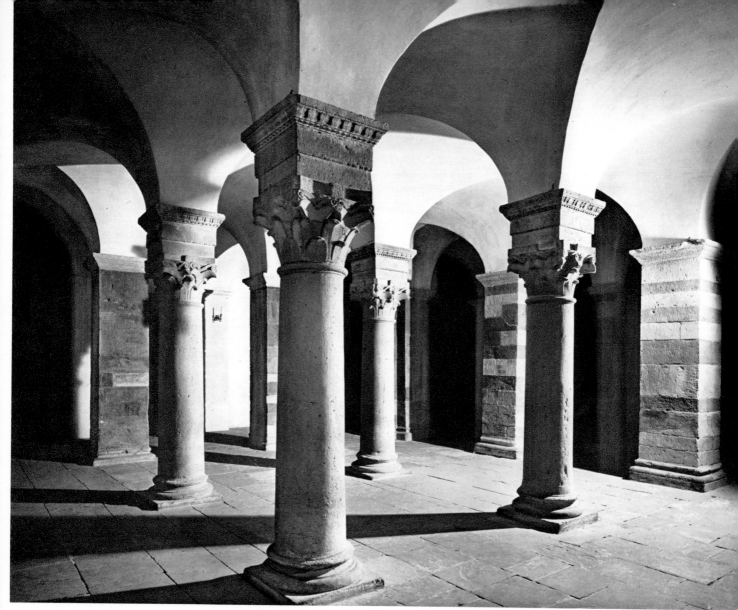

52 – CORVEY, ABBEY CHURCH. GROUND FLOOR OF THE WESTWORK.

level with the nave. Moreover the double-apse plan of Saint-Maurice appears
nowhere in Rome except in a ninth-century church erected by Charlemagne, that of
the Schola Francorum; it did not spread to Italy till the early Romanesque period
and even then remained rare. These two features link Saint-Maurice closely to the
churches of the Carolingian renaissance. The crypt on a level with the nave was an
inherited characteristic of the basilicas of Merovingian Gaul in which the saint's
tomb stood on the pavement of the sanctuary between the altar and the wall of the
apse. The Carolingian crypt was built over this tomb like a sort of triumphal monu-
ment. As for the double apse, one at each end of the church, it appears twice on the
St Gall plan and also at Fulda and the Cologne cathedral, besides Saint-Maurice
d'Agaune. It was in time widely adopted in the Rhineland, central Germania and,
in various forms, southern Gaul. This Carolingian church design differs in one

◀ 51 – CORVEY, ABBEY CHURCH. FAÇADE OF THE WESTWORK.

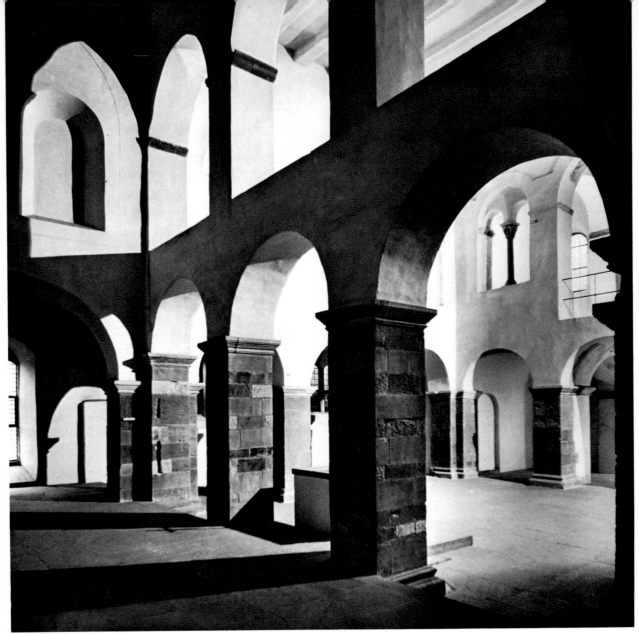

53 – CORVEY, ABBEY CHURCH. TRIBUNE OF THE WESTWORK.

respect from the double-apse basilicas of fifth-century Spain and North Africa. In the latter the counter-apse at the west end housed a tomb. In Carolingian architecture the west sanctuary housed the main altar. So it was at Agaune, Fulda, Centula and Reims cathedral. These churches, then, were not oriented but 'occidented.'

The history of the successive versions of the Fulda church throws light on the reasons for this arrangement. But first a few well-known facts should be borne in mind. Like the Temple of Solomon, the great early basilicas founded in Rome (St John Lateran, St Peter's) and at Jerusalem (Church of the Holy Sepulchre) had their entrance facing east, for it was then the custom to face the rising sun when praying. The prayer of the officiating priest in these churches was duly oriented, while that of the congregation was not. This was probably the reason why, towards the end of the fourth century, the position of the church was reversed, altar and

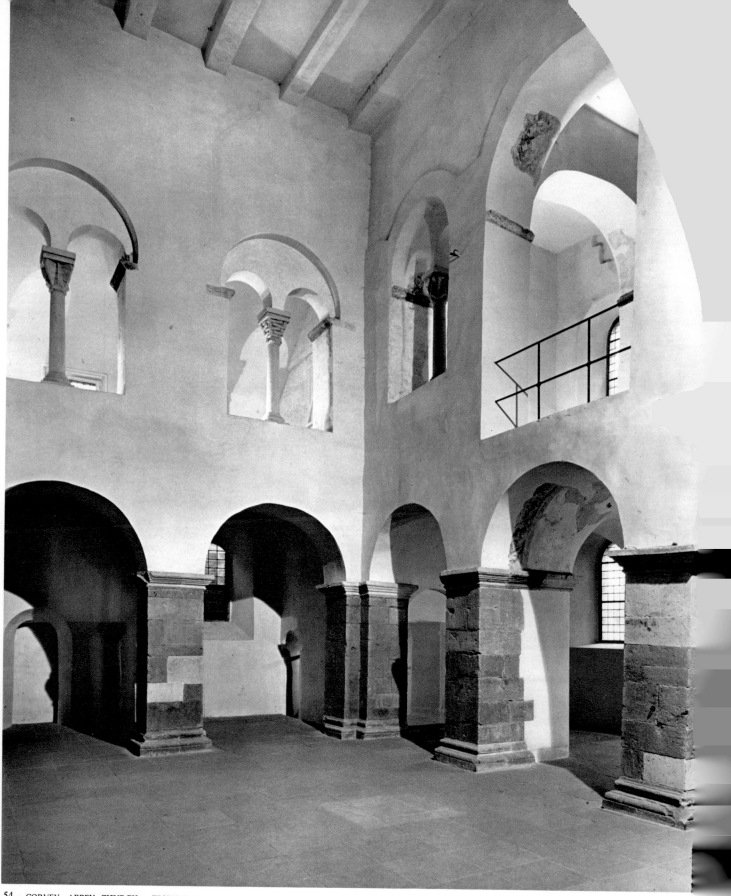

54 – CORVEY, ABBEY CHURCH. TRIBUNE OF THE WESTWORK.

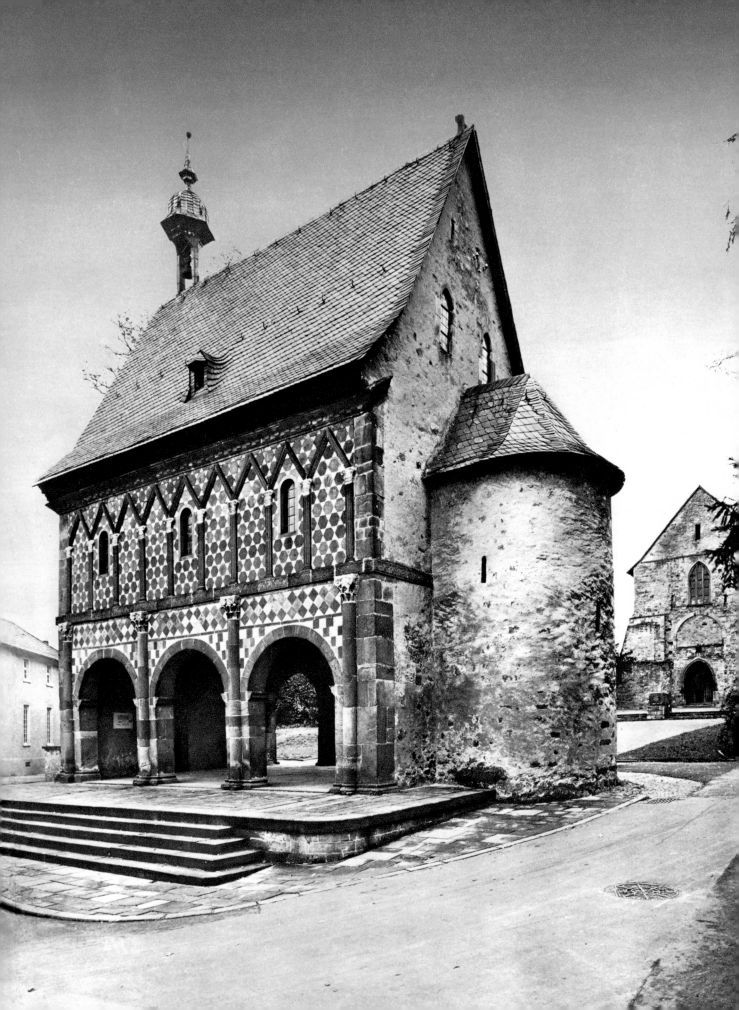

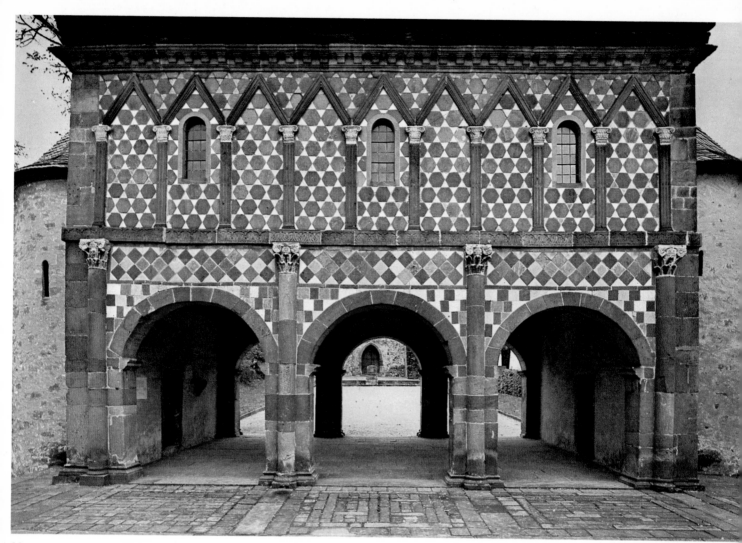

56 – LORSCH, ABBEY GATEWAY, WEST FAÇADE.

sanctuary then being placed at the east end. But the Constantinian basilicas remained as examples of an earlier, short-lived usage, and it was these churches—in particular St John Lateran, the cathedral of Rome—that became the model for the churches of Gaul beginning at the end of the eighth century.

A notable achievement of the Carolingian renaissance was the reform of the liturgy. This reform, initiated in Gaul by Pepin and generalized by Charlemagne, consisted essentially in adopting the Roman liturgical usages that then were used in the Lateran church and St Peter's. One of the most active advocates of the Roman liturgy was St Boniface, who founded the monastery of Fulda in one of the regions of Germania which the Franks had opened to Christianity. The first church soon proved too small, for the monks were numerous. It was accordingly rebuilt by Abbot Ratgar in 794. The new Fulda church reproduced the plan of St Peter's in Rome, with apse and altar at the west end, but with the addition of a smaller apse at the east end housing a secondary altar. This copy of St Peter's, only slightly smaller than its model, was the largest of all the churches erected in this period. When

◀ 55 – LORSCH, ABBEY GATEWAY, SEEN FROM THE SOUTHWEST.

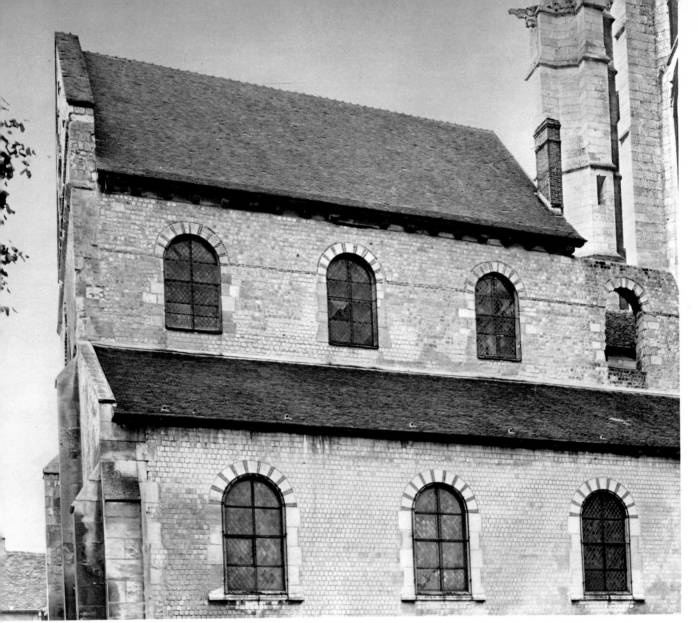

57 – BEAUVAIS, NOTRE-DAME DE LA BASSE-ŒUVRE. EXTERIOR, VIEW FROM THE SOUTH SIDE.

it was finished, a large atrium recalling that of St Peter's was added to it 'in the Roman manner'—'*more romano*,' wrote the Fulda chronicler.

Neither St John Lateran nor St Peter's had an east apse. The counter-apse at the east end seems to have made its first appearance in 794 at Fulda. One is tempted to regard it as the outcome of a sort of compromise between the reforming spirit and respect for local traditions. Such too, it would seem, were the secondary oratories placed at the east end of occidented churches of the Romanesque period in southern France, as at Arles-sur-Tech.

We know a good deal more about the origins of the Carolingian crypt as it appears at Saint-Philbert-de-Grand-Lieu, Saint-Médard of Soissons and Saint-Germain of Auxerre in the second quarter of the ninth century. This crypt was almost like a second church erected in honour of the saint whose tomb it housed at the end

of the nave, and nearly on a level with the nave; the crypt's vaulting supported the sanctuary, which itself was vaulted or timber-roofed, and which was reached by monumental staircases.

The Carolingian crypt was something new in Christian architecture. The crypts of Saint-Philbert-de-Grand-Lieu, Soissons and Auxerre differ in plan (thus testifying to the freedom of invention shown by the architects of this period), but all three have the same programme. The worshipper did not reach the saint's tomb by a narrow semicircular corridor, as in the churches of Rome. A broad, elbowed ambulatory provided room for a crowd of worshippers to move about or stop and pray by lamplight and tapers around the 'Holy of Holies.' Large rooms—privileged burial places and secondary oratories—served to group together inside the Carolingian crypt elements that had been scattered about outside the Early Christian basilica. At Soissons the burial chambers are large rooms with niches recessed into the walls, like antique mausolea. In erecting on the east side of the crypt an oratory of circular plan and raising it to several storeys, the architects of the Carolingian period added to religious architecture a new form which became fairly common in Burgundy (Saint-Germain of Auxerre, Flavigny, Saulieu, Dijon) and even existed in Germany (Hildesheim).

Opposite the raised sanctuary standing over the vast crypt, the Carolingians often erected at the other end of the nave (i.e., the west end) a tower-like block with vaulted storeys. The design of this 'westwork,' as attested by remains and documents, was as varied as that of the eastern crypts themselves. The ground floor could serve as a vestibule as at Saint-Germain of Auxerre and Lorsch; it could also house a crypt containing precious relics, as at Centula. At Centula, as in the abbey of Fontenelle and Reims cathedral, the first floor served as the west choir with the main altar of the church which was dedicated to the Holy Saviour, as in St John Lateran. Both at Centula and Reims, the westwork formed an entire parish church in itself, complete with baptismal font. At Seligenstadt on the Main, east of Mainz, in the church erected by Einhard in 831, there was a tribune in the westwork where Einhard sat during the services and which is known to have contained an altar and reliquaries. As in the Palatine Chapel at Aachen, the tribune was reserved for the great; this custom lasted throughout the Middle Ages. At Saint-Germain of Auxerre only part of the westwork can be reconstructed with any certainty; it is known to have housed an altar dedicated to John the Baptist. Its design seems to have been similar in some respects to the famous westwork of Corvey, which is still in existence.

There has been much discussion concerning the intended purpose of the large hall on the upper floor of the colossal Corvey westwork, but all archaeologists have recognized the exceptional merits of its architectural design. The westwork of the Corvey church was built between 873 and 885. The ground floor served as an entrance passage; it is badly lit (so were the westworks of Reims and Auxerre cathedrals, as we know from records of the late tenth century), for its groined vaulting rests on square pillars with very fine capitals set rather close to each other. But the two upper storeys form a vast tribune overlooking the nave and flooded with

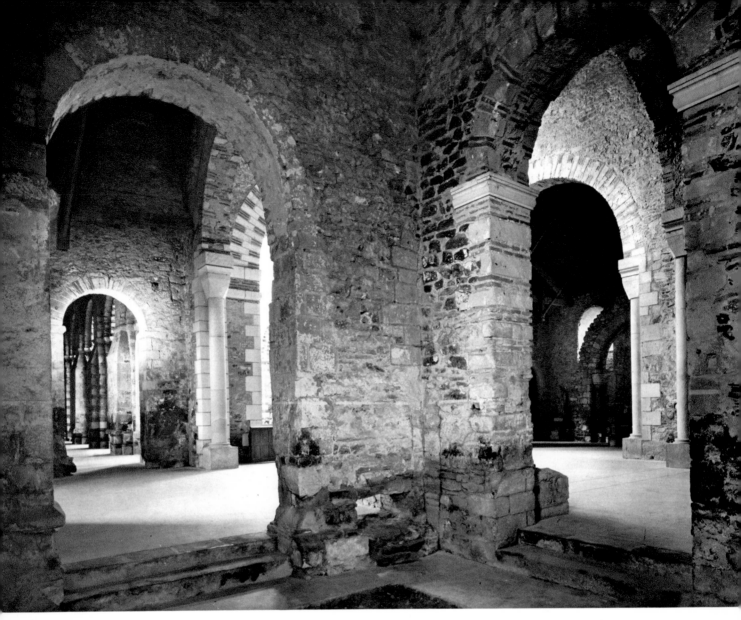

58 – SAINT-PHILBERT-DE-GRAND-LIEU, ABBEY CHURCH. TRANSEPT, FROM THE SOUTHEAST.

light. It is at Corvey, founded as its name indicates by a colony of monks from the abbey of Corbie in Picardy, and in Charlemagne's Palatine Chapel at Aachen that one is made fully aware of the grandeur and originality of Carolingian architecture. Of course this art had its models and its masters, but one cannot help marvelling at the fact that, where so few monuments still exist or can be reconstructed from excavations or documents, the variety of the solutions developed in response to the same programmes should be so great and so ingenious.

Roman architectural ideas and practices were still fairly familiar in early ninth-century Gaul. As we have pointed out, grid plans were utilized on the terrain for the construction of the Aachen chapel, Germigny-des-Prés, Saint-Germain of Auxerre and Saint-Médard of Soissons. One of the best chronicles of the ninth century, that of the monk Heiricus, tells in some detail how the partial reconstruction

59 – SAINT-PHILBERT-DE-GRAND-LIEU, ABBEY CHURCH. ROMANESQUE CONFESSIO. ▶

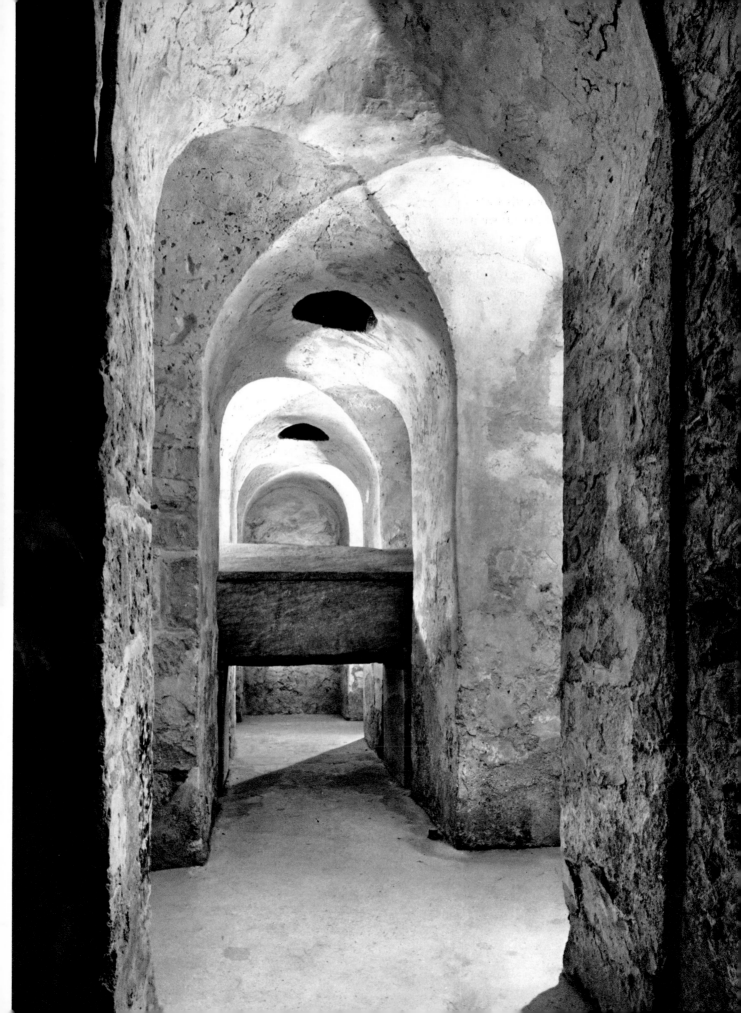

of the abbey church of Saint-Germain at Auxerre was undertaken and carried out from 841 to 865. It was decided on by Conrad, Count of Aargau (Argovia), uncle of Charles the Bald and lay abbot of the monastery, whose failing eyesight had been restored by the intercession of St Germanus. When Conrad returned to Aargau, his wife Aelis remained at Auxerre to superintend the undertaking. It had been decided to enlarge the basilica at the east end, on the side where the hill sloped down towards the river Yonne. The most famous architects were summoned to Auxerre. After drawing up a plan, they made a wax model of the projected building, so as to have an exact idea of its elevation and outward design. Then the 'master builders' and the 'foremen' were designated and the work got under way. The builders did not make shift with materials available locally. As there was no marble in the Auxerre region, parties of monks were dispatched twice to the south, first to Arles, then to Marseilles, in search of ancient Roman columns. They were given some and purchased others. The columns were then shipped up the Rhône and the Saône as far as Chalon; from there they were transported overland. The crypts and the upper sanctuary, which was completely vaulted, were solemnly consecrated by Charles the Bald on 6 January 859. The westwork of Saint-Germain, an enormous block which was not entirely demolished till 1820, was finished and consecrated a few years later, in 865. It would seem that, between these two great vaulted structures of several storeys erected at each end of the church, the nave of the original fifth-century basilica was preserved intact.

Indeed, as shown by vestiges of the old nave of Saint-Denis and a text giving some account of Saint-Remi of Reims, the Carolingian renaissance seems to have made no change in the traditional design of the aisled nave covered with a timber roof. In the ninth century monolithic columns continued to be used to support the nave arcading. As against this conservatism, however, genuine innovations were made in the technique of vaulting, in crypts and upper-storey sanctuaries, westworks and tribunes, chapels and oratories on the central plan.

The most remarkable new element appears in the tribune of the Palatine Chapel at Aachen: the combination of the diaphragm arch and the transverse barrel vault — a skilful application of the law of thrusts which was repeated a little over two centuries later in the narthex of Tournus. The ingenious use of the diaphragm arch to support the roofing of a turning element appears to be an architectural device peculiar to Gaul, for a typical example of it can still be found in early Romanesque architecture in the archaic ambulatory of the church of Auneau near Chartres.

The dome with spindle-shaped segments and the dome on squinches, both a legacy of late Roman architecture, exist at Aachen and Germigny-des-Prés. The wall arches (formerets)—which were subsequently to play an important part in the development of early Gothic—helped to support the domes on squinches at Germigny-des-Prés and the groined vaulting of the Saint-Médard crypt at Soissons. This device, which says much for the technical skill of the builders, comes as no surprise in a crypt whose vaulting, both semicircular and groined, is composed entirely of neatly cut ashlar blocks (while later, from the tenth to the mid-twelfth century, a rough rubble work vaulting was the rule in the early French Romanesque churches). Yet one

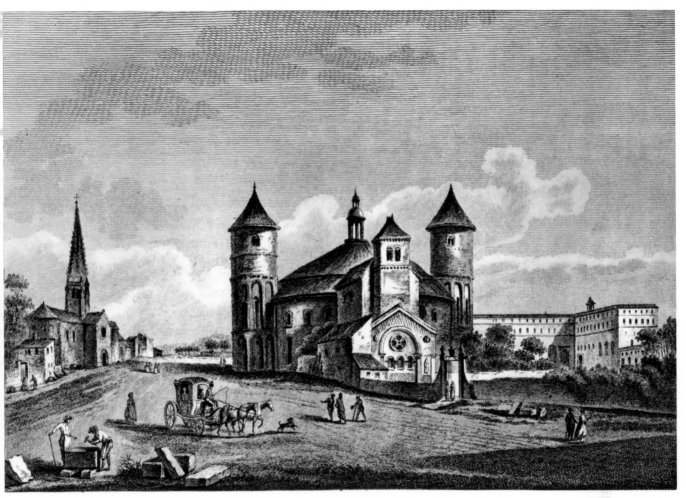

60 – DIJON, SAINT-BÉNIGNE, FROM AN ENGRAVING BY LALLEMAND. BIBLIOTHÈQUE NATIONALE, PARIS.

cannot help noticing a curious contrast in the masonry of the Saint-Médard crypt: the cyclopean stonework of the burial chambers is remarkable, but the wall niches were hacked out with a pick instead of being left in reserve when the wall itself was built. This juxtaposition of skilled workmanship and barbarous botching occurs repeatedly, in various forms, in works of the Carolingian period.

The pillar of cruciform section with shallow projections, inherited from Roman architecture, was a standard feature of vaulted constructions in the Carolingian period, as at Aachen, Germigny-des-Prés and Saint-Germain of Auxerre. At Auxerre the cruciform pillars of the westwork, much more massive than those in the crypt, bear a striking resemblance to the pillars which, about the year 1000, supported the vaulting over the double aisles (and possibly over the tribunes as well) of the vast cathedral of Orléans, the first of the great churches of Romanesque Europe to be almost entirely vaulted. Considerable interest attaches to this type of pier, for like the diaphragm arch and the transverse barrel vault it represents a factor of progress and a common tie between Carolingian art and Romanesque. Patrons,

monks and practitioners of the eleventh century were well aware, moreover, of what had been lost in France with the passing of Charlemagne and Charles the Bald, and what they owed to Carolingian art. We know today that at Saint-Philbert-de-Grand-Lieu the groin-vaulted *confessio*, the sarcophagus it contains, and above all the piers and projecting arches of brick and stone in the nave are a close imitation of the Carolingian choir, an imitation devised around the beginning of the eleventh century by monks from Tournus intent on reviving the cult of St Philbert. Likewise, at Germigny-des-Prés, the fake Carolingian dedication engraved in the Romanesque period on the pillars of Theodulf's oratory is a tribute paid by the monks of Saint-Benoît-sur-Loire to the glories of Charlemagne's time, as the chronicle of their monastery testifies. In the same period at Flavigny when the crypt and raised choir were rebuilt, the original Carolingian plan and layout were scrupulously respected; the only change made was in the rotunda on the east side of the chevet, which was now given a polygonal plan. But the finest tribute paid to Carolingian architecture could be seen before the French Revolution in the Romanesque church of Saint-Bénigne at Dijon, where the east rotunda of the Carolingian crypts had been converted into an immense three-storied *oratorium*. This was not an imitation of the Holy Sepulchre, as was formerly supposed, but the triumphal mausoleum of a civilization.

JEAN HUBERT

PART TWO

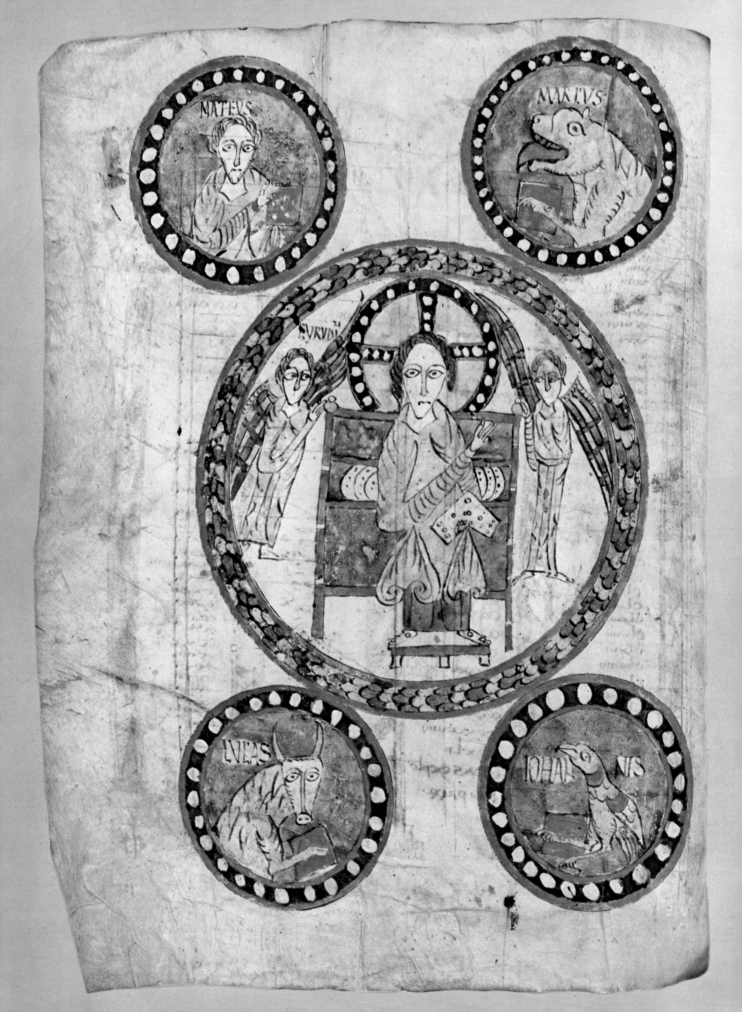

Book Painting

THE COURT ATELIERS

I T IS in illuminated books that we see the most striking, most numerous achievements of Carolingian painting, for with rare exceptions all the frescoes and mosaics have disappeared. This painting makes its appearance quite abruptly, almost one might say *ex nihilo*, after three centuries of widespread European political turmoil in the course of which the antique world gradually fell into ruin and Western art seemed to be dying out.

In Italy, the direct heirs of Greece and Rome preserved little more than vague memories of their glorious past, and the faint gleams of it that lingered on served but to emphasize the darkness of a night that threatened to be endless. Limited to decorative patterning, the art of the young countries of Europe went on repeating inherited motifs and techniques; its contacts with the declining civilization of the Mediterranean world had not as yet struck any spark of original inspiration, any real promise for the future. True, these contacts affected the insular art of the North and to some extent clarified it, but that art remained hard, schematic; until quite late in its history the art of the British Isles seemed incapable of renewal.

The Birth of Carolingian Book Painting

Nevertheless that spark was kindled. In 754, the third year of the reign of King Pepin, the very year in which, by a remarkable coincidence, the Carolingian dynasty officially began, the scribe Gundohinus completed a Gospel Book (whose illustration he supervised) at 'Vosevium'—a place which remains unidentified. This book was made to the order of a lady named Fausta and a monk, Fuculphus. Nothing like it had yet been seen on the continent north of the Alps: the art of the Carolingian book begins with Gundohinus, just as the Carolingian dynasty begins with Pepin.

◀ 61 – VOSEVIUM (?). GOSPEL BOOK OF GUNDOHINUS: CHRIST IN MAJESTY. BIBLIOTHÈQUE MUNICIPALE, AUTUN.

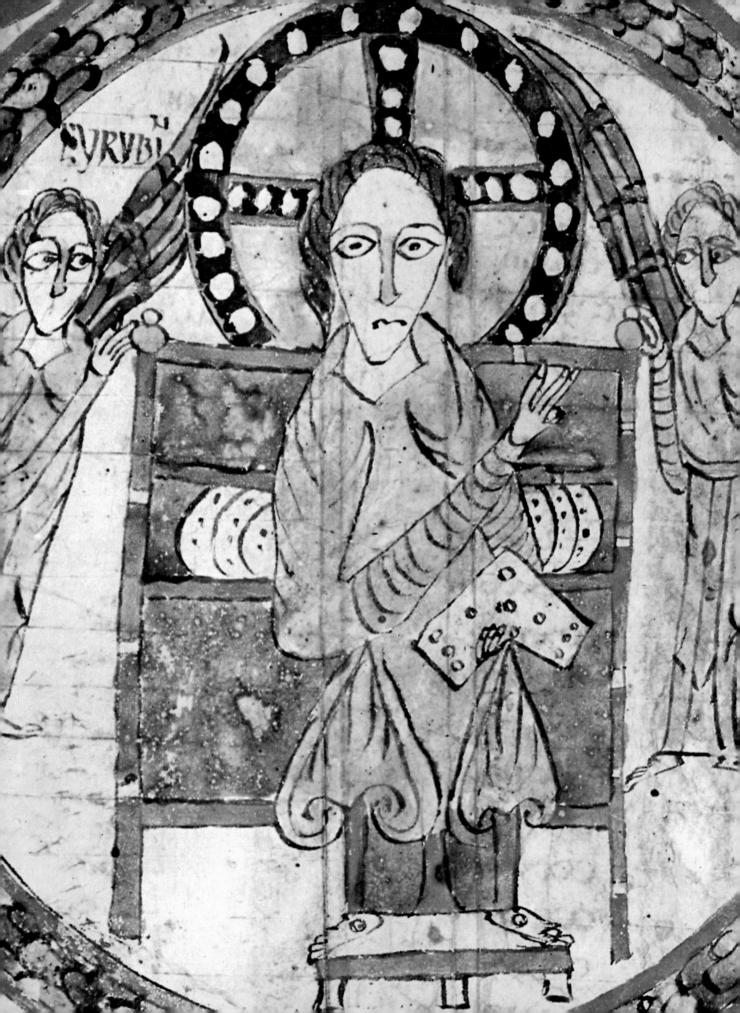

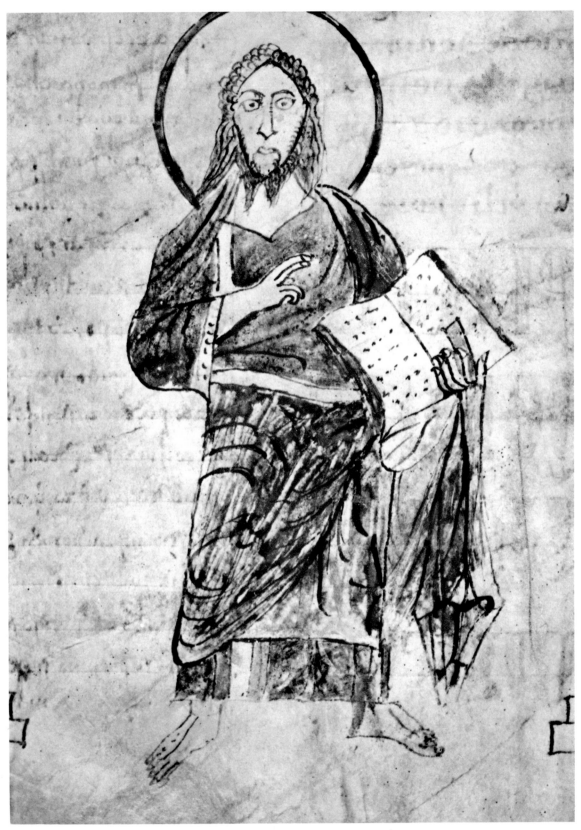

63 – VOSEVIUM (?). GOSPEL BOOK OF GUNDOHINUS: ST MATTHEW, DETAIL. BIBLIOTHÈQUE MUNICIPALE, AUTUN.

62 – VOSEVIUM (?). GOSPEL BOOK OF GUNDOHINUS: CHRIST IN MAJESTY, DETAIL.

It was on 6 January 754 that Pope Stephen II met Charlemagne's father on his estate at Ponthion, near present-day Vitry-le-François, and went with him to Saint-Denis to crown him king of the Franks. The pope was accompanied by a large concourse of cardinals and churchmen. This ceremony had been preceded by two embassies sent to Rome by Pepin in 750 to reconcile Pope Zacharias to the idea of a change of regime in the Frankish kingdom. The fact that Gundohinus went out of his way to specify the year of the new reign suggests that he recognized its importance, as did many contemporaries.

It might be rash to associate in any precise way the Gospel Book of Gundohinus with Pope Stephen's visit and Pepin's coronation; the concordance of dates may be a mere coincidence, but it is surely meaningful. Of more immediate importance is the question: whence did Gundohinus, or rather his illustrator, get his models? It is evident that they came from a particular part of northern Italy, the region intermediate between the Germanic north and the Roman south, from which the Merovingians had already borrowed so much in all the domains of art: Lombardy, which travellers crossed on the way from Rome to Gaul and which, owing to the proximity of Ravenna (annexed by the Lombards in 751), had maintained closer artistic contacts than any other region with the Byzantine world—with which, moreover, the pope and the Franks were still on friendly terms. The figure of Christ in the Gundohinus Gospels reproduces almost line for line the king image on the Val di Nievole helmet; the garment, the parallel lines on the sleeve and also the position of the right arm are similar, as is the hair plastered down on both sides of the face (a Lombard hair style as we learn from the Lombard historian Paul the Deacon and the gold cross of Duke Gisulf) and the low pedestal on which the figure stands; two guardian angels replace the soldiers of Agilulf. The circular band of leafage around Christ imitates the one around the Ittenheim warrior, while the medallions in round beaded frames have many Lombard equivalents. We may also note how closely this image recalls the one on the altar of Ratchis at Cividale, of exactly the same date as the Gundohinus Gospels. The standing evangelist figures that follow the figure of Christ derive from the Greek tradition; they are elongated or presented half-length, frontally, as at San Vitale in Ravenna. Thus the earliest known example of Carolingian book painting might easily pass for a Lombard work: all its images look back to northern Italy, to the barbarians who at that time were those most deeply imbued with the Mediterranean culture. There is one discrepancy, however: the curious palmettes marking the knees of Christ. Peculiar to the British Isles in the metallic, pointed form it here assumes, this motif is a drastically schematized interpretation of drapery folds on the legs of frontally seated figures. The same idiosyncrasy appears on the sarcophagus (c. 680) of Bishop Agilbert at Jouarre, whose affinities with insular art have been rightly pointed out. Here, as at Jouarre, the open book resting on the left leg is partly hidden by the knee. Moreover, the zoomorphic decoration of the initials is of the Merovingian type. Despite these barbarian traits, the Gundohinus Gospels show an independence of its milieu; the artist drew inspiration from Italian sources, from that mixed art trend which, to his way of thinking, stood for the Mediterranean tradition.

Book Illustration of the Court of Charlemagne.
The Godescalc Gospels

Nearly thirty years had passed when in 781 Pepin's son, Charles, met Pope Adrian I in Rome. As in 754, a book has commemorated for us this new encounter between the king of the Franks and the pope; this time, however, the book did not merely synchronize with the event but resulted from it. Carolingian art began with the coronation of Pepin, but it acquired its true character only with the journey to Rome of the future Charlemagne: from then on, it was a court art, the art of a dynasty, promoted by the king, his descendants, relatives, associates and officers of state. No sooner had Charles returned to Aachen than he commissioned a scribe named Godescalc to make a Gospel Book for his use, that is, a collection of pericopes, extracts from the Gospels arranged in their liturgical order. The book was completed before the death of Charles's wife Hildegarde on 30 April 783. Nothing is known about Godescalc, a Frank, judging by his name, except that he was a personal friend of the king, his *'ultimus famulus'* as he described himself in a dedication in which he lauded the sagacity and foresight of the king and the interest he took in the art of the book: *'providus et sapiens, studiosus in arte librorum.'* We can only guess at the models to which Godescalc had recourse, but it is evident that all belonged to the Byzantine world. Following the evangelist portraits is the first depiction in Western art of the Fountain of Life. This image, which from the fourth century on had been included in the repertory of the Christian art of the East, figured as the final decoration of the Gospel canons in the Greek translation of Eusebius, where it was given the form of the Holy Sepulchre at Jerusalem. This was the form which had been popularized in Italy by pilgrim flasks brought from the Holy Land, such as those preserved at Monza and Bobbio, which were probably gifts made by the Lombard queen Theodelinde. The posture of the evangelists grouped in the front of the book conforms to the Greek tradition. Indeed these portraits can best be compared with those of the sixth century in San Vitale, Ravenna, and their architectural setting with Greek equivalents admittedly later in date, but iconoclasm has deprived us of all their predecessors.

Charles appeared in Rome as master of the Western world; he went there for Easter after spending the winter of 780 at Pavia, the Lombard capital, where six years earlier he had captured King Desiderius and all his treasures. His son Pepin, baptized by Pope Adrian, became king of Italy, a fact Godescalc did not fail to mention in a note on the calendar of his Gospels. At Parma on his return journey Charles met the English scholar Alcuin whom he summoned to Aachen five years later to take charge of the Palace School. Undoubtedly the Godescalc Gospels was a by-product of Charles's stay in Rome and Lombardy; in this sense it may be said to have had its origin in Italy. But the work itself bears the mark of 'barbarian' craftsmanship. For at this time the work of insular artists, whether they came from Ireland or from England, was dominant north of the Alps; their graphic virtuosity in particular ensured their primacy everywhere. Many of the motifs common in

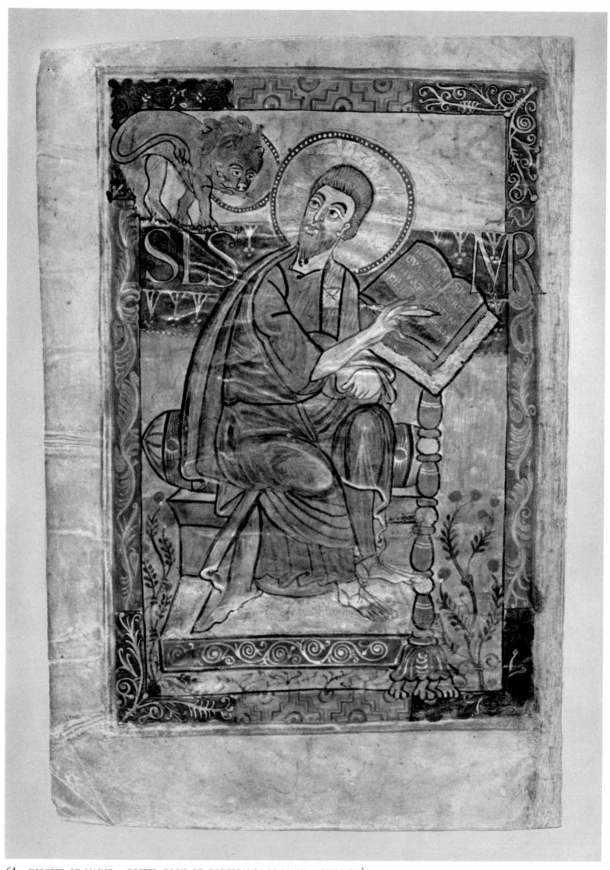

64 – DIOCESE OF MAINZ. GOSPEL BOOK OF GODESCALC: ST MARK. BIBLIOTHÈQUE NATIONALE, PARIS.

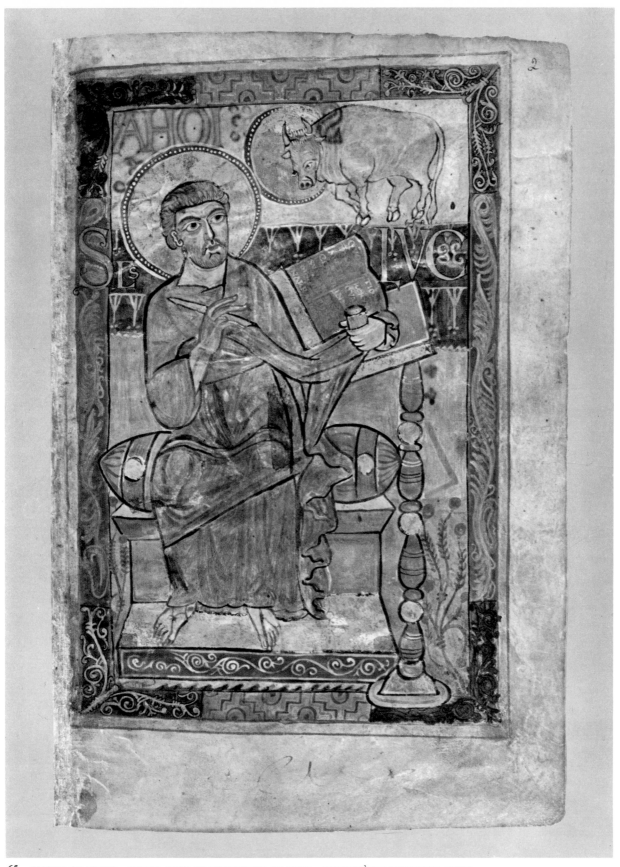

65 – DIOCESE OF MAINZ. GOSPEL BOOK OF GODESCALC: ST LUKE. BIBLIOTHÈQUE NATIONALE, PARIS.

manuscripts painted in the British Isles recur in this book: trumpets, scrolls, interlaces with shuttle-shaped angles, rows of teeth (or combs) and, above all, large initial letters of the distinctively Irish type (in the words *Liber, Initium*). Other motifs, however, are of Mediterranean origin: palmettes and branches lightly brushed in with white paint on a dark ground, Greek key patterns viewed in perspective, polychrome shadings, cones paired *tête-bêche*.

As a rule the art of Charlemagne's painters is characterized by the intermingling of these two art currents; but the Godescalc Gospels differ from the other illuminated manuscripts commissioned by the king by a Middle East flavour peculiar to it. Nowhere else in Carolingian court art is Christ represented with this plump face, darkly glowing eyes, bulging cheeks, pinched lips and what (though He is shown full face) gives the impression of a snub nose. Nor do we see elsewhere evangelist portraits with these lean, bearded faces and garments whose folds are indicated by light and dark stripes. No less distinctive is the technique: broad areas of colour lightly washed in, always in cold tones. Whatever was the origin and training of this painter's immediate successors, it is clear that his style was promptly superseded and that—at least in the royal *familia* and its ramifications—it had no sequel. The only other examples of it are to be found at Corbie, in the Psalter and the manuscript by George of Amiens described in the previous volume in this series. In them we find all the characteristics of the Godescalc Gospels and a reason for its 'Syrian' air: these artists obviously belonged to the same milieu. And was it not in part at Corbie, Adalard's abbey, where the Lombard king Desiderius once stayed, that Western painting took a new lease on life?

Painting at Charlemagne's Court:
The Second Team of Artists

A new lease on life, but, as things turned out, a precarious one, ill-adjusted and soon to peter out. It was resumed, however, some years later by a new team of artists. It is a curious fact that by the twelfth century at the latest the Godescalc Gospels were in the church of Saint-Sernin at Toulouse (capital of Charlemagne's son Louis, king of Aquitaine, the future Louis the Pious). How this book reached Toulouse, through whose hands it passed, is a matter of pure conjecture. It is possible that Charles himself gave it to his son. We may note that the Merovingian Gellone Sacramentary, too, found its way to the South and that Benedict of Aniane was a trusted adviser of King Louis. The period when painting was in abeyance seems to have lasted for some time. Thus a Psalter commissioned by Charles and copied by the scribe Dagulf after 783—it was to be a gift to Pope Adrian—contained no illustrations. Had the king had at his disposal a painter on whom he could rely, would he have left in this condition the Dagulf Psalter, a book presented to the pope with a dedication composed by Alcuin? Nor were there any paintings in the first part

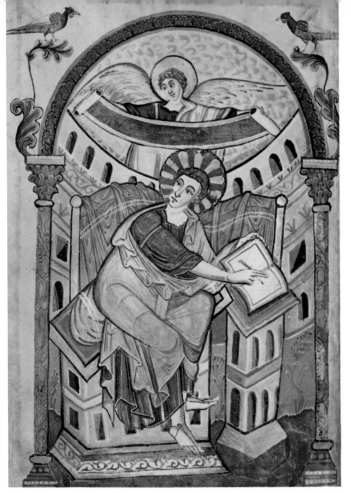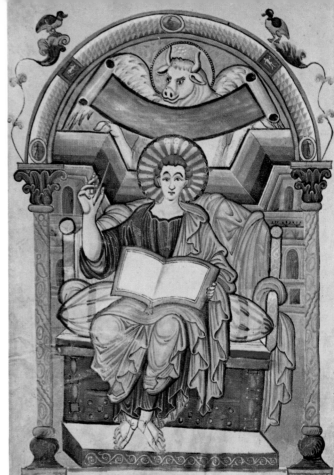

66-67 – MIDDLE RHINE. GOSPEL BOOK OF ADA: ST MATTHEW AND ST LUKE. STADTBIBLIOTHEK, TRIER.

of the Ada Gospels (named a putative sister of Charlemagne, otherwise unknown), written before 785 and now at Trier; while the second part, made later, was illustrated. This seems to confirm the view set forth above of an 'abeyance'—but let us admit, it is little more than guesswork. This much is certain: afterwards, Carolingian art was so closely associated with the royal household that the court must be regarded as the formative centre, without exception, of the artists who were to compose its various branches or 'schools.' All art activity was now controlled, and was to be controlled for years to come, by the patron, the giver of commissions to the artist, the man who supported him and for whom he worked. Once he disappeared, the artist too disappeared; with no work being forthcoming, he looked for another employer. The royal household always supplied the driving force and the various 'schools,' as we shall see, were not separated in watertight compartments; they followed each other chronologically (in the steps of their successive patrons), and the artists (or, what comes to the same thing, their techniques) shifted from one school to another. In short, despite its superficial diversity, there is only one Carolingian art properly so called—an art inseparable from the dynasty, without whose support it would not have existed. And it was the men alone, patrons and artists, who counted, not the places where they happened to reside.

The change of orientation took place some time after 795, when Charles was

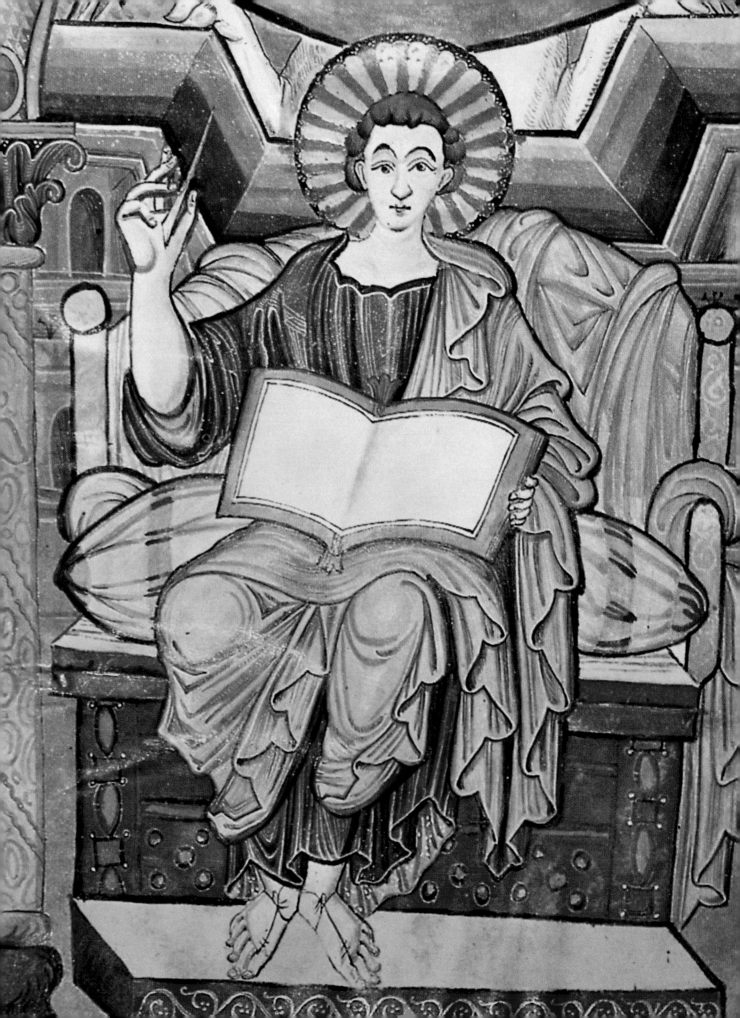

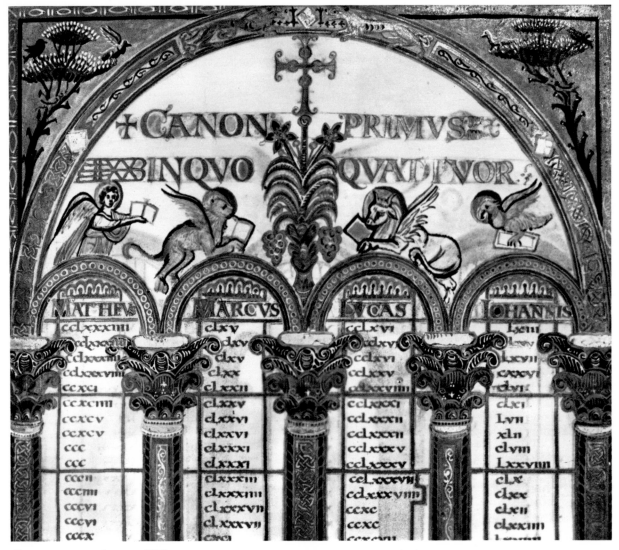

69 – GOSPEL BOOK (HARLEY 2788): CANON TABLES, DETAIL. BRITISH MUSEUM, LONDON.

settling into his newly built (perhaps not yet completed) palace at Aachen. Among
the members of Charles's court circle was a young man named Einhard, the king's
future biographer. A poet and a fine scholar, Einhard was also a practicing artist;
Alcuin gave him the nickname of Bazaleel, the biblical craftsman 'with knowledge
of all manner of workmanship' commanded to make the Ark of the Covenant.
We know of Einhard's own work by the design, in the form of a triumphal arch,
for the metal pedestal of a cross presented by him (c. 830) to his parish church at
Maastricht. This was a work of wholly Roman Imperial inspiration, as likewise
were the books painted for Charlemagne after the Godescalc Gospels. Quite likely
Einhard was the guiding spirit of the 'second team' of royal artists.

Among all the manuscripts decorated at Charles's court after the Godescalc
Gospels (apart from the Gospel Book in the British Museum, Harley ms. 2788,
which marks a new departure and whose peculiarities will be described at a later
page), four superb volumes have pride of place. Of the first only one picture and

◀ 68 – MIDDLE RHINE. GOSPEL BOOK OF ADA: ST LUKE, DETAIL.

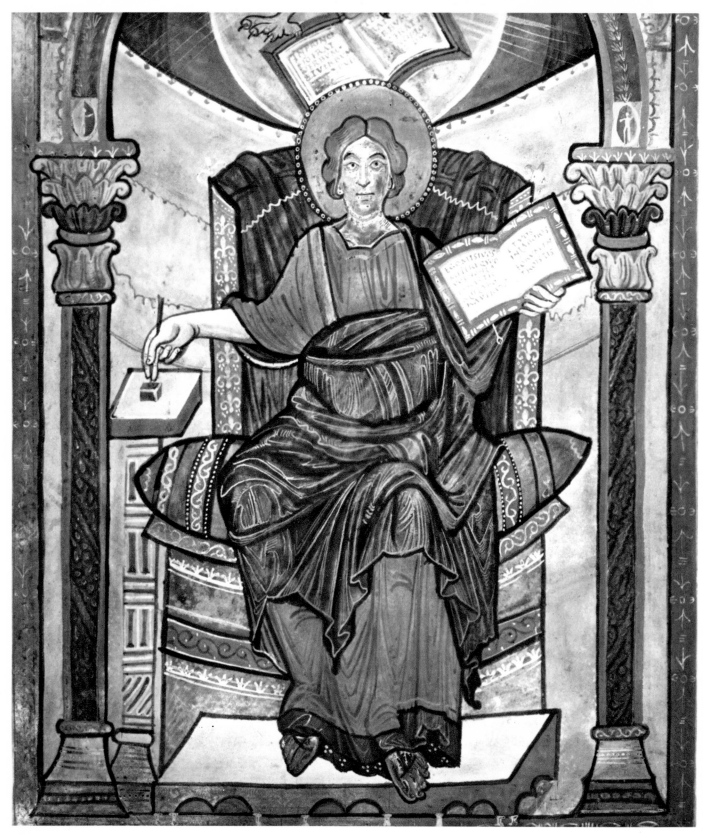

70 – GOSPEL BOOK (HARLEY 2788): ST JOHN, DETAIL. BRITISH MUSEUM, LONDON.

71 – GOSPEL BOOK (HARLEY 2788): ZACHARIAS AND THE ANGEL. BRITISH MUSEUM, LONDON. ▶

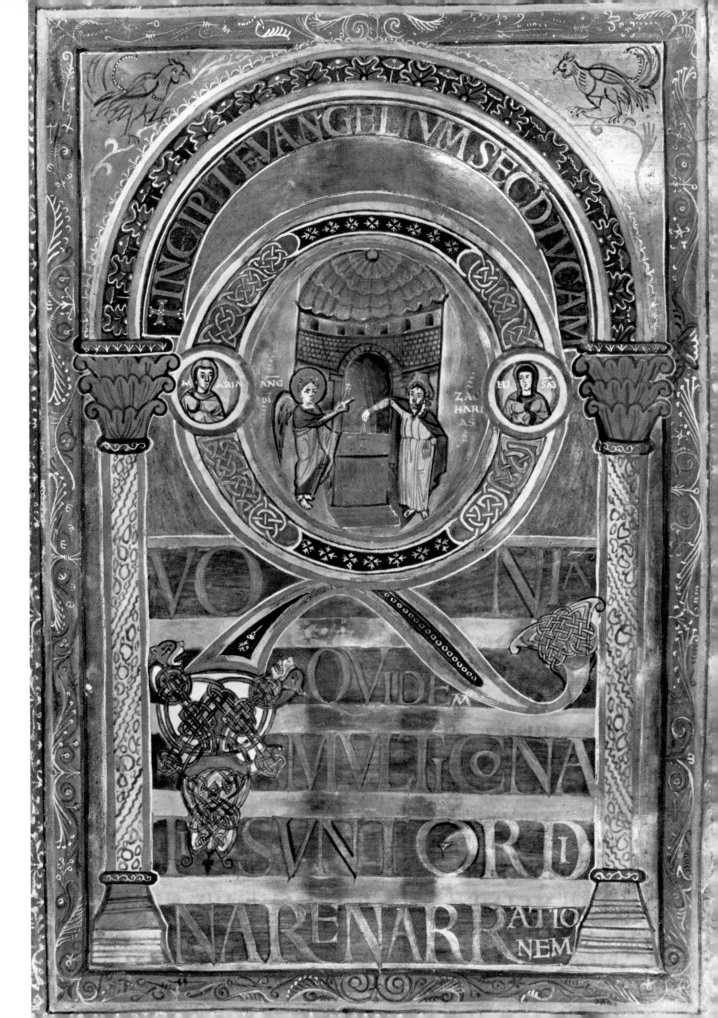

72 – MIDDLE RHINE. GOSPEL BOOK (COTTON CLAUD B. V.): ANNUNCIATION TO ZACHARIAS. LONDON.

two lines of text survived the fire which in 1731 destroyed the library of Sir Robert Cotton. This, the second Gospel Book made for the king, was perhaps intended to replace the Godescalc Gospels which he had given to his son Louis. Its figures are of the same Italo-Alpine type as those found, for example, on the contemporary ivory book cover of Genoelselderen, which comes from the same artistic milieu, and in the sixth-century Gospel Book of St Augustine of Canterbury. There is nothing to surprise us in this permanence of traditional forms, unaffected by the techniques employed and perpetuated over long periods by fidelity to the tradition of successive schools of craftsmen. These artists, servitors of a more or less exalted rank, belonged to the *familia*, to the group of men who were employed by the royal household on works of art of various kinds and therefore conformed to an accepted norm, whatever the branch in which they specialized—painting, ivory carving or metalwork.

The same Italo-Alpine style characterizes the small figures in the secondary scenes of the next Gospel Book made for Charlemagne and presented by Louis the Pious in 827 to the abbey of Saint-Médard at Soissons; for example the opening pages of the Gospel of Luke depicting the Annunciation, the Visitation and Christ Teaching. This last image is inscribed in the initial letter, one of those 'historiated' initials which had first appeared in the eighth century in the south of England. We would first draw attention, in the Saint-Médard Gospels, to a point of undoubted importance: a spiral column in the canon table is an exact copy of an antique column still to be seen today in St Peter's in Rome. In this manuscript the artists accumulated a wealth of ornamentation of the most various kinds with a view to producing an effect of sumptuousness—the result being, as one might expect, a plethora of decoration. There are passages each of which, taken separately, is a meticulously executed *tour de force;* details which, one feels, are designed to create a picture governed by a directive idea or a given theme, nobly conceived and majestically coherent; but the overall effect is one of confusion. Nothing could be clearer than the intention, nothing stranger than the means employed to formulate it, despite the obvious effort towards unity. The Adoration of the Lamb, which opens the book to introduce us to the revelation of the Gospels, is built up of three superimposed zones whose

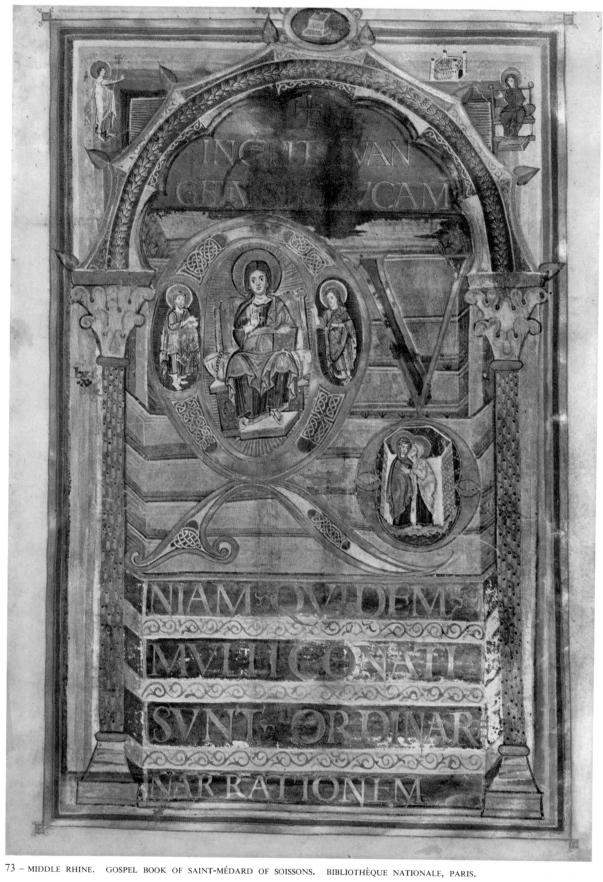

INCIPIT VAN
GELIVM SEC LVCAM

NIAM QVI DEMS
MVLTI CONATI
SVNT ORDINAR
NARRATIONEM

73 – MIDDLE RHINE. GOSPEL BOOK OF SAINT-MÉDARD OF SOISSONS. BIBLIOTHÈQUE NATIONALE, PARIS.

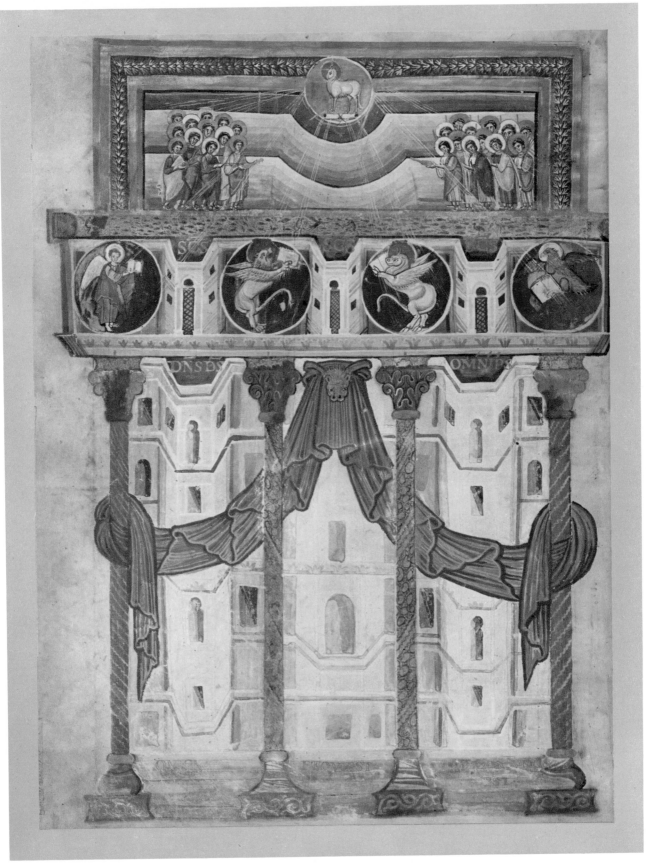

74 – MIDDLE RHINE. GOSPEL BOOK OF SAINT-MÉDARD OF SOISSONS. BIBLIOTHÈQUE NATIONALE, PARIS.

75 – MIDDLE RHINE. GOSPEL BOOK OF SAINT-MÉDARD OF SOISSONS: FOUNTAIN OF LIFE. BIBLIOTHÈQUE NATIONALE, PARIS.

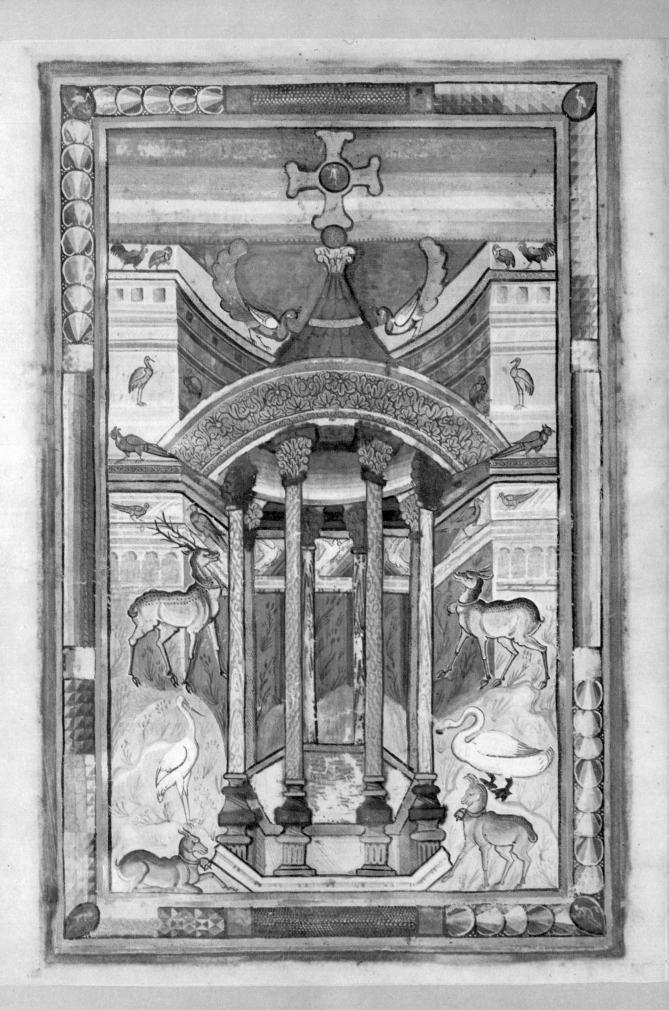

ascending movement is focused on the medallion at the top containing the Lamb. The medallion is the only element directly on the median line. All the others stand right and left of centre but tend towards the apex; they are swept upward by some all-pervading force, the force that lifts a large curtain (spanning some three quarters of the picture space) slung across the columns of a proscenium. The curtain rises theatrically on what looks like a huge stage set in the antique manner, a six-storied construction flooded with the radiance emanating from the Lamb. The design of the substructure, a façade with alternating recesses and salients, is continued on a reduced scale in the level above, which is surmounted in turn by a third zone whose horizontal lines melt into curves to match the rounded edge of the medallion. There is a contrast, certainly intentional, among the lowest zone, which is completely void, the middle band occupied only by the four evangelist symbols (acting as intermediaries) and the heavens in which the Lamb is enthroned, attended by the twenty-four elders of the Book of Revelation. This image of the empyrean, separated from the rest in accordance with the cosmography of the age and the text of the Apocalypse, represents the *mare vitreum*, the zenith from which falls a refreshing rain, i.e., lustral water. As they move upwards, the forms become less and less angular, and the number of personages increases as if to signify that life asserts itself more and more as we rise heavenwards. But materially speaking, nothing holds together; perspective effects are destroyed by horizontals which appear on the same plane as the buildings and simultaneously on a colonnade whose bases lie far in front of the structure proper. The artist has not understood the models for his reliefs; the celestial zone of water, like an earthly lake, with its fish and fishermen, is simply a copy of an antique mosaic, several examples of which have come down to us. Nor has the artist troubled to create a plausible landscape; by taking some concrete figurative motifs and imposing them, quite unchanged, onto a flat plane, he has built up a symbolic image. He gives no thought to weight and mass, which have ceased to count, for his interest lies elsewhere and all that he has in mind is the idea his picture will evoke. He has drained the ancient forms of all terrestrial content, disregarded their conventions; he has charged all with intimations of a world perceptible beyond appearances. Thus, despite his scrupulous fidelity to Mediterranean models, he is essentially medieval. After this impressive composition comes a Fountain of Life with deer and birds, signifying the Christians, coming to drink. This is a copy of the Fountain of Life scene in the Godescalc Gospels, and it suffers from the same imbalance as its predecessor, but its architecture is much more intricate. The evangelist portraits and large initials following are enclosed in arches and frames adorned with cameos and pictures containing tiny figures (these were soon to proliferate at Tours).

Like the Saint-Médard Gospels, the other two manuscripts of this group differ from the Godescalc Gospels in their classicism. This is true of the Abbeville Gospels, written on purple vellum at the abbey of Saint-Riquier, presided over by Angilbert; also of the Lorsch Gospels, in which the Gospel of St Matthew opens with a sequence of icons, portraits of the ancestors of Christ reminiscent of the emperor portraits paraded in the streets of Rome.

76 – MIDDLE RHINE. GOSPEL BOOK OF SAINT-MÉDARD OF SOISSONS: ST MARK. BIBLIOTHÈQUE NATIONALE, PARIS.

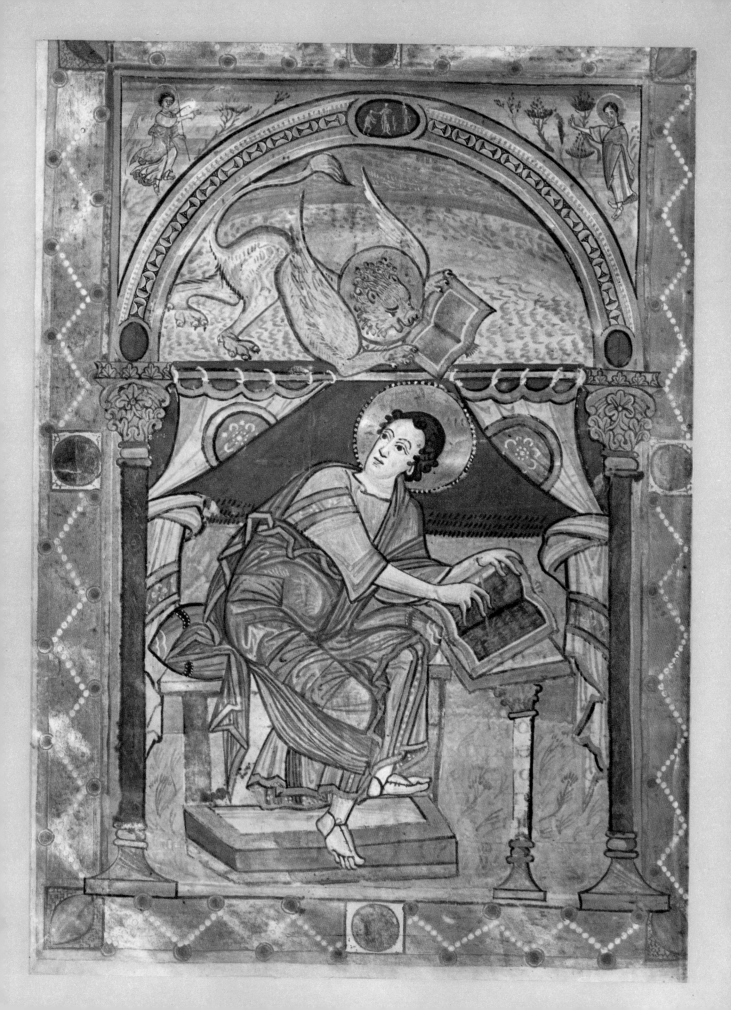

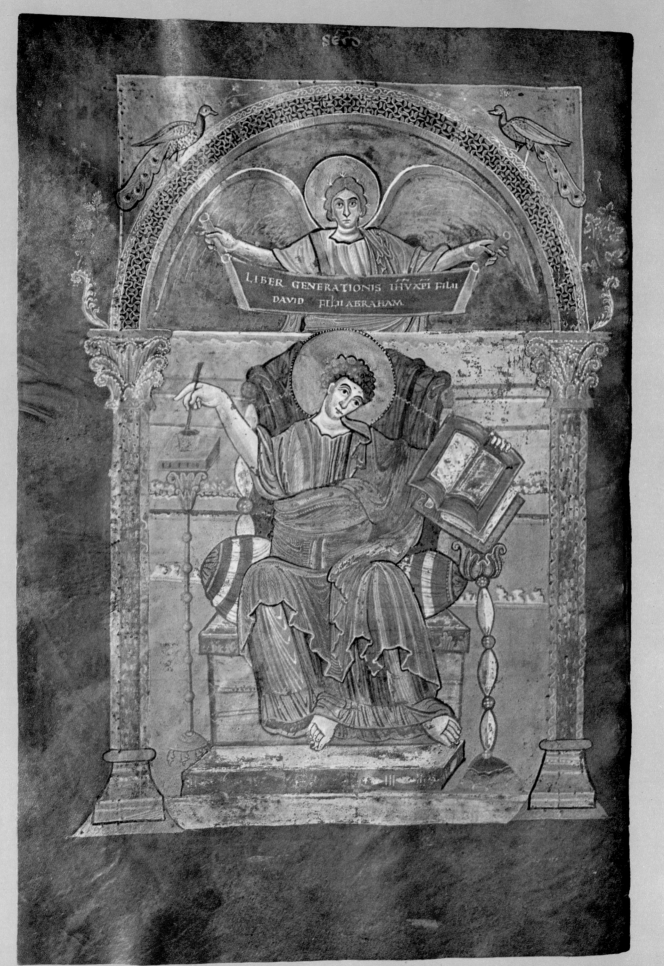

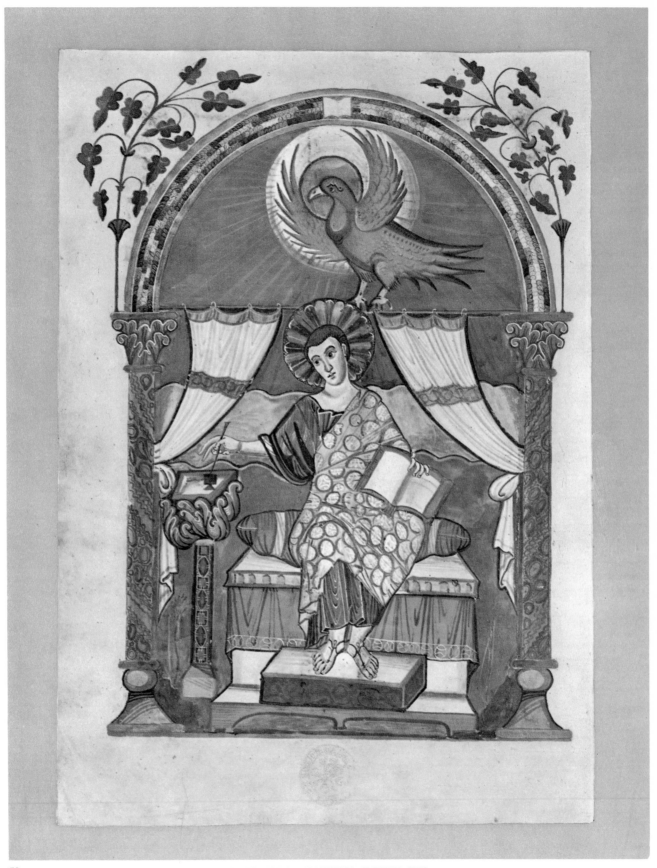

78 – MIDDLE RHINE. LORSCH GOSPELS: ST JOHN. BIBLIOTECA APOSTOLICA, VATICAN CITY.

◄ 77 – ABBEY OF SAINT-RIQUIER. ABBEVILLE GOSPELS: ST MATTHEW. BIBLIOTHÈQUE MUNICIPALE, ABBEVILLE.

The Aachen Painters under Louis the Pious.
The School of Ebbo at Reims

Italy's influence was considerable in the art of Charlemagne's painters, whose sources were first Lombard, then Greco-Roman. In the case of the artists whose works we shall now consider, it was a very different aspect of Italian art that caught their eyes: its Hellenistic, Alexandrian aspect. It is, however, to Rome and chiefly to northern Italy that we must turn once more to find the models and first artists of this new development; we say 'first' since a distinction must be drawn between two phases separated by a gap of about a decade. These early artists had been trained on the same lines as the painters of Pope John VII at Castelseprio and those of San Salvatore at Brescia, and like them, might, perhaps, have come from distant parts of the Mediterranean area to escape the Arab invasions of the seventh century. Actually, though, this hypothesis is unnecessary since we learn from various sources, many ancient bilingual texts in particular, that Hellenism had already established itself in northern Italy where Ravenna, as opposed to Roman Milan, was in effect the Byzantine capital. We would have trouble in associating with some specific personality this group of Carolingian works, were it not that one of them, the Ebbo Gospels, dating from the end of the first phase, was painted about 820 for an intimate friend of Louis the Pious, Ebbo, the archbishop of Reims (see p. 101). Now Louis, more than any other ruler of the day, had close personal contacts with Italy: he owned estates in northern Italy, in the neighbourhood of Brescia in fact; he had a long stay at Ravenna in 793, took part in the local Christmas festival and with his brother Pepin seized Benevento before going to join his father at Salzburg. The earliest of these books of Alexandrian lineage dates, it happens, to the decade 790-800, and there is much in favour of the view that it was made for the young prince.

This is the Coronation Gospel Book in Vienna, said to have been found on Charlemagne's knees when his tomb was opened by Otto III in the year 1000. Two similar but later Gospels exist, one in Aachen, the other (from Xanten, some twenty miles north of Aachen) in Brussels. By a lucky chance, the Xanten manuscript contains a loose sheet with an evangelist portrait on purple vellum which some scholars think to be a fragment of a fifth- or sixth-century volume (its date is, naturally, conjectural). However, its quality is so high and its style so markedly antique that it may well have been a page of a Gospel Book painted in northern Italy and brought by one of the painters summoned to Aachen by Louis the Pious. Though belonging to the same artistic family and milieu (all were painted at Aachen between 790 and 810, before Charlemagne's death), these three books are the work of different hands. The evangelist portraits in the Coronation Gospel Book illustrate a text which, in the margin of one of the sheets, bears the name *Demetrius presbyter*, the Latinized form of a Greek name; whether it is the name of the scribe himself or that of a painter, there is no knowing, but in any case it is that of someone who took part in the making of the manuscript. This man was a Greek, as was George, bishop of Amiens, who like him came to the North from Italy. If the

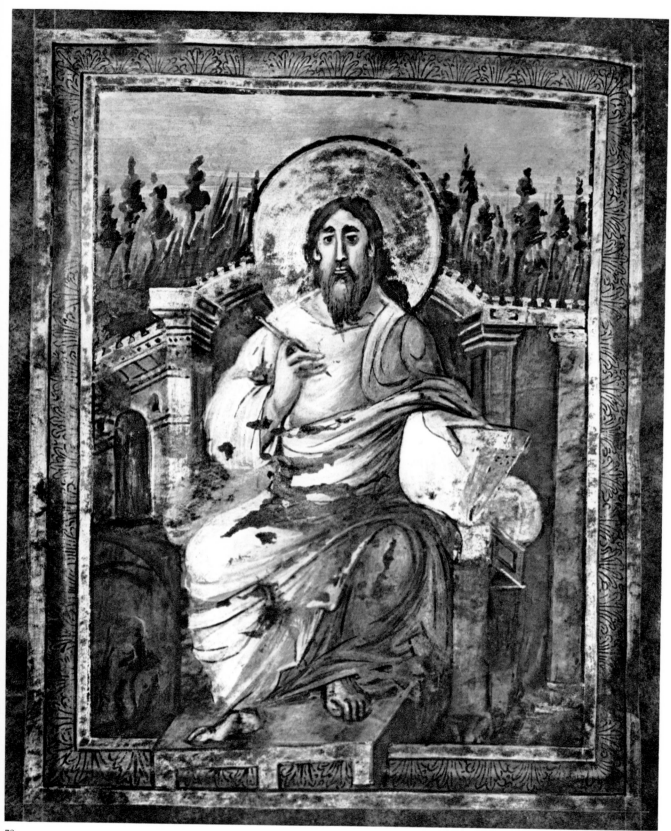

79 – AACHEN. CORONATION GOSPEL BOOK: ST JOHN. SCHATZKAMMER, KUNSTHISTORISCHES MUSEUM, VIENNA.

80 – AACHEN. CORONATION GOSPEL BOOK: ST MARK. KUNSTHISTORISCHES MUSEUM, VIENNA.

sequence of manuscripts assigned to the Reims School (of which these three Gospels
are, so to speak, the pioneers) was the work of Franks, as there is every reason to
believe, it was from this trilogy that they took guidance. In seeking to assess
the quality of these calm, beautifully conceived images and assign them their
chronology, we see their evident affiliation with one of the earliest Greek manuscripts
extant, the famous Vienna Dioscorides, illustrated before 512 at Constantinople for
Anicia Juliana, daughter of the Emperor Olybrius. These pictures are distinctive

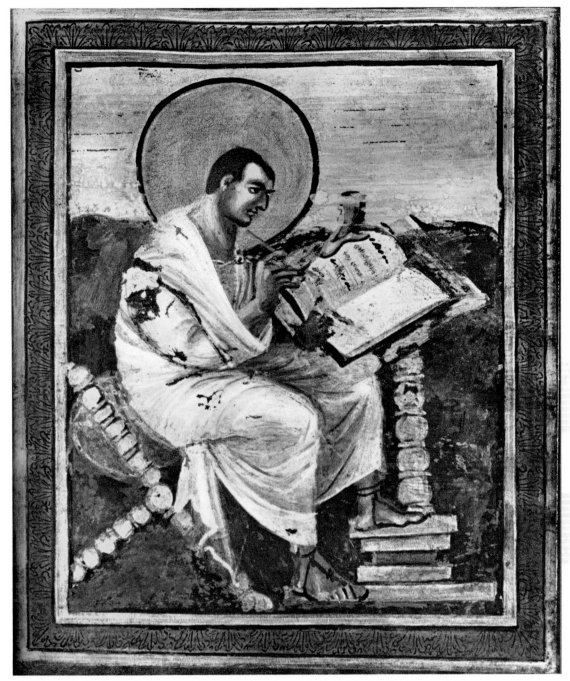

81 – AACHEN. CORONATION GOSPEL BOOK: ST MATTHEW. KUNSTHISTORISCHES MUSEUM, VIENNA.

in their harmony and antique dignity, and above all their feeling for space wholly lacking in northern works, their representation of figures in open settings unencumbered by the architectural elements that tend to clutter up from top to bottom the works of Charlemagne's painters. The evangelists are placed, alone or in groups, in open country, against a natural background. In the Xanten Gospel Book they are arrayed, draped in togas, in a straight line; two are writing and two reading, each with his head propped on his right arm, in an attitude of meditation characteristic

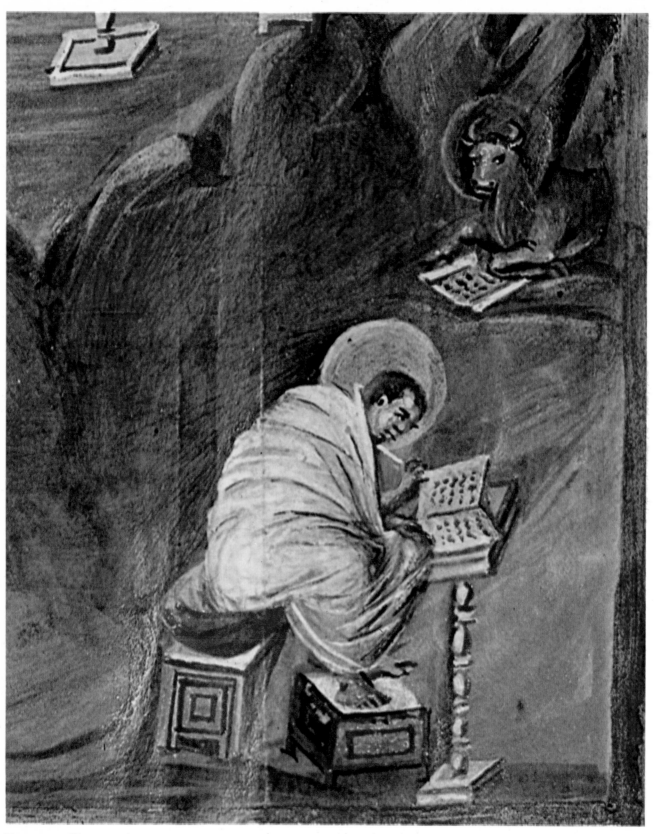

82 – AACHEN (?). GOSPEL BOOK: ST LUKE, DETAIL. CATHEDRAL TREASURY, AACHEN.

83 – AACHEN. XANTEN GOSPEL BOOK: EVANGELIST PORTRAIT, DETAIL. BIBLIOTHÈQUE ROYALE, BRUSSELS. ▶

of the thinker or poet, of which there are so many examples in antique art. Above them are set out their attributes perched on identical hillocks and dominated by the figure of Christ seated on the *orbis terrarum*. The evangelists have no haloes, and in the Coronation Gospels no attributes; both these omissions were, until the thirteenth century, characteristic of Byzantine art. The painters of Louis the Pious and their successors at Reims always gave the evangelists haloes, sometimes excessively large ones, while they often summarily indicated their small attributes: concessions in both cases to Latin taste and practice. In the Aachen Gospels the evangelists are also grouped on the same page, but relegated to the four corners, with their backs turned to each other. Behind each figure is a round, vault-shaped hillock (an Alexandrian device) isolating him from the others and containing a small recess for the attribute. In the background is a line of trees with a thin strip of bright sky at each end. Curiously enough, the painter began by placing a small wall behind two of the evangelists. The handling is quite different from that of the earlier Coronation Gospels but the idea behind each is the same: that the gospels, though independent texts, derive from the same source and that their concordance demonstrates their truth—just as the four quarters of the world, though separated, form a whole. This was an idea expounded by St Augustine in his *De consensu evangelistarum*, to which the painters gave expression in their own ways: the Xanten painter austerely, almost frigidly; the Aachen painter with more vivacity and something of that nervous energy which until now had made itself felt only in the Alexandrian-Mediterranean art of antiquity, but which was to be revived and pressed to its extreme limit by Ebbo's Frankish painters at Reims. In all three books we find a special technique differentiating them from all the other manuscripts of the early Middle Ages in the West: modelling produced by means of colour, with line playing only an ancillary part and indeed often disappearing entirely, and the application of muted colours in small juxtaposed touches in the impressionistic manner of the earliest Byzantine illuminations and Roman paintings of the Hellenistic period.

Like all their contemporaries these artists adopted the system of vertical projection, but they utilized it in a way those others had never contemplated. This system often consisted of transverse bands of narrative, registers of various sizes placed one above the other, whose boundaries were indicated simply by wavy lines between them. This line usually served no other purpose than that of dividing up the scenes (as in the Ashburnham Pentateuch, for example). Such, however, was not the case with one of the most famous productions of the Reims workshops at the time of Ebbo, the so-called Utrecht Psalter (see below). Here, as in its Alexandrian prototypes, the structural curves were disguised as hills or undulations of the ground on which the figures stand; thus the artist could isolate the scenes without using a clearcut dividing line, and could suggest the organic unity of each Psalm's episodes, images and implicit prefigurations of the New Testament. The painter of the Aachen Gospel Book used the same procedure. So it is that only in the Aachen Gospel Book and in that of Ebbo are the evangelists represented in the open air, at once united and separated, each with his writing desk, perched, like his attributes, on some windy crag. This practice, enabling a far more supple

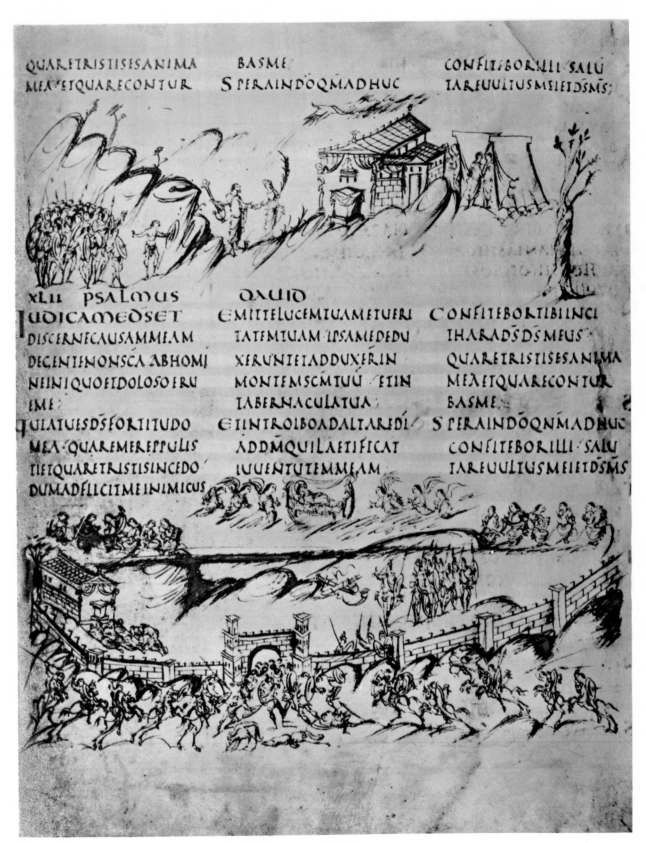

QUARETRISTISESANIMA
MEA ETQUARECONTUR

BASME
SPERAINDÖQMADHUC

CONFITEBORILLI SALU
TAREUULTUSMEIETDSMS;

XLII PSALMUS QAUID
IUDICAMEDSET EMITTELUCEMTUAMETUERI CONFITEBORTIBIINCI
DISCERNECAUSAMMEAM TATEMTUAM IPSAMEDEDU IHARADSDSMEUS
DEGENTENONSCA ABHOMI XERUNTETADDUXERIN QUARETRISTISESANIMA
NEINIQUOETDOLOSOERU MONTEMSCMTUÜ ETIN MEAETQUARECONTUR
EME TABERNACULATUA BASME
QULATUESDSFORTITUDO ETINTROIBOADALTAREDI SPERAINDÖQNMADHUC
MEA QUAREMEREPPULIS ADDMQUILAETIFICAT CONFITEBORILLI SALU
TIETQUARETRISTISINCEDO IUUENTUTEMMEAM TAREUULTUSMEIETDSMS
DUMADFLICITMEINIMICUS

84 – HAUTVILLERS. UTRECHT PSALTER. UNIVERSITY LIBRARY, UTRECHT.

99

XI. INFINEM PROC

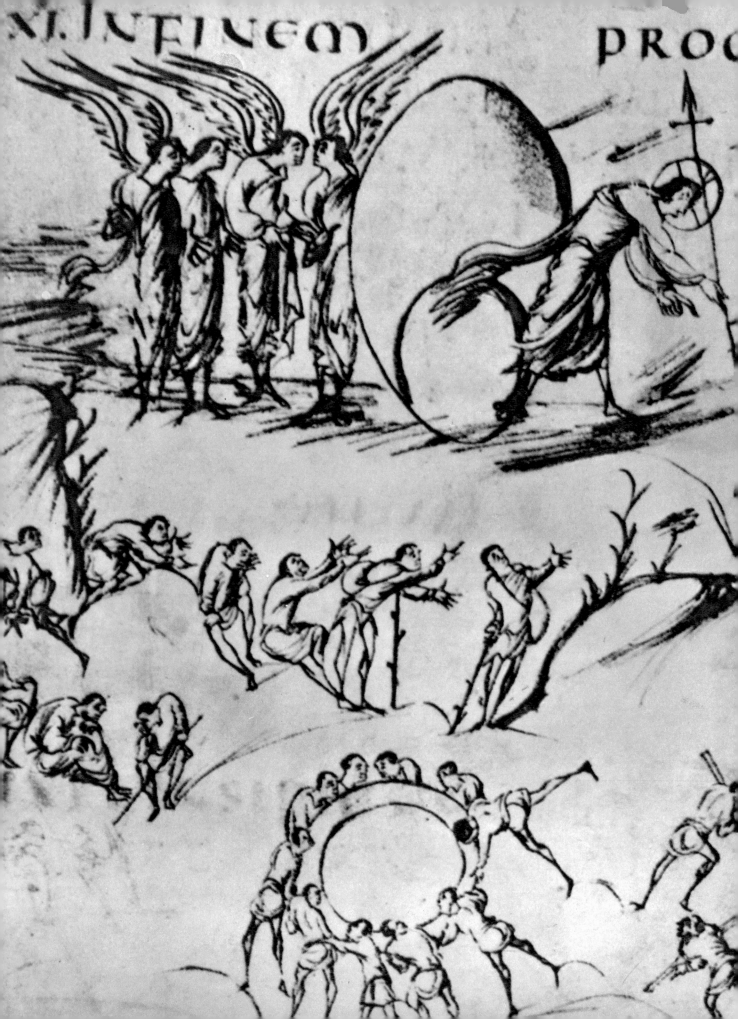

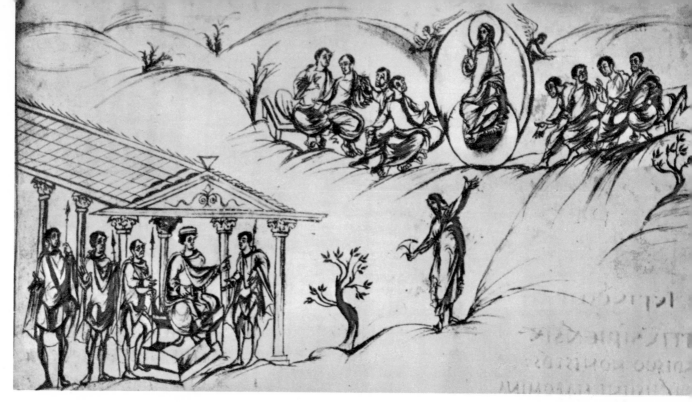

86 – HAUTVILLERS. UTRECHT PSALTER, DETAIL. UNIVERSITY LIBRARY, UTRECHT.

treatment of the motif than in the Xanten Gospels, led in time to remarkable results.

Whether or not these paintings can be assigned to the court art of Louis the Pious, it is certain that in them the Greek tradition appears at its purest, out of its time and place, as in the Castelseprio frescoes in northern Italy. These artists were not Franks; their dignity, their serenity, legacy of an ancient culture, were poles apart from the turbulent vitality of their barbarian pupils. If we hesitate to call them Greek emigrants, compatriots of Demetrius, and if the evidence of an affiliation cited above does not seem conclusive, we have only to look at the works of their successors, the painters who worked at Reims under the aegis of Archbishop Ebbo. These men were indigenous, a younger generation who had gone to school and learned all they knew from their elders, but they exploited this knowledge with an unusual zest.

None was better qualified than Ebbo to understand and carry out the emperor's intentions regarding Mediterranean models, and he evidently played the same part at the court of Louis as Einhard had played at the court of Charlemagne. Of Germanic extraction, son of a nurse of the future Louis the Pious, Ebbo had been the schoolmate and then (freed from his menial condition) a bosom friend of his foster brother who, after becoming king of Aquitaine in 781, was associated with the government of the empire in 813. Louis, impressed by Ebbo's industry and intelligence, appointed him imperial librarian. 'The vigour of his mind,' wrote Charles the Bald, 'combined with his tremendous energy, enabled him to enter the prelacy and rise rapidly to a high rank in it.' Appointed archbishop of Reims in 816 in place of the uncultured Gislemar (Ebbo showed no gratitude for his elevation, but heaped abuse on his benefactor when the emperor was deposed for the second time in 833) and eager to enhance the renown of his church, Ebbo enlisted the services of the best

◀ 85 – HAUTVILLERS. UTRECHT PSALTER, DETAIL. UNIVERSITY LIBRARY, UTRECHT.

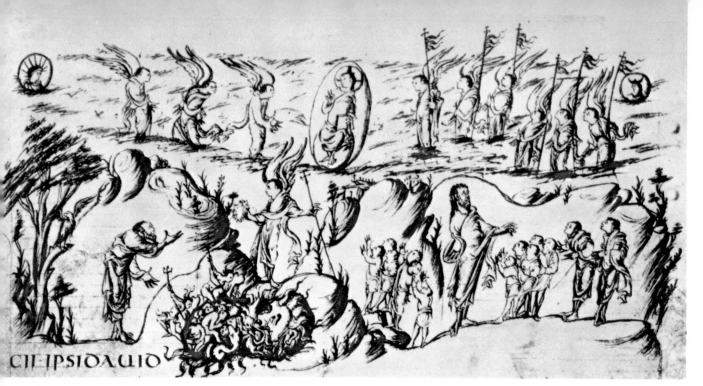

87 – HAUTVILLERS. UTRECHT PSALTER, DETAIL. UNIVERSITY LIBRARY, UTRECHT.

artists and presented them with benefices. It was in the abbey of Hautvillers (between Reims and Epernay), a country residence of the archbishops, where under his and Abbot Peter's auspices some of the finest illuminated manuscripts of the Carolingian period were produced, those which were to have the deepest, most lasting influence on Western art, on both painting and relief carving. Like many of his fellow barbarians, Ebbo was hot-tempered, harsh and domineering, but he also had a streak of what might be called shrewd sensibility. Charles the Bald knew him well and, while aware of his faults of character, could not help feeling an interest in, even a liking for, this singular man. In answer to the pope, who had asked for information about Ebbo, Charles recounted an anecdote which throws light both on the man himself and, indirectly, on the type of art he sponsored—curious, badly organized, but rich in promise for the future. In June 823 when Judith, wife of Louis the Pious, was awaiting the birth of her child (the future Charles the Bald), she gave Archbishop Ebbo a ring, as was the custom, to serve as a memento of the occasion. Ten years later, when Ebbo was in disgrace for his desertion of Louis at Soissons, and had gone into hiding in Paris at the house of a 'recluse' from his diocese, a man named Framegaud (whose signature appears on some of the Reims manuscripts), he had the romantic notion of sending this ring back to Judith to remind her of him. Judith was moved to tears by the memory of the days when friendship reigned between the foster brothers, and made an attempt, in vain, to reconcile them.

The Utrecht Psalter (so named after the university where it is now preserved) was written and illustrated at Hautvillers between the years 820 and 830; although the text conforms entirely to Latin usage, this need not necessarily mean that its makers were Carolingians. Yet such was undoubtedly the case. The extreme vivacity of the figures and the delicate precision of the pen strokes would seem surprising if we

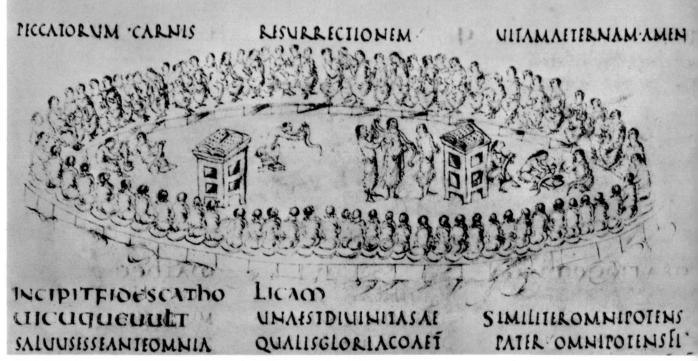

88 – HAUTVILLERS. UTRECHT PSALTER, DETAIL. UNIVERSITY LIBRARY, UTRECHT.

assumed that what we have here is a complete novelty, the product of a recently and arduously acquired skill. But we must have no illusions regarding these wholly delightful pictures. When we examine them closely, we find that their host of tiny figures can be reduced to a certain number of types and a limited repertory of gestures and attitudes, that for each given situation there is an unvarying set of gestures. One might be inclined to take them for mere sketches dashed off in the inspiration of the moment, were it not so evident that they are fully thought out and finished works. Certainly they have many qualities of the sketch: hasty and wonderfully agile. That these artists had both intelligence and sleight of hand is proved by the charming facility of their images. Yet these seemingly casual jottings were based on a schematic method, to which the unflagging fecundity of the artists was largely due. Gifted men like themselves could quickly master these procedures. The illustrators of the Utrecht Psalter owed everything, so far as style is concerned, to the Greek or rather to the Hellenistic tradition; this was their starting point, yet they were quite as remote from it as were Charlemagne's poets from their ancient models. Another Psalter of similar technique but with fewer illustrations is preserved at Troyes.

The Reims illuminations can be compared with Roman frescoes and stuccoes of the first century A.D., such as those in the Casa di Livia in Rome and at Boscoreale; there must have existed others, easily accessible to Carolingian artists, in the remains of the villas and palaces of Roman Gaul. A fragment such as the angel of the Annunciation in Santa Maria Antiqua, Rome (c. 700), near the Carolingians in time, shows already that exaggeration of ancient Hellenistic forms which was carried still further by the Reims illuminators. Evidently these small, elegant and agile figures appealed to the draughtsman, who selected those that caught his fancy, guided, it would seem, by a previous cycle of illustrations, of which we can gain

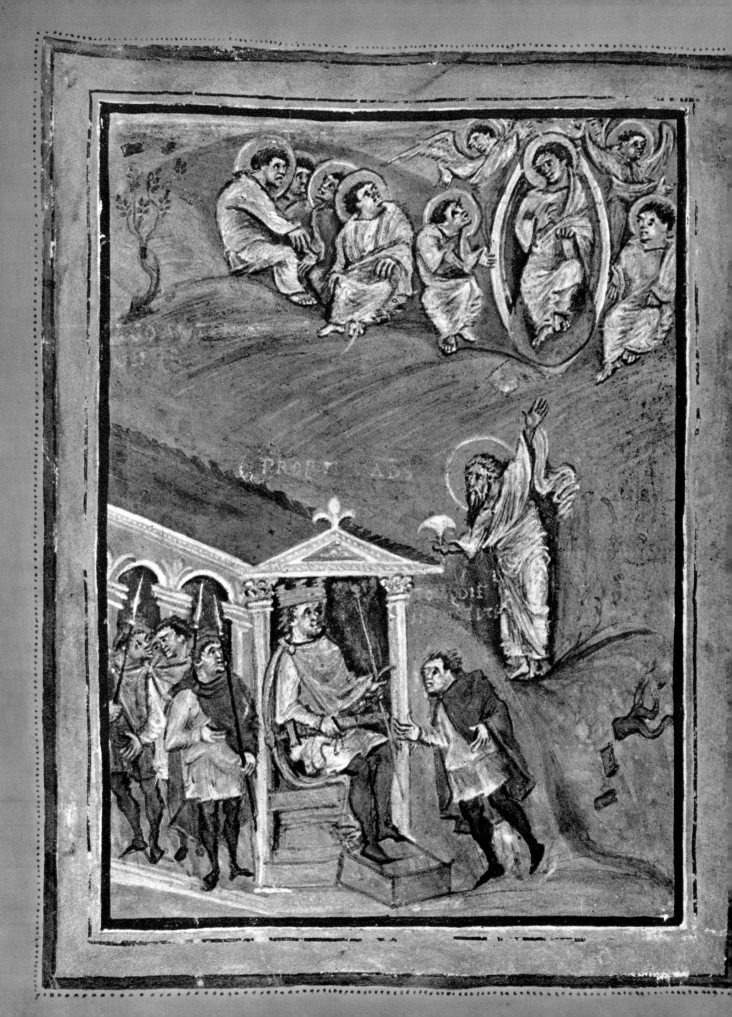

90-91 – HAUTVILLERS. PSALTER. BODLEIAN LIBRARY, OXFORD.

some idea from another Psalter at Oxford (whose text, however, differs at certain points), or a commentary. He selected, assembled, and dashed down his vivid figurations, in which nothing was really new but the zest giving them such vibrant life.

True, these artists chose their models, as we will see in some of the examples to be cited below, but always within a limited, narrow domain beyond which they did not look. This selectivity is somewhat surprising when we recall the diversity of the models from which Charlemagne's painters drew inspiration: books of the most varied origin, medals, engraved gems, paintings, mosaics, motifs stemming from East and West. But the Reims painters seem to have drawn on their own resources and to have been out of touch with the outside world. Their patron Ebbo, and their headquarters Hautvillers, had not the huge collections of the court at their disposal; all they had to go on was what their predecessors had bequeathed to them.

To the Reims group we also owe the remarkable Gospel Book written for Ebbo at Hautvillers before 823 under the supervision of Abbot Peter; adorned with paintings in the same style as the Utrecht Psalter, it is charged with a nervous energy verging on the bizarre. These painters were later to quiet down, but their art always retained that strained, almost frenzied accent to which was surely due their popularity with the imperial court. Though their artistic provenance was Hellenic, the makers of the Ebbo Gospels belied their origin by introducing into their figures a typically Carolingian wildness, the barbarian élan of the Frankish temperament.

◀ 89 – HAUTVILLERS (?). PSALTER. TROYES CATHEDRAL.

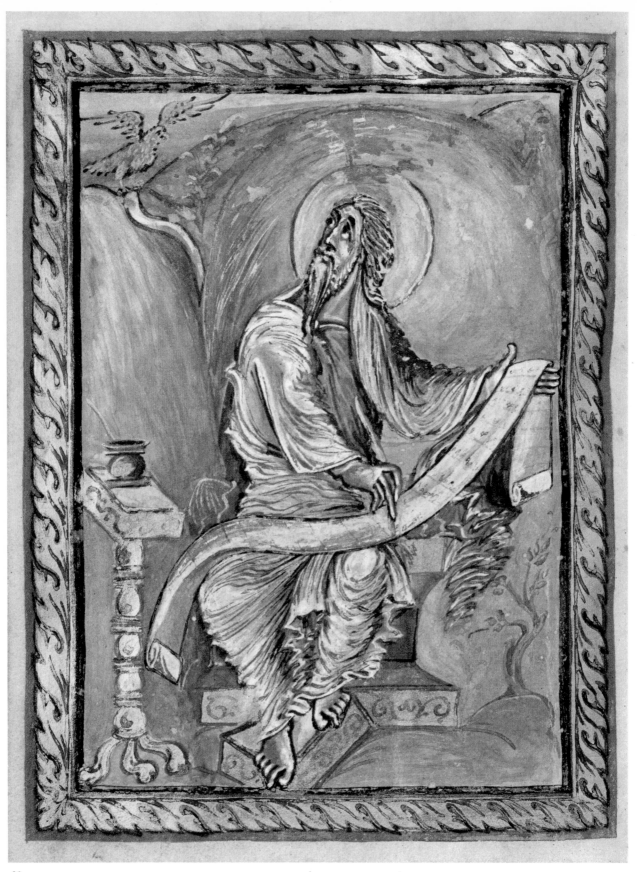

92 – HAUTVILLERS. GOSPEL BOOK OF EBBO: ST JOHN. BIBLIOTHÈQUE MUNICIPALE, ÉPERNAY.

93 – HAUTVILLERS. GOSPEL BOOK OF EBBO: ST MATTHEW. BIBLIOTHÈQUE MUNICIPALE, ÉPERNAY. ▶

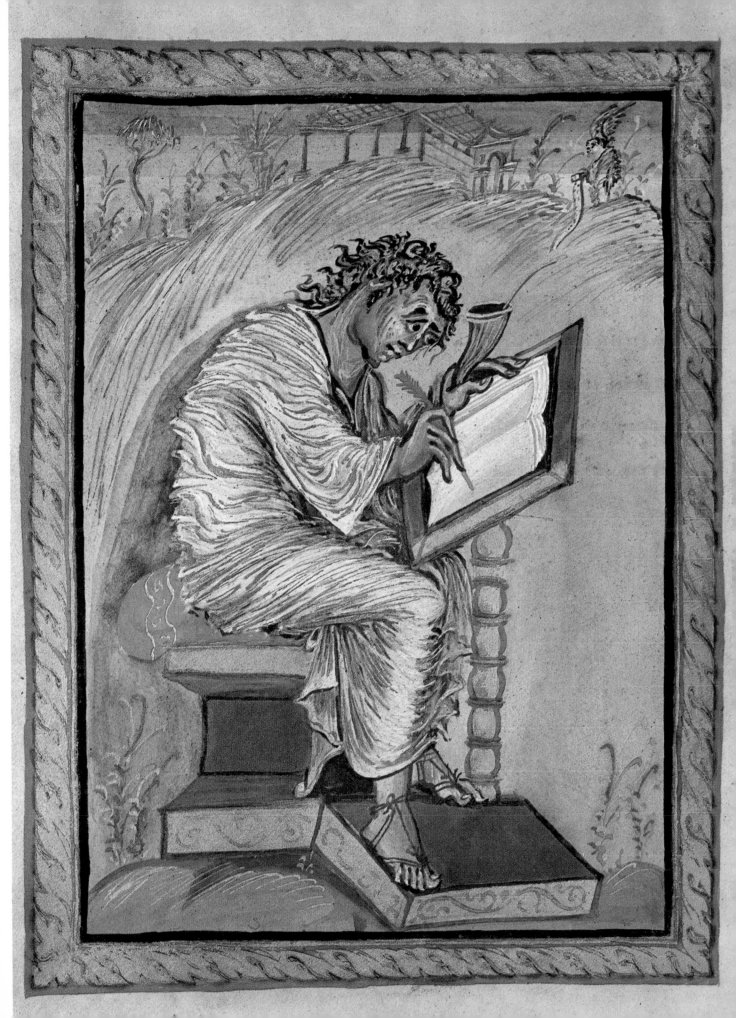

94 – HAUTVILLERS. GOSPEL BOOK OF EBBO: CANON TABLES. BIBLIOTHÈQUE MUNICIPALE, ÉPERNAY.

95 – HAUTVILLERS. GOSPEL BOOK OF EBBO: CANON TABLES, DETAIL. BIBLIOTHÈQUE MUNICIPALE, ÉPERNAY.

The pictures on the canon tables of the Ebbo Gospels usually contain triangular pediments, sometimes with plants growing on them, and rugged porticoes fretting the sky, reminiscent of ruined Roman temples. The painters could well have seen such buildings with their own eyes, but they evidently found it easier to take over the motifs ready-made from the Utrecht Psalter or from its models likewise adorned with leafage in the Hellenistic manner. But the Ebbo pediments carry, in place of acroteria, human figures which the artists seem to have taken straight from daily life, men at work such as they must have seen around them, depicted in attitudes that catch the eye; carpenters and roof-menders busily at work fitting together and nailing down the gables, hunters and unidentifiable figures of various kinds. Sometimes animals also appear on the pediments: goats, dragons, snakes, birds drinking or pecking grain from a bowl. All alike are observed and rendered with a curious felicity. Yet in fact none were done from life; we must not picture our painters going out, sketchbook in hand, looking for subjects. These carpenters on the roof, these

96 – HAUTVILLERS. GOSPEL BOOK OF EBBO: CANON TABLES, DETAIL. BIBLIOTHÈQUE MUNICIPALE, ÉPERNAY.

97 – HAUTVILLERS. GOSPEL BOOK OF EBBO: CANON TABLES, DETAIL. BIBLIOTHÈQUE MUNICIPALE, ÉPERNAY.

hunters drawing their bows, appeared also in the Utrecht Psalter and were derived from the same earlier models; indeed the artists' repertory, appearances notwithstanding, varies little. Carpenters had already been shown at work on the roof of a pedimented church in a sixth-century Byzantine ivory now in the Cathedral Treasury at Trier; hunters, animals and incidental figures of all kinds had formed part of the stock-in-trade of the Hellenistic painters and stucco-workers. While frankly recognizing the early Carolingians' undoubted talents, we would be quite wrong to regard them as in any sense pioneers or having any special interest in the world around them; to begin with, there was nothing really new in their way of seeing it. Still, their interest and curiosity rapidly developed, which goes far to explain the amazing lifelikeness of some of their delineations. Soon some quick-witted painters, also working at Reims, saw how to turn this expertise to good account; one of them, for the first time in the West, ventured to try his hand at the portrait done from life, in the manner of the ancients. Thus the lesson was not lost, and was never to be lost.

98 – HAUTVILLERS. VOLUME OF MEDICAL TEXTS: AESCULAPIUS DISCOVERING BETONY. BIBLIOTHÈQUE NATIONALE, PARIS.

There must have been books among the models used by the Reims artists, but none has come down to us. Apart from a coloured portrait of Aesculapius on the opening page of a collection of medical texts, the only illustrated book from Reims definitely known both to be an exact copy of an antique work and to have been in the possession of the Reims painters is a *Physiologus*, the earliest surviving Latin translation of a treatise compiled at Alexandria about the second century A.D. In this symbolic treatise on the nature of animals, which in its original form must have contained pictures (as did every work of a scientific character or with scientific pretensions), the Reims painters transmitted the gist of a far earlier work, now lost. They drew freely on its imagery, using a method also adopted in other Carolingian art centres. From the stock of available material—whose extent varied from place to place—they chose whatever served their turn. At Reims the supply of material consisted only of imported Hellenistic works, so they had to make do with these.

The illustrations of such a manual as the *Physiologus*, copious because of its didactic nature, and indispensable for an understanding of the text, took the form of

tur. Ita erant corpora trium puerorum quos ignis
non lesit. Sed magis aduersarios teagit qui eos infor
nace xps sua uirtute roborauit.

99 – HAUTVILLERS. PHYSIOLOGUS LATINUS: THE SALAMANDER. BÜRGERBIBLIOTHEK, BERNE.

isolated pictures with no precise religious or philosophical significance. Thus it was
possible to copy them as they stood and place them anywhere, indiscriminately,
simply because they were amusing, picturesque and pleasing to the eye. At Reims,
for example, the artists borrowed from the *Physiologus* one of the most original
and most lasting of the motifs of their canon tables (it was used in manuscripts of
the Reims region up to the eleventh century)—the flame-spouting dragon with a
curly tail. This creature also figures, oddly enough, in the concordance tables of
the illuminated Bibles, but its natural place was in the *Physiologus* where, like a
salamander, it spits fire at a dove hiding in the tree named *peredixion*. For according
to the *Physiologus*, the shadow of this tree struck fear into the dragon or serpent
because their prey, the dove, could always escape death if it stayed perched in the
shadowed side of the tree. This tree was the symbol of Christ who guarded the
Christian (the dove) from the attacks of Satan (the serpent). Obviously Christ, the
dove and the serpent were not out of place in the canon tables of a Gospel Book,
and in the Hincmar Gospels the painter might well have had some sort of apotropaic
purpose, i.e., regarded them as talismans. But he left out the tree, without which

100 – HAUTVILLERS. PHYSIOLOGUS LATINUS: JACOB BLESSING THE LION. BÜRGERBIBLIOTHEK, BERNE.

101 – HAUTVILLERS. GOSPEL BOOK OF HINCMAR: CANON TABLES. BIBLIOTHÈQUE MUNICIPALE, REIMS.

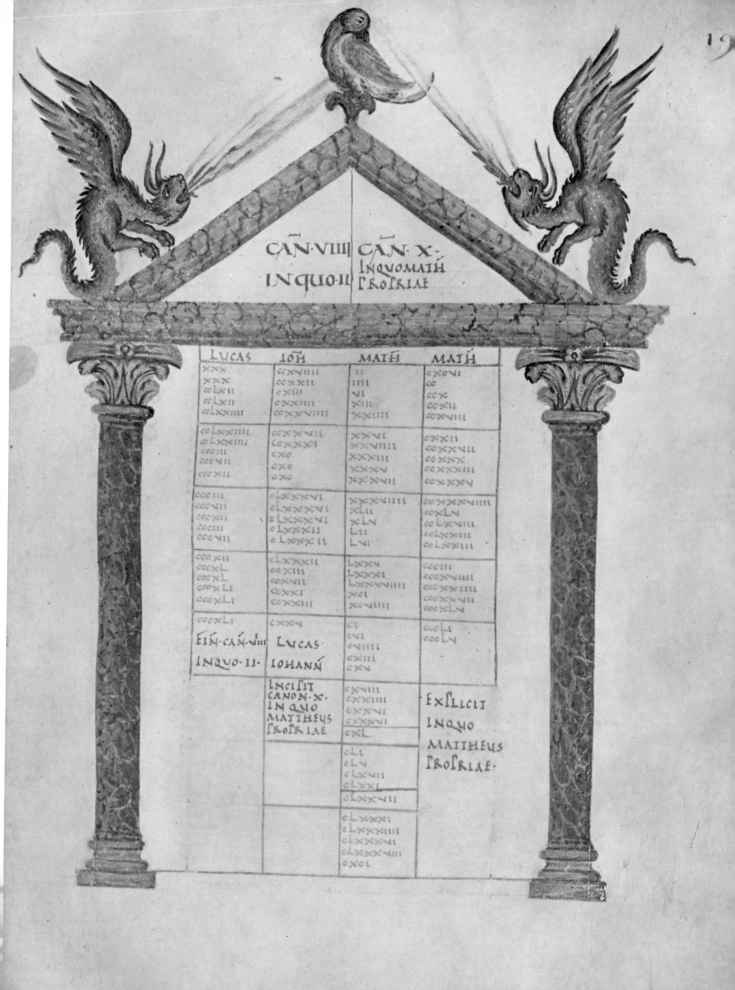

102 – HAUTVILLERS. GOSPEL BOOK OF HINCMAR: CANON TABLES, DETAIL. BIBLIOTHÈQUE MUNICIPALE, REIMS.

103 – HAUTVILLERS. GOSPEL BOOK OF HINCMAR: CANON TABLES, DETAIL. BIBLIOTHÈQUE MUNICIPALE, REIMS.

CĀN·III

INQUO·III

104 – HAUTVILLERS. GOSPEL BOOK OF HINCMAR: CANON TABLES, DETAIL. BIBLIOTHÈQUE MUNICIPALE, REIMS.

the symbol loses its point. The truth is simply that he found the 'flame-thrower' decorative and borrowed it from the *Physiologus* to adorn a page where he was at a loss for a motif. In the same way, Romanesque illuminators would have no hesitation about enlivening the margins of sacred texts with those quaint little figures that so shocked St Bernard: wrestlers, hunters pursuing some monstrous quarry, acrobats and so forth, all taken over (like the Reims dragon) from the antique or the Oriental repertory. (Gothic illuminators went even further in this direction, and nothing could be less in keeping with the spirit of antiquity than their medieval mixture of the sacred and the fanciful. In this respect the painters working for Ebbo already belonged to the Middle Ages and, unlike those of Louis the Pious, proved themselves true Carolingians. The scribe—perhaps he was also the painter— of the *Physiologus* had a Germanic name, Haecpertus—a far cry from Demetrius.) Another curious image figures in the Hincmar canon tables: a cock perched at the top of a gable, flanked by birds at regular intervals along the slopes. This may be a reminiscence of the sport of 'shooting the popinjay,' still popular in France. Archers try to bring down a cock or hens spaced out at different heights along a wood framework (often in the shape of a triangle) with spikes on which the birds are 'planted.' Were the Reims painters, with their keen eye for the amusing detail, the first to notice the similarity to the gables of their pediments? Perhaps, but we must remember that the 'popinjay' sport goes back to earliest antiquity and is shown in ancient reliefs (examples of which are extant).

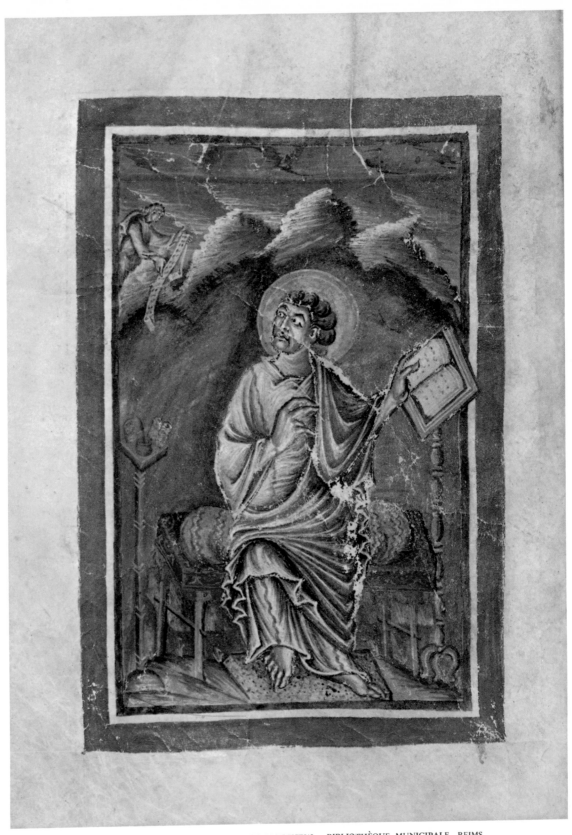

105 – HAUTVILLERS. GOSPEL BOOK OF HINCMAR: ST MATTHEW. BIBLIOTHÈQUE MUNICIPALE, REIMS.

106 – SAINT-DENIS (?). GOSPEL BOOK OF ST EMMERAM OF REGENSBURG: ST JOHN. BAYERISCHE STAATSBIBLIOTHEK, MUNICH. ▶

118

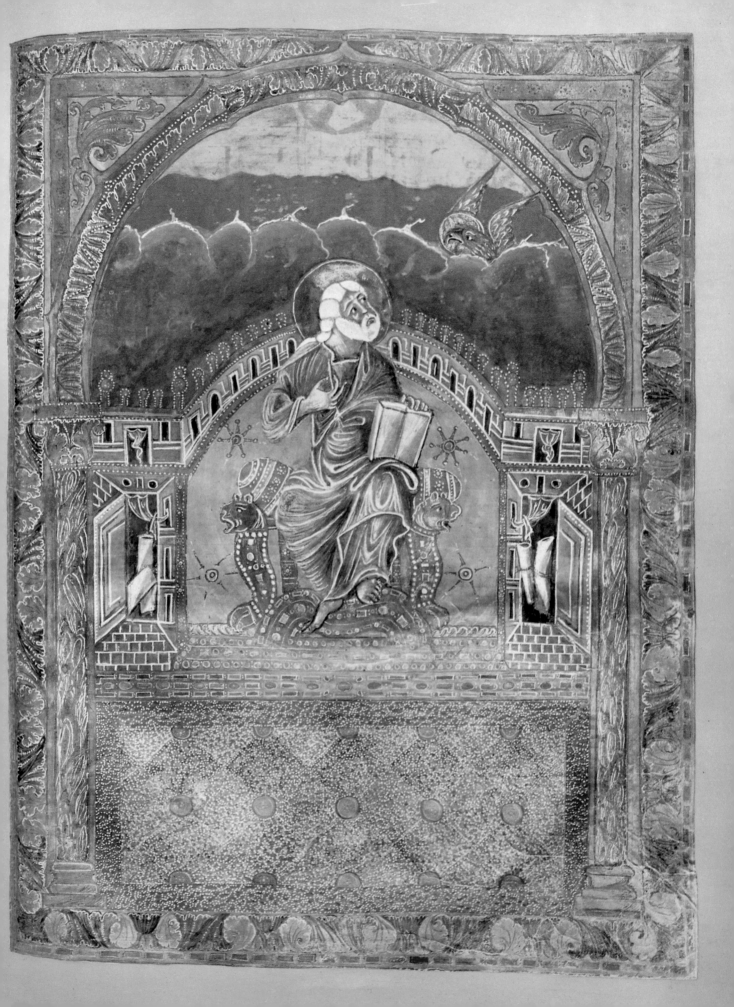

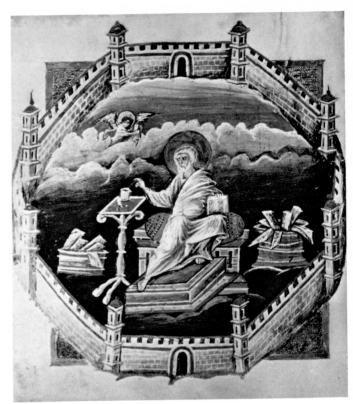

107 – REIMS. GOSPEL BOOK OF ST FLORIAN OF COBLENZ. DÜSSELDORF. 108 – GOSPEL BOOK OF THE CELESTINES. BIBL. DE L'ARSENAL, PARIS.

The liveliness and inventiveness of these artists' imagination is best illustrated by the changes imposed on the evolution of one of their favourite motifs. Ebbo's painters and those of Louis the Pious had inherited the backgrounds of hills encircling the subject of the picture, the summarily indicated landscape edged in the Hellenistic manner with patches of leafage and small buildings. In the Ebbo Gospels Matthew, Mark, Luke and John are represented thus, seated in the open air, their garments fluttering or bunched together by the wind. In the Aachen Gospels, also, the evangelists stand out against a hill, but here the hill had the specific function of separating the figures. A mere traditional setting in the Coronation Gospels, the hill was transformed at Hautvillers, in the Ebbo Gospels, into a ball-shaped mound no longer having any precise significance. Then one of the painters of Ebbo's time brilliantly saw how, without any drastic alterations, this setting could be made to play an active role—as if the artist had looked at it with a fresh eye and was struck by its possibilities. In the Hincmar Gospels he accordingly transformed the pointless hills into a cloud bank mantling the earth with shadows like the darkness of the Old Covenant. Behind the clouds rises the evangelist symbol; its radiance defines their summits and, focused on the evangelist like a searchlight, brings out each detail of his form. This compelling image inspired one of Charles the Bald's painters, last and most prolific of the Reims group, to paint in the St Emmeram Gospels (about 870) one of the most memorable illuminations of the age. As the eagle

120

soars up, the clouds melt away under its gaze and the light streaming from the widening tract of limpid sky floods St. John's face with its radiance as he looks up towards its source. The other evangelist portraits are inspired by the same idea, less dramatically but no less clearly indicated—that the Gospels filled a world of darkness with the light of Revelation. Half a century had elapsed since the painters employed by Louis the Pious took over from the Alexandrians what was a technical device; the Carolingians had given it a new meaning by replacing the antique terra firma with a vision of the medieval heavens.

A curious variant of this celestial setting should be mentioned. In the Celestine Gospels, of unknown provenance but close affiliation with those of Reims (some details of its decoration foreshadow the manuscripts made for Charles the Bald), each evangelist is placed beneath a bank of clouds above which emerges his symbol, and each entire scene is framed by a polygonal crenellated wall with square turrets. This wall, which had already figured in Byzantine paintings, recalls a primitive design sketched in the Aachen Gospels, as well as an exactly similar wall in an isolated drawing contemporary with the Utrecht Psalter: a fragment of the St Florian Gospel Book, now at Düsseldorf. But here, in the Düsseldorf drawing, a strip of ground crowded with figures replaces the cloud bank in the centre. It is evidence of an alternative version which did not find favour in Reims itself. In another, similar version in New York, likewise Greek and akin to that of the Palace School of Charlemagne, a building or a curtain upheld at each end forms the background behind the evangelist. Among many other examples (for there was a large number of Reims-inspired manuscripts) are the Loisel Gospels (date and exact provenance conjectural, but certainly deriving from Reims) and the Blois Gospels which, incidentally, are copies of those of Demetrius and thus confirm the close kinship of their maker with the painter of Louis the Pious. Their figures and techniques have a good deal in common with those of Charles the Bald's painter but are not to be confused with them.

Towards the middle of the ninth century the School of Reims, lacking firm control or effective leadership, began to fall to pieces. Its illuminators had only vague stylistic contacts with the Hautvillers artists; they were pupils or imitators of the great masters or of some collateral branch of the Reims artists. One, however, was to have a brilliantly successful career, first at Tours, then at the royal court.

Ebbo left Reims in 833. Relegated to Fleury (i.e. Saint-Benoît-sur-Loire), then to Fulda, he was not deposed until 845, when Hincmar, his successor and one of his bitterest political opponents, promptly dismissed his predecessor's personnel. Of the last manuscripts decorated in the Hautvillers manner, the only one inscribed with Hincmar's name gives him the title of 'abba'; none of the manuscripts in which he is called 'archbishop' is illustrated. We do not know in which of the Reims communities Hincmar was abbot. In any case, assuming he then employed any artist from Hautvillers who had already worked for Ebbo, nothing more is heard of the man. The School of Reims, properly so-called, died out with its founder and any subsequent works assignable to it belong to the collateral branch. This fact is all the more curious since Hincmar completed and adorned with paintings the cathedral begun by his predecessor; unfortunately none of these paintings has survived.

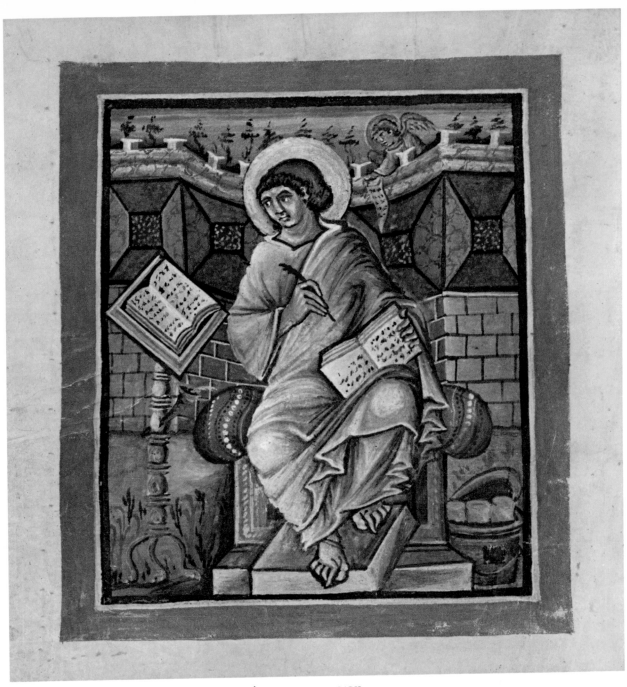

109 – LOISEL GOSPEL BOOK: ST MATTHEW. BIBLIOTHÈQUE NATIONALE, PARIS.

Soon after Ebbo's downfall one of the painters trained in the Reims School settled at Tours. Another, it would appear, moved to Metz. On their arrival, these 'emigrants' found themselves confronted by a well-established iconographic tradition, active groups of artists having programmes differing from their own. Naturally enough their work was affected by these contacts. For—and this is a point to bear in mind—individuals, not only influences, migrate and, as was to be expected, each painter largely retained his personal idiom while conforming to the new programmes.

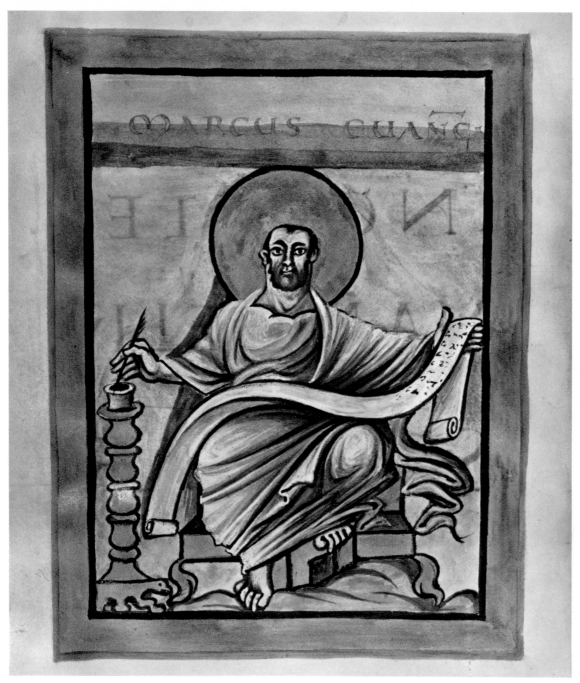

110 – BLOIS GOSPEL BOOK: ST MARK. BIBLIOTHÈQUE NATIONALE, PARIS.

Conversely, it seems most unlikely that any Tours painters changed their style beyond recognition as a result of contacts with the newcomers or a half-conscious assimilation of their methods. This is probably the best explanation of the infiltrations of the Reims School traceable at Tours, at Metz and elsewhere; there is certainly a striking concordance of dates between the end of each of the local schools and the series of recurrent osmoses which ensured the coherence and continuity of the artistic practice of the age.

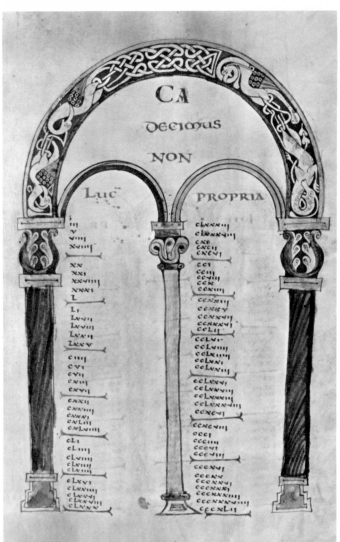

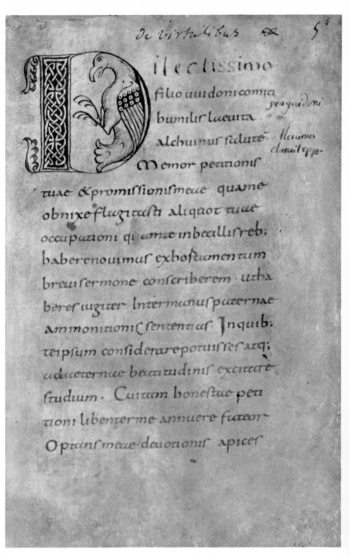

111 – TOURS. NEVERS GOSPEL BOOK. BRITISH MUSEUM, LONDON.

112 – TOURS. ALCUIN, 'DE VIRTUTIBUS ET VITIIS.' TROYES.

The Styles of Aachen and Reims Spread

At the bidding of Charlemagne, Alcuin had made his abbey of Saint-Martin at Tours a centre of Bible studies, where the sacred texts were revised and copied in the years 796–804. But even if he had wished to do so, he was unable to make Tours a centre for the production of fine books. All the lavish manuscripts were executed at the royal court, and the quite ordinary ones made at the abbey in his time were usually only rather clumsy imitations of those being produced at Saint-Amand under the supervision of Alcuin's friend Abbot Arn, later bishop of Salzburg. Most of the Tours manuscripts were Gospel Books with arcaded canon tables; the space within the arches was filled with queer metallic-looking creatures of insular derivation, reminiscent of those in the Book of Kells and the Lindisfarne Gospels. Alcuin, as an Englishman, seems to have surrounded himself with artists from his

113 – IRELAND. BOOK OF KELLS: VIRGIN AND CHILD. TRINITY COLLEGE LIBRARY, DUBLIN

124

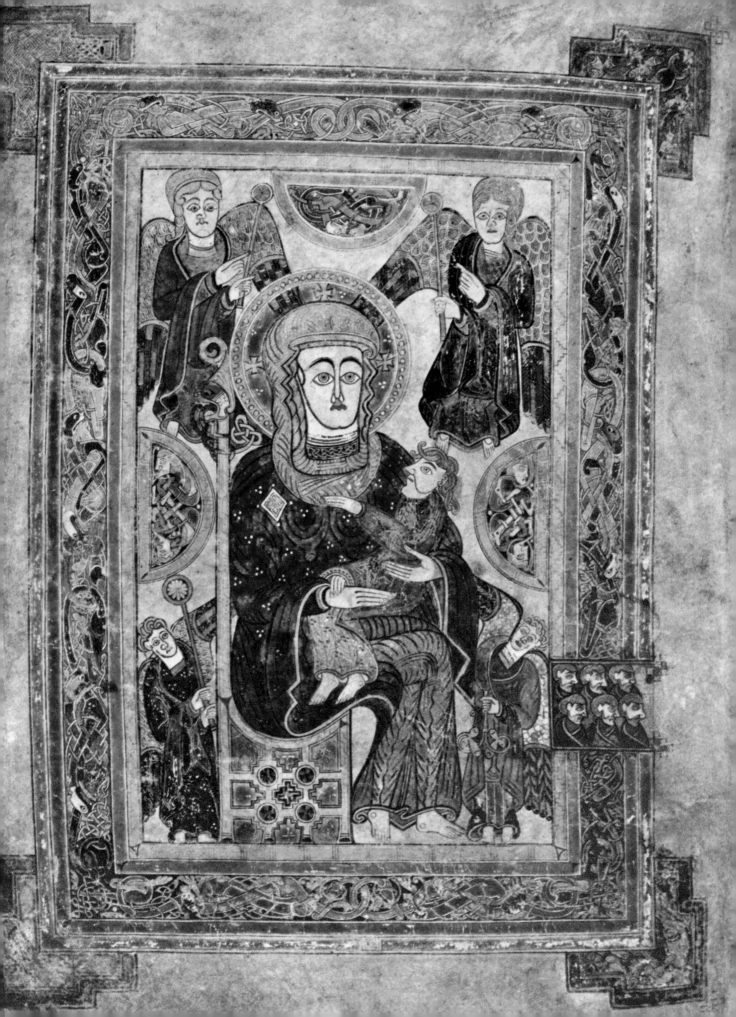

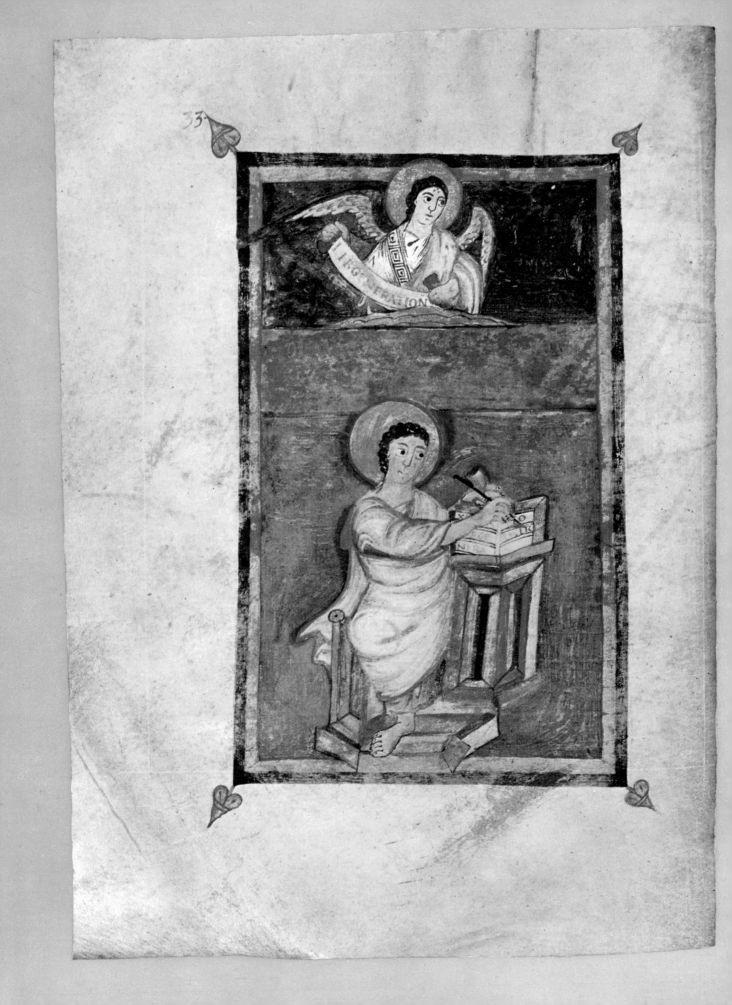

own country, but none was of outstanding merit. By now this great scholar was an old man, his sight was failing and he was in no position to play the patron.

Very different were his successors, the first of whom was his pupil Fridugisus, also an Englishman, abbot of Saint-Martin from 807 to 834. He kept in close touch with the Aachen court, served as chancellor of the empire from 819 to 832 and took a keen interest in books and scripts. He was a great civil servant, as were the next two abbots: Adalhard (834–843), a layman, seneschal of the court, and Count Vivian (843–851), also a layman, chamberlain to Charles the Bald. Men of high rank and loyal courtiers, they catered to the taste of their sovereign and employed the court illuminators as a matter of course, as Fridugisus had done after the death of Charlemagne. Thus we find striking similarities between the secondary figures in the Saint-Médard Gospels (figures which we know to have a long lineage behind them) and those in the manuscripts illuminated at Tours for Fridugisus. The decorative settings of the Tours canon table pictures, which copy exactly some of those in Charlemagne's Gospel Books, were to be magnificently developed by his successors. Actually, the art of the Tours painters was no more than mediocre and remained so until the time of Abbot Vivian; like the court art of the time, it was unimaginative, rather heavy-handed, strongly imbued with classicism. Indeed these painters may well have come from the court, as probably did some of their collaborators. They cannot be distinguished from among those who came from Aachen, but like them they seem to have belonged to the Italo-Alpine type. This may be accounted for by the friendship between Alcuin and Arn (who was abbot of Saint-Amand as well as bishop of Salzburg), the effects of which may have lasted after Alcuin's death. In any case the art of Tours was characterized from the outset by a clarity and sobriety resulting from a close imitation of the styles of antiquity and from a fine spareness in the page design. From the time of Fridugisus, there was a sharp break with the insular style which had still predominated in the manuscripts commissioned by Alcuin; nothing remained of it but the large initial letters with their interlace patterns, and these too were much simplified and always on a white ground. Colours were few but vivid, discreetly enhanced with gold and silver. This reticence contrasted with the taste for lavish display prevailing in the entourage of Charlemagne and with the agitated art of Reims. The Tours painters' cult of antiquity is evidenced by the Virgilian scenes decorating a liturgical fan with an ivory handle (see p. 238), and by the illustrations of a mathematical treatise by Boethius in Bamberg.

Chronologically, there is no reason why artists from the Aachen court should not have moved to the Loire valley after the death of Charlemagne. (Louis, the new emperor, had his own circle of painters at the time and in any case does not seem to have shown much interest in art after coming to the throne in 814.) The presence of Aachen artists there is confirmed by the fact that there now appeared at Tours, along with the secondary figures of the Saint-Médard Gospels, silhouettes, tiny figurines inset in medallions, cartouches and panels, profiles similar to coin effigies outlined in gold—motifs taken directly from engravings on fine stones and metal and carried by the Tours ateliers to a high degree of perfection. Antique cameos, intaglios and coins were much admired during the Middle Ages, and these marvels

◀ 114 – TOURS. GOSPEL BOOK: ST MATTHEW. BRITISH MUSEUM, LONDON.

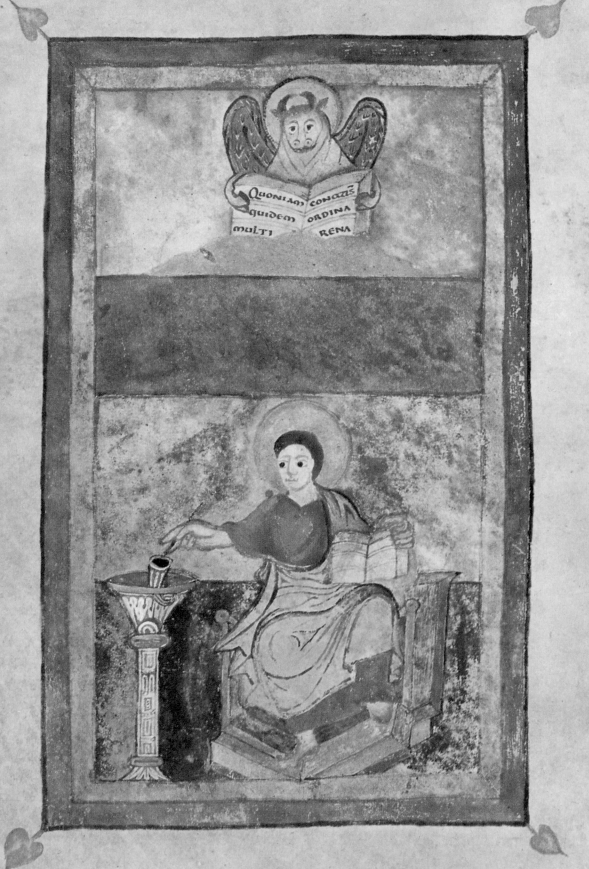

QUONIAM CONATUS QUIDEM ORDINA MULTI RENA

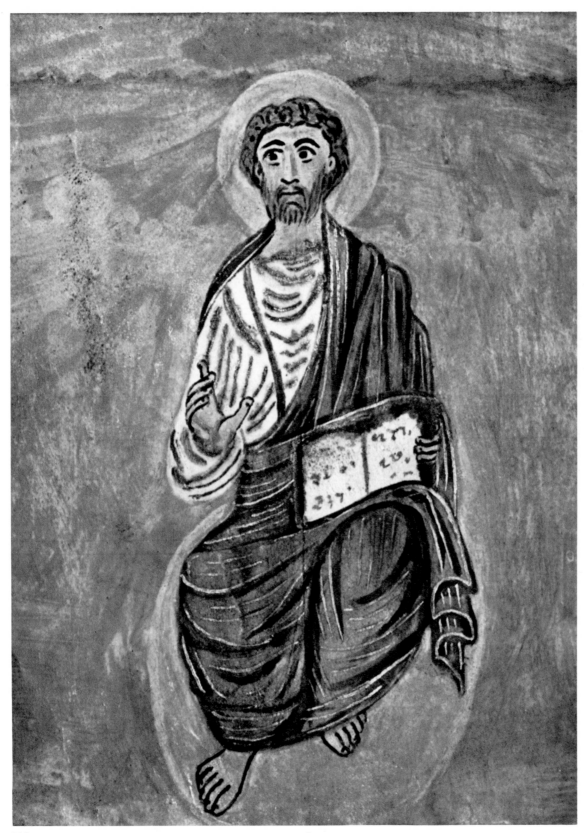

116 – TOURS. WEINGARTEN GOSPEL BOOKS: ST JOHN, DETAIL. WÜRTTEMBERGISCHE LANDESBIBLIOTHEK, STUTTGART.

115 – TOURS. GOSPEL BOOK: ST LUKE. BRITISH MUSEUM, LONDON.

117–118 – TOURS. BOETHIUS, 'DE ARITHMETICA': MUSIC, ARITHMETIC, GEOMETRY, ASTROLOGY — BOETHIUS AND SYMMACHUS. BAMBERG.

of delicate and precise workmanship were frequently used to adorn jewellery and the gold and enamelled bindings of Bibles, Gospels and other liturgical books made for the use of princes and cathedrals. Charlemagne's painters had already drawn inspiration from these precious objects, numbers of which were doubtless preserved in the imperial treasury. Simulated in colours, these pieces were transformed into figures tone on tone (intaglios) or monochromes on a coloured ground (cameos); in both cases, faces were always shown in profile. And soon the figures on engraved gems, 'lifted' from their stone supports, were utilized by the painters as independent motifs, first in the margins of manuscripts, then as complete pictures. These silhouetted figures also recall such monochrome friezes of Hellenistic inspiration, as those in the Farnesina in Rome. But it would seem that the influence of paintings of this kind took effect at Tours only indirectly, perhaps through the intermediary of the Reims artists, due to whom the silhouette technique persisted, in the form of engraved crystal, till the end of the Carolingian period. The illustrations of the St Gauzelin Gospels, made at Tours, and those of a Sacramentary illuminated for Rainaud, abbot of Marmoutier, were treated throughout in this manner.

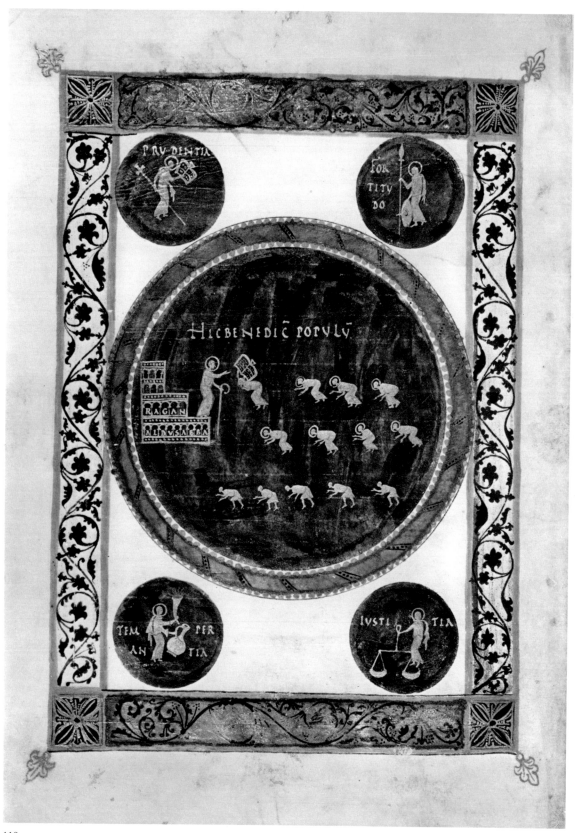

119 – AUTUN. MARMOUTIER SACRAMENTARY. BIBLIOTHÈQUE MUNICIPALE, AUTUN.

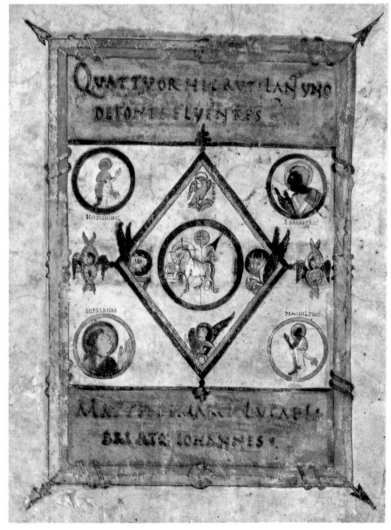

120 – TOURS. ST GAUZELIN GOSPELS. NANCY CATHEDRAL.

Tours was soon to profit by an influx of new talent, even more rewarding than that of the Aachen painters. This took place during the abbacy of Count Vivian (843–851), that is to say after the fall of Ebbo and the apparent dispersal of the group of artists he had employed. As it so happened, the newcomers came from Reims, so the coincidence seems worth noting. Artists related to those of Aachen appeared at Tours after the death of Charlemagne; and artists from Reims, or trained at Reims, came to Tours after the downfall of Ebbo, whose power had been on the wane from 833. These newcomers were to participate in an undertaking of considerable scope, begun at Tours but continued elsewhere; an illustrated Bible of which four copies have come down to us, or, actually, four successive editions produced over a period of nearly thirty years. Each edition shows an appreciable, highly interesting advance and enrichment over its predecessor.

The Alcuin Bible, the first of the series (first, at least, in its logical sequence), dates from the time of Abbot Adalhard (834–843); it contains only two pictures (true, the text of the Apocalypse is lacking), but already the general programme of

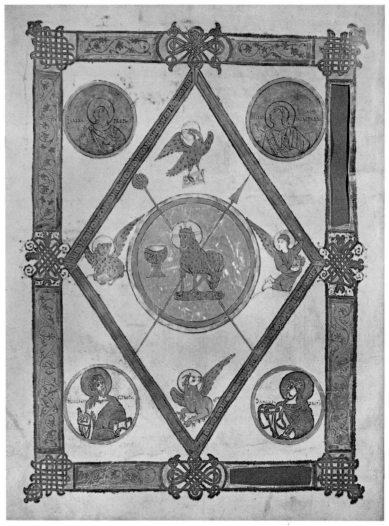

121 – TOURS-MARMOUTIER. ALCUIN BIBLE. STAATLICHE BIBLIOTHEK, BAMBERG.

the series is clear. The directive idea is that of man's destiny on earth and in the afterlife, of which the Old Testament gives at once a description and a prefiguration. The Creation and Fall are depicted on four superimposed registers at the beginning of the Old Covenant; the Redemption by a symbolic picture at the beginning of the New. Both compositions consist of silhouetted figures, the first being a frieze chronogically ordered from top to bottom: the Creation (the work of six days); the birth of Eve (the woman's role); the punishment; the human predicament after the Fall (Adam and Eve tilling the soil) and the crime of Cain. The toiling Adam and Eve are not abandoned, for God's hand is outstretched above them (this small detail shows both the artist's enlightened sensitivity and his perfect understanding of theology). On the second page is the Sacrificial Lamb in a central medallion surrounded by the four evangelist symbols. The lance and the sponge-tipped staff, instruments of the Saviour's sufferings, cross its body, and a chalice rests beside it to receive His precious blood. In the corners are four medallions; they represent the four major prophets who announced the Redemption accomplished by the Lamb.

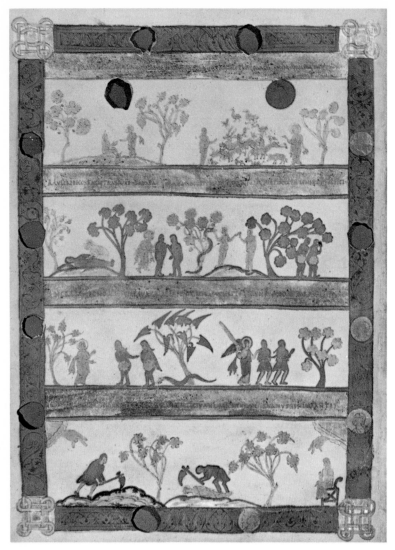

122 – TOURS-MARMOUTIER. ALCUIN BIBLE. STAATLICHE BIBLIOTHEK, BAMBERG.

The second book of the group, the Moûtier-Grandval Bible, written and illu-
minated at about the same time, treats more explicitly the theme of the Redemption
and devotes four instead of two pictures to it. All that does not directly bear on man's
immortal destiny, the kernel of the story is omitted: the creation of the heavens, and
plants and animals, the death of Abel, are all dispensed with. A new image com-
pletes the Old Testament cycle, that of Moses receiving the Tables of the Law on
Mount Sinai and delivering them to the Chosen People. In the front of the Gospels
it is no longer the Lamb but Christ Himself in glory who is represented, dominating
the world and holding the Book, guide of the Christian life. As in the first Bible,
the Atonement counterbalances the Fall. But in the New Testament, preceding
the Apocalypse, we find a new, symmetrical version of the table devoted to Moses,
which does not illustrate the following text but merely alludes to it in certain details.
On the celestial throne is the book with seven seals opened by the Lamb and the
Lion of Judah, scion of the house of David (another prefiguration of Christ) under

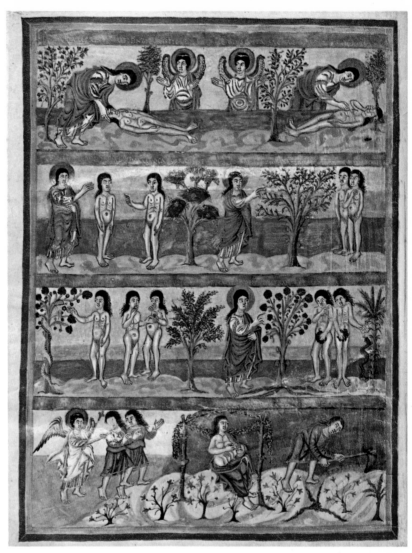

123 – TOURS. MOUTIER-GRANDVAL BIBLE. BRITISH MUSEUM. LONDON.

the watchful eyes of the evangelists as represented by their attributes. Below them is Moses (he has the same features as in the scene of the Tables of the Law), his veil being drawn aside by the evangelist symbols. Thus the New Testament unveils the message of the Old, and the Apocalypse, supreme revelation, proclaims after the Atonement the final triumph of Christ. The images duplicate the text, as it were, while remaining independent of it; they embody its meaning and its message but do not, strictly speaking, illustrate it; in short, they provide a synthetic resume of it like some illustrations in the Gellone Sacramentary and the Corbie Psalter. We see here, on a much more highly developed and intellectual plane, the same procedure as in the Flavigny Gospels of culling from the text its essential features and evoking its significance by figurative means, relying here on an effort of the thinking mind, there on the simple mechanism of sight. The painter may have been familiar with a fifth-century Bible decorated on similar principles for Pope Leo the Great; this assumption has been made on the strength of the architectural forms in the scene

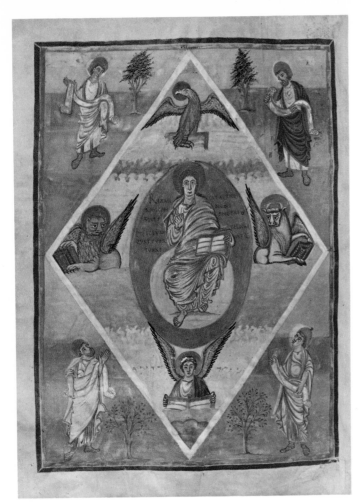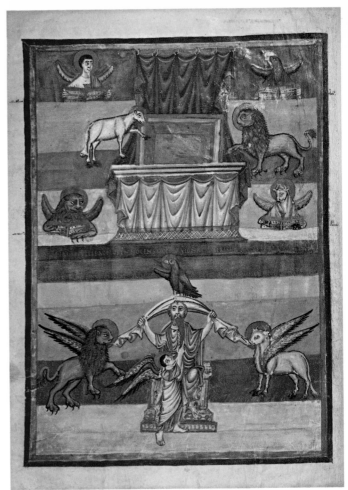

124-125 – TOURS. MOUTIER-GRANDVAL BIBLE. BRITISH MUSEUM, LONDON.

of the Tables of the Law and other details. But this is purely speculative, and we are justified in seeing in the Moûtier-Grandval Bible a Carolingian creation cast (like all such works) in an antique mould. The Bible illustrators, with a vast and varied repertory to draw on, chose whatever motifs best served their turn; in one scene the Victories on the portico reproduce those that appear on the palace of Theodoric in a mosaic at Sant'Apollinare Nuovo at Ravenna. The intellectual effort and selective planning that evidently went into the making of this picture sequence rule out any possibility of its being a mere copy of an earlier work; moreover, the peculiar apocalyptic image, explained in a distich composed in rather halting Latin (like all the other *tituli* or legends), is of an inspiration too medieval for it to be assigned even to very late antiquity. It is in fact typically Carolingian. (Here we sould add that the silhouettes in the Alcuin Bible cannot possibly come from any fifth-century painting. True, the Alcuin Bible might conceivably be merely a condensed version of the Moûtier-Grandval Bible, but this is unlikely.)

In the next two Bibles, made for the sovereign in person, many new pictures were added and the iconographic programme became more complex. One, like the Moûtier-Grandval Bible, was written and illustrated at the abbey of Saint-Martin,

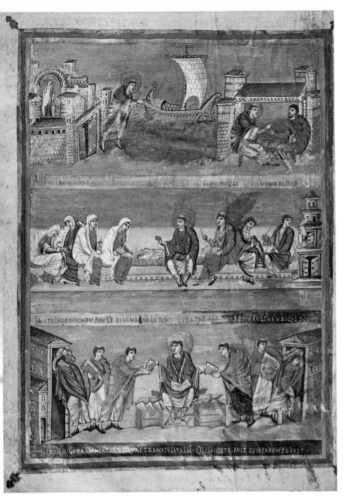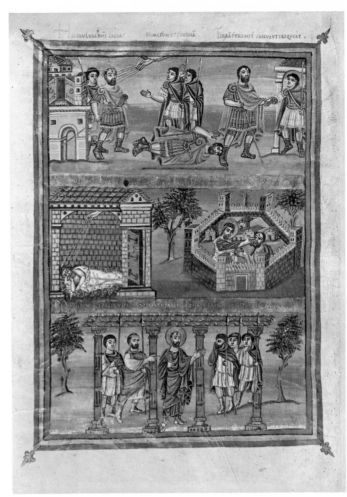

126-127 – TOURS. FIRST BIBLE OF CHARLES THE BALD. BIBLIOTHÈQUE NATIONALE, PARIS.

Tours, in the time of Abbot Vivian, about 846. It is known as the First Bible of Charles the Bald or the Vivian Bible. A painter trained in one of the many collateral branches of the school of Reims had made the Christ in Glory which replaced the Sacrificial Lamb in the Moûtier-Grandval Bible, and this same artist, whose hand is easily recognizable, painted four figures, three of them new, in the Vivian Bible; the other four pictures were shared between two of his colleagues at Tours.

Thus the number of illustrations was more than doubled, but the directive idea, previously so clear, was now encumbered with historical scenes. It is a distinctive trait of this painter, whom we may call the Reims artist, to prefer detailed narrative and history in the antique style, over the synthetic tendencies of 'barbarian' art. Of the scenes of the life of St Jerome, he made those on three registers of Jerome leaving Rome for Jerusalem, dictating his translation of the Bible and distributing copies of it. By his hand too is the scene of David and his companions making music—pink figures on a blue ground, executed with precision like carved crystals. Then, following the Conversion of St Paul as depicted by a Tours painter, comes his famous picture showing Abbot Vivian, accompanied by the monks of Saint-Martin, presenting his Bible to Charles the Bald, a vivid scene of contemporary life.

137

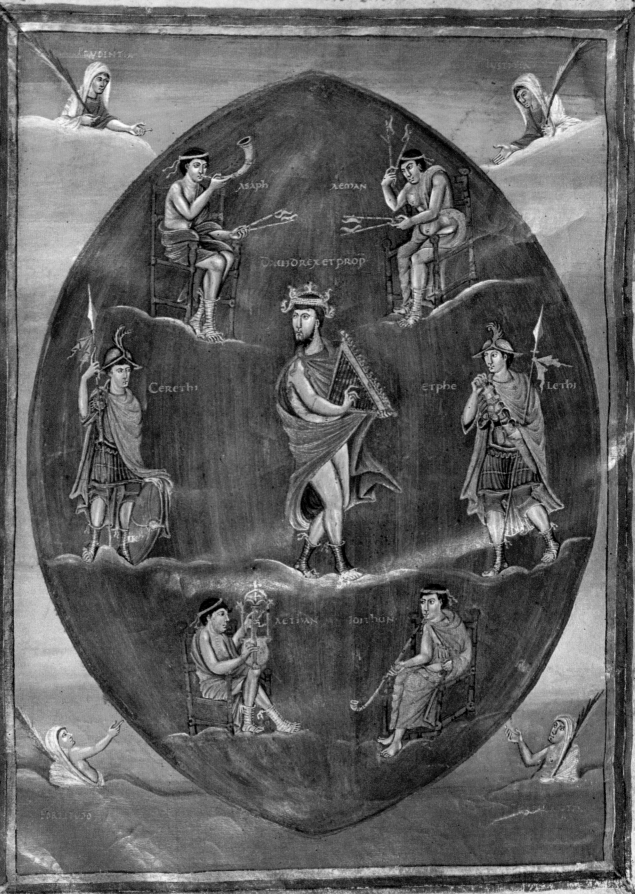

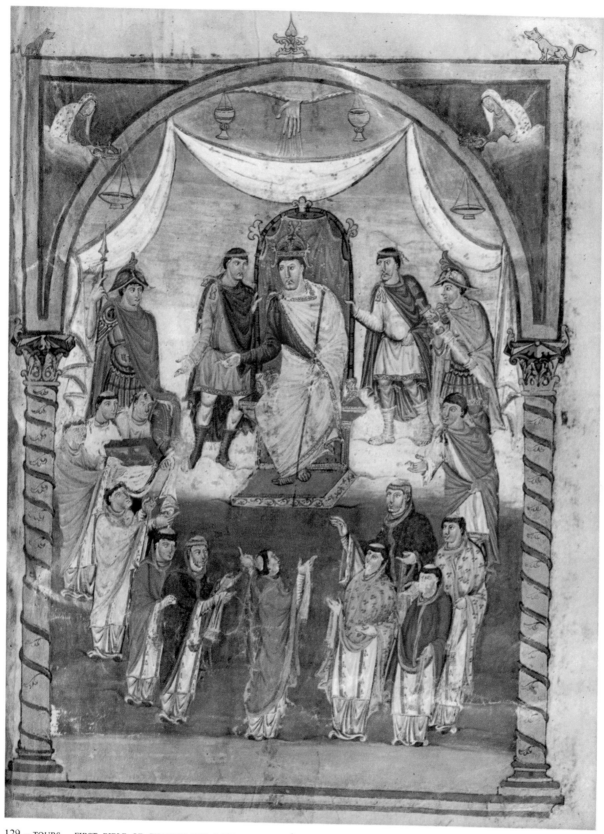

129 – TOURS. FIRST BIBLE OF CHARLES THE BALD. BIBLIOTHÈQUE NATIONALE, PARIS.

128 – TOURS. FIRST BIBLE OF CHARLES THE BALD. BIBLIOTHÈQUE NATIONALE, PARIS.

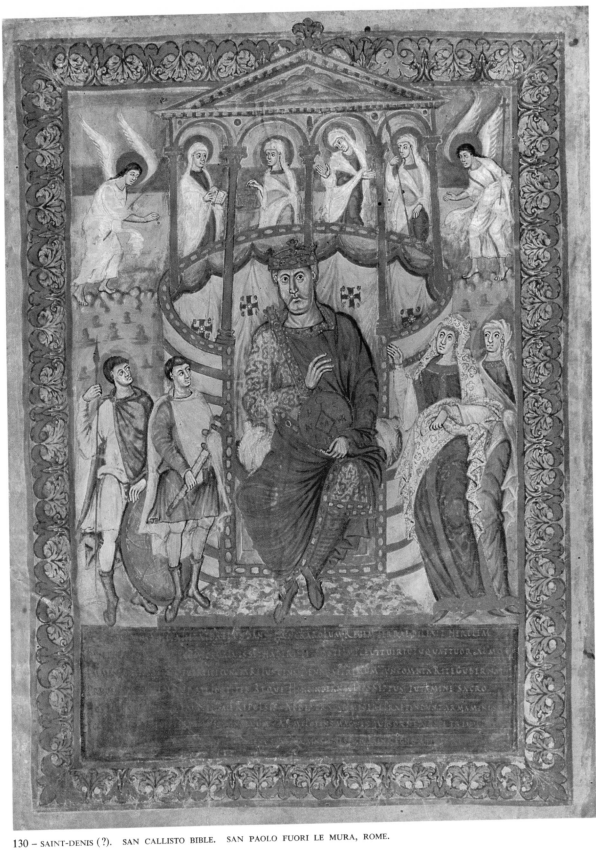

130 – SAINT-DENIS (?). SAN CALLISTO BIBLE. SAN PAOLO FUORI LE MURA, ROME.

The Painters of Charles the Bald

The production of Tours Bibles did not end with the First Bible of Charles the Bald; a fourth Bible, the San Callisto Bible, was made later, probably in 869, again for Charles the Bald but not in Tours itself. Its script, of the sort used at Reims, provides a striking confirmation of the continuity of Carolingian painting, apanage of the ruler and his family and quite independent of the monastic scriptoria. The abbey of Saint-Martin at Tours was then on the decline, though its scriptorium continued to function. The Reims artist, whom we have seen employed at Tours, was nearing the end of his career, and with age his style had hardened; seemingly he had to work against time and (this is not certain) to enlist the aid of other painters. No doubt the San Callisto Bible had to be ready for the wedding of Charles and Richilde in 869, when it was due to be presented to the king. Even more lavishly illustrated than the Vivian Bible, it contained not eight but twenty-four pictures, as well as large full-page illuminated initials: fifteen for the Old Testament (preceded by a large portrait of Charles enthroned beneath the Virtues, between his bodyguards and his wife attended by a lady-in-waiting) and seven for the New Testament. It is the painter's masterpiece, in which his personal taste for narrative painting definitely overruled the programme of the previous Bible. When we compare the scenes of the life of St Jerome with those in the Vivian Bible, we can measure the progress made by him in twenty-five years. True, his manner is a little heavier, but it is also more exact; the composition is livelier and more varied, movement accelerated, and spatial depth suggested. Instead of three superimposed pictures each centring on the figure of Jerome, there is a continuous narrative on registers running alternately from left to right, right to left, then again left to right (boustrophedon). We see the sail of the ship in which the saint is travelling belly in the wind; then (second register, right) we see the saint seated with his female assistants in an interior in which perspective depth is perfectly rendered, with copies of the Bible heaped in picturesque disorder on sagging shelves. Escaping from the dead hand of tradition, the Reims artist has made a breakthrough into the real world and seen there what no previous painter had even guessed at.

We have traced the evolution of this sort of decoration from its beginnings to its climax, outside Tours. At first it did not actually illustrate biblical episodes (in the manner of the Ashburnham Pentateuch), nor did it attempt (as did the Utrecht Psalter) to explain the Old Testament in terms of the New and demonstrate that the latter is the fulfilment of the former. In summing up the whole Bible, these early pictures expressed its underlying meaning and the spirit of its message. But little by little the artists lost sight of this guiding principle, so that in the end sumptuous historical pictures replaced the sober record of the Christian verities.

Under Charles the Bald Carolingian art entered its final and its finest hour. Around 848–851 it was once again to the ateliers of Tours, and this time to the Reims artist alone, that Lothair I, king of Italy, had recourse when he commissioned a Gospel Book, in which he had a portrait of himself included, for presentation to the collegiate church of St Martin. In a curious poem written under his orders, he

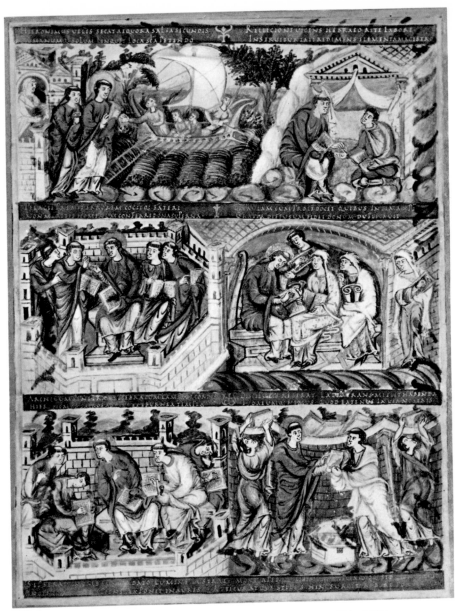

131 – SAINT-DENIS (?). SAN CALLISTO BIBLE. SAN PAOLO FUORI LE MURA, ROME.

confesses that, wishing to honour St Martin with a gift worthy of both donor and recipient, he was constrained to apply to the Tours atelier, there being none to equal it in his capital or elsewhere. (The British Museum Psalter attributed to him was probably made for Lothair II.)

Where was the royal atelier located after the decline of Saint-Martin of Tours? Either at Corbie or Saint-Denis, more probably the latter. Actually, the site matters little; it is the court that counts. The atelier was an adjunct of the court, worked for it exclusively and catered to the king's ostentatious taste. Charles the Bald had not his grandfather's genius for organization but, like him, encouraged learning

and cared for books, and his interest in religion and literature stimulated theological and philosophical activities in his entourage. From his reign date two compilations made for the use of laymen which were later to have an immense influence. His Book of Hours (more exactly, of prayers), the first of its kind, was still rudimentary, but it contained the basic elements of the great Books of Hours of the future. Unlike most of Charles's books it has few decorations—which suggests that it was in daily use; indeed the book (now in the Residenz, Munich) is so worn and shabby that the repainted portrait in the forefront is but the shadow of its former self.

Then we also have the Psalter of Charles the Bald, containing another portrait, an exceptionally handsome and convincing work; except for the picture of Lothair I and some medals, it is the only portrait of a Carolingian monarch done from life that has come down to us. In France we have to wait till the early fifteenth century before again finding an attempt at so accurate a likeness. The artist has not flattered his sitter; only a man assured of his royal master's esteem and the importance of his post could have dared to take such liberties. Charles is seated, facing the viewer, on a throne adorned with coloured marble inlays, under a gable from which emerges the hand of God, token of heavenly protection. Holding a globe and sceptre, he wears a robe of some plain but rich material embroidered with golden roses, and a cloak clasped with a large brooch on his right shoulder. His moustache droops in the Frankish manner, his thick hair belies his sobriquet 'the Bald' and is already streaked with grey, though at the time when the portrait was made, between 842 and 869, he could not have been more than forty-six (he was born in 823). He wears his crown at an almost rakish angle. His cheeks are puffy and his eyes turned sideways towards the companion picture of St Jerome on the facing page of the Psalter. There is a hint of anxiety and strain in the king's gaze, natural enough in the case of a man whose life was one long struggle and with whom began the disintegration of the Empire. Nevertheless a vainglorious inscription likens Charles to Josiah and Theodosius: Josiah the holy king, reformer of Judah, Theodosius the imperial lawmaker. Charles is placed on the same plane as the saintly translator of the Psalms, just as in the Gospel Book Lothair is shown on the same level as the Apostles and Christ Himself. This elevation of the two Carolingian kings to the rank of sacred, divine beings was a startling innovation; no one in the West, not even Charlemagne, had ventured to go so far, nor was anyone to do so subsequently. Thus we owe to Charles's painter the earliest portrait; in the space of barely a century the barbarian eye, under the guidance of antiquity, had adjusted itself to the spectacle of living, many-sided reality. One likeness of a contemporary Byzantine emperor has also come down to us: in a copy of the *Homilies* of St Gregory Nazianzen, dating from 880–886, are full-page portraits of Basil I and his wife, preceded and followed by full-page pictures of a large cross and Christ in Majesty. But Basil and Eudocia are shown standing, full face, with the hieratic immobility of all Byzantine ruler portraits, from that of Justinian at Ravenna (sixth century) to that of Manuel II Paleologus (fifteenth century). Both Charles the Bald and Lothair, however, are shown seated, in three-quarters view, with a sidewise glance: they firmly take their place in the living, moving world of men.

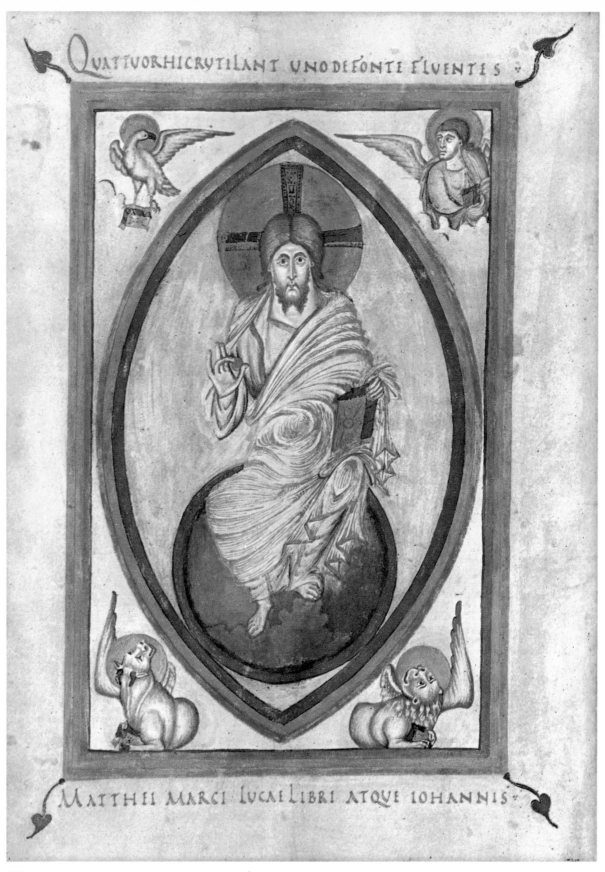

QVATTVORHICRVTILANT UNODEFONTE FLVENTES

MATTHEI MARCI LVCAELIBRI ATQVE IOHANNIS

132 – TOURS. GOSPEL BOOK OF LOTHAIR. BIBLIOTHÈQUE NATIONALE, PARIS.

133 – TOURS. GOSPEL BOOK OF LOTHAIR. BIBLIOTHÈQUE NATIONALE, PARIS.

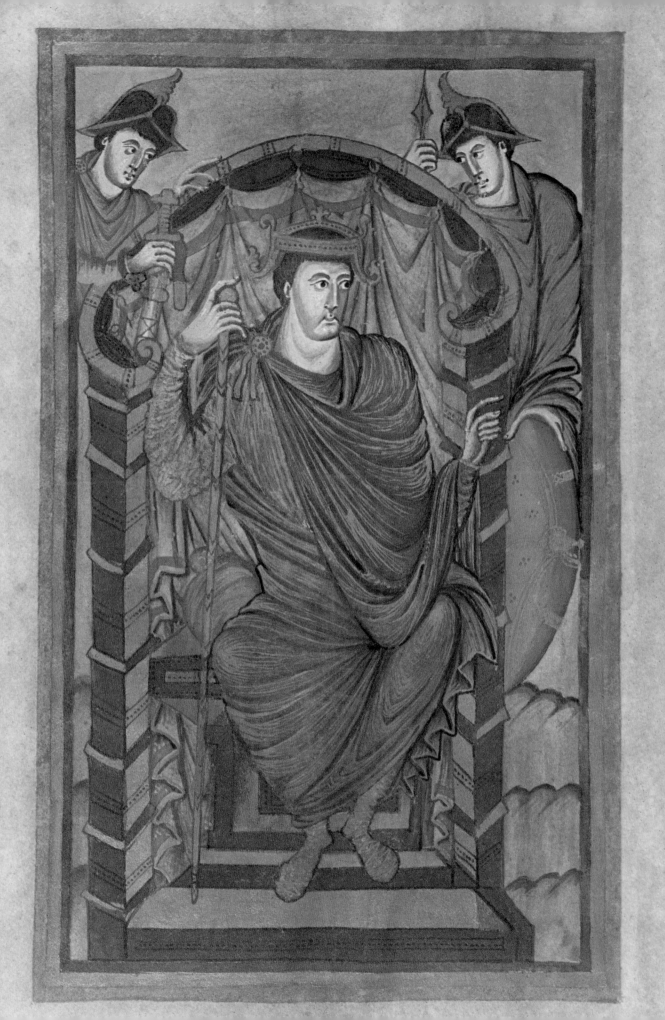

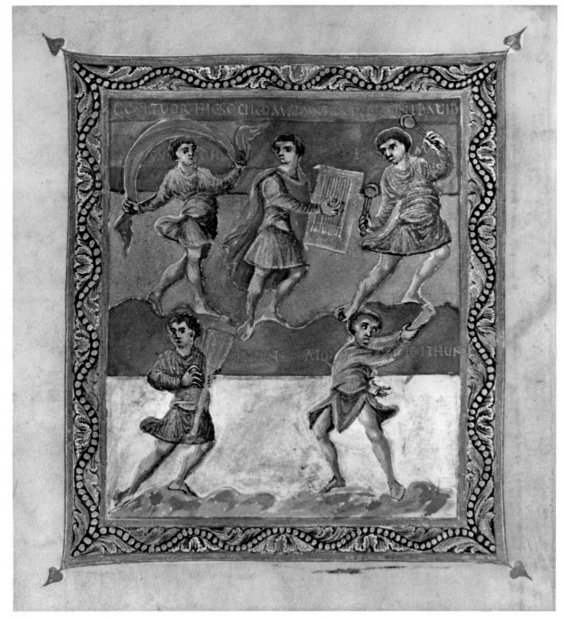

134 – SAINT-DENIS (?). PSALTER OF CHARLES THE BALD. BIBLIOTHÈQUE NATIONALE, PARIS.

The most powerful patron of Christendom, and an exacting one, Charles the Bald enlisted the services of the most gifted artist of the age, the man we have named the Reims painter. Heir of the old Hellenistic traditions, endowed with a fine feeling for the picturesque, a prodigious versatility and a gift for rapid execution, this man advanced from strength to strength in the course of a prolific career whose evolution can be traced in the many works unmistakably by his hand. He collaborated in the second Tours Bible, the so-called Moûtier-Grandval Bible (c. 840), and in the third, the First Bible of Charles the Bald (c. 846). Alone, or with assistants, he illuminated the Lothair Gospels (c. 849–851), then the Prüm Gospel Book (c. 850) which, like the scenes of the life of St Jerome in the First Bible of Charles the Bald, has a layout

146

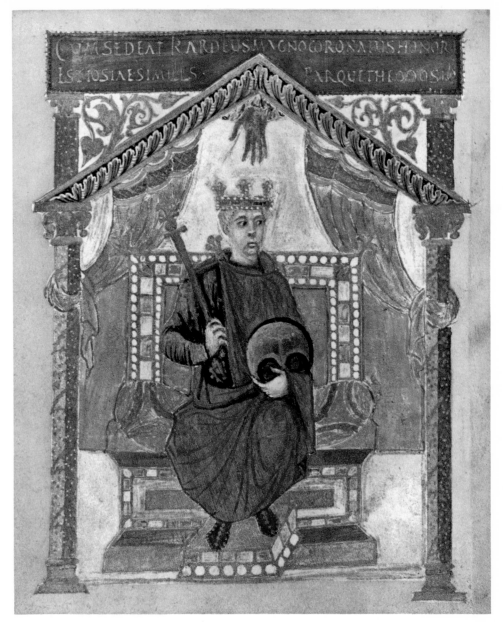

135 – SAINT-DENIS (?). PSALTER OF CHARLES THE BALD. BIBLIOTHÈQUE NATIONALE, PARIS.

of the kind favoured by the Tours illuminators: this was his Saint-Martin period.
As Charles's court artist he illuminated the San Callisto Bible (between 869 and 891),
the Metz Sacramentary (869?) and lastly, the consummation of thirty years of
toil, the famous 'golden' Gospels *(codex aureus)* of St Emmeram of Regensburg.

At the beginning of these last Gospels, a magnificent book whose text was
written in gold letters by Liuthard and Berenger, we see Charles enthroned with a
bodyguard at his side, blessed by the hand of God attended by angels, and paid
homage by personifications of the provinces. Next we see the Lamb on high with
the twenty-four elders of the Apocalypse gazing up in humble adoration; then
Christ in Majesty surrounded by the four evangelists and the major prophets; and

147

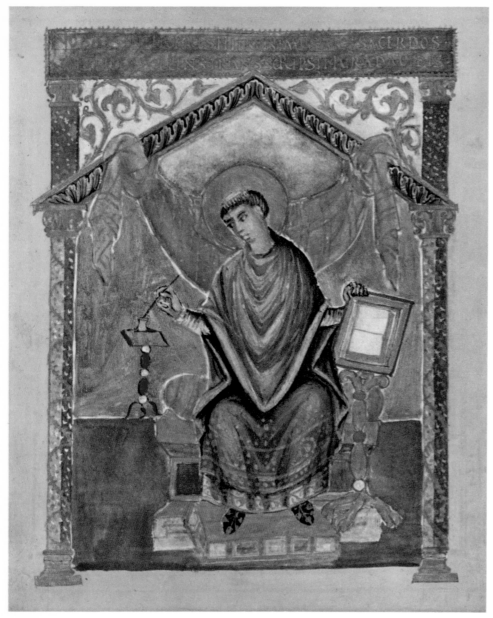

136 – SAINT-DENIS (?). PSALTER OF CHARLES THE BALD. BIBLIOTHÈQUE NATIONALE, PARIS.

finally portraits of each of the evangelists. The canon tables reproduce those of the Saint-Médard Gospels. Traces of the style of most of the great Carolingian manuscripts are to be found in these paintings, but for all their lavish opulence, carried to a point entailing some loss of firmness in the composition, they signify at once the climax and the end of Carolingian book painting.

The Reims painter's masterpiece, the Metz Sacramentary, was doubtless made for Charles the Bald, perhaps for his coronation as king of Lorraine in September 869. His deposition on August 8 of the following year would explain why the volume was left unfinished. Indeed, it seems less a sacramentary than a commemorative coronation book, in which only the canon tables were completed.

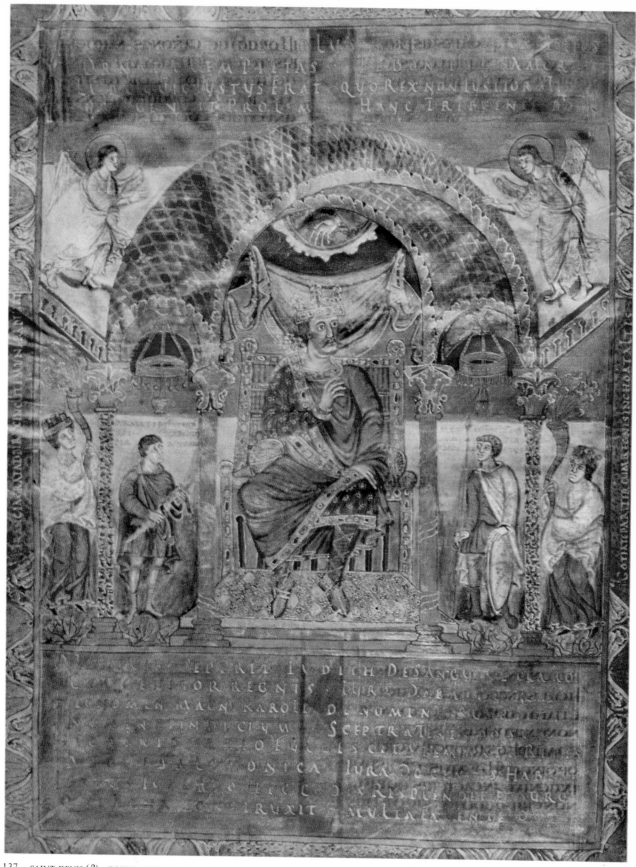

137 – SAINT-DENIS (?). GOSPEL BOOK OF ST EMMERAM OF REGENSBURG. BAYERISCHE STAATSBIBLIOTHEK, MUNICH.

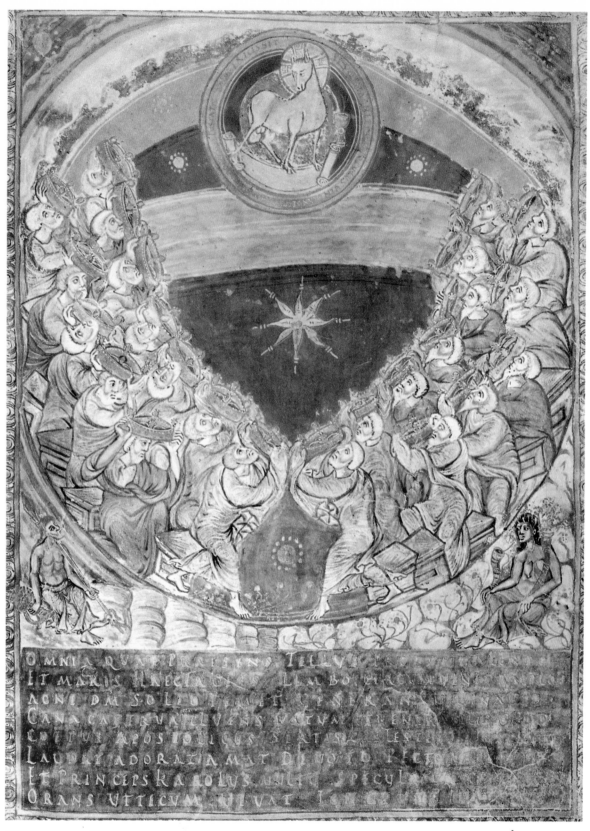

138 – SAINT-DENIS (?). GOSPEL BOOK OF ST EMMERAM OF REGENSBURG. BAYERISCHE STAATSBIBLIOTHEK, MUNICH.

139 – SAINT-DENIS (?). GOSPEL BOOK OF ST EMMERAM OF REGENSBURG, DETAIL.

150

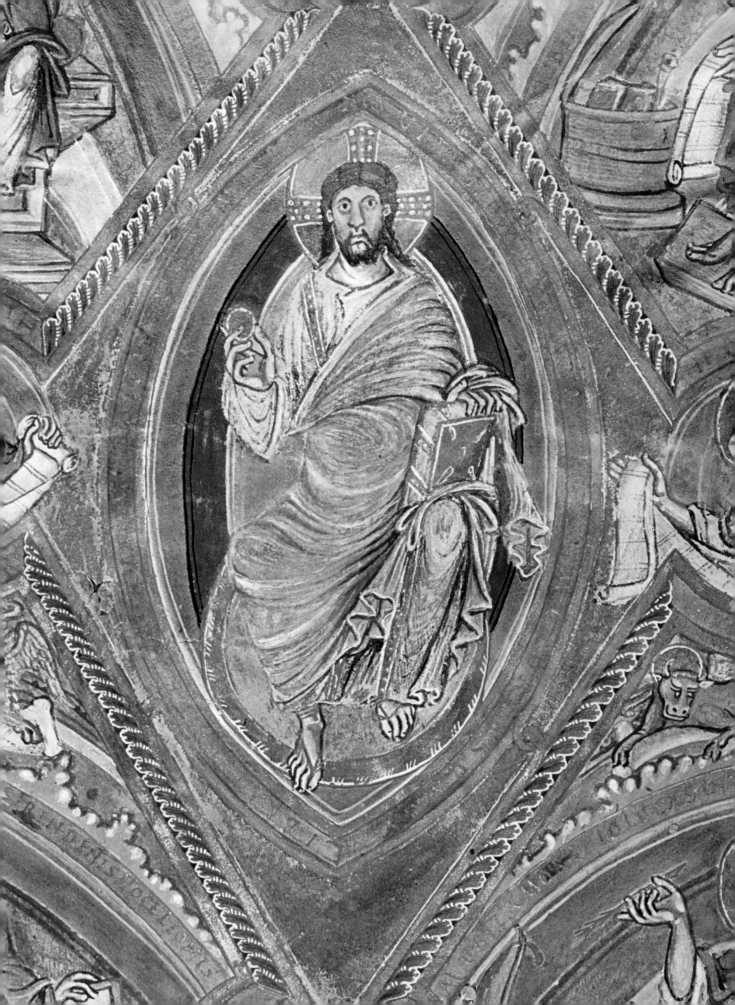

140 – SAINT-DENIS (?). METZ SACRAMENTARY: CORONATION SCENE. BIBLIOTHÈQUE NATIONALE, PARIS.

141 – SAINT-DENIS (?). METZ SACRAMENTARY: SAINTS IN HEAVEN. BIBLIOTHÈQUE NATIONALE, PARIS. ▶

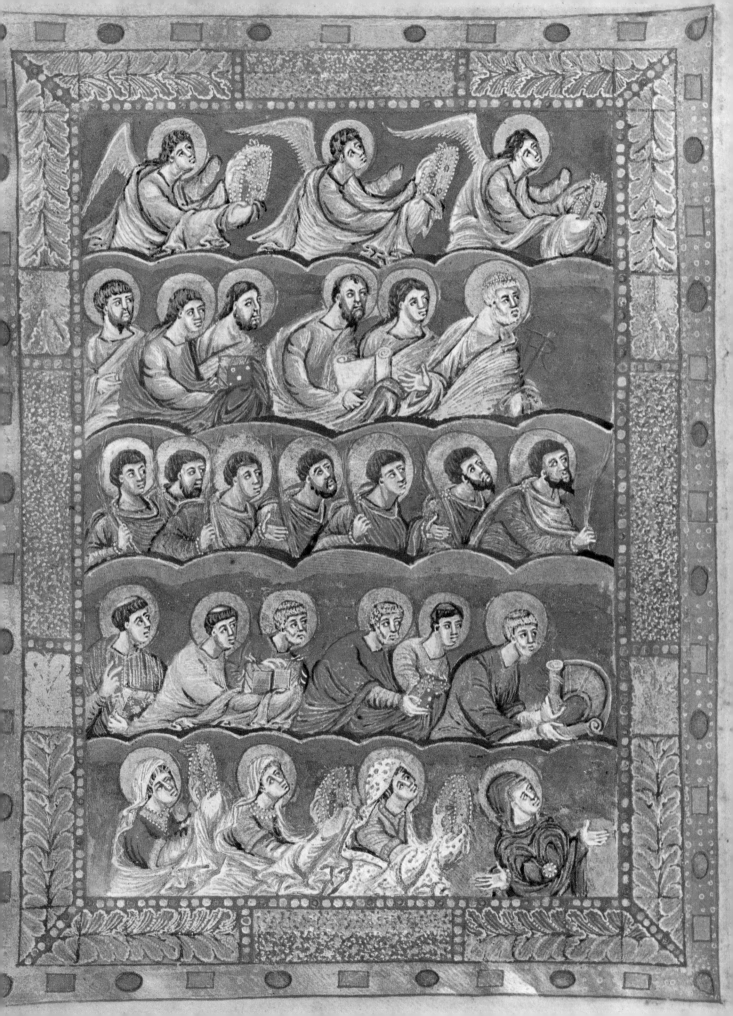

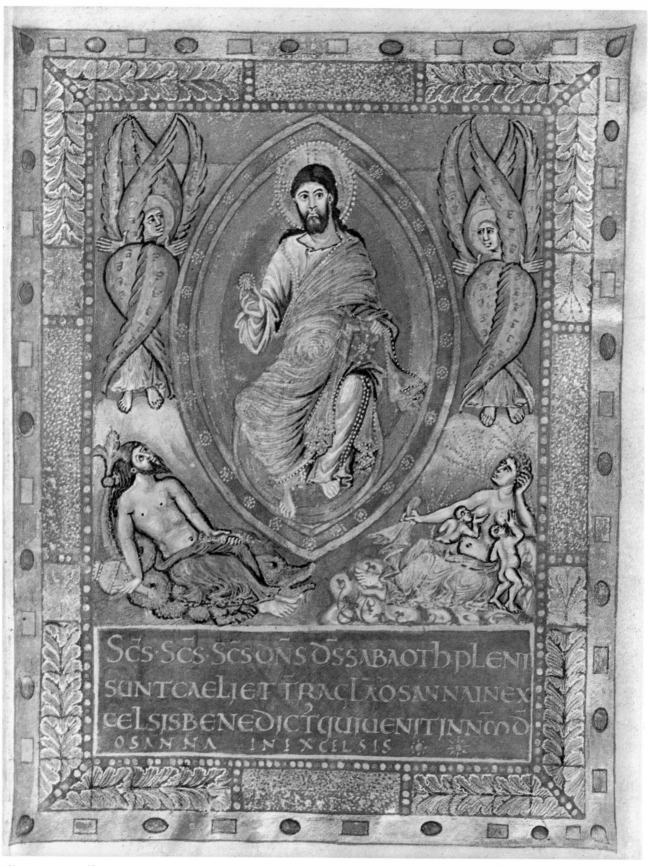

142 – SAINT-DENIS (?). METZ SACRAMENTARY: CHRIST IN MAJESTY, MASTER OF HEAVEN AND EARTH. BIBLIOTHÈQUE NATIONALE, PARIS.

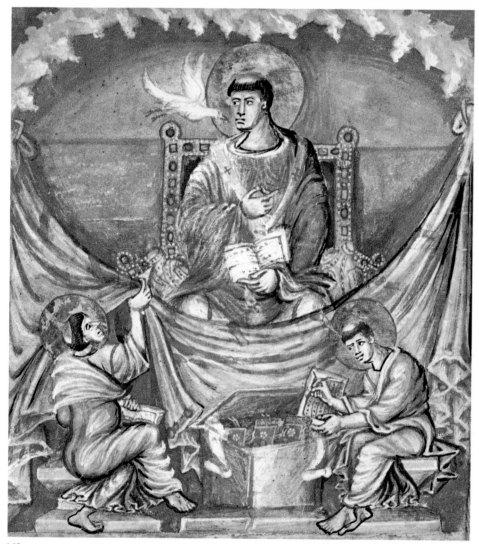

143 – SAINT-DENIS (?). METZ SACRAMENTARY: ST GREGORY. BIBLIOTHÈQUE NATIONALE, PARIS.

The book begins with a picture of the crowning of a youthful prince who is escorted by two archbishops clad in the pallium; almost exactly the same scene figures in the San Callisto Bible (where the theme is the anointing of Solomon by Zadok and Nathan). Here the prince and the archbishops are unidentifiable; they may be allegories. Then, before an image of Christ teaching, come the male and female saints of Paradise, a Christ as master of heaven and earth, and a fine portrait of St Gregory. The saint is seated on a thronelike chair, with his clear-cut, resolute face turned to the right, and his limbs from the knee down hidden behind a curtain hung between him and the two scribes at his feet. One is writing, while the other is parting the curtain to see what is happening; the Holy Ghost in the form of a dove is whispering in Gregory's ear, and he has paused in his dictation to listen.

As he lifts the curtain the scribe strikes a curious dancelike attitude, which was often used by the Reims illuminators to depict a man rising to his feet or simply, as here, reaching up to an object above his head. This attitude had made its first

appearance at Reims in the Utrecht Psalter; it persisted unchanged down to the St Emmeram Gospels, after figuring in the Metz Sacramentary and the San Callisto Bible. An unnatural stance, it is strained to the utmost in the many variations of it made by the Carolingian painters. Early examples are found among the figures in the canon tables of the Saint-Médard Gospels: the artists of Louis the Pious, precursors and masters of Ebbo's artists, worked at Aachen, as we have seen, at the same time as Charlemagne's, and the same models may have passed freely among them all. This figure has a long history behind it; like others, it illustrates the way in which the Carolingians treated motifs bequeathed by antiquity. Its origin is sufficient explanation. A Roman relief in the Museo delle Terme in Rome—of Alexandrian inspiration, be it noted—gives us the key. It shows some women performing a ritual dance under the eyes of an array of Egyptian deities posted in niches above them. The women contort their limbs, twist their hips, stretch their arms towards the gods, and their undulating bodies perfectly convey the idea of self-abandon mimed by the rhythmic movement of the dance. The Reims artists, acquainted with figures of this kind, seen from behind in three-quarters view, copied this distinctive twist with its revelation of the flexions of naked limbs glimpsed beneath light, clinging garments. But in taking over a procedure widely current in antiquity, they applied it mechanically, wherever it served their turn, but never to represent a dance—the only theme to which it was really appropriate. The last of many instances of it is a very fine drawing in a Gospel Book of the Meuse region, datable to the late ninth century, in which a figure personifying the Church holds up a chalice towards Christ crucified, to receive the blood flowing from His side. The curious twist of the body, which is swathed in a clinging garment that reveals the play of muscles beneath, assuredly derives from the Alexandrian relief; here the Church is substituted for the Egyptian dancing girl.

Who was this fine artist, the glory of Carolingian painting, whom we have called the Reims artist? We simply do not know. The scribe who wrote the Psalter of Charles the Bald added his name to the litanies: '*Hic calamus facto Liuthardi fine quievit*' ('here, its task accomplished, Liuthard's pen has come to rest'). Liuthard's name appears again, with his brother Berenger's, at the end of the St Emmeram Gospels: '*Hactenus undosum calamo descripsimus aequor... En Berengarius Liuthardus nomine dicti*' ('with our pen we have delineated the surging sea [a common image of the time, meaning the Bible], we who bear the names of Liuthard and Berenger'). Here again the reference is to the script alone, since the handwriting is similar in both books while the illustrations are not. A Gospel Book in Darmstadt (apparently unconnected with Charles the Bald) contains a third signature of Liuthard—but is it the same man? Here he describes himself as a painter, not a scribe. The evangelist portraits, in the best Reims style, are therefore by his hand, and they have nothing in common with the art of the Psalter of Charles the Bald or the St Emmeram Gospels. In the San Callisto Bible, the last work of the Reims painter, there figures the name of a certain Ingobert, 'copyist and faithful scribe'—here again the writer, not the painter. In brief, we have to accept the fact that nothing is known about the painters of Charles the Bald.

144 – MEUSE REGION. GOSPEL BOOK: CHRIST ON THE CROSS. BIBLIOTHÈQUE NATIONALE, PARIS.

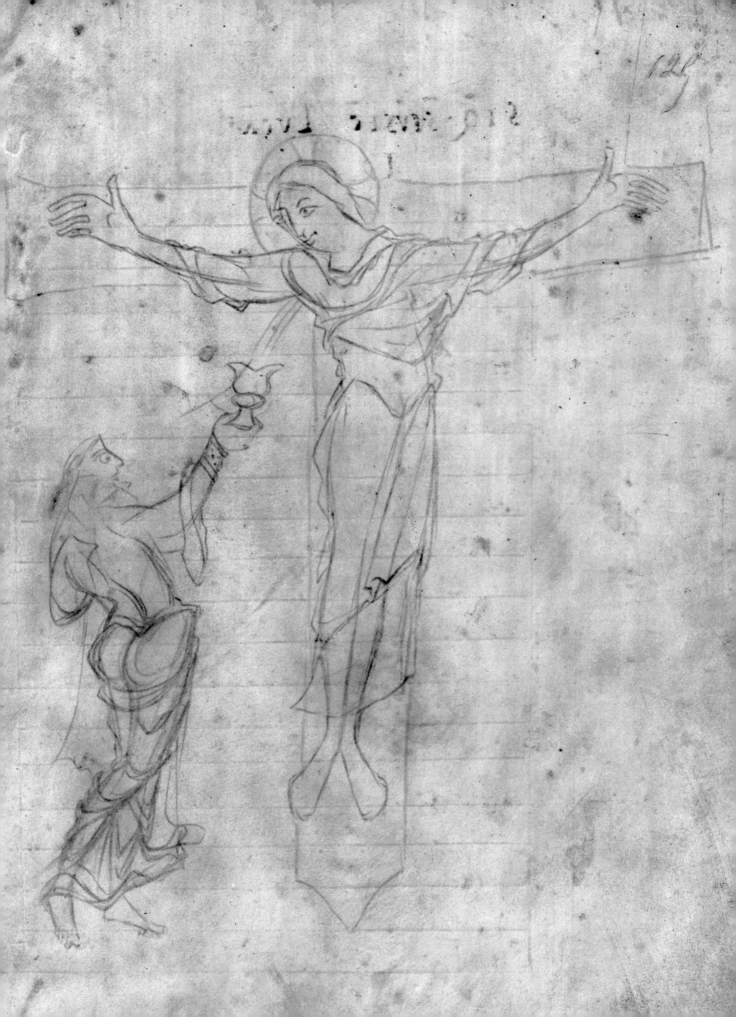

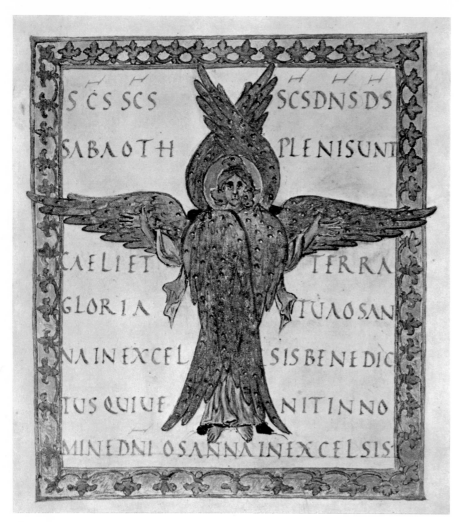

Drogo's Atelier at Metz

We are still concerned with a member of the Carolingian family when we turn to Drogo, an illegitimate son of Charlemagne by a woman named Regina; he was born in 807, after the death of Liutgard, the emperor's wife. Like Ebbo, Drogo was educated at the palace; his half brother Louis had him ordained priest at Frankfurt in 823 and in 826 appointed him bishop of Metz, a position he held till his death in 855. He remained faithful to Louis, then to Lothair. During his time Metz developed into an active art centre, producing many works of high quality, paintings and ivories, the credit for which may justly be assigned to the bishop, who was versed in the same intellectual disciplines as Louis and Ebbo. Drogo's role as a promoter and patron of the arts is proved by the fact that the masterpiece of the Metz school, the so-called Drogo Sacramentary, bears his name in gold letters at the end of a list of the bishops of Metz; it must have been made for him personally.

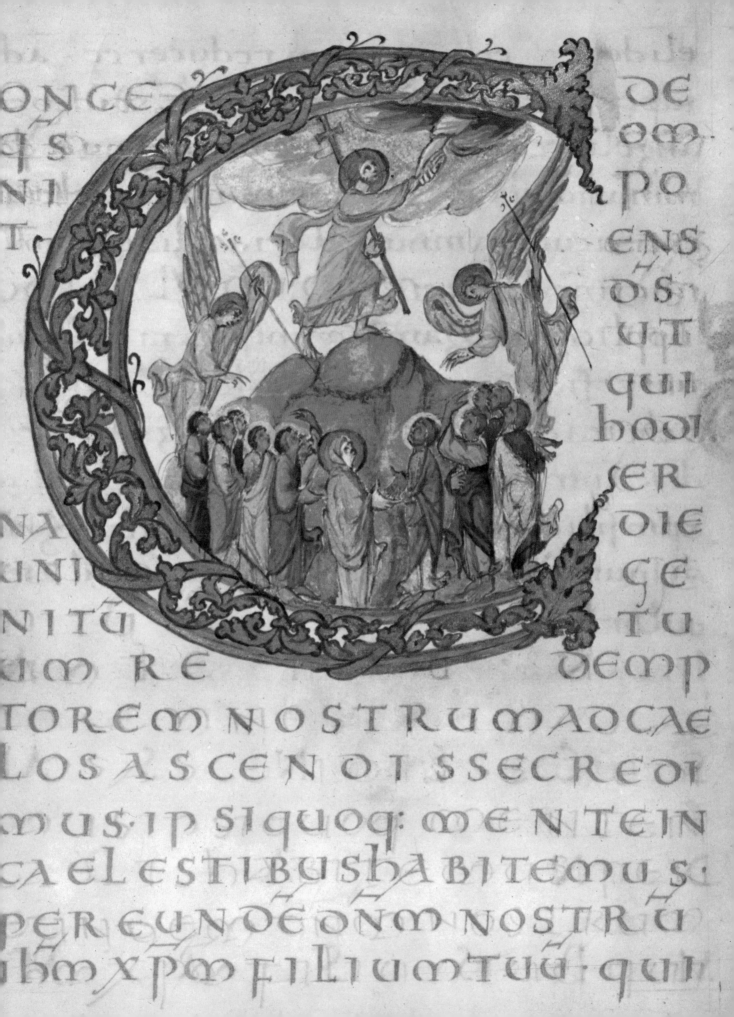

ONCE
QS
NI
T

DE
OM
PO
ENS
DS UT
QUI
HODI
ER
DIE
GE
TU

NA
UNI
NITU
UM RE DEMP

TOREM NOSTRUM AD CAE
LOS ASCENDISSE CREDI
MUS IPSIQUOQ: MENTE IN
CAELESTIBUS HABITEMUS:
PER EUNDEM DNM NOSTRU
IHM XPM FILIUM TUU QUI

147 – METZ. DROGO SACRAMENTARY: THE HOLY WOMEN AT THE TOMB. BIBLIOTHÈQUE NATIONALE, PARIS.

The art of Metz stems from Hautvillers; either the young bishop borrowed artists from his elder Ebbo or—more likely, in view of the dates—a group of Reims painters, or painters trained by them, settled at Metz after the downfall of Ebbo, as another group migrated to Tours. The Drogo Sacramentary, made after 844, has no full-page pictures, only historiated lettrines containing tiny figures deriving from those of Reims. Methods employed in the Utrecht Psalter are combined with the silhouetted forms of Tours; both alike, as we know, were inherited from the painters of Charlemagne and Louis the Pious. Thus the family tradition continued. But the Metz painter must also have seen mural decorations or mosaics like those in the Santa Costanza mausoleum in Rome, that fourth-century work still permeated with antique motifs: foliage scrolls, *putti* at play among light structures outlined against the background. (Since persons of rank generally took their whole household with them on their travels, quite possibly this painter accompanied Drogo when he went to Rome in 844 with a large group of prelates and high officials escorting Louis II, Lothair's son, who was crowned king of Italy by Pope Sergius II. It was

then that Drogo in his capacity of papal legate in Gaul and Germania was invested with the pallium which he is shown wearing on the cover of his Sacramentary.) The painter is sparing in his use of colours, which are mostly almond green and violet, and this discretion gives his work a peculiar elegance that is stressed by the luxuriant vine scrolls clustering round the stems and loops of the initials and tempering their rigid outlines. The figure subjects taken from the text are inserted in the initials without being integrated into them as in the Corbie Psalter or the Gellone Sacramentary: another indication of the Mediterranean taste for analysis, for concrete, individualized forms, so different from the decorative synthesis of the North—a taste the Carolingian painter was trying to assimilate. Already in an insular work, the Canterbury Psalter, the figure of David had been placed inside one of the initials; this was a volume strongly influenced by antique figure painting. Although the example had been followed at Aachen by Charlemagne's painters, it was at Metz that the historiated initial, used as the basic decorative element of a manuscript, acquired the definitive form which was to continue in Romanesque and Gothic art.

INCIPT
LIBVA
GECRA

CAUT AUTEM

XECSUNT

UERBAQUAELOCU
TUS ESTMOYSES
ADOMNETSRAHEL
TRANSIORDANEN

149-150 – SAINT-AMAND (?). SECOND BIBLE OF CHARLES THE BALD. BIBLIOTHÈQUE NATIONALE, PARIS.

Franco-Insular Painting

Our study of some details of the evolution of Carolingian painting has revealed indisputable links between the various groups of painters; the same is true of the other contemporary arts of stone and ivory carving and goldwork. The various aspects assumed by painting within a relatively short period—barely a century— follow each other like the generations of a family, each different from but stemming from its predecessor without any drastic changes, and all so closely interlinked as to defy any strict chronological tabulation. In a word, Carolingian art evolved like life itself, the life of a family. One of its forms, however, is an exception to this rule imposed by the reigning dynasty; and of this final form, no precedent is to be found in the court art hitherto in vogue. What is equally remarkable is that after giving rise to a work of a most unusual kind, this late art became almost completely static and, though more prolific than any other, hardly evolved at all. Although its sole distinctive feature was a straining after the novel and bizarre, it was curiously uninventive, repeating itself ad infinitum. The reason was that it emerged too late, at a period when Carolingian power was waning and the creative urge diminishing. It was given a sort of official consecration by Charles the Bald but had no aftermath. This new development was in effect a sudden reversion to a much earlier art, the decorative art of the British Isles, as if nothing had happened in the domain of painting for a hundred years. A violent reaction against the excesses of the figural style, this curious return to the past—generally described as Franco-Saxon or Franco-Insular art—was the earliest of the revolution in taste, of which so many were to follow. Henceforth painting and European art in general were to oscillate between the narrative and the decorative, between the classical and the baroque, as a direct result of their dual ancestry, Mediterranean and barbarian.

What was the starting point, the immediate cause, of this final avatar of Carolingian art which, given its proliferation, must have had a seminal centre? Attention has been drawn to the presence at the court of the famous scholar John Scotus Erigena ('son of Erin'), yet the magnificent Second Bible of Charles the Bald, presented to the king about 871–877, is unique of its kind; none of the other Franco-Insular manuscripts can be associated with the king or his family or his entourage. It is true that Charles's wife, Ermentrude, who died in 869, had presented the abbey of Saint-Vaast with three of the six manuscripts written in gold and silver letters which it possessed in the thirteenth century, and which may have included a Franco-Insular Gospel Book now in Arras and known to have been brought there from Saint-Vaast—but this remains a moot point. Some have thought that the active centre at this time was Saint-Denis, of which Charles was abbot and where many works of art were made for him. But the abbey of Saint-Amand seems more likely, for sound historical, liturgical and palaeographic reasons; for instance, Charles was its patron. In any case this group of works, dating to the last quarter of the ninth century, can be localized approximately in a region midway between Trier and the

North Sea. It was here that the School of Echternach had produced those insular-style Gospel Books which, with their clear, elegant layout, were the distant precursors of the Second Bible of Charles the Bald. The works of this region show the abiding influence of the insular tradition: from those of the abbey of Saint-Bertin, which had already provided Louis the Pious with a Psalter executed in a similar style, to those of St. Maximin of Trier and even, in the eleventh century, those of Verdun. When we compare the First Bible of Charles the Bald, with that of San Callisto, so elaborately ornamented, or with the St Emmeram Gospels, this Second Bible is in marked contrast. It contains no figures, no ornaments taken directly from the

IHS NAZAREN
REX IVDÆORV

153 – NORTHERN FRANCE (?). GOSPEL BOOK OF FRANCIS II: ST LUKE. BIBLIOTHÈQUE NATIONALE, PARIS.

154 – SAINT-OMER. PSALTER OF LOUIS THE GERMAN. STAATSBIBLIOTHEK, BERLIN.

animal or even the vegetable kingdom; everything in it is pure patterning, and one might imagine it had been censored by some ruthless iconoclast. The entire Franco-Insular group shows, with rare exceptions (and these are figures of the Reims type), an exclusive taste for the strictly decorative. The colours are almost always metallic, gold and silver, sprinkled with touches of light green, bright yellow and carmine. It is the flawless beauty of the script, the huge initials, the canon tables stripped of all ornaments, that justify our seeing in this Second Bible the grand finale of Carolingian art. The lessons of the past century had not been lost; though nothing now survived of their material innovations, there remained the stately, well-balanced

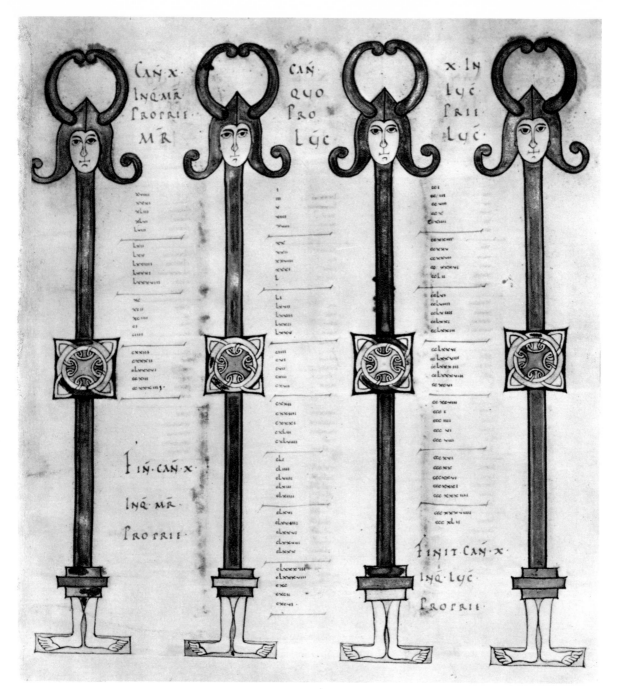

155 – SAINT-AMAND (?). GOSPEL BOOK: CANON TABLES. BIBLIOTHÈQUE MUNICIPALE, TOURS.

composition, the clearly thought-out programme, and that sober elegance, achieved by other means, which we find in the Metz and Tours artists—and this just when these qualities were being submerged by the exuberance of the great Reims painter of Charles the Bald. Thus regained, these qualities could not be lasting; while they do honour, if not to the king to whom the Second Bible was presented, at least to those who designed it, subsequent works from the atelier of, presumably, Saint-Amand show that this taste was little appreciated outside the royal court.

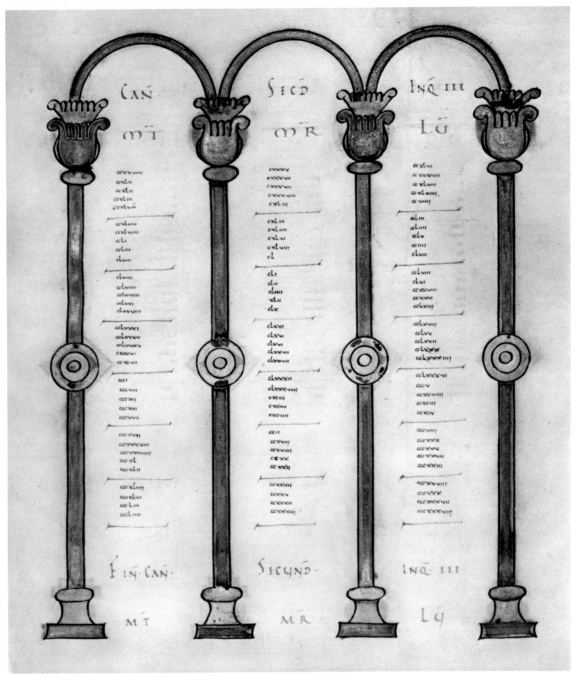

156 – SAINT-AMAND (?). GOSPEL BOOK: CANON TABLES. BIBLIOTHÈQUE MUNICIPALE, TOURS.

So we now turn from the court and its dependencies to the marginal art of the provinces. Under Charles the Bald's successors, artistic enterprise passed from the king's direct control, and the great Carolingian art died with the last art patron of the dynasty. In the following pages we survey the after-developments: local offshoots inherited the techniques of an earlier age or were quickened by the intense activity that prevailed at the court and spread outwards from it, and deposited here and there seeds which in some cases bore fruit and in others came to nothing.

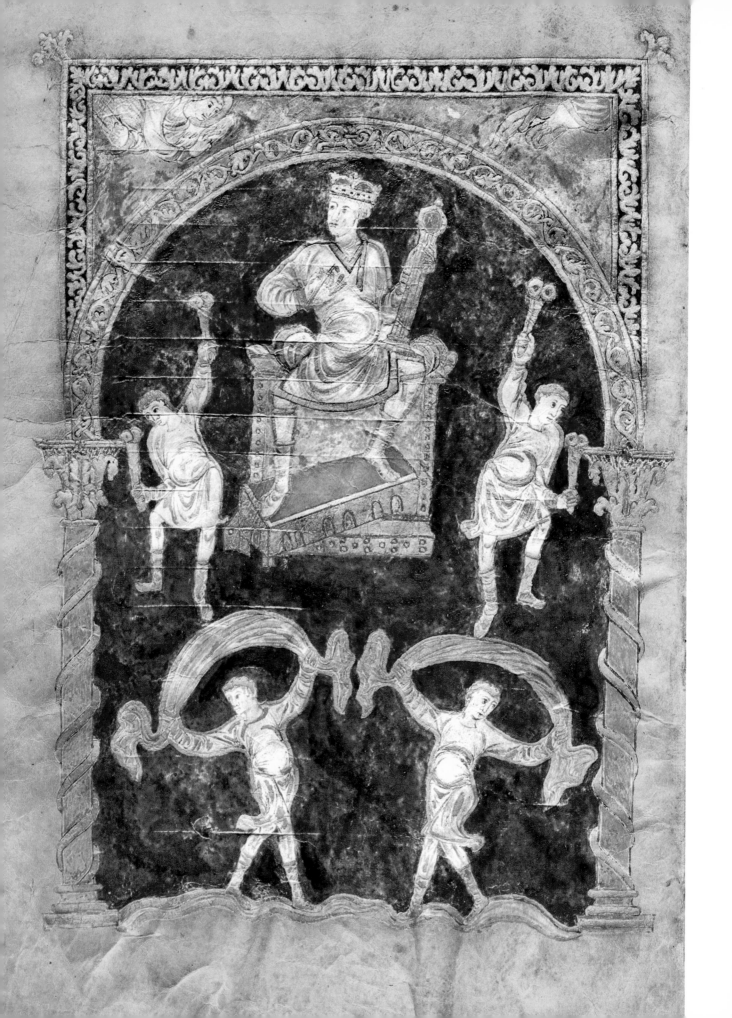

UNOFFICIAL PAINTING

Under its various aspects Carolingian court painting appears to have enjoyed a continuous, centralized development. It was closely associated with the dynasty that sponsored it and whose history it reflects; the dynasty was instrumental in its rise and evolution, from its hesitant beginnings to its mature mastery, and on to the strange Franco-Insular outburst which ended a century dedicated to the antique.

Quite different was provincial painting, sponsored by abbeys unconnected by any direct ties with the sovereign power. Disparate and erratic, these manuscript paintings appeared here and there in isolated groups at the instance of an abbot or under the stimulus of local circumstances, reflecting relations more or less closely maintained with neighbouring or distant regions. Such works lacked the sustained backing or patronage that would have enabled them to evolve and fully develop over a long period of time. These local and ephemeral flowerings can perhaps best be understood by reviewing the mingled art currents that nurtured them (though why they drew on one rather than another is not always very clear): antique and Mediterranean currents, insular and barbarian currents. Although these are, as we see, the same sources that nurtured court painting, the provincials were unable to draw from them any new or original effects, unable, in a word, to create; however blended together, the borrowings remain obvious. It is a minor art, of interest for the devices it reveals better than court painting, but deserving the name Carolingian only by virtue of being contemporary with the latter. It can be dealt with briefly.

Perhaps the only exception to this general tendency is the art of St Gall. Close to the ruler on account of its high standing in the Empire and the immunity it enjoyed, but geographically remote from the official art centre and in closer touch with Italy and alpine Bavaria, for nearly a century the abbey of St Gall was the seat of a school of painting incomparably less brilliant than that of the court, but active and thriving nonetheless. Founded in 612 by Gallus, a companion of the Irish monk Columban, St Gall was of no artistic importance until it was taken under the protection of Louis the Pious, who in 816 withdrew the abbot from the jurisdic-

157 – ST GALL. GOLDEN PSALTER: DAVID WITH MUSICIANS AND DANCERS. STIFTSBIBLIOTHEK, ST GALL.

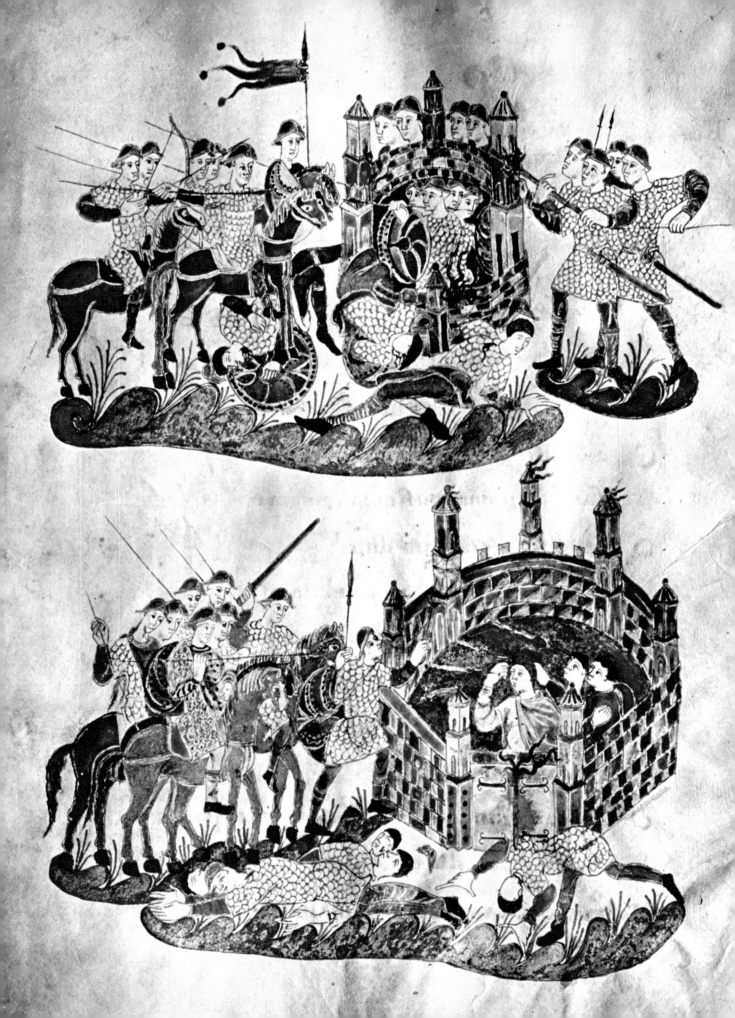

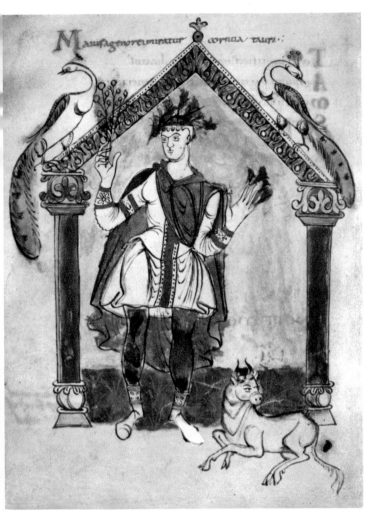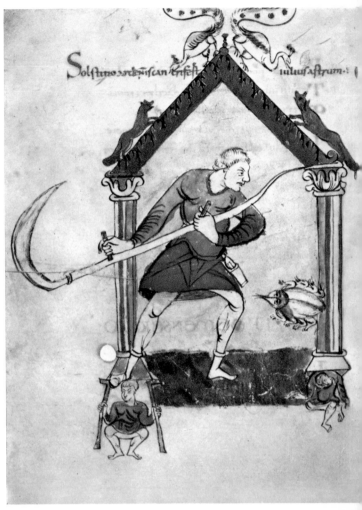

159–160 – ST GALL (?). MARTYROLOGY OF WANDALBERT: MONTHS OF MAY AND NOVEMBER, DETAILS. BIBLIOTECA APOSTOLICA, VATICAN CITY.

tion of the bishop of Constance. It is just as well to point out at once that, in spite of the monastery's origins, Irish or English artists had an inappreciable share, if any, in the illuminated manuscripts executed there. The figure paintings belong to the alpine trend originating in Italy; they reveal both Merovingian reminiscences (unusual in Carolingian art, even in its provincial forms) and insular reminiscences (common everywhere at that time). Apparent echoes of official art can be explained by the independent use of the same models.

So the only painting we have from the oldest of the illuminated St Gall manuscripts, the badly battered Wolfcoz Psalter (named after a scribe active between 807 and 830), recalls in much more rudimentary form the evangelists painted at Aachen a few years earlier for Louis the Pious: grouped vertically, the psalmists are distributed over the page in the same way as the physicians in the Vienna Diosco-

158 – ST GALL. GOLDEN PSALTER: SIEGE AND SACK OF A TOWN. STIFTSBIBLIOTHEK, ST GALL.

rides, like a gathering of ancient philosophers and thinkers, whose dress and attitude they imitate. This motif was taken over by the St Gall painter (as it was by the Aachen painter) from the Hellenizing milieux of Lombardy; this is quite clear from the style of the Psalter, degenerate though it is. But while the figures of the Aachen painter (and those of the Xanten manuscript as well, which makes use of a similar theme) are successfully converted from antique personages into evangelists and shown engaged in an occupation that defines them clearly, the St Gall figures remain indistinguishable from any other thinkers.

Another St Gall manuscript, the Golden Psalter *(Psalterium Aureum)* of the late ninth century, shows us David's collaborators in their usual roles of musicians and dancers; this scene has been aptly compared with the similar one in the Psalter of Charles the Bald, but in fact it is closer to one in the Vatican copy of *Cosmas Indicopleustes*, a manuscript of Alexandrian ancestry that shows the dancer motif in a form closer to the antique original, a form we have already met with in official art. It is unlikely, however, that this motif reached St Gall by way of Carolingian court art. Such borrowings were made directly, like the exclusively Byzantine inspiration behind a third St Gall Psalter, of the early ninth century (of which only one picture, now in Zurich, remains).

No provincial atelier had closer affinities with the school of Reims than that of St Gall. The drawings, whether heightened with colour or not, that form the majority of the figure scenes in St Gall manuscript painting, particularly in the Golden Psalter where episodes in the life of David are represented, or in the Martyrology of Wandalbert, are akin to those of Hautvillers but less proficient: both descend from a common ancestor, the Greco-Latin art of northern Italy, but one is more successful than the other. The same origin can be detected in a curious Gospel Book written at St Gall about the middle of the ninth century by an Irish monk who described in Latin the illustrations he saw in his Greek model: thus Ireland, Greece and Rome were unexpectedly united in this alpine crossroads—a meeting in which court art seems to have had no part. The methods that lay at the source of Hautvillers book painting reappeared in many St Gall manuscripts, varying with the artist and the period. They appear, for example, in a vigorous drawing representing St Paul reviled by the Jews and in a magnificent coloured Prudentius now in Berne; movement, less excited than in the crowd scenes of the Utrecht Psalter, is similarly conveyed by the gesticulation of hands with expressive fingers and thumbs and by rounded backs bending under the stress of momentum—traditional devices inherited from the Santa Maria Antiqua and Castelseprio painters. In the Prudentius the horseman personifying Pride was modeled after some work similar to the Barberini diptych in the Louvre, and the martyrs surrounding Faith are treated like the figure of Stilicho on an ivory at Monza originating in northern Italy. Much later, about 925, the same features, more harshly handled, reappeared in a Book of the Maccabees now at Leyden. The Psalter of Folchard, of about 860, reveals no specifically 'Reimsian' characteristics, but the tympana and spandrels of its arcades with fluted, festooned columns enclose figure scenes of a distinctly Italo-Alpine type. The initial letters of St Gall manuscripts develop the bird and fish themes of Merovingian miniatures

161 – ST GALL. EPISTLES OF ST PAUL: PAUL REVILED BY THE JEWS. STIFTSBIBLIOTHEK, ST GALL. ▶

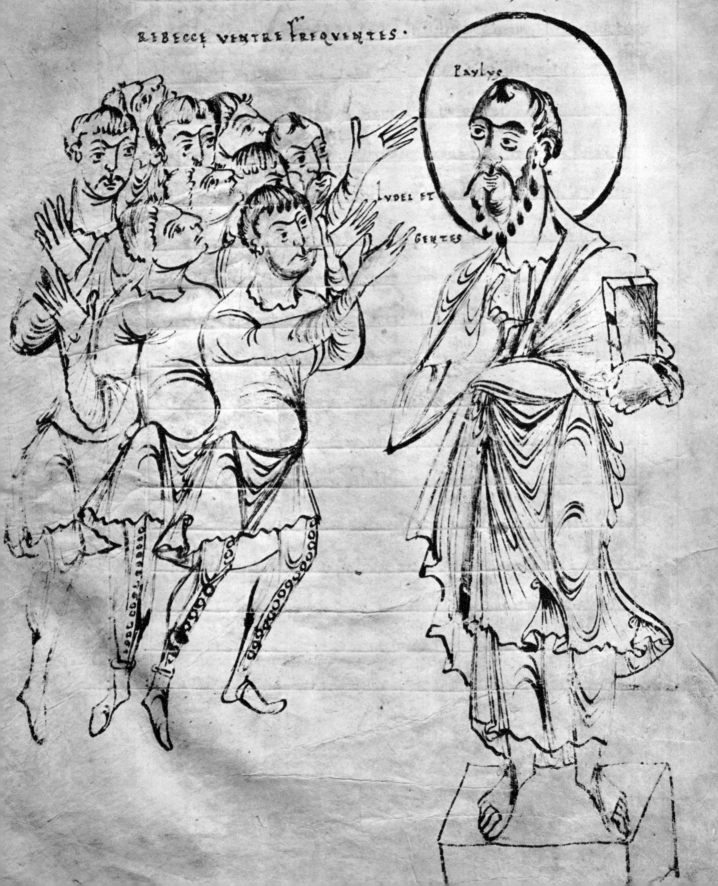

ARGVMENTVM EPISTOLAE AD ROMANOS · PRESENS TEXTVS
HABET · MERITIS VT GRA DIFFERT · REDDENS CONCORDES
REBECCE VENTRE FREQVENTES ·

PAVLVS

IVDEI ET
GENTES

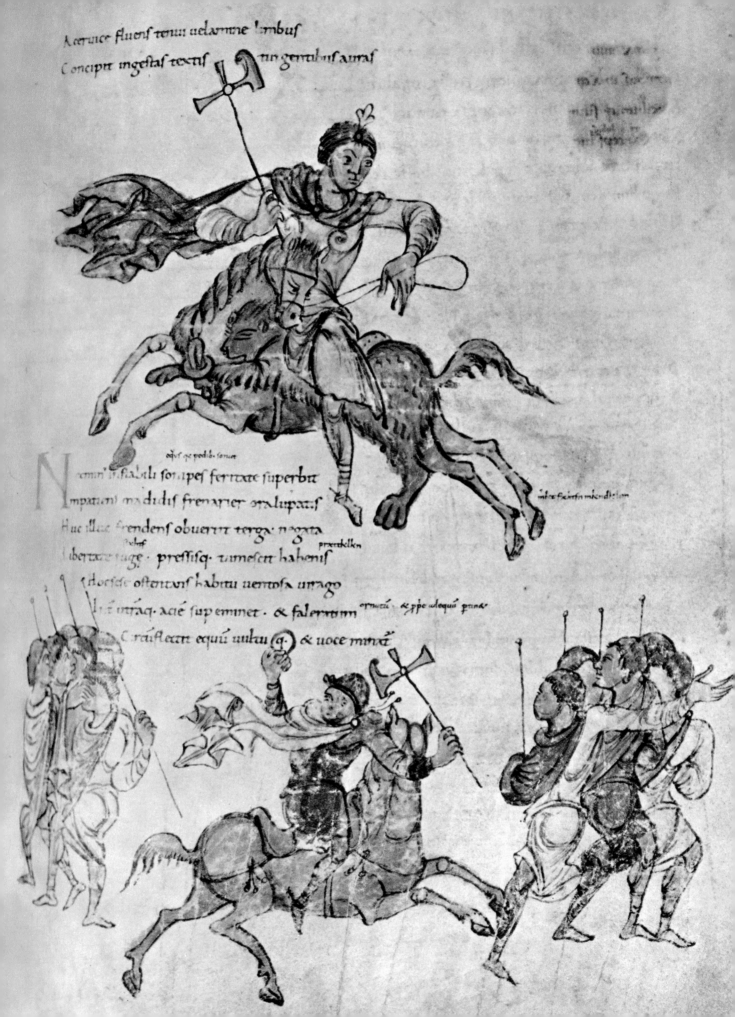

A ceruice fluens tenui uelamine limbus
Concipit ingeftas tectis in gentibus auras

odus qc pedib. fonat

Nemin' in fiabili fonipes feritate fuperbit
Impaciens madidis frenarier oralupatis
Huc illuc frendens obuertit terga negata
Libertate fuge presfisq. tumefcit habenis
Et horfefe oftentans habitu nemofa iurago
Hac inraq. acie fupeminet. & faleritum ornatú & ppe udequú punæ
Ctrifletetr equú uultu q. & uoce minæ

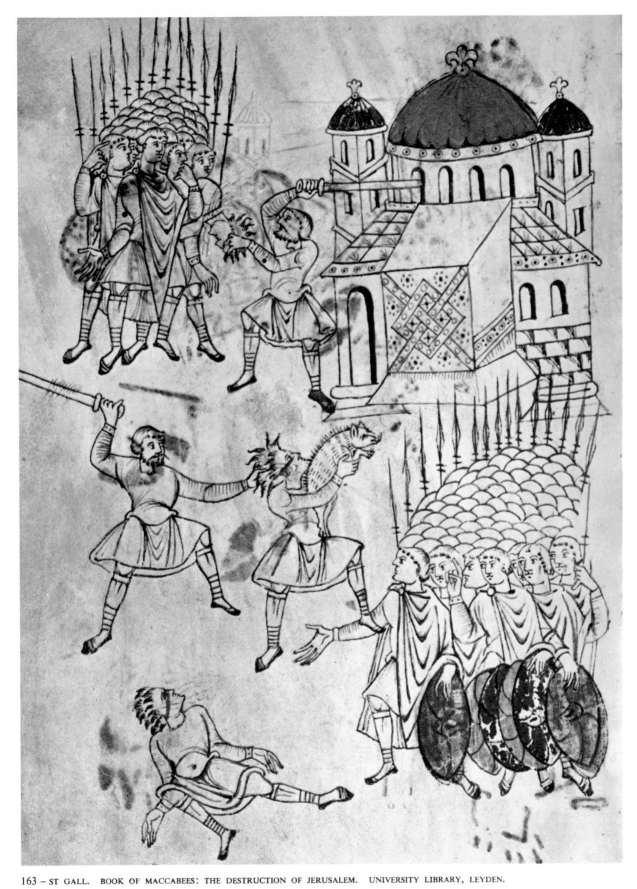

163 – ST GALL. BOOK OF MACCABEES: THE DESTRUCTION OF JERUSALEM. UNIVERSITY LIBRARY, LEYDEN.

162 – ST GALL (?). PRUDENTIUS, 'PSYCHOMACHIA': PRIDE (ABOVE) AND HUMILITY AND HOPE (BELOW). BÜRGERBIBLIOTHEK, BERNE.

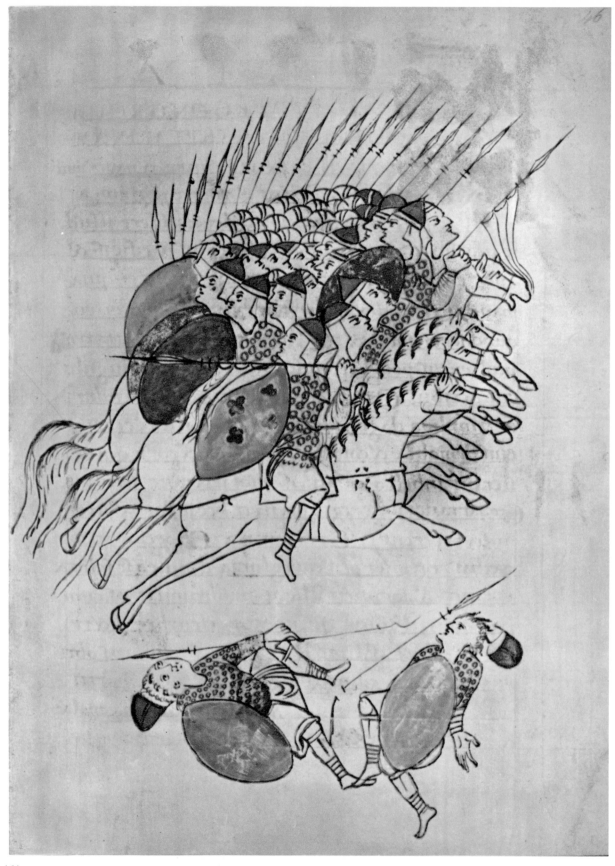

164 – ST GALL. BOOK OF MACCABEES: MOUNTED WARRIORS. UNIVERSITY LIBRARY, LEYDEN.

165 – ST GALL. PSALTER OF FOLCHARD. STIFTSBIBLIOTHEK, ST GALL.

166 – SALZBURG. ST JOHN CHRYSOSTOM, 'HOMILIES ON THE GOSPEL OF ST MATTHEW.' NATIONALBIBLIOTHEK, VIENNA.

by combining them with cable mouldings and elongated animals of insular aspect in which gold and silver predominate, and with leafage recalling that in the Drogo Sacramentary, of gold on a coloured ground, and of a form which, stylized with the passage of time, was to characterize the ornament of 'Reichenau' and Echternach manuscripts in the tenth and eleventh centuries.

The situation of the bishopric of Salzburg was not unlike that of the abbey of St Gall. The monastery had been founded by monks from the British Isles, and after the Irishman Ferkil (called Virgil) had been installed by Pepin in 745 as abbot of Sankt Peter and bishop of Salzburg, English and Irish clerics contributed to its intellectual growth. Its geographical position and the ties formed in the eighth century between the Bavarian dynasty of the Agilofings and that of the Lombard kings, together with the relative proximity of Ravenna, opened the region to northern Italian influences and ensured the supremacy of Mediterranean art forms.

A Gospel Book known as the Codex Millenarius, produced at Kremsmünster about the year 800, and others written at Salzburg by the scribe named Cutbercht derived from the same Italic model but were probably illuminated by a group of Anglo-Saxon artists who had long resided north of the Alps; the same group painted the frescoes in the small chuch of Naturno (Naturns) in the Italian Tyrol. This phenomenon is comparable to the one that presided over the formation of Anglo-Saxon painting itself: the insular scribes and illuminators, whose activity everywhere was sporadically maintained outside the imperial ateliers, interpreted in their own way the repertory bequeathed by antiquity, and they played, as will be remembered, a key part in the rise of official art at the Carolingian court. Inserted in an early ninth-century Salzburg Gospel Book is a portrait of St John Chrysostom standing against a background patterned with characteristic plant forms. It reveals an active influence from the Middle East at Salzburg, just as at Corbie about the same time; but the illuminators, insular artists at both places, fell far short of the mastery shown by their contemporaries in Gaul.

The Bavarian monk Arn, of Freising, a pupil and friend of Alcuin, was abbot of Saint-Amand in Gaul and at the same time bishop, then archbishop of Salzburg. Due to him, a current of literary and artistic exchanges was established between northern Gaul and Bavaria: Salzburg scribes and illuminators drew inspiration from manuscripts executed at Saint-Amand, while from Salzburg Saint-Amand received works illustrated in the Italo-Alpine manner. Of the latter, we have three Apocalypse manuscripts, preserved at Valenciennes, Cambrai and Trier. The Valenciennes manuscript was made at Saint-Amand; it is signed 'Otoltus indignus presbyter,' a name which had been recorded forty years earlier in the ninth century in the diocese of Salzburg. The other two derive from a single model. These three works have nothing in common with the Franco-Insular manuscripts attributed to Saint-Amand. Certain British features noticeable in the Valenciennes Apocalypse derive from earlier Salzburg manuscripts; similar features appear in the Codex Millenarius and the Cutbercht Gospels. This link between Gaul and Bavaria, extending to Italy as well, is attested by still another work: a glossed Psalter written and illuminated in the abbey of Mondsee, near Salzburg, in the late eighth century, which belonged

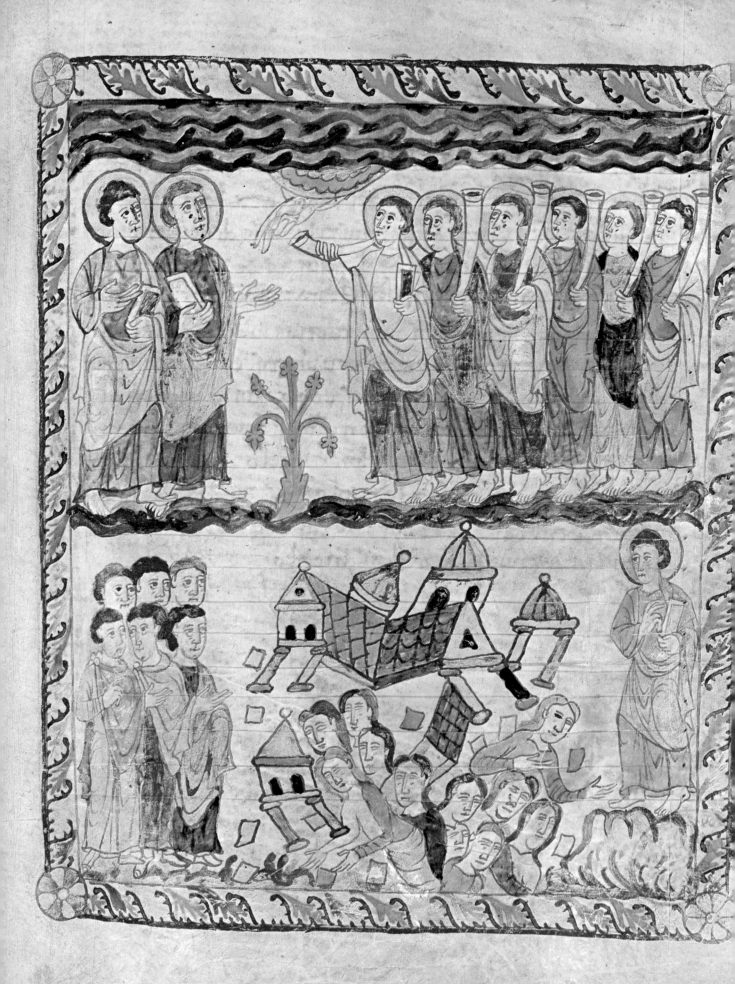

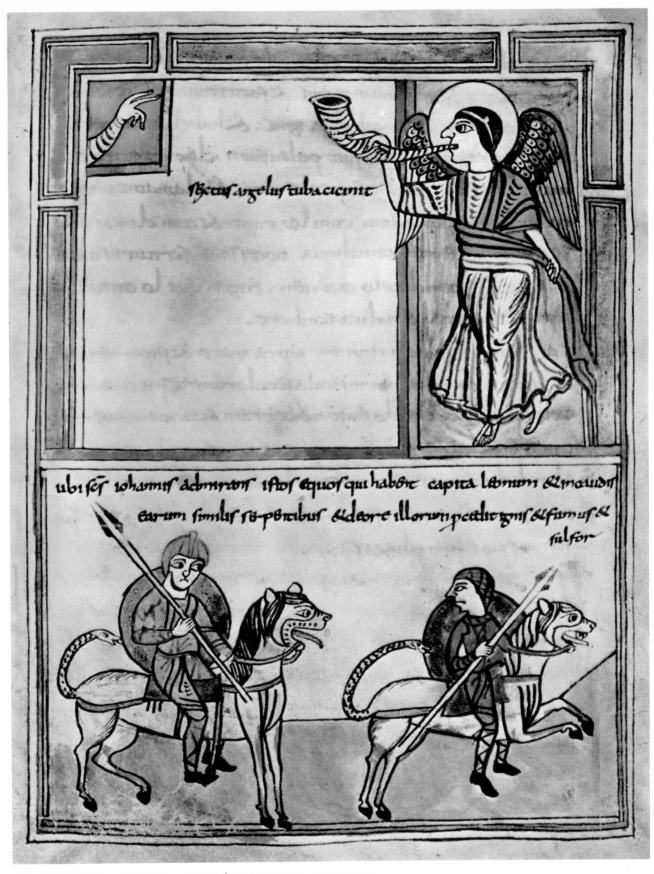

Beatus angelus tuba cicinit

ubi scs iohannis admiratur istos equos qui habet capita leonum & inauditu earum similis serpentibus & deore illorum pcedit ignis & fumus & fulfor

168 – SAINT-AMAND. APOCALYPSE. BIBLIOTHÈQUE MUNICIPALE, VALENCIENNES.

◀ 167 – SAINT-AMAND. APOCALYPSE. BIBLIOTHÈQUE MUNICIPALE, CAMBRAI.

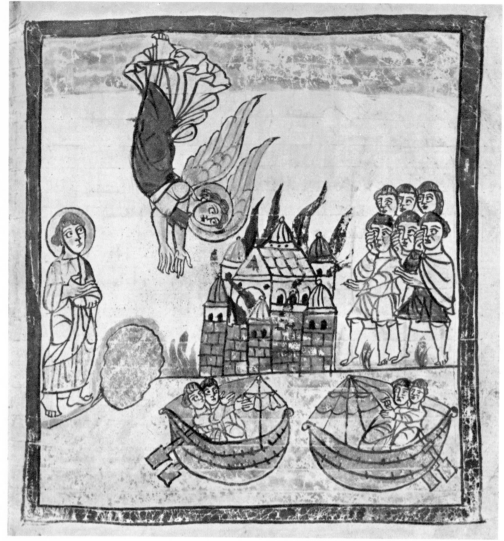

169 – NORTHERN OR EASTERN FRANCE (?). APOCALYPSE. STADTBIBLIOTHEK, TRIER.

shortly afterwards to the nuns of Notre-Dame of Soissons, among whom were Rothrude, one of Charlemagne's daughters, and Hildegarde, who was probably a nun in this convent in the time of Abbess Gila. The Mondsee Psalter is thought to have been taken to Gaul by Liutpirc, wife of Tassilo III, Duke of Bavaria.

The imperial workshops of Aachen are credited with three small ivory plaques representing Christ and the symbols of Matthew and John, each in a medallion; they were copied in two Gospel Books of the late ninth century, one from Saint-Amand, now at Valenciennes, and the other, in Franco-Insular style, at Cambrai. These three plaques—and two more (of Mark and Luke) which are lost and known only from the manuscript copies—reproduced Early Christian originals of very high quality. Whatever their date, they bear witness to a north Italian presence in Mosan Gaul, a presence which lasted well into the Romanesque period, as though the Meuse and Schelde regions had been destined to maintain the artistic relations established by the Carolingian dynasty with southeastern Europe, Bavaria and Italy.

170 – EASTERN FRANCE. GOSPEL BOOK: SYMBOL OF ST MATTHEW. BIBLIOTHÈQUE MUNICIPALE, CAMBRAI.

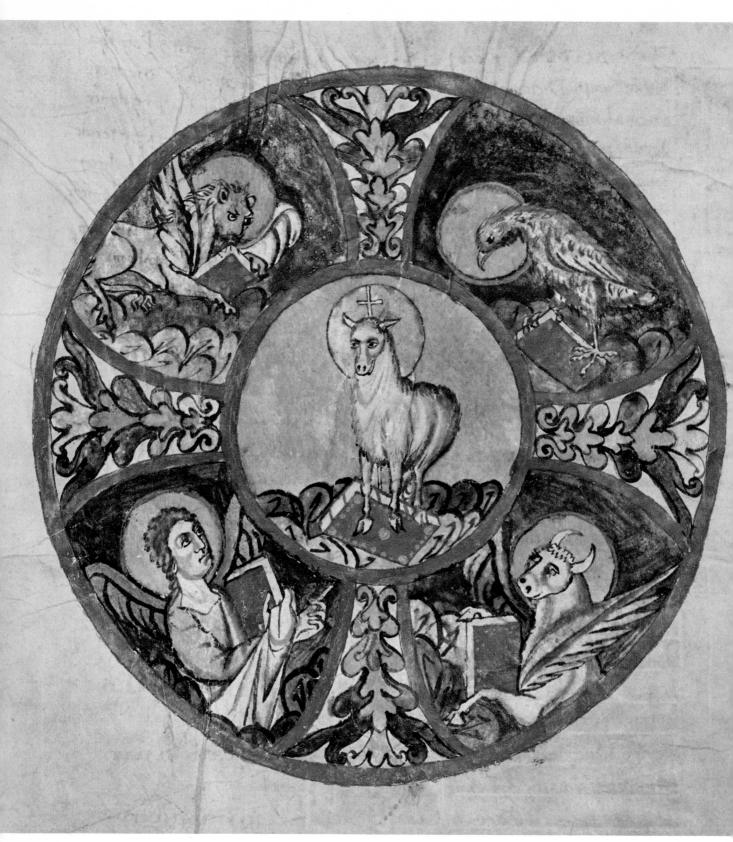

171 – SAINT-AMAND (?). GOSPEL BOOK: THE LAMB SURROUNDED BY THE EVANGELIST SYMBOLS. BIBLIOTHÈQUE MUNICIPALE, VALENCIENNES.

186

THA IS PHÆDRIA PARMENO

THA M *ifcrunmuerter neilludgruuuf phædru*

172 – REIMS. TERENCE, 'COMEDIES': CHARACTERS IN 'THE EUNUCH.' BIBLIOTHÈQUE NATIONALE, PARIS.

The connections between Saint-Amand and Salzburg made themselves felt as far afield as Tours, and something has already been said about their effect there on the school of illuminators at the abbey of Saint-Martin.

It is still difficult to localize with any certainty the many illustrated copies of classical or late antique scientific and literary works which were executed in Gaul, Germania and Italy during the ninth and tenth centuries: Terence, Prudentius (whose *Psychomachia* became an inexhaustible source of themes for medieval artists, both manuscript illuminators and fresco painters), Donatus and other grammarians, Martianus Capella (whose *Liber de nuptiis Mercurii et Philologiae*, a strange medley of philosophy and astrology, enjoyed a long vogue), Isidore of Seville, various books on astronomy, cosmography, medicine, geometry, and finally the treatises of those Roman *agrimensores* who taught the barbarians the science of land surveying. All these manuscripts contain a wealth of highly interesting illustrations, but they have little bearing on Carolingian art; these drawings, in which colour is rare (the fine St Gall Prudentius is a signal exception), give us vivid glimpses of the world of antiquity and it is enough merely to mention them here.

It is equally difficult to fix the place of origin of a ninth-century Gospel Book illustrated with drawings (Crucifixion, Descent from the Cross) which were faithfully copied, even to the final signature, from a Gospel Book of undetermined date (but probably of the eighth century) owned by a bookseller named Gaudiosus, who had his shop in Rome near the church of San Pietro in Vincoli; the Crucifixion is closely patterned after the fresco in the *presbyterium* of Santa Maria Antiqua. This later Gospel Book was preserved at Saint-Aubin of Angers, although it may not have been written there. Like the illustrated copies of scientific works, it transmits, without any reinterpretation, a genuine image of an earlier period.

173 – REIMS. TERENCE, 'COMEDIES': FRONTISPIECE WITH MASKS. BIBLIOTHÈQUE NATIONALE, PARIS.

174 – SAINT-AMAND (?). PRUDENTIUS, 'PSYCHOMACHIA': AVARICE. BIBLIOTHÈQUE MUNICIPALE, VALENCIENNES. ▶

eu foras puator·
bello ples
Quam trage multa bellicosus tps̄ A
monstra demas insaniens et repugnandu
preceta cor dis seruentis uicerit;

Si superatu rudeles· fortuitu· capaua uerant·
Ultum feroces forte reges coeperant
habitante· sin i· peccatricib; ciuitatib;
othammorantem criminosis urbibus
surbes· i· incolebat· i· alienuf
sdome & gomorre· quas fouebat aduena·
ualens· Abrahe· i· dignitatis·
ollens honore patruelis gloriae;

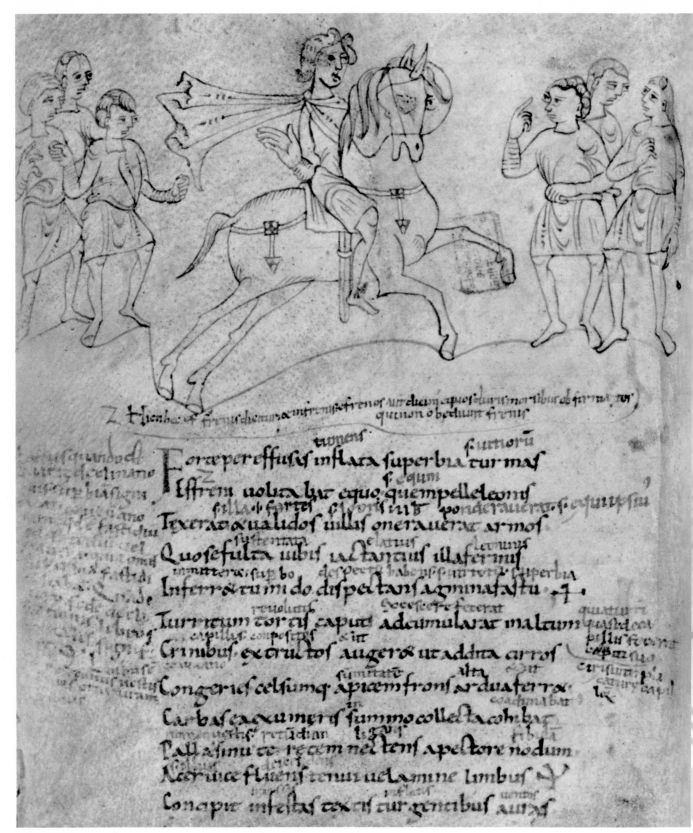

Z Hienber of frenrchennra emtronuse frenos autrehem capuof durummortibus oberurma ten
quenon o bedeunt frenuf

tumens furmorii
Forc per effusis inflata superbia turmas
 s equm
Effrem nobra hr equo quempelle leonis
 sella b fortes efonsiius ponderauergy s efunipsui
Texerat a ualidos uills onerauerat armos
 sustentan elatius leouunus
Quos efulta uibis uactantius illa fermis
 immittera sup bo despecta habens surrorus superbia
Inferrortu in do dispeltans agminafastu ·:·
 reuoluens hoc os ore feruerat quatuir i
Turritium torcis caput adcumulart malcum quasd ca
 capillis composset s in pillis feuera
Criminbus ex cructos augerat ut addita crros s afro
 sumitate alta eqiu cristamip
Congeries celsumq apicem frons ardua terra canurecapal
 coadunabat lx
Carbas eacxu meris summo collect a cohibat
 nomenuerris peruictar leguir fibula
Palla sinuce re gem nec tens apectore nodum
 deter deter
Necriuice fluens tenui uelamine limbus ·:·
 unflatis uentis
Concipit infestas texcis turgentibus aurys

175 – SAINT-AMAND (?). PRUDENTIUS, 'PSYCHOMACHIA': PRIDE. BIBLIOTHÈQUE MUNICIPALE, VALENCIENNES.

190

ueniens subsolani orientem nubibus inrigat. Testiur uentorum aust
cardinalis qui & nothus uocatur. Plage meridiane ex humili flans
humidus calidus atque fulmineus generant largas nubes & pluuias
loca tristimas soluens & iam flores. Euroauster calidus uentus a dex
tris intonat austri temperatur. Euronotus uentus calidus a si
nistris austri inspirat. Quartus uentorum cardinalis zephirus
qui & fabonius dicit ab occidente interiore flat

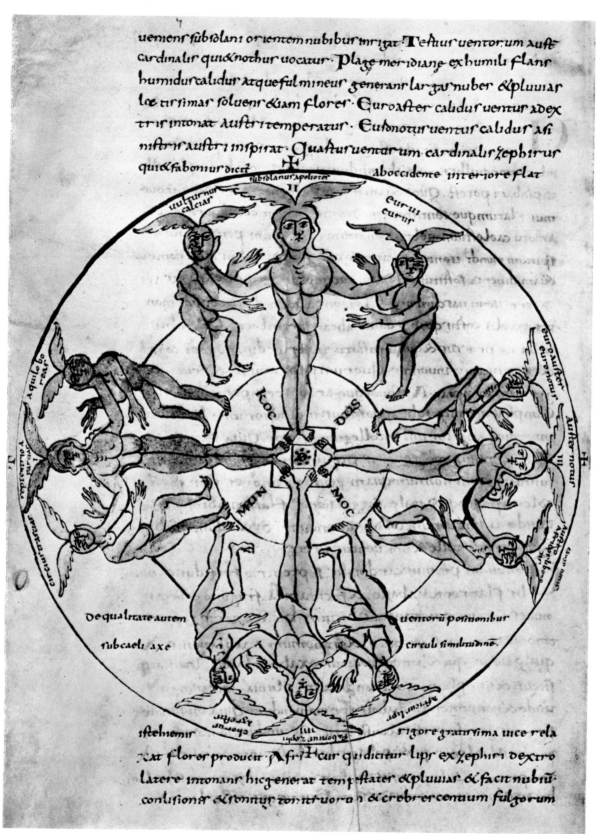

De qualitate autem uentorum possitionibus
sub caeli axe circuli similitudine

iste hiemis rigore gratissima uice rela
xat flores producit. Afristeur qui dicitur lips ex zephiri dextro
latere intonant hic generat tempestates & pluuias & facit nubiū
confusiones & sonitus tonitruorum & crebros centum fulgorum

176 – LAON (?). ISIDORE OF SEVILLE, 'DE NATURA RERUM': WHEEL OF THE WINDS. BIBLIOTHÈQUE MUNICIPALE, LAON.

191

The trends of official art and its derivatives could not but exert a strong influence on provincial painters. The classicism of Charlemagne's court artists at Aachen was accordingly taken up in the ateliers of the neighbouring abbey of Fulda, where it competed, sometimes in the pages of the same manuscripts, with insular motifs imported by British missionaries—for Fulda was founded under the aegis of Pepin by the Anglo-Saxon monk Boniface. Of two Gospel Books written at Fulda towards the mid-ninth century by insular scribes and left unfinished (some of the headings and rubrics were added subsequently in Carolingian minuscule), one was provided, on blank or newly inserted sheets, with magnificent canon tables and remarkable evangelist portraits of an inspiration as purely antique as the best paintings from Charlemagne's ateliers. They appear to be by a hand contemporary with the original script. Two distinct groups were evidently at work at Fulda, and the one representing the classical trend enjoyed a prestige attested by works executed at the abbey in the pure tradition first of Charlemagne's painters, then of the Tours painters. The personality of Rabanus Maurus, a pupil of Alcuin and abbot of Fulda in 822, undoubtedly had something to do with the introduction there of the Tours style, as is shown by a copy of his famous poem *De Laudibus Sanctae Crucis* with the verses ingeniously broken up to form large allegorical figures—a copy whose illustrations, peopled with short, thickset personages, represent, by way of Saint-Martin of Tours, a rather degenerate offshoot of the Italo-Alpine family.

The Goth Theodulf, bishop of Orléans from about 788 to 821 and abbot of Fleury and Micy, brought Spanish ideas to Gaul and cast them in forms inspired by the prevailing classical taste. Apart from the text itself and its layout, the copies of the Bible that he wrote out at Charlemagne's request contain nothing which recalls his origins: the script is an admirable small Carolingian minuscule, and the illuminations consist of canon tables designed in the best official manner. Except for its general layout and divisions, this Bible is quite unlike the slightly later Visigothic Bible now at La Cava, near Naples, which is also unillustrated. At Germigny, not far from Fleury, Theodulf had an oratory built and decorated with mosaics; a Gospel Book from Fleury may also have been made for him. It opens with a fine miniature showing the symbols of the four evangelists, with wings dotted with eyes and with no haloes, like those in the mosaics of the late fifth or early sixth century at Naples, Capua and Santa Pudenziana, Rome. The decoration of the Gospel Book preserved at Tours is in the same vein, but of a different type.

But it was the prolific school of Reims that went through the richest, most extensive cycle of development, spreading through northern Gaul, into the Rhineland (to Cologne in particular), to Freising, and towards the Danube to Weltenburg; it was Reims painting too, so highly original, that best preserved its character and above all its quality. Finally, in and around Cologne, the Franco-Insular school produced a considerable number of mediocre works. We should have a most unflattering impression of these last insular offshoots, equally unremarkable in the British Isles themselves, and elsewhere quite monstrous, were it not that one of them, stemming directly from the British Isles it is true, appeared at Fleury, the abbey of Theodulf (who, however, had nothing to do with it personally).

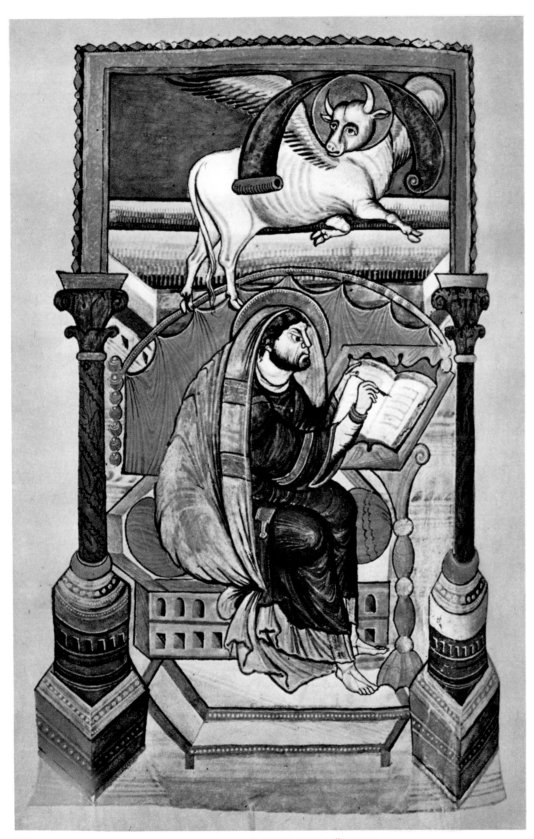

177 – FULDA. GOSPEL BOOK: ST LUKE. UNIVERSITÄTSBIBLIOTHEK, WÜRZBURG.

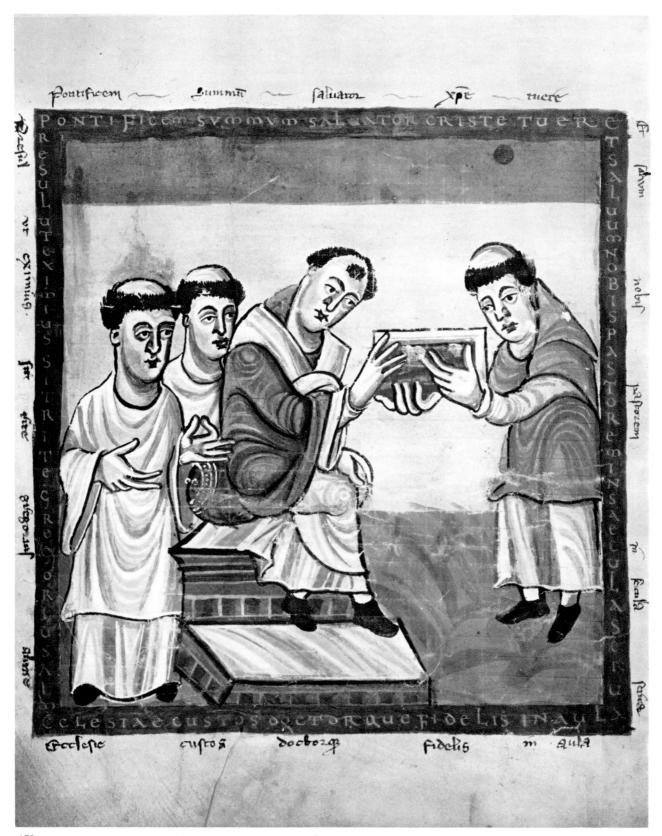

178 – FULDA. RABANUS MAURUS, 'DE LAUDIBUS SANCTAE CRUCIS': RABANUS PRESENTING HIS BOOK TO GREGORY IV. VIENNA.

179 – FLEURY. GOSPEL BOOK: EVANGELIST SYMBOLS. BÜRGERBIBLIOTHEK, BERNE.

194

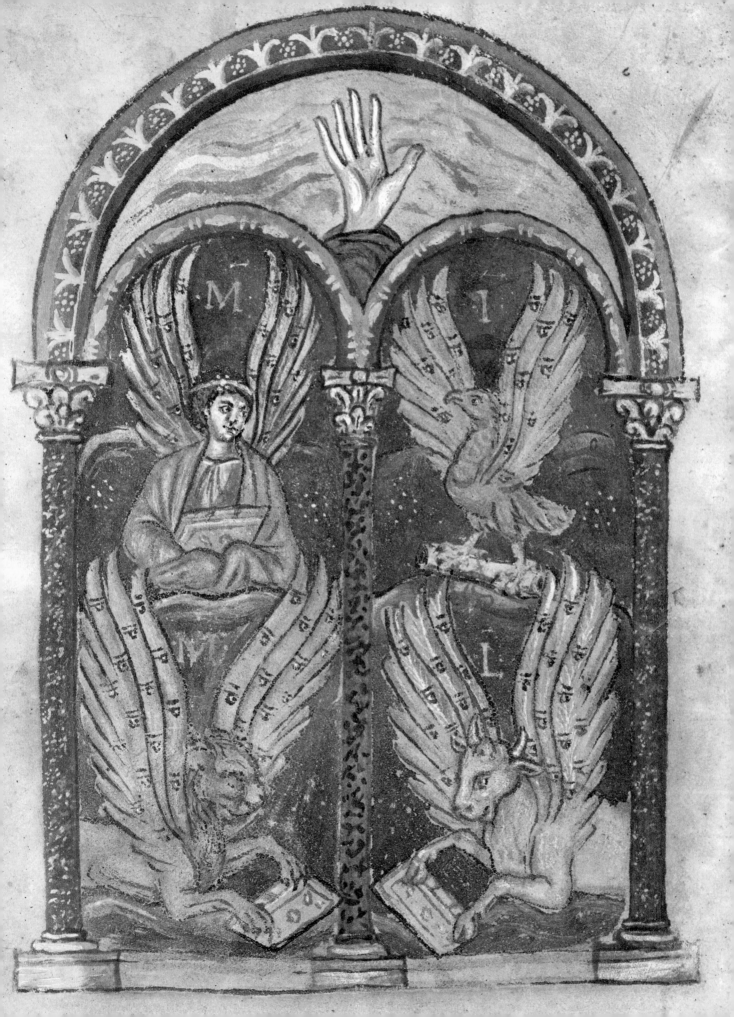

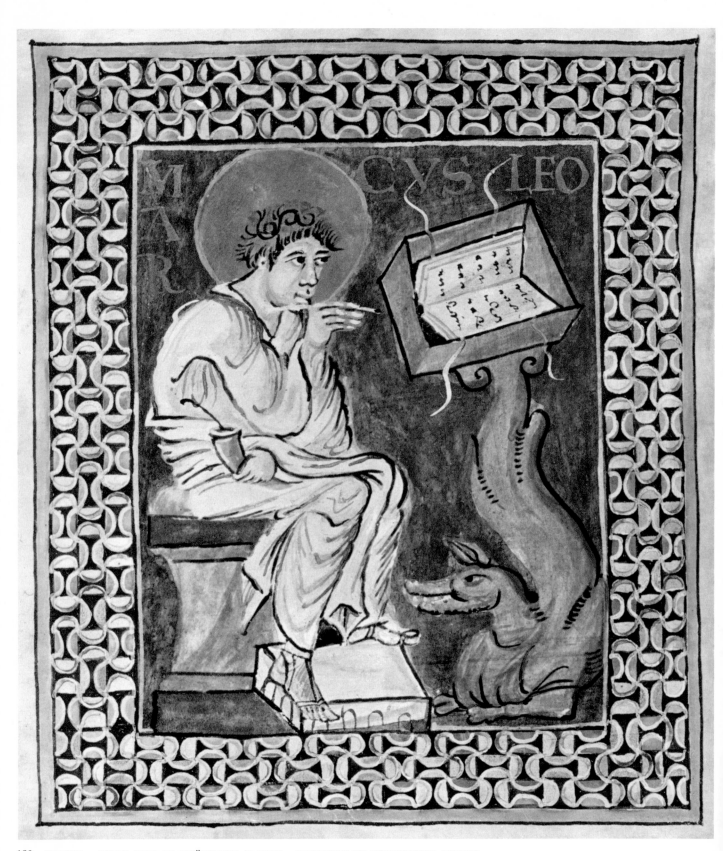

180 – FREISING. GOSPEL BOOK OF SCHÄFTLARN: ST MARK. BAYERISCHE STAATSBIBLIOTHEK, MUNICH.

181 – WELTENBURG. GOSPEL BOOK OF WELTENBURG: ST MATTHEW. NATIONALBIBLIOTHEK, VIENNA.

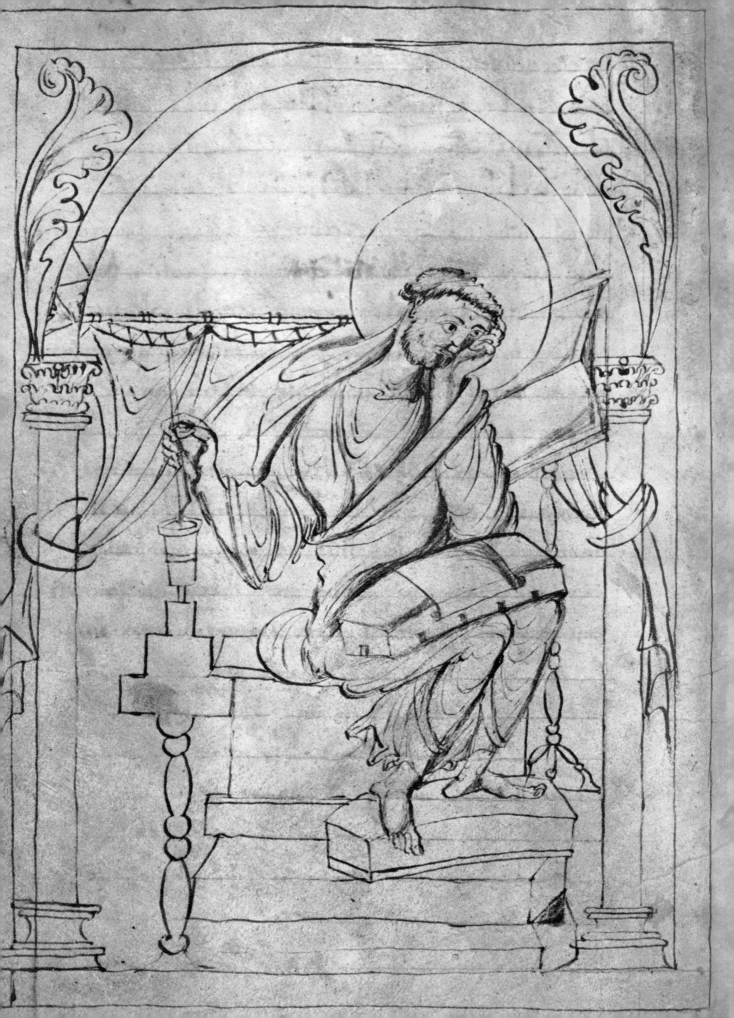

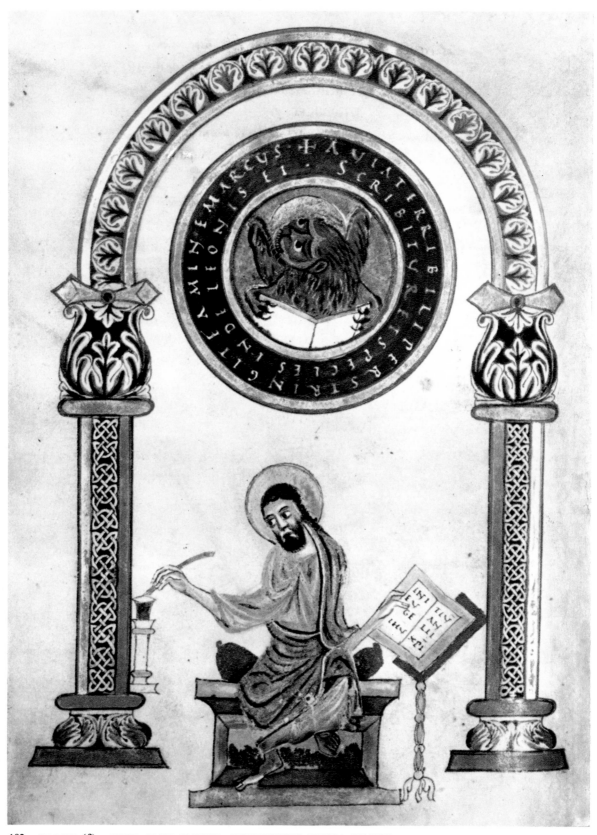

182 – COLOGNE (?). GOSPEL BOOK: ST MARK. KUNSTGEWERBE MUSEUM, COLOGNE.

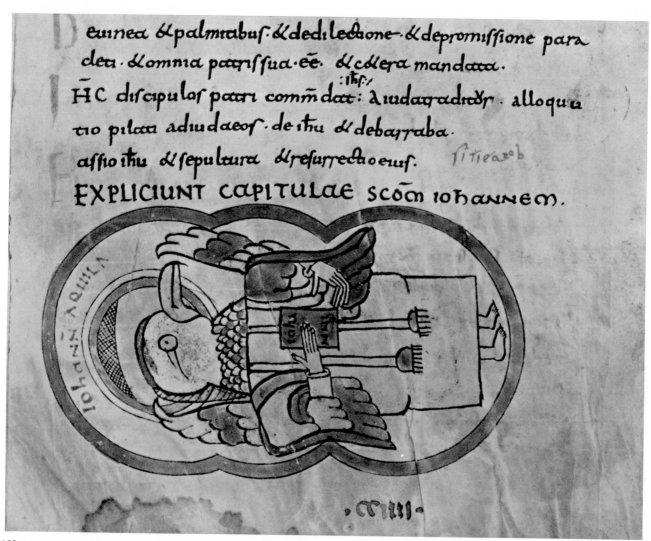

183 – BRITTANY. GOSPEL BOOK: ANIMAL-HEADED SYMBOL OF ST JOHN. BIBLIOTHÈQUE MUNICIPALE, TROYES.

It is in Brittany that we find the monstrous offshoot. At Landévennec in partic-
ular and at other undetermined places, Gospel Books were illustrated (they are so
uncouth, one hesitates to say decorated) with animal-headed evangelist portraits;
that is, the head of each evangelist is replaced by that of the animal symbolizing
him. These outlandish figures stamp the sacred text with a half-pagan character;
here we leave the realm of art for that of magic. Gradually losing their barbarian
overtones, such figures spread throughout the West down to the fifteenth century,
extending to northern Germany and Scandinavia. They first appeared, as far as
we know, in England and Spain in the seventh century. This is not the only coinci-
dence between the art of two countries both indebted to Middle Eastern and Coptic
art, for these animal saints came from Egypt (as Émile Mâle pointed out long ago),
and from Egypt too came some of the ornamental motifs of insular art which have
been dealt with in the preceding pages.

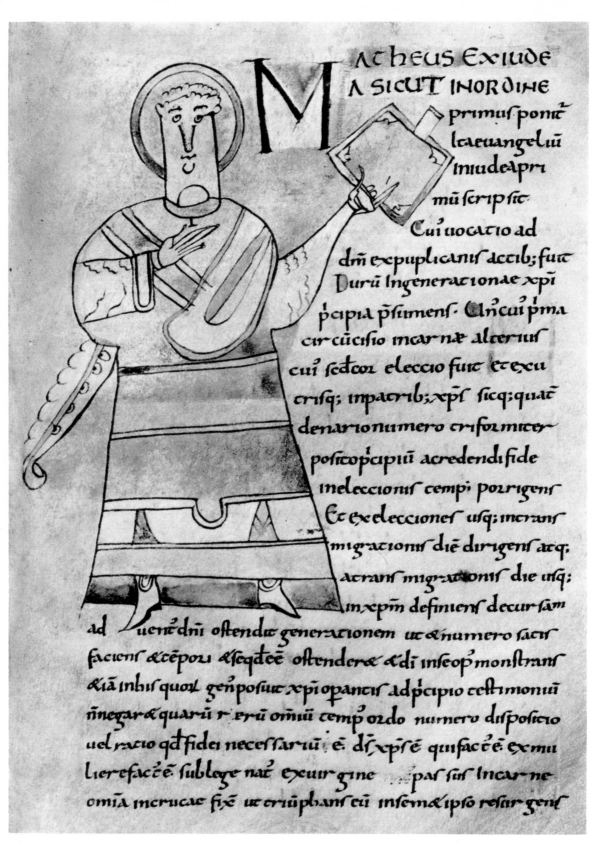

184 – BRITTANY. GOSPEL BOOK: ANIMAL-HEADED SYMBOL OF ST MATTHEW. BIBLIOTHÈQUE MUNICIPALE, BOULOGNE.

185 – BRITTANY. GOSPEL BOOK: ANIMAL-HEADED SYMBOL OF ST MARK. BIBLIOTHÈQUE MUNICIPALE, BOULOGNE.

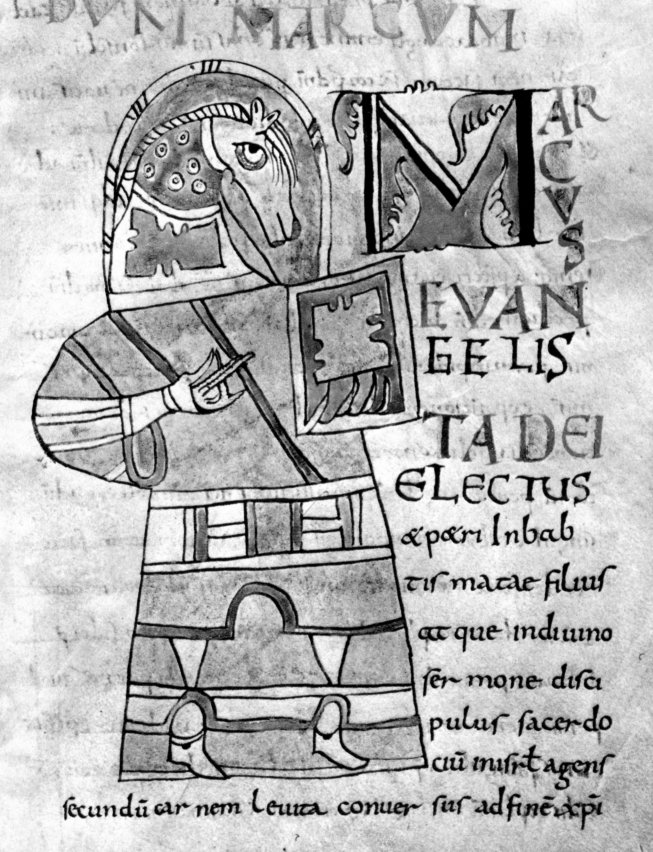

MAR
CVS
EVAN
GELIS
TA DEI
ELECTVS
& p&ri Inbab
tir matae filiur
atque induino
fer mone difci
pulur facerdo
cíu mifrt agenf

secundū car nem leuita conuer sif ad fine xpi

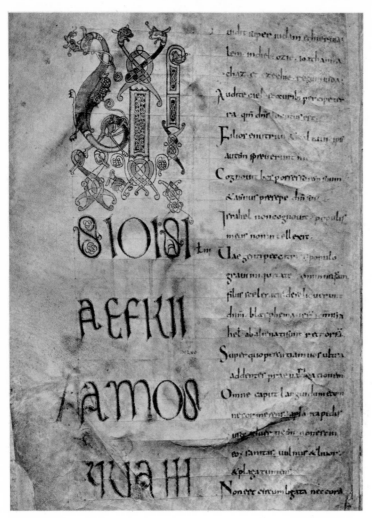

186 – FLEURY. BOOK OF THE PROPHETS. BIBL. MUNICIPALE, ORLÉANS.

The other insular offshoot is to be found at Fleury (i.e., Saint-Benoît-sur-Loire), where the classicism of Theodulf had no effect on book painting and where there seems to have been no consistent line of development, for we find the greatest variety of styles. Until about 830 the Fleury painters, like those of St Gall, kept to Merovingian decorative themes. Acrobats and wrestlers adorn certain lettrines—antique reminiscences due perhaps to the proximity of Tours—and the bold, graceful initials of these early ninth-century Gospel Books and biblical texts are indistinguishable from the models devised at York and Canterbury. Fleury, where this survey of provincial Carolingian painting comes to an end, already heralds the diversity of Romanesque book painting: here, currents flowing from remote antique and barbarian sources, held in check elsewhere by dictatorial patrons, ran freely, just as they were to do in the late tenth century and afterwards, before submitting to the discipline which shaped the Gothic masterpieces. Meanwhile the art of the Carolingian rulers was continued in Germany and England in the marvels produced by the Ottonian and the Winchester illuminators.

JEAN PORCHER

187 – IRELAND. GOSPEL BOOK OF MACDURNAN: THE FOUR EVANGELIST SYMBOLS. LAMBETH PALACE LIBRARY, LONDON.

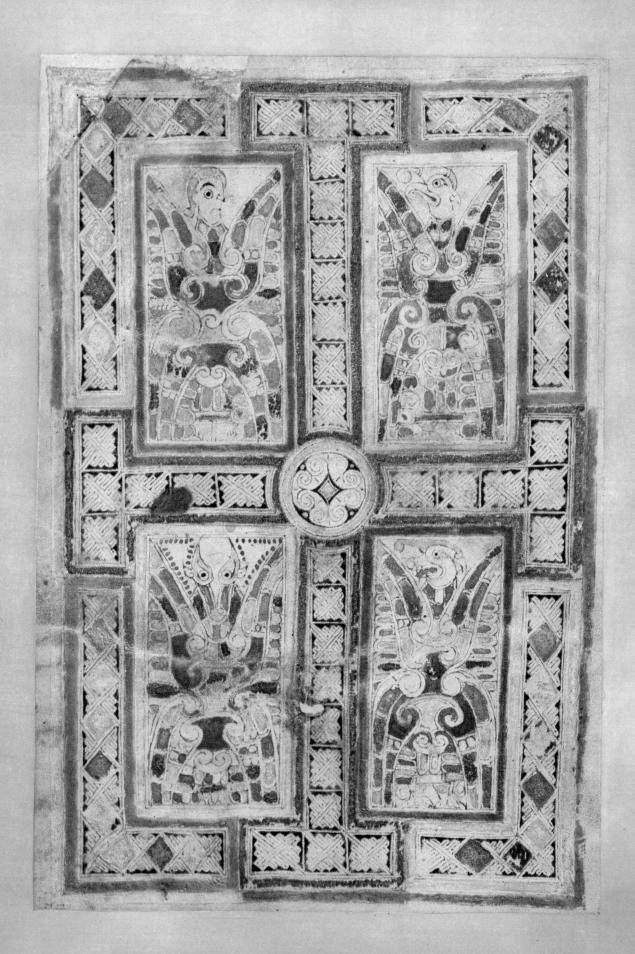

PART THREE

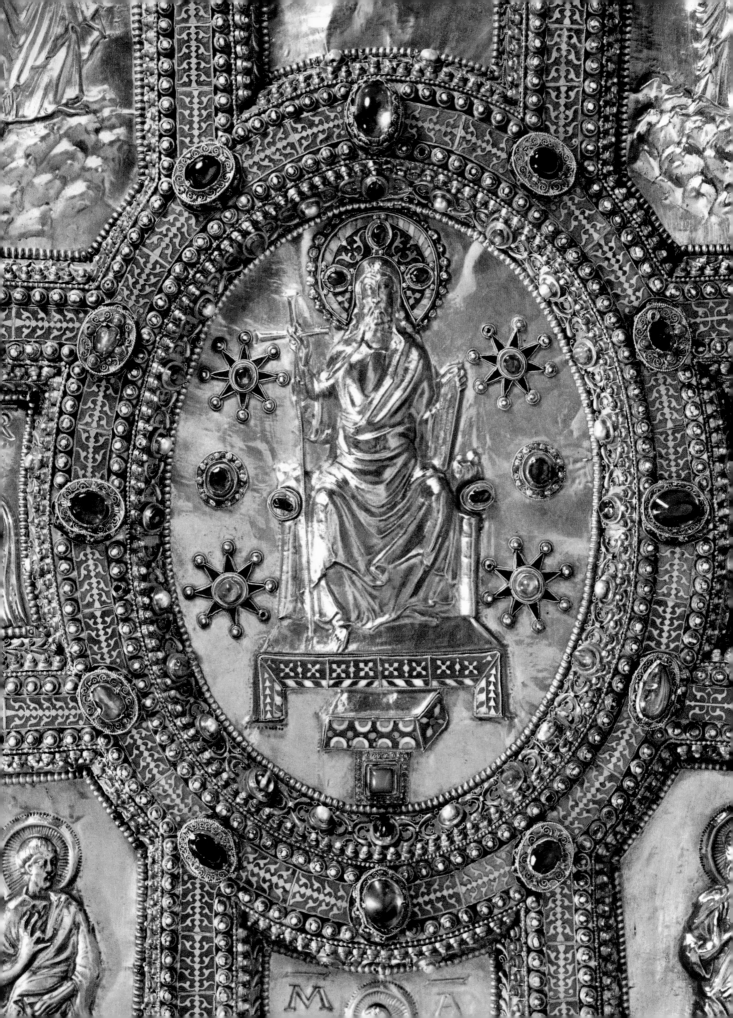

Sculpture and Applied Art

The Heritage of Antiquity *To my wife*

WHEN the migration of peoples had come to an end and the Carolingian kings had established a new political and social order, artistic activities found new impulses in new directions. These innovations can be most clearly seen in the countries north of the Alps. At the emperor's court and in the wealthy monasteries that flourished under imperial patronage, the centralized power in the hands of the new masters, headed by Charlemagne, gave rise to artistic centres of the first importance. Bearing as it did the imprint of a single sovereign, art assumed an appearance of unity. On the other hand, the artistic production of the provincial monasteries decreased in importance. Furthermore, we know all too little about the secular art because of the very few objects that have come down to us. This is due to the gradual abandonment of the custom of placing objects in tombs as Christianity became more widespread.

Consequently, in the field of sculpture and applied art, our knowledge is limited to the great ecclesiastical art preserved in church treasuries. But even that is only a minute fraction of the wealth of the period, of whose existence we have documentary evidence. Virtually all cathedral churches and important abbeys contained immense treasures donated by sovereigns and dignitaries. Suffice it to recall the works that were formerly preserved at Saint-Denis, Reims, Metz, Saint-Riquier, Luxeuil and Auxerre. Charlemagne's victorious campaigns against the Avars and other foes brought the kingdom of the Franks a vast quantity of vessels of precious metals, which the emperor later donated to the pope and to various churches and monasteries. In addition, as a result of the sovereign's friendly relations with the Islamic world and the Byzantine Empire, the Carolingian court and the imperial abbeys obtained possession of a great many works of art; some of them arrived by sea, others via the 'Baltic bridge' in the north. These foreign products—rock crystal, glassware and textiles—newly influenced the output of the Frankish workshops.

At first glance, antiquity seems to have been the predominant influence in Carolingian art, due to Charlemagne's political ideas. Although his first reaction to the

188 – MILAN. SANT'AMBROGIO. ALTAR, DETAIL OF THE FRONT: MAJESTAS DOMINI.

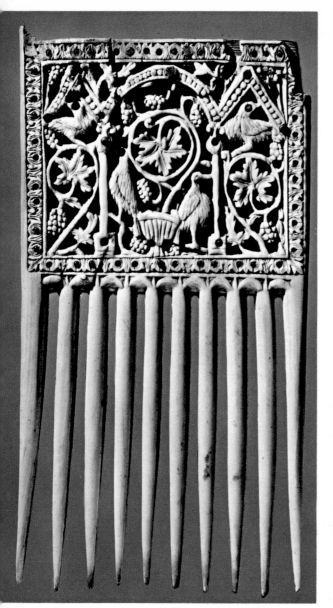

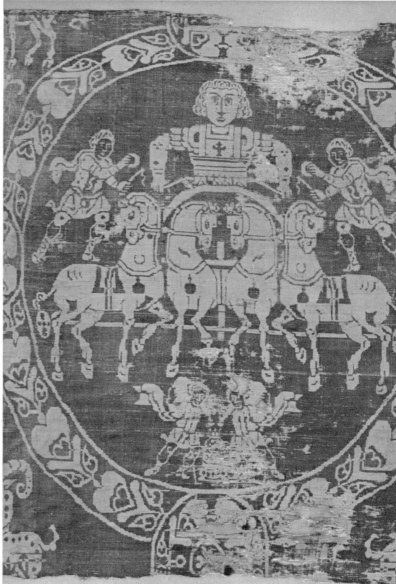

189 – COMB OF ST GAUZELIN. CATHEDRAL TREASURY, NANCY. 190 – FRAGMENT OF CLOTH WITH A QUADRIGA. CATHEDRAL TREASURY, AACHEN.

ancient tradition had been one of rebuttal, after he was crowned in Rome on Christmas Day, 800, his consciousness of the dignity of a Roman emperor led him to adopt the imperial principle of the *civitas Dei* in order to exploit the heritage of ancient Rome as a solid foundation for his new power. It is mainly works of his Palace School that have been preserved in the church treasuries, chiefly because of their historical importance. As a result, our view of the general artistic ideas of the period is somewhat distorted. Objects produced in the provincial workshops were more liable to destruction. Those still extant show hardly any antique influence and prove that the Merovingian stylistic tradition was far from dead.

Moreover, in those works the influence of insular art is clear to see. It appears chiefly in art of the territories that received Irish, Scottish and Anglo-Saxon missions;

for instance, the regions that border on the Rhine as far south as St Gall and the Germanic lands down to Salzburg. In the same way, the secular products of the popular workshops—swords, spurs, belt buckles and brooches—derive rather from the Germanic or Nordic tradition. Many a precious object pillaged by the Northmen is still preserved in the Scandinavian countries, as for instance the gold buckle of Hon in Norway. Also worthy of mention in this context are the brooches from the treasure of Muizen, in Belgium, which contained coins dated between 866 and 884.

The objects that have come down to us or are described in manuscripts of that day differ totally in shape and kind from those of the Merovingian period. The development of the liturgy and still more the love of pomp that characterized the wealthy founders of the new abbeys helped lead to the production of a great many objects whose ornamentation became increasingly luxurious. Chalices became larger and more sumptuous; the covers of ecclesiastical manuscripts came to be lavishly adorned with ivory, gold and precious stones. Ivory chairs of state disappeared, but in their place we find others made of metal copied from antique models, like the 'Throne of Dagobert,' richly decorated altar frontals like the *paliotto* in Saint' Ambrogio, Milan, metal vessels for holy water, and the precious sculptured ornamentation of tombs, choir railings and *ciboria*. Frequent mention is made of extremely rich altar crosses, of which many remarkable specimens have survived, such as the Rupert Cross at Bischofshofen, which might easily be taken for an Anglo-Saxon work, or the so-called Cross of the Ardennes in Nuremberg. There is a great deal of documentary evidence for the existence of precious silks. They were nearly all imported from the Orient and very few have survived.

Bur our attention is caught first and foremost by the very numerous reliquaries. The steadily growing devotion to relics was accompanied by a greater richness of ornamentation in metal, ivory and enamel. Such ancient techniques as filigree work and the use of gems for ornamentation were still largely employed after being brought to a higher degree of execution. Decoration with coloured enamels had only just been introduced and from the end of the eighth century the enameller's skill was called upon to embellish articles for religious worship and crowns for secular use. On the other hand, silver plating and inlay work lost popularity.

Sculpture in the round was still a rarity. We know that Charlemagne had the large equestrian statue of Theodoric transported from Ravenna to Aachen. And the equestrian statuette of an emperor, now in the Louvre, is an example of a copy from an ancient work. Otherwise we have very little information concerning sculpture in the round. It was only towards the end of the tenth century that works of any size appeared, mostly for use as reliquaries.

When we observe certain seventh-century works of art, we realize that the monuments dating from the early days of the Carolingian period at the end of the eighth century mark a further development of the artistic genius of the Merovingian age. Although we do not possess the link in the chain that connects the two periods, objects still extant like the Tassilo chalice at Kremsmünster, the Enger reliquary in Berlin, and the first cover of the Lindau Gospels, in New York, enable us to verify the survival of pre-Carolingian decorative art. One of its major characteristics is so

direct a derivation from the animal style of the British Isles that we are justified in speaking of an Irish-Anglo-Saxon artistic province on Germanic soil. The Tassilo chalice is a typical example of this trend. Its ornamentation is so closely akin to that of Anglo-Saxon models that scholars such as Johannes Brönstedt and others attributed it to the Northumbrian school. But its dedication by Duke Tassilo of Bavaria (748–788) and his wife Liutpirc dates it with certainty, and it was in all probability executed on the occasion of the foundation of the monastery of Krems-münster (c. 770), to which it was donated. Stylistic and historical considerations seem to indicate that it was manufactured at Salzburg, where the bishop, an Irishman called Virgil, cultivated the traditional art of his nation. The five oral divisions of the bowl, in which Christ and the four evangelists are portrayed in simple line drawings in niello work, recall the style of the Anglo-Saxon manuscripts such as the Gospel Book of Cutbercht, in Vienna, or of those produced in the Salzburg workshops under the influence of scribes from northern England. The plant and animal tracery in the angular fields between the medallions, around the upper edge, and on the foot also prove that the chalice is closely related to the art of the English miniaturists of the late eighth century. A superficial glance would seem to show that

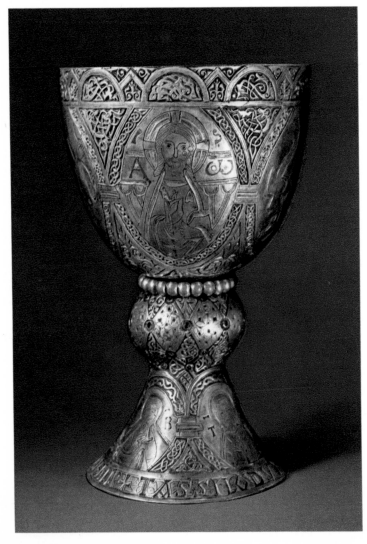

◀ 191 – CHALICE OF TASSILO. ABBEY TREASURY, KREMSMÜNSTER.

192 – FIRST COVER OF THE LINDAU GOSPELS. NEW YORK. ▶

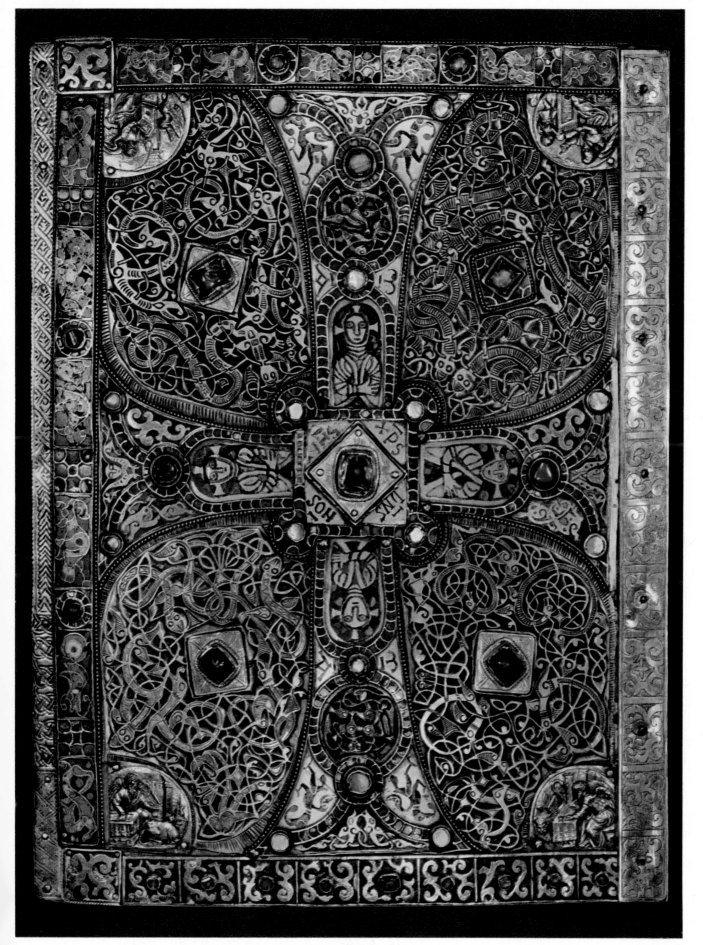

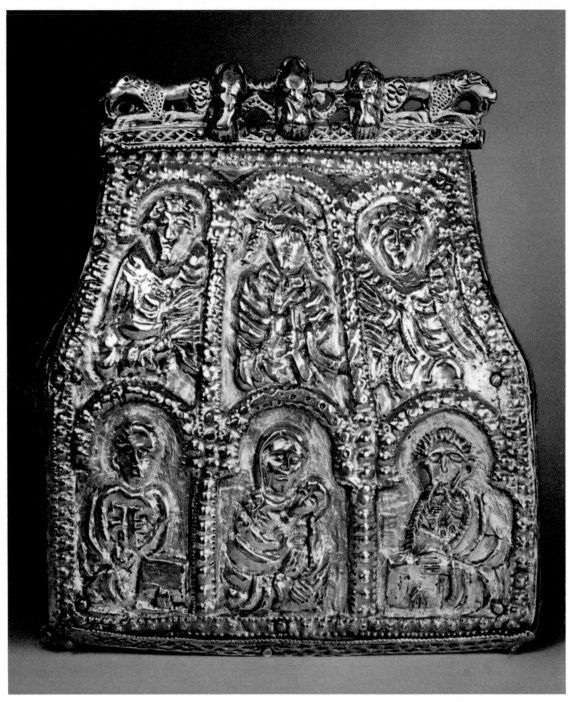

193 – ENGER RELIQUARY: CHRIST BETWEEN TWO ANGELS AND VIRGIN BETWEEN TWO APOSTLES. BERLIN.

the animal ornamentation is similar to what we know of seventh-century Merovingian art. However, more detailed examination of the chalice reveals that the animals are portrayed in their entirety in perfect accord with the most recent developments of Nordic art. More or less at this same time we find the same style of animal representation on a pouch-shaped reliquary at Chur, in which the resemblance to the insular models is extremely striking.

212

Perhaps the most remarkable example of this animal ornamentation at the very dawn of the Carolingian period is offered by the first cover of the Lindau Gospels now in the Pierpont Morgan Library, New York. The volume, from the aristocratic nunnery of Lindau, was probably executed in southern Germany in about 800 or slightly later. On it we can see a cross with curved arms surrounded by a narrow border embellished with animals in cloisonné enamel and set with garnets and incrustations of champlevé enamel. The spandrels are filled with splendid animal tracery. Book covers of the same type are found on Irish manuscripts, and the animal designs so closely resemble those occurring in Anglo-Saxon ornamentation that a great many scholars have agreed in viewing this work as imported from the British Isles. However, certain continental motifs and the resemblance to the Theodelinde book cover at Monza (c. 603) prove that its origin must be sought in southern Germany, perhaps in the St. Gall district. For instance, the four bust images of Christ in champlevé enamel on the arms of the cross recall the silver-plated busts on some belts from the Bavarian territory, and the animal ornamentation in the spandrels and at the tips of the vertical branches of the cross call to mind certain silver-plated buckles from Burgundy. On the other hand, the animals in cloisonné enamel on the border of the cover are still technically very close to the earliest known Italo-Byzantine enamel round the edge of the Castellani fibula in the British Museum and on armlets in the archaeological museum at Salonica. The linear arrangement of cloisonné-mounted garnets also links this work with many objects of the late Merovingian period, such as the round fibula of Wittislingen and the abbot's crosier of Delémont. Owing to its close stylistic affinity with the Tassilo chalice on the one hand and with various early Carolingian objects on the other, such as the Rastede (Oldenburg) earrings, the Lindau book cover may be dated to about the year 800.

The closest parallel to the first Lindau book cover is provided by the Enger reliquary in Berlin. Several scholars view this work as a christening gift presented to Duke Widukind of Saxony by his godfather Charlemagne in about 785. The decoration is symbolical: on the front a faceted cross is formed by the precious and semiprecious stones, while the angles are filled with shapes of cloisonné animals which, though somewhat more primitive in design, recall those that embellish the Lindau book cover. This work too demonstrates the continuity of Merovingian art, which we can see in the decoration in precious stones like that of the reliquary of Teuderigus at Saint-Maurice d'Agaune. It is uncouth compared with the Carolingian pouch-shaped reliquaries of a later date, such as the pouch of St Stephen in the Imperial Jewel Collection in Vienna or the simply designed piece in the Monza Treasury, whose surface is covered with precious stones arranged symmetrically to reveal clearly the form of a cross. The extremely stylized animals on the clasp of the Enger reliquary may be considered as almost the first stage in the development of the similar motif at Monza. The stiff, stylized forms of the reliefs on the back of the reliquary—representing Christ between two angels and the Virgin between two apostles under semicircular arches—recall those of insular examples and are closely linked with the miniatures of the same period. What a long way we have travelled from the original types of the first centuries of Christian art!

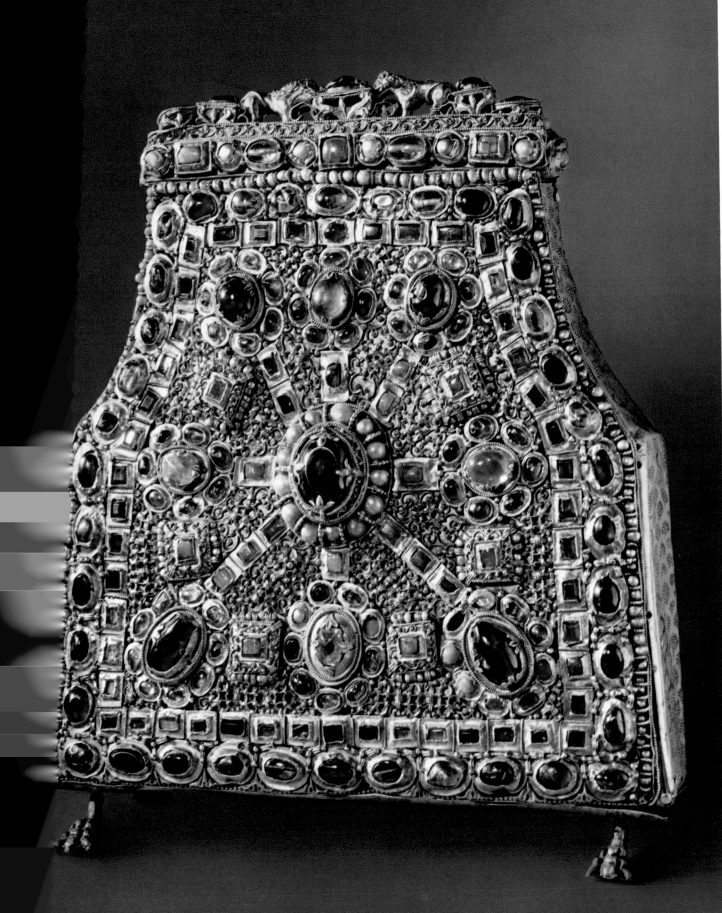

195 – CROSS. BAYERISCHE NATIONALMUSEUM, MUNICH.

196 – CROSS OF THE ANGELS. CÁMARA SANTA, OVIEDO CATHEDRAL.

Spain

The same type of primitive cloisonné enamelwork with plant and animal motifs reappears in a curious form in some goldsmiths' work in Spain. In particular, the animals—adorned with garnets and enamel—on the lid of an agate casket donated by Fruela II in 910 and now in the Cámara Santa at Oviedo, are very similar in style to the Lindau book cover and the small cross in the Bavarian National Museum in Munich. For this reason we are led to presume that the casket lid is older and was perhaps executed by an itinerant artist. There is also an astonishing resemblance between these works and the enamels on the Santiago cross (874), now lost and the Victory cross at Oviedo (908), both of which were donated by Alfonso III. The latter have such a strikingly primitive quality that they were thought to have been taken from still earlier objects. The close kinship of these Asturian works with others made in Italy can be clearly seen in the Cross of the Angels at Oviedo, a beautifully executed object donated by Alfonso II in 808. At first sight its shape recalls earlier northern Italian crosses, such as the Cross of Desiderius (756–774) at Brescia and that of Berengarius at Monza. The extremely delicate filigree work

194 – RELIQUARY. CATHEDRAL TREASURY, MONZA.

that entirely covers the front is very much like that on certain round fibulas of Lombard origin.

So we can see that the continuous evolution undergone by art during the seventh and early eighth centuries, and prolonged well into the ninth, spread to Spain as well. What still remains to be discovered is if direct Byzantine influences made themselves felt there or if, in this case too, Italy played the part of intermediary. It would seem, however, that during the ninth century the influence of Carolingian art reached Spain from France. This can be inferred from the filigree work on the Victory cross at Oviedo in which one notices the very close affinity with the ornamentation on the cover of the Psalter of Charles the Bald in the Bibliothèque Nationale, Paris. In 906 Alfonso III also commissioned an imperial crown at Tours.

197 – RELIQUARY OF BISHOP ALTHEUS. CATHEDRAL TREASURY, SION.

Italy

How far North Italian influence made itself felt can be seen in the reliquary at Sion donated by Bishop Altheus (780–799) in honour of the Virgin Mary. It is true that the animal ornamentation alongside the inscription and name of the donor at the bottom is typically Germanic. But the embossed figures of the Virgin and St John, as well as the plant motifs and even more the two plaques in cloisonné enamel portraying the four evangelists and a third no doubt representing the Virgin framed by a helianthus, reveal a strong affinity with the art of northern Italy. The cloisonné enamels also give a clear impression of being improvements on such primitive objects as the Castellani fibula in London or the Senise earrings in Naples. To realize how close the link is between these works, which were undoubtedly executed in Italy, and those of the Orient, we have merely to compare them with the enamels preserved in the Fieschi-Morgan collection in New York. From a stylistic point of view, their relationship with the enamels of the Milan altar *(paliotto)* is far slighter, if one refuses to accept as such the blue ground that is elsewhere so typical of Milan.

The candelabra with plant motifs on the gold and enamel ewer at Saint-Maurice d'Agaune and the iron faldstool with niello inlays at Pavia are close to Italo-Byzantine art. The same style of severely linear folds appears in northern Italy in a ninth-century reliquary at Cividale adorned with saints under arcades. Once again, the shape of the reliquary is of Merovingian type and the barbarized cameos which date probably from the seventh century, were copied from antique models. Similar gems occur on the reliquary of Teuderigus at Saint-Maurice d'Agaune, the Gospel Book of Lebuinus at Utrecht, and the Cross of Desiderius at Brescia or in the Dumbarton Oaks Collection in Washington. Another closely related piece is the cameo in the Virgin's Crown in the treasury of Essen Cathedral.

Relief work in silver continued to be practiced in northern Italy for a very long time, as we can see from the plaque representing St Leopardus, preserved in the church of Osimo. In Rome, relief was treated in a still more severely linear manner, as for example in the two silver reliquaries from the treasury of the Sancta Sanctorum in the Vatican, which were executed from a gemmed and an enamelled cross (the former of which has been lost) during the reign of Pope Pascal I (817–824). In each the silversmith's work is so similar in style (only the lid of the gemmed cross is reproduced here) that one is justified in attributing them both to the same Roman workshop. Like the mosaics of the same period, they offer a remarkable example of the conservative character of the Roman style, which differed so greatly from that of Milan. However, the two scenes of Christ's childhood on the enamelled cross (on whose sides we can decipher the name of Pope Pascal who commissioned it), stylistically totally different from those on the silver casket, are more lifelike and animated. The freshness of this narrative is undoubtedly due to the fact that the enameller, far more than the silversmith, sought his inspiration in the Eastern Church and may perhaps have found it in earlier Syro-Palestinian models. But the strong colours of the enamels, especially a certain translucid green, distinguish this cross from ancient Eastern works, such as those we can see in the Fieschi-Morgan

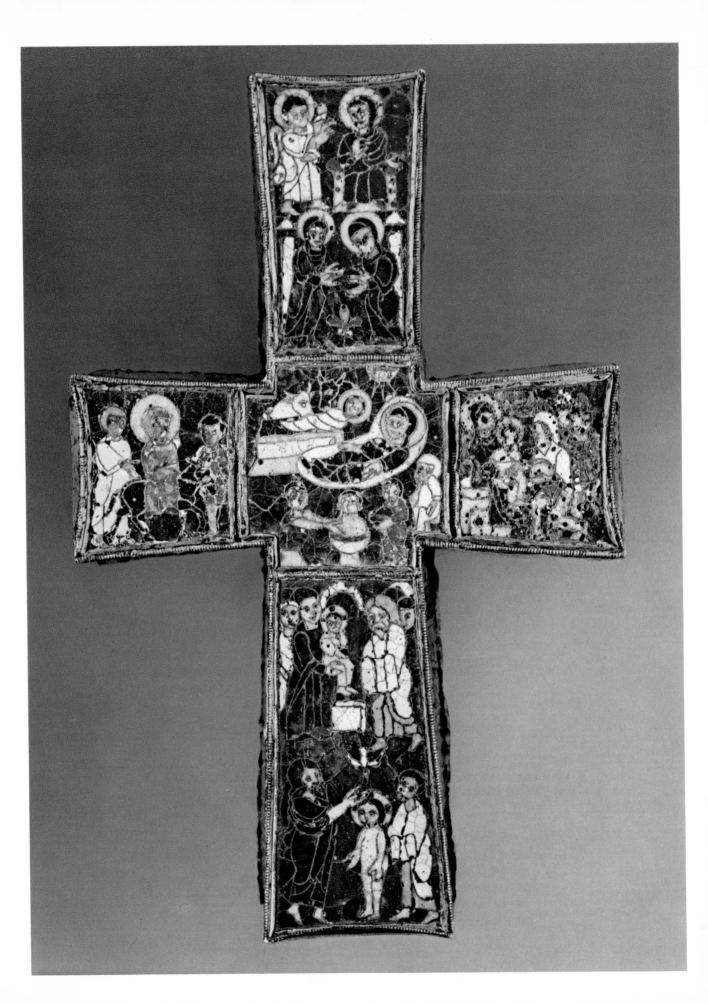

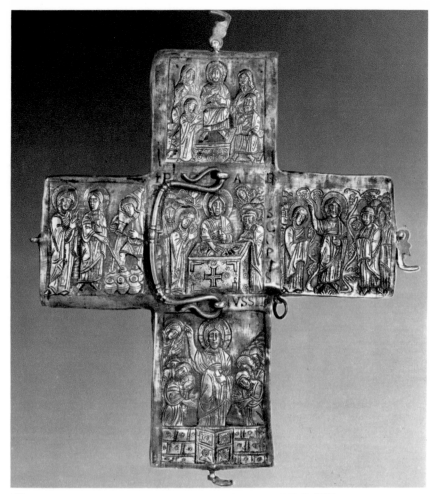

199 – LID OF A RELIQUARY: CHRISTOLOGICAL SCENES. VATICAN CITY.

collection, as well as from the reliquary of Bishop Altheus and other Western works of the same type. The enamelwork differs so greatly from others in Italy that one might be justified in attributing it to an Eastern artist.

Compared with the art of northern Italy, that of central Italy in general and Rome in particular occupied a position of secondary importance during the entire ninth century. Proof of this is provided by the ivory diptych from Rambona, in the Vatican, representing the Crucifixion and the Virgin in Glory (c. 900) or by the figure of an enthroned evangelist at Trento (formerly in Vienna). Ornamental sculpture in stone remained true to the conventions it had evolved in the eighth century. The type of ornament most in favour during the ninth continued to be interlaced ribbons and extremely stylized animals in the oriental style. Rome offers more facilities than anywhere else for studying that art from the reign of Pope Adrian I (772–795) to that of Stephen V (885–891). Still, a great many orna-mental works of this kind can be found throughout both northern and central Italy, among them some reliably dated crosses in Bologna. The extremely interesting cross engraved on both front and back with interlaced ribbons and stunted tendrils at Budrio, near Bologna, which bears the inscription of Bishop Vitalis

◀ 198 – RELIQUARY CROSS OF POPE PASCAL I: SCENES OF THE LIFE OF THE VIRGIN. BIBLIOTECA APOSTOLICA, VATICAN CITY. MUSEO SACRO.

219

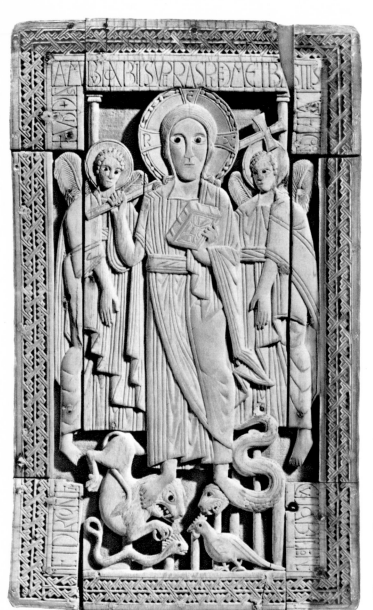
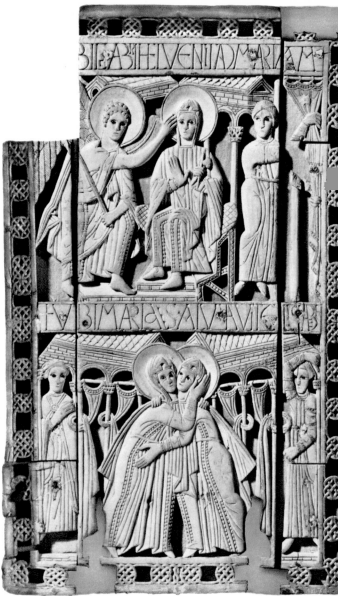

200–201 – GENOELSELDEREN DIPTYCH: CHRIST TRIUMPHANT – ANNUNCIATION AND VISITATION. MUSÉES ROYAUX D'ART ET D'HISTOIRE, BRUSSELS.

(789–814), belongs to this group. It dates from the beginning of the ninth century.

Alongside this group, which perpetuated the Merovingian tradition during the first years of the Carolingian era and consists of works that make an almost anti-classical impression, there are objects executed as early as the end of the eighth century that reveal a perfect knowledge of ancient art and intentionally return to late antique and early Christian models. One of these is the ivory diptych from Genoelselderen, in Brussels, representing Christ crushing underfoot the dragon and the basilisk. Stylistically, the design of the ornamental borders and the linear treatment of the drapery are directly derived from insular art. Judging from the inscrip-

202 – IVORY DIPTYCH: CHRISTOLOGICAL SCENES. CATHEDRAL TREASURY, MILAN.

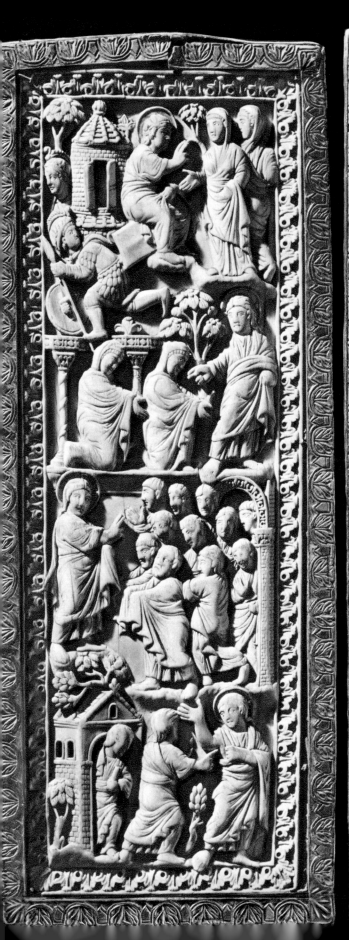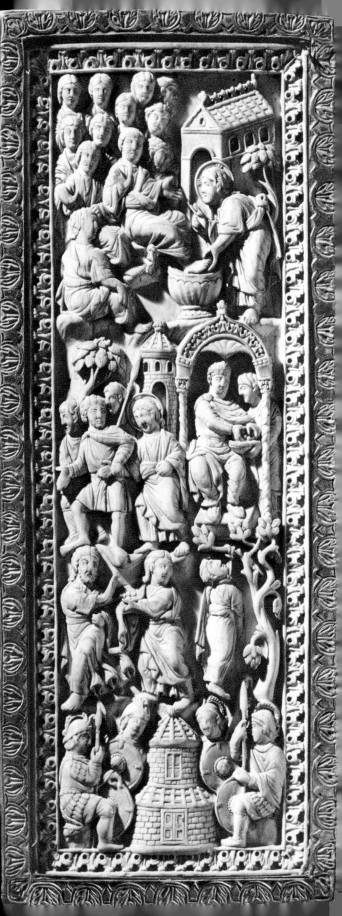

tion alone, we might be tempted to say the diptych came from England. But we can also clearly see a link with the Trier Apocalypse (see p. 181) and therefore with northern France. For all their stylistic and iconographic peculiarities, which might lead us to attribute them to an earlier period, two ivory pyxes adorned with Christological scenes, one in Vienna and one in London, must be viewed as copies executed during the Carolingian era, in the late eighth or early ninth century.

At that time enthusiasm for classical art led artists to copy objects in ivory in so masterly a fashion that it is no easy matter to establish the late date at which they were made. It is not surprising that a great many of these copies were made in Milan, where there were still a quantity of objects that dated back to the earliest Christian times. The best example is a diptych in Milan, with Christological scenes displaying the same arrangement of the figures, treatment of drapery and vigorous handling of bodies as, for instance, in the scenes of the Passion on a small fifth-century casket in the British Museum. And only a certain stiffness in the folds and the schematic treatment of the architecture warrant the conclusion that the Palermo diptych in the Victoria and Albert Museum, London, is a Carolingian copy and not a fifth-century original.

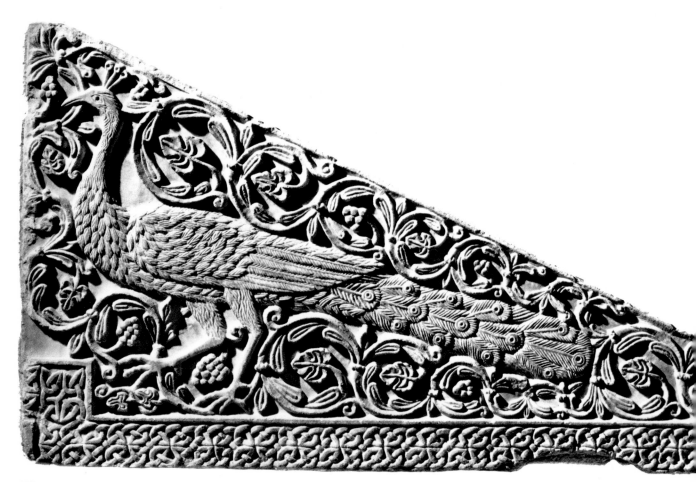

203 – MARBLE FRAGMENT OF AN AMBO WITH A PEACOCK. MUSEO CRISTIANO, BRESCIA.

204–205 – AACHEN, PALATINE CHAPEL. TRIBUNE, BRONZE RAILING – THE WOLF PORTAL, DETAIL: LION'S MUZZLE.

The Palace School of Charlemagne

In northern Europe, too, artists copied works of the late antique period, and the objects produced in metal and carved ivory at Charlemagne's court reveal most clearly the signs of a new creative intention. The works dating from the early years of the Carolingian era bear witness to the classical spirit that was nurtured by the emperor himself and by the men of letters who surrounded him. It is in this context that Charlemagne afforded the most singular proof of his political ambition, namely, the *renovatio* of the Roman Empire. In this effort he consciously opposed Byzantium and the Empire of the East; the fact of such political rivalry tempts one to infer that he also rejected Eastern art. Thus the architecture and decoration of the Palatine Chapel at Aachen were inspired entirely by late antique models of the type found in Rome and especially in Ravenna, and by those that had been removed from Ravenna to Aachen.

It is this antiquarian spirit that pervades the eight bronze railings of the parapet of the tribune (already mentioned by Einhard), in particular those that were executed last. They were long thought to have been taken from the mausoleum of Theodoric in Ravenna. Undoubtedly the pattern is the same as on the stone balustrades of Sant' Apollinare Nuovo in Ravenna, but the relief is flatter and the design differs considerably from the sculptural motifs of antique models. Traces of a foundry have been unearthed at Aachen in the vicinity of Charlemagne's palace, so one may presume that these railings were executed locally. The same may be said of the leaves of the great Wolf Portal and the three smaller side doors. The arrangement of the heavy bronze doors, which were cast in a single piece, is simple and linear, but here too the acanthus-leaf ornament that surrounds the lion's mask has a less vigorous relief than the models from which it was copied.

The so-called statuette of Charlemagne in bronze preserved in the Louvre, an imitation of an ancient classical model, probably represents one of the emperor's successors in triumph wearing the imperial robes and crown; possibly it is the ideal effigy of a Carolingian monarch. In contrast, the origin of the 'Throne of Dagobert' (Cabinet des Médailles in Paris), one of the major symbols of French history, has always been a subject of dispute. Discovered in damaged condition (*'disruptam'*) by Abbot Suger of Saint-Denis, after being restored it was used for the coronation of the kings of France. In shape it resembles the Roman curule chairs we know from the consular diptychs of the Eastern Empire dating from the sixth century. Its lower part alone is antique. Its upper part, notably the arms and back embellished with openwork tracery, dates from Suger's day. The attribution of this work to St Eligius, who lived during the reign of King Dagobert, obviously rests on legend, for at that time there was certainly no possibility of executing such a stylistically and technically outstanding copy of an antique work.

Completely antique in character was the base in gold and silver, now unfortunately lost, that was formerly in the Treasury of St Servatius at Maastricht. Known today only from two seventeenth-century drawings, the 'Einhard reliquary,' as it was called, belonged no doubt to a cruciform reliquary (see p. 35). It is a copy of a Roman triumphal arch with the effigy of a victorious emperor on horseback. The date can be inferred from the inscription, which names Einhard as the donor.

The antiquarian trend of Charlemagne's Palace School is most clearly manifest in the ivories which, though derived from antique models, have an individual quality of their own. The school was patronized by court dignitaries like Alcuin and Einhard, who may well have called in able carvers from Italy. It went into a decline at the emperor's death but its influence remains visible in some later reliefs, such as the Crucifixion at Narbonne and the Christ Enthroned in Berlin. Its products were closely linked with the miniatures in the Trier manuscript that was written about the year 800 for the Abbess Ada, and for that reason Adolf Goldschmidt coined the name 'Ada Group' for the artists who made them. Whether they worked at the Court of Aachen itself or in the rich imperial monasteries at Trier or Lorsch is hard to say. We come across the same problem in connection with the later Carolingian schools, whose production was always conditioned by the will of the reigning monarch. The

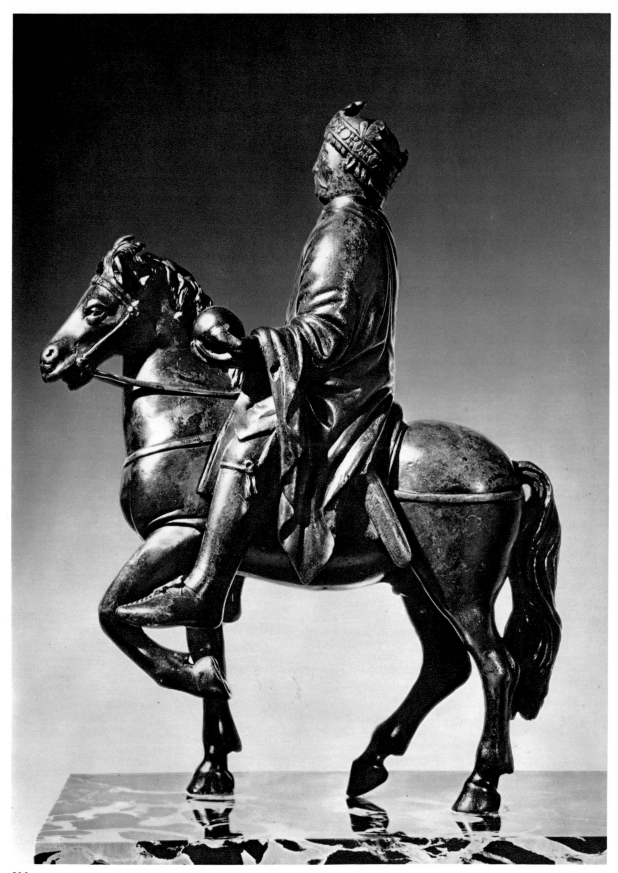

206 – SO-CALLED STATUETTE OF CHARLEMAGNE. LOUVRE, PARIS.

208 – IVORY COVER OF THE DAGULF PSALTER. LOUVRE, PARIS.

◀ 207 – IVORY BOOK COVER: CHRIST TRIUMPHANT AND CHRISTOLOGICAL SCENES. BODLEIAN LIBRARY, OXFORD.

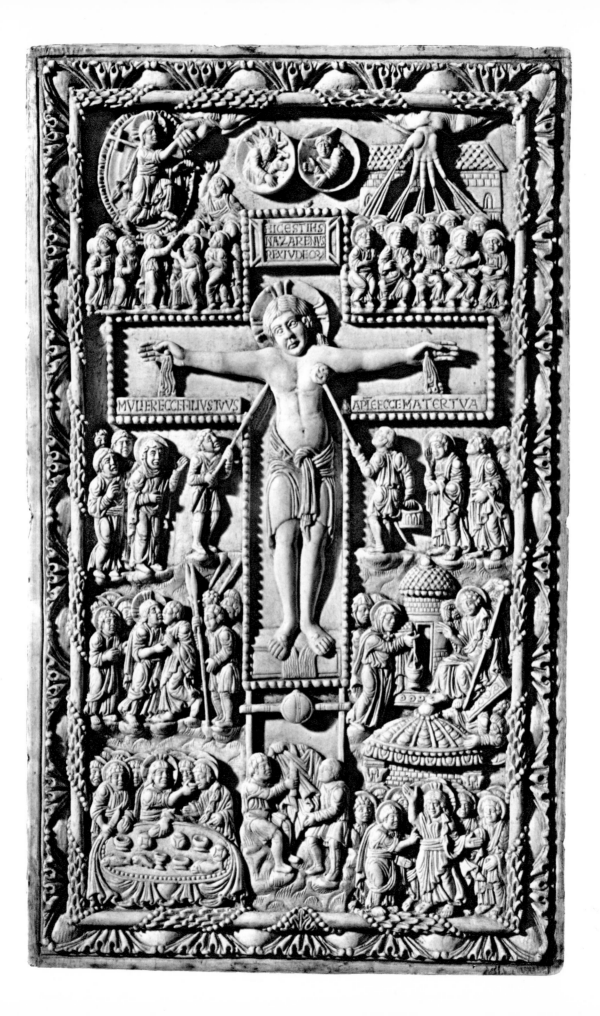

centres of that production changed very often, for each new master gave preference to the school of his own palace or of the monasteries he patronized, whether Metz, Tours, Reims, Corbie or Saint-Denis. Thus we cannot restrict research to the Palace School of Charlemagne at Aachen but must consider other places of origin. The ivory panels used as book covers were also supplied by monastery workshops.

When we examine these works we are amazed to see how close the artists kept to their antique models, although they do not seem to have preferred any particular style. The ivory covers of the Dagulf Psalter in the Louvre, those with the Christological scenes at Oxford and those with the Holy Women at the Tomb in Florence found their inspiration in Western works of the early fifth century. On the other hand, the St Michael at Leipzig and the covers of the Lorsch Gospels derived from oriental models of Justinian's day. We know that French churches once contained a quantity of late antique and early Christian objects that may have served as models for sculptors of a later date. Thanks to a lucky chance we still possess the fragments of a five-part diptych of early Christian workmanship on which the splendid book cover at Oxford was modelled. In the centre is an effigy of Christ in Triumph and round the edge a series of Christological scenes. The figure of Christ crushing 'basilisks and lions' can be seen repeated several times at Ravenna in the guise of Christ Victorious with the cross resting on His shoulder: for instance, in Bishop Neon's Baptistery and on the tympanum of the city gate in a mosaic in Sant' Apollinare Nuovo. The diptych's two early fifth-century side panels are in Paris and Berlin.

Very obvious imitations can be found also in other ivories. One example is the Harrach diptych in the Schnütgen Museum, Cologne, in which the women at the Tomb recall those on the early Christian book cover in the Bavarian National Museum in Munich. And the Nativity on the Oxford book cover calls to mind the representation of the same scene at Nevers. Architectural details were also copied, as in the Harrach diptych, the Dagulf Psalter and the Aachen diptych, for instance from such early works as the five-part diptych in Milan. The arcades resemble those of the Archangel Michael in London and the throne of Maximilan at Ravenna. Another typical and antiquarian feature is the tall format used occasionally by the Palace School. It too occurs in diptychs of the late antique period.

But it is in the Oxford book cover that we can see most clearly how a Carolingian sculptor transformed his model. Though the iconography scrupulously reproduces that of the fifth century, the style reflects the new manner. The difference is most evident in the handling of the volumes: the figures are pressed closer together, their movements are less natural, and the three-dimensional effect has almost disappeared. Moreover, their anatomical structure is not displayed. In accordance with the medieval spirit, the bodies are dissembled by almost manneristic masses of folds.

The same transformation is also manifest in the front and back covers of the Dagulf Psalter, which, commissioned by Charlemagne as a gift to Pope Adrian I (772–795), are the earliest dated ivories of the Ada School. In contrast to their late antique models and like the Oxford work, the Dagulf figures and ornamentation seem stilted and lifeless; again, there is almost no three-dimensional effect. As in the case of other book covers, the subject matter matches the manuscript: David

◀ 209 – IVORY BOOK COVER: CRUCIFIXION AND CHRISTOLOGICAL SCENES. CATHEDRAL TREASURY, NARBONNE.

210 – IVORY COVER OF THE LORSCH GOSPELS. MUSEO SACRO, BIBLIOTECA APOSTOLICA, VATICAN CITY. ▶
211 – IVORY COVER OF THE LORSCH GOSPELS. VICTORIA AND ALBERT MUSEUM, LONDON. ▶

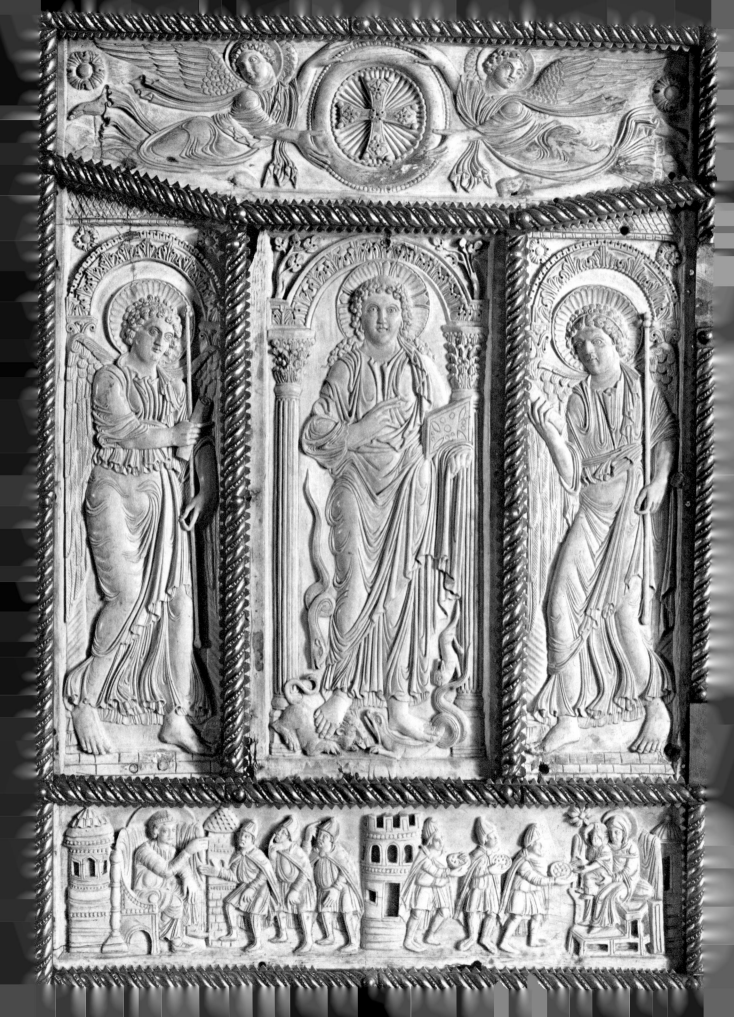

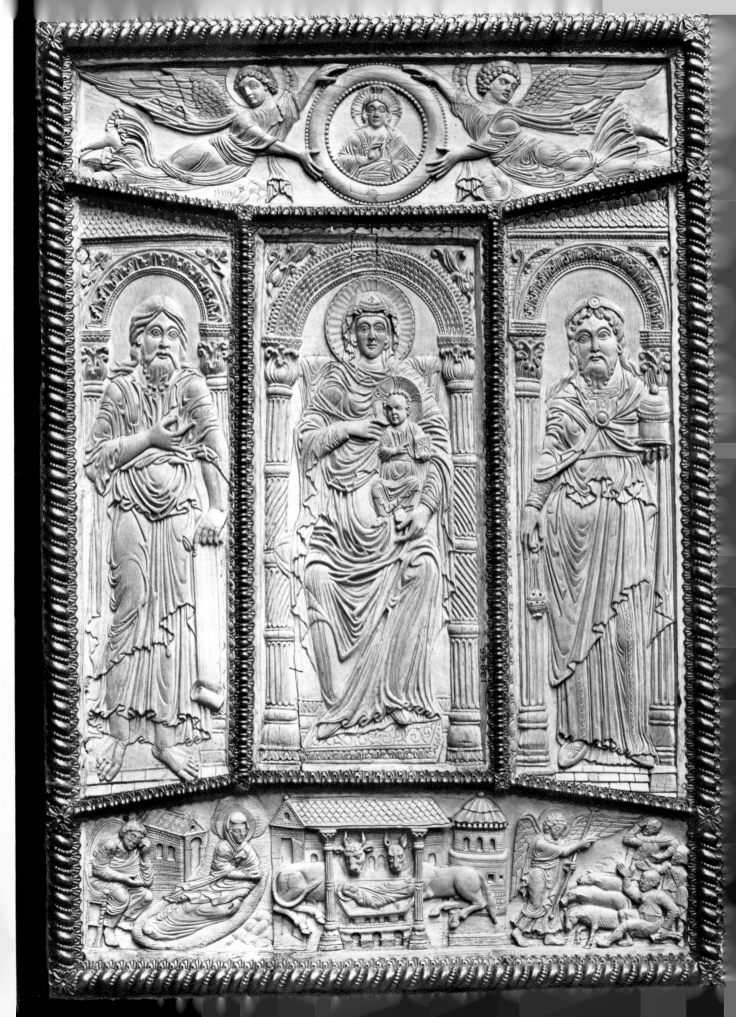

choosing the scribes for his Psalms and playing the harp; the pope dispatching his envoys to St Jerome and Jerome dictating his version of the Psalms. Some reliefs related to the Dagulf covers show more liveliness in the movement of the drapery; for instance, the panel representing the Crucifixion and the Holy Women at the Tomb (the upper part of which, now lost, was formerly in Berlin, while the lower part is preserved in Florence), the Harrach diptych and the Oxford cover. In this respect the Aachen diptych and the Crucifixion at Narbonne are outstanding works. The latter gives the impression of being a late copy, but so far as the iconography is concerned its link with the Palace School is very close.

The Lorsch Gospels covers—the victorious Christ in the Vatican and the Virgin in Triumph in the Victoria and Albert Museum—mark the culminating point of this monumental style and a turning point in the output of the Palace School. They repeat so exactly a sixth-century design that parts of the two panels have been viewed

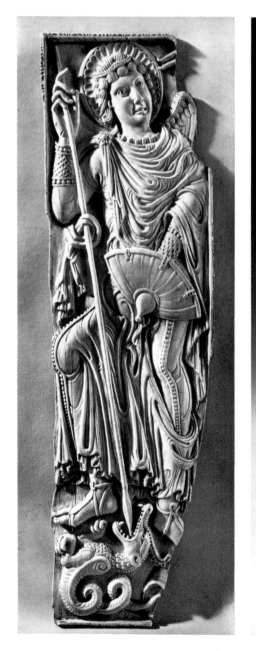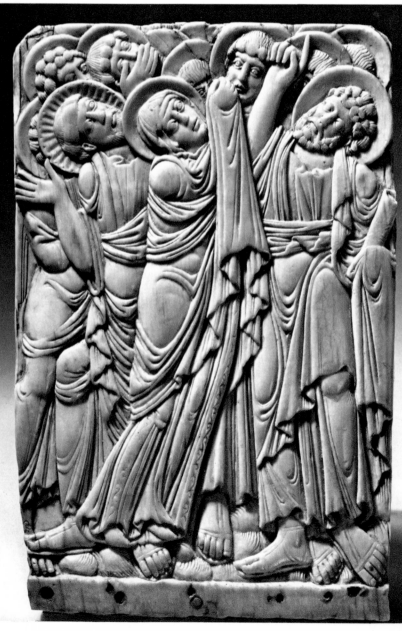

as antique originals. Some scholars went so far as to ascribe them to the Ottonian period. However, just as the miniatures of the relevant manuscript came from the Lorsch scriptorium, so the reliefs too may have been executed at Lorsch. They undoubtedly date from about 810, and their subject matter pinpoints the political tendency of the court to assimilate Imperial Roman iconography. In the late antique Barberini diptych (Paris, Louvre) the emperor had been placed on a par with the heavenly hierarchy; here the Blessed mirror the earthly hierarchy. But while the panel with the figure of Christ closely follows late antique models, that with the Virgin enthroned between Zacharias and John the Baptist reveals the rich drapery of the Palace School and a recasting of the antique forms in the crucible of a new, less rigid style.

In the St Michael ivory at Leipzig the feeling for physical detail has been virtually eliminated. While the fragment of an Ascension at Darmstadt calls to mind, in some particulars, the Lorsch Gospels covers, it is also linked with the diptych of the Crucifixion and the Holy Women at the Tomb in Florence. It is superior in quality to many products of the Palace School. The evolution of the 'Carolingian renaissance' was not brought to an end by the death of Charlemagne in 814: the quest for a balance between the styles of antiquity and those characteristic of the period continued into the second half of the ninth century.

Art after Charlemagne

The great humanists who belonged to the emperor's circle and survived him were no doubt anxious to prolong the antiquarian trend after his death. It was in this spirit that artistic production maintained the same high level of quality during the reigns of Louis the Pious, Louis the German and Lothair I. It seems improbable that an important school continued to function at the imperial court under those three monarchs; but the style of Charlemagne's Palace School spread to the peripheral centres. This is demonstrated by the book cover with Christ in Majesty in Berlin (Goldschmidt, I, no. 23), the ivory with the two sovereigns in triumph at Florence (Goldschmidt, I, no. 10) whom József Deér identified as Charlemagne the conqueror of heretics and barbarians and the St Gregory (?) in the Vienna National Library (Goldschmidt, I, no. 21). But from then on the bishops, whose power had greatly increased and the rich Benedictine abbeys played an increasingly decisive part in artistic production. With the disappearance of a strong central power, the ancient bishoprics and the monasteries began to make it clear that they meant to exercise control in the sphere of art, particularly when they were governed by representatives of the great Frankish nobility.

The first city where the arts experienced a new period of prosperity was Metz, where the powerful Archbishop Drogo (826–855), a half brother of Louis the Pious, was closely connected with the imperial court. A number of important ivory reliefs produced by that school are still extant. Their origin can be established beyond

212 – IVORY WITH ST MICHAEL. MUSEUM FÜR KUNSTHANDWERK, LEIPZIG.

213 – IVORY FRAGMENT OF AN ASCENSION. HESSISCHES LANDESMUSEUM, DARMSTADT.

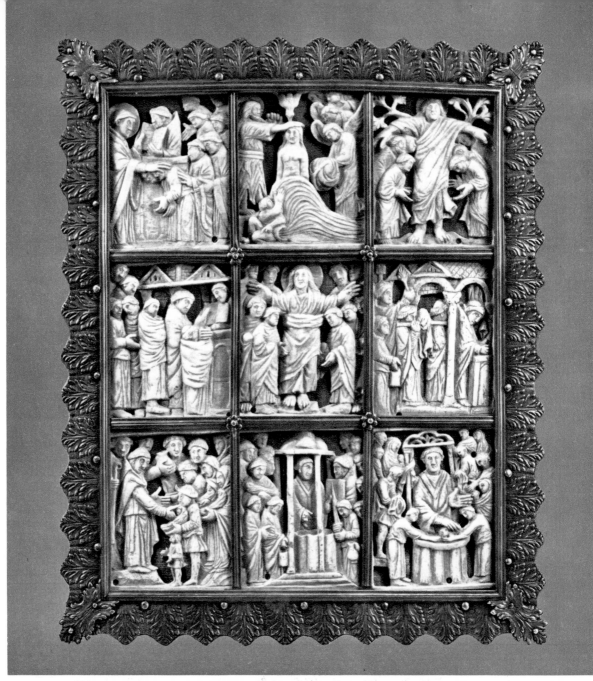

214 – IVORY COVER OF THE DROGO SACRAMENTARY. BIBLIOTHÈQUE NATIONALE, PARIS.

any doubt due to their kinship with the Drogo Sacramentary (Paris, Bibliothèque Nationale) and also with the miniatures of the Metz School. We might add that a great many ivory reliefs mentioned by Adolf Goldschmidt as coming from the Metz School derive from manuscripts that were written in that city. The small openwork reliefs on the cover of the Drogo Sacramentary—they reproduce liturgical scenes and episodes from the life of Christ inspired by the text of the volume itself—display a flatter, more pictorial method of treating the subject and a greater scenic unity than those of Charlemagne's Palace School. There is a possibility that this style was influenced by the works of the Reims School, which was also going through

234

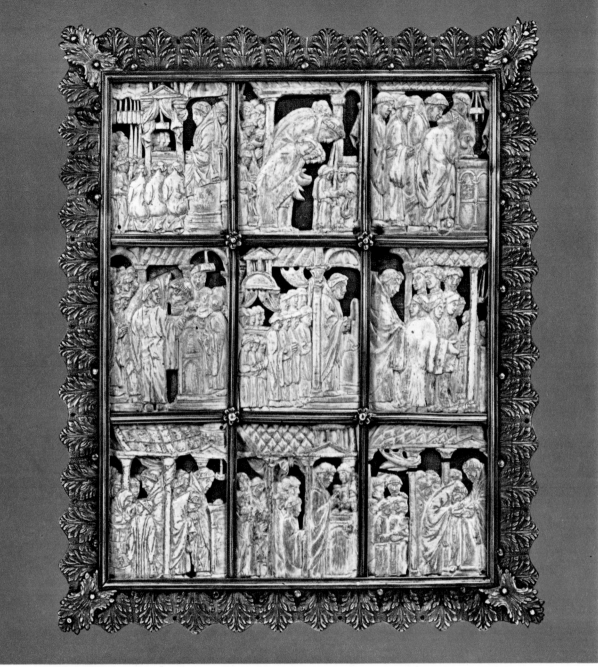

215 – IVORY COVER OF THE DROGO SACRAMENTARY. BIBLIOTHÈQUE NATIONALE, PARIS.

a period of renaissance at that time. Also closely related are the ivories with scenes from Christ's childhood and Passion that formerly adorned the front and back covers of a Metz Gospel Book now in the Bibliothèque Nationale (lat. 9388).

These ivories demonstrate that the Metz School continued to utilize early Christian models but, more than Charlemagne's Palace School, gave them the imprint of its own style. The figures are smaller and more lifelike; light and shade are much used to animate the scenes. On the other hand, the principal figures are mostly set in the foreground. A third book cover not far removed from the foregoing is preserved in the Liebighaus at Frankfurt; it is a five-part diptych in the early

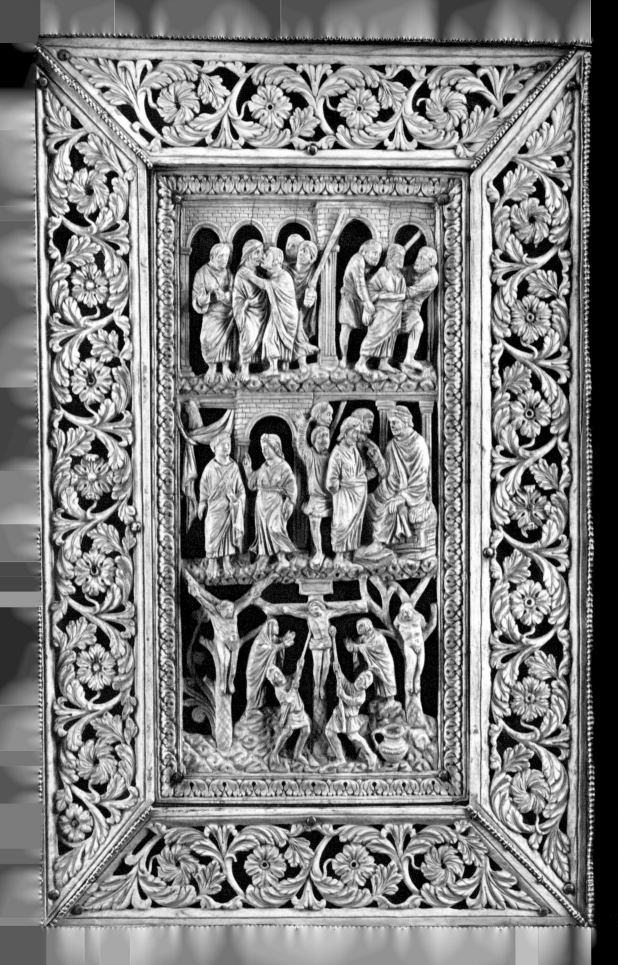

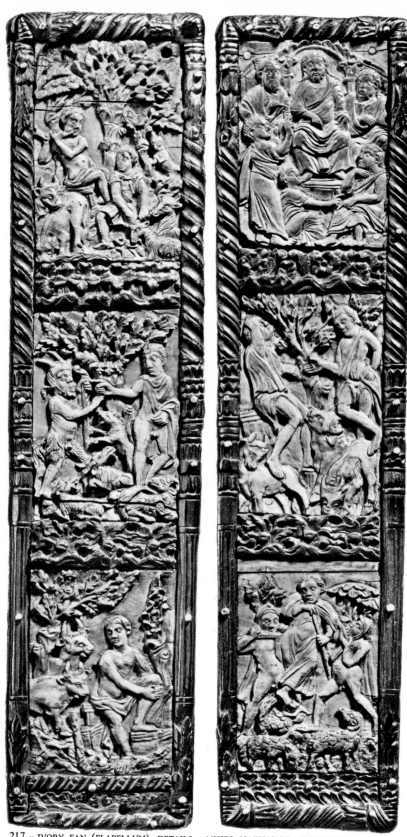

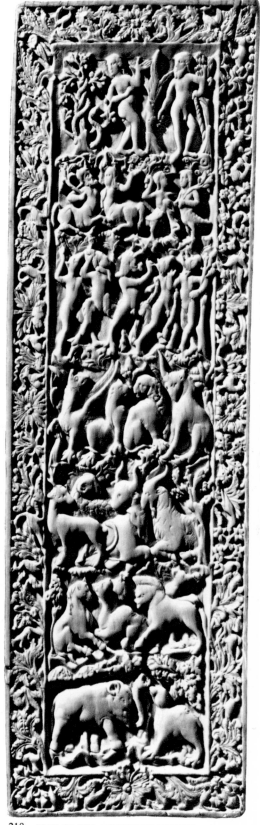

217 – IVORY FAN (FLABELLUM), DETAILS. MUSEO NAZIONALE, FLORENCE.

218 – LEAF OF THE AREOBINDUS DIPTYCH. PARIS.

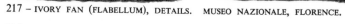

◄ 216 – IVORY COVER OF A GOSPEL BOOK: PASSION SCENES. BIBLIOTHÈQUE NATIONALE, PARIS.

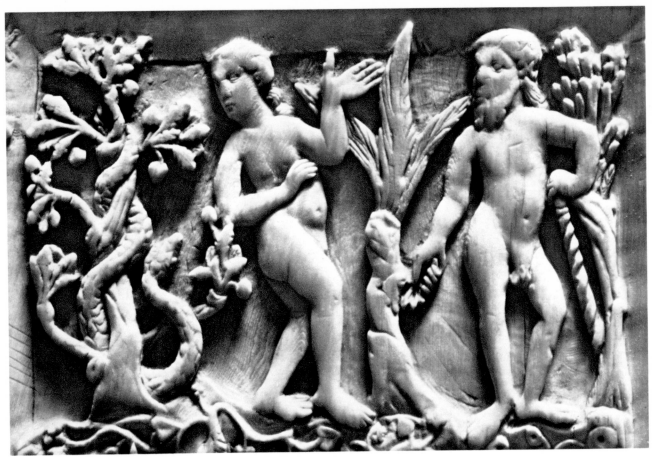

219 – LEAF OF THE AREOBINDUS DIPTYCH, DETAIL: ADAM AND EVE. LOUVRE, PARIS.

Christian style. The centre panel, which represents the temptation of Christ, is surrounded by four scenes from His childhood on a smaller scale.

A younger school linked with this older group and now known as the Second Metz School appeared during the second half of the ninth century. Though it borrowed a great many elements from its predecessor, its style developed in the direction of increasingly lively movement and gradually disappearing antiquarian character. Because its products were also influenced by other West Frankish work-shops, such as that of Saint-Denis, they must therefore be given a later dating; all the more so because of their obvious links with the ivories produced at Metz during the tenth century. Most of the group are quite remarkable carvings from the second half of the ninth, as exemplified by the book covers in Berlin (Goldschmidt, I, no. 81), in the Würzburg University Library (Goldschmidt, I, no. 82), in Paris (Goldschmidt, I, no. 83) and in Coburg Castle (Goldschmidt, I, no. 87). To these must be added the exquisitely carved comb of St Heribert in the Schnütgen Museum at Cologne (Goldschmidt, I, no. 92), the Brunswick casket (Goldschmidt, I, no. 96) and the side panel of a casket in the Kofler Collection, Lucerne.

Quite rightly attributed to the School of Tours is the magnificent flabellum from Saint-Philibert at Tournus, now in the Florence National Museum. The name 'Johel' carved in the ivory stands no doubt for Abbot Gelo, who towards the middle

of the ninth century succeeded Hilbold at Cunault and distinguished himself in all the arts. The style of the fan's miniatures, which are closely allied to its ivory reliefs, is another reason for attributing this work to the Tours School. What surprises us is the genuinely antique spirit pervading the reliefs on the handle, which give the impression of having been copied from a manuscript of Virgil's *Eclogues*. The six panels, interpreted in the Christian sense, represent Meliboeus with the flock of goats, Pan and Gallus, Alexis, Damon, Palaemon and the poet foretelling the birth of the Redeemer. The scrollwork on the handle also evinces a revival of classical motifs, while the saints on the cup-shaped capital—one of them is St Philibert—display the highly developed style of the Tours School. The vigorous handling of the drapery folds and the physical details of the figures are an advance from the style of the older Metz School and prepare the way for the works of the second half of the ninth century. Unfortunately, very few pieces of this type from the Tours School are still extant, but the fan has a certain kinship with the Garden of Eden on an ivory book cover in the Louvre recalling models of the late antique period, and with the curious diptych in the Musée de Cluny, Paris, whose centaurs and other fabulous creatures differ from their models by their greater elegance and liveliness.

Art under Charles the Bald

After the division of the Carolingian empire in 843, Charles the Bald (died 877) once more concentrated all the imperial forces in the lands of the West Franks. The immense number of fine manuscripts and the splendid pieces of goldsmiths' work executed at his order in the workshops he controlled at Corbie, Reims and Saint-Denis show that, like Charlemagne, he exploited the arts to enhance the royal prestige. He too had a marked predilection for antiquity, as is proved by the decoration of the lost reliquary ('Ecrin de Charlemagne') of Saint-Denis, which was studded with precious stones. He lent his support to the artistic zeal of his most intimate friends, Archbishop Hincmar of Reims and Abbot Hilduin of Saint-Denis. Due to the two prelates and to the monarch himself, the fame of the abbey of Saint-Denis soon spread far and wide. It came to be considered one of the foremost schools for the goldsmith's art, and its name was soon so well known that other monasteries sent their monks there for training. This flourishing school extended its influence as far afield as Winchester. During the last years of the reign of Charles the Bald, when Charles himself was secular abbot of Saint-Denis (876–877), the monastery became, if possible, still more important and received showers of gifts, particularly from the ruler. Many of the works produced in its workshops have an eclectic character: they reveal certain influences of Charlemagne's Palace School and occasionally the more classical impact of the Tours School. When the Saint-Denis School reached the peak of its evolution towards the middle and during the second half of the ninth century, it was artistically far ahead of all its predecessors. In its works the illusion of perspective is more marked, the figures achieve greater life and

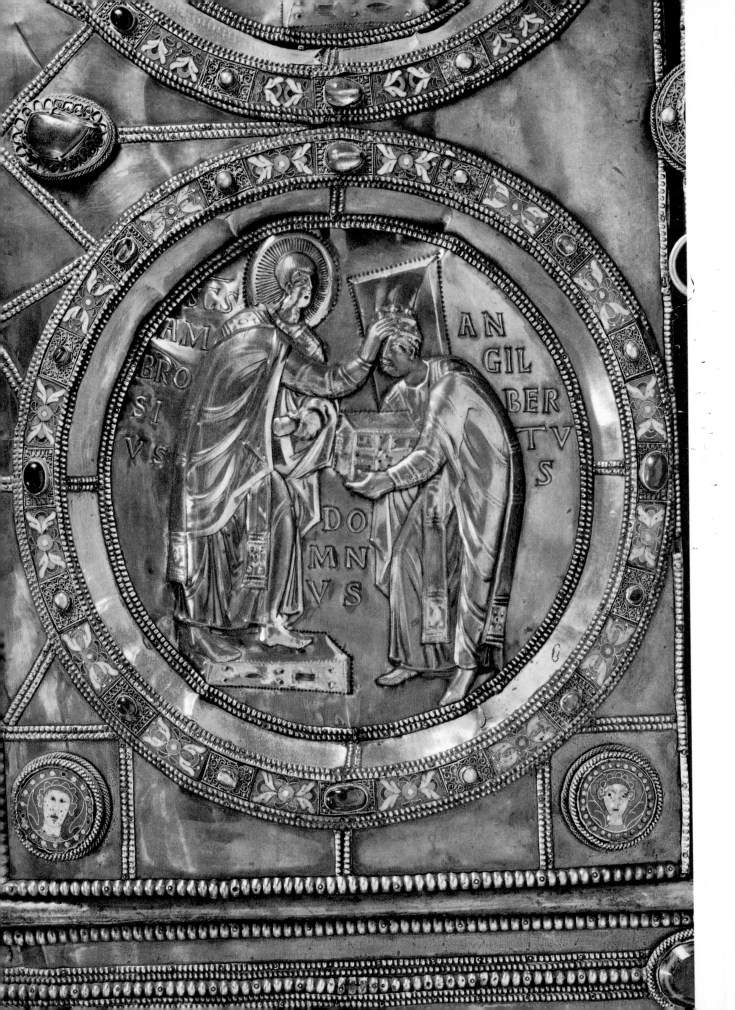

AM
BRO
SI
VS

AN
GIL
BER
TV
S

DO
MN
VS

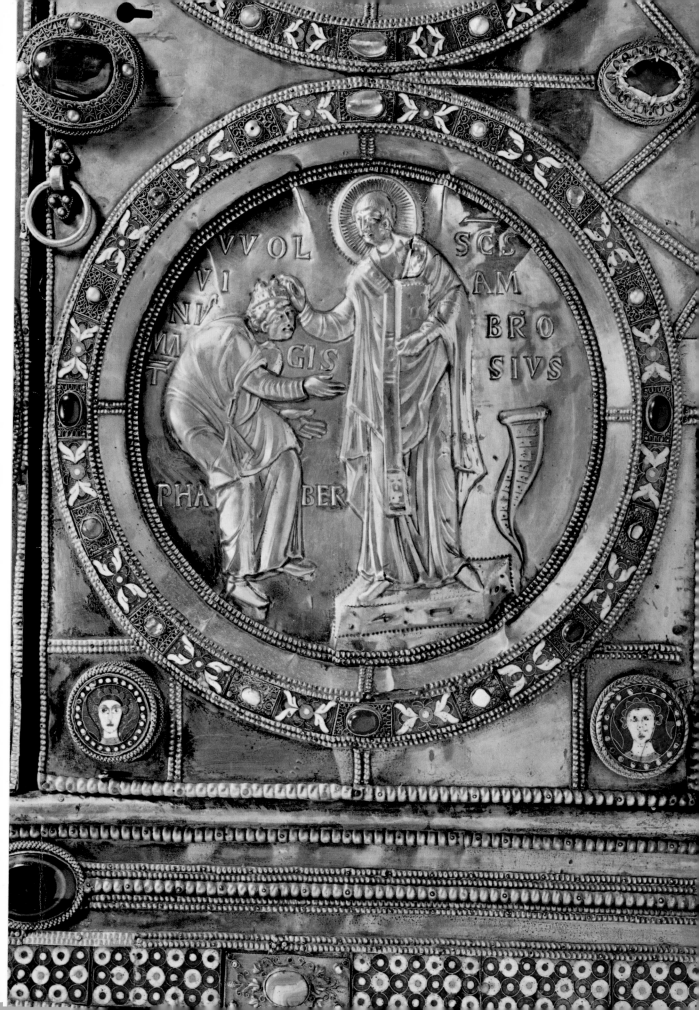

WVOL
VI
NIS
MM
T

GIS

PHA BER

SCS
AM
BRO
SIVS

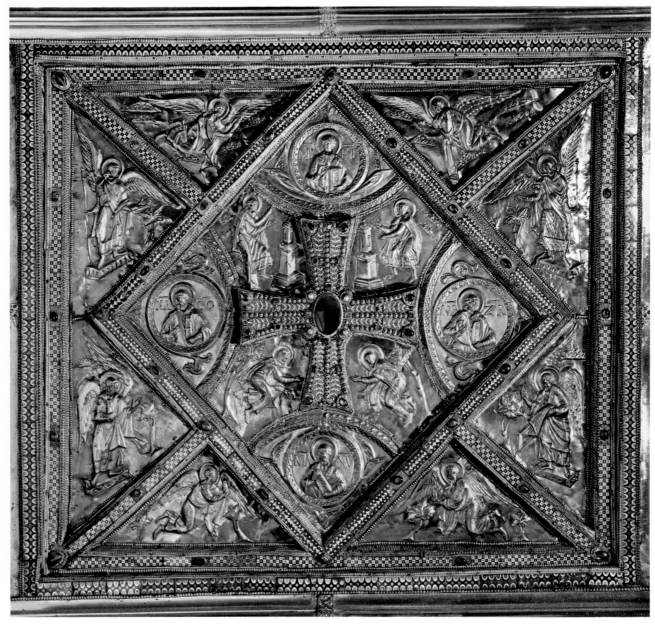

223 – MILAN, SANT'AMBROGIO. ALTAR, SIDE.

progressive than Vuolvinius, whose style calls to mind the cubic forms of the Tours School. The tranquil outlines of Vuolvinius' figures are simpler and completely separated from their space, which is vaguely indicated by a few scattered architectural elements. In this way, through his broad conception of forms and his taste for simplicity, Vuolvinius achieved a more monumental effect than did the master of the front, who, however, is his superior on a purely artistic plane. The latter displays a livelier manner, seen in his more spirited drawing; here and there we can recognize Byzantine models or references to the style of the Utrecht Psalter. But he is less

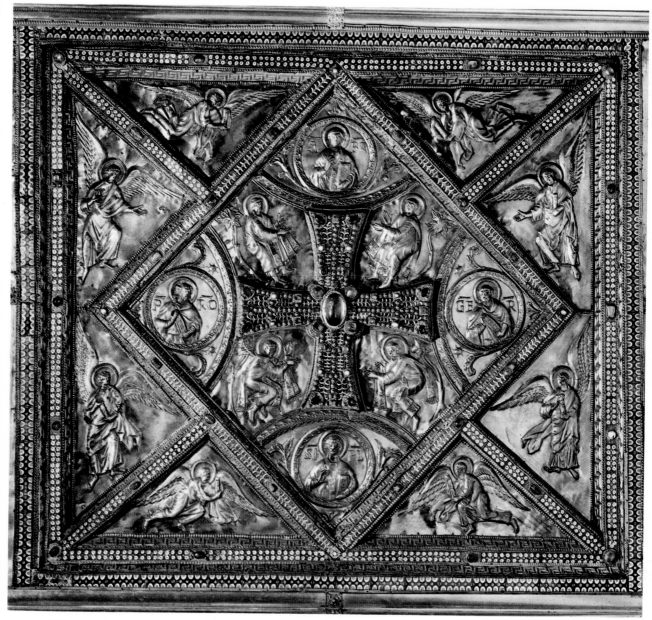

224 – MILAN, SANT'AMBROGIO. ALTAR, SIDE.

antiquarian, with the result that his figures are almost reminiscent of the Reichenau School. Although on the spatial level a stronger illusionistic impression is apparent, the bodily forms are all but erased and pictorially dominated by the uniform rhythm of the drapery. When we consider the reliefs in detail, we find that the style of the Christological ones is not absolutely consistent, so that we are tempted to presume them to be the work of two different artists. They have, however, certain traits in common: for instance, a more intense psychological characterization and a dramatic representation of the action that is unequalled by the scenes on the back.

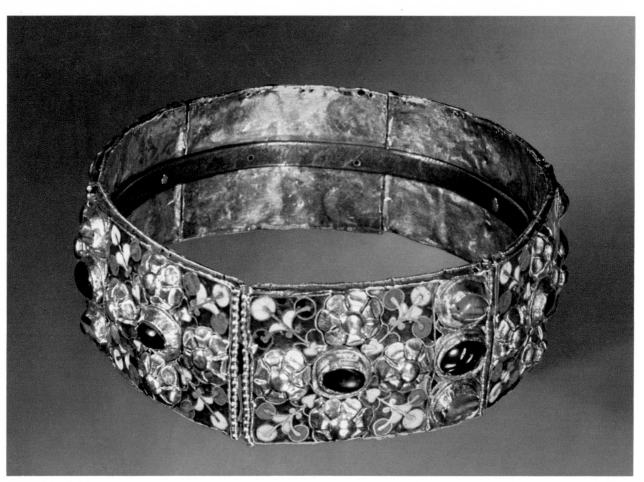

225 – IRON CROWN WITH ENAMELLED GOLD PLAQUES. CATHEDRAL TREASURY, MONZA.

The Sant' Ambrogio altar was probably executed in Milan, which had been an important art centre since Roman times. It remains to be seen whether Angilbert summoned Vuolvinius and the master of the Christological reliefs to Milan from one of the West Frankish abbeys and whether they were personally in contact with Reichenau. The use of cloisonné enamel to frame the scenes and of disks around the heads that recall antique enamels is important as a means to identify this altar with the Lombard art of northern Italy. This type of cloisonné enamel was unknown in northern Europe; therefore the small enamel plaques on the Altheus reliquary at Sion also seem to have been influenced by the Milanese school. The altar is also linked with the iron crown at Monza, particularly in the technical treatment and the colouring of the enamels. Also recalling the art of the Milanese enamellers is the little portable altar from Adelhausen in the Augustinermuseum at Freiburg im Breisgau, undoubtedly made in an Upper Rhenish workshop in the ninth century.

The new style revealed for the first time by the masters of the Sant' Ambrogio altar and of the Utrecht Psalter reached its full development shortly after the middle of the century. It can be seen in a great many works, most of which were linked with

226 – LOTHAIR CRYSTAL: SCENES OF THE LIFE OF ST SUSANNA. BRITISH MUSEUM, LONDON. ▶

227 – ROCK CRYSTAL: THE CRUCIFIXION. AUGUSTINERMUSEUM, FREIBURG IM BREISGAU. ▶

the patronage of Charles the Bald and his court. A number of important pieces have been lost and are known only from documents. But some of the most outstanding, including the gifts donated by the king to the abbey of Saint-Denis, are extant.

A group of engraved rock crystals, produced no doubt in Lorraine, is typical of this stylistic transformation. In some of the earliest, for instance the seals of Theodulf, abbot of Fleury (died 821) at Halberstadt, of Lothair II (855–869) at Aachen and of Archbishop Ratpodus of Trier (833–915) at Hamburg, the influence of antique models is still evident. The most important piece still extant, in the British Museum, bears the inscription of Lothair II and is completely covered with eight scenes from the life of St Susanna. The lively movement of the figures and the graphic, nervous manner of their treatment reveals a link with the Utrecht Psalter. Of the remaining specimens that have come down to us, the two representations of Christ's Baptism at Rouen and Freiburg im Breisgau are still allied stylistically with the Lothair Crystal. Others—for instance, the Crucifixions in the British Museum, the Augustinermuseum at Freiburg im Breisgau, the Cabinet des Médailles in Paris, and Count Cini's collection in Venice—already evince the decline of this art form which took place towards the end of the ninth century.

An obvious affinity with the style of the Utrecht Psalter can be seen in a group of carved ivories, to which Adolf Goldschmidt gave the collective name of Liuthard after the copyist of three royal manuscripts. It includes the covers of the Psalter of Charles the Bald in the Bibliothèque Nationale and of a prayer book he owned, formerly in the Zurich Cathedral and now in the Swiss National Museum in that city. It also contains the large plaque of the Crucifixion in Munich, from the cover

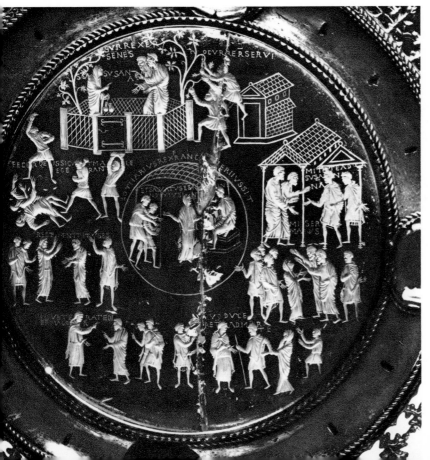
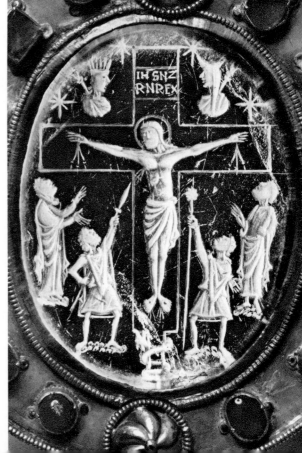

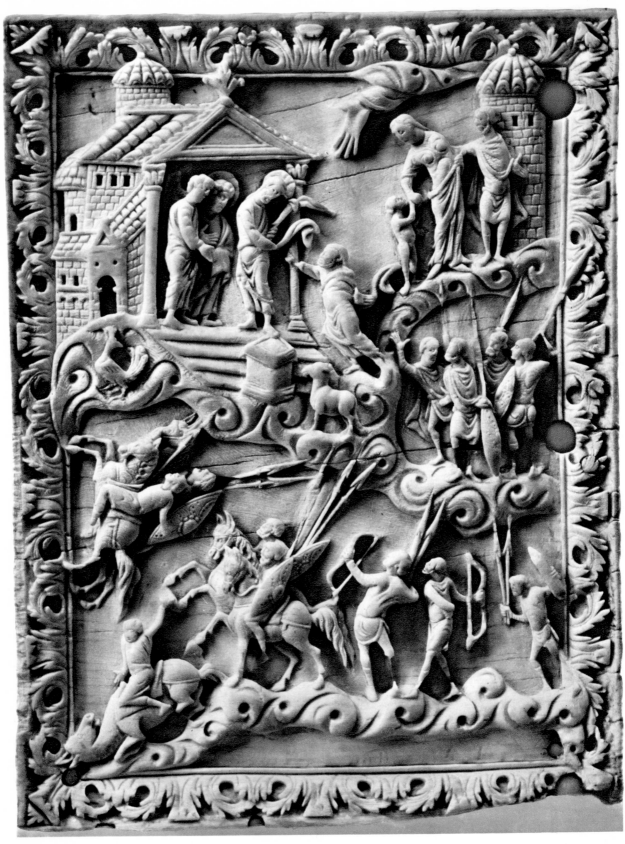

228 – IVORY BOOK COVER. SCHWEIZERISCHES LANDESMUSEUM, ZURICH.

229 – COVER OF THE GOSPEL BOOK OF HENRY II. BAYERISCHE STAATSBIBLIOTHEK, MUNICH.

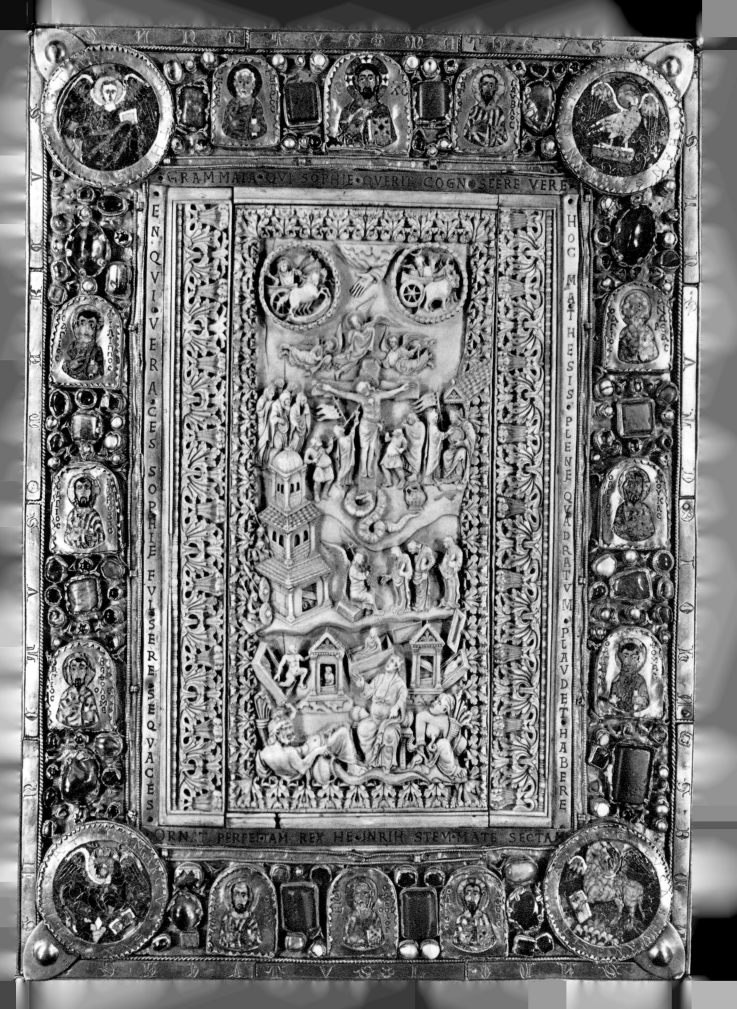

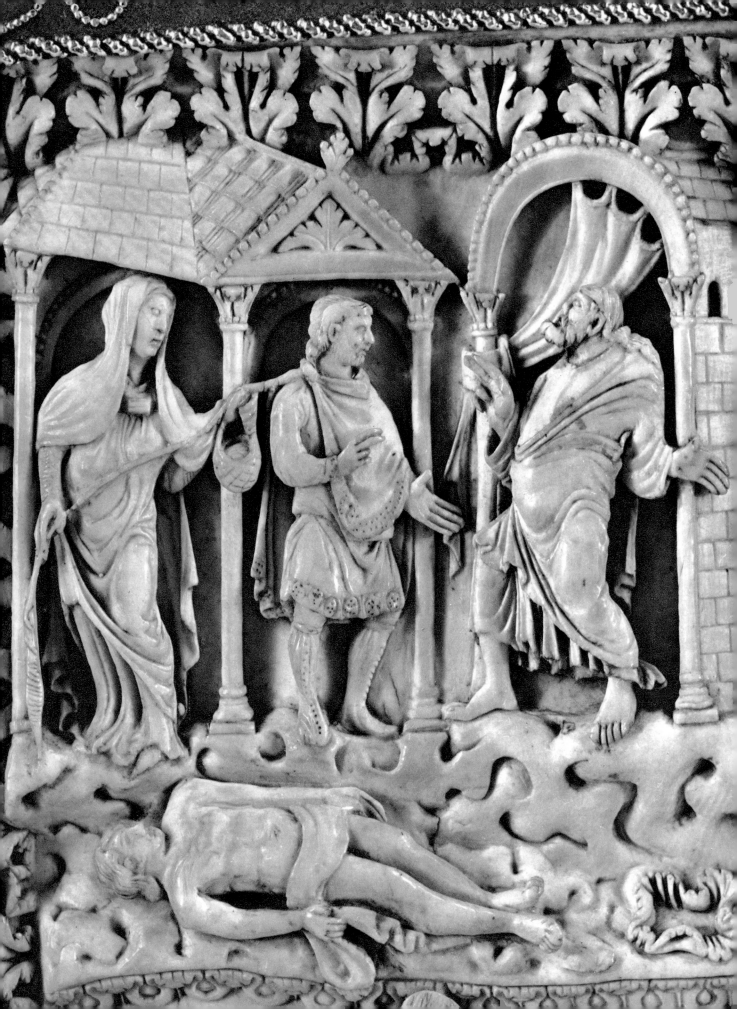

of a royal manuscript donated by Henry II to Bamberg Cathedral, and a number of other objects scattered in various collections. The two ivory plaques on the cover of the Psalter of Charles the Bald, which was copied by Liuthard (c. 842–869), reproduce the illustrations of Psalms L and LVI in the Utrecht Psalter. On the back Nathan charges David and Bathsheba with the murder of Uriah; on the front the soul of the Psalmist seeks refuge in God's lap from lions and men who threaten him. The carver transposed the line drawings from the manuscript to the ivory with great spirit: the figures, distributed respectively in two and four registers, move within their frames in a lively, almost nervous manner. This master at the court of Charles rendered his theme with an extremely lifelike movement—in contrast to the rather hieratic postures of the figures in the scenes we have observed in Charlemagne's Palace School—and mustered his figures with psychological insight, insisting on absolute unity of action. The effects he obtained in this way far surpass in intensity those achieved by the artist of the Christ on the Sant' Ambrogio altar in Milan, in which the influence of the Eastern Church, as displayed by the Utrecht Psalter, is still more in evidence. The Zurich plaques were carved by a less skilful artist. The scenes from Psalms XXIV and XXVI have also been transposed in relief after the manner of the drawings in the Utrecht Psalter. They show us the Psalmist before the Temple in which Christ stands, and the distribution of the scrolls of the Law.

The Crucifixion on the Gospel Book of Henry II in Munich was carved by the master to whom we owe the front cover of the Psalter of Charles the Bald. It is surrounded by the Holy Women at the Tomb, the Resurrection, the Sun and the Moon mounted on four-horse chariots, Oceanus, Gaea and Roma, in a sumptuous frame embellished with enamels and precious stones. This grandiose composition is one of the finest and most perfectly balanced products of the School of Charles the Bald. Executed in about 870, perhaps at Saint-Denis itself, it is surpassed by no other work of that period. A small book cover with the scene of Abner and Joab by the pool of Gibeon, formerly in the Treasury of Saint-Denis and now in the Louvre, is similar in style but less impressive. Towards the end of the century composition lost vigour and movement lost liveliness, but the style lived on none-theless. The workshop where these extraordinary ivory carvings were produced remains unknown. Many products were inspired by the Second Metz School, whose impact, almost a century later, was still felt in the monastery workshops of the Eastern Empire.

Among works of Charles the Bald's Palace School those executed in precious metals can bear successful comparison with the carved ivories. Saint-Denis, in parti-cular, received a quantity of valuable gifts from the monarch, which were very likely executed in the abbey's own workshops. Many of these pieces have been lost and are known only from old drawings or engravings. By a lucky chance we know of one of the most important, the abbey's famous altar frontal: it is depicted in a Franco-Flemish painting entitled 'The Mass of Saint Giles' dating from the end of the fifteenth century and now in the National Gallery, London. The reliefs in repoussé gold comprised, in the centre, a Christ in Majesty that recalls the one on the cover of the St Emmeram Gospels and represents a great advance in plastic

230 – COVER OF THE PSALTER OF CHARLES THE BALD, DETAIL. BIBLIOTHÈQUE NATIONALE, PARIS.

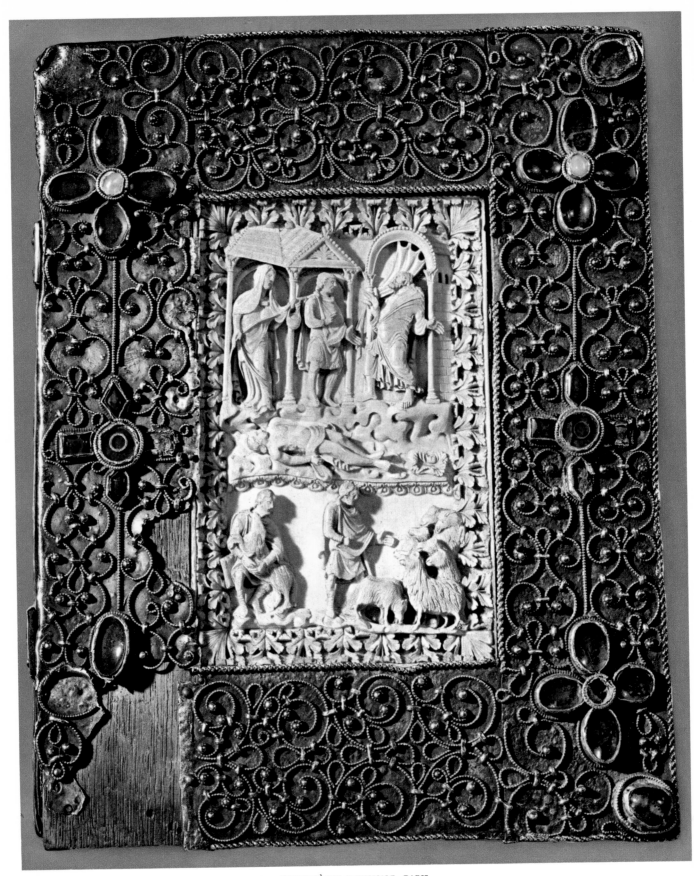

231 – COVER OF THE PSALTER OF CHARLES THE BALD. BIBLIOTHÈQUE NATIONALE, PARIS.

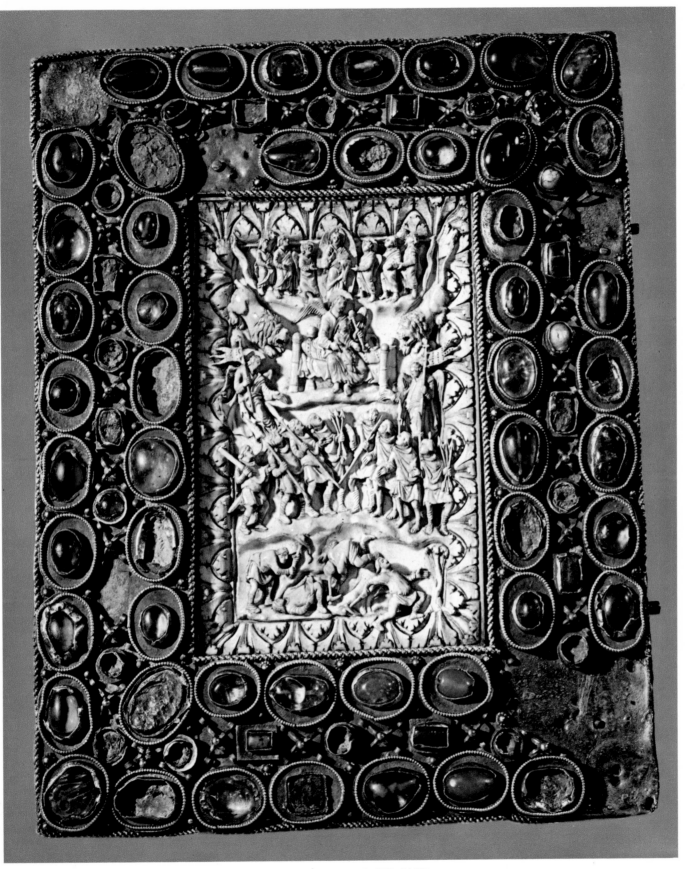

232 – COVER OF THE PSALTER OF CHARLES THE BALD. BIBLIOTHÈQUE NATIONALE, PARIS.

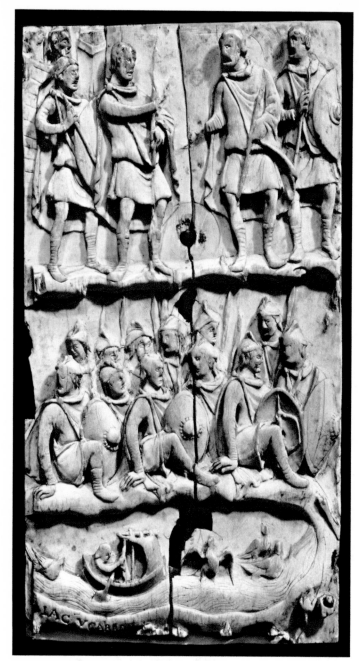

233 – IVORY BOOK COVER: JOAB AND ABNER. LOUVRE, PARIS.

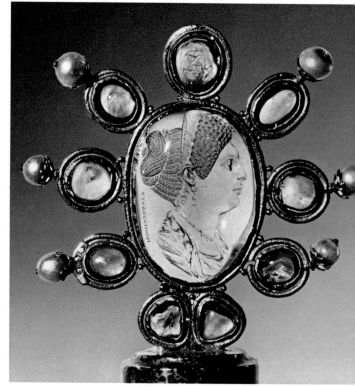

234 – INTAGLIO FROM THE 'ECRIN DE CHARLEMAGNE.' PARIS.

portrayal over the Christ on the Milan altar. The lateral fields represented two saints under arcades above which hung crowns flanked by angels.

Another of the abbey's sumptuous treasures that disappeared during the troubled times of the French Revolution, the 'Ecrin de Charlemagne,' was also probably donated by the same monarch. It was a reliquary over three feet high, shaped like the façade of a church, which we know from a drawing of 1791 now in the Bibliothèque Nationale. Only the gem that topped it, an antique intaglio representing Julia, daughter of the Emperor Titus (79–81 A.D.), is still kept in the Cabinet des

235 – GOLD COVER OF THE CODEX AUREUS FROM ST EMMERAM OF REGENSBURG. BAYERISCHE STAATSBIBLIOTHEK, MUNICH. ▶

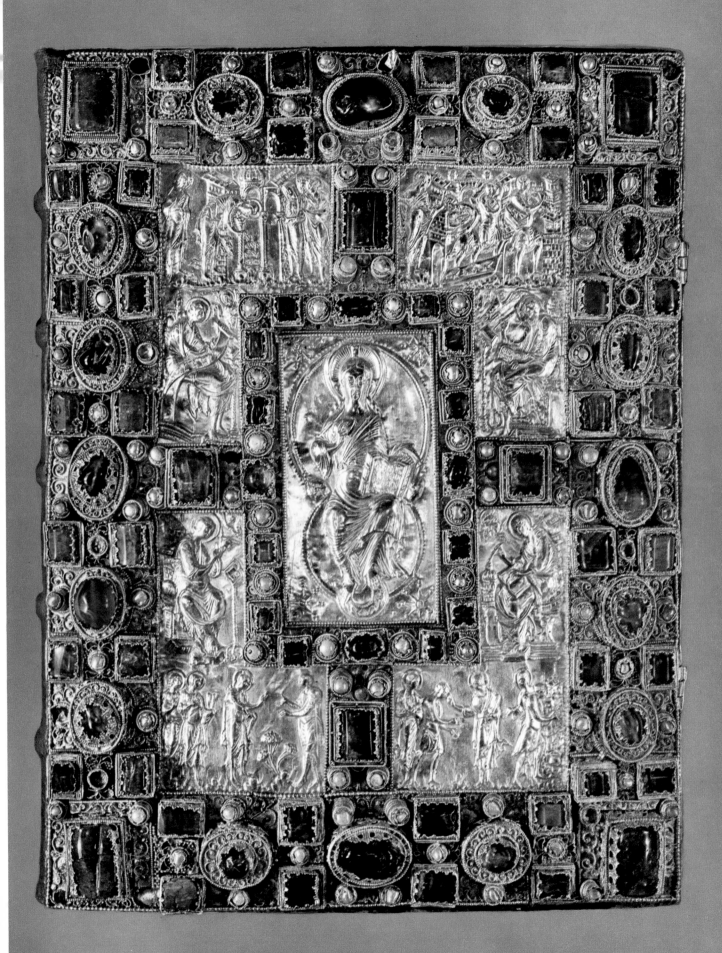

Médailles. The setting of the gem proves that the work was not earlier than the reign of Charles the Bald. The stones are set in the same simple manner one sees on the cover of his Psalter in the Bibliothèque Nationale.

The three finest pieces of goldsmiths' work that have survived from the Palace School of Charles the Bald are the second cover of the Lindau Gospels, now in the Pierpont Morgan Library, New York, the portable altar *(ciborium)* of King Arnulf, and the cover of the St Emmeram Gospels in Munich. Technically and stylistically they form a group that demonstrates the unbroken development of the style initiated by the Utrecht Psalter. Since the manuscript of the St Emmeram Gospels was penned by the brothers Berenger and Liuthard for the king in 870 and since the style of the reliefs relates them very closely to the miniatures within, we may infer that the metalwork was executed at the same time. The manuscript was probably produced at Corbie, so the cover may well have the same origin; but for other equally valid reasons it might be ascribed to Saint-Denis. (Some scholars, such as Georg Swarzenski, date this work to the late Reims period; and if we accept the close analogy between the miniatures and the reliefs, they might very well have been produced in the same workshop. But Carl Nordenfalk rejects this possibility.) An argument in favour of the latter attribution is that in 835 the abbey received as a gift the Greek manuscript of the works of Dionysius, the *Areopagite*, which was translated there in 858. The iconographic novelty in the second Lindau cover of the representation of the Sun and Moon above the Cross and the angels hovering in the corners was evidently inspired by the description in Dionysius' letters to Polycarp. The second Lindau cover is also related stylistically to the Sant' Ambrogio altar as is seen by comparing the angels on the cover with those on the side panels of the altar. But the cover is livelier and more nervous, in the manner of the Utrecht Psalter.

The simple, calm forms of the circular reliefs on the sides of the reliquary of St Stephen in the Vienna Treasury also recall the mid-century school. The surface arrangement and the wealth of ornamentation in precious stones around the edges are typical of the stylistic phase of the St Emmeram Gospels and the 'Talisman of Charlemagne' at Reims. In about 896 the Gospel Book was presented by King Odo or Charles the Simple to King Arnulf, who sent it together with the *ciborium* to the monastery of St Emmeram at Regensburg. It was restored there under Abbot Ramwold (975–1001). In the centre Christ is seated on a throne surrounded by the four Evangelists. In the corners are represented the woman taken in adultery, the money changers driven from the temple, the healing of the leper and the blind man restored to sight. The opulent border is embellished with a profusion of precious stones, in which the dominant colours are blue, green and gold.

Despite a few minor differences in the style of the reliefs, the *ciborium* of King Arnulf in Munich is very closely related to the second Lindau cover and still more to the St Emmeram Gospels. The *ciborium* and the Gospels have the same history. On the base of the former is an inscription naming King Arnulf as the donor. On the four tympana are the Hand of God, the Lamb, the Angel and the Globe; on the sloping sides of the roof, scenes from the New Testament: the temptation of Christ, the raising of Lazarus, the parable of the lilies of the field, the calling of

236 – SECOND COVER OF THE LINDAU GOSPELS. PIERPONT MORGAN LIBRARY, NEW YORK. ▸

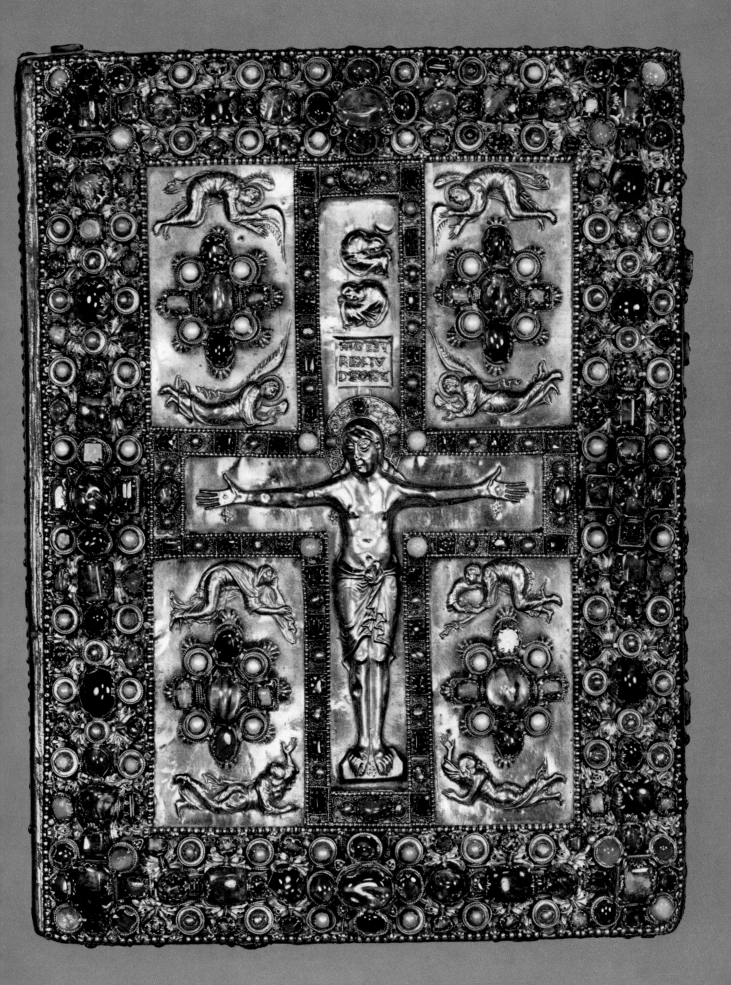

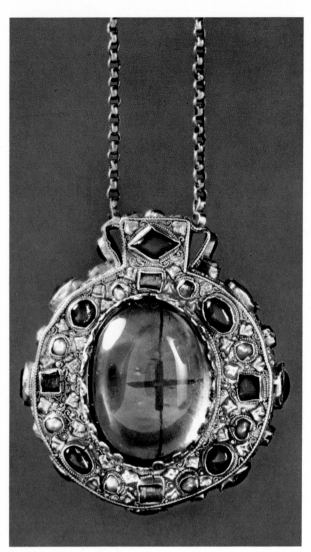

237 – 'TALISMAN OF CHARLEMAGNE.' REIMS CATHEDRAL.

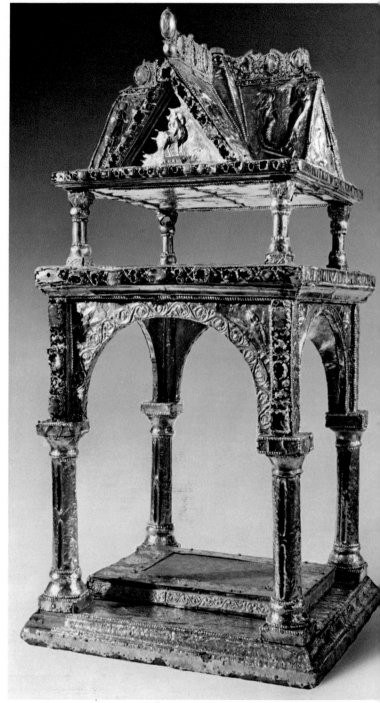

238 – CIBORIUM OF KING ARNULF. SCHATZKAMMER DER RESIDENZ, MUNICH.

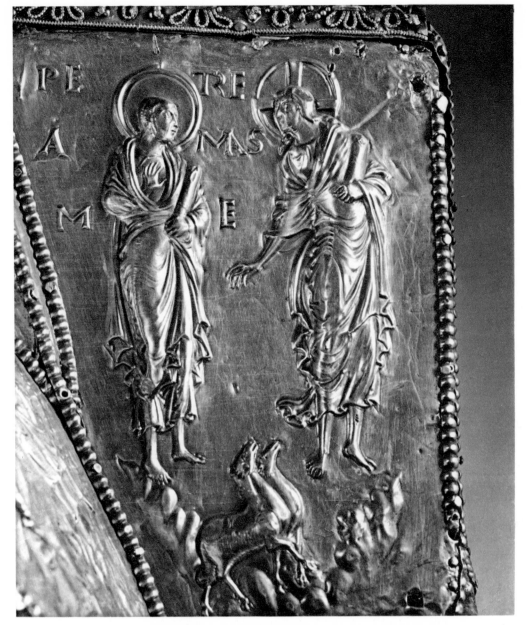

239 – CIBORIUM OF KING ARNULF, DETAIL: CHRIST AND ST PETER. SCHATZKAMMER DER RESIDENZ, MUNICH.

Peter and the resurrection of the young man of Nain. Stylistically, the reliefs are still very close to the drawings in the Utrecht Psalter, while at the same time they resemble the miniatures of the so-called Corbie School. Since the St Emmeram Gospels date from about 870, the *ciborium* may be attributed to a time very close to that year. True, the reliefs on the book cover display a certain technical progress, while those of the altar are still linked with earlier works, such as the ivory plaques of the Psalter of Charles the Bald and the Lothair Crystal with the life of St Susanna in London. The book cover represents a more advanced phase of evolution and already points the way to the following period. In particular, the figures are more mutually coherent and their bodily forms are more forcefully asserted; while those

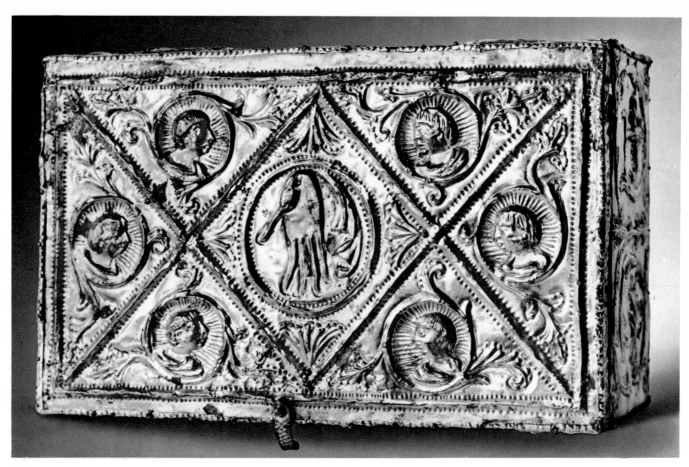

240 – BRONZE RELIQUARY. COLLEGIATE CHURCH OF ST VITUS, ELLWANGEN.

on the altar are still executed rather in the nervous, incorporeal manner of the Utrecht Psalter. They give the impression of hovering in an immaterial space and call to mind works in chased bronze such as the Ellwangen casket, whose lid and front are adorned with planets and princely personages. Thus the St Emmeram Gospels mark the transition to an art that came to full fruition about 900.

There is no work still extant from this latter period that can be compared with those I have just described. Nonetheless, the Tuotilo ivories at St Gall, made about 900, represent a further development of this style. Needless to say, we must keep in mind that these ivories are the products of a provincial school. The Christ in Majesty and the four evangelists, in particular, are good examples of the continuity of the themes treated on the St Emmeram Gospels. The composition of the scenes is now governed by a stricter symmetry, and the highest points of the relief form a single plane parallel to the background. Gone are the multiple planes of Carolingian reliefs, and the most remarkable innovation consists in the altered relationship of the subject matter to the spectator. The political change in the Frankish Empire under the House of Saxony (911–1024) also made itself felt in the artistic sphere.

W. F. VOLBACH

241 – IVORY BOOK COVER: MAJESTAS DOMINI. STIFTSBIBLIOTHEK, ST GALL. ▶

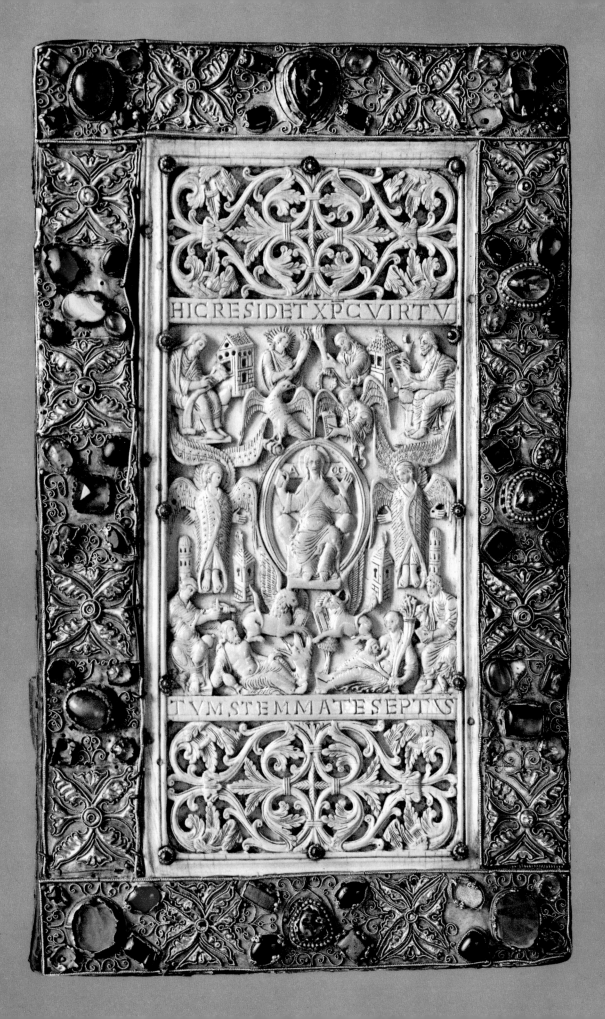

Conclusion

ONE of the objects of this book has been to show by means of pictures—by bringing before the reader's eyes the actual sources of our knowledge—the interest and relevance of the civilization of the Carolingian period. This period constitutes an important chapter in the history of art; indeed it represents a decisive intermediate stage between antiquity and the Middle Ages.

As in the case of the preceding period, the interpretation of art forms so remote from our own time raised problems so complex that three specialists had to be called on to cope with them. Moreover, though the Carolingian Empire at the time of its greatest extent covered a large part of western Europe, it will be noted that this book does not deal with the countries lying outside its frontiers, such as the British Isles, Scandinavia and Spain. These will be dealt with in further volumes of the Arts of Mankind series.

Discoveries made in the course of the past thirty years have to a large extent revolutionized our previous knowledge of Carolingian art. An attempt has been made in this volume to present a critical synthesis of these recent investigations.

One result is that we now have a much clearer idea of the limitations of our knowledge. There is in particular one very important gap in our sources of information. It is commonly supposed that barbarian goldsmiths' work was exclusively a product of the Merovingian period. This is an error. In his account of the siege of Paris by the Northmen in 885 and 886, a contemporary, Abbo of Saint-Germain-des-Prés, ends his long descriptive poem with invectives against the love of luxury. His words are informed with a kind of tragic grandeur because they were prompted, we feel, by what he had seen around him in daily life. He upbraids the Parisians with having kindled the wrath of God by their display of wealth, above all by the extravagant luxury of their clothes and jewellery. A few years later the chronicler Richerus indignantly levels the same charges against the clergy and monks of Reims. Indeed,

there can be no doubt that the notables of that day decked themselves out no less richly than did the Merovingian leuds. This is confirmed by a passage in the chronicle of the monk Heiricus of Auxerre: in 841, to thank St Germanus for having restored his eyesight, Conrad, count of Aargau, 'took off his gold bracelets' and laid them as an offering on the tomb of the bishop of Auxerre.

But whereas entire cases of ornaments, weapons and even items of clothing of the Merovingian period can be admired in our museums, not as much has been preserved from the Carolingian period. From the ninth century on, an accident of history has deprived us of an essential source of archaeological information—objects found in graves. The custom of burying the dead man with the clothes, weapons and ornaments which he needed for his life in the next world goes back to very early times. It was practised in Roman antiquity but became general among the Franks from the sixth to the eighth century.

The reason that this custom died out in the course of the ninth century can readily be inferred: since Gallo-Roman times the cemeteries had been situated outside towns, in the suburbs, for the dead were not permitted to be buried within the ramparts; now, with the Norse invasions in full spate, the insecurity of these defenceless cemeteries *extra muros* became an object of concern, as in the case of the *areae* and catacombs of Rome two centuries earlier. Norse raiders and individual looters were breaking into the tombs to strip the dead of their valuables. Two facts concerning these burials have now been established: first, excavations have shown that the graves in cemeteries situated *extra muros* no longer contain any precious objects; secondly, the precise indications given in *Gallia Christiana* for each town in Gaul show that in a great many dioceses, from the third quarter of the ninth century on, bishops and officials were buried *intra muros*, generally inside the cathedral. This was the origin of our urban cemeteries of the Middle Ages. It should be noted that for these dead protected by the town walls and the paving of the cathedrals, the Church continued to observe the ancient custom. A great many of the graves inside cathedrals have been opened in the course of time: the dead men were found clad in their ceremonial robes and wearing their jewels. Unfortunately almost nothing remains today of these grave furnishings, which were dispersed as soon as they were found.

Another category of goldsmiths' work, one much more important than mere objects of personal adornment, for the history of art, is now almost entirely beyond our ken. I refer to the many ninth-and tenth-century altar frontals in gold or silver, often inlaid with precious stones, which were melted down under the Old Regime or during the Revolution. The main recorded examples of these lost altar frontals are mentioned in our Chronological Table. Some of them contained such a weight of precious metal that the funds obtained by selling them off sufficed to rebuild the church of which they had been the principal ornament. Our knowledge of these lost masterpieces is usually limited to a brief mention of them in documents. Nothing

is known of the technical details of their execution. From the few recorded indications we have, we can divine something of the iconographic richness of the scenes in embossed metal which decorated not only the front of the altar but the sides as well. Nothing can compensate for the loss of these magnificent altar frontals, veritable large-scale sculptures, which were a creation of the Carolingian period and served as models for the first works of Romanesque sculpture.

It must be admitted that even in the field of architecture the gaps in our knowledge are equally great. Of ninth-century work, the only part we know well is 'official art,' to extend to architecture the expression so aptly applied by Jean Porcher to the scriptoria and painters' ateliers which catered to the taste of the court and the ruler's entourage.

It is true that, where architecture is concerned, the official art of the period governed not only the construction of the palaces and villas belonging to men of high rank, like the country residence of Theodulf at Germigny, but also the construction of the great monastic and cathedral complexes, for new institutions required new designs adapted to their needs.

But just how much do we know about the architecture of the new monasteries, some fifty of them, which were founded in Gaul between the Loire and the Mediterranean, most of them between the mouth of the Rhône and the valley of the Garonne, or about the twenty-five other monasteries built by the Franks south of the Alps, chiefly in Lombardy, during the first half of the ninth century? Practically nothing. Our ignorance is even more complete regarding rural architecture, and this is a serious lacuna. If we were better informed about this latter architecture, we should probably find that it goes far to explain certain rustic modes of building and decorating which characterize early Romanesque architecture in France. One of the plates in this book illustrates an early medieval bas-relief in the Brescia museum which bears out this hypothesis, at least in Italy, for it combines antique reminiscences with curious animal images drawn from folk art.

Another point is even more instructive. There are good grounds today for regarding the tenth-century monastic churches erected in the Spanish March, in Roussillon and Catalonia, as a Carolingian art exported to these borderlands at the same time that a political, military and religious organization was established there to contain and keep a watch on the Moors of Spain—an organization which moreover proved so effective that it successfully protected these provinces against the Norse invaders. Although strongly marked by local practices, this rustic art reflects the major architecture of northern Gaul at the end of the Carolingian period. The same is true of many small country churches in the Montpellier region, whose significance has only just been realized.

Of course the study of folk survivals in Carolingian art is by no means devoid of interest, since it bears directly on a much-discussed problem: the origins of Romanesque art. But that is not the heart of the matter. The facile achievements which the Carolingian artists owed to their skill in imitating the antique must not make

us overlook the great burst of creative power which gave a new lease on life to architecture at that time, leading to the development of new techniques and practices by which all medieval architecture was later to benefit.

For centuries the Mediterranean basin had been the home of stone-built architecture. Yet the completely vaulted church of the medieval West was not the creation of Rome or Lombardy. Despite the profound impact of Byzantine influences, Italy kept, on the whole, to the timber-roofed basilica whose harmonious design had been worked out there as early as the fourth century.

The new type of church appeared in Gaul five centuries later. It was the outcome of rational calculation applied to the problem of disposing, at both the west and the east ends of the timber-roofed nave, sanctuaries and oratories on two or even three entirely vaulted storeys which would answer the needs of the new liturgy and also those of the cult of relics.

The Carolingian crypt with its mighty vaults, standing on the same level as the nave and communicating with it, was much more than a simple development of the Roman *confessio*, enlarging on it by the addition of burial places for churchmen and high-ranking laymen. It amounted in effect to a second church added to the first, a place of retreat conducive to meditation and miracles. It was entered through narrow passages, by the flickering light of lamps which were kept burning day and night round the 'Holy of Holies,' the sacred place where the venerated tomb lay. Here were worked the wonders which pilgrims and worshippers entreated of God through the intercession of the saints.

Standing over the crypt, the raised sanctuary too was often vaulted, giving it at times a shadow-laden atmosphere of mystery. In front of the choir reserved for the monks or canons, and beside the ambo, was a life-size figure of Christ on the cross, a majestic wood carving plated with gold- or silver-leaf.

In some places, beginning in the second half of the ninth century, a further step was taken: of displaying, for the veneration of the faithful, a bust of the saint whose relics were preserved in the church. These reliquary shrines, given the form of the human figure, preceded and inspired two works of very different quality: the reliquary statue of St Foy in the church of Conques and the superb gold Virgin given by Abbess Mathilda about the year 1000 to the Essen Cathedral. We all know how important a part statuary was to play in the art and piety of the Middle Ages. That statuary owed nothing either to pagan antiquity or to Byzantium. It has its source in the reliquary statues designed in the Carolingian period with the express purpose of representing the martyr or confessor by an image in the round, giving the illusion of life much more tellingly than could be done in a mosaic or a painting.

The characteristic 'westwork' of Carolingian churches—a monumental structure at the west end, with altar and sanctuary on the upper storey so as to allow free entrance into the nave on the ground floor—led to an increasingly skilful use of the antique pillar of cruciform section to carry the thrust of transverse arches and

various types of vaulting. So, by about the year 1000 it was possible to cover a large double-aisled church like Orléans Cathedral almost entirely with vaulting.

With their double-apse plan, entailing substantial additions at both the west and the east end, the churches of the Carolingian period covered a considerable area; some of them attained a size never afterwards surpassed. An even more arresting innovation was the height to which these towered churches rose. The westwork of the abbey church of Corvey, a mighty 'hand of peace' reaching heavenwards over the monastery and the surrounding countryside, remains the finest symbol of that yearning for the heights which the architects of the ninth century so keenly felt.

Churches with corner towers had been built from late antiquity (witness San Lorenzo, Milan), but the bell tower, whether detached or not, was created in Gaul, not in Italy. Monte Gargano, where the archangel Michael appeared to the bishop of Sipontum in 492, overlooks the Adriatic, but Carolingian Gaul not only consecrated mountaintops to the archangels, it also established lofty oratories over the entrance of the church or at the top of the chevet—sacred aeries, so to speak, where the winged servants of Heaven were invited to come down and protect mankind from lightning and sin.

At a time when town walls were being rebuilt everywhere to ward off the Norse invaders, the stone-built church towering over the city came to be regarded as a holy citadel, defended by the relics of its saints and the prayers of its clergy.

JEAN HUBERT

PART FOUR
General Documentation

SCIENTIFIC ADVISOR: MADELEINE DANY

Supplementary Illustrations

243 – OSTIA, HORREA EPAGATHIANA. NICHE.

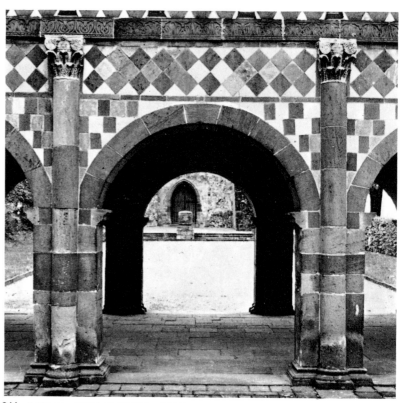

244 – LORSCH, ABBEY GATEWAY. WEST FAÇADE.

245 – AACHEN, PALATINE CHAPEL. DOOR.

246 – SOISSONS, ABBEY OF SAINT-MÉDARD. ENTRANCE OF THE CRYPT.

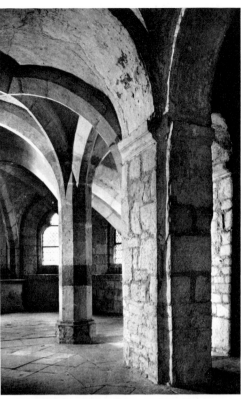

47 – OSTIA, HORREA EPAGATHIANA.

248 – AUXERRE, SAINT-GERMAIN. CRYPTS.

249 – SOISSONS, SAINT-MÉDARD. CRYPTS.

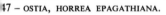

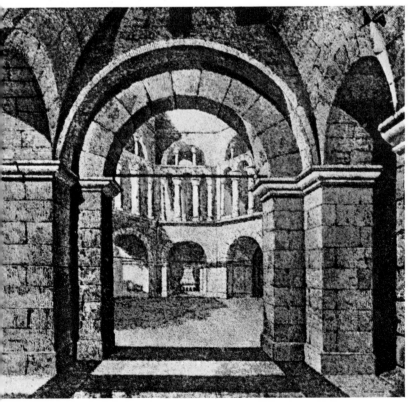

250 – AACHEN, PALATINE CHAPEL. GROUND FLOOR BEFORE RECONSTRUCTION.

251 – GERMIGNY-DES-PRÉS, CHURCH.

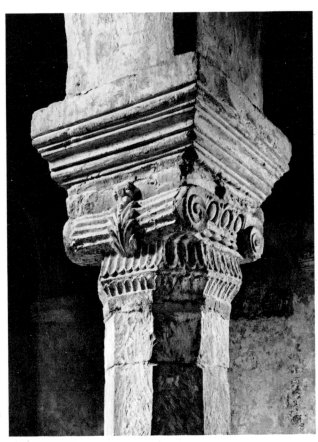

252-253 – AUXERRE, SAINT-GERMAIN, CRYPTS. ILLUSIONIST PAINTING AND CAPITAL.

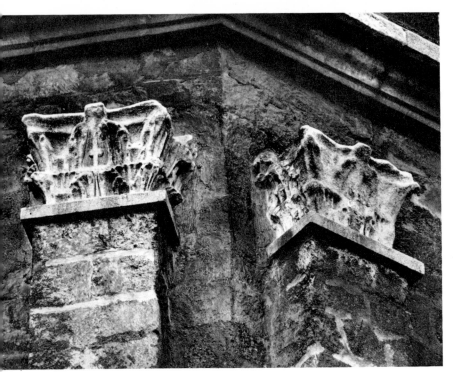

254 – AACHEN, PALATINE CHAPEL. OUTER WALL.

255 – GERMIGNY-DES-PRÉS. CAPITAL. ORLÉANS.

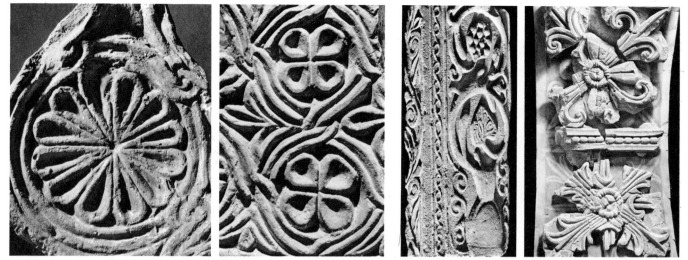

256-257 – GERMIGNY-DES-PRÉS. STUCCO CARVINGS. MUSÉE HISTORIQUE, ORLÉANS. 258–259 – BRESCIA, SAN SALVATORE. FOLIAGE ORNAMENTS.

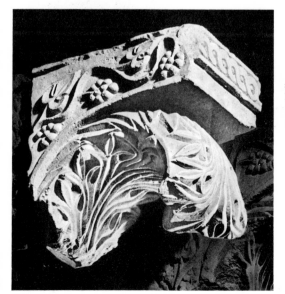

260–261 – FRAGMENTS OF AN AMBO (?) AND A FRIEZE. CHURCH MUSEUM, JOHANNESKIRCHE, MÜSTAIR.

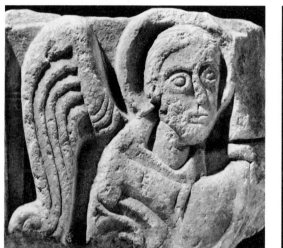

262 – MILAN, SANTA MARIA D'AURONA. CORBEL. 263 – BRESCIA, SAN SALVATORE. STUCCO DECORATION OF AN ARCH.

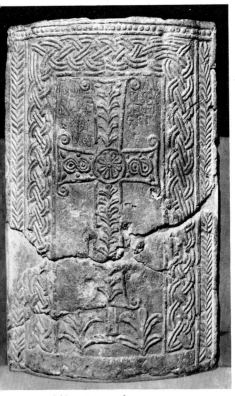

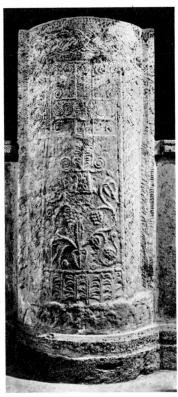

264 – ROMAINMÔTIER, CHURCH. AMBO. 265 – SAINT-MAURICE, CHURCH. AMBO. 266–267 – METZ AND ANGERS. CLOSURE SLABS.

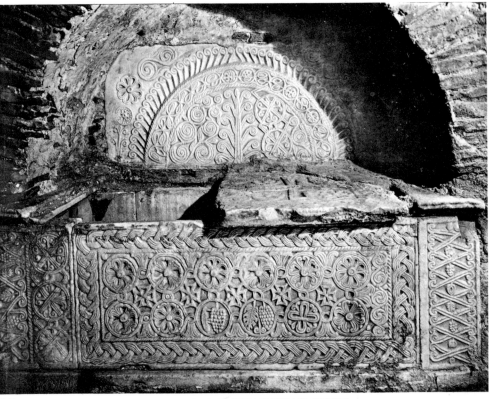

268 – ESTOUBLON. TOMB STELE. 269 – ALBENGA, BAPTISTERY. WALL-NICHE TOMB WITH INTERLACE DESIGNS.

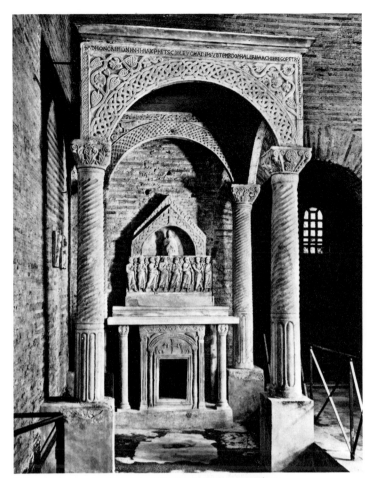

270 – RAVENNA, SANT'APOLLINARE IN CLASSE. CIBORIUM.

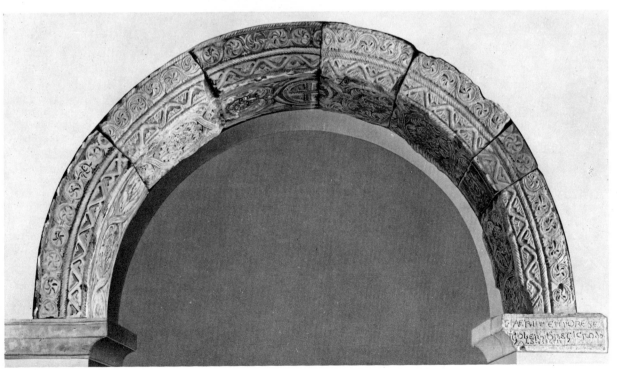

271 – GLONS. ARCH OF A CIBORIUM (?). CAST. MUSÉES ROYAUX D'ART ET D'HISTOIRE, BRUSSELS.

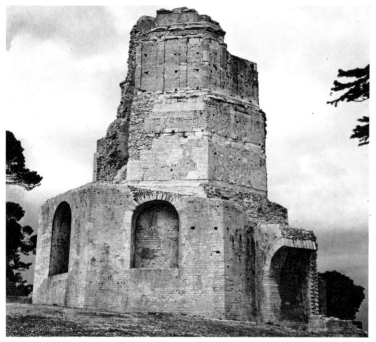

272 – NÎMES. TOUR MAGNE.

273 – AACHEN. PALATINE CHAPEL.

274 – BRESCIA. SAN SALVATORE.

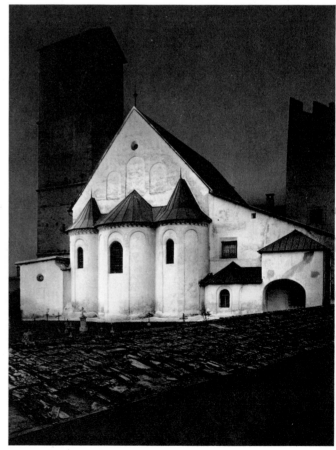

275 – MÜSTAIR. JOHANNESKIRCHE.

II. BOOK PAINTING

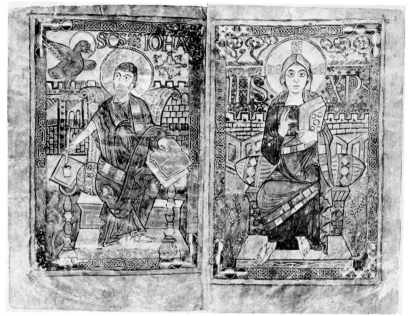

276–277 – DIOCESE OF MAINZ. GODESCALC GOSPELS. BIBL. NAT., PARIS.

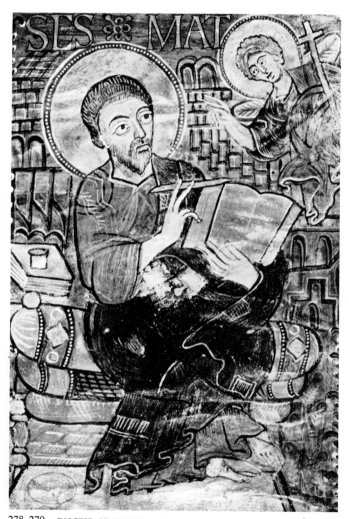

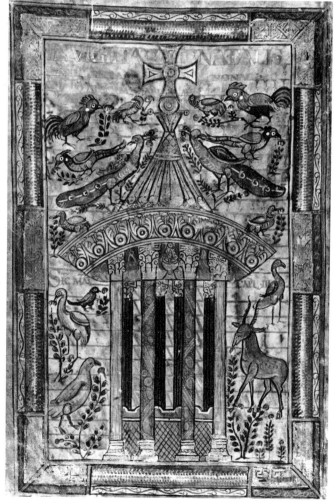

278–279 – DIOCESE OF MAINZ. GODESCALC GOSPELS. BIBLIOTHÈQUE NATIONALE, PARIS.

279

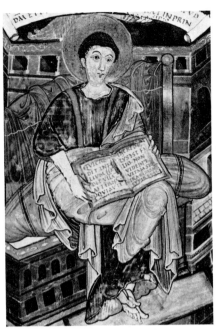

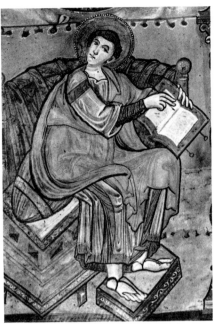

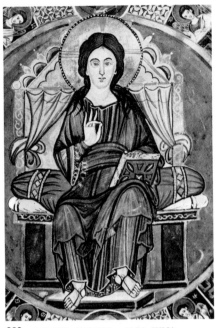

280 – GOSPEL BOOK OF SAINT-MÉDARD. 281 – ABBEVILLE GOSPELS. ABBEVILLE. 282 – LORSCH GOSPELS. ALBA IULIA.

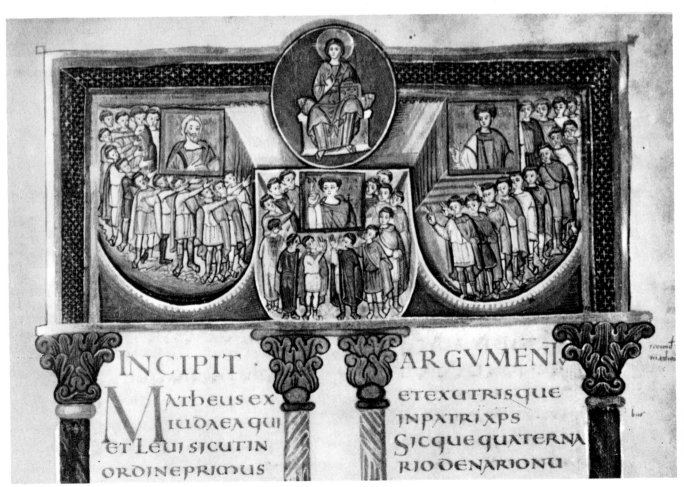

283 – MIDDLE RHINE. LORSCH GOSPELS, DETAIL. BATTHYANEUM LIBRARY, ALBA IULIA.

284 – AACHEN. XANTEN GOSPELS. BRUSSELS.

285 – REIMS. EBBO GOSPELS. ÉPERNAY.

286–287 – REIMS. EBBO GOSPELS. BIBLIOTHÈQUE MUNICIPALE, ÉPERNAY.

288–289 – REIMS. EBBO GOSPELS, DETAILS. BIBLIOTHÈQUE MUNICIPALE, ÉPERNAY.

Quando uenerit homo & uoluerit
occidere eum totum corpus tradit
capit auu custodit. Debemus & nos
in tempore temptationis totum cor
pus tradere· capitauu custodire idē
xpm non neganter sicut fecerunt
sci martyres omnis enim caput xpi est

OENAR FORMICAE

Quando recondit triticum interra diuid & grana eius

290 – HAUTVILLERS. PHYSIOLOGUS LATINUS: ON THE FOURTH NATURE OF THE SERPENT, DETAIL. BÜRGERBIBLIOTHEK, BERNE.

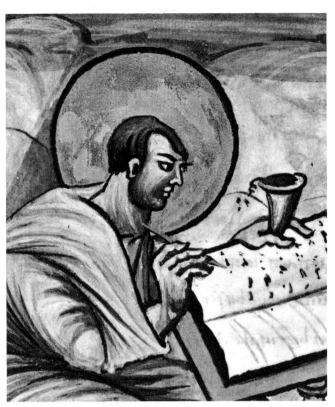

291 – LOISEL GOSPELS, DETAIL. BIBLIOTHÈQUE NATIONALE, PARIS.

292 – REIMS. BLOIS GOSPELS, DETAIL. BIBL. NAT., PARIS.

293 – LAON. GOSPEL BOOK. BIBLIOTHÈQUE MUNICIPALE, LAON.

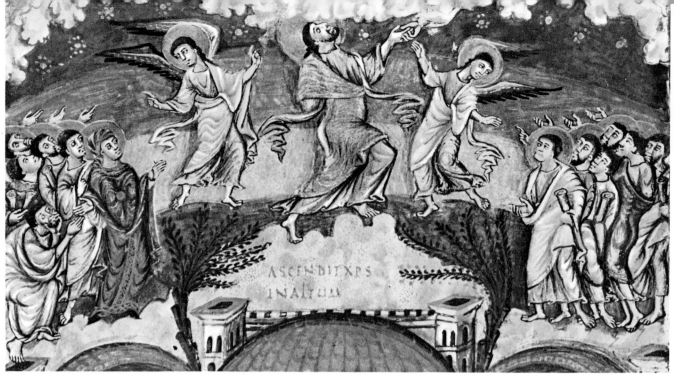

294 – SAINT-DENIS (?). SAN CALLISTO BIBLE: ASCENSION, DETAIL. SAN PAOLO FUORI LE MURA, ROME

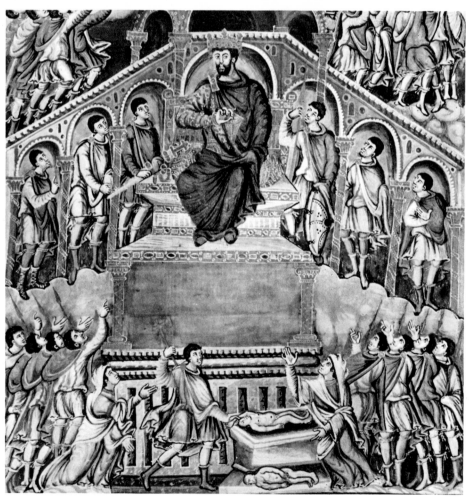

295 – SAINT-DENIS (?). SAN CALLISTO BIBLE, DETAIL. SAN PAOLO FUORI LE MURA, ROME.

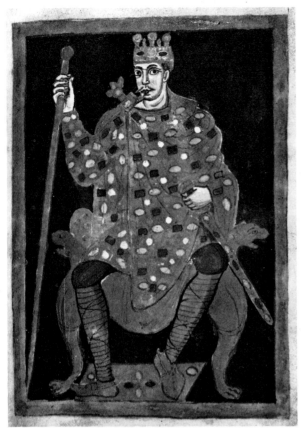

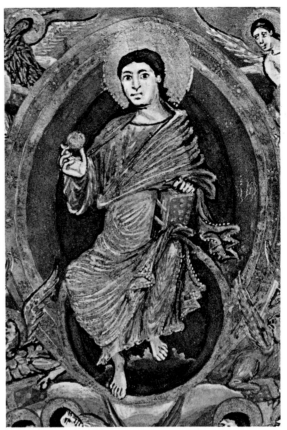

296 – TOURS. LOTHAIR PSALTER. BRITISH MUSEUM, LONDON.

297 – SAINT-DENIS (?). METZ SACRAMENTARY. PARIS.

298–299 – METZ. DROGO SACRAMENTARY, DETAILS. BIBLIOTHÈQUE NATIONALE, PARIS.

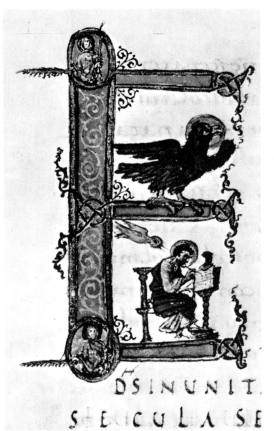
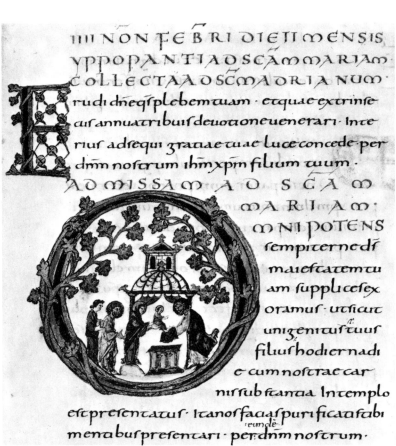

DSINUNIT
SECULA SE

300–301 — METZ. DROGO SACRAMENTARY, DETAILS. BIBLIOTHÈQUE NATIONALE, PARIS.

302 — ST GALL. WOLFCOZ PSALTER, DETAIL. ZENTRALBIBLIOTHEK, ZURICH.

303 – ST GALL (?). PRUDENTIUS, 'PSYCHOMACHIA.' BERNE.

304 – SAINT-AMAND (?). APOCALYPSE. VALENCIENNES.

305 – SAINT-AMAND. APOCALYPSE. BIBLIOTHÈQUE MUNICIPALE, CAMBRAI.

306 – EASTERN FRANCE (?). APOCALYPSE. STADTBIBLIOTHEK, TRIER.

307 – SAINT-AMAND. GOSPELS, DETAIL. VALENCIENNES.

308 – FLEURY. ISIDORE OF SEVILLE, 'DE NATURA RERUM'. PARIS.

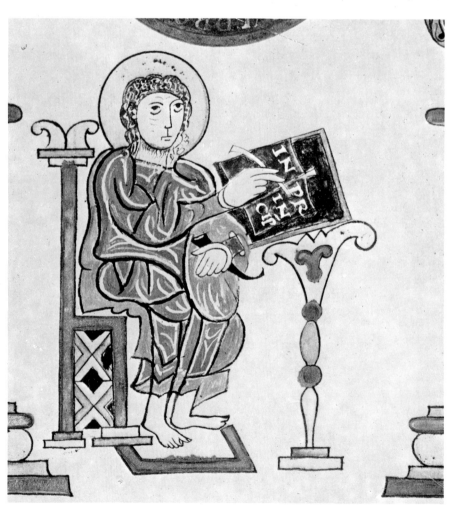

309 – COLOGNE. GOSPEL BOOK: ST JOHN THE EVANGELIST. COLOGNE CATHEDRAL.

310 – BUCKLE. OSLO.

311 – 'CROSS OF THE ARDENNES.' NUREMBERG.

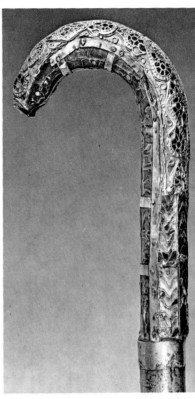

312 – CROSIER OF ST GERMANUS.

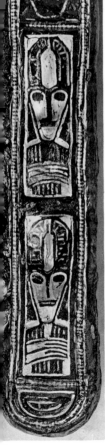

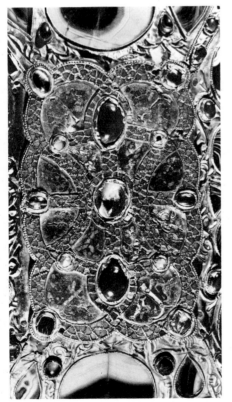

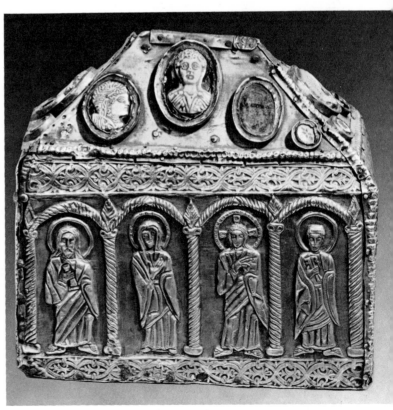

3 – BELT. MUNICH. 314 – CASKET, DETAIL: LID. OVIEDO. 315 – RELIQUARY. CATHEDRAL TREASURY, CIVIDALE.

316 – CROWN, DETAIL. ESSEN.

317 – BOOK COVER, DETAIL. UTRECHT.

318 – EPITAPH OF ST CUMIAN. BOBBIO.

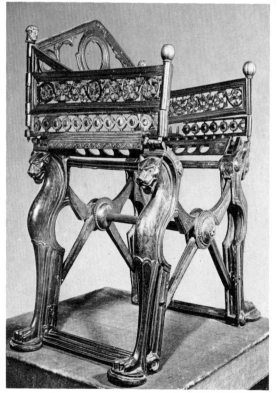

319 – CROSS. CHURCH, PIEVE DI BUDRIO.

320 – 'THRONE OF DAGOBERT.' BIBL. NATIONALE, PARIS.

321 – AACHEN. BRONZE RAILING, DETAIL

290

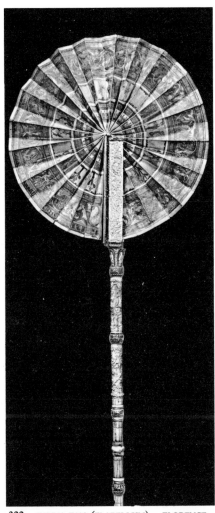

322 – IVORY FAN (FLABELLUM). FLORENCE.

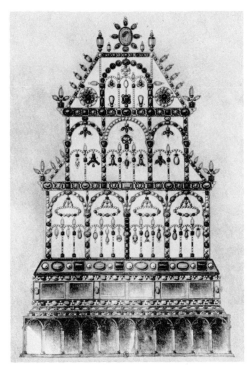

323 – 'ÉCRIN CHARLEMAGNE.' DRAWING.

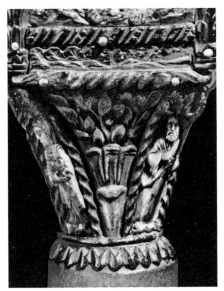

324 – IVORY FAN, DETAIL. FLORENCE.

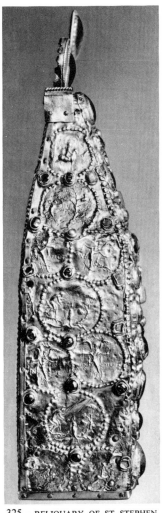

325 – RELIQUARY OF ST STEPHEN.

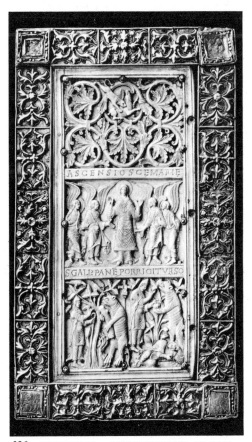

326 – BOOK COVER. STIFTSBIBLIOTHEK, ST GALL.

Plans

The relative age of the different parts of a building is indicated by the shading: dark for the older parts, light for the later.

For some monuments it has not been possible to indicate the orientation.

For commentaries, see the corresponding numbers in the List of Illustrations.

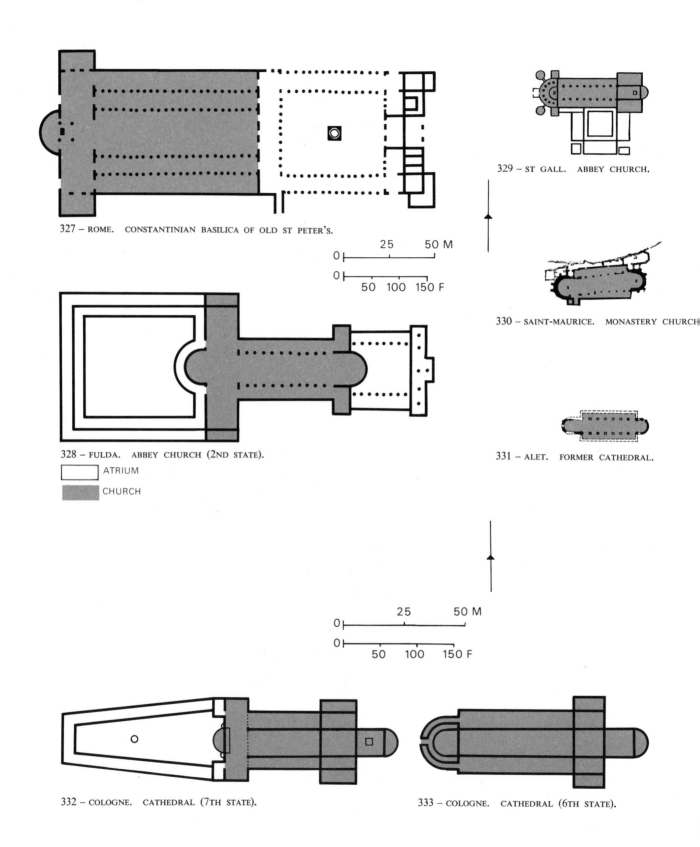

327 – ROME. CONSTANTINIAN BASILICA OF OLD ST PETER'S.

329 – ST GALL. ABBEY CHURCH.

328 – FULDA. ABBEY CHURCH (2ND STATE).

ATRIUM

CHURCH

330 – SAINT-MAURICE. MONASTERY CHURCH

331 – ALET. FORMER CATHEDRAL.

25 50 M

50 100 150 F

332 – COLOGNE. CATHEDRAL (7TH STATE).

333 – COLOGNE. CATHEDRAL (6TH STATE).

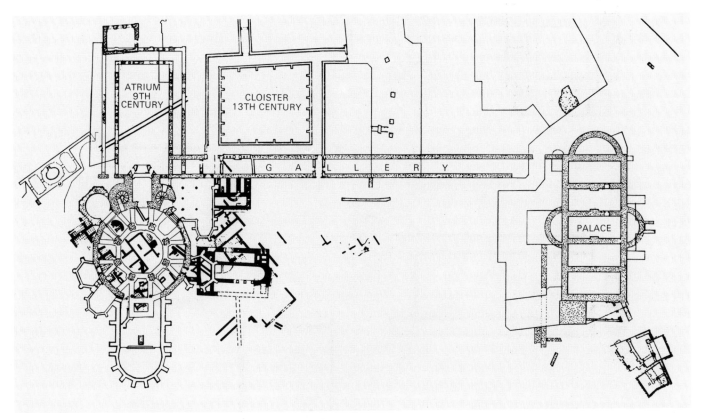

334 – AACHEN. OVERALL PLAN OF THE 1911 EXCAVATIONS.

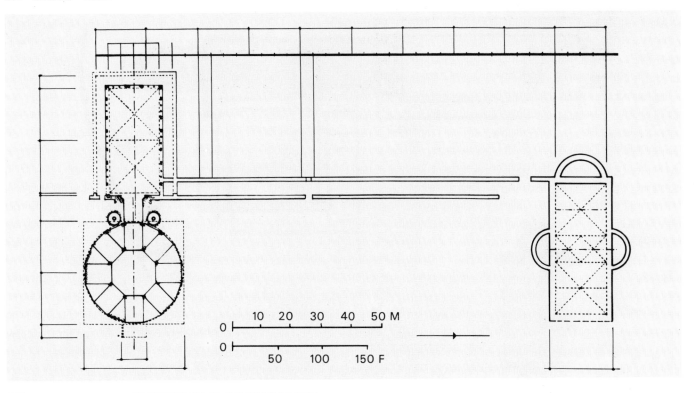

335 – AACHEN. PALACE, RECONSTRUCTION OF THE MODULAR GRID.

336 A AND B – LORSCH. FIRST ABBEY: PLAN AND ELEVATION.

```
              10   20   30   40   50 M
0├────┼────┼────┼────┼────┤
0├──────┼──────┼──────┤
              50       100     150 F
```

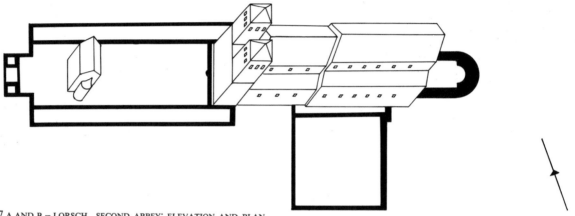

337 A AND B – LORSCH. SECOND ABBEY: ELEVATION AND PLAN.

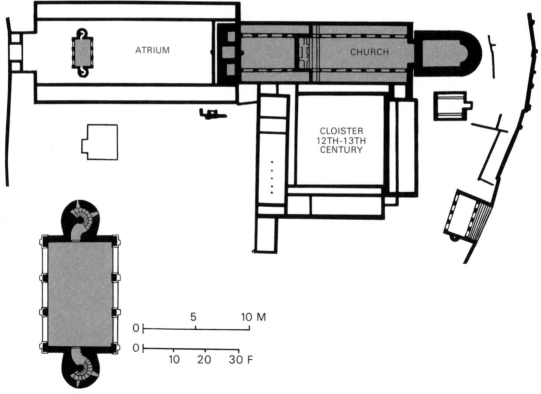

```
            5        10 M
0├────┼────┤
0├──────┼──────┼──────┤
     10    20    30 F
```

338 – LORSCH. ABBEY GATEWAY.

339–340–341 – SAINT-RIQUIER. TWO VIEWS OF THE MONASTERY FROM 17TH CENTURY ENGRAVINGS AND EXCAVATION PLAN.

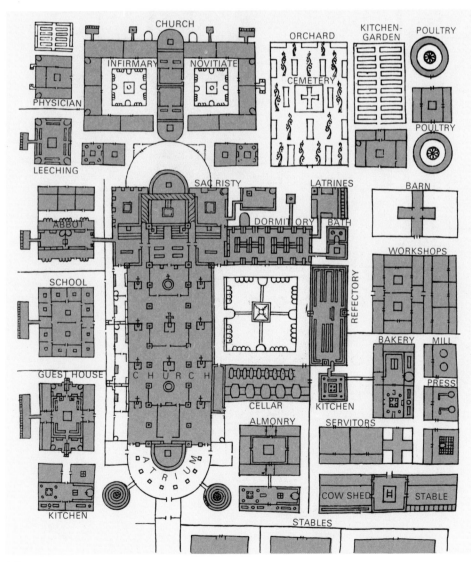

342 – ST GALL. PLAN FOR A PROJECTED RECONSTRUCTION OF THE ABBEY, DETAIL.

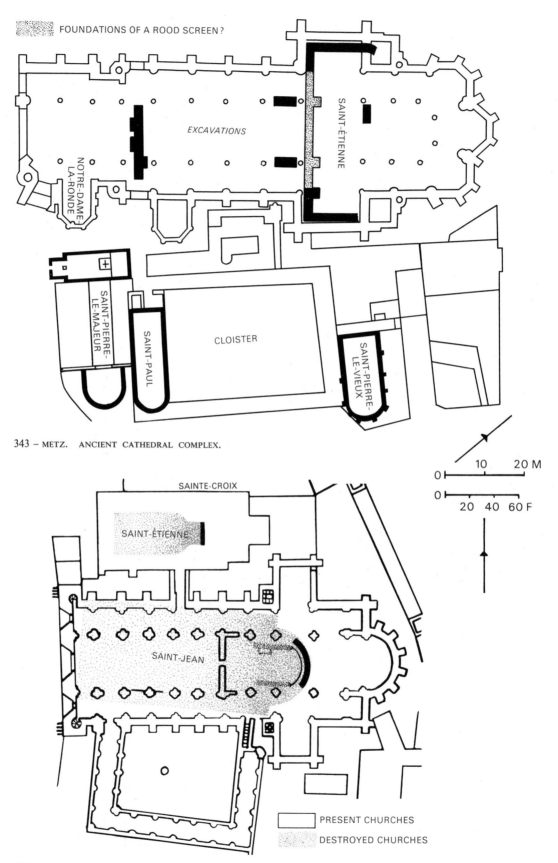

FOUNDATIONS OF A ROOD SCREEN?

SAINT-ÉTIENNE

NOTRE-DAME-LA-RONDE

EXCAVATIONS

SAINT-PIERRE-LE-MAJEUR

SAINT-PAUL

CLOISTER

SAINT-PIERRE-LE-VIEUX

343 – METZ. ANCIENT CATHEDRAL COMPLEX.

SAINTE-CROIX

SAINT-ÉTIENNE

SAINT-JEAN

0 10 20 M

0 20 40 60 F

PRESENT CHURCHES

DESTROYED CHURCHES

344 – LYONS. ANCIENT CATHEDRAL COMPLEX.

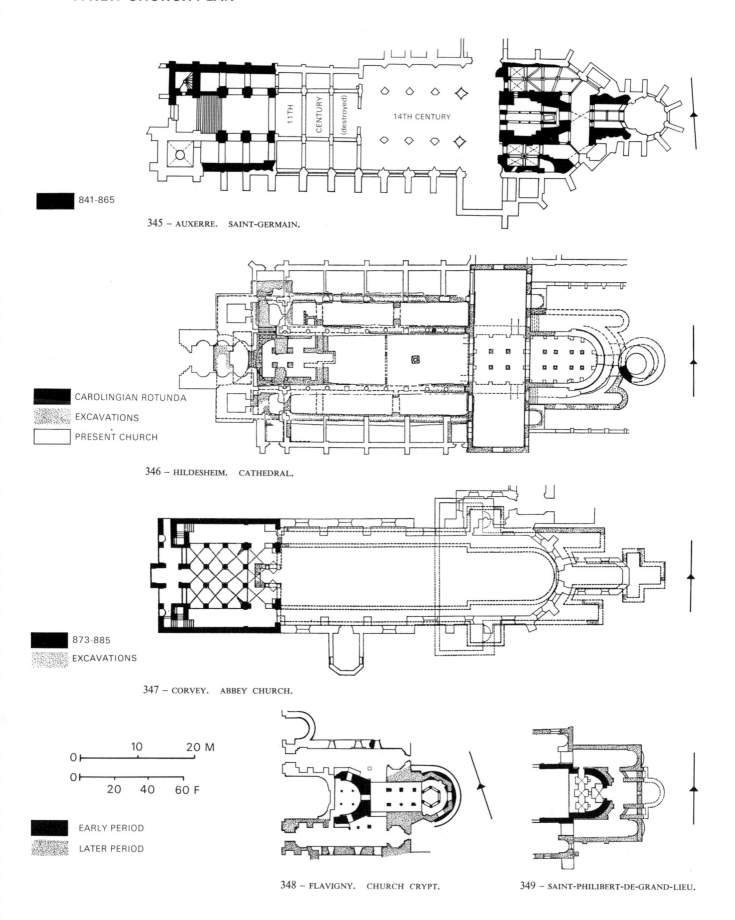

841-865

345 – AUXERRE. SAINT-GERMAIN.

11TH CENTURY (destroyed)

14TH CENTURY

CAROLINGIAN ROTUNDA

EXCAVATIONS

PRESENT CHURCH

346 – HILDESHEIM. CATHEDRAL.

873-885

EXCAVATIONS

347 – CORVEY. ABBEY CHURCH.

10 20 M
0

0
20 40 60 F

EARLY PERIOD

LATER PERIOD

348 – FLAVIGNY. CHURCH CRYPT.

349 – SAINT-PHILIBERT-DE-GRAND-LIEU.

350 – MÜSTAIR. JOHANNESKIRCHE.

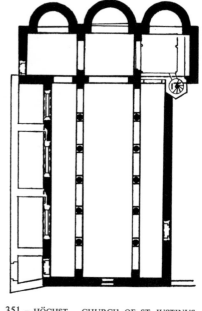

351 – HÖCHST. CHURCH OF ST JUSTINUS.

352 – CHUR. CHURCH OF ST LUCIUS.

5 10 M
0
0
10 20 30 F

■ EARLY PERIOD
▨ LATER PERIOD

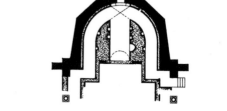

353 – RAVENNA. SANT'APOLLINARE NUOVO, CRYPT.

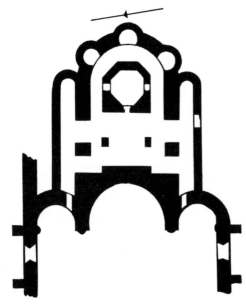

354 – SENS. SAINT-PIERRE-LE-VIF, CRYPT.

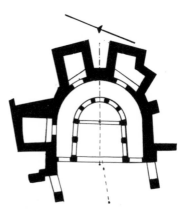

355 – SAINT-MAURICE. CHURCH.

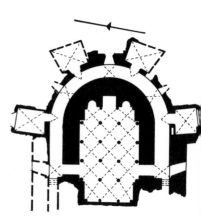

356 – CLERMONT-FERRAND. CATHEDRAL.

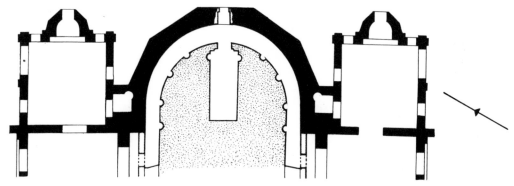

357 – RAVENNA. SANT'APOLLINARE IN CLASSE, CRYPT.

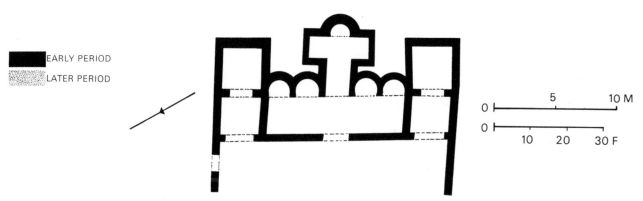

▮ EARLY PERIOD
▨ LATER PERIOD

```
          5              10 M
0 ┝━━━━━━━┿━━━━━━━━┥
0 ┝━━━━━━━┿━━━━━━━━┥
      10     20    30 F
```

358 – BOLOGNA. SAN STEFANO.

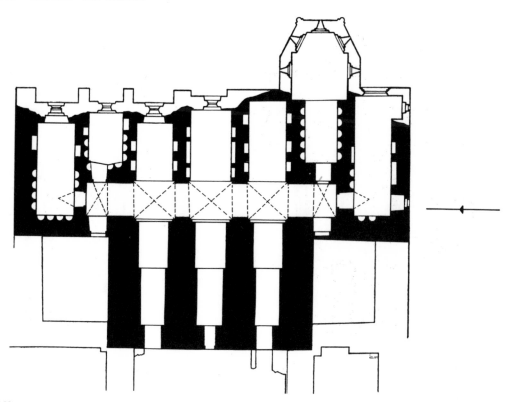

359 – SOISSONS. ABBEY CHURCH OF SAINT-MÉDARD, CRYPTS.

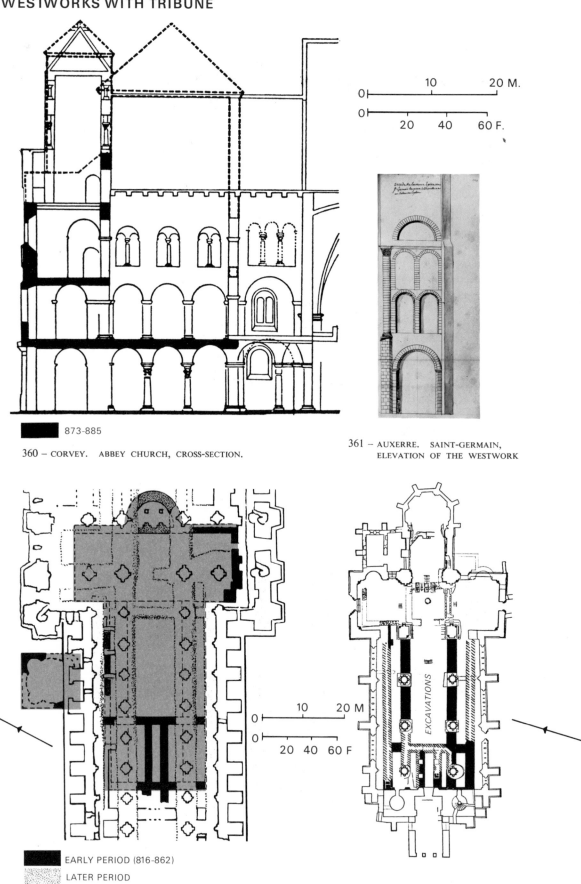

873-885

360 – CORVEY. ABBEY CHURCH, CROSS-SECTION.

361 – AUXERRE. SAINT-GERMAIN,
ELEVATION OF THE WESTWORK

10 20 M.

20 40 60 F.

EARLY PERIOD (816-862)

LATER PERIOD

362 – REIMS. CAROLINGIAN CATHEDRAL.

363 – MINDEN. CATHEDRAL.

EXCAVATIONS

10 20 M

20 40 60 F

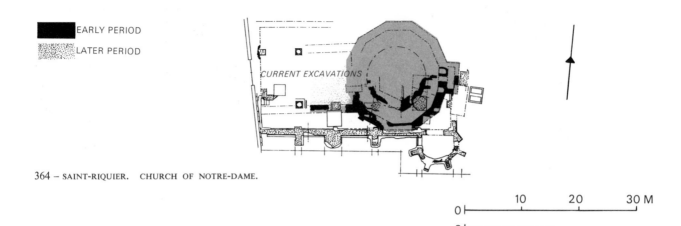

EARLY PERIOD

LATER PERIOD

CURRENT EXCAVATIONS

364 – SAINT-RIQUIER. CHURCH OF NOTRE-DAME.

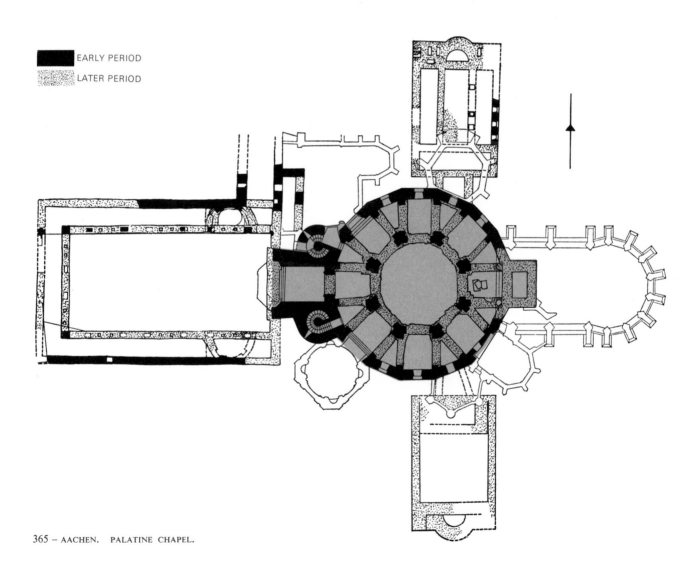

EARLY PERIOD

LATER PERIOD

365 – AACHEN. PALATINE CHAPEL.

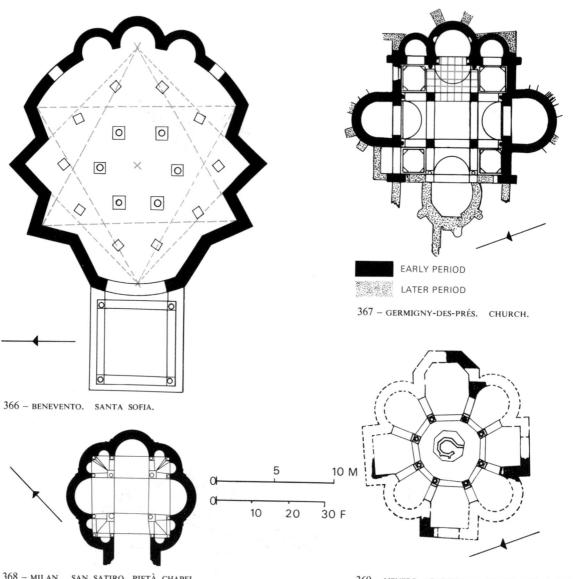

366 – BENEVENTO. SANTA SOFIA.

367 – GERMIGNY-DES-PRÉS. CHURCH.

■ EARLY PERIOD

░ LATER PERIOD

5 10 M

10 20 30 F

368 – MILAN. SAN SATIRO, PIETÀ CHAPEL.

369 – NEVERS. BAPTISTERY UNDER THE CATHEDRAL.

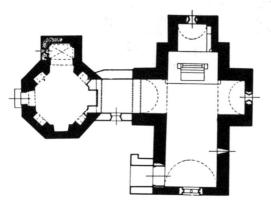

370 – SETTIMO VITTONE. SAN LORENZO AND ITS BAPTISTERY.

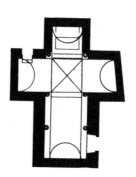

371 – BARDOLINO. SAN ZENO.

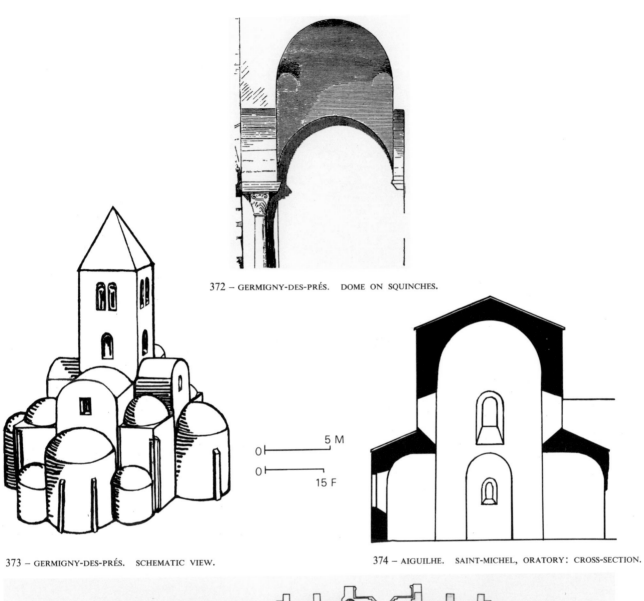

372 – GERMIGNY-DES-PRÉS. DOME ON SQUINCHES.

373 – GERMIGNY-DES-PRÉS. SCHEMATIC VIEW.

5 M

0

0

15 F

374 – AIGUILHE. SAINT-MICHEL, ORATORY: CROSS-SECTION.

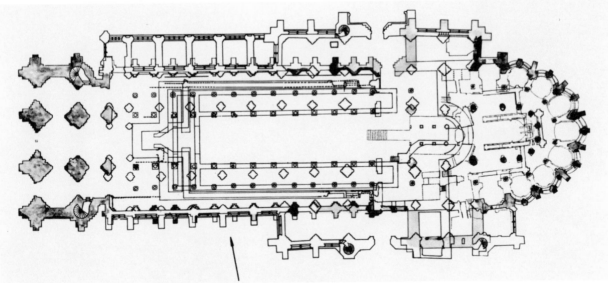

375 – SAINT-DENIS. FORMER ABBEY CHURCH, AFTER THE EXCAVATIONS OF JULES FORMIGÉ.

305

List of Manuscripts Reproduced

The numbers in italics refer to the illustrations in this book.

Chronological Table

	EVENTS	WORKS OF ART
700		

711–713. Arab conquest of Spain.

716–754. St Boniface founds and organizes the Church of Germany.

712–744. *Ciborium* of Valpolicella (inscription).

731–741. In Rome Pope Gregory III places six columns of onyx in front of the *confessio* of St Peter's.

732–735. Charles Martel halts the Arab invasion of Gaul and subjugates Aquitaine.

739–740. At the abbey of San Pietro in Valle, near Ferentillo, stone slab with figure reliefs, inscribed with the name of Duke Hildericus.

About 740. Altar given by Duke Ratchis to the church of San Martino at Cividale (inscription).

742. Carloman calls on St Boniface to reform the Frankish clergy. Birth of Charlemagne.
742–766. St Chrodegang bishop of Metz.

743–751. Reign of Childeric III, last Merovingian king.

744. Founding of the monastery of Fulda by Sturm, a disciple of St Boniface.

744. Tomb of St Cumian at Bobbio.

749. Founding of the monastery of Gorze in the diocese of Metz.

About 750. Construction of the abbey of Fulda. Gold cover of the Lindau Gospels.

751–768. Reign of Pepin, crowned king at Soissons by St Boniface.

752. Stephen II becomes pope. Aistulf attacks the papal state.

752–757. In Rome Pope Stephen II adds a bell tower to St Peter's.

753–754. Stephen II crosses the Alps and crowns Pepin at Saint-Denis. Pepin's campaign against the Lombards.

754. Pope Stephen II consecrates the abbey church of Saint-Denis, restored by Fulrad, abbot since 749. Gundohinus Gospels.

About 754. St Chrodegang, bishop of Metz, draws up a new rule for the clergy of his cathedral, regulating their common life as canons. The Church of Metz adopts the Roman liturgy.

756. Siege of Rome by Aistulf. Pepin leads as new expedition into Italy. Death of Aistulf.

757–774. Desiderius succeeds Aistulf as king of the Lombards.

760. Great Mosque of Baghdad.

About 760. From Rome Pope Paul I sends King Pepin the *Antiphonary* and the *Responsorial*, urging him to adopt the Roman liturgy for the Church of Gaul.

761–771. Iconoclast controversy.

762–c. 786. Altar in Cividale cathedral inscribed with the name of the patriarch Sigwald.

763. Construction of the first monastery of Lorsch.

765, 797 and 802. French embassies to Baghdad.

Before 768. Church of Santa Sofia at Benevento.

768. Death of Pepin. Crowning of Charlemagne at Noyon and of Carloman at Soissons. Arab embassy to Gaul.
768–772. Pontificate of Pope Stephen III.

769. The Lateran synod condemns the iconoclasts.

About 769. Founding of the abbey of Brantôme.

771. Death of Carloman. Charlemagne reigns alone.

772. Founding of the abbey of Kremsmünster.
772–774. Desiderius invades the papal state and assumes the title of Patrician of the Romans. Charlemagne besieges Pavia. He proclaims himself king of the Lombards. He pays his first visit to Rome.
772–795. Pontificate of Pope Adrian I.

772–795. In Rome, under Pope Adrian I, six silver-plated images are placed on the doors of St Peter's: Christ between the archangels Michael and Gabriel, and the Virgin between St Andrew and St John. The church of Santa Maria in Cosmedin rebuilt. A Psalter written by Dagulf is given to the pope.

	EVENTS	WORKS OF ART
775		775. Dedication of the abbey church of Saint-Denis in the presence of the king and the court. 775–800. Tomb of St Pontius at Cimiez, near Nice (inscription). 777. A second monastery built at Lorsch on a more suitable site, a short distance from the first. After 777. The palace of Nijmegen built for Charlemagne.
	778. Charlemagne in Spain. Roncevaux. Founding of the abbeys of Lagrasse and Arles-sur-Tech. 779–780. Expeditions to Saxony. Founding of the abbey of Cormery.	
		About 780. Epitaph of St Vultchaire at Saint-Maurice d'Agaune.
	781–782. Charlemagne spends Easter in Rome. He summons Theodulf and Alcuin to Gaul. About 782. Founding of the abbeys Aniane and Charroux.	781–783. Godescalc Gospels. After 783. Dagulf Psalter.
	785. Conquest of Saxony. Charlemagne demands tribute from the subjects of the papal state.	785. Work begins on the Great Mosque of Cordova. About 785. Ada Gospels.
	787. Charlemagne at Capua and Benevento. Creation of the Saxon bishoprics. The second council of Nicaea decides in favour of images. 787–789. Charlemagne provides for the establishment of monastic and cathedral schools. 788. Conquest of Istria.	787. At Ingelheim, near Mainz, Charlemagne begins construction of a palace, which Louis the Pious had finished and decorated with paintings. 788–821. The two Bibles of Theodulf. About 788. Marble tomb of Archbishop Gratiosus at Ravenna.
	789. *Admonitio generalis* of Charlemagne for the extension of the Roman liturgy introduced into Gaul by his father Pepin. 790–792. The *Libri carolini*.	790–799. Reconstruction of the abbey of Saint-Riquier at Centula by Angilbert. 790–800. Coronation Gospels, Aachen Gospels, Xanten Gospels. 790–819. Enlargement of the abbey church of Fulda. About 790. The abbey of Moyenmoutier orders a metal reliquary shrine for the remains of St Hidulf. About 790-after 800. Construction of Charlemagne's palace and chapel at Aachen.
	791. Evangelization of Pannonia. 791–796. War against the Avars. Revolt of north Saxony. About 791. Angilbert made councillor of Charlemagne and abbot of Saint-Riquier. First raids by the Northmen in England. After 791. Einhard at the court of Charlemagne.	791. Epitaph of Bishop Arricius (Musée de l'Ariège, Foix). 794–808. Aaron, bishop of Auxerre, raises a gold and silver *ciborium* over the main altar of the cathedral of St Stephen. 795. Epitaph of Pope Adrian I, engraved at Charlemagne's behest.
	795–816. Pontificate of Pope Leo III. 796–804. Alcuin abbot of Saint-Martin at Tours where he lives from 801. About 797. Death of Paul the Deacon, author of the *History of the Lombards*. Before 798–821. Theodulf abbot of Saint-Benoît-sur-Loire and bishop of Orléans about 799.	796–816. At Porto, near the mouth of the Tiber, stone *ciborium* with inscription and interlace designs. About 798. In Rome Pope Leo III places bronze doors at the entrance to the *confessio* of San Paolo fuori le Mura.

EVENTS	WORKS OF ART
	799. Consecration of the palace church at Nijmegen. 799–814. Leidrad, archbishop of Lyons, rebuilds the church of the Saints-Apôtres, later dedicated to Saint Nizier.
799–816. Leidrad, friend of Alcuin and Theodulf, and *missus* of Charlemagne, is bishop of Lyons.	
	799–after 816. Construction of the cathedral of Saint-Jean at Lyons by Archbishop Leidrad and his successor Agobard 799–818. Construction at Germigny-des-Prés of the villa and the oratory of Theodulf, bishop of Orléans and abbot of Fleury (Saint-Benoît-sur-Loire). The dedication of the oratory apparently took place in 806.
800 800. Charlemagne crowned emperor in Rome by Pope Leo III. Capitulary *De Villis*.	
About 800. Founding of the abbeys of Caunes, Chanteuges, Cruas, Montolieu and Saint-Savin-sur-Gartempe.	About 800. Cutbercht Gospel Book. Mondsee Psalter. Codex Millenarius. Work begins on Cologne Cathedral under Archbishop Hildebold. Stone *ciborium* in the Cortona museum with inscription and reliefs. Wooden cart from the Oseberg Ship Burial preserved in Oslo museum. Marble cross with inscription and vine scrolls in the church of San Giovanni in Monte at Bologna.
801. Expedition to Dalmatia. Capture of Barcelona.	
About 801–after 817. Magnus, one of the *missi* of Charlemagne, is bishop of Sens.	
804. Founding of the abbey of Gellone. Death of Alcuin.	
805–806. Conquest of Bohemia.	
807. Harun al-Rashid gives the Franks right of access to the holy places.	
	807–824. Under Angelelme, bishop of Auxerre, the altars of the cathedral complex, Saint-Etienne, Notre-Dame and Saint-Jean, are plated with silver. 807–830. Wolfcoz Psalter.
809–812. Conquest of Venetia and of the Spanish March.	
810. Frisia ravaged by Danish raiders.	810. *Ciborium* with inscription, interlace designs and vine scrolls in Sant'Apollinare in Classe, Ravenna. About 810. St Gall Psalter.
813–c. 847. Frothaire bishop of Toul.	
814. Death of Charlemagne. Death of Angilbert. Founding of the abbey of Cornelismünster, near Aachen. 814–821. The abbey of Noirmoutier and the Isle of Ré repeatedly ravaged by the Northmen.	
814–840. Reign of Louis the Pious.	814–826. Construction of the church of Saint-Quentin.
816. Statute of Aachen permitting cathedral canons to have separate dwellings within the chapter precincts.	
	816–827. Pictures of Louis the Pious, Pope Stephen IV and Archbishop Ebbo on the pediment of Reims Cathedral. Inscription commemorating the coronation of the emperor by the pope. 816–837. The 'St Gall plan,' a project for the reconstruction of the St Gall monastery drawn on parchment, is sent to Abbot Gozbert.
816–840. Agobard bishop of Lyons.	816–841. Construction of the crypts of Saint-Médard at Soissons. 816–862. Construction of Reims Cathedral.
817. Louis the Pious makes Einhard the preceptor of his son Lothair. 817–824. Pontificate of Pope Pascal I.	817–824. Several churches in Rome are enriched with mosaics and goldwork by Pope Pacal I. Chapel of San Zeno in the church of Santa Prassede, Rome.
After 817–828. Jeremiah, former chancellor of Charlemagne, is bishop of Sens.	
818. Hinduin abbot of Saint-Denis.	

EVENTS	WORKS OF ART
	About 819. The monks of Noirmoutier, harassed by Norse raiders, move to their villa at Déas and there rebuild the church.
820. The Northmen appear at the mouth of the Seine.	820–822. Construction of the church of St Michael, on a circular plan, at the abbey of Fulda.
	820–830. Utrecht Psalter.
	About 820. Construction of the abbey church of Charroux with the help of Louis the Pious. Ebbo Gospels.
Before 821. Einhard's *Vita Karoli (Life of Charlemagne)*.	821–828. Aldric, abbot of Ferrières, builds the church of Saint-Pierre.
821. Death of Benedict of Aniane and Theodulf.	821–c. 840. Reliquary in the form of a triumphal arch given by Einhard to the abbey of St Servatius at Maastricht.
About 822. Founding of the monasteries of Corvey and Herford in Westphalia.	Before 823. Abbot Hilduin builds at Saint-Médard of Soissons an oratory dedicated to the Trinity, the Virgin and all saints.
823. Birth of Charles the Bald. Coronation of Lothair I by Pope Pascal I.	823-833. Reconstruction of the abbey of Fontenelle (later Saint-Wandrille) by Abbot Ansegisus.
823-855. Drogo, a natural son of Charlemagne, is bishop of Metz.	
About 823. *De ecclesiasticis officiis* by Amalarius.	
824. The poet Ermoldus Nigellus exiled to Strasbourg.	824–835. Gold altar *(paliotto)* given to the church of Sant'-Ambrogio of Milan by Bishop Angilbert II.
	824–857. Heribald, bishop of Auxerre, restores the cathedrals of Saint-Étienne and Notre-Dame. He erects the baptistery in which he deposits the relics of the martyrs Alexander and Chrysanthus, which he had brought back from Rome. Saint-Étienne was decorated with 'very fine paintings' and stained-glass windows.
827. Einhard writes his account of the transfer of the relics of Sts Marcellinus and Peter from Rome to Gaul. He founds the abbey of Seligenstadt.	827. Marble cross with inscription and vine scrolls in the church of Budrio. A modern copy in stone is in the Museo Civico at Bologna.
827-844. Pontificate of Pope Gregory IV.	
Before 828. Founding of the monastery of Schänis.	
828. Founding of the abbey of Saint-Genou.	828. Work on the royal palace at Gondreville, near Toul, by order of Frothaire, bishop of Toul.
829-836. Aldric, *praeceptor palatii* and abbot of Ferrières, is bishop of Sens.	
830. Revolt of the sons of Louis the Pious.	830. The monastery of Noirmoutier fortified against the Norse raiders.
831. Louis the Pious regains power.	831-832. Dedication of the church of Saint-Sauveur at Saint-Martial of Limoges in the presence of Louis the Pious.
	831-840. Construction of the church of Seligenstadt.
About 831. Founding of the abbey of Saint-Sauveur at Redon.	832. Dedication to the Virgin, St John and all saints of a two-storey oratory in the apse of the abbey church of Saint-Denis.
832-833. The sons of Louis the Pious again in revolt.	
832-857. Aldric, confessor of Louis the Pious, is bishop of Le Mans.	Before 833. Abbot Ansegisus gives a silver altar slab with figure reliefs to the abbey church of Saint-Germer; to the abbey of Luxeuil he gives a silver altar frontal and a silver cross.
	833-835. At Le Mans Bishop Aldric builds the cathedral churches of Saint-Étienne and Saint-Sauveur (Holy Saviour), the latter also being dedicated to the Virgin. A large gold and silver crucifix is set up at the entrance to the choir of the latter church.
	834-843. Tours Bible.
	835 and 845. Relics of St Quentin transferred to the crypt of the church of Saint-Quentin by Abbot Hugh, a natural son of Charlemagne. Ten years later the body of St Cassian is deposited in the same crypt by Wenilon, archbishop of Sens.

825

EVENTS	WORKS OF ART
836. Consecration of the church of St Castor of Koblenz by Hetti, archbishop of Trier.	836. Harassed by the Northmen, the monks of Noirmoutier remove the relics of St Philbert to Déas.
	836–853. Rebuilding of the choir of the Déas church at Saint-Philbert-de-Grand-Lieu.
838. Coronation of Charles the Bald. Death of Pepin of Aquitaine. The Saracens devastate Marseilles.	
After 838. Death of Ermoldus Nigellus.	
839. New division of the empire.	
840. Death of Louis of Pious. Death of Einhard at Seligenstadt. Beginning of the Danish invasions of England.	840. Epitaph of Adelberge at Saint-Martin of Tours.
840–877. Reign of Charles the Bald.	840–877. Gold altar given to Saint-Denis by Charles the Bald.
	About 840. Moûtier-Grandval Bible.
841. Norse raid on the port of Quentovic and destruction of the abbey of Jumièges.	841–865. Construction of the crypts and westwork of Saint-Germain of Auxerre on the initiative of Count Conrad, uncle of Charles the Bald.
842. The oath of Strasbourg, cementing the alliance of Charles the Bald with his brother Louis the German, to resist the pretensions of Lothair I. Arles sacked by the Saracens.	842–852. Construction of the Great Mosque of Samarra.
	842–869. Psalter of Charles the Bald.
843. Treaty of Verdun. Nantes sacked and the abbey of Indret wrecked by the Northmen. The monks leave Vertou. Final destruction of the port of Quentovic.	
About 844. The abbeys of Condom in Aquitaine and Saint-Josse in the Canche valley destroyed by the Northmen.	
845. Norse invaders destroy Centula and the basilica of St Geneviève in Paris. Exodus of the monks from Saint-Germain-des-Prés in Paris to Coulainville in the Brie region. Saint-Germain-des-Prés sacked by the Northmen. The monks of Saint-Philbert-de-Grand-Lieu take refuge at Cunault.	After 844. Drogo Sacramentary.
845–882. Hincmar archbishop of Reims.	845–882. Hincmar gives to Reims Cathedral a gold altar with an inscription and an image of the Virgin and Child. He also has the tomb of St Remi embellished with goldwork, enamels and precious stones, including an engraved gem representing the baptism of Christ.
	846. The monks of Saint-Bertin prepare to defend the abbey against the Northmen, and the neighbouring town, Saint-Omer, is fortified.
	About 846. First Bible of Charles the Bald (Vivian Bible).
847–855. Pontificate of Pope Leo IV.	847–855. In Rome Pope Leo IV repairs the damage by the Saracens in St Peter's and San Paolo fuori le Mura. He enriches St Peter's with a gold antependium with reliefs showing the Resurrection, his own portrait and that of the Emperor Lothair I.
848. The monastery of La Réole destroyed by the Northmen.	848–857. Lothair Gospels.
849. Death of the poet and theologian Walafrid Strabo.	
849–850. Saracen raids in Provence.	
850. The monastery of St Bavo in Ghent destroyed by Norse raiders.	850. Dedication of the church of Montier-la-Celle, near Troyes, whose westwork consisted of two vaulted storeys.
	About 850. Metz Sacramentary. Prüm Gospel Book. Bertha of Aquitaine gives to Lyons Cathedral an altar cloth adorned with a pascal lamb and inscriptions.
851. The abbey of Fontenelle (Saint-Wandrille) destroyed by Norse raiders.	851. The ramparts of Angers are rebuilt in anticipation of a Norse attack.
	852. Dedication of Saint-Remi of Reims, whose crypt 'of the finest workmanship,' was built to the order of Archbishop Hincmar.
853. The Northmen ruin the abbey of Saint-Germer, near Beauvais, and the abbey of Saint-Florent, near Saumur. Angers, Poitiers and Tours devastated. The relics of St Martin transferred to Cormery, then to Orléans. The monks of Saint-Philbert-de-Grand-Lieu move again, first to Messay, then to Saint-Jean-sur-Mayenne.	852–876. Construction of Hildesheim Cathedral.
855. Death of the Emperor Lothair I. Founding of the abbey of Beaulieu-sur-Dordogne.	855. The St Gall monastery fortified against the Northmen.

850

EVENTS	WORKS OF ART
	855–858. In Rome Pope Benedict III sets up in St John Lateran a gold and silver figure of the Redeemer trampling a lion and a dragon under foot.
856. Orléans sacked by the Northmen. The monks of Saint-Martin of Tours take refuge at Léré. Paris attacked by the Northmen. Exodus of the monks of Saint-Germain-des-Prés to Combs-la-Ville. 856–875. The relics of St Foy brought to Conques.	
857. The relics of St Wandrille brought to Saint-Omer. Destruction of the monastery of Saint-Cyprien at Poitiers. The bishop of Chartres, Frotbaldus, slain by the Northmen.	857–860. Bishop Abbo of Auxerre adds a west bell tower to the cathedral of St Stephen; it is finished later under Bishop Christianus (860–873).
858. Translation of the relics of the martyrs George, Aurelius and Natalia from Cordova to Saint-Germain-des-Prés. 858–867. Pontificate of Pope Nicholas I.	
859. The monks of Saint-Germain-des-Prés take refuge at Nogent-sur-Seine. 859–860. Expedition of the Norse sea rovers around the coast of Spain. In Roussillon they destroy the monastery of Arles-sur-Tech. Transfer of the relics of St Maixent to Ebreuil, then to Autun and, about 868, to Brittany.	About 860. Tower of the abbey church of Saint-Bertin rebuilt. Psalter of Folchard.
861. Saint-Germain-des-Prés and Saint-Maur-des-Fossés sacked by the Northmen. The monks of Saint-Germain-des-Prés take refuge at Nogent-l'Artaud, those of Ferrières at Auxerre.	
862. Saint-Faron of Meaux wrecked by the Northmen. Death of Lupus (Loup) of Ferrières. The monasteries of Glanfeuil and Saint-Florent sacked. First Hungarian raids in Germania.	862. At Auxerre transfer of the relics of the bishop St Amator (Amâtre) to a recently built crypt. 862–864. Construction of the church and crypt of the monastery of Maxent by Duke Solomon.
863. The abbey of Saint-Cybard at Angoulême destroyed and Poitiers sacked. Founding of the abbey of Pothières. 863–864. Charles the Bald in Aquitaine. Norse raiders penetrate inland as far as Clermont. Transfer of the body of St Regina to Flavigny. Assembly of Pistes (Pîtres). Defensive measures against the Northmen.	863–875. Thiotrod, abbot of Lorsch, builds the church of St Michael on the Heiligenberg, near Heidelberg. About 864. The existence at this time of stained-glass windows with figure scenes is proved by a passage in the *Life of St Ludger*.
865. The abbey of Saint-Benoît-sur-Loire sacked	
866. Death of Robert the Strong.	866–910. Reliquary shrine given to Astorga Cathedral by Alfonso III the Great, king of Asturias.
867–872. Pontificate of Pope Adrian II.	
868. Founding of the abbey of Altrip in the diocese of Trier. Driven from his see by the Northmen, Actard, bishop of Nantes, takes refuge at Thérouanne.	About 868. Psalter of Charles the Bald.
869. Death of Lothair II. Roland, bishop of Arles, is captured by the Saracens and dies.	869. The monastery of Saint-Denis fortified against the Northmen. A large crucifix given by Duke Solomon to the abbey of Saint-Sauveur at Redon. Ramparts of Le Mans, Tours and Dijon rebuilt to defend the towns against the Northmen. 869–891. San Callisto Bible. About 869. Second Bible of Charles the Bald. About 870. Gospel Book (Codex Aureus) of St Emmeram of Regensburg. Portable altar *(ciborium)* given by the Emperor Arnulf to the abbey of St Emmeram, Regensburg. 871. Epitaph of Amelius at Saint-Hilaire-le-Grand of Poitiers. 871–880. The church of Saint-Bénigne at Dijon rebuilt by Abbot Isaac.
872. Angers attacked by the Northmen. 872–882. Pontificate of Pope John VII.	873. Epitaph with interlace designs of Bernoin, bishop of Viviers, at Bourg-Saint-Arnoul. 873–885. Construction of the abbey church at Corvey.
About 873. The monks of Corbon, in the Perche district, take refuge at Blois with the body of St Laumer.	874. The ramparts of Autun rebuilt.

EVENTS	WORKS OF ART

875

875. Charles the Bald crowned emperor in Rome. Louis the German invades France. The abbey of Saint-Valérien at Tournus given by Charles the Bald to the monks of Saint-Philbert-de-Grand-Lieu.

876. Charles II king of Italy. Death of Louis the German, whose kingdom is attacked by Charles. The Seine valley invaded for the seventh time by the Northmen. Frothair, bishop of Bordeaux, takes refuge at Bourges.

877. A collegiate church served by a hundred clerics is founded near the royal palace at Compiègne. Capitulary of Quiersy. Charles the Bald in Italy. His death.
877–879. Reign of Louis II the Stammerer.

878. Carloman king of Italy. Pope John VIII in France seeking aid against the Hungarians. Founding of the abbey of Saint-Michel de Cuxa.

879–882. Death of Louis the Stammerer, who is succeeded by Louis III and Carloman. The Northmen attack Ghent. The relics of St Vaast (Vedastus) taken to a place of safety. Part of the Low Countries occupied by the Northmen. Burning of the church of St Vaast at Arras and the abbey of Péronne.

About 880. Founding of the abbey of Andlau.

881. Charles the Fat emperor. The abbey of Centula (Saint-Riquier) again destroyed by the Northmen. They devastate the Boulonnais and Ponthieu districts and the Scarpe valley. They attack Liège, Cologne, Bonn and Aachen, whose treasure is removed to Stavelot.

882. Death of Hincmar of Reims. Sacking of the abbeys of Liessies, Saint-Ghislain, and St Maximin of Trier.
882–885. Norse raiders in the Rhineland. They are defeated by the Franconian count, Henry.
882–890. Many monasteries in Brittany sacked by the Northmen; the monks take refuge in the Berry region.

883. Destruction of the monasteries of Saint-Quentin, Arras, Montierender and Saint-Loup of Troyes.

884. Death of Carloman. Charles the Fat, son of Louis the German, is elected king.

885–886. Paris besieged by the Northmen.
885–891. Pontificate of Pope Stephen V.

886. The monasteries of Saint-Germain of Auxerre, Bèze, Dijon and Flavigny wrecked by the Northmen. The bishop of Nantes takes refuge at Angers.
886–888. The suburbs of Sens and the Champagne region devastated by the Northmen.

887. Charles the Fat deposed. Odo (Eudes), duke of France, is elected king.

888. Odo crushes the Northmen at Montfaucon.

889–891. The Northmen attack the Rhineland. They are defeated at Louvain by Arnulf.

About 890–972. The Saracens occupy Fraxinetum (La Garde-Freinet) in Provence.

891. New Norse incursions in the valley of the Somme.

875. Charles the Bald founds the town of Carlopolis near his palace at Compiègne. Arras fortified against the Northmen.

876. Epitaph on slate of Ghiswaal at Bazouges.

878. Fortification of Compiègne. Consecration of the abbey church of Flavigny by Pope John VIII.

879. The defences of the monastery of Saint-Bertin are stengthened.

879–887. Wibald, bishop of Auxerre, builds a two-storey sanctuary at the west end of St Stephen's Cathedral.

About 879. Construction of the oratory of San Satiro, Milan.

880–886. *Homilies* of St Gregory Nazianzen.

882. Epitaph of Bishop Anspertus at Sant'Ambrogio, Milan.

883. Fortification of Soissons.

About 885. Restoration of the abbey church of St Martin, Autun.

886. Fortification of the monastery of Saint-Quentin.
886–887. The ramparts of Angoulême and Langres rebuilt.

About 886. Reconstruction of the church of Saint-Geosmes, of which a closure slab with interlace designs has survived.

Before 887. Reliquary bust of St Maurice given to Vienne Cathedral by Boso, king of Provence.

887–909. Herifrid, bishop of Auxerre, has an altar cloth made for his cathedral, brocaded in gold in the Phrygian manner.

889–890. Fortification of the monasteries of Vézelay, Tournus and Corbie.

About 890. Theodard, bishop of Narbonne, provides his cathedral with a life-size crucifix of gold and silver and an altar of 'purest marble.'

EVENTS	WORKS OF ART
892. The monastery of Prüm destroyed by the Northmen. The monks of Stavelot take refuge at Sélestat. 892–923. Reign of Charles III the Simple, son of Louis II; Charles is deposed in 922 and replaced by Robert, brother of Odo (Eudes), duke of France, then by Rudolph (Raoul), brother-in-law of Hugh the Great. 894. Founding of the abbey of St Peter and St Paul at Aurillac by Count Giraldus. 897. Assassination of Pope Stephen VI.	892. Town walls of Troyes rebuilt. After 897–c. 910. Nantes Cathedral, destroyed by the Northmen, is rebuilt and fortified by Bishop Fulcherius. 898–922. Marble altar slab of Capestang dated by an inscription to the reign of Charles the Simple.
899. First Hungarian raid in Lombardy and Venetia. From 899 to 955 there were thirty-five Hungarian incursions into Italy. 900. Bavaria invaded by the Hungarians.	900. Fortification of the monastery of St Columba near Sens. Epitaph of Argrimus, bishop of Langres. 900–922. Gold altar of Saint-Remi of Reims, representing Christ with two donors at his feet, Archbishop Herveus and Fulk, his predecessor. About 900. Reconstruction of the church of St Aphrodisius at Béziers by the vicount of Béziers
903. Pontificate of Pope Leo V. 906–910. The Hungarians destroy the Moravian state and ravage southern Germany. 910. The abbey of Cluny founded by Duke William of Aquitaine. About 910. Founding of the abbey of Souillac. 911. Treaty of Saint-Clair-sur-Epte. 912–913. The Hungarians ravage Swabia and Franconia. They are defeated by the Bavarians. 914–928. Pontificate of Pope John X. About 914. Founding of the abbey of Brogne (present-day Saint-Gérard). 917. Hungarian raids in Alsace and Lorraine. Founding of the abbey of Déols. 917–926. Southern Italy ravaged by the Saracens. 918. Death of Conrad I. Bremen destroyed by the Hungarians.	913. Epitaph of Count Wifred in the church of San Pau del Camp at Barcelona. 918–933. Under Bishop Gaudri, the two superimposed oratories built at the west end of Auxerre cathedral by Bishop Wibald (879–887) are replaced by a door with a porch in front of it.
919. Lorraine raided by the Hungarians. 923–936. Revolt against Charles the Simple, who is replaced by Robert, brother of Odo (Eudes), then by Rudolph (Raoul), brother-in-law of Hugh the Great. 924. The Rhone valley devastated by the Hungarians. 926. Lorraine and Champagne invaded by the Hungarians. 927–942. St Odo, second abbot of Cluny. 929. Founding of the Caliphate of Cordova. Death of Charles the Simple. 930. Hungarian raid in Burgundy. 933. Reform of the abbey of Gorze.	920–940. The crypts of Saint-Pierre-le-Vif at Sens are enlarged. About 925. Manuscript of the Book of Maccabees. 930. Dedicatory inscription at Err (Pyrénées-Orientales). 933–961. Gui, bishop of Auxerre, enlarges the choir of St Stephen's Cathedral and erects a choir screen. About 934. Partial restoration of the ruins of Jumièges in order to house a community of twelve monks.

900

925

EVENTS	WORKS OF ART
936–937. Reform of the abbeys of Saint-Ghislain in Hainaut and St Bavo of Ghent by Gerard of Brogne. 936–954. Reign of Louis IV, son of Charles III the Simple. 936–973. Reign of Otto I the Great. Before 937. Founding of the abbey of Saint-Gildas, near Châteauroux, to house the monks of Saint-Gildas-de-Rhuis. 937. Burgundy and the Berry region raided by the Hungarians.	936–962. Bishop Godescalc of Le Puy builds the oratory of Saint-Michel d'Aiguilhe. After 936. Reconstruction of Alet cathedral at Saint-Servan. 938. Fortification of Saint-Martin of Tours. 939. Epitaph of Solomon at Saint-Hilaire-le-Grand of Poitiers. 940-984. Stephen II, bishop of Clermont, has a gold statue of the Virgin made for his cathedral, and has the statue of St Foy at Conques remodelled. 944. Saint-Hilaire-le-Grand of Poitiers and the abbey of Saint-Maixent are fortified. 948–981. Marble altar slab with an inscription made at Montolieu in the time of Abbot Trasmirus.
948–994. St Majolus (Mayeul), abbot of Cluny.	949–998. Construction of Notre-Dame de la Basse-Œuvre at Beauvais.
951 and 954. Fresh Hungarian incursions into Burgundy. 954–986. Reign of Lothair, son of Louis IV. 955. Battle of Lechfeld. End of the Hungarian invasions in Germania.	952. At Saint-Martial of Limoges a gold statue of St Martial is made by the monk Gozberg. About 955. Beginning of the construction of the second abbey church at Cluny. After 955. Construction of the church of Saint-Étienne at Déols.
959. Death of Gerard of Brogne.	960–980. Reliquary statues of St Valerian at Saint-Pourçain-sur-Sioule and at Tournus. About 961. Construction of the church at Gernrode. Herznach bas-relief representing the Crucifixion. Before 962. Gospel Book, chalice and paten of St Gauzelin, bishop of Toul.
962. Founding of the monastery of Payerne. Imperial coronation of Otto I.	965. In Cologne, St Maria im Capitol and its cloister are under construction. After 965. Reliquary statue of St Lazarus at Avallon.
966. Death at Reims of the historian Flodoard. 972. Gerbert (later Pope Sylvester II) begins teaching in the school of Reims. The Saracens are driven from their stronghold at Fraxinetum (La Garde-Freinet) in Provence. 972-1008. Notger bishop of Liège. 973–983. Reign of Otto II. War between Lothair and Otto II.	972. Dedicatory inscription of the church of the Château d'Étoile at Saint-Michel de Montblanc (Hérault). Consecration of the new abbey church founded at Aurillac by Count Giraldus in 894. 972-1008. At Liège Notger builds the church of St John, a replica of the Palatine Chapel at Aachen. 974. Dedication of the church of St Andrew at Cologne by Archbishop Gero.
	975. Consecration of the seven altars of the abbey church of Saint-Michel-de-Cuxa. A large silver crucifix given to the abbey of Saint-Benoît-sur-Loire by the knight Adelelm. 975-995. Gebhart II, bishop of Constance, enriches the main altar of his cathedral with a golden altar slab, with reliefs representing the Virgin and apostles, and an altar canopy (ciborium). 976. The archbishop of Reims, Adalbero, does away with the west 'crypts' of his cathedral so that the church may be 'larger and its arrangement more worthy.' About 976. Beginning of the construction of Mainz Cathedral by Archbishop Willigis. Immo, abbot of St Gall, begins a gold and enamelled altar frontal, finished by his successor.

950

975

EVENTS	WORKS OF ART
	977. Dedicatory inscription in the church of Tannay (Ardennes).
	977–999. Sevin, archbishop of Sens, has a gold altar slab made for St Stephen's Cathedral.
	About 980. Adalbero, archbishop of Reims, orders stained-glass windows with figure scenes for his cathedral.
After 980. Founding of the collegiate church of Saint-Mexme at Chinon by the archbishop of Tours, Archambaut de Seuilly.	
983–1002. Reign of Otto III.	
	984. Beginning of the reconstruction of Metz Cathedral by bishop Theodoric I.
	985. Fortification of Saint-Martial of Limoges.
986–987. Reign of Louis V, son of Lothair.	
987. Hugh Capet elected king of France.	

CHRONOLOGICAL TABLE DRAWN UP BY JEAN HUBERT

Bibliography

1. ACHTER (I.), *Zur Rekonstruktion der karolingischen Klosterkirche Centula*, in *Zeitschrift für Kunstgeschichte*, XIX, 1956, pp. 133-154.

2. ADHÉMAR (Jean), *Influences antiques dans l'art du Moyen-Age français*, in *Studies of the Warburg Institute*, VII, London, 1939.

3. ALBIZZATI (Carlo), *Il ciborio carolingio nella basilica ambrosiana di Milano*, in *Rendiconti della pontificia Accademia romana di archeologia*, II, Rome, 1924, p. 197 sq.

4. ALFÖLDI (András), *Die Goldkanne von Saint-Maurice d'Agaune*, in *Zeitschrift für schweizerische Archäologie und Kunstgeschichte*, X, 1948-1949, p. 1 sq.

5. AMANN (Émile), *The Church of the Early Centuries*, trans. from French by E. Raybould, Sands, and Co., London. St Louis, B. Herder Book Co., 1930.

6. ARBMAN (Holger), *Schweden und das karolingische Reich, Studien zu den Handelsverbindungen des 9. Jahrhunderts*, Stockholm, Wahlström and Widstrand, 1937. (Thesis.)

7. ARBMAN (Holger), *Die Kremsmünsterer Leuchter*, in *Meddelanden från Lunds Universitets Historiska Museum*, Lund, 1958, p. 170-192.

8. ARENS (Fritz) and BÜHRLEN (R.,) *Die Kunstdenkmäler in Wimpfen am Neckar*, Mainz, 1958.

9. ARSLAN (Edoardo), *La pittura e la scultura veronese del secolo VIII al secolo XIII*, Milan, Facoltà di lettere di Pavia, 1943.

10. *Art du haut Moyen-Age dans la région alpine*, in *Actes du IIIe Congrès international pour l'étude du haut Moyen-Age, 1951*, Lausanne, Urs Graf Verlag, 1954.

11. *Arte del primo millennio. Atti del primo Convegno per lo studio dell'arte dell'alto medioevo tenuto presso l'Università di Pavia, 1950*, Turin, Andrea Viglongo, 1952.

12. *Atti dell'ottavo Congresso di studi sull'arte dell'alto medioevo* : I, *Stucchi e mosaici alto-medioevali*; II, *La chiesa di S. Salvatore in Brescia*, Milan, Ceschina, 1962.

13. AUBERT (Marcel), *L'Art religieux en Rhénanie*, Paris, A. et J. Picard, 1924.

14. AUBERT (Marcel), *Carolingia Arte*, in *Enciclopedia italiana*, IX, Rome, Istituto dell'Enciclopedia italiana, 1931, pp. 119-121.

15. AUBERT (Marcel) [under the direction of], *La Cathédrale de Metz*, Paris, A. et J. Picard, 1931, 2 vol.

16. AURENHAMMER (Hans), *Lexikon der christlichen Ikonographie*, Vienna, Verlag Brüder Hollinek, 1967, 1 vol. containing fascicules 1-6. (In publication since 1924.)

17. AUZIAS (Léonce), *L'Aquitaine carolingienne (778-887)*, Toulouse, Private, 1938. (Bibliothèque méridionale, 2d series.)

18. AYUSO MARAZUELA (Mgr Teófilo), *La Biblia visigótica de la Cava dei Tirreni. Contribución al estudio de la Vulgata en España*, in *Estudios biblicos*, XIV and XV, Madrid, Consejo Superior de Investigaciones Cientificas, 1955, pp. 49-65 and 1956, pp. 5-56.

19. BABELON (Jean), *L'Orfèvrerie française*, Paris, Larousse, 1946.

20. BALDWIN-SMITH (E.), *Architectural Symbolism of Imperial Rome and the Middle Ages*, Princeton, 1956.

21. BANDMANN (Günther), *Früh- und hochmittelalterliche Altarordnung*, in *Das erste Jahrtausend*, I, Düsseldorf, 1963. pp. 371-411. (Exposition.)

22. BANDMANN (Günther), *Die Vorbilder der Aachener Pfalzkapelle*, in *Karl der Grosse*, III, Düsseldorf, L. Schwann, 1965, pp. 424-463.

23. BARON (Edith), *Mainzer Buchmalerei in karolingischer und frühottonischer Zeit*, in *Jahrbuch für Kunstwissenschaft*, VII, Berlin, Ernst Gall, 1930, pp. 107-129.

24. BARSALI (Isa Bellı di), *Corpus della scultura altomedievale*, I, *La diocesi di Lucca*, Spoleto, Centre italiano di studi sull'alto medioevo, 1959.

25. BASCAPÈ (Cl.), *L'altare d'oro di Sant'Ambrogio*, in *S. Ambrogio. Ragguaglio della basilica e della parrocchia*, III, Milan, 1955.

26. BAUM (Julius), *Die Malerei und Plastik des Mittelalters*, II, *Deutschland, Frankreich und Britannien*, Potsdam-Wildpark, 1930.

27. BAUM (Julius), *Karolingische geschnittene Bergkristalle*, in *Frühmittelalterische Kunst in den Alpenländern*, Olten-Lausanne, Urs Graf Verlag, 1954, pp. 111-117.

28. BAUM (Julius), *Die Flechtwerkplatten von St. Aurelius in Hirsau*, in *Zeitschrift für württembergische Landesgeschichte*, XVII, 1958, pp. 241-252.

29. BAUM (Julius), *Karolingische Bildnerkunst aus Ton und Stein im Iller- und Nagold-Tal*, in *Beiträge zur Kunstgeschichte und Archäologie des Frühmittelalters. Akten zum VII. international Kongress für Frühmittelalterforschung 1958*, edited by H. FILLITZ, Graz-Cologne, H. Böhlau Verlag, 1962, pp. 167-178.

30. BECKWITH (John), *The Werden Casket Reconsidered*, in *The Art Bulletin*, XL, New York, 1958, p. 1 sq. *The attribution of the Werden Casket to the Carolingian period is certainly erroneous.*

31. BECKWITH (John), *The Andrews Diptych*, London, 1958. (Victoria and Albert Museum, "Museum Monograph," XII.)

32. BECKWITH (John), *Early Mediaeval Art*, London and New York, 1964.

33. BECKWITH (John), *Byzantine Influence on Art at the Court of Charlemagne*, in *Karl der Grosse*, III, *Karolingische Kunst*, Düsseldorf, L. Schwann, 1965, pp. 288-301.

34. BEHN (Friedrich), *Die karolingische Klosterkirche von Lorsch am der Bergstrasse nach den Ausgrabungen 1925-1928 und 1932-1933*, Berlin, 1934.

35. BEHN (Friedrich), *Kloster Lorsch*, Mainz, E. Schneider, 2d ed., 1949.

36. *Beiträge zur Kunstgeschichte und Archäologie des Frühmittelalters*, Graz-Cologne, H. Böhlau Verlag, 1962.

37. BELTING (Hans), *Studien zum beneventanischen Hof im 8. Jahrhundert*, in *Dumbarton Oaks Papers*, XVI, 1962.

38. BENOIT (Fernand), *La basilique Saint-Pierre-et-Saint-Paul à Arles. Étude sur les chancels paléochrétiens*, in *Provence historique*, VII, 1957, pp. 8-21. *Chancels from the 5th to the end of the 8th century.*

39. BENOIT (François), *L'Occident médiéval, du romain au roman*, Paris, Laurens, 1933. (Manuels d'histoire de l'art, " L'Architecture. ")

40. BENSON (Gertrude R.), *New Light on the Origin of the Utrecht Psalter. The Latin Tradition and the Reims Style on the Utrecht Psalter*, in *The Art Bulletin*, XIII, University of Chicago, 1931, pp. 13-79.

41. BERNARD (Honoré), *Premières fouilles à Saint-Riquier*, in *Karl der Grosse*, III, *Karolingische Kunst*, Düsseldorf, L. Schwann, 1965, pp. 369-374.

42. BESSON (Marius), *Antiquités du Valais (V^e-X^e siècle)*, Fribourg, Fragniere frères, 1910.

43. BEUMANN (H.) and GROSSMANN (D.), *Das Bonifatiusgrab und die Klosterkirche zu Fulda*, in *Marburger Jahrbuch für Kunstwissenschaft*, XIV, 1949, pp. 17-56.

44. BEUTLER (Christian), *Das Grab des heiligen Sola*, in *Wallraf-Richartz Jahrbuch*, XX, Cologne, 1958, p. 55 sq.

45. BEUTLER (Christian), *Das Kreuz des heiligen Odo aus St. Martin von Autun*, in *Wallraf-Richartz Jahrbuch*, XXII, Cologne, 1960, p. 49 sq.

46. BEUTLER (Christian), *Documents sur la sculpture carolingienne*, in *Gazette des Beaux-Arts*, 6th period, LX and LXI, Paris-New York, P.U.F., 1962, pp. 445-458, and 1963, pp. 193-200.

47. BEUTLER (Christian), *Bildwerke zwischen Antike und Mittelalter unbekannte Skulpturen aus der Zeit Karls des Grossen*, Düsseldorf, L. Schwann, 1964.

48. BIRCHLER (Linus), *Zur karolingischen Architektur und Malerei in Münster-Müstair*, in *Art du haut Moyen-Age dans la région alpine*, Lausanne, Urs Graf Verlag, 1954, pp. 167-252.

49. BISCHOFF (Bernhard), *Die kölner Nonnenhandschriften und das Skriptorium von Chelles*, in *Karolingische und ottonische Kunst (Forschungen zur Kunstgeschichte und christliche Archäologie)*, III, Wiesbaden, 1957, pp. 394-441.

50. BISCHOFF (Bernhard), *Aus Alkuins Erdentagen*, in *Medievalia et Humanistica*, XIV, 1962, pp. 31-37.

51. BISCHOFF (Bernhard), *Kreuz und Buch im Frühmittelalter und in den ersten Jahrhunderten der spanischen Reconquesta*, in *Bibliotheca docet, Festgabe für Carl Wehmer*, XXVIII, Amsterdam, 1963, pp. 19-36.

52. BISCHOFF (Bernhard), *Die künstlerische Bedeutung von Lorsch im Spiegel seiner Handschriften*, in *Die Reichsabtei Lorsch. Festschrift zum Gedenken an ihre Stiftung 764*, Heidelberg, 1964-1965.

53. BISCHOFF (Bernhard), *Die Hofbibliothek Karls des Grossen*, in *Karl der Grosse*, II, Düsseldorf, L. Schwann, 1965, pp. 42-62.

54. BISCHOFF (Bernhard), *Panorama der Handschriftenüberlieferung aus der Zeit Karls des Grossen*, in *Karl der Grosse*, II, Düsseldorf, L. Schwann, 1965, pp. 233-255.

55. BISCHOFF (Bernhard), *Eine karolingische Prachthandschrift in Aachener Privatbesitz*, in *Aachener Kunstblätter*, XXXII, 1966, pp. 46-53.

56. BISCHOFF (Bernhard), and HOFFMANN (J.), *Libri sancti Kyliani. Die Würzburger Schreibschule und ihre Dombibliothek im VIII. und IX. Jahrhundert*, Würzburg, 1952. ("Quellen und Forschungen zur Geschichte des Bistums und Hochstifts Würzburg, " VI.)

57. BISCHOFF (Bernhard), FISCHER (Bonifatius) and MÜTHERICH (Florentine), *Der Stuttgarter Psalter*, 1965. (Facsimile and text.)

58. BLOCH (Peter), *Zum Dedikationsbild im Lob des Kreuzes des Hrabanus Maurus*, in *Das erste Jahrtausend. Kultur und Kunst in werdenden Abendland an Rhein und Ruhr*, I, Düsseldorf, 1962, pp. 471-494.

59. BLOCH (Peter), *Das Apsismosaik von Germigny-des-Prés, Karl der Grosse und der alte Bund*, in *Karl der Grosse*, III, *Karolingische Kunst*, Düsseldorf, L. Schwann, 1965, pp. 234-262.

60. BLONDEL (Louis), *Les premiers édifices chrétiens de Genève de la fin de l'époque romaine à l'époque romane*, in *Genava*, XI, 1933, pp. 77-101.

61. BLONDEL (Louis), *La villa carolingienne de Saint-Gervais à Genève*, in *Genava*, 1941, pp. 187-201; 1951, pp. 24-27; 1953, pp. 74-75; 1954, pp. 210-216.

62. BLONDEL (Louis), *Les anciennes basiliques d'Agaune. Étude archéologique*, in *Vallesia*, III, 1948, pp. 9-57.

63. BLONDEL (Louis), *Aperçu sur les édifices chrétiens dans la Suisse occidentale avant l'an mille*, in *Art du haut Moyen-Age dans la région alpine*, Olten-Lausanne, Urs Graf Verlag, 1954, pp. 371-407.

64. BLONDEL (Louis), *Le martyrium de Saint-Maurice d'Agaune*, in *Vallesia*, 1957, pp. 283-292.

65. BŒCKELMANN (Walter), *Grundformen im frühkarolingischen Kirchenbau des östlichen Frankreiches*, in *Wallraf-Richartz Jahrbuch*, XVIII, Cologne, 1956, pp. 27-70.

66. BŒCKLER (Albert), *Abendländische Miniaturen bis zum Ausgang des romanischen Zeit*, Berlin-Leipzig, Walter de Gruyter and Co., 1930.

67. BŒCKLER (Albert), *Elfenbeinreliefs der ottonischen Renaissance*, in *Phœbus*, IV, 1949, p. 145 sq.

68. BŒCKLER (Albert), *Ars Sacra. Kunst des frühen Mittelalters*, Munich, 1950.

69. BŒCKLER (Albert), *Die Evangelistenbilder der Ada-Gruppe*, in *Münchner Jahrbuch der bildenden Kunst*, 3d series, III-V, Munich, 1952-1953, pp. 121-144.

70. BŒCKLER (Albert), *Die Kanonbogen der Ada-Gruppe und ihre Vorlagen*, in *Münchner Jahrbuch der bildenden Kunst*, V, Munich, 1954, pp. 7-22.

71. BŒCKLER (Albert), *Malerei und Plastik in ostfränkischen Reich*, in *Settimane di studio del Centro italiano di studi sull'alto medioevo*, I, Spoleto, 1954, p. 173 sq.

72. BŒCKLER (Albert), *Das Erhardbild im Utacodex*, in *Studies in Art and Literature for Belle da Costa Greene*, Princeton, N.J., 1954, p. 219 sq.

73. BŒCKLER (Albert), *Formgeschichtliche Studien zur Ada-Gruppe*, in *Abhandlungen der Bayerischen Akademie der Wissenschaften*, new series, XLII, Munich, 1956, pp. 8-13.

74. BOGNETTI (Gian Piero), *Storia di Milano. L'alto medioevo (493-1002)*, II, Milan-Rome, Istituto dell'Enciclopedia italiana, 1954.

75. BOGNETTI (Gian Piero), CHIERICI (Gaetano) and DE CAPITANI D'ARZAGO (Alberto), *Santa Maria di Castelseprio*, Milan-Rome, Istituto dell'Enciclopedia italiana, 1948.

76. BOGYAY (Thomas von), *Zum Problem der Flechtwerksteine*, in *Karolingische und ottonische Kunst*, Wiesbaden, 1957, pp. 262-275.

77. BOGYAY (Thomas von), *Eine karolingische Schrankenplatte von der Fraueninsel am Chiemsee*, in *Das Münster*, XIII, 1960, p. 235 sq.

78. BOINET (Amédée), *La Miniature carolingienne*, Paris, A. et J. Picard, 1913.

79. BOINET (Amédée), *Le Psautier carolingien du trésor de la cathédrale de Troyes*, in *Gutenberg Jahrbuch*, 1952, pp. 14-17.

80. BORCHGRAVE D'ALTENA (Joseph de), *A propos de l'ivoire de Genoelselderen*, in *Bulletin des Musées royaux d'art et d'histoire*, Brussels, 1946, p. 29 sq.

81. BORCHGRAVE D'ALTENA (Joseph de), *Reliefs carolingiens et ottoniens*, in *Revue belge d'archéologie et d'histoire*, 1954.

82. BOÜARD (Michel de), *Le Hague-Dike*, in *Cahiers archéologiques*, VIII, 1956, pp. 117-145. *Fortification built by the Normans.*

83. BOUTEMY (André), *Une pièce à verser au dossier de Framegaud, le manuscrit pourpre des Évangiles de Reims, no. 11*, in *Scriptorium*, II, 1948, pp. 289-290.

84. BOUTEMY (André), *Quel fut le foyer du style franco-saxon?*, in *Congrès archéologique et historique de Belgique*, LXXXIII, Tournai, 1949, pp. 749-773.

85. BOUTEMY (André), *Le style franco-saxon, style de Saint-Amand*, in *Scriptorium*, III, 1949, pp. 260-264.

86. BOUTEMY (André), *Manuscrits pré-romans du pays mosan*, in *L'Art mosan*, Paris, A. Colin, 1953, pp. 51-70. (Bibliothèque générale de l'École pratique des Hautes Études, journées d'études, Paris, February, 1952.)

87. BOUTEMY (André), *Le type de l'évangéliste et la lettre ornée dans les évangéliaires rémois du IXe siècle*, in *Bulletin de la Société nationale des antiquaires de France*, 1954-1955, pp. 25-28.

88. BOUTEMY (André), *Les décors des canons dans les évangéliaires rémois du IXe siècle*, in *Bulletin de la Société nationale des antiquaires de France*, 1954-1955, pp. 41-44.

89. BOUTEMY (André), *Le manuscrit 48 de Leyde et l'enluminure franco-saxonne*, in *Actes du XVIIe Congrès international d'histoire de l'art*, The Hague, 1955, pp. 212-220.

90. BOUTEMY (André), *Nouvelles réflexions sur les Évangiles de Notger*, in *Annales du XXXVIe Congrès de la Fédération archéologique et historique de Belgique*, Ghent, 1956, pp. 481-495. *Artistic activity at the Stavelot "scriptorium" in the 9th and 10th centuries.*

91. BOVINI (Giuseppe) and OTTOLENGHI (L.), *Catalogo della mostra degli avori dell'alto medioevo*, Ravenna, 1956.

92. BRAUN (Joseph), *Meisterwerke der deutschen Goldschmiedekunst*, I, Munich, 1922.

93. BRAUN (Joseph), *Der christliche Altar in seiner geschichtlichen Entwicklung*, Munich, 1924, 2 vol.

94. BRAUN (Joseph), *Die Reliquiare des christlichen Kultes und ihre Entwicklung*, Freiburg-im-Breisgau, 1940.

95. BRAUNFELS (W.) and SCHNITZLER (H.) [under the direction of], *Karls des Grossen Bronzewerkstatt*, in *Karl der Grosse*, II, Düsseldorf, L. Schwann, 1965, p. 168 sq.

96. BRAUNFELS (W.) et SCHNITZLER (H.) [under the direction of], *Karl der Grosse*, III, Düsseldorf, L. Schwann, 1965.

97. BRÉHIER (Louis), *L'Art en France des invasions barbares à l'époque romane*, Paris, La Renaissance du Livre, 1930. (Collection "A travers l'art français.")

98. BRUCKNER (Albert), *Scriptoria medii aevi Helvetica*, I-XI, Geneva, 1935-1967.

99. BRUSIN (Giovanni) and ZOVATTO (P.L.), *Monumenti paleocristiani di Aquileia e di Grado*, Udine, 1957.

100. BUCHTHAL (Hugo), *A Byzantine Miniature of the Fourth Evangelist and its Relatives*, in *Dumbarton Oaks Papers*, XV, 1961, pp. 129-139.

101. BUDDENSIEG (J.), *Ein goldener Armreif in Fulda*, in *Kunstchronik*, XII, 1959, p. 237 sq.

102. BULLOUGH (Donald A.), *The Age of Charlemagne*, London, Paul Elek Productions, 1965. New York, G.P. Putnam's sons.

103. CALECA (Antonino), *L'evangeliario altomedievale de Perugia*, in *Critica d'arte*, XIV, 1967, pp. 17-35.

104. CAREY (F. M.), *The Scriptorium of Reims during the Archbishopric of Hincmar*, in *Classical and Mediaeval Studies in Honor of E. K. Rand*, New York, 1938, pp. 41-60.

105. CATTANEO (Raffaele), *L'architettura in Italia dal secolo IV al mille circa*, Venice, 1880. (French edition, Venice, 1890.)

106. CAUMONT (Arcisse de), *Sur les tombeaux et les cryptes de Jouarre*, in *Bulletin monumental*, IX, Paris, 1843, p. 183 sq.

107. CECCHELLI (Carlo), *Il tesoro del Laterano, I*, in *Dedalo*, VII, 2, 1926-1927, p. 139 sq.

108. CECCHELLI (Carlo), *I monumenti del Friuli dal secolo IV all'XI*, Milan-Rome, 1943.

109. CECCHELLI (Carlo), *Pittura e scultura carolingie in Italia*, in *Settimane di studio del Centro italiano di studi sull'alto medioevo, 1953*, I, *Problemi della civiltà carolingia*, Spoleto, Centro italiano di studi sull'alto medioevo, 1954, pp. 181-214.

110. CECCHELLI (Carlo), *Ispirazione classica e biblica nell'iconografia carolingia*, in *Studi romani*, 4th year, no. V, September-October, 1956, Rome, 1956, pp. 523-538.

111. *Charlemagne, Aix-la-Chapelle - Karl der Grosse, Werk und Wirkung*, Aachen, Düsseldorf, L. Schwann, 1965. (Exhibition catalogue, German edition.)

112. *Charlemagne. Œuvre, rayonnement et survivances. Dixième exposition sous les auspices du Conseil de l'Europe*, Aachen, 1965. (Exhibition catalogue, French edition.)

113. CHAUME (Maurice), *Les Origines du duché de Bourgogne*, Dijon, Rebourseau, 1925-1937, 4 vol.

114. CHIERICI (Gino), *La chiesa di S. Satiro a Milano*, Milan, Edizioni dell'Arte, 1942.

115. CHRIST (H.), *Die sechs Münster der Abtei Reichenau*, Reichenau, 1956.

116. CLAPHAM (Sir Alfred William), *English Romanesque Architecture before the Conquest*, Oxford, Clarendon Press, 1930.

117. CLAUSSEN (Hilda), *Spätkarolingische Umgangskrypten im sächsischen Gebiet*, in *Karolingische und ottonische Kunst*, Wiesbaden, 1957, pp. 118-140.

118. CLEMEN (Paul), *Merovingische und karolingische Plastik*, in *Bonner Jahrbuch*, XCII, Bonn, 1892, p. 222 sq.

119. CLEMEN (Paul), *Die Kunstdenkmäler der Stadt Aachen*, Düsseldorf, 1916.

120. COENS (Maurice), *Recueil d'études bollandiennes*, Brussels, Société des Bollandistes, 1963, pp. 296-300.

121. COLETTI (Luigi), *Il Tempietto di Cividale. Rilievi di monumenti a cura del Consiglio nazionale delle ricerche*, Rome, Libreria dello Stato, 1952.

122. COLIN (J.), *La plastique "gréco-romaine" dans l'empire carolingien*, in *Cahiers archéologiques*, II, Paris, Klincksieck, 1947, p. 87 sq.

123. CONANT (Kenneth John), *Mediaeval Academy Excavations at Cluny*, VII, in *Speculum*, XXIX, 1954, pp. 1-12.

124. CONANT (Kenneth John), *Carolingian and Romanesque Architecture 800 to 1200*, Harmondsworth-Baltimore-Victoria, Penguin Books, 1959, 2d ed., 1966. ("The Pelican History of Art.")

125. *Congrès archéologique*, Paris, 1931. (93d session, held at Orléans.)

126. CONWAY (Martin), *The Treasury of St. Maurice d'Agaune*, I, in *The Burlington Magazine*, XXI, London, 1912, p. 258 sq.

127. CONWAY (Martin), *The Abbey of Saint-Denis and its Treasuries*, in *Archaeologia*, LXVI, London, 1914-1915, p. 103 sq.

128. CORBIN (Solange), *L'Église à la conquête de sa musique*, Paris, Gallimard, 1960.

129. COUFFON (René), *Essai sur l'architecture religieuse en Bretagne du Ve au Xe siècle*, in *Mémoires de la Société d'histoire et d'archéologie de Bretagne*, XXIII, Rennes, 1943, pp. 36 sq.

130. COUTIL (Léon), *L'Art mérovingien et carolingien. Sarcophages, stèles funéraires, cryptes, baptistères, églises, orfèvrerie et bijoux*, Bordeaux, 1927; 2d ed., Bordeaux, 1930. *Concise account with numerous illustrations.*

131. CROQUISON (Dom Joseph), *Une vision eschatologique carolingienne*, in *Cahiers archéologiques*, IV, Paris, 1949, pp. 105 to 129.

132. CROQUISON (Dom Joseph), *Le Sacramentaire de Charlemagne*, in *Cahiers archéologiques*, VI, Paris, 1952, pp. 55-70.

133. CROQUISON (Dom Joseph), *L'iconographie chrétienne à Rome d'après le "Liber Pontificalis,"* in *Byzantion*, XXXIV (1964), Paris, 1965, p. 535 sq.

134. CROSBY (Sumner McK.), *The Abbey of Saint-Denis (475-1122)*, New Haven, Yale University Press, 1942. (Thesis.)

135. CROSBY (Sumner McK.), *L'Abbaye royale de Saint-Denis*, Paris, P. Hartmann, 1953.

136. CROZET (René), *Les premières représentations anthropozoomorphiques des évangélistes (VIe-IXe) dans l'enluminure*, in *Études mérovingiennes*, Paris, A. et J. Picard, 1953, pp. 53-63.

137. CROZET (René), *La représentation anthropozoomorphique des évangélistes dans l'enluminure et dans la peinture murale aux époques carolingienne et romane*, in *Cahiers de civilisation médiévale*, I, Poitiers, 1958, pp. 182-187.

138. DA COSTA GREENE (Bella) and HAARSEN (Heta P.), *The Pierpont Morgan Library. Exhibition of Illuminated Manuscripts held at the New York Public Library*, New York, 1933-1934.

139. DALTON (Ormonde M.), *The Crystal of Lothair*, in *Archaeologia*, IX, London, 1904, p. 25 sq.

140. DASNOY (André), *Les sculptures mérovingiennes de Glons*, in *Revue belge d'archéologie et d'histoire de l'art*, XXII, 1953, pp. 137-152.

141. DEÉR (József), *Ein Doppelbildnis Karls den Grossen*, in *Wandlungen christlicher Kunst im Mittelalter*, II, Baden-Baden, 1953, p. 414 sq.

142. DEGEN (K.), *Das Schmuckstück aus Seeheim*, in *Kunst in Hessen und am Mittelrhein*, I-II, Darmstadt, 1962, p. 117 sq.

143. DEHIO (Georg) and BEZOLD (Gustav von), *Die kirchliche Baukunst des Abendlandes*, Stuttgart, 1884-1901, 7 vol.

144. DEHIO (Georg) and GALL (Ernst), *Handbuch der deustschen Kunstdenkmäler*, Munich-Berlin, 2d ed., 1949, 5 vol.

145. DELEHAYE (Hippolyte), *Les Origines du culte des martyrs*, Brussels, Société des Bollandistes, 1912, 2d ed., 1933.

146. DELISLE (Léopold), *Les bibles de Théodulphe*, in *Bibliothèque de l'École des chartes*, XL, 1879, pp. 1 sq and 259.

147. DELISLE (Léopold), *Mémoire sur l'école calligraphique de Tours*, in *Mémoires de l'Académie des Inscriptions et Belles-Lettres*, XXXII, 1885, pp. 29-57.

148. DELISLE (Léopold), *Mémoire sur d'anciens sacramentaires*, in *Mémoires de l'Académie des Inscriptions et Belles-Lettres*, XXXII-I, 1886, pp. 57-423.

149. DELISLE (Léopold), *L'Evangéliaire de Saint-Vaast d'Arras et la calligraphie franco-saxonne du IXe siècle*, Paris, Champion, 1888.

150. DESCHAMPS (Paul), *Étude sur la renaissance de la sculpture à l'époque romane*, in *Bulletin monumental*, 1925, pp. 5-98. *List of relief arts in the Carolingian era, after monuments and texts.*

151. DESCHAMPS (Paul), *Tables d'autel de marbre exécutées dans le midi de la France au Xe et au XIe siècle*, in *Mélanges Ferdinand Lot*, Paris, Champion, 1925, pp. 137-168.

152. DESCHAMPS (Paul), *Étude sur la paléographie des inscriptions lapidaires de la fin de l'époque mérovingienne aux dernières années du XIIe siècle*, in *Bulletin monumental*, 1929, pp. 5-88.

153. DESCHAMPS (Paul), *Le décor d'entrelacs carolingien et sa survivance à l'époque romane*, in *Comptes rendus de l'Académie des Inscriptions et Belles-Lettres*, 1939, pp. 387-396.

154. DESCHAMPS (Paul), *A propos des pierres à décor d'entrelacs et des stucs de Saint-Jean de Müstair*, in *Frühmittelalterliche Kunst in den Alpenländern*, Olten-Lausanne, Urs Graf Verlag, 1954, p. 253 sq.

155. DESCHAMPS (Paul), *Quelques témoins de décors de stuc en France pendant le haut Moyen-Age et l'époque romane*, in *Atti dell'ottavo Congresso di studi sull'arte dell'alto medioevo*, I, Milan, 1962, pp. 179-185.

156. DESCHAMPS (Paul) and THIBOUT (Marc), *La peinture murale en France. Le haut Moyen-Age et l'époque romane*, Paris, Plon, 1951.

157. DESLANDRES (Y.), *La Décoration des manuscrits dans la région parisienne du IXe au début du XIIIe siècle*, 1950, pp. 41-44. (École nationale des chartes. Positions des thèses, 1950.)

158. DEWALD (E. T.), *The Stuttgart Psalter*, Princeton, N. J., 1930.

159. DEWALD (E. T.), *The Illustrations of the Utrecht Psalter*, Princeton, N. J., 1933.

160. DINKLAGE (K.), *Karolingische Schmuck aus dem Speyer und Wormsgau*, in *Pfälzer Heimat*, VI, 1955, p. 43 sq.

161. DOBERER (Erika), *Studien zu dem Ambo Kaiser Heinrichs II im Dom zu Aachen*, in *Karolingische und ottonische Kunst*, Wiesbaden, 1957, pp. 308-359.

162. DOBERER (Erika), *Die ornementale Steinskulptur an der karolingischen Kirchenausstattung*, in *Karl der Grosse*, III, *Karolingische Kunst*, Düsseldorf, L. Schwann, 1965, pp. 203-234.

163. DOBIAS ROZDESVENSKAIA (Olga), *Histoire de l'atelier graphique de Corbie de 651 à 830 reflétée dans es Corbeienses Leninpolitani*, Leningrad, 1934.

164. DOPPELFELD (Otto), *Der unterirdische Dom. Grabungen im Dom zu Köln*, Cologne, 1948.

165. DOPPELFELD (Otto), *Die Ausgrabung unter dem Kölner Dom*, in *Neue Ausgrabungen in Deutschland, Römisch-Germanische Kommission des deutschen archäologischen Instituts*, Berlin, 1958.

166. DUCHESNE (Louis), *Christian Worship: Its Origin and Evolution. A study of the Latin liturgy up to the time of Charlemagne*, trans. from French by M. L. McClure. London, Christian Knowledge Society, 1931.

167. DUCHESNE (Louis), *Fouilles de la cathédrale d'Alet*, in *Bulletin de la Société archéologique d'Ille-et-Vilaine*, XXI, 1891, pp. 1-10.

168. DUFOUR BOZZO (Colette), *Corpus della scultura altomedievale*, IV, *La diocesi di Genova*, Spoleto, Centro italiano di studi sull'alto medioevo, 1966.

169. DUFRENNE (Suzy), *Les copies anglaises du Psautier d'Utrecht*, in *Scriptorium*, XVIII (2), Brussels, 1964, pp. 185-198.

170. DUFT (Johannes), *Studien zum St. Galler Klosterplan*, Saint-Gall, Fehr'sche Buchhandlung, 1962. ("Historischer Verein des Kantons St. Gallen," 42.)

171. DULAY (Suzanne), *La Règle de saint Benoît d'Aniane et la réforme monastique de l'époque carolingienne*, Nîmes, Larguier, 1935. (Thesis.)

172. DUPONT (André), *Les Cités de la Narbonnaise première depuis les invasions germaniques jusqu'à l'apparition du Consulat*, Nîmes, Impr. Chastenin frères et Alméras, 1942. (Thesis.)

173. DUPONT (Jacques), *Le linceul de saint Remi*, in *Bulletin de liaison du Centre international d'étude des textiles anciens*, Lyons, 1962, p. 38.

174. DURAND (Georges), *L'église de Saint-Riquier*, in *La Picardie historique et monumentale*, IV, fascicule 3, 2d part, Amiens-Paris, Antiquaires de Picardie and A. et J. Picard, 1907-1911.

175. DURLIAT (Marcel), *L'église abbatiale de Moissac, des origines à la fin du XIᵉ siècle*, in *Cahiers archéologiques*, XV, Paris, Imprimerie nationale and Klincksieck, 1965, pp. 155-178.

176. DURLIAT (Marcel), *Tables d'autel à lobes de la province ecclésiastique de Narbonne (IX-XIᵉ siècle)*, in *Cahiers archéologiques*, XVI, Paris, Imprimerie nationale and Klincksieck, 1966, pp. 51-76.

177. DURRIEUX (Paul), *L'origine du manuscrit célèbre, dit le Psautier d'Utrecht*, in *Mélanges Julien Havet*, Paris, E. Leroux, 1895, pp. 639-657.

178. DURRIEUX (Paul), *Ingobert, un grand calligraphe du IXᵉ siècle*, in *Mélanges Émile Chatelain*, Paris, Honoré Champion, 1910, pp. 1-12.

179. EBERSOLT (Jean), *Orient et Occident. Recherches sur les influences byzantines et orientales en France avant les croisades*, Paris-Brussels, Van Oest, 1928-1929, 2 vol.

180. EFFMANN (Wilhelm), *Die Kirche der Abtei Korvey*, Paderborn, 1929. Work by Aloys Fuchs, published posthumously.

181. EICHLER (Hans), *Les peintures carolingiennes de la crypte de l'église Saint-Maximin à Trèves*, in *Mémorial d'un voyage d'études de la Société nationale des antiquaires de France en Rhénanie, 1951*, Paris, Klincksieck, 1953, pp. 163-170.

182. EGINHARDUS [EINHARD], *The Life of Charlemagne*, trans. by Lewis Thorpe, Penguin Books, Harmondsworth and Baltimore, 1969.

183. EITNER (L. E. A.), *The Flabellum of Tournus*, in College Art Association of America Monograph I, 1944.

184. EKKEHARDUS, *Casus sancti Galli*, Saint-Gall, 1877.

185. ELBERN (Victor H.), *Der karolingische Goldaltar von Mailand*, Bonn, 1952. ("Bonner Beiträge zur Kunstwissenschaft," II.)

186. ELBERN (Victor H.), *Die bildende Kunst. Karolingerzeit zwischen Rhein und Elbe*, in *Das erste Jahrtausend*, I, Düsseldorf, L. Schwann, 1962, pp. 412-435.

187. ELBERN (Victor H.), *Das erste Jahrtausend. Kultur und Kunst in werdenden Abendland am Rhein und Ruhr*, Düsseldorf, L. Schwann, 1962-1964. (2 vol. of text and 1 vol. of plates.)

188. ELBERN (Victor H.), *Liturgisches Gerät in edlen Materialien zur Zeit Karls des Grossen*, in *Karl der Grosse*, III, Düsseldorf, L. Schwann, 1965.

189. ENGELBREGT (J. H. A.), *Het Utrechts Psalterium*, Utrecht, 1965.

190. ENNEN (E.), *Frühgeschichte der europäischen Stadt*, Bonn, 1953.

191. ENNEN (E.), *Les différents types de formation des villes européennes*, in *Le Moyen-Age*, LXII, 1956, pp. 397-411.

192. ESTERHUES (Fr.), *Zur frühen Baugeschichte der Corvey Abteikirche*, drawn in part from the review *Westfalen*, XXXI, 1953, pp. 320-335.

193. FALKE (Otto von), *Karolingische Kelche*, in *Pantheon*, XV, 1935, p. 138 sq.

194. FAYMONVILLE (K.), *Das Münster zu Aachen*, Düsseldorf, 1916. ("Die Kunstdenkmäler der Rheinprovinz," X, 1.)

195. FEIGEL (A.), *Lorscher Elfenbeine*, in *Laurissa Jubilans Festschrift*, Lorsch, 1964, pl. XVIII-XIX.

196. FÉLIBIEN (Dom Michel), *Histoire de l'abbaye royale de Saint-Denys en France*, Paris, 1706.

197. FÉVRIER (Paul-Albert), *Le Développement urbain en Provence, de l'époque romaine à la fin du XIVᵉ siècle*, Paris, E. de Boccard, 1964. (Thesis.) *Archaeology and urban history.*

198. FICHTENAU (Heinrich von), *Das karolingische Imperium, soziale und geistige Problematik eines Grossreiches*, Zurich, 1949.

199. FICHTENAU (Heinrich von), *Byzanz und die Pfalz zu Aachen*, Graz, Hermann Böplans, 1951.

200. FILLITZ (Hermann), *Neue Forschungen zu den Reichskleinodien*, in *Österreichische Zeitschrift für Kunst und Denkmalspflege*, XII, Vienna, 1958, p. 80 sq.

201. FILLITZ (Hermann), *Katalog der weltlichen und geistlichen Schatzkammer*, Vienna, 3d ed., 1961.

202. FILLITZ (Hermann), *Zum sogenannte Rupertuskreuz aus Bischofshofen*, in *Österreichische Zeitschrift für Kunst und Denkmalspflege*, XVII, Vienna, 1963, p. 184 sq.

203. FILLITZ (Hermann), *Christian Beutler, Bildwerke zwischen Antike und Mittelalter Rezension*, in *Kunstchronik*, XIX, 1966, p. 6 sq.

204. FILLITZ (Hermann), *Die Elfenbeinreliefs zur Zeit Karls des Grossen*, in *Aachener Kunstblätter*, XXXII, Aachen, 1966, p. 14 sq.

205. FINK (A.), *Zum Gandersheimer Runenkastchen*, in *Karolingische und ottonische Kunst*, Wiesbaden, 1957, p. 277 sq.

206. FISCHER (Bonifatius), *Bibelausgaben des frühen Mittelalters*, in *Settimane di studio del Centro italiano di studi sull'alto medioevo*, x, Spoleto, 1963, p. 561.

207. FISCHER (Bonifatius), *Bibeltext und Bibelreform unter Karl dem Grossen*, in *Karl der Grosse*, II, *Die geistige Leben*, Düsseldorf, L. Schwann, 1965, pp. 156-217.

208. FISHER (E. A.), *The Greater Anglo-Saxon Churches. An Architectural Historical Study*, London, Faber and Faber, 1962.

209. FOLZ (Robert), *Le Souvenir et la légende de Charlemagne dans l'Empire germanique médiéval*, Paris, 1950. (Publication of l'Université de Dijon, VII.)

210. FOLZ (Robert), *Le Couronnement impérial de Charlemagne*, Paris, Gallimard, 1964.

211. FORMIGÉ (Jules), *L'Abbaye royale de Saint-Denis. Recherches nouvelles*, Paris, P.U.F., 1960.

212. FORSYTH (George H., Jr.), *The Church of St. Martin in Angers*, Princeton University Press, 1953. (Text and atlas.)

213. FOSSARD (Denise), *Le tombeau carolingien de saint Pons à Cimiez*, in *Cahiers archéologiques*, XV, 1965, pp. 1-15.

214. FOURNIER (Gabriel), *Problèmes d'archéologie carolingienne*, in *L'Information historique*, XXIII, 1961, pp. 54-63.

215. FOURNIER (Gabriel), *Le Peuplement rural en basse Auvergne durant le haut Moyen-Age*, Paris, P.U.F., 1962. (Thesis.)

216. *Franconia Sacra. Meisterwerke kirchlicher Kunst des Mittelalters in Franken. Mainfränk. Museum Würzburg*, Munich, 1952.

217. FRANCOVICH (Geza de), *Arte carolingia ed ottoniana in Lombardia*, in *Römisches Jahrbuch für Kunstgeschichte*, VI, 1942-1944, pp. 113-255.

218. FRANCOVICH (Geza de), *Problemi della pittura e della scultura preromanica*, in *Settimane di studio del Centro italiano di studi sull'alto medioevo, 1954*, II, 1, Spoleto, 1955, p. 370 sq.

219. FRANCOVICH (Geza de), *Osservazioni sull'altare di Ratchis a Cividale e sui rapporti tra Occidente ed Oriente nei secoli VII e VIII D.C.*, in *Scritti di storia dell'arte in onore di Mario Salmi*, I, Rome, De Luca edit., 1961, pp. 173-236.

220. FRANCOVICH (Geza de), *Il problema cronologico degli stucchi di S. Maria in Valle a Cividale*, in *Atti dell'ottavo Congresso di studi sull'arte dell'alto medioevo*, I, Milan, 1962, p. 65 sq.

221. FRANKL (Paul), *Die frühmittelalterliche und romanische Baukunst*, Potsdam, 1926.

222. FREEMAN (Ann), *Theodulph of Orléans and the Libri Carolini*, in *Speculum*, XXXII, 1957, pp. 663-705.

223. FREEMAN (Ann), *Further Studies in the Libri Carolini*, in *Speculum*, XL, 1965, pp. 203-290.

224. FRENZEL (G.), *Restaurierungsdokumentation der lorscher Grabungsbefundes 1965*, in *Restaurierungskartie hessisches Landesmuseum*, Darmstadt, 1965.

225. FRIEND Jr. (Albert Mathias), *The Carolingian Art in the Abbey of St. Denis*, in *Art Studies*, I, Princeton, N.J., 1923, p. 76 sq and pp. 132-148.

226. FRIEND Jr. (Albert Mathias), *Two Manuscripts of the School of St. Denis*, in *Speculum*, I, 1926, pp. 59-70.

227. FRIEND Jr. (Albert Mathias), *Portraits of the Evangelists in Greek and Latin Manuscripts*, in *Art Studies*, V and VII, Cambridge, Mass., 1927, pp. 115-117, and 1929, pp. 3-32.

228. FRIEND Jr. (Albert Mathias), *The Canon Tables of the Book of Kells*, in *Medieval Studies in Memory of A. Kingsley Porter*, II, Cambridge, Mass., 1939, pp. 621-641.

229. FROLOW (Anatole), *La Relique de la vraie croix. Recherches sur le développement d'un culte*, Paris, Institut français d'études byzantines, 1961.

230. *Frühmittelalterliche Kunst. Neue Beiträge zur Kunstgeschichte des 1. Jahrtausends*, Baden-Baden, Verlag für Kunst und Wissenschaft, 1954.

231. FUCHS (A.), *Zum Problem der Westwerke*, in *Karolingische und ottonische Kunst*, Wiesbaden, 1957, pp. 109-117.

232. GAEHDE (J. E.), *The Painters of the Carolingian Bible Manuscript of S. Paolo fuori le mura*, New York (manuscript), 1963. (Dissertation.)

233. GALL (Ernst), *Karolingische und ottonische Kirchen*, Burg-Magdebourg, Opter, 1930. ("Deutsche Bauten," vol. XVII.)

234. GALL (Ernst), *Zur Frage der Westwerke*, in *Jahrbuch des Römisch-Germanischen Zentralmuseums Mainz*, I, Mainz, 1954, pp. 245-252.

235. GANSHOF (François-Louis), *Étude sur le développement des villes entre Loire et Rhin au Moyen-Age*, Paris-Brussels, P.U.F., 1943.

236. GANSHOF (François-Louis), *La revision de la Bible d'Alcuin*, in *Bibliothèque d'Humanisme et Renaissance*, 1947, pp. 7-20.

237. GANTNER (Joseph), *Histoire de l'art en Suisse, depuis les origines jusqu'au début du XXe siècle*, I, Neuchâtel, V. Attinger, 1938 (1st. ed. in German, Leipzig, 1936.)

238. GARAUD (Marcel), *Les incursions des Normands en Poitou et leurs conséquences*, in *Revue historique*, CLXXX, Paris, Félix Alcan, 1937, pp. 241-267.

239. GAUTHIER (Marie-Madeleine S.), *Le trésor de Conques*, in *Rouergue roman*, Saint-Léger-Vauban, Zodiaque, La Pierre-qui-Vire, 1963, pp. 98-145.

240. GERKE (Friedrich), *Das lorscher Glasfenster*, in *Beiträge zur Kunst des Mittelalters*, Berlin, 1950, p. 186.

241. GERKE (Friedrich), *Das älteste Christusmosaik in Ravenna*, Suttgart, 1965. ("Werkmonographien zur bildenden Kunst," no. 104.)

242. GINHART (K.), *Der fünfundzwanzigste karolingische Flechtwerkstein in Kärnten*, in *Carinthia*, I, 1957, p. 218 sq.

243. GIRARD (Raymond), *La crypte de Saint-Laurent de Grenoble*, in *Cahiers d'histoire publiés par les universités de Clermont, Lyon et Grenoble*, VI, 1961, pp. 155-163.

244. GISCHIA (Léon), MAZENOD (Lucien) and VERRIER(Jean), *Les Arts primitifs français*, Paris, Arts et métiers graphiques, 1941.

245. GOLDSCHMIDT (Adolph), *Die Elfenbeinskulpturen aus der Zeit der karolingischen und sächsischen Kaiser*, Berlin, Deutscher Verein für Kunstwissenschaft, 1914-1926, 4 vol.

246. GOLDSCHMIDT (Adolph), *Die deutschen Bronzetüren des frühen Mittelalters*, Marbourg, 1926.

247. GOLDSCHMIDT (Adolph), *Die deutsche Buchmalerei*, I, Munich and Florence, Pantheon casa editrice, 1928, 2 vol.

248. GOLDSCHMIDT (Adolph), *German Illumination*, Paris-Florence, 1928.

249. GOLDSCHMIDT (Adolph), *Ivory Panels of Lorsch*, in *Speculum*, XIV, 1939, p. 257 sq.

250. GOLDSCHMIDT (Adolph), *An Early Manuscript of the Æsop Fables of Avianus, and Related Manuscripts*, in *Studies in Manuscript Illumination*, I, Princeton, Princeton University Press, 1947.

251. GOMBRICH (Ernst), *Eine verkannte karolingische Pyxis im Wiener kunsthistorisches Museum*, in *Jahrbuch der kunsthistorischen Sammlungen in Wien*, new series, III, 1933, p. 1 sq.

252. GÓMEZ MORENO (Mannel), *Iglesias mozárabes*, Madrid, 1919, 2 vol.

253. GRABAR (André), *Martyrium. Recherches sur le culte des reliques et l'art chrétien antique*, Paris, Collège de France, 1946-1948. (2 vol. of text and 1 vol. of plates.)

254. GRABAR (André). *Les fresques de Castelseprio*, in *Gazette des Beaux-Arts*, Paris-New York, 1950, pp. 107-114.

255. GRABAR (André), *Early Christian Art*, New York and London, 1968. ("The Arts of Mankind.")

256. GRABAR (André), *The Golden Age of Justinian*, New York and London, 1966. ("The Arts of Mankind.")

257. GRABAR (André) and NORDEN-FALK (Carl), *Early Medieval Painting from the Fourth to the Eleventh Century*, New York, Skira, 1957.

257a. GREENE (Bella da Costa). Cf. DA COSTA.

258. GRIBOMONT (Jean), *Conscience philologique chez les scribes*, in *Settimane di studio del Centro italiano di studi sull'alto medioevo*, X, 1963, pp. 600-630.

259. GRIMME (E. G.), *Die "Lukasmadonna" und das "Brustkreuz Karls des Grossen,"* in *Miscellanea pro arte. H. Schnitzler zur Vollendung des 60. Lebensjahr*, Düsseldorf, 1965, p. 48 sq.

260. GRISAR (Hartmann), *Die römische Kapelle Sancta Sanctorum und ihr Schatz*, Freiburg-im-Breisgau, 1908.

261. GRODECKI (Louis), *Ivoires français*, Paris, Larousse, 1947.

262. GRODECKI (Louis), *L'Architecture ottonienne*, Paris, A. Colin, 1958.

263. GROSSMANN (Dieter), *Kloster Fulda und seine Bedeutung für den frühen deutschen Kirchenbau*, in *Das erste Jahrtausend*, I, Düsseldorf, L. Schwann, 1962, pp. 344-370.

264. GUILMAIN (Jacques), *Interlace Decoration and the Influence of the North on Mozarabic Illumination*, in *The Art Bulletin*, XLII, 1960, pp. 211-218.

265. GUILMAIN (Jacques), *Observations in some Early Interlace Initials and Frame Ornaments in Mozarabic Manuscripts of Leon, Castile*, in *Scriptorium*, XV, 1961, pp. 23-35.

266. GUILMAIN (Jacques), *The Illumination of the Second Bible of Charles the Bald*, in *Speculum*, April, 1966, pp. 246-260.

267. HACKENBROCH (Y.), *Italienisches Email des frühen Mittelalters*, Basel-Leipzig, 1938.

268. HAHN (H.), *Die Ausgrabungen am Fuldaer Domplatz*, in *St. Bonifatius*, Fulda, 1954, pp. 641-686.

269. HALPHEN (Louis), *Charlemagne et l'empire carolingien*, Paris, Albin Michel, 1947. ("L'Évolution de l'humanité," 33.)

270. HASELOFF (Günther), *Der Tassilokelch*, Munich, 1951.

271. HASELOFF (Günther), *Das sogemannte Messer des heiligen Petrus im Domschatz zu Bamberg*, in *Bayerische Vorgbl.*, XVIII-XIX, Munich, 1951-1952, p. 83 sq.

272. HASELOFF (Günther), *Der Abtsstab des heiligen Germanus zu Delsberg*, in *Germania*, XXXIII, 1955, p. 210 sq.

273. HAUCK (Karl), *Statue Karls des Grossen in Aachen*, in *Symposion*, Mainz, 1960.

274. HAUTTMANN (Max), *Die Kunst des frühen Mittelalters*, Berlin, Propyläen Verlag, 1929.

275. HÉBRARD (Jean), *Anciens autels du diocèse de Montpellier*, Montpellier, 1942.

276. HEITZ (Carol), *Recherches sur les rapports entre architecture et liturgie à l'époque carolingienne*, Paris, S.E.V. P.E.N., 1963.

277. HENRY (Françoise), *Irish Art in the Early Christian Period (to 800 A.D.)*, Ithaca, Cornell University Press, 1965.

278. HENRY (Françoise), *L'Art irlandais*, Saint-Léger-Vauban, Zodiaque, 1963-1964, 3 vol. ("La Nuit des temps," 18, 19, 20.)

279. HINKS (Roger), *Carolingian Art*, London, 1935; 2d ed., Ann Arbor, Mich., 1962.

280. HINZ (H.), *Die karolingische Keramik in Mitteleuropa*, in *Karl der Grosse*, III, Düsseldorf, L. Schwann, 1965, p. 262 sq.

281. HOFFMANN (H.), *Die Aachener Theoderichstatue*, in *Das erste Jahrtausend*, Düsseldorf, 1962, p. 318 sq.

282. HOLMQVIST (Wilhelm), *Eine Studie zur kontinentalen Tierornamentik*, in *Wallraf-Richartz Jahrbuch*, XV, Cologne, 1953, p. 9 sq.

283. HOLTER (Kurt), *Drei Evangelienhandschriften der Salzburger Schreibschule des IX. Jahrhunderts*, in *Österreichische Zeitschrift für Kunst und Denkmalpflege*, XII, 1958, pp. 85-91.

284. HOLTER (Kurt), *Das alte und neue Testament in der Buchmalerei nördlich der Alpen*, in *Settimane di studio del Centro italiano di studi sull'alto medioevo*, X, *La bibbia nell'alto medioevo*, Spoleto, 1963, pp. 413-471.

285. HOLTER (Kurt), *Der Buchschmuck in Süddeutschland und Oberitalien*, in *Karl der Grosse*, III, Düsseldorf, L. Schwann, 1965, pp. 74-114.

286. HOMBURGER (Otto), *Die kunstgeschichtliche Stellung des Psalteriums*, in *Zeitschrift für schweizerische Archäologie und Kunstgeschichte*, V, Basel, 1943, pp. 44-50.

287. HOMBURGER (Otto), *Eine unveröffentliche Evangelienhandschrift aus der Zeit Karls des Grossen*, in *Zeitschrift für schweizerische Archäologie und Kunstgeschichte*, V, 1943, pp. 149-163.

288. HOMBURGER (Otto), *Früh- und vormittelalterliche Stücke im Schatz des Augustinerchorh. Stifte von Saint-Maurice und in der Kathedrale zu Sitten*, in *Frühmittelalterliche Kunst in den Alpenländern*, Olten-Lausanne, Urs Graf Verlag, 1954, p. 347 sq.

289. HOMBURGER (Otto), *Die illustrierten Handschriften des Burger Bibliothek. Die vorkarolingischen und karolingischen Handschriften*, Berne, 1955.

290. HOMBURGER (Otto), *Eine spätkarolingische Schule von Corbie*, in *Karolingische und ottonische Kunst, Werden, Wesen, Wirkung*, Wiesbaden, 1957, pp. 412-426.

291. HOMBURGER (Otto), *L'art carolingien de Metz et l'"école de Winchester,"* in *Gazette des Beaux-Arts*, 6th period, LXII, Paris-New York, P.U.F., July-August 1963, pp. 35-46. (Essays in honor of Jean Porcher.)

292. HORN (Walter), *On the Origins of the Mediaeval Bay System*, in *Journal of the Society of Architectural Historians*, XVII, 1958, pp. 2-24. *Influence of wooden architecture on stone architecture.*

293. HORN (Walter) and BORN (E.), *The Aisled Mediaeval Timber Hall*, Berkeley, University of California Press, 1966.

294. HUBERT (Jean), *La tête de Christ de Saint-Martin d'Autun*, in *Bulletin de la Société nationale des antiquaires de France*, Paris, 1936, pp. 132-140.

295. HUBERT (Jean), *L'Art préroman*, Paris, Van Oest, 1938.

296. HUBERT (Jean), *Miniatures de la Bible de Moûtier-Grandval*, in *Bulletin de la Société nationale des antiquaires de France*, Paris, 1948-1949, pp. 167-168.

297. HUBERT (Jean), *L'"Ecrin" dit de Charlemagne*, in *Cahiers archéologiques*, IV, Paris, Klincksieck, 1949, p. 71 sq.

298. HUBERT (Jean), *Cryptae inferiores et cryptae superiores dans l'architecture religieuse de l'époque carolingienne*, in *Mélanges d'histoire du Moyen-Age dédiés à Louis Halphen*, Paris, P.U.F., 1951, pp. 351-357.

299. HUBERT (Jean), *L'étude de l'ancienne topographie des monastères. Problèmes et méthodes*, in *Bulletin des relations artistiques France-Allemagne*, Mainz, May 1951.

300. HUBERT (Jean), *L'Architecture religieuse du haut Moyen-Age en France. Plans, notices et bibliographie*, Paris, Imprimerie nationale, 1952. (Bibliothèque de l'École pratique des Hautes Études, Section des sciences religieuses, Collection chrétienne et byzantine.)

301. HUBERT (Jean), *La "crypte" de Saint-Laurent de Grenoble et l'art du sud-est de la Gaule au début de l'époque carolingienne*, in *Arte del primo millennio. Atti del secondo Convegno per lo studio dell'alto medioevo*, Turin, 1953, pp. 327-334.

302. HUBERT (Jean), *La renaissance carolingienne et la topographie religieuse des cités épiscopales*, in *Settimane di studio del Centro italiano di studi sull'alto medioevo*, I, Spoleto, 1953, pp. 219-225.

303. HUBERT (Jean), *Quelques sources de l'art carolingien*, in *Settimane di studio del Centro italiano di studi sull'alto medioevo*, I, Spoleto, 1954, pp. 219-226.

304. HUBERT (Jean), *Les églises à rotonde orientale*, in *Art du haut Moyen-Age dans la région alpine*, Lausanne, Urs Graf Verlag, 1954, pp. 308-329.

305. HUBERT (Jean), *Saint-Riquier et le monachisme bénédictin en Gaule à l'époque carolingienne*, in *Settimane di studio del Centro italiano di studi sull'alto medioevo*, IV, Spoleto, 1957, pp. 293-309.

306. HUBERT (Jean), *L'abbaye de Déols et les constructions monastiques de la fin de l'époque carolingienne*, in *Cahiers archéologiques*, IX, 1957, pp. 155-164.

307. HUBERT (Jean), *L'époque carolingienne*, in René HUYGHE, *Art and Mankind*, II, London, Paul Hamlyn, 1963. (French ed., 1958.)

308. HUBERT (Jean), *Évolution de la topographie et de l'aspect des villes de Gaule du V^e au X^e siècle*, in *Settimane di studio del Centro italiano di studi sull'alto medioevo*, VI, Spoleto, 1958-1959, pp. 529-558.

309. HUBERT (Jean), *Date des cryptes de Saint-Médard de Soissons*, in *Bulletin de la Société nationale des antiquaires de France*, Paris, 1959, pp. 123-124.

310. HUBERT (Jean), *Les cryptes de Saint-Médard de Soissons et l'art carolingien*, in *Centre international d'études*, 1959, pp. 12-70. (Bulletin three times a year).

311. HUBERT (Jean), *La vie commune des clercs et l'archéologie*, in *La vita commune del clero nei secoli XI e XII*, I, Milan, 1962, pp. 90-116. (Publications of the Catholic University of Milan, 3d series.)

312. HUBERT (Jean), *L'église Saint-Michel de Cuxa et l'occidentation des églises au Moyen-Age*, in *Journal of the Society of Architectural Historians*, 1963, pp. 163-170.

313. HUBERT (Jean), PORCHER (Jean) and VOLBACH (Wolfgang Fritz), *Europe of the Dark Ages*, London, 1969. U.S. edition, *Europe of the Invasions*, New York, 1969. ("Arts of Mankind.")

314. HUGOT (Leo), *Pfalz Karls des Grossen in Aachen*, in *Karl der Grosse*, III, *Karolingische Kunst*, Düsseldorf, L. Schwann, 1965, pp. 534-573.

315. IMDAHL (Max), *Die Miniaturen des karolingischen Malers Liuthard*, in *Münstersche Forschungen*, IX, Münster-Cologne, 1955, pp. 1-40.

316. JALABERT (Denise), *La Flore sculptée des monuments du Moyen-Age en France. Recherches sur les origines de l'art français*, Paris, A. et J. Picard, 1965.

317. JANKUHN (Herbert), *Kunstgewerbe in Haithabu*, in *I.P.E.K.*, Berlin, 1934, p. 117 sq.

318. JANTZEN (Hans), *Ottonische Kunst*, Munich, 1947.

319. JENNY (Wilhelm Albert von), *Das sogennante Rupertuskreuz in Bischofshofen*, in *Arte del primo millennio*, Turin, 1952, p. 382 sq.

320. JONES (L. W.), *The Script of Cologne from Hildebald to Hermann*, Cambridge, Mass., 1932.

321. JONES (L. W.) *The Text of the Bible and the Script and Art of Tours*, in *Harvard Theological Review*, XXVIII, 1935, pp. 135-179.

322. JONES (L. W.) and MOREY (Charles Rufus), *The Miniatures of the Manuscripts of Terence Prior to the XIIth Century*, Princeton, 1931, 2 vol.

323. JOUVEN (Georges), *Fouille des cryptes et de l'abbatiale Saint-Pierre de Flavigny*, in *Les Monuments historiques de la France*, 1960, pp. 9-28.

324. JURASCHEK (Franz von), *Die frühesten Kirchen von Österreich*, in *Beiträge zur Kunstgeschichte und Archäologie des Frühmittelalters*, Graz-Cologne, 1962, pp. 3-20.

325. JURASCHEK (Franz von), *Die Apokalypse von Valenciennes*, in *Veröffentlichungen der Gesellschaft für österreichische Frühmittelalterforschung*, I, Linz, n.d.

326. KANTOROWICZ (Ernst H.), *The Carolingian King in the Bible of S. Paolo fuori le mura*, in *Late Classical and Mediaeval Studies in Memory of Albert Mathias Friend Jr.*, Princeton, 1955, pp. 287-300.

327. *Karl der Grosse, Werk und Wirkung.* (Exhibition catalogue, German ed. Cf. Bibl. no. 111.)

328. KAUFFMANN (Georg), *Der karolingische Psalter in Zürich und sein Verhältnis zu einigen Problemen byzantinischer Psalterillustration*, in *Zeitschrift für schweizerische Archäologie und Kunstgeschichte*, XVI, Basel, 1956, pp. 65-74.

329. KAUTZSCH (Rudolf), *Die römische Schmuckkunst in Stein von 6. bis zum 10. Jahrhundert*, in *Römisches Jahrbuch für Kunstgeschichte*, III, 1939.

330. KAUTZSCH (Rudolf), *Die langobardische Schmuckkunst in Oberitalien*, in *Römisches Jahrbuch für Kunstgeschichte*, V, 1941, p. 1 sq.

331. KESSLER (H. L.,), *The Sources and the Construction of the Genesis, Exodus, Majestas and Apocalypse Frontispiece Illustrations in the ninth-century Touronian Bibles*, Princeton University (manuscript), 1965. (Dissertation.)

332. KIRCHNER (Joachim), *Die Heimat des Eginocodex*, in *Archiv für Urkundenforschung*, X, 1926, pp. 111-127.

333. KITZINGER (E.), Review of Kœhler (Wilhelm), *Die karolingischen Miniaturen*, III, in *Art Bulletin*, XLIV, no. 1, New York, March, 1962, pp. 61-65.

334. KLAUSER (Theodor), *Das römische Capitulare Evangeliorum*, in *Liturgiegeschichtliche Quellen und Forschungen*, XXVIII, Münster, 1935.

335. KLAUSER (Theodor BOUR) and (R. S.), *Un document du IXᵉ siècle, notes sur l'ancienne liturgie de Metz et ses églises, antérieur à l'an mille*, in *Annuaire de la Société d'histoire et d'archéologie de la Lorraine*. XXXVIII, 1929, pp. 477-643.

336. KLEEBERG (A.V.), *Die Wandgemälde in der Sankt-Prokulus-Kirche zu Naturns*, Bolzano, 1958.

337. KLEINCLAUSZ (Arthur), *L'Empire carolingien. Les origines et les transformations*, Paris, Hachette, 1902.

338. KLEINCLAUSZ (Arthur), *Charlemagne*, Paris, Hachette, 1934.

339. KOCH (A.), *Die Mölsheimer Goldfibel —ein frühkarolingisches Denkmal*, in *Zeitschrift für Kunstgeschichte*, IV, 1935, p. 205 sq.

340. KŒHLER (Wilhelm), *Die Denkmäler der karolingischen Kunst in Belgien*, in *Belgische Kunstdenkmäler*, I, Munich, F. Bruckmann, 1923, pp. 1 to 26.

341. KŒHLER (Wilhelm), *Die Tradition der Ada-Gruppe und die Anfänge des ottonischen Stiles in der Buchmalerei*, in *Festschrift zum 60. Geburtstage von Paul Clemen*, Düsseldorf, 1926, pp. 255-272.

342. KŒHLER (Wilhelm), *Touronische Handschriften aus der Zeit Alkuins*, in *Mittelalterliche Handschriften, Festgabe zum 60. Geburtstage von Hermann Degering*, Leipzig, 1926, pp. 172-180.

343. KŒHLER (Wilhelm), *Die Schule von Tours*, in *Die karolingischen Miniaturen*, I, Berlin, 1930-1933. (2 vol. of text and 1 vol. of plates.)

344. KŒHLER (Wilhelm), *An Illustrated Evangelistary of the Ada-School and its Model*, in *Journal of the Warburg and Courtauld Institute*, XV, 1952, pp. 48-66.

345. KŒHLER (Wilhelm), *The Fragments of an Eighth-Century Gospelbook in the Morgan Library (Ms. 564)*, in *Studies in Art and Literature for Belle da Costa Greene*, Princeton, Princeton University Press, 1954, pp. 238-265.

346. KŒHLER (Wilhelm), *Die karolingischen Miniaturen*, II, *Die Hofschule Karls des Grossen*, Berlin, edited by the Deutscher Verein für Kunstwissenschaft, 1958. (1 vol. of text and 1 vol. of plates.)

347. KŒHLER (Wilhelm), *Die karolingischen Miniaturen*, III, *Die Gruppe des Wiener Krönungsevangeliars. Metzer Handschriften*, Berlin, 1960. (1 vol. of text and 1 vol. of plates.)

348. KRAUTHEIMER (Richard), *Corpus basilicarum christianarum, saec. IV-IX*, I, Vatican City, 1937-1945.

349. KRAUTHEIMER (Richard), *The Carolingian Revival of Early Christian Architecture*, in *The Art Bulletin*, XXIV, 1942, pp. 1-31.

350. KREUSCH (Felix), *Über Pfalzkapelle und Atrium zur Zeit Karls des Grossen*, Aachen, 1958. (Dom zu Aachen. " Beiträge zur Baugeschichte, " IV.)

351. KREUSCH (Felix), *Beobachtungen an der Westanlage der Klosterkirche zu Corvey. Ein Beitrag zum Frage ihrer Form und Zweckbestimmung*, Cologne, H. Böhlau Verlag, 1964.

352. KREUSCH (Felix), *Kirche, Atrium und Portikus der Aachener Pfalz*, in *Karl der Grosse*, III, *Karolingische Kunst*, Düsseldorf, 1965, pp. 463-534.

353. *Kunst des frühen Mittelalters, Berner Kunstmuseum, juin-octobre 1949*, Berne 1949.

354. *Kunstdenkmäler (Die) der Schweiz. Les monuments d'art et d'histoire de la Suisse*, Société d'histoire de l'art en Suisse, Bâle. (In publication since 1927.)

355. LAFAURIE (Jean), *Migrations des peuples et haut Moyen-Age en Occident*, in *A Survey of Numismatic Research (1960-1965)*, II, *Mediaeval and Oriental Numismatics*, edited by KOLBIORT SKAARE and GEORGES CAMILES, Copenhagen, International Numismatic Commission, 1967, pp. 13-51. (Overview and bibliography, " Les Carolingiens, " pp. 38-51.)

356. LAMY-LASSALLE (C.), *Fresques de Saint-Michel d'Aiguilhe*, in *Bulletin de la Société nationale des antiquaires de France*, Paris, 1958, pp. 86-90.

357. LANTIER (Raymond) and HUBERT (Jean), *Les Origines de l'art français*, Paris, G. Le Prat, 1947.

358. LAPAIRE (Claude), *Les Constructions religieuses de Saint-Ursanne et leurs relations avec les monuments voisins (VIIᵉ-XIIIᵉ siècle)*, Porrentruy, 1960. (Thesis, l'Université de Lausanne.)

359. LASTEYRIE (Robert de), *L'Architecture religieuse en France à l'époque romane*, Paris, A. et J. Picard, 1911; 2d ed. 1929, revised by M. Aubert.

360. LATOUCHE (Robert), *Les Origines de l'économie occidentale (IVᵉ-XIᵉ siècle)*, Paris, Albin Michel, 1956. (" L'Évolution de l'humanité, " 43.)

361. LATOUCHE (Robert), *Caesar to Charlemagne: The Beginnings of France*, trans. from French by Jennifer Nicholson. London and New York, 1968.

362. LAUER (Philippe), *Les Enluminures romanes des manuscrits de la Bibliothèque Nationale*, Paris, Gazette des Beaux-Arts, 1927.

363. LAUER (Philippe), *L'Évangéliaire carolingien de Lyon*, Lyon, 1928.

364. LEBOUTEUX (Pierre), *Bulletin archéologique du Comité des travaux historiques*, Paris, 1967, p. 250 sq.

365. LEHMANN (Edgar), *Der frühe deutsche Kirchenbau. Die Entwicklung seiner Raumanordnung bis 1080*, Berlin, 1938; 2d ed., 1949. (1 vol. of text and 1 vol. of plates.)

366. LEHMANN (Edgar), *Zum Buche von Wilhelm Rave über Corvey*, drawn in part from the review *Westfalen*, XXXVIII, 1960, pp. 12-35.

367. LEHMANN (Edgar), *Die Architektur zur Zeit Karls des Grossen*, in *Karl der Grosse*, III, *Karolingische Kunst*, Düsseldorf, 1965, pp. 301-320.

368. LEHMANN (Edgar), *Die Anordnung der Altäre in der karolingischen Klosterkirche zu Centula*, in *Karl der Grosse*, III, *Karolingische Kunst*, Düsseldorf, 1965, pp. 374-384.

369. LEHMANN (Edgar), *Kaiseturm und Reform als Bauherren in hochkarolingischen Zeit*, in *Festschrift Peter Mëtz*, Berlin, 1965.

370. LEHMANN-BROCKHAUS (Otto), *Die Kunst des X. Jahrhunderts im Lichte der Schriftquellen. Sammlung Heitz. Akademische Abhandlungen zur Kulturgeschichte*, III, 6, Leipzig-Strasbourg-Zurich, Heitz, 1935.

371. LEIDINGER (Georg), *Der Codex Aureus der Bayerischen Staatsbibliothek in München*, I-V : plates, VI : text, Munich, Hugo Schmidt, 1921-1925.

372. LEITSCHUH (Franz Friedrich), *Geschichte der karolingischen Malerei, ihr Bilderkreis und seine Quellen*, Berlin, 1894.

373. LEPRIEUR (Paul), *La Période carolingienne*, Paris, 1905.

374. LEROQUAIS (Victor), *Les Évangiles de Jouarre, un manuscrit inconnu de l'école franco-saxonne*, in *Miscellanea Giovanni Mercati (Studi e testi, 126)*, VI, Vatican City, 1946, pp. 234-257.

375. LESNE (Mgr Émile), *Histoire de la propriété ecclésiastique en France*, Lille, 1910-1943, 6 vol. (Publication of the Facultés catholiques of Lille.)

376. LESNE (Mgr Émile), *Les Livres, scriptoria et bibliothèques du commencement du VIIIe à la fin du XIe siècle*, in *Mémoires et travaux publiés par des professeurs des Facultés catholiques de Lille*, fasc. XLVI, Lille, 1938.

377. *Libri Carolini, sive Caroli Magni capitulare de imaginibus, recensuit Hubertus Bastgen*, in *Monumenta Germaniae historica, Legun sectio III, Concilia, tomi II Supplementum*, Hanover, Societas Aperiendis Fontibus, 1924.

378. LIEFTINCK (G.I.), *Het Evangeliarium van Egmond*, in *Huldeboek Pater Dr. B. Kruitwagen, O.F.M.*, The Hague, 1949, pp. 261-275.

379. LINDENSCHMIT (Ludwig), *Sporen aus karolingische Zeit*, in *Die Altertümer unserer heidnischen Vorzeit*, V, Mainz, 1911.

380. LONGHURST (M. H.), *Catalogue of Carvings in Ivory, Victoria and Albert Museum*, I, London, 1927.

381. LONGHURST (M. H.) and MOREY (Charles Rufus), *The Covers of the Lorsch Gospels*, I, in *Speculum*, III, 1928, p. 70 sq.

382. LOO (Alfred de), *Découverte d'un " trésor " à Muysen (province de Brabant)*, in *Bulletin des Musées royaux d'art et d'histoire*, X, Brussels, 1909, p. 74 sq.

383. LOT (Ferdinand), PFISTER (Christian) and GANSHOF (François-Louis), *Histoire du Moyen-Age*, I, *Les Destinées de l'Empire en Occident de 395 à 888*, Paris, P.U.F., 1928; 2d. ed., 1940.

384. LOUIS (René), *Les Églises d'Auxerre des origines au XIe siècle*, Paris, Clavreuil, 1952.

385. McGURK (Patrick), *The Gent Livinus Gospels and the Scriptorium of Saint-Amand*, in *Sacris erudiri*, XIV, 1963, p. 164 sq.

386. MACLAGAN (E.), *Notes on the Panels from a Carolingian Ivory Diptych in the Ravenna and South Kensington Museum*, in *Antiquarian Journal*, II, London, 1922, p. 193 sq.

387. MANN (Albert), *Grossbauten vorkarolingischer Zeit und aus der Epoche von Karl dem Grossen bis zu Lothar I*, in *Karl der Grosse*, III, *Karolingische Kunst*, Düsseldorf, 1965, pp. 320-323.

388. MANTUANI (Joseph), *Tuotilo und die Elfenbeinschnitzerei am Evangelium longum*, in *Studien zur deutschen Kunstgeschichte*, XXIV, Strasbourg, 1900.

389. *Manuscrits (Les) à peinture en France du VIIe au XIIe siècle*, Paris, Bibliothèque Nationale, 1954. (Exhibition catalogue.)

390. *Mémorial d'un voyage d'études de la Société nationale des antiquaires de France en Rhénanie, 1951*, Paris, Klincksieck, 1953.

391. MERTENS (Jacques), *Quelques édifices religieux à plan central découverts récemment en Belgique*, in *Genava*, n.s., XI, 1963, pp. 141-161.

392. MERTON (A.), *Die Buchmalerei von St. Gallen*, Leipzig, 1912; 2d ed., 1923.

393. MESSERER (W.), *Zum Lovenianus Codex der Biblioteca Vallicelliana*, in *Miscellanea, Bibliotheca Hertziana*, Munich, 1961, p. 59 sq.

394. METZ (P.), *Das Kunstgewerbe von der Karolingerzeit bis zum Beginn der Gotik*, in BOSSERT (Helmuth Theodor), *Geschichte des Kunstgewerbes, aller Zeiten und Völker*, V, Berlin, 1932, p. 197 sq.

395. MEYER-BARKHAUSEN (W.), *Ein karolingisches Bronzegitter als Schmuckmotiv des Elfenbeinkelches von Deventer*, in *Zeitschrift für bildende Kunst*, LXIV, 1930-1931, p. 244 sq.

396. MEYER-BARKHAUSEN (W.), *Die Kapitelle der Justinuskirche in Höchst am Main*, in *Jahrbuch der Preussischen Kunst*, LIV, Berlin, 1933, p. 83 sq.

397. MEYER-BARKHAUSEN (W.), *Karolingische Kapitelle und ihre Vorbilder*, in *Kunstchronik*, VI, 1953, pp. 262-263.

398. MICHELI (Geneviève-Louise), *L'Enluminure du haut Moyen-Age et les influences irlandaises*, Brussels, La Connaissance, 1939. (Thesis.)

399. *Miscellanea di studi bresciani sull'alto medioevo*, Brescia, 1959. (Published on the occasion of the VIIIe Congrès international de l'art du haut Moyen-Age, 1959.)

400. MITCHELL (H.P.), *An Enamel of the Carolingian Period from Venice*, in *Archaeological Journal*, LXXIV, 1917, p. 122 sq.

401. MONTESQUIOU-FEZENSAC (Bernard de), *L'Arc de triomphe d'Éginhard*, in *Cahiers archéologiques*, IV, Paris, Klincksieck, 1948, p. 79 sq.

402. MONTESQUIOU-FEZENSAC (Bernard de), *A Carolingian Rock Crystal from the Abbey of Saint-Denis at the British Museum*, in *Antiquarian Journal*, XXXIV, London, 1954, p. 38 sq.

403. MONTESQUIOU-FEZENSAC (Bernard de), *Ivoires narratifs de l'époque carolingienne*, in *Mémoires de la Société nationale des antiquaires de France*, Paris, 1954, p. 137 sq.

404. MONTESQUIOU-FEZENSAC (Bernard de), *L'Arc de triomphe d'Éginhard*, in *Karolingische und ottonische Kunst*, Wiesbaden, 1957, p. 43 sq.

405. MONTESQUIOU-FEZENSAC (Bernard de), *Le talisman de Charlemagne*, in *Art de France*, II, Paris, Hermann, 1962, pp. 66-76.

406. MONTESQUIOU-FEZENSAC (Blaise de), *L'arc d'Éginhard*, in *Cahiers archéologiques*, VIII, 1956, pp. 147-174.

407. MOOSBRUGGER-LEU (R.), *Der Abtsstab des heiligen Germanus*, in *Ur-Schweiz*, XX, 1956, p. 54 sq.

408. MOREY (Charles Rufus), *The Covers of the Lorsch Gospels*, II, in *Speculum*, IV, 1929, p. 411 sq.

409. MOREY (Charles Rufus), *Gli oggetti di avorio e di osso. Catalogo del Museo sacro*, I, Vatican City, 1936.

410. MOREY (Charles Rufus), RAND (Edward Kennard) and KRAELING (Carl H.), *The Gospel Book of Landévennec (The Hartness Gospels) in the New York Public Library*, in *Art Studies, Mediaeval, Renaissance and Modern*, Cambridge, Mass., 1931, pp. 225 to 286.

411. MORHAIN (E.), *Découvertes archéologiques dans l'église de Cheminot*, in *Annuaire de la Société d'histoire et d'archéologie lorraine*, LIII, 1953, pp. 87-103.
Closure slabs from the beginning of the Carolingian era, similar to those from Saint-Pierre-en-Citadelle in Metz, which formerly were wrongly attributed to the 7th century.

412. *Mostra storica nazionale della miniatura*, Florence, 1953.

413. MÜLLER (Iso), *Stucchi e mosaici alto-medioevali*, in *Atti dell' ottavo Congresso di studi sull'arte dell'alto medioevo*, I, Milan, 1962, pp. 111-127.

414. MÜTHERICH (Florentine), *Observations sur l'enluminure de Metz*, in *Gazette des Beaux-Arts*, Paris, 6th period, LXII, July-August 1963, pp. 47-63. (Essays in honor of Jean Porcher.)

415. MÜTHERICH (Florentine), *Die Reiterstatuette aus der Metzer Kathedrale*, in *Studien zur Geschichte der europäischen Plastik. Festschrift Th. Müller*, Munich, 1965.

416. MÜTHERICH (Florentine), *Die Buchmalerei am Hofe Karls des Grossen*, in *Karl der Grosse*, III, Düsseldorf, L. Schwann, 1965, pp. 9-53.

417. NEUMÜLLER (Dom Willibrord) and HOLTER (Kurt), *Der Codex Millenarius*, Graz-Cologne, H. Böhlau Verlag, 1959.

418. NIVER (C. M. S.), *A Study of Certain of the more Important Manuscripts of the Franco-Saxon School*, extract from *Harvard University Graduate School of Arts and Sciences, Summary of Theses, 1941*, Cambridge, Mass., 1941.

419. NORDENFALK (Carl), *Vier Kanonstafeln eines spätantiken Evangelienbuches*, in *Göteborgs Kungl. Vetenskap och Vitterhetssamhällets Handlingar, femte följden*. series A, Vol. 6, no. 5, Göteborg, 1937.

420. NORDENFALK (Carl), *Ein karolingisches Sakramentar aus Echternach und seine Vorläufer*, in *Acta archæologica*, II, Copenhagen, 1931, pp. 207-244.

421. NORDENFALK (Carl), *Metodische Fortschritte und materieller Landerwerb in der Kunstforschung*, in *Acta archaeologica*, III, Copenhagen, 1932, pp. 276-288.

422. NORDENFALK (Carl), *Beiträge zur Geschichte der turonischen Buchmalerei*, in *Acta archaeologica*, VII (1), Copenhagen, 1936, pp. 281 to 304.

423. NORDENFALK (Carl), *Carolingian Illumination* in *Early Medieval Painting from the Fourth to the Eleventh Century*, New York, Skira, 1957.

424. NORDENFALK (Carl), Review of W. KŒHLER, *Die Hofschule Karls des Grossen*, II, Berlin, 1958, in *Kunstchronik*, XII, 1959, p. 305 sq.

425. NORDENFALK (Carl), Review of W. KŒHLER, *Die karolingischen Miniaturen*, III, *Die Gruppe des Wiener Krönungsevangeliars*, in *Kunstchronik*, XIV, Zentralinstitut für Kunstgeschichte, Munich, 1961, pp. 243-253.

426. NORDHAGEN (Per Jonas), *Freskene i Castelseprio og tidligmiddel alderens " hellenisme, "* in *Kunst og Kultur*, XL, Oslo, Gyldendal Norsk Forlag, 1957, pp. 79-94.

427. OMONT (Henri), *Les Comédies de Térence du manuscrit de Paris*, reproduction des 151 dessins du manuscrit latin 7899 de la Bibliothèque Nationale, Paris, Berthaud, 1907.

428. OMONT (Henri), *Manuscrits illustrés de l'Apocalypse aux IXe et Xe siècles*, in *Bulletin de la Société de reproduction de manuscrits à peinture*, Paris, 1922, pp. 62-95.

429. OTTO (R.), *Zur stilgeschichtliche Stellung des Arnulfciboriums und des Codex Aureus aus St. Emmeram in Regensburg*, in *Zeitschrift für Kunstgeschichte*, XV, 1952, p. 1 sq.

430. PANAZZA (Gaetano), *Lapidi e sculture paleocristiane e preromaniche di Pavia*, in *Arte del primo millenio*, Turin, 1952, pp. 211-300.

431. PANAZZA (Gaetano), *La basilica di S. Salvatore in Brescia*, in *Arte lombarda*, V, 1961, pp. 161-186; VI, 1962, pp. 165-178.

432. PANAZZA (Gaetano) and PERONI (A.), *La chiesa di S. Salvatore in Brescia*, in *Atti dell'ottavo Congresso di studi sull-arte dell'alto medioevo*, II, Milan, 1962, pp. 1-323.

433. PANOFSKY (Dora), *The Textual Basis of the Utrecht Psalter Illustrations*, in *The Art Bulletin*. XXV, 1943, pp. 50-58.

434. *Patrologie latine*, Paris, Migne, 1844-1855. (217 books in 218 vols.)

435. PATZELT (E.), *Die karolingische Renaissance*, Vienna, 1924.

436. PERONI (A.), *La ricomposizione degli stucchi preromanici di S. Salvatore in Brescia*, in *Atti dell'ottavo Congresso di studi sull'arte dell'alto medioevo*, II, Milan, 1962, p. 229 sq.

437. PETRICIOLI (J.), *La scultura preromanica figurata in Dalmazia ed il problema della sua cronologia*, in *Atti dell'ottavo Congresso di studi sull'arte dell'alto medioevo*, I, Milan, 1962, p. 360 sq.

438. PHILIPPE (Joseph), *L'Évangéliaire de Notger et la chronologie de l'art mosan des époques préromane et romane*, Brussels, Palais des Académies, 1956.

439. *Physiologus Bernensis*. Voll-faksimile Ausgabe des Codex Bongarsianus 318 der Burger Bibliothek, Bern. Wissenschaftlicher Kommentar von CHR. VON STEIGER und O. HOMBURGER, Basel, Alkuin Verlag, 1964.

440. PIRENNE (Henri), *Mohammed and Charlemagne*, London, Allen & Unwin, 1939. New York, Barnes & Noble, 1955.

441. PITTIONI (Richard), *Der frühmittelalterliche Grabfund von Köttlach, Landkreis Gloggnitz, Niederdonau*, 1943.

442. PLANCHENAULT (René), *La tête du Christ dit " de Saint-Odon, "* in *Les Monuments historiques de la France*, II, 1937, p. 200 sq.

443. PLANITZ (Hans), *Die deutsche Stadt im Mittelalter von der Römerzeit bis zu den Zunftkämpfen*, Cologne-Graz, H. Böhlau Verlag, 1954.

444. PLAT (Gabriel), *L'Art de bâtir en France, des Romains à l'an 1100, d'après les monuments anciens de la Touraine, de l'Anjou et du Vendômois*, Paris, Van Oest, 1939.

445. PŒSCHEL (Erwin), *In den karolingischen Klosterplan in Sankt Gall*, in *Neue Zürcher Zeitung*, 29 September 1957.

446. PORCHER (Jean), *Une crucifixion mosane*, in *La Revue des arts*, VI, Paris, 1956, p. 197 sq.

447. PORCHER (Jean), *L'Évangéliaire de Charlemagne et le Psautier d'Amiens*, in *La Revue des arts*, VII, Paris, 1957, pp. 51-58.

448. PORCHER (Jean), *Les débuts de l'art carolingien et l'art longobard*, in *Atti dell'ottavo Congresso di studi sull'arte dell'alto medioevo*, I, Milan, 1962, pp. 55-60.

449. PORCHER (Jean), *La peinture provinciale (régions occidentales)*, in *Karl der Grosse*, III, Düsseldorf, L. Schwann, 1965, pp. 54-74.

450. PORTER (A. Kingsley), *The Tomb of Hincmar and Carolingian Sculpture in France*, in *The Burlington Magazine*, XL, London, 1927, p. 75 sq.

451. POUS (A. M.), *Untersuchungen zum Kompositions-schema vorromanischer römischer Chorschranken von der byzantinischen bis zur langobardischen Zeit*, in *Karolingische une ottonische Kunst*, Wiesbaden, 1957, p. 236 sq.

452. PRAETE (S.), *A Manuscript from Charlemagne's Scriptorium*, in *The Classical World*, 1960, pp. 282-284.

453. PROCHNO (Joachim), *Das Schreiber und Dedikationsbild in der deutschen Buchmalerei*, I, *800-1100*, Leipzig-Berlin, 1929.

454. PROU (Maurice), *Catalogue des monnaies françaises de la Bibliothèque Nationale. Les monnaies carolingiennes*, Paris, Rollin et Feuardent, 1896.

455. PROU (Maurice), *Chancel carolingien orné d'entrelacs à Schaennis (canton de Saint-Gall)*, in *Mémoires de l'Académie des Inscriptions et Belles-Lettres*, XXXIX, 1912, pp. 122-138.

456. PUIG I CADAFALCH (José), *La Géographie et les origines du premier art roman*, Paris, Laurens, 1935.

457. PUIG I CADAFALCH (José), *L'Art wisigothique et ses survivances*, Paris, F. de Nobele, 1961.

458. RADEMACHER (Franz), *Zwei ottonische Goldfibeln*, in *Festschrift für August Oxé*, 1938, p. 273 sq.

459. RADEMACHER (Franz), *Unbekannte karolingische Elfenbeine*, in *Pantheon*, XV, 1942, p. 21 sq.

460. RAHN (Johann Rudolf), *Das Psalterium aureum von Sankt Gallen, ein Beitrag zur Geschichte der karolingischen Miniaturen mit Text*, Saint-Gall, 1878.

461. RAMACKERS (Johannes), *Die Werkstattheimat der Grabplatte Papst Hadrians*, I, in *Römische Quartalschrift für christliche Altertumskunde und Kirchengeschichte*, LIX (1-2), Rome-Fribourg-Vienna, 1964, pp. 36-78.

462. RAND (E. K.), *A Survey of the Manuscripts of Tours. Studies of the Script of Tours*, I, Cambridge, Mass., 1929.

463. RAND (E.K.) and JONES L.W.), *The Earliest Book of Tours with Supplementary Descriptions of other Manuscripts of Tours*, Cambridge, Mass., 1934.

464. RASMO (Niccoló), *Note preliminari su S. Benedetto di Malles*, in *Atti dell'ottavo Congresso di studi sull'arte dell'alto medioevo*, I, Milan, 1962, pp. 86-110.

465. RAVE (W.), *Das Westwerk der frühen Benediktinerkirchen*, in *Bulletin des relations artistiques France-Allemagne*, Mainz, 1951.

466. RAVE (W.), *Corvey*, Münster, 1958.

467. REIL (J.), *Christus am Kreuz in der Bildkunst des Karolingerzeit*, in *Studien über christliche Denkmäler*, XXI, Leipzig, 1930.

468. REINECKE (P.), *Spätmerovingsiche-karolingische Grabfunde aus Süddeutschland*, in *Altertümer unserer heidnischen Vorzeit*, V, 1911.

469. REINHARDT (Hans), *Comment interpréter le plan carolingien de Saint-Gall*, in *Bulletin monumental*, LXXXVI, 1937, pp. 265-279.

470. REINHARDT (Hans), *Der St. Galler Klosterplan*, Saint-Gall, Verlag der Fehr'schen Buchhandlung, 1952. ("Historischer Verein des Kantons St. Gallen," 92.)

471. REINHARDT (Hans), *Studien zum St. Galler Klosterplan*, in *Mitteilungen zur vaterländischen Geschichte*, XVII, 1962.

472. REINHARDT (Hans), *La Cathédrale de Reims*, Paris, P.U.F., 1963.

473. REINHARDT (Hans) and FELS (Étienne), *Étude sur les églises-porches carolingiennes et leur survivance dans l'art roman*, in *Bulletin monumental*, XCII, 1933, pp. 331-365 and XCVI, 1937, pp. 425-469.

474. RENLE (Adolf), *Neue Gedanken zum St. Gallen Klosterplan*, drawn in part from the review *Zeitschrift für schweizerische Archäologie und Kunstgeschichte*, XXIII, 1963-1964, pp. 91-109.

475. REY (Raymond), *L'Art roman et ses origines. Archéologie préromane et romane*, Toulouse, private, 1945.

476. REY (Raymond), *L'ivoire de Narbonne*, in *Bulletin de la commission archéologique de Narbonne*, XXII, Narbonne, 1947-1948, p. 79 sq.

477. RICE (D. Talbot), *English Art (871-1100)*, Oxford University Press, 1952.

478. ROOSENS (Héli), *Trouvaille de monnaies carolingiennes à Muizen-lès-Malines*, in *Revue belge de numismatique*, XCVI, Brussels, 1950, p. 203 sq.

479. ROSA (G.), *Le arti minori dalla conquista longobarda al Mille*, in *Storia di Milano*, II, Milan, 1954, p. 673 sq.

480. ROSENBAUM (E.), *The Andrews Diptych and some Related Ivories*, in *The Art Bulletin*, XXXVI, New York, 1954, p. 253 sq.

481. ROSENBAUM (E.), *The Vine Columns of Old St. Peter's in Carolingian Canon Tables*, in *Journal of the Warburg and Courtauld Institute*, XVIII, 1955, pp. 1-15.

482. ROSENBAUM (E.), *The Evangelist Portraits of the Ada School and their Models*, in *The Art Bulletin*, XXXVIII, 1956, pp. 81-90.

483. ROSENBERG (M.), *Das Stephansreliquiar im Lichte des Utrechtpsalters*, in *Jahrbuch der preussischen Kunstsammlungen*, XLIII, 1922, p. 122 sq.

484. ROSS (M. C.), *The Earliest Spanish Cloisonné Enamels*, in *Notes Hispanic*, 1942, p. 87 sq.

485. RÜSCH (E. G.), *Tuotilo, Mönch und Künstler*, Saint-Gall, 1953.

486. SAGE (Walter), *Zur archäologischen Untersuchung karolingischer Pfalzen in Deutschland*, in *Karl der Grosse*, III, *Karolingische Kunst*, Düsseldorf, L. Schwann, 1965, pp. 232-336.

487. SAGE (Walter), *Frühmittelalterlicher Holzbau*, in *Karl der Grosse*, III, *Karolingische Kunst*, Düsseldorf, L. Schwann, 1965, pp. 573-590.

488. SALET (Francis), *Chronique de l'art préroman*, in *Bulletin monumental*, CXX, Paris, 1962-1964, p. 379 sq.

489. SALMI (Mario), *Stucchi e littostrati nell'alto medioevo italiano*, in *Atti dell'ottavo Congresso di studi sull'arte dell'alto medioevo: I, Stucchi*, Milan, 1962, pp. 21-51.

490. SANTANGELO (A.), *Cividale. Catalogo delle cose d'arte e di antichità d'Italia*, I (10), Rome, 1936.

491. SAUER (Joseph), *Ein unbekannter Kristallschnitt des 9. Jahrhunderts*, in *Festschrift P. Clemen*, 1926, p. 241 sq.

492. SCHADE (Herbert, S. J.), *Untersuchungen zu der karolingischen Bilderbibel zu St. Paul vor der Mauern in Rom*, Munich (manuscript), 1954. (Dissertation.)

493. SCHADE (Herbert, S. J.), *Die Libri Carolini und ihre Stellung zum Bild*, in *Zeitschrift für katholische Theologie*, LXXIX, Vienna, 1957, pp. 69-78.

494. SCHADE (Herbert, S. J.), *Hinweise zur frühmittelalterlichen Ikonographie, I, Adams grosses Gesicht; II, Die Enthüllung des Moses*, in *Das Münster*, XI, 1958, pp. 375-392.

495. SCHADE (Herbert, S. J.), *Studien zur karolingischen Bilderbibel aus St. Paul vor den Mauern in Rom, I*, in *Wallraf-Richartz Jahrbuch*, XXI, Cologne, Dumont-Schauberg, 1959, pp. 9-40.

496. SCHADE (Herbert, S. J.), *Studien zur karolingischen Bilderbibel aus St. Paul vor den Mauern in Rom, II*, in *Wallraf-Richartz Jahrbuch*, XXII, Cologne, Dumont-Schauberg, 1960, pp. 13-48.

497. SCHALLER (Dieter), *Die karolingischen Figurengedichte des Codex Bernensis 212*, in *Medium Aevum vivum. Festschrift für Walther Bulst*, Heidelberg, C. Winter Universitätsverlag, 1960, pp. 22-47.

498. SCHEFOLD (Karl), *Die Bildnisse der antiken Dichter, Redner und Denker*, Basel, B. Schwabe, 1943.

499. SCHIFFERS (H.), *Karls des Grossen Reliquienschatz und die Anfänge der Aachenfahrt*, in *Veröffentlichung des bischöflichen Diözesarchivs Aachen*, X, Aachen, 1951.

500. SCHLOSSER (Julius von), *Schriftquellen zur Geschichte der karolingischen Kunst*, in *Quellenschriften für Kunstgeschichte und Kunsttechnik des Mittelalters und der neu Zeit*, new series, IV, Vienna-Leipzig, Carl Graeser, 1892.

501. SCHLUNK (Helmut), *Are visigodo. Arte asturiano*, in *Ars Hispaniae*, II, Madrid, 1947.

502. SCHLUNK (Helmut), *The Crosses of Oviedo*, in *The Art Bulletin*, XXXII, New York, 1950, p. 91 sq.

503. SCHMIDT (B.), *Untersuchungen und Funde in der Aurelius Kirche in Hirsau*, in *Fundberichte aus Schwaben*, new series, XIV, 1957, p. 149 sq.

504. SCHNITZLER (Hermann), *Südwestdeutsche Kunst um das Jahr 1000 und die Schule von Tours*, in *Trier Zeitschrift*, XIV, Darmstadt, 1939, pp. 154-181. (See review by SWARZENSKI in *The Art Bulletin*, New York, XXIV, 1942, pp. 287-289.)

505. SCHNITZLER (Hermann), *Die Komposition der Lorscher Elfenbeintafeln*, in *Münchner Jahrbuch der bildenden Kunst*, series 3, I, Munich, 1950, p. 26 sq.

506. SCHNITZLER (Hermann), *Der Dom zu Aachen*, Düsseldorf, L. Schwann, 1950.

507. SCHNITZLER (Hermann), *Rheinische Schatzkammer, I*, Düsseldorf, L. Schwann, 1957.

508. SCHNITZLER (Hermann), *Eine Metzer Emaustafel*, in *Wallraf-Richartz Jahrbuch*, XX, Cologne, 1958, p. 41 sq.

509. SCHNITZLER (Hermann), *Rheinische Schatzkammer*, in *The Art Bulletin*, New York, XL, 1958, p. 264 sq.

510. SCHNITZLER (Hermann), *Die Sammlungen des Baron von Hüpsch. Ausstellung des Hessischen Landesmuseums im Schnütgen Museum Köln*, Cologne, 1964.

511. SCHNITZLER (Hermann), *Das Kuppelmosaik der Aachener Pfalzkapelle*, in *Aachener Kunstblätter*, XXIX, 1964, pp. 17-41.

512. SCHNITZLER (Hermann), *Ada-Elfenbeine des Barons von Hüpsch*, in *Festschrift H. von Einem*, Berlin, 1965, p. 244 sq.

513. SCHNITZLER (Hermann), *Die Elfenbeinskulpturen der Hofschule*, in *Karl der Grosse*, Düsseldorf, L. Schwann, 1965, p. 309 sq.

514. SCHRADE (Hubert), *Zur Frühgeschichte der mittelalterlichen Monumentalplastik*, in *Westfalen*, V, XXXV, 1957, p. 63 sq.

515. SCHRADE (Hubert), *Vor- und frühromanische Malerei. Die karolingische, ottonische und frühsalische Zeit*, Cologne, 1958.

516. SCHRADE (Hubert), *Zum Kuppelmosaik der Pfalzkapelle und zum Theoderichdenkmal in Aachen*, in *Aachener Kunstblätter*, XXX, 1965, pp. 25-37.

517. SCHRAMM (Percy Ernst), *Das Herrscherbild in der Kunst des frühen Mittelalters*, in *Vorträge der Bibliothek Warburg*, II, Hamburg, 1922-1923.

518. SCHRAMM (Percy Ernst), *Die deutschen Kaiser und Könige in Bildern ihrer Zeit, I, Bis zur Mitte des XII. Jahrhunderts (751-1152); II, Die Entwicklung des menschlichen Bildnisses*, Leipzig, W. Götz, 1928-1929.

519. SCHRAMM (Percy Ernst), *Herrschaftszeichen und Staatssymbolik*, in *Schriften der Monumenta Germaniae*, XIII (1-3), Stuttgart, 1954-1956.

520. SCHRAMM (Percy Ernst) and MÜTHERICH (Florentine), *Denkmäle der deutschen Könige und Kaiser*, Munich, Prestel Verlag, 1962.

521. SCHWABL (F.), *Neue Fragen zur frühen Baugeschichte der St. Emmeramskirche in Regensburg*, published by H. BÖRNER in *Historische Verein für Oberpfalz und Regensburg*, XCIII, 1952, p. 62 sq.

522. SCHWARTZ (J.), *Quelques sources antiques d'ivoires carolingiens*, in *Cahiers archéologiques*, XI, Paris, Klincksieck, 1960, pp. 145-162.

523. SELIGMANN (Jacques), *L'orfèvrerie carolingienne*, in *Travaux des études du groupe d'Histoire de l'art de la Faculté des Lettres de Paris*, Paris, 1928, p. 137 sq.

524. SERRA (Joselita), *Corpus della scultura alto-medievale, II, La diocesi di Spoleto*, Spoleto, Centro italiano di studi sull'alto mediovo, 1961.

525. *Settimane di studio del Centro italiano di studi sull'alto medioevo*, since 1951.

526. SNIJDER (G. A. S.), *Antique and Mediaeval Gems on Bookcovers at Utrecht*, in *The Art Bulletin*, XIV, New York, 1932, p. 5 sq.

527. SNIJDER (G. A. S.), *Frühmittelalterliche Imitationen antiker Kameen*, in *Germania*, XVII, 1933, p. 118 sq.

528. STEIN (F.), *Adelsgräber des 8. Jahrhunderts im rechtsrheinischen Deutschland*, in *Germanische Denkmäler der Völkerwanderungszeit*, IX, Berlin, 1966.

529. STEINMANN (O.), *Die karolingische Stuckfragmente von St. Martin*, in *Akten zur III. international Kongress für Frühmittelalterforschung*, Olten-Lausanne, 1954, p. 147 sq.

530. STEPHANY (Erich), *Der Dom zu Aachen*, Gladbach, Kühlen, 1958.

531. STERN (Henri), *Recueil général des mosaïques de la Gaule*, Paris, Centre national de la Recherche scientifique, 1957-1967; in publication since 1957, 4 vols. published. (Supplement to *Gallia*, X.)

532. STERN (Henri), *Mosaïques de pavement préromanes et romanes en France*, in *Cahiers de civilisation médiévale*, V, 1962, pp. 13-33.

533. STERN (Henri), *Notes sur les mosaïques de pavement médiévales en France*, in *Atti dell'ottavo Congresso di studi sull'arte dell'alto medioevo*, I, Milan, 1962, pp. 273-283.

534. STETTINER (Richard), *Die illustrierten Prudentius Handschriften*, Berlin, 1905. (1 vol. of text and 1 album of plates.)

535. STOLLENMAYER (P.), *Der Tassilokelch*, in *Festschrift zum 400. jährigen Bestande des öffentlichen Obergymnasiums der Benediktiner zu Kremsmünster*, 1949.

536. STOLLENMAYER (P.), *Tassilo Leuchter. Tassilo-Zepter*, in *102. Jahresbericht des öffentlichen Obergymnasiums der Benediktiner zu Kremsmünster*, 1959.

537. STONE (Laurence), *Sculpture in Britain: The Middle Age*, London, Brandford, 1955.

538. STROH (A.), *Die Reihengräber der karolingisch-ottonischen Zeit in der Oberpfalz*, Kallmünz, 1934.

539. STRZYGOWSKI (Josef), *Der Bilderkreis des griechischen Physiologus des Kosmas Indikopleustes und Oktateuch nach Handschriften der Bibliothek zu Smyrna*, in *Byzantinisches Archiv*, 2d cahier, Leipzig, 1899, p. 37 sq.

540. STUCKELBERG (Ernst Alfred), *Les stucs de Disentis*, in *Mémoires de la Société nationale des antiquaires de France*, LXXII, Paris, 1913, p. 1 sq.

541. *Studien zum St. Gallen Klosterplan*, in *Mitteilungen zur vaterländischen Geschichte*, XIII, Saint-Gall, Fehr'sche Buchhandlung St. Gallen, 1962.

542. SWARZENSKI (Georg), *Die Regensburger Buchmalerei des 10. und 11. Jahrhunderts*, Leipzig, 1901.

543. SWARZENSKI (Georg), *Die karolingische Plastik und Malerei in Reims*, in *Jahrbuch der preussischen Kunstsammlungen*, XXIII, 1902, p. 81 sq.

544. SWARZENSKI (Georg), *Die Salzburger Malerei von den ersten Anfängen bis zur Blütezeit des romanischen Stils*, Leipzig, 1908-1913.

545. SWARZENSKI (Hanns), *The Xanten Purple Leaf and the Carolingian Renaissance*, in *The Art Bulletin*, XXII, University of Chicago, 1940, pp. 7-24.

546. SWARZENSKI (Hanns), *Recent Literature, chiefly Periodical on Mediaeval Minor Arts*, in *The Art Bulletin*, XXIV, University of Chicago, 1942, pp. 287-289. (Review of HERMANN SCHNITZLER, *Südwestdeutsche Kunst um das Jahr 1000 und die Schule von Tours*.)

547. SWARZENSKI (Hanns), *An Unknown Carolingian Ivory*, in *Bulletin of the Museum of Fine Arts*, L, Boston, 1952, p. 2 sq.

548. SWARZENSKI (Hanns), *Just a Dragon*, in *Studies in Art and Literature for Belle da Costa Greene*, Princeton, N.J., 1954, p. 172 sq.

549. SWARZENSKI (Hanns), *Monuments of Romanesque Art*, London, 1954.

550. SWARZENSKI (Hanns), *The "Dowry Cross" of Henri II*, in *Late Classic and Mediaeval Studies in Honor of A. M. Friend*, Princeton, N.J., 1955, p. 301 sq.

551. TARALON (Jean), *Le trésor de Conques*, in *Bulletin de la Société nationale des antiquaires de France*, Paris, 1954-1955, pp. 47-54.

552. TARALON (Jean), in *Les Monuments historiques*, 1966, p. 26 sq.

553. TARALON (Jean), *Treasures of the Churches of France*, New York, George Braziller, 1966.

554. TATUM (G. B.), *Paliotto of Sant' Ambrogio at Milan*, in *The Art Bulletin*, XXVI, University of Chicago, 1944, p. 15 sq.

555. THIELE (Georg), *Antike Himmelsbilder*, Berlin, 1898.

556. THÜMMLER (Hans), *Die frühromanische Baukunst in Westfalen*, in *Westfalen*, XXVIII, 1948, pp. 161-214.

557. THÜMMLER (Hans), *Die karolingische Baukunst*, in *Karolingische und ottonische Kunst*, Wiesbaden, 1957, pp. 84-108.

558. TIKKANEN (Johan Jakob), *Die Psalterillustration im Mittelalter*, I, 3, *Abendländische Psalterillustration der Utrecht Psalter*, Helsinki-Leipzig, Hiersemann, 1900, pp. 153-320.

559. TISCHLER (F.), *Der Stand der Sachsenforschung*, in *35. Bericht der Romisch-Germanischen Kommission 1954*, 1956, p. 21 sq.

560. TOESCA (Pietro), *Storia dell'arte italiana*, I, *Il medioevo*, I, Turin, 1913-1927.

561. TORP (Hjalmar), *Due opere dell'arte aulica longobarda*, in *Atti dell'ottavo Congresso di studi sull'arte dell'alto medioevo*, I, Milan, 1962, pp. 61-64. *S. Salvatore de Brescia and the "Tempietto" of Cividale*.

562. *Trésors (Les) des églises de France*, catalogue de l'exposition du Musée des Arts décoratifs, Paris, Caisse nationale des Monuments historiques, 1965.

563. *Trierer (Die) Ada Handschrift*, founded and edited by K. MENZEL, P. CORSSEN, H. JANITSCHEK, A. SCHNUETGEN, K. WETTNER, K. LAMPRECHT, Leipzig, 1889.

564. TSELOS (Dmitri), *The Sources of the Utrecht Psalter*, Minneapolis, Minn. (author), 1955.

565. TSELOS (Dmitri), *A Greco-Italian School of Illuminators and Fresco Painters. Its Relations to the Principal Reims Manuscripts and to the Greek Frescoes in Rome and Castelseprio*, in *The Art Bulletin*, XXXVIII, 1956, pp. 1-30.

566. TSELOS (Dmitri), *The Influence of the Utrecht Psalter in Carolingian Art*, in *The Art Bulletin*, XXXIX, 1957, p. 87 sq.

567. TSELOS (Dmitri), *English Manuscript Illustration and the Utrecht Psalter*, in *The Art Bulletin*, XLI, (2), June, 1959, pp. 137-150.

568. ULBERT (G.), in *Materialhefte zur bayerische Vorgeschichte*, VIII, 1956, p. 14 sq.

569. UNDERWOOD (P.), *The Fountain of Life in Manuscripts of the Gospels*, in *Dumbarton Oaks Papers*, V, 1950, pp. 41-138.

570. USENER (K. H.), Review of G. DE FRANCOVICH, *Arte carolingia e ottoniana in Lombardia*, in *Römisches Jahrbuch*, 1942-1944, *Kunstchronik*, II, 1949, p. 87 sq.

571. USENER (K. H.), *Eine neue These über den Mailänder Paliotto*, in *Beitrag zur Kunst des Mittelalters*, Berlin, 1950, p. 104 sq.

572. USENER (K. H.), *Die Ausstellung "Ars sacra,"* in *Kunstchronik*, III, 1950, p. 141 sq.

573. USENER (K.H.), *Zur Datierung der Stephansbursa*, in *Miscellanea H. Schnitzler zu 60. Geburtstag*, Düsseldorf, 1965, p. 37 sq.

574. VALLERY-RADOT (Jean), *Les chapelles hautes dédiées à saint Michel*, in *Bulletin monumental*, LXXXVIII, 1929, pp. 453-478.

575. VALLERY-RADOT (Jean), *Saint-Philibert de Tournus*, Paris, Girodias, 1955. ("L'Inventaire monumental," 1.)

576. VENTURI (Adolfo), *Storia dell'arte italiana : II, Dall'arte barbarica alla romanica; III, L'arte romanica*, Milan, Ulrico Hoepli, 1902-1904; reprint, 1967.

577. VERBEEK (Albert), *Die Aussenkrypta. Werden einer Bauform des frühen Mittelalters*, in *Zeitschrift für Kunstgeschichte*, XXX, 1950, p. 7-38.

578. VERBEEK (Albert), *Kölner Kirchen*, Cologne, 1959.

579. VERCAUTEREN (F.), *Études sur les Civitates de la Belgique Seconde*, Brussels, Académie royale de Belgique, 1934.

580. VERCAUTEREN (F.), *Comment s'est-on défendu au IX^e siècle dans l'Empire franc contre les invasions normandes?*, in *Annales du XXX^e Congrès de la Fédération archéologique et historique de Belgique*, 1936, pp. 117-132.

581. VERDIER (Philippe), *Les chevets à déambulatoire sans chapelles rayonnantes*, in *Art du haut Moyen-Age dans la région alpine*, Lausanne, Urs Graf Verlag, 1954, pp. 321-325.

582. VERDIER (Philippe), *Deux plaques d'ivoire de la Résurrection avec la représentation d'un Westwerk*, in *Revue suisse d'art et d'archéologie*, XXII, 1962, p. 3 sq.

583. VERZONE (Paolo), *L'architettura religiosa dell'alto medioevo nell'Italia settentrionale*, Milan, Editions Esperia, 1942; 2d ed., 1961.

584. VERZONE (Paolo), *Les églises du haut Moyen-Age et le culte des anges*, in *L'Art mosan. Journées d'études*, Paris, 1953, pp. 71-80.

585. VERZONE (Paolo), *L'arte preromanica in Liguria ed i rilievi decorativi dei secoli barbari*, Turin, Andrea Viglongo, 1955.

586. VIEILLARD - TROIEKOUROFF (May), *La cathédrale de Clermont du V^e au XIII^e siècle*, in *Cahiers archéologiques*, XI, Paris, Klincksieck and Imprimerie nationale, 1960, pp. 199-247.

587. VIEILLARD - TROIEKOUROFF (May), *Tables de canons et stucs carolingiens*, in *Stucchi e mosaici alto-medioevali. Atti dell'ottavo Congresso di studi sull'arte dell'alto medioevo*, I, Milan, 1962, pp. 154-178.

588. VIEILLARD - TROIEKOUROFF (May), *L'architecture en France au temps de Charlemagne. Fouilles récentes*, in *Karl der Grosse*, III, *Karolingische Kunst*, Düsseldorf, L. Schwann, 1965, pp. 336-369.

589. VIEILLARD - TROIEKOUROFF (May), *Art carolingien et art mosan parisien, les illustrations astrologiques jointes aux Chroniques de Saint-Denis et de Saint-Germain-des-Prés (IX^e-XI^e siècle)*, in *Cahiers archéologiques*, XVI, 1966, pp. 77-106.

590. VIEILLARD - TROIEKOUROFF (May), FOSSARD (D.), CHATEL (E.), and LAMY-LASSALLE (C.), *Les anciennes églises suburbaines de Paris (IV^e-X^e siècle)*, in *Mémoires de la Société de l'histoire de Paris et de l'Ile-de-France*, XI, 1950, pp. 18-282.

591. VOGEL (Walther), *Die Normannen und das fränkische Reich*, Heidelberg, 1906. ("Heidelberger Abhandlungen zur mittleren und neueren Geschichte," 14.)

592. VOLBACH (Wolfgang Fritz), *Die Elfenbeinbildewerke. Bildwerke des Deutschen Museums*, I, Berlin and Leipzig, 1923.

593. VOLBACH (Wolfgang Fritz), *Die Elfenbeinarbeiten der Spätantike und des frühen Mittelalters*, catalogue 7 of Römisch-Germanischen Zentralmuseums Mainz, Mainz, 1952.

594. VOLBACH (Wolfgang Fritz), *Ivoires mosans du haut Moyen-Age originaires de la région de la Meuse*, in *L'Art mosan*, Paris, 1953, p. 39 sq. (Bibliothèque générale de l'École pratique des Hautes Études, 6th section.)

595. VOLBACH (Wolfgang Fritz), *Les ivoires sculptés, de l'époque carolingienne au XII^e siècle*, in *Cahiers de civilisation médiévale*, I, Poitiers, 1958, p. 17 sq.

596. VOLBACH (Wolfgang Fritz), *Ein mittelalterlicher Türsturz aus Ingelheim*, in *Mitteilungen des Oberhessischen Geschichtsvereins*, new series, XLIV, Giessen, 1960, p. 15 sq.

597. VOLBACH (Wolfgang Fritz), *Das Ellwanger Reliquienkästchen*, in *Ellwangen 764-1964*, Ellwangen, 1964, p. 767 sq.

598. *Vorläufer und Anfänge christlicher Architektur. Früher deutscher Kirchenbau*, colloquium held in Munich in April, 1953, in *Kunstchronik*, VI, 1953, pp. 229-266.

599. *Vorromanische Kirchenbauten*, catalogue of monuments, up to the Ottonian, edited by the *Zentral Institut für Kunstgeschichte*, by FRIEDRICH OSWALD, LEO SCHAEFER, HANS RUDOLF SENNHAUSSER, I, A-J, Munich, Prestel Verlag, 1966.

600. WALKER (Robert M.), *Illustrations to the Priscillian Prologues in the Gospel Manuscripts of the Carolingian Ada School*, in *The Art Bulletin*, XXX, University of Chicago, 1948, pp. 1-10.

601. WALLACH (Luitpold), *The Unknown Author of the Libri Carolini*, in *Didascaliae, Studies in Honor of Anselm M. Albareda*, New York, Bernard Rosenthal, 1961, pp. 469-515.

602. WALLACH (Luitpold), *The Libri Carolini and Patristics Latin and Greek Prolegomena to a Critical Edition*, in *The Classical Tradition. Literary and Historical Studies in Honor of Harry Caplan*, New York, 1966, pp. 451-498.

603. WARNER (O.), *The Crystal of Lothair*, in *Apollo*, LII, 1950, p. 87 sq.

604. WEBER (Louis), *Einbanddecken, Elfenbeintafeln, Miniaturen, Schriftproben aus Metzer liturgischen Handschriften*, I, *Jetzige Pariser Handschriften*, Metz-Frankfurt, 1912.

605. WEITZEL (W.), *Die deutschen Kaiserpfalzen und Königshofe von 8. bis zur 16. Jahrhundert*, Halle, 1905.

606. WEITZMANN (Kurt), *Illustrations in Roll and Codex*, Princeton, Princeton University Press, 1947.

607. WEIZSÄCKER (Heinrich), *Die mittelalterlichen Elfenbeinskulpturen in der Stadtbibliothek*, in FRIEDRICH CLEMENS EBRARD, *Die Stadtbibliothek in Frankfurt am Main*, 1896, pp. 174-179.

608. WENTZEL (Hans), *Mittelalterlichen Gemmen in den Sammlungen Italiens*, in *Mitteilungen des kunsthistorischen Instituts in Florenz*, VII, 1956, p. 239 sq.

609. WENTZEL (Hans), *Die "croce del re Desiderio" in Brescia und die Kameen aus Glas und Glaspaste in frühen Mittelalter*, in *Atti dell'ottavo Congresso di studi sull'arte dell'alto medioevo*, Milan, 1962, p. 303-320.

610. *Werdendes Abendland an Rhein und Ruhr*, Essen, 1956. (Exhibition catalogue.)

611. WERNER (Joachim), *Münchner Jahrbuch der bildenden Kunst*, Munich, 1954, p. 23 sq.

612. WERNER (Joachim), *Frühkarolin-gische Silberohrringe von Rastede. Beitrag zur Tierornamentik des Tassilo-kelches und verwandter Denkmäler*, in *Germania*, XXXVII, 1959, p. 179 sq.

613. WESSEL (K.), *Das Mailänder Passionsdiptychon*, in *Zeitschrift für Kunstwerke*, V, 1951, p. 125 sq.

614. WESTON (Karl E.), *The Illustrated Terence Manuscripts*, in *Harvard Studies in Classical Philology*, XIV, 1903, pp. 38-54.

615. WESTON (Karl E.), *The Relation of the Scene Headings to the Miniatures in Manuscripts of Terence*, in *Harvard Studies in Classical Philology*, XIV, 1903, pp. 54-174.

616. WEYRES (Wilhelm), *Der karolingische Dom von Köln*, in *Karl der Grosse*, III, *Karolingische Kunst*, Düsseldorf, L. Schwann, 1965, pp. 383-424.

617. Will (Ernest), *Recherches dans la collégiale de Saint-Quentin*, in *Cahiers archéologiques*, IX, Paris, Klincksieck, 1957, pp. 165-186.

618. WILL (Robert) and HIMLY (François-J.), *Les édifices religieux en Alsace à l'époque préromane (Ve-Xe siècle)*, in *Revue d'Alsace*, XCIII, 1954, pp. 36-76.

619. WILMART (Dom André), *Dodaldus, clerc et scribe de Saint-Martin de Tours*, in *Speculum*, VI, 1931, pp. 573-599.

620. WIRTH (K. A.), *Bemerkungen zum Nachleben Vitruvs im 9. und 10. Jahrhundert und zu den Schlestadter Vitruv Codex*, in *Kunstchronik*, XX, 1967, pp. 281-291. (New publication of architectural drawings studied by VICTOR MORTET, in *Bibliothèque de l'École des chartes*, 1898, p. 62.)

621. WIXOM (William D.), *Treasures from Mediaeval France*, Cleveland, Museum of Art, 1967.

622. WOODRUFF (Helen), *The Illustrated Manuscripts of Prudentius*, in *Art Studies*, 1929, p. 33 sq.

623. WOODRUFF (Helen), *The Physiologus of Bern: A Survival of Alexandrian Style in a Ninth Century Manuscript*, in *The Art Bulletin*, XIII, 1930, pp. 226-253.

624. WORMALD (Francis), *The Utrecht Psalter*, Utrecht, 1953. (Conference held by Amis de l'Institut d'histoire de l'art d'Utrecht.)

625. WRIGHT (D. H.), *The Codex Millenarius and its Model*, in *Münchner Jahrbuch der bildenden Kunst*, 3d series, XV, Munich, 1964, pp. 37-55.

626. ZIMMERMANN (Ernst Heinrich), *Die Fuldaer Buchmalerei in karolingischer und ottonischer Zeit*, in *Kunstgeschichtliches Jahrbuch der K.K. Zentralkommission*, IV, Vienna, 1910, pp. 1-104.

627. ZIMMERMANN (Walter), *Ecclesia lignea und ligneis tabulis fabricata*, in *Bonner Jahrbücher des Rheinischen Landesmuseums in Bonn*, CLVIII, 1958, pp. 414-453, 1 map.

628. *Zur Methodik und Auswertung von Grabungen im Bereich der Baukunst des Mitellalters*, colloquium held in Munich in March, 1955, in *Kunstchronik*, VIII, 1955, pp. 113-163. *110 church plans of the high Middle Ages found during excavations.*

Additions :

629. BRAUNFELS (W.), *The Lorsch Gospels*, New York, George Braziller, 1967. Facsimile edition.

630. HENRY (Françoise), *Irish Art during the Viking Invasions (A.D. 800-1200)*, Ithaca, Cornell University Press, 1967.

631. KITZINGER (Ernst), *Early Medieval Art*, London, The Bristish Museum, 1940, 2d ed., 1955. Bloomington, Indiana University Press, 1967.

632. PANOFSKY (Erwin), *Renaissance and Renaiscences in Western Art*, Stockholm, 1960, chap. 2.

BIBLIOGRAPHICAL INDEX

GENERAL

2, 5, 6, 10, 11, 13, 14, 16, 17, 26, 32, 33, 36, 39, 42, 50, 68, 74, 96, 97, 102, 107, 110, 111, 112, 113, 120, 125, 128, 130, 143, 145, 166, 171, 172, 179, 182, 184, 190, 191, 196, 197, 198, 199, 209, 210, 215, 217, 219, 229, 230, 235, 237, 238, 244, 252, 253, 255, 256, 257, 269, 274, 276, 277, 278, 279, 295, 303, 307, 311, 313, 318, 327, 335, 337, 338, 340, 353, 354, 355, 357, 360, 361, 373, 375, 383, 390, 399, 434, 435, 440, 443, 448, 456, 457, 475, 477, 488, 501, 525, 537, 560, 576, 591, 599, 630, 631, 632.

ARCHITECTURE

General Works: 20, 21, 37, 60, 63, 65, 76, 105, 108, 116, 124, 129, 130, 143, 144, 172, 186, 187, 214, 216, 221, 231, 233, 234, 276, 293, 298, 299, 300, 302, 304, 308, 312, 324, 348, 349, 359, 365, 367, 369, 387, 391, 397, 444, 473, 486, 487, 557, 559, 583, 584, 585, 598, 605, 620, 628.
Specialized Works: 1, 8, 12-2, 15, 22, 34, 35, 38, 41, 43, 48, 59, 61, 62, 64, 82, 97, 99, 106, 114, 115, 117, 119, 121, 123, 134, 135, 161, 164, 165, 167, 170, 174, 175, 176, 180, 192, 194, 199, 208, 211, 212, 213, 224, 240, 243, 260, 262, 263, 268, 275, 292, 301, 305, 306, 309, 310, 314, 323, 350, 351, 352, 358, 364, 366, 368, 384, 396, 411, 430, 431, 432, 441, 445, 455, 464, 465, 466, 469, 470, 471, 472, 474, 490, 503, 506, 521, 530, 541, 556, 561, 574, 575, 577, 578, 579, 580, 581, 586, 588, 590, 596, 616, 617, 618, 627.

SCULPTURE

General Works: 9, 26, 46, 47, 71, 97, 109, 130, 150, 152, 153, 162, 168, 218, 316, 329, 380, 437.

Specialized Works: 24, 140, 151, 154, 155, 294, 430, 442, 450, 469, 524.

PAINTING

General Works: 9, 26, 48, 71, 75, 78, 97, 100, 109, 110, 118, 120, 122, 137, 156, 181, 218, 220, 254, 257, 271, 315, 333, 356, 412, 423, 425, 426, 436, 489, 515, 516, 518, 520, 544, 555.
Book Painting: 18, 23, 40, 49, 51, 52, 53, 54, 55, 56, 57, 58, 66, 69, 70, 72, 73, 78, 79, 83, 84, 85, 86, 87, 88, 89, 90, 98, 100, 103, 104, 107, 109, 110, 131, 132, 133, 136, 137, 138, 146, 147, 148, 149, 157, 158, 159, 163, 169, 177, 178, 189, 206, 207, 222, 223, 225, 226, 227, 228, 232, 236, 247, 248, 250, 258, 264, 265, 266, 283, 284, 285, 286, 287, 289, 290, 291, 296, 315, 320, 321, 322, 325, 326, 328, 331, 332, 333, 334, 336, 341, 342, 343, 344, 345, 346, 347, 362, 363, 370, 371, 372, 374, 376, 377, 378, 385, 389, 392, 393, 398, 410, 412, 414, 416, 417, 418, 419, 420, 421, 422, 423, 424, 425, 427, 428, 433, 438, 439, 446, 447, 449, 452, 453, 460, 462, 463, 481, 482, 492, 493, 494, 495, 496, 497, 498, 500, 504, 534, 539, 542, 543, 545, 558, 563, 564, 565, 566, 567, 569, 587, 589, 600, 601, 602, 604, 606, 614, 615, 619, 620, 621, 622, 623, 624, 625, 626.
Mosaïcs and stucs : 12-1, 75, 121, 220, 241, 257, 413, 436, 489, 511, 529, 531, 532, 533, 540, 587, 629.

APPLIED ART

General Works: 29, 81, 97, 107, 110, 118, 122, 126, 127, 141, 142, 160, 188, 203, 225, 260, 280, 282, 288, 317, 394, 396, 468, 469, 479, 490, 506, 507, 509, 510, 514, 517, 519, 520, 528, 538, 546, 548, 549, 552, 559, 566, 570, 571, 610.
Bronzes : 95, 246, 273, 281, 395, 415.
Enamels: 267, 400, 484, 508.
Ivories: 31, 67, 80, 81, 91, 195, 204, 245, 249, 261, 381, 382, 386, 388, 403, 408, 409, 459, 476, 480, 505, 512, 513, 522, 547, 582, 592, 593, 594, 595, 604, 607, 613.

Coins: 355, 454, 478.

Goldwork: 3, 4, 7, 19, 25, 28, 30, 44, 45, 77, 92, 93, 94, 101, 126, 127, 130, 183, 185, 193, 200, 201, 202, 205, 239, 242, 259, 270, 272, 297, 319, 339, 379, 380, 401, 404, 406, 407, 429, 451, 458, 467, 483, 485, 499, 502, 523, 535, 536, 550, 551, 552, 553, 554, 562, 571, 572, 573, 597, 609, 612.

Crystals: 27, 139, 251, 402, 405, 491, 526, 527, 603, 608.

Textiles: 173, 553, 562.

List of Illustrations

Unless otherwise specified, the reference numbers in parentheses refer to other entries in the List of Illustrations and to the corresponding plates.

Frontispiece. Carolingian Art, Palace School under Byzantine influence. **AACHEN.** *Gospel Book: The Four Evangelists.* *(Cf. 82.)* Early 9th century. Unnumbered MS, folio 14 verso, Treasury of Aachen Cathedral. Miniature painting on vellum, 12 × 9 ½ in. (Photo Ann Münchow, Aachen.)

1. Carolingian Art. **AACHEN, Palatine Chapel.** *Bronze Door, detail.* About 800. In situ. (Arts of Mankind Photo.)

 The bronze doors of the Palatine Chapel, as well as the admirable bronze railings in the tribune, are not ancient works taken over and reemployed here. Einhard expressly mentions them as having been designed and cast at the behest of Charlemagne himself. (Cf. 35.)

2. Carolingian Art. **SAINT-RIQUIER, Abbey.** *From an old print.* Bibliothèque Nationale, Paris. (B. N. Photo, after Paul Petau, *De Nithardo Caroli Magni nepote ac tota ejusdem Nithardi presepia breve syntagma*, Paris, 1613.)

 Engraved from a miniature in a manuscript copy of the Chronicle of Saint-Riquier, *written by the monk Hariulf about 1088 and destroyed in a fire at the abbey in 1719.*

 Another engraving made from the same miniature was published by Mabillon. (Cf. 340.)

 The print gives a schematic representation of the three abbey churches, connected by porticoes enclosing a triangular area in which stood the abbey buildings (not shown on the print). Excavations have confirmed that the church of Notre-Dame, in the foreground, was indeed built on a central plan, but they have further shown that it did not have radiating chapels. (Cf. 341, 364.)

3. Carolingian Art. **SAINT-DENIS, Nave of the Abbey Church** (consecrated in 775). *Column Base.* 8th century. Musée Lapidaire, Saint-Denis, near the basilica. Stone. Height 23 ½ in. (Arts of Mankind Photo.)

 This large stone base from the Carolingian church of Saint-Denis was for many years in the Musée de Cluny, Paris.

 Two other column bases were found in the excavations conducted by S. M. Crosby. They stood in the nave of the (destroyed) Carolingian church and supported the marble columns which were repaired and reinstalled by Abbot Suger (so he himself tells us). Such column bases were traditionally decorated with relief carvings; others can be seen at Bari and in Sant'Apollinare in Classe, Ravenna. The decorative pattern on the Saint-Denis base has several elements in common with that on the bronze doors of Charlemagne's Palatine Chapel in Aachen.

4. Carolingian Art. **LORSCH, Abbey Gateway.** *Upper Hall, Painted Decoration.* Probably early 9th century. In situ. (Arts of Mankind Photo.)

 There is every reason to believe that this upper room served as a reception hall for the monastery's distinguished visitors.

 In the Middle Ages it was converted into a chapel dedicated to the Angels. (Cf. 55, 338.)

 The Carolingian decorations were found under some medieval frescoes that had been painted over them. These decorations in the antique style, so fortunately preserved, show us what the inside of the Carolingian palaces looked like.

 Similar chequerwork patterns appear in a great many wall paintings of the Middle Ages, for example in the narthex of Tournus and at Le Puy. No doubt many such frescoes in the antique style were painted in buildings of the Carolingian period.

5. Carolingian Art. **AUXERRE, Abbey Church of Saint-Germain, Crypts.** *Painted Decorations on the Vaults.* 9th century (before 857). In situ. (Arts of Mankind Photo.)

6. Carolingian Art. **AUXERRE, Abbey Church of Saint-Germain, Crypts, Oratory of Saint-Étienne.** *The Arrest of St Stephen.* 9th century (before 857). In situ. (Arts of Mankind Photo.)

 Situated in the crypts of Saint-Germain of Auxerre, on the northwest side, the Oratory of St Stephen (Saint-Étienne) contained an altar (now lost) which Bishop Heribald, who died in 857, had had decorated with a silver bas-relief. This altar probably stood against the west wall of the north aisle of the crypt. The scene of the Arrest of St Stephen is painted on the upper part of this wall. (Cf. 5.) The painting is set within a semicircle as if to imitate the decoration of an apsidal vault. The symmetry of the left- and right-hand sides of the composition is unduly emphasized, as in the main apse mosaic at Germigny-des-Prés. (Cf. 10.)

7. Carolingian Art. **AUXERRE, Abbey Church of Saint-Germain, Crypts.** *The Stoning of St Stephen at the Gates of Jerusalem.* 9th century (before 857). In situ. (Arts of Mankind Photo.)

 The main lines of the composition correspond to the diagonals of a fairly wide-meshed grid of which nothing remains visible but which can be reconstituted with considerable certainty. It was standard practice with Carolingian artists to use a regulating grid, a simple network of squares, when decorating a large wall surface.

8. Carolingian Art. **AUXERRE, Abbey Church of Saint-Germain, Crypts.** *Decorative Painting.* 9th century (before 857). In situ. (Arts of Mankind Photo.)

 The scenes of the life of St Stephen painted in the Auxerre crypts have rightly been compared to contemporary manuscript paintings. But the decoration of the vaults and arches has nothing in common with manuscript illumination. Here fresco painting was treated quite independently of the other arts, an independence which was either a heritage or a revival of the fresco practice of antiquity.

9. Carolingian Art. **MILAN, San Satiro, Pietà Chapel.** *Decorative Painting.* In situ. (Arts of Mankind Photo.)

 The church of San Satiro was built by Bishop Anspertus (873-881). An annex of the present church (which is a Renaissance church of classical design), the Pietà Chapel appears to go back to the time of the original late Carolingian church.

10. Carolingian Art. **GERMIGNY-DES-PRÉS, Church.** *Apse Mosaic.* About 800. In situ. (Arts of Mankind Photo.)

 This representation of the Ark of the Covenant, which as André Grabar has shown owes nothing to Byzantine mosaic techniques, is accompanied by a metrical Latin inscription which may be translated as follows: 'Heed the holy Oracle and the cherubim, consider the splendour of the Ark of God, and so doing, address your prayers to the Master of Thunder and join with them the name of Theodulf.' (Cf. 11.)

11. Carolingian Art. **GERMIGNY-DES-PRÉS, Church.** *Apse Mosaic, detail: An Angel.* About 800. In situ. *(Cf. 10.)* (Photo Giraudon.)

12. Carolingian Art. **SAINT-QUENTIN, Collegiate Church, Crypt.** *Mosaic Pavement.* 814-876. In situ. (Arts of Mankind Photo.)

 The excavations of Ernest Will (cf. Bibliography, No. 617, pp. 165-186) have shown that this mosaic pavement belonged to the church erected by Count Fulrad, abbot from 814 to 826. The design of intersecting star-patterned circles recalls the one on the small reliquary given by Mumma to the abbey of Fleury or Saint-Benoît-sur-Loire. (Cf. Bibliography, No. 313, p. 311.)

13. **CASTELSEPRIO, Santa Maria Foris Portas.** *Nativity, detail.* In situ. (Arts of Mankind Photo.)

 The dating of these famous wall paintings discovered in 1944 has given rise to impassioned discussion and controversy. (Cf. Bibliography, No. 313, pp. 93 ff.)

14. **CASTELSEPRIO, Santa Maria Foris Portas.** *The Adoration of the Magi.* In situ. (Arts of Mankind Photo.)

 Rarely can the word masterpiece be applied to frescoes: here it can. Particularly striking is the highly architectural character of these compositions, even though they are laid out in a sequence of panels—an arrangement which makes it difficult to achieve overall effects.

15. **BRESCIA, San Salvatore.** *View of the Interior.* In situ. The ground plan of the basilica forms a rectangle 59 ft long and 47½ ft wide, divided into a central nave (23 ft wide) and side aisles, with an apse (16½ ft in diameter) at the east end. (Arts of Mankind Photo.)

 The clearing of the wall paintings and stuccoes in the former abbey church of San Salvatore at Brescia is one of the great archaeological discoveries of this century. (Cf. 274.) The monastery was founded in 753 by Aistulf, king of the Lombards, but the church was rebuilt and decorated in the early 9th century. (Cf. Bibliography, No. 313, p. 121.)

16. **BRESCIA, San Salvatore.** *Fresco, South Wall.* Early 9th century. In situ. (Arts of Mankind Photo.)

17. **BRESCIA, San Salvatore.** *Fresco, Fragment.* Museo Cristiano, Brescia. (Arts of Mankind Photo.)

18. Carolingian Art. **MALLES, San Benedetto, East Wall.** *A Donor.* In situ. (Arts of Mankind Photo.)

 This monastic oratory of the very early 9th century has a rectangular plan and measures only 15 ft 9 in in width, in the clear. The fact that it stands on what was then a busy highroad over the Alps into Italy, on the way to Milan and Rome, no doubt accounts for the wealth of its decorations. (Cf. 19.) Fragments of a chancel parapet or closure slab are now in the Bolzano museum, as are a number of stucco reliefs from the east wall of the sanctuary. (Cf. 25.) The columns in the oratory were topped with animal figures and human heads. Other heads carved in stucco of the same period have been found at Disentis (Grisons, Switzerland), a monastery founded in the 7th century. It seems probable that similar stucco decorations, painted in bright colours, also figured in other early 9th-century churches in this Alpine region.

19. Carolingian Art. **MALLES, San Benedetto, East Wall.** *Niches forming Apses.* In situ. (Arts of Mankind Photo.)

 Between the niches on the east wall are the two full-length figures of a donor abbot presenting a model of the oratory to God and a sword-bearing warrior of high rank. It has been suggested that this latter figure may represent Charlemagne, but this seems highly unlikely. (Cf. 18.)

20. Carolingian Art. **MÜSTAIR, Johanneskirche (Church of St John).** *Frescoes, North Wall.* In situ. (Arts of Mankind Photo.)

 The plan (cf. 350) and a general view (cf. 275) show clearly the main features of this large rectangular hall church with a timber roof and a triple apse at the east end. The division into central nave and side aisles dates only from the Middle Ages. The wall paintings, arranged in superimposed registers, originally had a decorative and didactic function which they then lost. As in many churches of the Merovingian period (cf. Bibliography, No. 313, pp. 343-352), side porches ran along the nave of this large monastic church of the early 9th century.

21. Carolingian Art. **MÜSTAIR, Johanneskirche (Church of St John).** *Frescoes, North Apse.* In situ. (Arts of Mankind Photo.)

 Part of the early 9th-century apse frescoes were covered over with other paintings in the Middle Ages. Unfortunately, after they were brought to light some twenty years ago, their over-restoration thus altered the character of a fresco cycle that was highly typical of the Carolingian period. (Cf. 275, 350.)

22. Carolingian Art. **MÜSTAIR, Johanneskirche (Church of St John), North Wall.** *Scenes of the Life of Christ, detail.* In situ. (Arts of Mankind Photo.)

 A description of the abbey church of Saint-Faron at Meaux, written by an anonymous poet of the 9th century, applies equally well to this church: 'In the vault of the apse appears a figure painted on a star-spangled ground, the figure of Christ the Lord. Following each other on the walls are Bible stories, fine windows and pictures of the Fathers and the Popes.' (Cf. L. Delisle, Le Cabinet des Manuscrits de la Bibliothèque Nationale, III [Paris, 1881], 264.)

23. **MÜSTAIR, Johanneskirche (Church of St John), West Wall.** *The Last Judgment, detail.* In situ. (Arts of Mankind Photo.)

 Before being carved on the west front of Romanesque churches, the Last Judgment was painted on the inside west wall in churches of the Carolingian period.

 At Müstair the actual details of the execution are of mediocre quality, but the composition as a whole produces a grandiose effect.

24. **METZ, Former Church of Saint-Pierre-en-Citadelle.** *Closure Slabs or Chancel Parapets.* Musée Central, Metz. Stone. (Arts of Mankind Photo.)

 These closure slabs should be compared with the bas-relief of the same period, also discovered in 1895 in the pavement of the church of Saint-Pierre-en-Citadelle, which was published by W. F. Volbach. (Cf. Bibliography, No. 313, p. 291.) These carvings, long assigned to the Merovingian period, do not seem to be earlier than the late 8th century, in view of the fact that exactly similar slabs have been found at Cheminot, 15 miles from Metz; they come from the church built there after the royal villa at Cheminot was given, in 783, to the abbey of Saint-Arnoul of Metz.

25. **MALLES, San Benedetto.** *Closure Slabs or Chancel Parapets.* Museo dell'Alto Adige, Bolzano. (Arts of Mankind Photo.)

 This bas-relief is not an altar frontal, as Garber supposed. Niccolò Rasmo, curator of the Bolzano museum, has shown that it belonged to the partition closing off the sanctuary of the church; he has also proposed some judicious reconstructions of the stucco designs. (Cf. 18.)

26. **AIX-EN-PROVENCE.** *Closure Slab or Chancel Parapet.* Musée Granet, Aix-en-Provence. White marble. Height 34½ in, width 28 in, thickness 2¾ in. (Museum Photo, Henri Ély, Aix-en-Provence.)

27. **SCHÄNIS, Church, Crypt.** *Closure Slabs reused as an Altar Frontal.* In situ. (Photo Bernhard Nobel, Flawil.)

 The parish church of Schänis (canton of St Gall, Switzerland) was originally the church of a nunnery founded and built there in the first quarter of the 9th century by Hunfrid, Count of Istria, then of the Two Rhaetias. These white marble slabs, which now decorate the altar of the crypt, were found in about 1910 in excavations and soundings of the upper church. A study of the carvings, which undoubtedly go back to the early 9th century, marked the point of departure for Maurice Prou's famous paper on closure slabs with interlace designs, published in 1912.

28. **MILAN, Sant'Ambrogio, Chapel of San Vittore in Ciel d'Oro.** *Closure Slab or Chancel Parapet reused as an Altar Frontal.* In situ. (Arts of Mankind Photo.)

29. *Model of the Einhard Reliquary.* Private Collection, Paris. (Arts of Mankind Photo.)

About 828 Einhard gave to the abbey of St Servatius of Maastricht, of which he was abbot, a silver reliquary in the form of a Roman triumphal arch 11 inches high. At the top of the arch was the following inscription: AD TROPAEUM AETERNAE VICTORIAE SUSTINENDUM EINHARDUS PECCATOR HUNC ARCUM PONERE AC DEO DEDICARE CURAVIT.

This reliquary disappeared at the time of the French Revolution. But in 1945, at the Bibliothèque Nationale, Count Blaise de Montesquiou-Fezensac discovered an old drawing of it. On the basis of this, it has been possible to construct an accurate model of the arch. Various figures were represented in relief on chased silver plates overlaying the wooden core. This group of figure scenes is a particularly valuable piece of evidence for our knowledge of Carolingian iconography. Under the arch, opposite each other on the two upright sides, are the figures of two horsemen, Constantine and the reigning sovereign. This was the source of the equestrian statues of Constantine represented on the façades of Romanesque churches. For us, moreover, the Maastricht reliquary also brings to mind the small models which were used in Carolingian times to facilitate the construction of churches, as we know from a text which mentions the use of a model for the reconstruction and enlargement of the abbey church of Saint-Germain at Auxerre.

30. **AACHEN, Palatine Chapel, Tribune.** *Bronze Parapet.* In situ. (Arts of Mankind Photo.)

We know from Einhard that the admirable bronze railings in the tribune of the Palatine Chapel were made to the order of Charlemagne. (Cf. 35.) Our comparative plates (pp. 36-37) show how skilfully the railings imitate the designs on Roman monuments. The resemblance is so close that it cannot be put down to a mere survival of Roman techniques. What we have here is unquestionably a deliberate (and highly successful) attempt to revive those techniques — in other words, a 'renaissance.' The architects of the 16th century were less successful in copying Roman scrollwork.

31. *Carved Slab, detail.* Santa Maria Vecchia, Gussago. (Arts of Mankind Photo.)

Don G. Pottieri, the parish priest of Gussago (near Brescia), has kindly pointed out that this slab may have come from the abbey of Leno, about 15 miles south of Brescia.

32. **NIMES, Maison Carrée.** *Entablature, detail.* In situ. (Photo Yvan Butler, Geneva.)

33. **LORSCH, Abbey Gateway.** *West Façade, detail.* (Cf. 55, 56.) In situ. (Arts of Mankind Photo.)

34. **ST GALL.** *Plan for a Projected Reconstruction of the Abbey.* Stiftsbibliothek, St Gall. (Library Photo, Gebrüder Zumbühl, St Gall.)

This famous drawing was made in red ink on five sheets of parchment sewn together and measuring 43 ¼ inches in length and 29 ½ inches in width. From an inscription on it addressed to Gozbert, abbot of St Gall from 816 to 837, we learn that this manuscript plan, showing a projected layout of the abbey buildings, was drawn up by a personage (unnamed) of some importance, since he addresses Gozbert as 'my son.' According to the chronicle of the Gall monastery, the reconstruction of the church was begun in 830. So the plan must have been drawn up some time between 816 and 830. That it was a carefully considered project is shown by the fact that it offers two different ground plans, with different proportions, for the church. Cf. 342 for the distribution and purpose of the various buildings.

35. Carolingian Art. **AACHEN, Palatine Chapel.** *Interior.* In situ. (Arts of Mankind Photo.)

Among the major buildings erected under Charlemagne, Einhard (cf. Bibliography, No. 182, chapters 11 and 26) mentioned the 'admirable' Palatine Chapel or Minster of Aachen dedicated to the Virgin. 'He saw to it that it was adorned with gold and silver and candelabra, as well as balustrades and doors of solid bronze.' (Cf. 1, 30.) And Einhard adds: 'Since he could nowhere else procure the columns and marbles necessary for its construction, he sent to Rome and Ravenna for them.' He was authorized to do so by Pope Adrian I about 787. The work of construction may not have begun before 790; in 798 it was not yet completed. An inscription, now lost, recorded the name of the architect: Odo (Eudes) of Metz. Among the many analogies between this remarkable monument and other buildings erected in Gaul at the same period, are the polygonal plan (cf. 365), the doors, and the piers of cruciform section. The combination of transverse barrel vault and diaphragm arch, of which the earliest known example is here in the tribune of the Palatine Chapel, reappears in the 11th century in the narthex of the abbey church of Saint-Philibert at

Tournus. The same combination was probably used in other Carolingian churches of Gaul besides the Palatine Chapel of Aachen.

36. Carolingian Art. **AACHEN, Palatine Chapel.** *Dome, Interior.* In situ. (Arts of Mankind Photo.)

The dome covers a space over 50 feet in diameter. Its spindle-shaped segments recall the vaults of the Late Empire (cf. Bibliography, No. 313, p. 9); but similar segmented vaults appear in other early medieval monuments (cf. ibid. p. 112). The dome mosaic, made between 1810 and 1873, was the work of the Salviati firm of Venice; it is but one of several unfortunate restorations carried out during the 19th century in the Palatine Chapel, which in 1821 had been raised to cathedral status.

The original mosaic, covered over in 1730 by a stucco decoration, is known to us only by a drawing published by Ciampini in 1699 and some sketches by Peiresc. (Cf. Bibliography, No. 294, pp. 132-140.) It was a grandiose work. In the centre was the figure of Christ, 13 feet high, wearing a purple cloak and raising his hand in benediction. Behind his throne appeared the globe of the world, consisting of circular zones of five different colours. At his feet, spaced out around the circumference of the dome, were the twenty-four elders of the Apocalypse, life-size figures clad in white tunics, rising from their thrones and holding out to Christ their golden crowns inlaid with gems. All these figures stood out against a light blue ground spangled with golden stars.

37. Carolingian Art. **AACHEN, Palatine Chapel.** *Ambulatory.* In situ. (Arts of Mankind Photo.)

The structure of this ambulatory, covered with groined vaults with no cross-ribs, is flawless. One notes here, as at Saint-Médard of Soissons (cf. 45), the presence of wall arches (formerets), a type of support which played a key part in the building of cross-ribbed vaults as they were worked out in the Ile-de-France in the 12th century.

38. Carolingian Art. **AACHEN, Palatine Chapel.** *Tribune.* In situ. (Arts of Mankind Photo.)

It was noted above (35) that the vaulting of the tribune combines the diaphragm arch with the transverse barrel vault. The barrel vaults appear to be a few years later in date than the diaphragm arches, which would mean that the latter were originally designed to support a wooden roof. This is an arrangement that appears in France in Romanesque churches, for example at Dangeau (Eure-et-Loir).

39. Carolingian Art. **AACHEN, Palatine Chapel**, Tribune. *Imperial Throne.* In situ. (Arts of Mankind Photo.)

This throne, made of stone, very probably dates from the time of Charlemagne. It stands in the tribune, facing the altar, in accordance with a tradition which dates back to the Late Empire and was continued in the two-storeyed palace chapels of the Middle Ages. The imperial loggia at Aachen was connected with the palace by a two-storeyed wooden gallery built on the west side of the large inner courtyard.

40-41. **GERMIGNY-DES-PRÉS.** *Church before Reconstruction and Arcading in the Apse. From watercolours made by the architects Delton (1841) and Lisch (1873).* (Arts of Mankind Photo.)

This church was originally an oratory attached to the villa built on the banks of the Loire as a summer residence for Theodulf, missus dominicus of Charlemagne, bishop of Orléans and abbot of Fleury (Saint-Benoît-sur-Loire). According to an 11th-century inscription, the oratory was consecrated in 806. Burnt by the Northmen, converted into a priory church about 1067 and later made the parish church with the addition of a nave, it was entirely and inaccurately rebuilt from 1867 to 1876. Only the apse mosaic (cf. 10) and the capping of the four central piers (cf. 251) were retained in the present building. The layout and arrangements of the original oratory are, however, well known from old plans and the excavations of 1930. (Cf. Bibliography, No. 125, pp. 540 ff.)

42. **GERMIGNY-DES-PRÉS.** *Church after Reconstruction: Interior, View from the West.* In situ. (Arts of Mankind Photo.)

The plan (cf. 367) of this oratory, entirely vaulted with domes and barrel vaults, occurs throughout the Roman Empire beginning in late antiquity. (Cf. 373.) Some fine Armenian churches of the 7th century are built on a variant of this plan, which must also have existed in Rome itself, since it was known and imitated by Renaissance architects.

43. **GERMIGNY-DES-PRÉS.** *Church after Reconstruction: Interior, View from the West.* In situ. (Arts of Mankind Photo.)

At the entrance of the apse are short coupled columns recalling the superimposed orders of classical antiquity. The same coupled columns appear in a contemporary, though perhaps slightly earlier building, the crypts of Saint-Laurent of Grenoble. (Cf. Bibliography, No. 313, pp. 112-113.) Another important structural element of the original

Germigny oratory was the dome on squinches (cf. 372), which thus existed in Gaul at the beginning of the 9th century; this element too was a legacy of the architecture of the Late Empire (Naples baptistery).

44. Carolingian Art. **MILAN, San Satiro, Pietà Chapel.** *Interior, View from the West. (Cf. 368.)* In situ. (Arts of Mankind Photo.)

45. **SOISSONS, Abbey Church of Saint-Médard, Crypts.** *Interior, View from the North.* In situ. (Arts of Mankind Photo.)

As I have shown elsewhere (cf. Bibliography, No. 309, pp. 123-124), it was the transfer from Rome to Soissons in 826 of the relics of St Sebastian and St Gregory, and the crowds of worshippers thus attracted to Soissons, that led the monks of Saint-Médard to rebuild their abbey church, whose crypt was finished in 841. (Cf. 249, 359.)

46. **SAINT - PHILBERT - DE - GRAND - LIEU, Abbey Church.** *Crypts.* In situ. (Arts of Mankind Photo.)

In 677 the villa of Déas (near Nantes, in Brittany) was given to the abbey of Noirmoutier, and a 'new monastery' was built there in 819 as a refuge for the monks of Noirmoutier, which was exposed to the Norse searovers. The transept of the present church goes back to that period. In 836 the monks of Noirmoutier moved to Déas with the relics of their patron saint Philbert (or Philibert), which thus became Saint-Philbert-de-Grand-Lieu. To house the relics, they built the crypts, which still exist, in at least two building campaigns, between 847 and 853. (Cf. 349.) It has recently been shown by Pierre Lebouteux (cf. Bibliography, No. 364) that the confessio (cf. 59) and the nave (cf. 58) were not built until the late 11th century when the monks of Tournus took possession of the abbey to establish there one of their principal priories and to re-institute the cult of St Philbert.

47. **SAINT-PHILBERT - DE - GRAND - LIEU, Abbey Church, Crypts.** *Chapel of the Holy Saviour, seen from the East.* In situ. (Arts of Mankind Photo.)

This oratory, facing west, is situated at the extreme east end of the crypts built from 847 to 853. Its structure is massive but skilful. (Cf. 349.)

48. **AUXERRE, Abbey Church of Saint-Germain.** *Crypts, East Side.* In situ. (Arts of Mankind Photo.)

View of the vaulted passage connecting the ambulatory of the confessio with the east rotunda rebuilt in the

14th century. The Saint-Germain crypts were begun in 841 and finished about 860. The cruciform piers, the groined vaults and the mouldings prefigure the architecture of the Romanesque period. (Cf. 248, 345.)

49. **AUXERRE, Abbey Church of Saint-Germain, Crypts.** *Pillar at the Entrance of the Ambulatory.* In situ. (Arts of Mankind Photo.)

This imitation in stone of the Ionic capital of classical antiquity is somewhat barbaric. Its styling is much inferior to that of the marble capitals carved in the 6th and 7th centuries in the workshops of southwestern Gaul. (Cf. Bibliography, No. 313, pp. 34-37, 49-50, 80-82.) Unable to operate in the face of the Arab invasions and the unsettled conditions of the 8th century, these workshops of marble carvers had closed down. As a result, it became less and less common to reuse the marble columns of ancient Roman buildings. New techniques were worked out to replace the ancient practices. So it was that the pillar made of successive courses of stone and the thick abacus with a whole series of mouldings, both of which were everywhere in use by the 11th and 12th centuries, appeared already in the Carolingian crypt of Auxerre.

50. **AUXERRE, Abbey Church of Saint-Germain, Crypts.** *Confessio, seen from the West.* In situ. (Arts of Mankind Photo.)

It was in this confessio—the central part of the crypts, and called conditorium or 'Holy of Holies'—that the tomb containing the relics of St Germanus was solemnly deposited on 6 January 860 in the presence of Charles the Bald.

The stone and stucco capitals were carved with some skill. They support two architraves in the antique manner, made of oaken beams and admirably executed. (Cf. 345.)

The east end of the confessio, with the altar and tomb of St Germanus, underwent several modifications during the Middle Ages.

51. **CORVEY, Abbey Church.** *Façade of the Westwork.* (Arts of Mankind Photo.)

The abbey of Corvey (Corbeia nova), between Cassel and Hanover, was founded in 822 by monks from Corbie, in Picardy, who gave it the same name. The imposing westwork or Vorhalle is 60 feet wide. On the ground floor of the westwork is a groin-vaulted entrance passage, called crypta in the Middle Ages; on each side of it rises a square tower. On the upper floor is a vast two-storeyed tribune, which was origi-

nally surmounted by a third tower. Begun in 873, the westwork was consecrated in 885. At that time the façade and towers were lower than at present, the upper parts having been rebuilt or raised, from the level of the gable high over the entrance, in the time of Wibald, abbot of Stavelot and Corvey, who in 1146 summoned two master builders from his first abbey (Stavelot) for that purpose.

52. **CORVEY, Abbey Church.** *Ground Floor of the Westwork.* (Arts of Mankind Photo.)

A comparison of these carved capitals with those in the crypts of Saint-Germain of Auxerre (cf. 48-50) indicates the progress made in a few years' time by the Carolingian workshops. Ottonian art of the 10th and 11th centuries was able to add little to these carvings of the last quarter of the 9th century, produced, it is true, in a region which was spared the devastations of the Norse raiders. (Cf. 347, 360.)

53-54. **CORVEY, Abbey Church.** *Tribune of the Westwork.* (Arts of Mankind Photo.)

This tribune, like that in the westwork of Saint-Germain of Auxerre, was dedicated to St John the Baptist.

At Auxerre there was an altar dedicated to John the Baptist, and at Reims the tribune of the cathedral included a baptistery. One of the purposes of the west tribune in Carolingian times seems to have been to provide a suitable place at the west end of the church for the parish service, which was already being held in the Benedictine monasteries. This is known to have been the case at Saint-Riquier, and so it appears to have been too at St Gall, judging by the famous plan. This would explain the vast galilees or narthexes of 11th- and 12th-century monastic churches of the order of St Benedict: there stood the lay worshippers when the monks left the choir enclosure to walk in procession or to celebrate the divine service in the nave of the church. In Carolingian times the tribune also served as a loggia for high-ranking persons and officials. Einhard mentions in one of his writings that he had his appointed seat in the tribune of the Seligenstadt church. In our day there has been much discussion and disagreement among scholars as to the purpose of the westwork of Carolingian churches. The many explanations offered by archaeologists is one token of the richness of invention shown by the church architects of the Carolingian period.

55-56. **LORSCH, Abbey Gateway.** *Views from the South-West and the West.* (Arts of Mankind Photo.)

The first monastery of Lorsch, near Worms, was founded in 763. (Cf. 336 A and B.) Its foundations were brought to light in the excavations of 1882, for the first site was abandoned and the monastery was transferred to a better piece of ground a short distance away. Here Abbot Heinrich (778-784) erected the church of the new monastery, which was subsequently remodelled many times. In front of this church stood a vast atrium, and at the far end of it was built—like a Roman triumphal arch at the entrance of a forum—a triumphal gateway, called a Torhalle by German archaeologists. (Cf. 337 A and B, 338.) The interior of the upper room was decorated with wall paintings. (Cf. 4.) The external decoration of the gateway is no less remarkable. Like an almost contemporary building, the baptistery of Saint-Jean at Poitiers (cf. Bibliography, No. 313, pp. 45-48), the design of the Lorsch gateway derives from the public monuments of the Late Empire. The engaged columns are undoubtedly a misconstrued imitation of an antique model, for the half-column is simply backed against the wall and not embedded in it. The decorative stonework is an imitation of the antique. (Cf. ibid., pp. 32-33, 243-244.) The same pattern of stones carved in squares, lozenges and polygons occurs in the west wall of the Jouarre crypts. (Cf. ibid., p. 79.)

57. **BEAUVAIS, Notre-Dame de la Basse-Œuvre.** *Exterior, View from the South Side.* (Arts of Mankind Photo.)

As I have shown elsewhere (cf. Bibliography, No. 295, pp. 35-36), this church of the cathedral complex of Beauvais was probably built between the years 949 and 988. This dating seems to be confirmed by excavations and soundings, which in particular have cleared the threshold of a side door. Here, as in so many buildings of the 10th century, we see the opus mixtum of stone and brick. The oldest part of the wall masonry was laid with perfect regularity, but is devoid of any carving. The façade carvings date to the 12th century.

58-59. **SAINT-PHILBERT-DE-GRAND-LIEU, Abbey Church.** *Transept from the South-East and Romanesque Confessio in the Crypts.* (Arts of Mankind Photo.)

The photograph of the transept gives only a glimpse of the nave, which many scholars used to assign, like the transept, to the early years of the 9th century. The double arches of the nave arcading cannot, however, be dated to the early Carolingian period, and Pierre Lebouteux has recently shown that a later dating is confirmed by other elements in the nave.

In adapting this, their priory church near Nantes, for the cult of the relics it contained, the monks of Tournus did their best to harmonize the new nave with the existing transept and choir by employing the same masonry of brick and stone. A sounding made by Pierre Lebouteux has also shown that the groin-vaulted confessio and the tomb it houses both date to the early Romanesque period. (Cf. 46.)

60. **DIJON, Church of Saint-Bénigne.** *From an engraving by Georges Lallemand (c. 1575-1635).* Bibliothèque Nationale, Paris. (B. N. Photo.)

Nothing remains of the abbey church erected about 871-880, apart from a few fragments of closure slabs. Like the monastic churches built in Burgundy at that time, it undoubtedly contained an oratory in the form of a rotunda at the back of the apse. The church, built by Abbot William of Volpiano (985-1017), has also almost entirely disappeared, but we know that it was a much bigger church with a much more elaborate rotunda or oratorium at the east end; largely rebuilt at the beginning of the 12th century, the rotunda had a diameter of over 65 feet and rose to a height of four storeys. The church plan with an east rotunda was the most original church design devised in the Carolingian period.

61. Carolingian Art. **VOSEVIUM (?).** *Gospel Book of Gundohinus: Christ in Majesty between Two Angels, surrounded by four medallions with the evangelist symbols.* 754. Folio 12 verso, MS 3, Bibliothèque Municipale, Autun. Miniature painting on vellum, 12 ⁵/₈ × 9 ⁵/₈ in. (Arts of Mankind Photo.)

Manuscript formerly in Autun Cathedral.

62. Carolingian Art. **VOSEVIUM (?).** *Gospel Book of Gundohinus: Christ in Majesty, detail of the previous plate.* (Cf. 61.) 754. Folio 12 verso, MS 3, Bibliothèque Municipale, Autun. (Arts of Mankind Photo.)

63. Carolingian Art. **VOSEVIUM (?).** *Gospel Book of Gundohinus: St Matthew, detail.* 754. Folio 186 verso, MS 3, Bibliothèque Municipale, Autun. Miniature painting on vellum. Page size, 12 ⁵/₈ × 9 ⁵/₈ in. (Arts of Mankind Photo.)

64. Carolingian Art, Palace School. **Diocese of Mainz.** *Gospel Book of Godescalc (Gospels of Charlemagne): St Mark.* 781-783. Folio 1 verso, Nouv. acq. lat. 1203, Bibliothèque Nationale, Paris. Miniature painting on purple vellum, 12 ¼ × 8 ¼ in. (B. N. Photo.)

65. Carolingian Art, Palace School. **Diocese of Mainz.** *Gospel Book of Godescalc (Gospels of Charlemagne): St Luke.* 781-783. Folio 1 recto, Nouv. acq. lat. 1203, Bibliothèque Nationale, Paris. Miniature painting on purple vellum, 12 ¼ × 8 ¼ in. (B. N. Photo.)

66. Carolingian Art, Palace School. **Middle Rhine region.** *Gospel Book of Ada: St Matthew.* About 800. Folio 15 verso, Cod. 22, Stadtbibliothek, Trier. Miniature painting on vellum, 14 ½ × 9 ⅝ in. (Photo Hermann Thörnig, Trier.)

67. Carolingian Art, Palace School. **Middle Rhine region.** *Gospel Book of Ada: St Luke. (Cf. 68.)* About 800. Folio 85 verso, Cod. 22, Stadtbibliothek, Trier. Miniature painting on vellum, 14 ½ × 9 ⅝ in. (Photo Hermann Thörnig, Trier.)

68. Carolingian Art, Palace School. **Middle Rhine region.** *Gospel Book of Ada: St Luke, detail. (Cf. 67.)* About 800. Folio 85 verso, Cod. 22, Stadtbibliothek, Trier. (Photo Hermann Thörnig Trier.)

69. Carolingian Art, Palace School. *Gospel Book: Canon Tables, detail.* About 800. Folio 11 verso, Harley 2788, British Museum, London. Miniature painting on vellum. Page size, 14 ½ × 10 ¼ in. (British Museum Photo.)

70. Carolingian Art, Palace School. *Gospel Book: St John, detail.* About 800. Folio 161 verso, Harley 2788, British Museum, London. Miniature painting on vellum. Page size, 14 ½ × 10 ¼ in. (British Museum Photo.)

71. Carolingian Art, Palace School. *Gospel Book: Beginning of St Luke. In the centre of the initial letter of 'Quoniam': Zacharias and the Angel.* About 800. Folio 109 recto, Harley 2788, British Museum, London. Miniature painting on vellum, 14 ½ × 10 ¼ in. (British Museum Photo.)

72. Carolingian Art, Palace School. **Middle Rhine region.** *Gospel Book: Annunciation to Zacharias.* Late 8th century. Folio 132 verso, Cotton Claud. B. v, British Museum, London. Miniature painting on vellum, 1 ¾ × 5 ⅞ in. (British Museum Photo.)

Painted strip tipped in at the end of the text, at the bottom of folio 132 verso.

73. Carolingian Art, Palace School. **Middle Rhine region.** *Gospel Book of Saint-Médard of Soissons: Beginning of St Luke. At the top, left and right: Annunciation. In the initial Q of 'Quoniam': Christ Teaching. In the letter O of 'Quoniam': Visitation.* Early 9th century. Folio 124 recto, Lat. 8850, Bibliothèque Nationale, Paris. Miniature painting on vellum, 14 ⅜ × 10 ¼ in. (B. N. Photo.)

74. Carolingian Art, Palace School. **Middle Rhine region.** *Gospel Book of Saint-Médard of Soissons: Heavenly Jerusalem, Evangelist Symbols, Adoration of the Lamb.* Early 9th century. Folio 1 verso, Lat. 8850, Bibliothèque Nationale, Paris. Miniature painting on vellum, 14 ⅜ × 10 ¼ in. (B. N. Photo.)

75. Carolingian Art, Palace School. **Middle Rhine region.** *Gospel Book of Saint-Médard of Soissons: Fountain of Life.* Early 9th century. Folio 6 verso, Lat. 8850, Bibliothèque Nationale, Paris. Miniature painting on vellum, 14 ⅜ × 10 ¼ in. (B. N. Photo.)

76. Carolingian Art, Palace School. **Middle Rhine region.** *Gospel Book of Saint-Médard of Soissons: St Mark.* Early 9th century. Folio 81 verso, Lat. 8850, Bibliothèque Nationale, Paris. Miniature painting on vellum, 14 ⅜ × 10 ¼ in. (B. N. Photo.)

77. Carolingian Art, Palace School. **Saint-Riquier, Abbey.** *Gospel Book of Saint-Riquier (Abbeville Gospels): St Matthew.* About 800. Folio 17 verso, MS 4, Bibliothèque Municipale, Abbeville. Miniature painting on purple vellum, 13 ¾ × 9 ⅝ in. (Arts of Mankind Photo.)

78. Carolingian Art, Palace School. **Middle Rhine region.** *Gospel Book of Lorsch: St John.* About 800. Folio 67 verso, Pal. lat. 50, Biblioteca Apostolica, Vatican City. Miniature painting on vellum, 14 ⅝ × 10 ¾ in. (Vatican Library Photo.)

79. Carolingian Art, Palace School under Byzantine influence. **AACHEN.** *Coronation Gospel Book: St John.* Early 9th century. Folio 178 verso, unnumbered manuscript, Schatzkammer, Kunsthistorisches Museum, Vienna. Miniature painting on purple vellum, 12 ¾ × 9 ⅞ in. (Museum Photo.)

80. Carolingian Art, Palace School under Byzantine influence. **AACHEN.** *Coronation Gospel Book: St Mark.* Early 9th century. Folio 76 verso, unnumbered manuscript, Schatzkammer, Kunsthistorisches Museum, Vienna. Miniature painting on purple vellum, 12 ¾ × 9 ⅞ in. (Museum Photo.)

81. Carolingian Art, Palace School under Byzantine influence. **AACHEN.** *Coronation Gospel Book: St Matthew.* Early 9th century. Folio 15 recto, unnumbered manuscript, Schatzkammer, Kunsthistorisches Museum, Vienna. Miniature painting on purple vellum, 12 ¾ × 9 ⅞ in. (Museum Photo.)

82. Carolingian Art, Palace School under Byzantine influence. **AACHEN (?).** *Gospel Book: St Luke, detail. (Cf. Frontispiece.)* Early 9th century. Folio 14 verso, unnumbered manuscript, Treasury of Aachen Cathedral. (Photo Ann Münchow, Aachen.)

83. Carolingian Art, Palace School under Byzantine influence. **AACHEN, XANTEN.** *Xanten Gospel Book: Evangelist Portrait, detail.* Early 9th century. Folio 16 verso, MS 18723, Bibliothèque Royale, Brussels. Miniature painting on purple vellum. Page size, 10 ⅛ × 7 ½ in. (Royal Library Photo. © Bibliothèque Royale de Belgique, Brussels.)

This painting is considered by some scholars to be a remnant of a 5th- or 6th-century Gospel Book painted in northern Italy.

84. Carolingian Art, School of Reims. **HAUTVILLIERS.** *Utrecht Psalter, Psalm XLIII [44]: above, the Psalmist with a Lute and Truth personified; below, Battle of the People of David; in the centre, the Psalmist invoking God's Help.* 820-830. Folio 25 recto, Script. eccl. 484, Bibliotheek der Rijksuniversiteit, Utrecht. Pen and ink drawing on vellum, 13 × 9 ⅞ in. (Utrecht University Library Photo.)

85. Carolingian Art, School of Reims. **HAUTVILLERS.** *Utrecht Psalter, Psalm XI [12], detail: Christ handing a Spear to an Angel; the Poor and Needy; Figures round a Table and Two Men turning a Swivel.* 820-830. Folio 6 verso, Script. eccl. 484, Bibliotheek der Rijksuniversiteit, Utrecht. Pen and ink drawing on vellum. Page size, 13 × 9 ⅞ in. Size of the detail, c. 5 × 5 ½ in. (Utrecht University Library Photo.)

86. Carolingian Art, School of Reims. **HAUTVILLERS.** *Utrecht Psalter, Psalm LII [53], d tail: Doeg the Edomite; above, Christ; in the centre, the Psalmist; lower left, Saul and Doeg.* 820-830. Folio 30 recto, Script. eccl. 484, Bibliotheek der Rijksuniversiteit, Utrecht. Pen and ink drawing on vellum. Size of the detail, 5 ½ × 9 ⅝ in. (Utrecht University Library Photo.)

87. Carolingian Art, School of Reims. **HAUTVILLERS.** *Utrecht Psalter, Psalm CII [103], detail: above, representation of Heaven, with Christ surrounded by Nine Angels, the Sun and the Moon; lower left, an Angel handing a Crown to the Psalmist; lower right, Moses and the Children of Israel.* 820-830. Folio 59 recto, Script. eccl. 484, Bibliotheek der Rijksuniversiteit, Utrecht. Pen and ink drawing on vellum. Size of the detail, 5 ⅓ × 9 ⅝ in. (Utrecht University Library Photo.)

88. Carolingian Art, School of Reims. **HAUTVILLERS.** *Utrecht Psalter, detail: the Catholic Faith; representation of a Church Council.* 820-830. Folio 90 verso, Script. eccl. 484, Bibliotheek der Rijksuniversiteit, Utrecht. Pen and ink drawing on vellum. Page size, 13×10 ¼ in. Size of the detail, 5 ⅛ $\times 9$ ½ in. (Utrecht University Library Photo.)

89. Carolingian Art, School of Reims. **HAUTVILLERS (?).** *Psalter, illustration of Psalm LI [52]: below, Saul and Doeg the Edomite; Ahimelech accused by Saul; above, Christ with the Elect.* First half of the 9th century. Folio 41 verso, MS 12, Troyes Cathedral. Miniature painting on vellum, 8×6 ⅛ in. (Arts of Mankind Photo.)

90. Carolingian Art, School of Reims. **HAUTVILLERS.** *Psalter (Codex aureus purpureus), illustration of Psalm LI [52]: Doeg.* Mid-9th century. Folio 51 verso, Douce 59, Bodleian Library, Oxford. Miniature painting on vellum, 7 ⅜ $\times 5$ ¾ in. (Bodleian Library Photo.)

91. Carolingian Art, School of Reims. **HAUTVILLERS.** *Psalter (Codex aureus purpureus), illustration of Psalm CI [102]: Poor Man and Two Kings appealing to Christ.* Mid-9th century. Folio 100 verso, Douce 59, Bodleian Library, Oxford. Miniature painting on vellum, 7 ⅜ $\times 5$ ¾ in. (Bodleian Library Photo.)

92. Carolingian Art, School of Reims. **HAUTVILLERS.** *Gospel Book of Ebbo: St John. (Cf. 242.)* First quarter of the 9th century (before 823). Folio 134 verso, MS 1, Bibliothèque Municipale, Épernay. Miniature painting on vellum, 10 ¼ $\times 8$ ¼ in. (Arts of Mankind Photo.)

93. Carolingian Art, School of Reims. **HAUTVILLERS.** *Gospel Book of Ebbo: St Matthew.* First quarter of the 9th century (before 823). Folio 18 verso, MS 1, Bibliothèque Municipale, Épernay. Miniature painting on vellum, 10 ¼ $\times 8$ ¼ in. (Arts of Mankind Photo.)

94. Carolingian Art, School of Reims. **HAUTVILLERS.** *Gospel Book of Ebbo: Canon Tables.* First quarter of the 9th century (before 823). Folio 11, MS 1, Bibliothèque Municipale, Épernay. Miniature painting on vellum, 10 ¼ $\times 8$ ¼ in. (Arts of Mankind Photo.)

95. Carolingian Art, School of Reims. **HAUTVILLERS.** *Gospel Book of Ebbo: Canon Tables, detail: Pediment Figure (Acroterium).* First quarter of

the 9th century (before 823). Folio 13 verso, MS 1, Bibliothèque Municipale, Épernay. Miniature painting on vellum. Page size, 10 ¼ $\times 8$ ¼ in. (Arts of Mankind Photo.)

96. Carolingian Art, School of Reims. **HAUTVILLERS.** *Gospel Book of Ebbo: Canon Tables, detail: Pediment Figure (Acroterium).* First quarter of the 9th century (before 823). Folio 13 recto, MS 1, Bibliothèque Municipale, Épernay. Miniature painting on vellum. Page size, 10 ¼ $\times 8$ ¼ in. (Arts of Mankind Photo.)

97. Carolingian Art, School of Reims. **HAUTVILLERS.** *Gospel Book of Ebbo: Canon Tables, detail: Pediment Figure (Acroterium).* First quarter of the 9th century (before 823). Folio 12 recto, MS 1, Bibliothèque Municipale, Épernay. Miniature painting on vellum. Page size, 10 ¼ $\times 8$ ¼ in. (Arts of Mankind Photo.)

98. Carolingian Art, School of Reims. **HAUTVILLERS.** *Volume of Medical Texts, detail: Aesculapius discovering Betony.* Mid-9th century. Folio 18 verso, Lat. 6862, Bibliothèque Nationale, Paris. Pen and ink drawing on vellum. Page size, 11×7 ⅞ in. Size of the detail, 5 ⅞ $\times 7$ ⅞ in. (B. N. Photo.)

99. Carolingian Art, School of Reims. **HAUTVILLERS.** *Physiologus latinus, detail: The Salamander [De nat(u)ra animalis qui di(ci)t(ur) Salamandra].* About 830. Folio 17 verso, Cod. 318, Bürgerbibliothek, Berne. Miniature painting on vellum. Page size, 10×6 ⅞ in. (Arts of Mankind Photo.)

100. Carolingian Art, School of Reims. **HAUTVILLERS.** *Physiologus latinus: Jacob blessing the Lion; Animals whose King is the Lion.* About 830. Folio 7 recto, Cod. 318, Bürgerbibliothek, Berne. Miniature painting on vellum. Page size, 10×6 ⅞ in. (Arts of Mankind Photo.)

101. Carolingian Art, School of Reims. **HAUTVILLERS.** *Gospel Book of Hincmar: Canon Tables.* First half of the 9th century. Folio 19 recto, MS 7, Bibliothèque Municipale, Reims. Miniature painting on vellum, 11 ¾ $\times 8$ ⅞ in. (Arts of Mankind Photo.)

102. Carolingian Art, School of Reims. **HAUTVILLERS.** *Gospel Book of Hincmar: Canon Tables, detail: Pediment Figures (Acroteria).* First half of the 9th century. Folio 15 recto, MS 7, Bibliothèque Municipale, Reims. Miniature painting on vellum. Page size, 11 ¾ $\times 8$ ⅞ in. (Arts of Mankind Photo.)

103. Carolingian Art, School of Reims. **HAUTVILLERS.** *Gospel Book of Hincmar: Canon Tables, detail: Pediment Figures (Acroteria).* First half of the 9th century. Folio 15 verso, MS 7, Bibliothèque Municipale, Reims. Miniature painting on vellum. Page size, 11 ¾ $\times 8$ ⅞ in. (Arts of Mankind Photo.)

104. Carolingian Art, School of Reims. **HAUTVILLERS.** *Gospel Book of Hincmar: Canon Tables, detail: Pediment Figures (Acroteria).* First half of the 9th century. Folio 17 recto, MS 7, Bibliothèque Municipale, Reims. Miniature painting on vellum. Page size, 11 ¾ $\times 8$ ⅞ in. (Arts of Mankind Photo.)

105. Carolingian Art, School of Reims. **HAUTVILLERS.** *Gospel Book of Hincmar: St Matthew.* First half of the 9th century. Folio 21 verso, MS 7, Bibliothèque Municipale, Reims. Miniature painting on vellum, 11 ¾ $\times 8$ ⅞ in. (Arts of Mankind Photo.)

106. Carolingian Art, School of Reims. **SAINT-DENIS (?).** *Gospel Book (Codex aureus) of St Emmeram of Regensburg: St John.* 870. Folio 97 recto, Clm. 14000, Bayerische Staatsbibliothek, Munich. Miniature painting on vellum, 15 ¾ $\times 11$ ¾ in. (Bavarian National Library Photo.)

107. Carolingian Art, School of Reims. **REIMS.** *Gospel Book of St Florian of Coblenz (fragments): Christ in the Temple.* About 830. No folio (detached leaf inserted in the forefront of a Rabanus Maurus), B. 113, Landesbibliothek, Düsseldorf. Miniature painting on vellum, 10 ¾ $\times 4$ ⅛ in. (Photo Landesbildstelle Rheinland, Düsseldorf.)

108. Carolingian Art, School of Reims (?). *Gospel Book of the Celestines: St Matthew.* Mid-9th century. Folio 17 verso, MS 1171, Bibliothèque de l'Arsenal, Paris. Miniature painting on vellum, 10 ⅝ $\times 8$ ⅝ in. (Photo Bibliothèque Nationale, Paris.)

The origin of this manuscript is unknown. It has been pointed out, however, that it has affinities with a manuscript in the Pierpont Morgan Library, New York (MS 319), which comes from Marchiennes (Nord), near Douai.

109. Carolingian Art, aftermath of the School of Reims. *Loisel Gospel Book: St Matthew.* 845-882. Folio 15 verso, Lat. 17968, Bibliothèque Nationale, Paris. Miniature painting on vellum, 8 ⅝ $\times 6$ ¾ in. (B. N. Photo.)

110. Carolingian Art, aftermath of the School of Reims. *Blois Gospel Book: St Mark.* Second quarter of the 9th century. Folio 73 verso, Lat. 265, Bibliothèque Nationale, Paris. Miniature painting on vellum, $11 \times 7\,^7/_8$ in. (B. N. Photo.)

111. Carolingian Art, School of Tours, in the insular tradition. **TOURS.** *Nevers Gospel Book: Canon Tables.* About 800. Folio 27 recto, Harley 2790, British Museum, London. Miniature painting on vellum, $12\,^1/_4 \times 8\,^5/_8$ in. (British Museum Photo.)

112. Carolingian Art, School of Tours, in the insular tradition. **TOURS.** *Alcuin, 'De virtutibus et vitiis' (on Virtues and Vices): Zoomorphic Initial.* About 800. Folio 5, MS 1742, Bibliothèque Municipale, Troyes. Miniature painting on vellum, $7\,^1/_8 \times 4\,^1/_2$ in. (Arts of Mankind Photo.)

113. Carolingian Art. **IRELAND or NORTHUMBRIA.** *The Book of Kells: Virgin and Child.* 8th century. Folio 7 verso, MS 58 (A. 1, 6), Trinity College Library, Dublin. Miniature painting on vellum, $12\,^7/_8 \times 10$ in. (Library Photo, The Green Studio, Dublin.)

114. Carolingian Art, School of Tours. **TOURS.** *Gospel Book: St Matthew.* Between 807 and 834. Folio 17 verso, Add. 11848, British Museum, London. Miniature painting on vellum, $11\,^3/_4 \times 8\,^5/_8$ in. (British Museum Photo.)

115. Carolingian Art, School of Tours. **TOURS.** *Gospel Book: St Luke.* Between 807 and 834. Folio 109 verso, Add. 11848, British Museum, London. Miniature painting on vellum, $11\,^3/_4 \times 8\,^5/_8$ in. (British Museum Photo.)

116. Carolingian Art, School of Tours. **TOURS.** *Weingarten Gospel Book: St John, detail.* Between 807 and 834. Folio 146 verso, HB 11 40, Württembergische Landesbibliothek, Stuttgart. Miniature painting on vellum. Page size, $13\,^1/_4 \times 9\,^3/_4$ in. (Bildarchiv Foto, Marburg.)

117. Carolingian Art, School of Tours. **TOURS.** *Boethius, 'De arithmetica': Music, Arithmetic, Geometry, Astrology.* About 850. Folio 2 verso, Misc. class. 5, Staatliche Bibliothek, Bamberg. Miniature painting on vellum, $9\,^1/_8 \times 6\,^7/_8$ in. (Bamberg Library Photo.)

118. Carolingian Art, School of Tours. **TOURS.** *Boethius, 'De arithmetica': Boethius and Symmachus.* About 850. Folio 9 verso, Misc. class. 5, Staatliche Bibliothek, Bamberg. Miniature painting on vellum, $9\,^1/_8 \times 6\,^7/_8$ in. (Bamberg Library Photo.)

119. Carolingian Art, School of Tours. **AUTUN.** *Marmoutier Sacramentary: Abbot Rainaud (Raganaldus) blessing the People.* About 850. Folio 173 verso, MS 19 bis, Bibliothèque Municipale, Autun. Miniature painting on vellum, $13\,^1/_8 \times 9\,^1/_2$ in. (Arts of Mankind Photo.)

Manuscript written for Abbot Raganaldus of Marmoutier.

120. Carolingian Art, School of Tours. **TOURS.** *Gospel Book of St Gauzelin: the Lamb, with the Attributes of the Evangelists and Prophets.* About 840. Folio 3 verso, unnumbered manuscript, Treasury of Nancy Cathedral. Gold and silver on purple vellum. Page size, $8\,^7/_8 \times 12$ in. Size of the motif, $8\,^7/_8 \times 6\,^7/_8$ in. (Arts of Mankind Photo.)

Comes from the abbey of Bouxières-aux-Dames, near Nancy, founded by Gauzelin in 935-936. Executed at the behest of a certain Arnaldus (ΑΡΝΛΛΩ IOBNTH) of Orléans, an official at the court of Louis the Debonair.

121. Carolingian Art, School of Tours. **TOURS - MARMOUTIER.** *Alcuin Bible: the Sacrificial Lamb surrounded by the Four Evangelists and their Symbols.* About 840. Folio 339 verso, Misc. class. Bibl. I, Staatliche Bibliothek, Bamberg. Miniature painting on vellum, $18\,^5/_8 \times 13\,^7/_8$ in. (Bamberg Library Photo.)

122. Carolingian Art, School of Tours. **TOURS - MARMOUTIER.** *Alcuin Bible: Story of Adam or Genesis.* About 840. Folio 7 verso, Misc. class. Bibl. I, Staatliche Bibliothek, Bamberg. Miniature painting on vellum, $18\,^5/_8 \times 13\,^7/_8$ in. (Bamberg Library Photo.)

123. Carolingian Art, School of Tours. **Saint-Martin of TOURS.** *Moûtier-Grandval Bible: Genesis.* About 840. Folio 25 verso, Add. 10546, British Museum, London. Miniature painting on vellum, 20×15 in. (British Museum Photo.)

124. Carolingian Art, School of Tours. **Saint-Martin of TOURS.** *Moûtier-Grandval Bible: Christ in Majesty, with the Evangelist Symbols and Evangelist Portraits.* About 840. Folio 352 verso, Add. 10546, British Museum, London. Miniature painting on vellum, 20×15 in. (British Museum Photo.)

125. Carolingian Art, School of Tours. **Saint-Martin of TOURS.** *Moûtier-Grandval Bible: the Teachings of the Gospels discovered by the Evangelists.* About 840. Folio 449, Add. 10546, British Museum, London. Miniature painting on vellum, 20×15 in. (British Museum Photo.)

126. Carolingian Art, School of Tours. **Saint-Martin of TOURS.** *First Bible of Charles the Bald (Vivian Bible): St Jerome leaving Rome for Jerusalem; St Jerome at Work with Eustochius, Paulinus and Scribes; St Jerome distributing Copies of his Translation of the Bible.* About 846. Folio 3 verso, Lat. 1, Bibliothèque Nationale, Paris. Miniature painting on vellum, $19\,^1/_2 \times 14\,^3/_4$ in. (B. N. Photo.)

127. Carolingian Art, School of Tours. **Saint-Martin of TOURS.** *First Bible of Charles the Bald (Vivian Bible): Conversion of St Paul on the road to Damascus; Healing of St Paul; St Paul Teaching.* About 846. Folio 386 verso, Lat. 1, Bibliothèque Nationale, Paris. Miniature painting on vellum, $19\,^1/_2 \times 14\,^3/_4$ in. (B. N. Photo.)

128. Carolingian Art, School of Tours. **Saint-Martin of TOURS.** *First Bible of Charles the Bald (Vivian Bible), beginning of the Psalms: David and his Musicians.* About 846. Folio 215 verso, Lat. 1, Bibliothèque Nationale, Paris. Miniature painting on vellum, $19\,^1/_2 \times 14\,^3/_4$ in. (B. N. Photo.)

129. Carolingian Art, School of Tours. **Saint-Martin of TOURS.** *First Bible of Charles the Bald (Vivian Bible): Abbot Vivian, surrounded by Monks, presenting the Book to Charles the Bald.* About 846. Folio 423 recto, Lat. 1, Bibliothèque Nationale, Paris. Miniature painting on vellum, $19\,^1/_2 \times 14\,^3/_4$ in. (B. N. Photo.)

130. Carolingian Art, School of Tours. **SAINT-DENIS (?).** *San Callisto Bible (Bible of San Paolo fuori le Mura): Charles the Bald on his Throne; above, Two Angels and the Four Cardinal Virtues.* 869-870. Folio 1, unnumbered manuscript, Basilica of San Paolo fuori le Mura, Rome. Miniature painting on vellum, $15\,^1/_2 \times 12$ in. (Basilica Photo.)

131. Carolingian Art, School of Tours. **SAINT-DENIS (?).** *San Callisto Bible (Bible of San Paolo fuori le Mura): St Jerome correcting the Translation of the Bible; St Jerome leaving Rome for Jerusalem; Discussion between Jerome, Paul and Eustochius; St Jerome distributing Copies of his Translation.* 869-870. Folio 2 verso, unnumbered manuscript, Basilica of San Paolo fuori le Mura, Rome. Miniature painting on vellum, $15\,^1/_2 \times 12$ in. (Basilica Photo.)

132. Carolingian Art, School of Tours. **Saint-Martin of TOURS or MARMOUTIER.** *Gospel Book of Lothair: Christ in Majesty surrounded by the Evangelist Symbols.* 849-851. Folio 2

verso, Lat. 266, Bibliothèque Nationale, Paris. Miniature painting on vellum, $9\,^7/_8 \times 12\,^5/_8$ in. (B. N. Photo.)

Executed to the order of Lothair I, under the supervision of Sigilaus, '. . . in honour of St Martin, in the community of that saint.' By this is meant either the abbey of Saint-Martin at Tours or the abbey of Marmoutier near Tours.

133. Carolingian Art, School of Tours. **Saint-Martin of TOURS or MAR-MOUTIER.** *Gospel Book of Lothair: Lothair on his Throne, with Two Bodyguards.* 849-851. Folio 1 verso, Lat. 266, Bibliothèque Nationale, Paris. Miniature painting on vellum, $9\,^7/_8 \times 12\,^5/_8$ in. (B. N. Photo.)

134. Carolingian Art, so-called School of Corbie, aftermath of the School of Tours. **SAINT-DENIS (?).** *Psalter of Charles the Bald: David and his Musicians.* Between 842 and 869. Folio 1 verso, Lat. 1152, Bibliothèque Nationale, Paris. Miniature painting on vellum, $9\,^1/_2 \times 7\,^5/_8$ in. (B. N. Photo.)

Written for Charles the Bald by the scribe Liuthard, who signed the manuscript at the end: 'HIC CALAMUS FACTO LIUTHARDI FINE QUIEVIT.'

135. Carolingian Art, so-called School of Corbie, aftermath of the School of Tours. **SAINT-DENIS (?).** *Psalter of Charles the Bald: Portrait of Charles the Bald.* Between 842 and 869. Folio 3 verso, Lat. 1152, Bibliothèque Nationale, Paris. Miniature painting on vellum, $9\,^1/_2 \times 7\,^5/_8$ in. (B. N. Photo.)

136. Carolingian Art, so-called School of Corbie, aftermath of the School of Tours. **SAINT-DENIS (?).** *Psalter of Charles the Bald: St Jerome Writing.* Between 842 and 869. Folio 4, Lat. 1152, Bibliothèque Nationale, Paris. Miniature painting on vellum, $9\,^1/_2 \times 7\,^5/_8$ in. (B. N. Photo.)

137. Carolingian Art, so-called School of Corbie, aftermath of the School of Tours. **SAINT-DENIS (?).** *Gospel Book (Codex aureus) of St Emmeram of Regensburg: Charles the Bald with Figures personifying the Provinces and a Bodyguard.* 870. Folio 5 verso, Clm. 14000, Bayerische Staatsbibliothek, Munich. Miniature painting on vellum, $15\,^3/_4 \times 11\,^3/_4$ in. (Bavarian National Library Photo.)

138. Carolingian Art, so-called School of Corbie, aftermath of the School of Tours. **SAINT-DENIS (?).** *Gospel Book (Codex aureus) of St Emmeram of Regensburg: Adoration of the Lamb.* 870. Folio 6 recto, Clm. 14000,

Bayerische Staatsbibliothek, Munich. Miniature painting on vellum, $15\,^3/_4 \times 11\,^3/_4$ in. (Bavarian National Library Photo.)

139. Carolingian Art, so-called School of Corbie, aftermath of the School of Tours. **SAINT-DENIS (?).** *Gospel Book (Codex aureus) of St Emmeram of Regensburg: Christ in Majesty with the Evangelists, the Evangelist Symbols and the Major Prophets, detail.* 870. Folio 6 verso, Clm. 14000, Bayerische Staatsbibliothek, Munich. Miniature painting on vellum. Page size, $15\,^3/_4 \times 11\,^3/_4$ in. (Bavarian National Library Photo.)

140. Carolingian Art, so-called School of Corbie. **SAINT-DENIS (?).** *Metz Sacramentary: Allegorical Representation of a Coronation (of Charles the Bald?), with the Archbishops of Trier and Reims.* About 870. Folio 2 verso, Lat. 1141, Bibliothèque Nationale, Paris. Miniature painting on vellum, $10\,^5/_8 \times 8\,^1/_4$ in. (B. N. Photo.)

Originally in the treasury of Metz Cathedral, then at the abbey of Jumièges, near Rouen, before coming to the Bibliothèque Nationale.

141. Carolingian Art, so-called School of Corbie. **SAINT-DENIS (?).** *Metz Sacramentary: Saints and Angels in Heaven looking towards Christ.* About 870. Folio 5 verso, Lat. 1141, Bibliothèque Nationale, Paris. Miniature painting on vellum, $10\,^5/_8 \times 8\,^1/_4$ in. (B. N. Photo.)

142. Carolingian Art, so-called School of Corbie. **SAINT-DENIS (?).** *Metz Sacramentary: Christ in Majesty, Master of Heaven and Earth.* About 870. Folio 6, Lat. 1141, Bibliothèque Nationale, Paris. Miniature painting on vellum, $10\,^5/_8 \times 8\,^1/_4$ in. (B. N. Photo.)

143. Carolingian Art, so-called School of Corbie. **SAINT-DENIS (?).** *Metz Sacramentary: St Gregory dictating his Sacramentary to Two Scribes, detail.* About 870. Folio 3, Lat. 1141, Bibliothèque Nationale, Paris. Miniature painting on vellum. Page size, $10\,^5/_8 \times 8\,^1/_4$ in. (B. N. Photo.)

144. Carolingian Art, School of Eastern France. **Meuse region.** *Gospel Book: Christ on the Cross, with a Figure personifying the Church catching the Blood flowing from His Side.* Second half of the 10th century. Folio 125, Lat. 9453, Bibliothèque Nationale, Paris. Pen and ink drawing on vellum, $10\,^1/_2 \times 7\,^1/_4$ in. (B. N. Photo.)

145. Carolingian Art, School of Metz. **METZ.** *Drogo Sacramentary: Seraph,*

Illustration and Beginning of the Sanctus. About 850. Folio 15, Lat. 9428, Bibliothèque Nationale, Paris. Miniature painting on vellum, $10\,^1/_2 \times 8\,^1/_2$ in. (B. N. Photo.)

146. Carolingian Art, School of Metz. **METZ.** *Drogo Sacramentary: Historiated Initial C with the Ascension.* About 850. Folio 71 verso, Lat. 9428, Bibliothèque Nationale, Paris. Miniature painting on vellum, $10\,^1/_2 \times 8\,^1/_2$ in. (B. N. Photo.)

147. Carolingian Art, School of Metz. **METZ.** *Drogo Sacramentary: Historiated Initial D with the Holy Women at the Tomb.* About 850. Folio 58, Lat. 9428, Bibliothèque Nationale, Paris. Miniature painting on vellum, $10\,^1/_2 \times 8\,^1/_2$ in. (B. N. Photo.)

148. Carolingian Art, School of Metz. **METZ.** *Drogo Sacramentary: Historiated Initial D with the Pentecost.* About 850. Folio 78, Lat. 9428, Bibliothèque Nationale, Paris. Miniature painting on vellum, $10\,^1/_2 \times 8\,^1/_2$ in. (B. N. Photo.)

149. Carolingian Art, Franco-Insular School. **SAINT-AMAND (?).** *Second Bible of Charles the Bald: Ornamental Initial, detail.* 871-877. Folio 44 verso, Lat. 2, Bibliothèque Nationale, Paris. Miniature painting on vellum, $17 \times 13\,^1/_4$ in. (B. N. Photo.)

Written and illuminated for Charles the Bald, who bequeathed it to the abbey of Saint-Denis.

150. Carolingian Art, Franco-Insular School. **SAINT-AMAND (?).** *Second Bible of Charles the Bald: Ornamental Initial H ('Haec sunt').* 871-877. Folio 68 recto, Lat. 2, Bibliothèque Nationale, Paris. Miniature painting on vellum, $17 \times 13\,^1/_4$ in. (B. N. Photo.)

Written and illuminated for Charles the Bald, who bequeathed it to the abbey of Saint-Denis.

151. Carolingian Art, Franco-Insular School. **SAINT-AMAND (?).** *Gospel Book of Saint-Vaast of Arras: Ornamental Title, Beginning of a Pericope.* Second half of the 9th century. Folio 43 recto, MS 233, Bibliothèque Municipale, Arras. Miniature painting on vellum, $10\,^7/_8 \times 9\,^1/_2$ in. (Arts of Mankind Photo.)

152. Carolingian Art, Franco-Insular School. Northern France (?). *Gospel Book of Francis II: Crucifixion.* Second half of the 9th century. Folio 12 verso, Lat. 257, Bibliothèque Nationale, Paris. Miniature painting on vellum, $11\,^3/_4 \times 8\,^7/_8$ in. (B. N. Photo.)

153. Carolingian Art, Franco-Insular School. Northern France (?). *Gospel Book of Francis II: St Luke.* Second half of the 9th century. Folio 94 verso, Lat. 257, Bibliothèque Nationale, Paris. Miniature painting on vellum, 11 ¾ × 8 ⅞ in. (B. N. Photo.)

154. Carolingian Art, Franco-Insular School. **SAINT-OMER.** *Psalter of Louis the German: Ornamented Page.* Between 814 and 840. Theol. lat. folio 83, Stiftung Preussischer Kulturbesitz, Staatsbibliothek, Berlin. Miniature painting on vellum, 11 ½ × 9 ¾ in. (Bildarchiv Foto, Marburg.)

155. Carolingian Art, Franco-Insular School. **SAINT-AMAND (?).** *Gospel Book: Canon Tables.* Second half of the 9th century. Folio 10 recto, MS 23, Bibliothèque Municipale, Tours. Miniature painting on vellum, 11 ½ × 9 ½ in. (Photo Bibliothèque Nationale, Paris.)

156. Carolingian Art, Franco-Insular School. **SAINT-AMAND (?).** *Gospel Book: Canon Tables.* Second half of the 9th century. Folio 7, MS 23, Bibliothèque Municipale, Tours. Miniature painting on vellum, 11 ½ × 9 ½ in. (Photo Bibliothèque Nationale, Paris.)

157. Carolingian Art. **ST GALL.** *Golden Psalter (Psalterium aureum): David with Musicians and Dancers. (Cf. dust jacket.)* 9th century. Folio 2, Cod. 22, Stiftsbibliothek, St Gall. Miniature painting on purple vellum, 14 ½ × 11 in. (Arts of Mankind Photo.)

158. Carolingian Art. **ST GALL.** *Golden Psalter (Psalterium aureum): Siege and Sack of a Town.* 9th century. Folio 141, Cod. 22, Stiftsbibliothek, St Gall. Miniature painting on purple vellum, 14 ½ × 11 in. (Arts of Mankind Photo.)

159. Carolingian Art. **ST GALL (?).** *Martyrology of Wandalbert: Month of May, Taurus.* Early 10th century. Folio 10 recto, Reg. lat. 438, Biblioteca Apostolica, Vatican City. Miniature painting on vellum, 11 ½ × 5 ¾ in. (Vatican Library Photo.)

160. Carolingian Art. **ST GALL (?).** *Martyrology of Wandalbert: Month of November, Scorpio.* Early 10th century. Folio 15 verso, Reg. lat. 438, Biblioteca Apostolica, Vatican City. Miniature painting on vellum, 11 ½ × 5 ¾ in. (Vatican Library Photo.)

161. Carolingian Art. **ST GALL.** *Epistles of St Paul: Paul reviled by the Jews.* First half of the 10th century. Folio 12, Cod. 64, Stiftsbibliothek, St Gall. Pen and ink drawing on vellum, 8 ¼ × 6 ¾ in. (Arts of Mankind Photo.)

162. Carolingian Art. **ST GALL (?).** *Prudentius, 'Psychomachia': Pride (above), Humility and Hope (below).* 10th century. Folio 42, Cod. 264, Bürgerbibliothek, Berne. Pen and ink drawing on vellum, 10 ⅞ × 8 ¼ in. (Arts of Mankind Photo.)

163. Carolingian Art. **ST GALL.** *Book of Maccabees: The Destruction of Jerusalem.* First half of the 10th century. Folio 9, Cod. Perizoni 17, Bibliotheek der Rijksuniversiteit, Leyden. Pen and ink drawing on vellum, 10 × 7 in. (Leyden University Library Photo.)

164. Carolingian Art. **ST GALL.** *Book of Maccabees: Mounted Warriors.* First half of the 10th century. Folio 46 recto, Cod. Perizoni 17, Bibliotheek der Rijksuniversiteit, Leyden. Pen and ink drawing on vellum, 10 × 7 in. (Leyden University Library Photo.)

165. Carolingian Art. **ST GALL.** *Psalter of Folchard: in a lunette, St Jerome Writing.* Third quarter of the 9th century. Folio 9, Cod. 23, Stiftsbibliothek, St Gall. Miniature painting on vellum, 15 ⅛ × 11 ½ in. (Arts of Mankind Photo.)

166. Carolingian Art. **SALZBURG.** *St John Chrysostom, 'Homilies on the Gospel of St Matthew': Portrait of the Author (St John Chrysostom).* First half of the 9th century. Folio 1 verso, Cod. 1007, Österreichische Nationalbibliothek, Vienna. Miniature painting on vellum, 10 ⅜ × 6 ¾ in. (Austrian National Library Photo.)

167. Carolingian Art. **SAINT-AMAND.** *Apocalypse: The Hand of God blessing a Group of Holy Figures; St John and Others witnessing the Destruction of a City.* 9th century. Folio 25 recto, MS 386, Bibliothèque Municipale, Cambrai. Miniature painting on vellum, 12 ¼ × 9 in. (Arts of Mankind Photo.)

168. Carolingian Art. **SAINT-AMAND.** *Apocalypse: Angel and Two Horsemen.* 9th century. Folio 19 recto, MS 99, Bibliothèque Municipale, Valenciennes. Miniature painting on vellum, 10 ⅝ × 7 ⅞ in. (Arts of Mankind Photo.)

169. Carolingian Art. **Northern or Eastern France (?), TOURS (?).** *Apocalypse: Angel casting the Millstone into the Sea.* First half of the 9th century. Folio 59 verso, Cod. 31, Stadtbibliothek, Trier. Miniature painting on vellum, 10 ¼ × 8 ½ in. (Photo Nelles, Trier.)

170. Carolingian Art, aftermath of the Franco-Insular School. **Eastern France, Meuse region.** *Gospel Book: Symbol of St Matthew.* 9th century. Folio 17 recto, MS 327, Bibliothèque Municipale, Cambrai. Miniature painting on vellum, 9 ⅝ × 7 ¼ in. (Arts of Mankind Photo.)

171. Carolingian Art. **SAINT-AMAND (?).** *Gospel Book: The Lamb surrounded by the Evangelist Symbols.* 9th century. Folio 138 verso, MS 69, Bibliothèque Municipale, Valenciennes. Miniature painting on vellum. Diameter, 6 ½ in. Page size, 10 ¼ × 8 in. (Arts of Mankind Photo.)

172. Carolingian Art, School of Reims. **REIMS.** *Terence, 'Comedies': Three Characters in 'The Eunuch' (Thais, Phaedria, Parmeno).* Second half of the 9th century. Folio 37, Lat. 7899, Bibliothèque Nationale, Paris. Pen and ink drawing on vellum, 10 ¼ × 8 ½ in. (B. N. Photo.)

173. Carolingian Art, School of Reims. **REIMS.** *Terence, 'Comedies': Frontispiece with Masks.* Second half of the 9th century. Folio 125, Lat. 7899, Bibliothèque Nationale, Paris. Pen and ink drawing on vellum, 10 ¼ × 8 ½ in. (B. N. Photo.)

174. Carolingian Art. **SAINT-AMAND (?).** *Prudentius, 'Psychomachia': Avarice.* 9th century. Folio 1 verso, MS 412, Bibliothèque Municipale, Valenciennes. Pen and ink drawing heightened with colour on vellum, 9 × 6 ⅛ in. (Arts of Mankind Photo.)

175. Carolingian Art. **SAINT-AMAND (?).** *Prudentius, 'Psychomachia': Pride.* 9th century. Folio 12 verso, MS 412, Bibliothèque Municipale, Valenciennes. Pen and ink drawing heightened with colour on vellum, 9 × 6 ⅛ in. (Arts of Mankind Photo.)

176. Carolingian Art. **LAON (?).** *Isidore of Seville, 'De natura rerum': Wheel of the Winds.* 9th century. Folio 5 verso, MS 422, Bibliothèque Municipale, Laon. Miniature painting on vellum, 11 ⅝ × 7 in. (Arts of Mankind Photo.)

177. Carolingian Art. **FULDA.** *Gospel Book: St Luke.* Second quarter of the 9th century. Folio 105 verso, M. P. Theol., Universitätsbibliothek, Würzburg. Miniature painting on vellum, 11 ⅛ × 7 ⅞ in. (Würzburg University Library Photo.)

178. Carolingian Art, aftermath of the Tours Style. **FULDA.** *Rabanus Maurus, 'De laudibus Sanctae Crucis': Rabanus presenting his Book to Greg-*

ory IV. 831-840. Folio 2 verso, Cod. 652, Österreichische Nationalbibliothek, Vienna. Miniature painting on vellum, $15\,^7/_8 \times 12\,^1/_8$ in. (Austrian National Library Photo.)

179. Carolingian Art. **FLEURY (SAINT-BENOIT-SUR-LOIRE).** *Gospel Book: Evangelist Symbols.* About 820. Folio 8 verso, Cod. 348, Bürgerbibliothek Berne. Miniature painting on vellum, $9\,^3/_4 \times 7\,^7/_8$ in. (Arts of Mankind Photo.)

180. Carolingian Art. **FREISING.** *Gospel Book of Schäftlarn: St Mark.* 854-875. Folio 81 verso, Clm. 17011, Bayerische Staatsbibliothek, Munich. Miniature painting on vellum, $7\,^1/_4 \times 8\,^1/_4$ in. (Bavarian National Library Photo.)

181. Carolingian Art, **Danube** region. **WELTENBURG.** *Gospel Book of Weltenburg: St Matthew.* 9th century. Folio 14 verso, Cod. 1234, Österreichische Nationalbibliothek, Vienna. Pen and ink drawing on vellum, $10\,^7/_8 \times 7\,^3/_4$ in. (Austrian National Library Photo.)

182. Carolingian (Franco-Rhenish) Art. **COLOGNE (?).** *Gospel Book: St Mark.* Second half of the 9th century (?). Manuscript with no page or reference numbers, Kunstgewerbe Museum, Cologne. Miniature painting on vellum, $9\,^7/_8 \times 7\,^1/_4$ in. (Rheinisches Bildarchiv, Kölnisches Stadtmuseum.)

Fragment of a Gospel Book, the other half of which is preserved in the Schnütgen Museum, Cologne.

183. Carolingian Art. **LANDÉVENNEC (?), BRITTANY.** *Gospel Book: Animal-headed Symbol of St John.* Early 10th century. Folio 108 verso, MS 960, Bibliothèque Municipale, Troyes. Miniature painting on vellum, $9\,^7/_8 \times 6\,^1/_2$ in. (Arts of Mankind Photo.)

184. Carolingian Art. **LANDÉVENNEC (?), BRITTANY.** *Gospel Book: Animal-headed Symbol of St Matthew.* 9th century. Folio 8 recto, MS 8, Bibliothèque Municipale, Boulogne. Miniature painting on vellum, $10\,^5/_8 \times 7\,^3/_4$ in. (Arts of Mankind Photo.)

185. Carolingian Art. **LANDÉVENNEC (?), BRITTANY.** *Gospel Book: Animal-headed Symbol of St Mark.* 9th century. Folio 42 recto, MS 8, Bibliothèque Municipale, Boulogne. Miniature painting on vellum, $10\,^5/_8 \times 7\,^3/_4$ in. (Arts of Mankind Photo.)

186. Carolingian Art. **FLEURY (SAINT-BENOIT-SUR-LOIRE).** *Book of the Prophets: Ornamental Initials with Scrollwork and Animals.* 8th-9th cen-

tury. Page 7, MS 17, Bibliothèque Municipale, Orléans. Miniature painting on faded vellum. Page size, $14\,^5/_8 \times 9\,^1/_2$ in. (Arts of Mankind Photo.)

187. Carolingian Art. **IRELAND.** *Gospel Book of MacDurnan: The Four Evangelist Symbols.* Mid-9th century. Folio 100, Lambeth Palace Library, London. Miniature painting on vellum, $4\,^3/_8 \times 6\,^1/_4$ in. (Photo John R. Freeman Ltd. London.)

188. Carolingian Art. **MILAN, Sant' Ambrogio. VUOLVINIUS.** *Altar, detail of the front: Majestas Domini.* (*Cf. 221.*) About 850. In situ. Gold, silver gilt, precious stones and enamels. Overall size: height $33\,^1/_2$ in, width $86\,^1/_2$ in, depth 48 in. (Arts of Mankind Photo.)

189. Syrian (?) Art. *Comb of St Gauzelin (922-962).* 8th century. Cathedral Treasury, Nancy. Ivory, $8\,^1/_4 \times 4\,^3/_4$ in. (Arts of Mankind Photo.)

See also the relief ornaments carved in bone from Moslem Egypt and the façade of the Umayyad palace at Mshatta (Jordan).

190. Byzantine Art. *Fragment of Cloth with a Quadriga in a Medallion.* 8th century. Cathedral Treasury, Aachen. Yellow silk on a purple field. (Arts of Mankind Photo.)

Part of the same piece of cloth as the fragment now in the Musée de Cluny, Paris. It came from the reliquary of Charlemagne.

191. Carolingian (Insular) Art. *Chalice of Tassilo.* Second half of the 8th century. Abbey Church Treasury, Kremsmünster. Copper cast, gilt and niello'd. Height 10 in, diameter $6\,^1/_4$ in. (Photo Ann Münchow, Aachen.)

From Regensburg (?). Made for Duke Tassilo of Bavaria and his wife Liutpirc, as recorded in the inscription on the foot: 'TASSILO DUX FORTIS † LIUTPIRC VIRGA REGALIS.' Probably made at Salzburg about 777, under very strong Northumbrian influence. The inner bowl has disappeared.

192. Carolingian Art. *First Cover of the Lindau Gospels.* About 800 (restored about 1600). J. Pierpont Morgan Library, New York. Silver gilt and niello'd, almandines and enamels. $13\,^1/_2 \times 10\,^1/_4$ in. (Morgan Library Photo.)

Comes from the Convent of Noble Ladies at Lindau, on the Lake of Constance. The codex inside is a St Gall manuscript of the late 9th century. Like the Tassilo chalice, this

cover may have been made at Salzburg; it too shows a strong Northumbrian influence. (Cf. 236 for the second cover of the Lindau Gospels.)

193. Carolingian Art. *Enger Reliquary, back: Christ between Two Angels and the Virgin between two Apostles.* About 780. Stiftung Preussischer Kulturbesitz, Staatliche Museen, Berlin. Gold and chased silver gilt over an oak core. $6\,^1/_4 \times 5\,^3/_4$ in. (Photo Elsa Postel, Berlin.)

A work of the Alamannic school and closely related to the first cover of the Lindau Gospels. (Cf. 192.) The Enger reliquary is recorded as being at Herford (Westphalia) in 1414 and in Berlin in 1888. (Cf. Bibliography, No. 313, p. 316, for the front of this reliquary.)

194. Carolingian Art. *Reliquary, front: Decoration based on a Cross Design.* 9th century (restored about 1680). Cathedral Treasury, Monza. Gold, filigree, stones, gems and pearls; the design on the other side is in chased gold. $13\,^3/_8 \times 10\,^1/_4$ in. (Arts of Mankind Photo.)

The Monza reliquary was made for the teeth of St John. On the other side is a Crucifixion.

195. Carolingian Art. *Cross with a Bird in the Centre.* Late 8th century. Bayerisches Nationalmuseum, Munich. Gold, iron, almandines and glass; bird in champlevé enamel. (Photo Elisabeth Römmelt.)

On the strength of its technique, this cross can be attributed to the Carolingian period. It was purchased from an antique dealer in Württemberg.

196. Spanish (Asturian) Art. *Cross of the Angels.* 808. Cámara Santa, Oviedo Cathedral. Gold on a wooden core, with filigree work, stones and enamels. $18\,^1/_4 \times 17\,^1/_2$ in. (Photo Enric Gras, Barcelona.)

Inscription on the arms of the cross, at the back: † SUSCEPTUM PLACIDE MANEAT HOC IN ONORE DI OFFERT ADEFONSUS HUMILIS SERVUS XRI QUISQUIS AUFERRE PRESUMSERIT MIHI FULMINE DIVINO INTEREAT IPSE NISI LUBENS UBI VOLUNTAS DEDERIT MEA HOC OPUS PERFECTUM EST IN ERA DCCCXLVLI HOC SIGNO TUETUR PIUS — HOC SIGNO VINCITUR INIMICUS.

197. Carolingian Art. *Reliquary of Bishop Altheus, back.* Late 8th century. Cathedral Treasury, Sion. Silver gilt on a wooden core with cloisonné enamels. $7 \times 5\,^1/_2$ in. (Photo De Bellet, Geneva.)

This reliquary in the old cathedral town of Sion (canton of the Valais, Switzerland) bears a dedicatory inscription on the bottom: 'HANC CAPSAM DICATA IN HONORE SCE MARIAE ALTHEUS EPS FIERI ROGAVIT.' *(Cf. Bibliography, No. 313, p. 315, for the front of the reliquary.)*

198. Italian (Roman) Art. *Reliquary: Enamelled Cross of Pope Pascal I (817-824) with Scenes of the Life of the Virgin.* About 817-824. Museo Sacro, Biblioteca Apostolica, Vatican City. Gold and cloisonné enamels. Height 10 ¾ in, width 7 ¹/₈ in, thickness 1 ³/₈ in. (Vatican Library Photo.)

This reliquary was formerly in the treasury of the Sancta Sanctorum. The back became detached and was lost. On the sides, the dedicatory inscription: 'ACCIPE QUAESO A DOMINA MEA REGINA MUNDI HOC VEXILLUM CRUCIS QUOD TI (BI) PASCHALIS EPISC (OPUS) OPT (ULIT).'

Its style is close to that of the Beresford Hope Cross in the Victoria and Albert Museum, London. It shows a very strong influence of the Christian East.

199. Italian (Roman) Art. *Lid of the Reliquary of Pope Pascal I (817-824) with Scenes of the Life of Christ.* 817-824. Museo Sacro, Biblioteca Apostolica, Vatican City. Chased silver. (Vatican Library Photo.)

Formerly in the treasury of the Sancta Sanctorum. Reliquary of the gemmed cross formerly in the treasury of the Sancta Sanctorum and now lost. (Cf. Europe in the Dark Ages, 246; Bibliography, No. 313.) On the lid is the inscription: † PASCHALIS EPISCOPUS PLEBI DEI FIERI IUSSIT. *In the same style as the enamelled cross. (Cf. 198.)*

200-201. Carolingian (Anglo-Saxon) Art. *Genoelselderen Diptych: Christ Triumphant (left), Annunciation and Visitation (right).* Late 8th century. Musées Royaux d'Art et d'Histoire, Brussels. Ivory. Each leaf, 11 ¾ × 7 ¹/₈ in. (Arts of Mankind Photo.)

Comes from the church of St Martin at Genoelselderen (Limburg, Belgium). The ornamental designs and the lettering speak in favour of an English origin; or these ivories may have been carved in some region (the Meuse region, for example) exposed to the influence of Anglo-Saxon art.

202. Carolingian Art. **MILAN.** *Diptych with Christological Scenes.* Early 9th

century. Cathedral Treasury, Milan. Ivory. Each leaf, 12 ³/₈ × 4 ½ in. (Arts of Mankind Photo.)

Copy of an Early Christian prototype, like the ivory diptychs in Aachen and London. (Cf. Bibliography, No. 245, I, Fig. 22.)

203. Merovingian (North Italian) Art. **BRESCIA, San Salvatore.** *Fragment of an Ambo with a Peacock.* 8th century. Museo Cristiano, Brescia. Marble. Length 49 ¼ in. (Arts of Mankind Photo.)

Carved in a style akin to that of Byzantine sculpture.

204. Carolingian Art. **AACHEN, Palatine Chapel.** *Tribune, Railing, detail.* Early 9th century. In situ. Bronze, cast in a single piece. Height 4 ft, length 13 ft, 9 in. (Arts of Mankind Photo.)

The bronze railings of the tribune are composed of eight separate pieces. The foundry in which they were probably cast stood quite close to the Palatine Chapel, whose bronze doors (as we know from Einhard) were also made for Charlemagne. (Cf. Bibliography, No. 182, p. 30.) The ornamental design of the railings is similar to that of the ivory Deventer chalice. (Cf. Bibliography, No. 245, I, Fig. 152.)

205. Carolingian Art. **AACHEN, Palatine Chapel.** *Wolf Portal, detail: Lion's Muzzle.* Early 9th century. In situ. Bronze. Size of the door, 13 ft × 9 ft. Diameter of the lion's head, 11 ½ in. (Arts of Mankind Photo.)

There are three other bronze doors besides this one, all of them patterned on antique prototypes.

206. Carolingian Art. *So-called Statuette of Charlemagne.* About 860-870. Louvre, Paris. Bronze cast and gilt. Height 9 ¼ in. Height of figure alone, 7 ½ in. (Arts of Mankind Photo.)

Made in imitation of an antique prototype, this statuette represents a Carolingian king, but it can hardly be Charlemagne. The sword and the horse were recast in the Renaissance.

207. Carolingian Art, Palace School of Charlemagne. *Ivory Book Cover: in the centre, Christ Triumphant trampling a lion, an adder, a dragon and a basilisk, surrounded by scenes of His childhood and miracles.* Early 9th century. Douce 176, Bodleian Library, Oxford. Uppermost part of a leather binding of the 17th century. 8 ¼ × 4 ⁷/₈ in. (Bodleian Library Photo.)

Copy of a western Early Christian prototype, of which two panels are extant, one in the Louvre, Paris, the

other in the Staatliche Museen, Berlin. See also the fragment of a diptych at Nevers.

208. Carolingian Art, Palace School of Charlemagne. *Ivory Cover of the Dagulf Psalter: David choosing his secretaries; playing the harp; sending an embassy to St Jerome; dictating the Psalms.* Between 783 and 795. Louvre, Paris. Each leaf, 6 ⁵/₈ × 3 ¼ in. (Louvre Photo, Maurice Chuzeville.)

The Dagulf Psalter, written for Pope Adrian I (772-795), was at first in the abbey of Limburg an der Lahn, then at Speyer in 1065; from 1450 to 1520 it was in Bremen Cathedral. It is now preserved in the Österreichische Nationalbibliothek, Vienna.

This ivory book cover is the only dated work of Charlemagne's Palace School. The Bodleian ivory (cf. 207) and the Aachen diptych are closely related pieces. (Cf. Bibliography, No. 245, I, Fig. 62.)

209. Carolingian Art. *Ivory Book Cover: Crucifixion and Christological Scenes.* 9th century. Cathedral Treasury, Narbonne. Ivory probably already designed as a book cover. 10 × 6 ⁷/₈ in. (Arts of Mankind Photo.)

This ivory postdates those executed by the Palace School of Charlemagne, as for example the Berlin Crucifixion, the Aachen diptych or the one from the Harrach Collection (cf. Bibliography, No. 245, I, Figs. 18 and 182) now on loan to the Schnütgen Museum, Cologne. It derives from Early Christian prototypes.

210. Carolingian Art, Palace School of Charlemagne. *Ivory Cover of the Lorsch Gospels (Codex Aureus): Christ between Two Angels.* About 810. Museo Sacro, Biblioteca Apostolica, Vatican City. 14 ⁷/₈ × 10 ⁷/₈ in. (Vatican Library Photo.)

This ivory carving with the figure of Christ trampling 'the lion and the dragon' (Psalms 91: 13) copies an Early Christian prototype of the 6th century, perhaps of the school of Ravenna. It represents the later period of Charlemagne's Palace School, as do the Darmstadt Ascension (cf. 213) and the Leipzig St Michael (cf. 212). It comes from St Nazarius, Lorsch. (Cf. 211 for the back cover.)

211. Carolingian Art, Palace School of Charlemagne. *Ivory Cover of the Lorsch Gospels (Codex Aureus): Virgin and Child between Zacharias and John the Baptist.* About 810. Victoria and Albert Museum, London. 15 ¹/₈ × 10 ⁵/₈ in. (Museum Photo.)

The back cover of the Lorsch Gospels is by the hand of another, slightly less skilful ivory carver. Like the front cover, it is a copy of an Early Christian prototype; this is especially obvious in the panel at the top. The Virgin corresponds fairly closely to the one on the Berlin diptych. The manuscript itself, separated from its covers, is now divided between the Batthyaneum Library at Alba Iulia (Rumania) and the Vatican Library. This ivory carving is typical of the later phase of Charlemagne's Palace School; it may well have been executed in the Lorsch monastery, where the miniatures were painted. (Cf. 210 for the front cover.)

212. Carolingian Art, Palace School of Charlemagne. *St Michael.* About 810. Museum für Kunsthandwerk, Leipzig. Ivory; the eyes are encrusted with glass paste. 13 ³/₈ × 4 in. (Photo Walter Danz, Halle.)

Based on a consular diptych of 470 in the name of Severus. This ivory represents the later phase of Charlemagne's Palace School, as do the Lorsch covers (cf. 210-211) and the Darmstadt Ascension (cf. 213).

213. Carolingian Art, Palace School of Charlemagne. *Ivory Fragment of an Ascension: The Virgin amid the Apostles.* Early 9th century. Hessisches Landesmuseum, Darmstadt. The frame is broken off on two sides. 5 ½ × 3 ⁵/₈ in. (Photo Ann Münchow, Aachen.)

The style of this work is very close to that of such ivory carvings as the Berlin Crucifixion (Staatliche Museum), the Florence Holy Women at the Tomb (Museo Nazionale) and the Lorsch covers (cf. 210-211); all derive from Early Christian ivories like the Munich Holy Women at the Tomb (Bayerisches Nationalmuseum), with which the Carolingian court artists were undoubtedly familiar. (Cf. Bibliography, No. 256, p. 332.)

214-215. Carolingian Art. **METZ.** *Ivory Covers of the Drogo Sacramentary.* About 855. Lat. 9428, Bibliothèque Nationale, Paris. 10 ½ × 8 ½ in. (B. N. Photo.)

The Drogo Sacramentary was written during the time when Drogo was archbishop of Metz (826-855); it records the date of his death. These ivory carvings are very close to the book covers in the Liebighaus at Frankfurt. (Cf. Bibliography, No. 245, I, Fig. 75.)

216. Carolingian Art, School of Metz. *Cover of a Gospel Book: Passion Scenes.* Mid-9th century. Lat. 9393, Bibliothèque Nationale, Paris. Open-

work ivory, gold, gilt metal, filigree work. 12 ⁵/₈ × 9 ½ in. (B. N. Photo.)

Like the ivories of the Drogo Sacramentary (cf. 214-215), this is a characteristic example of the Metz school of ivory carving, still strongly influenced by Early Christian prototypes. It came from Metz Cathedral.

217. Carolingian Art, School of Tours. *Liturgical Fan (Flabellum), details: Six Scenes from Virgil's Eclogues.* Mid-9th century. L. Carrand Collection, Museo Nazionale, Florence. Ivory. (Photo Alinari, Florence.)

A faithful copy of classical prototypes. (Cf. 322.)

218. Carolingian Art. *Leaf of the Ivory Diptych of the Consul Areobindus: Paradise.* Mid-9th century. Louvre, Paris. 13 ¾ × 4 ³/₈ in. (Arts of Mankind Photo.)

Reuse of the consular diptych of Areobindus (Byzantium, anno 506). Representation of Paradise; below, centaurs, sirens and satyrs faithfully copied from classical prototypes. (Cf. 219.)

Purchased from an antique dealer.

219. Carolingian Art. *Leaf of the Ivory Diptych of the Consul Areobindus: Paradise, detail of Adam and Eve. (Cf. 218.)* Mid-9th century. Louvre, Paris. (Louvre Photo, Maurice Chuzeville.)

220. Carolingian Art. **MILAN, Sant' Ambrogio. VUOLVINIUS.** *Altar (paliotto), detail of the back: Angilbert presenting the Altar to St Ambrose. (Cf. 222 for another detail of the back.)* About 850. In situ. (Arts of Mankind Photo.)

221. Carolingian Art. **MILAN, Sant' Ambrogio. VUOLVINIUS.** *Altar, front: Majestas Domini and Twenty Christological Scenes.* About 850. In situ. Gold, silver gilt, precious stones and enamels. Overall size: height 33 ½ in, width 86 ½ in, depth 48 in. (Arts of Mankind Photo.)

The dedicatory inscription reads: 'DOMNUS ANGILBERTUS ET VUOLVINI (US) PHABER.' The donor was Bishop Angilbert II (824-859); Vuolvinius was the master craftsman in charge of the work. Alongside Vuolvinius, another outstanding master and several lesser artists undoubtedly worked on the Milan altar. The enamels are related to those of the Altheus reliquary at Sion (cf. 197) and those on the iron crown at Monza (cf. 225). This antependium surrounds all four sides of the altar. (Cf. 188.)

222. Carolingian Art. **MILAN, Sant' Ambrogio. VUOLVINIUS.** *Altar,*

detail of the back: Vuolvinius receiving a Crown from St Ambrose. (Cf. 220 for another detail of the back.) About 850. In situ. (Arts of Mankind Photo.)

223-224. Carolingian Art. **MILAN, Sant' Ambrogio. VUOLVINIUS.** *Altar, the two sides: in the centre, a gemmed cross between four medallions enclosing busts of saints (Ambrose, Protasius, Gervasius and Simplician on the Gospel side; Martin, Nabor, Nazarius and Maternus on the Epistle side); outside the central square, eight angels venerating the Cross.* About 850. In situ. (Arts of Mankind Photo.)

225. Carolingian (Italian) Cross. *Iron Crown.* Second half of the 9th century. Cathedral Treasury, Monza. Iron and six gold plates with enamels and precious stones. Height 2 ¾ in, diameter 19 in. (Arts of Mankind Photo.)

Inside, an iron hoop, allegedly a relic made from a nail of the True Cross. According to the legend, this crown was used during the Middle Ages for the coronation of kings and emperors in Italy. Since the 15th century, it has been regarded as the crown of the Lombard kings; since the 16th century, it has been venerated as a relic of the True Cross. The enamels are in the style of those on the Altheus reliquary at Sion (cf. 197) and on the Milan altar (cf. 188, 220-224).

226. Carolingian Art. *Lothair Crystal: Scenes of the Life of St Susanna.* Second half of the 9th century. British Museum, London. Rock crystal. Diameter of the crystal alone, 4 ¹/₈ in; with the frame, 7 ¹/₈ in. (British Museum Photo.)

Over the central circle is the dedicatory inscription: 'LOTHARIUS REX FRANCORUM FIERI IUSSIT.' This was Lothair II (855-869). The crystal was probably carved in Lorraine; its technique is close to that of the seal of Lothair on the cross of Lothair (treasury of Aachen Cathedral). The frame goes back only to the Gothic period.

Purchased in 1855 from an antique dealer, this crystal had been at the abbey of Waulsort on the Meuse (Belgium) since the 10th century.

227. Carolingian Art. **LORRAINE, METZ (?).** *Rock Crystal: The Crucifixion.* Second half of the 9th century. Augustinermuseum, Freiburg-im-Breisgau. Rock crystal, 3 ¹/₈ × 2 ½ in. (Photo Verlag Karl Alber, Freiburg-im-Breisgau.)

The inscription reads: 'IHS NAZARENUS RE (X) IUDEOR (UM).' Technically very close to the Lothair Crystal in the British Museum (cf. 226) and to the Crucifixion in the collection of Count Cini, Venice.

228. Carolingian Art, School of Charles the Bald. *Ivory Book Cover.* About 846-869. Schweizerisches Landesmuseum, Zurich. 4 ½ × 3 ³/₈ in. (Swiss National Museum Photo.)

This was probably the original cover of the Prayer Book of Charles the Bald which is now in the treasury of the Residenz at Munich. This prayer book, as recorded in the manuscript itself (folios 38 verso and 39 recto), belonged to the king personally and was finished before the death of his wife (869). The style of this relief is very close to that of the ivory covers of the Psalter of Charles the Bald in the Bibliothèque Nationale, Paris. (Cf. 230-232.) It is also related to the miniatures of the Utrecht Psalter (cf. 84-88), from which we may conclude that it was probably carved at Reims. It was in Zurich Cathedral in the 14th century, and later in the monastery of Rheinau before coming to the Swiss National Museum in Zurich.

229. Carolingian (West Frankish) Art, School of Charles the Bald. *Cover of the Book of Pericopes of Henry II: in the centre, the Crucifixion; above, the Hand of God between the Sun and the Moon; below, the Holy Women at the Tomb and the Resurrection.* Ivory carving, about 870; gold frame with precious stones and enamels, between 1007 and 1012. Clm. 4452, Bayerische Staatsbibliothek, Munich. Size of the ivory, 11 ½ × 7 ⁵/₈ in. Size of the whole cover, 17 ½ × 9 in. (Munich Library Photo.)

According to Homburger, this ivory belonged to the Gospel Book of Charles the Bald in Munich (Cod. lat. 14000, Clm. 55) which, like the Codex Aureus of Paris, was written by Liuthard. (Cf. 230-232 for the ivory covers of the Psalter of Charles the Bald.) The supposition that the Byzantine enamels on the frame come from the crown of Otto III or the Empress Theophano remains unconfirmed. Around the ivory runs the dedicatory inscription of Henry II. The carving was given to Bamberg Cathedral by Henry himself.

230. Carolingian Art, School of Charles the Bald. *Cover of the Psalter of Charles the Bald, detail: Nathan reproaching David and Bathsheba for the Murder of Uriah. (Cf. 231-232.)* Before 869. Lat. 1152, Bibliothèque Nationale, Paris. (B. N. Photo.)

231-232. Carolingian Art, School of Charles the Bald. *Covers of the Psalter of Charles the Bald: Scenes illustrating Psalms 51 and 57.* Before 869. Lat. 1152, Bibliothèque Nationale, Paris. Ivory and silver-gilt frame with filigree

work and precious stones. Size of the ivory, 5 ½ × 5 ¼ in. Size of the cover, 9 ½ × 7 ⁵/₈ in. (B. N. Photo.)

This psalter was written for Charles the Bald by Liuthard during the lifetime of Charles's wife Hermentrude (died 869). The style of these two ivories is close to those of Munich (cf. 229) and Zurich (cf. 228). They came to the Bibliothèque Nationale from Metz Cathedral. (Cf. 230.)

233. Carolingian Art. *Ivory Book Cover: The Encounter of Joab and Abner at the Pool of Gibeon.* Louvre, Paris. Height 6 in. (Louvre Photo, Maurice Chuzeville.)

When this ivory was in the treasury of Saint-Denis it had a frame inlaid with precious stones. (Cf. Bibliography, No. 196.)

234. Antique and Carolingian (West Frankish) Art. Inscribed with the name of the Greek artist 'EVODOS.' *Intaglio surrounded by Gems from the 'Casket of Charlemagne' ('Écrin de Charlemagne'), with the Portrait of Julia, daughter of Titus.* Antique stones with 9th-century setting. Cabinet des Médailles, Bibliothèque Nationale, Paris. Bluish white aquamarine (also called rock crystal) with sunk design, surrounded by sapphires and pearls set in gold rims. Intaglio alone, 2 × 1 ½ in; with the setting (but without the pearls), 3 ½ in. (B. N. Photo.)

The stones may have come from Byzantium. On the sapphire at the top is a dolphin; on the other side is inscribed the word 'AMOX.' The casket itself was destroyed in the French Revolution; a drawing of 1791 shows what it looked like. (Cf. 323.)

235. Carolingian (West Frankish) Art, Palace School of Charles the Bald. *Cover of the Gospel Book (Codex Aureus) of St Emmeram of Regensburg: Christ and New Testament Saints.* About 870. Clm. 14000, Bayerische Staatsbibliothek, Munich. Chased gold with precious stones and pearls. 16 ½ × 13 in. (Munich Library Photo.)

Boeckler (cf. Bibliography, No. 68, p. 50) has pointed out that, since the style of the reliefs is so close to that of the miniatures in the codex, the cover must have been made expressly for the codex, perhaps at Corbie. In the opinion of Rosenberg, the reliefs show some relation with Reims. The setting of the stones is similar to that of the paten of Charlemagne (Louvre), which was part of the chalice of Charlemagne at Saint-Denis. (Cf. O. K. Werckmeister, Der Deckel des Codex Aureus, Baden Baden and Strasbourg, 1962.)

236. Carolingian Art. *Second Cover of the Lindau Gospels: Crucifixion.* About 880. J. Pierpont Morgan Library, New York. Gold reliefs, precious stones and pearls. Height 13 ½ in. (Morgan Library Photo.)

For the dating, see Schnitzler (Bibliography, No. 509, p. 264) and Swarzenski (Bibliography, No. 550, p. 301). Comes from the Convent of Noble Ladies at Lindau, on the Lake of Constance. (Cf. 192 for the first cover of the Lindau Gospels.)

237. Carolingian Art. *'Talisman of Charlemagne.'* About 870. Cathedral Treasury, Reims. Chased gold, filigree work, precious stones and pearls. Height 2 ½ in, width 2 ⁷/₈ in, thickness, 1 ½ in. (Photo Ann Münchow, Aachen.)

According to legend, this talisman was found round the emperor's neck when his sarcophagus was opened at Aachen in 1166. Judging by the technique of the cabochons, it appears to date only from the second half of the 9th century, perhaps from the time of Charles the Bald. Cf. Taralon, Les Monuments historiques de la France, 1966, p. 24. This work may be compared in particular with the inlaid stones on the ciborium of Arnulf (cf. 238) and with the cover of the Metz Gospel Book (Lat. 9383) in the Bibliothèque Nationale, Paris.

238. Carolingian (West Frankish) Art. *Ciborium of King Arnulf: Portable Altar with Reliefs illustrating Episodes of the New Testament.* About 870. Schatzkammer der Residenz, Munich. Gold plate on a wooden core, with filigree work and precious stones. Height 23 ¼ in, width 12¼ in, depth 9 ½ in. (Residenz Photo.)

According to Boeckler (Bibliography, No. 68, p. 71), probably made at Reims and given by King Arnulf to St Emmeram of Regensburg in 893. The dedicatory inscription on the lower part may be a later addition. The ciborium was restored at Regensburg in the 10th century, in the time of Abbot Ramwold (975-1001). (Cf. 239.) In style very close to the cover of the St Emmeram Gospels (cf. 235) and the second Lindau cover (cf. 236).

239. Carolingian (West Frankish) Art. *Ciborium of King Arnulf, detail: Christ and St Peter. (Cf. 238.)* About 870. Schatzkammer der Residenz, Munich. (Residenz Photo.)

240. Carolingian Art. *Reliquary.* About 870. Collegiate Church of St Vitus, Ellwangen. Bronze lightly gilt. Height 4 ¾ in, width 11 ¾ in, depth

5 ½ in. (Photo Staatliches Amt für Denkmalpflege, Stuttgart.)

The reliefs on this side of the reliquary may be personifications of the seven planets. (Cf. Bibliography, No. 597, pp. 767 ff.) On the other side are three medallions with the busts of a woman and two crowned men. The style invites comparison with the reliefs on the ciborium of King Arnulf (cf. 238-239) and with the second cover of the Lindau Gospels (cf. 236).

241. Carolingian Art. **TUOTILO.** *Book Cover: Majestas Domini.* About 900. Cod. 53, Stiftsbibliothek, St Gall. Ivory with silver-gilt frame and precious stones. Overall height 15 ⁵/₈ in. Height of the ivory 12 ½ in. (Arts of Mankind Photo.)

According to Ekkehard (De Casibus sancti Galli, Cod. 615, p. 87), this ivory and the one on the back cover were carved by Tuotilo, who was active at St Gall between 895 and 912 (cf. 326 for the back cover). Close in style to the cover of Codex 60 at St Gall, this carving also recalls the ivory cover of Duke Ursus in the Cividale museum.

242. Carolingian Art, School of Reims. **HAUTVILLERS.** *Gospel Book of Ebbo: St John, detail. (Cf. 92.)* First quarter of the 9th century (before 823). Folio 134 verso, MS 1, Bibliothèque Municipale, Épernay. (Arts of Mankind Photo.)

243. **OSTIA, Horrea Epagathiana.** *Niche.* Mid-2nd century A.D. In situ. (Photo De Antonis, Rome.)

These warehouses (horrea) were built in the mid-2nd century A.D. for Epagathius, a rich merchant of the port of Ostia. They have been studied by Gilbert Picard (cf. Empire romain, Architecture universelle, Fribourg, 1965, p. 53). Among many examples of decorative masonry in ancient Roman architecture, this one has been chosen in order to show the true origin of the polychrome stonework on the abbey gateway at Lorsch, which at one time was assumed to be a creation of early medieval art. (Cf. 55-56, 244.)

244. **LORSCH, Abbey Gateway.** *West Façade.* In situ. (Arts of Mankind Photo.)

The pattern-work masonry consists of squares, lozenges and polygons (cf. 55-56, 243), as on the west wall of the Jouarre crypts (cf. Bibliography, No. 313, p. 79). Such decorative patterns were imitated even on closure slabs of the 8th century. (Cf. 266.)

245. **AACHEN, Palatine Chapel.** *Door.* In situ. (Arts of Mankind Photo.)

The original stones were replaced by new ones in the course of the over-zealous restorations carried out in the 19th century, but the original aspect of the door was respected.

246. **SOISSONS, Abbey Church of Saint-Médard.** *Entrance of the Crypt, North Door.* In situ. (Arts of Mankind Photo.)

Like all the great crypts of churches built in Gaul in the Carolingian period, that of Saint-Médard of Soissons was not an underground construction but stood very nearly on a level with the nave. Two identical doors in the west wall of the crypt gave access to the church. Our photograph shows the north door. Its design is very similar to that of the Aachen door shown in the previous plate (245). It is a type of door that must have been in general use throughout Gaul in the 9th century, for it appears in a great many early Romanesque churches (Vienne Cathedral, south wall of the choir; Agde Cathedral, etc.). It derives from Late Roman architecture (Palace of Diocletian, Split).

247. **OSTIA, Horrea Epagathiana.** *Cruciform Pillar.* Mid-2nd century A.D. In situ. (Photo De Antonis, Rome.)

This example of a pillar of cruciform section of the mid-2nd century A.D. may be compared with those which have been found in the ancient remains of the palace of Sirmione on Lake Garda and in the 'building with three naves' at Bavay (Nord), cleared in 1946.

248. **AUXERRE, Abbey Church of Saint-Germain, Crypts.** *Cruciform Pillar.* In situ. (Arts of Mankind Photo.)

The photograph shows the groin-vaulted passage connecting the ambulatory of the crypt with the oratory of circular plan rebuilt in the 14th century. Here, as in some of the pillars in the Palatine Chapel at Aachen (cf. Bibliography, No. 295, plate XIIa), the cross-ribs are carried by the projecting part of the cruciform pillars. Pillars of exactly the same proportions, but much larger, existed in the Carolingian westwork of Saint-Germain, as we know from an 18th-century plan. (Cf. 345.) This Carolingian pillar of cruciform section certainly derives from the antique pillar whose section and aspect are similar. It would be hard to over-emphasize the importance of this architectural element handed down by antiquity. It was the supporting member which made possible the construction of completely vaulted churches of the Middle Ages, as is shown by the foundations of Orléans Cathedral (of c.

1000) which have been cleared by excavations. Beginning in the second half of the 11th century, the projecting part of the cruciform pillar became more pronounced owing to the use of the engaged column. (Cf. 48.)

249. **SOISSONS, Abbey Church of Saint-Médard.** *Crypts, interior, seen from the North.* (Arts of Mankind Photo.)

The engaged pilasters, set off from the pillar, perform the same function as cruciform pillars: they carry the springing of the groined vaults and that of the large cross-ribs. This masonry vaulting was executed with a skill and precision which, after the Carolingian period, did not appear again until the second quarter of the 12th century in the Paris area and later still in the south of France. (Cf. 45.)

250. **AACHEN, Palatine Chapel.** *Ground Floor before Restoration.* Steel engraving. (After Jean Hubert, L'Art préroman [Paris, Éditions d'Art et d'Histoire, 1938], plate VIc.)

Drawing by Guilleumot, made about 1860. The value of this drawing lies in the fact that it shows us what the masonry of the pillars and walls looked like, and what the mouldings looked like, before the regrettable restorations carried out in the late 19th century. This view shows the entrance of the Palatine Chapel on the west side. (Cf. 35.)

251. **GERMIGNY - DES - PRÉS, Church.** *Interior Pillar.* In situ. (Arts of Mankind Photo.)

When the Germigny church was rebuilt in the 19th century, the capping of the four square pillars around the central part of the church was reinstalled in the new edifice. (Cf. 42.)

The abaci here are indented at the corners, like those of the cruciform pillars in Saint-Germain of Auxerre and in the Palatine Chapel of Aachen.

252-253. **AUXERRE, Abbey Church of Saint-Germain, Crypts.** *Illusionist Painting and Capital.* In situ. (Arts of Mankind Photo.)

The ancient technique of trompe-l'œil painting was applied both here, in the Saint-Germain crypts (cf. 5), and in the upper room of the abbey gateway at Lorsch (cf. 4).

254. **AACHEN, Palatine Chapel.** *Outer Wall.* (Arts of Mankind Photo.)

The pilasters on the outer wall of the drum of the dome are surmounted by capitals whose design is an original interpretation of the Corinthian capitals of Roman architecture. (Cf. 268.)

255. **GERMIGNY-DES-PRÉS.** *Capital.* Musée Historique, Orléans. (Arts of Mankind Photo.)

Several stone capitals from the Germigny church of Theodulf, demolished and rebuilt in the 19th century, are preserved in the Orléans museum. The abacus of the capital shown here has no moulding.

256-257. **GERMIGNY-DES-PRÉS.** *Stucco Carvings.* Musée Historique, Orléans. (Arts of Mankind Photo.)

A whole series of buildings—notably Saint-Victor of Marseilles (cf. Bibliography, No. 313, p. 13) and the east semidome of Saint-Laurent of Grenoble (ibid., p. 112)—show that the ancient technique of stucco decoration continued to be practised down to Carolingian times. The carving of the Germigny stuccoes is more proficient than that of the stone capitals of the same period. This is understandable when we remember that the stone capital had only lately taken the place of the marble capitals of the 7th and 8th centuries, whereas the art of the stucco-worker had never ceased to be practised in northern Italy and Gaul. It is known, for example, that the walls of the monastery church of Saint-Saturnin of Angers, founded by Bishop Magnobodus in the 7th century and probably rebuilt in the Carolingian period, were decorated with stucco reliefs with figural scenes, alternating with mosaics. (Cf. Bibliography, No. 434.)

258. **BRESCIA, San Salvatore.** *Terracotta Scrollwork. (Cf. 15.)* Museo Cristiano, Brescia. 7 × 16 in. (Arts of Mankind Photo.)

259. **BRESCIA, San Salvatore.** *Stucco Flower Ornaments. (Cf. 15.)* In situ. (Arts of Mankind Photo.)

260. *Fragment of an Ambo (?).* Church Museum, Johanneskirche, Müstair. Marble. 11 ¾ × 9 in. (Arts of Mankind Photo.)

261. *Fragment of a Frieze.* Church Museum, Johanneskirche, Müstair. Marble. 9 × 21 ½ in. (Arts of Mankind Photo.)

This dragon with its body tangled in interlaces is a rare example of the imitation by a stone carver of the motifs on barbarian jewellery; other instances are one of the carved steps of the Hypogée des Dunes at Poitier (cf. Bibliography, No. 313, p. 70) and an arch stone of about the 8th century found by Lucien Musset in his excavations of the church of Deux-Jumeaux (Calvados) in Normandy.

262. **MILAN, Santa Maria d'Aurona.** *Corbel.* Museo Archeologico, Castello Sforzesco, Milan. Stone. (Arts of Mankind Photo.)

Santa Maria d'Aurona having been demolished, it is difficult to arrive at a secure dating of all the pieces of sculpture from this church which are now preserved in the archaeological museum of the Castello Sforzesco. Some of these fragments are undoubtedly of the 8th century. Italian archaeologists assign this fine corbel to the same period.

263. **BRESCIA, San Salvatore.** *Stucco Decoration of an Arch. (Cf. 15.)* In situ. (Arts of Mankind Photo.)

264. **ROMAINMOTIER, Church.** *Ambo.* In situ. (Photo De Bellet, Geneva.)

The abbey of Romainmôtier (Canton of Vaud, Switzerland) was founded about 636. For the plan of the successive churches whose foundations were brought to light under the pavement of the present church during the excavations of 1904, see the previous volume of this series (Bibliography, No. 313, p. 339). Still preserved in the church is this precious stone ambo. It was wrongly attributed to the 7th century by Eugène Bach (cf. Congrès archéologique de la Suisse romande, 1953, p. 361). A comparison with the securely dated sculptures shows that it must have been carved for the church that was finished about the year 753. Incised above the arms of the cross is the following inscription: 'IN DEI NOMINE CUDINUS ABBA IUSSIT FIERI.' Unfortunately nothing whatever is known of Abbot Cudinus.

265. **SAINT-MAURICE, Church.** *Ambo.* In situ. (Photo De Bellet, Geneva.)

For the abbey of Saint-Maurice d'Agaune (Canton of the Valais, Switzerland), see the previous volume (Bibliography, No. 313, pp. 338, 368). This ambo, so fortunately preserved, was made for the church towards the end of the 8th century. Standing in front of the choir facing the congregation, it served as a reading desk and pulpit.

266. **METZ, Saint-Pierre-en-Citadelle, Church.** *Closure Slab.* Musée Central, Metz. (Arts of Mankind Photo.)

A barbarian imitation of decorative stonework with lozenge patterns. (Cf. 243, 244.)

267. **ANGERS, Former Church of Saint-Martin.** *Closure Slab. (Cf. Bibliography, No. 313, p. 348.)* In situ. (Arts of Mankind Photo.)

268. **ESTOUBLON, Church.** *Tomb Stele.* In situ. (Photo Studio Lorion, Digne.)

This stele, originally placed over a tomb, was found under the pavement of the church of Estoublon (Basses-Alpes) in upper Provence, near Digne. Its inscription, published and commented on by H. de Gerin-Ricard (cf. Bulletin archéologique du Comité des travaux historiques, 1909, pp. 272-276), indicates that this small stele must have been carved in the reign of Louis the Pious (814-840). Note the similarity between this pillar crowned with a capital and the outer pilasters on the drum of the dome of the Palatine Chapel, Aachen. (Cf. 254.)

269. **ALBENGA, Baptistery.** *Wall-Niche Tomb with Interlace Designs.* In situ. (Arts of Mankind Photo.)

The baptistery at Albenga (Italian Riviera, near Savona) goes back to the 5th or 6th century. (Cf. Bibliography, No. 313, pp. 5-6.) Towards the end of the 8th century this wall-niche tomb was installed and carved (with designs like those of a closure slab) for the burial of some important but unidentified person.

270. **RAVENNA, Sant'Apollinare in Classe.** *Ciborium.* In situ. (Photo Anderson.)

The ciborium is a stone canopy, decorated with carvings, which was placed over the main altars of a church. This one, at Sant'Apollinare in Classe, now stands in a corner of the nave. Over its main arch runs an inscription recording the fact that it was carved by order of a priest named Peter in the time of Archbishop Valerius (806-816): '† AD HONOREM DOMINI JESU CHRISTI ET SANCTI ELUCADII SUB TEMPORE DOMINI VALERI ARCHIEPISCOPI, EGO PETRUS PRESBYTER FECI.'

271. **GLONS, Church.** *Arch of a Ciborium (?). Cast.* Musées Royaux d'Art et d'Histoire, Brussels. (Photo Institut royal du patrimoine artistique, Brussels. © A.C.L., Brussels.)

The remains of the pre-Romanesque church of Glons (near Liège, Belgium) have been studied by André Dasnoy (cf. Bibliography, No. 140, pp. 137-152). It has been possible to reconstruct an arch composed of large segments. The top of the arch and the intrados are richly decorated. An arch of this kind, which in view of its style appears to me to date from the late 8th century, is more likely to have come from the ciborium or the sanctuary of a church than from the nave arcading. This work says much for the level of skill achieved in the decorative carving of eastern Gaul in the time of Charlemagne.

272. **NIMES, Tour Magne.** *Exterior View.* *(Cf. 273.)* In situ. (Photo H. Roger-Viollet.)

273. **AACHEN, Palatine Chapel.** *Exterior View, detail.* (Arts of Mankind Photo.)

In proposing here a comparison between the Palatine Chapel of Charlemagne and the famous Tour Magne, a ruined Roman tower on Mont Cavalier overlooking Nîmes and one of the finest triumphal monuments to have come down to us from antiquity, I do not mean to suggest that the latter was copied by the Frankish architect. It seems evident, nevertheless, that the architect took inspiration from some Roman construction more or less similar to the Nîmes tower, such as could still be seen in the 8th century in the towns of northern Gaul and the Rhineland. (Cf. 272.)

274. **BRESCIA, San Salvatore.** *View of the Exterior, detail.* (Arts of Mankind Photo.)

The robust, highly skilled construction of the arcaded walls of San Salvatore has its origin in the church architecture of the Late Empire, as exemplified by San Simpliciano in Milan, a large basilica founded by St Ambrose. (Cf. 15.)

275. **MÜSTAIR, Johanneskirche (Church of St John).** *Exterior View of the Apse.* (Arts of Mankind Photo.)

The triapsidal plan existed in Italy as early as the mid-6th century (Parenzo Cathedral), but at that time the side apses were no more than niches pierced in the back wall at the east end of the side aisles. Both inside (cf. 20-21) and outside, the chevet of the abbey church of St John at Müstair (canton of the Grisons, Switzerland) is very different. It can be considered typical of the architecture of this period, for there exist many survivals of it in early Romanesque architecture, from the church of St Peter at Müstair (Grisons, Switzerland) to the chevet of the church of Neuwiller (Alsace). The same arrangement and the same proportions of the triapsidal chevet are to be found both at Müstair and at Germigny-des-Prés. (Cf. 350 and 367.) But at Müstair the side porches have also been provided with apses. (Cf. 21.)

276. Carolingian Art, Palace School. **Diocese of Mainz.** *Gospel Book of Godescalc (Gospels of Charlemagne): St John.* 780-783. Folio 2 verso, Nouv. acq. lat. 1203, Bibliothèque Nationale, Paris. Miniature painting on vellum, 12 ¼ × 8 ¼ in. (B. N. Photo.)

277. Carolingian Art, Palace School. **Diocese of Mainz.** *Gospel Book of Godescalc (Gospels of Charlemagne): Christ in Majesty.* 780-783. Folio 3 recto, Nouv. acq. lat. 1203, Bibliothèque Nationale, Paris. Miniature painting on vellum, 12 ¼ × 8 ¼ in. (B. N. Photo.)

278. Carolingian Art, Palace School. **Diocese of Mainz.** *Gospel Book of Godescalc (Gospels of Charlemagne): St Matthew.* 780-783. Folio 1 recto, Nouv. acq. lat. 1203, Bibliothèque Nationale, Paris. Miniature painting on vellum, 12 ¼ × 8 ¼ in. (B. N. Photo.)

279. Carolingian Art, Palace School. **Diocese of Mainz.** *Gospel Book of Godescalc (Gospels of Charlemagne): Fountain of Life.* 780-783. Folio 3 verso, Nouv. acq. lat. 1203, Bibliothèque Nationale, Paris. Miniature painting on vellum, 12 ¼ × 8 ¼ in. (B. N. Photo.)

280. Carolingian Art, Palace School. *Gospel Book of Saint-Médard of Soissons: St John, detail.* Early 9th century. Folio 180 verso, Lat. 8850, Bibliothèque Nationale, Paris. Miniature painting on vellum, 14 ³/₈ × 10 ¼ in. (B. N. Photo.)

281. Carolingian Art, Palace School. **SAINT-RIQUIER, Abbey.** *Gospel Book of Saint-Riquier (Abbeville Gospels): St Luke, detail.* About 800. Folio 101 recto, MS 4, Bibliothèque Municipale, Abbeville. Miniature painting on purple vellum, 13 ¾ × 9 ⁵/₈ in. (Arts of Mankind Photo.)

282. Carolingian Art, Palace School. **Middle Rhine region.** *Lorsch Gospels: Christ in Majesty, detail.* Early 9th century. Folio 18 verso, R. II, 1, Batthyaneum Library, Alba Iulia, Rumania. Miniature painting on vellum, 14 ⁵/₈ × 10 ⁵/₈ in. (Fotoreportaj Casa Scintell, Bucharest.)

283. Carolingian Art, Palace School. **Middle Rhine region.** *Lorsch Gospels: Christ in Majesty; Procession of Icons, Portraits of Christ's Ancestors, detail.* Early 9th century. Folio 14 recto, R. II, 1, Batthyaneum Library, Alba Iulia, Rumania. Miniature painting on vellum, 14 ⁵/₈ × 10 ⁵/₈ in. (Photo Central State Library of the Socialist Republic of Rumania.)

Fragment of a Gospel Book, the second part of which is preserved in the Vatican Library (Pal. lat. 50). Elements of the cover are divided between the Victoria and Albert Museum, London, and the Museo Sacro, Rome.

284. Carolingian Art, Palace School under Byzantine influence. **AACHEN.** *Gospel Book of Xanten: Christ in Majesty and the Evangelists.* Early 9th century. Folio 17, MS 18723, Bibliothèque Royale, Brussels. Miniature painting on purple vellum, 10 ¹/₂ × 7 ½ in. (Library Photo; © Bibliothèque Royale de Belgique, Brussels.)

285. Carolingian Art, School of Reims. **REIMS.** *Gospel Book of Ebbo: St Mark, detail.* First quarter of the 9th century (before 823). Folio 60 verso, MS 1, Bibliothèque Municipale, Épernay. Miniature painting on vellum. Size of detail, 5 ½ × 7 ³/₈ in. (Arts of Mankind Photo.)

286. Carolingian Art, School of Reims. **REIMS.** *Gospel Book of Ebbo: St Luke, detail.* First quarter of the 9th century (before 823). Folio 90 verso, MS 1, Bibliothèque Municipale, Épernay. Miniature painting on vellum. Size of detail, 5 ½ × 7 ³/₈ in. (Arts of Mankind Photo.)

287. Carolingian Art, School of Reims. **REIMS.** *Gospel Book of Ebbo: Pediment Figure (Acroterium) of the Canon Tables.* First quarter of the 9th century (before 823). Folio 15 verso, MS 1, Bibliothèque Municipale, Épernay. Miniature painting on vellum. (Arts of Mankind Photo.)

288. Carolingian Art, School of Reims. **REIMS.** *Gospel Book of Ebbo: Pediment Figure (Acroterium) of the Canon Tables.* First quarter of the 9th century (before 823). Folio 13 verso, MS 1, Bibliothèque Municipale, Épernay. Miniature painting on vellum. (Arts of Mankind Photo.)

289. Carolingian Art, School of Reims. **REIMS.** *Gospel Book of Ebbo: Pediment Figure (Acroterium) of the Canon Tables.* First quarter of the 9th century (before 823). Folio 11 verso, MS 1, Bibliothèque Municipale, Épernay. Miniature painting on vellum. (Arts of Mankind Photo.)

290. Carolingian Art, School of Reims. **HAUTVILLERS.** *Physiologus latinus: On the Fourth Nature of the Serpent, detail.* About 830. Folio 12 verso, Cod. 318, Bürgerbibliothek, Berne. Miniature painting on vellum, 6 ⁷/₈ × 9 ⁷/₈ in. (Arts of Mankind Photo.)

291. Carolingian Art, aftermath of the School of Reims. *Gospel Book of Loisel: St Luke, detail.* Between 845 and 882. Folio 83 verso, Lat. 17968, Bibliothèque Nationale, Paris. Miniature painting on vellum. Page size, 8 ⁷/₈ × 6 ¾ in. (B. N. Photo.)

292. Carolingian Art, aftermath of the School of Reims. **REIMS.** *Gospel Book of Blois: St Matthew, detail.* 9th century. Folio 11 verso, Lat. 265, Bibliothèque Nationale, Paris. Miniature painting on vellum, $11 \times 7\,^7/_8$ in. (B. N. Photo.)

293. Carolingian Art, School of Tours. *Gospel Book: Decorated Title, Incipit of the Gospel of St Matthew.* Mid-9th century. Folio 26, MS 63, Bibliothèque Municipale, Laon. Miniature painting on vellum, $11\,^5/_8 \times 9\,^1/_4$ in. (Arts of Mankind Photo.)

Came to the library from the Cathedral of Laon.

294. Carolingian Art, School of Tours. **SAINT-DENIS.** *San Callisto Bible: Ascension, detail.* 869-870. Folio 292 verso, unnumbered MS, Basilica of San Paolo fuori le Mura, Rome. Miniature painting on vellum, $15\,^1/_2 \times 12$ in. (Basilica Photo.)

295. Carolingian Art, School of Tours. **SAINT-DENIS.** *San Callisto Bible: Charles the Bald with Officials, detail.* 869-870. Folio 185 verso, unnumbered MS, Basilica of San Paolo fuori le Mura, Rome. Miniature painting on vellum, $15\,^1/_2 \times 12$ in. (Basilica Photo.)

296. Carolingian Art, School of Tours. **Saint-Martin of TOURS or MARMOUTIER (?).** *Lothair Psalter: Portrait of Lothair II (?).* 840-850. Folio 4 recto, Add. 37768, British Museum, London. Miniature painting on vellum, $9\,^1/_4 \times 7\,^3/_4$ in. (British Museum Photo.)

297. Carolingian Art, School of Corbie. **SAINT-DENIS (?).** *Metz Sacramentary: Christ in Majesty, detail.* About 870. Folio 5 recto, Lat. 1141, Bibliothèque Nationale, Paris. Miniature painting on vellum, $10\,^5/_8 \times 8\,^1/_4$ in. (B. N. Photo.)

298. Carolingian Art, School of Metz. **METZ.** *Drogo Sacramentary: Te igitur, Historiated Initial and Letters with Scenes of the Life of Christ.* About 850. Folio 15 verso, Lat. 9428, Bibliothèque Nationale, Paris. Miniature painting on vellum, $10\,^1/_2 \times 8\,^1/_2$ in. (B. N. Photo.)

299. Carolingian Art, School of Metz. **METZ.** *Drogo Sacramentary: Vere dignum, Decorated Initial.* About 850. Folio 10 verso, Lat. 9428, Bibliothèque Nationale, Paris. Miniature painting on vellum, $10\,^1/_2 \times 8\,^1/_2$ in. (B. N. Photo.)

300. Carolingian Art, School of Metz. **METZ.** *Drogo Sacramentary: Historiated Initial E with St John the Evangelist, detail.* About 850. Folio 29 recto, Lat. 9428, Bibliothèque Nationale, Paris. Miniature painting on vellum, $10\,^1/_2 \times 8\,^1/_2$ in. (B. N. Photo.)

301. Carolingian Art, School of Metz. **METZ.** *Drogo Sacramentary: Historiated Initial O with the Presentation in the Temple.* About 850. Folio 38 recto, Lat. 9428, Bibliothèque Nationale, Paris. Miniature painting on vellum, $10\,^1/_2 \times 8\,^1/_2$ in. (B. N. Photo.)

302. Carolingian Art. **ST GALL.** *Wolfcoz Psalter: David before Nathan, detail.* First half of the 9th century. Folio 53, MS C 12, Zentralbibliothek, Zurich. Miniature painting on vellum. Page size, $9 \times 12\,^3/_8$ in. (Photo De Bellet, Geneva.)

303. Carolingian Art. **ST GALL (?).** *Prudentius, 'Psychomachia': Faith against Idolatry, Chastity against Lust.* 10th century. Folio 35 verso, Cod. 264, Bürgerbibliothek, Berne. Pen drawing on vellum, $10\,^7/_8 \times 8\,^1/_4$ in. (Arts of Mankind Photo.)

304. Carolingian Art. **SAINT-AMAND.** *Apocalypse: Woman and Dragon.* Late 9th century. Folio 24 recto, MS 99, Bibliothèque Municipale, Valenciennes. Miniature painting on vellum, $10\,^5/_8 \times 8$ in. (Arts of Mankind Photo.)

305. Carolingian Art. **SAINT-AMAND.** *Apocalypse: The Seven Angels and the Falling Star; St John watching the Fall of Four Personages, detail.* 9th century. Folio 16 recto, MS 386, Bibliothèque Municipale, Cambrai. Miniature painting on vellum. Page size, $12\,^1/_4 \times 9$ in. Size of detail, $9\,^5/_8 \times 8\,^1/_2$ in. (Arts of Mankind Photo.)

306. Carolingian Art. **Eastern France or School of Tours (?).** *Apocalypse: Christ followed by Eleven Angels on Horseback; the Well of the Abyss, detail.* Second half of the 9th century. Folio 64 verso, MS 31, Stadtbibliothek, Trier. Miniature painting on vellum, $10\,^3/_8 \times 8\,^1/_2$ in. (Photo Nelles, Trier.)

307. Carolingian Art. **SAINT-AMAND.** *Gospel Book: Attributes of St John.* 9th century. Folio 110 verso, MS 69, Bibliothèque Municipale, Valenciennes. Miniature painting on vellum. Diameter, $3\,^1/_8$ in. Page size, $10\,^1/_4 \times 8$ in. (Arts of Mankind Photo.)

308. Carolingian Art. **FLEURY (SAINT-BENOIT-SUR-LOIRE).** *Isidore of Seville, 'De natura rerum': Constellation, detail.* 9th century. Folio 161 recto, Lat. 5543, Bibliothèque Nationale, Paris. Miniature painting on vellum. Page size, $8\,^3/_4 \times 6\,^1/_4$ in. Size of detail, $4\,^3/_4 \times 4\,^1/_2$ in. (B. N. Photo.)

309. Carolingian Art. **COLOGNE.** *Gospel Book (beginning of the Gospel of St John): St John the Evangelist, detail.* Second half of the 9th century. Folio 160 verso, MS 14, Cologne Cathedral. Miniature painting on vellum. (Photo Rheinisches Bildarchiv, Kölnisches Stadtmuseum.)

310. Carolingian Art. *Three-branched Buckle.* Mid-9th century. Universitetets Oldsaksamling Myntkabinet, Oslo. Repoussé gold with filigree work. $3\,^3/_4 \times 4\,^1/_8$ in. (Universitetets Photo.)

Found at Hon, Norway, in a grave with coins of the Emperor Michael III (842-867) and perhaps looted from France. West Frankish workmanship, like the first cover of the Lindau Gospels. (Cf. 192.)

311. Carolingian Art. *Processional Cross, called 'Cross of the Ardennes.'* Second half of the 9th century. Germanisches Nationalmuseum, Nuremberg. Gold and copper gilt on a wooden core, with filigree work, gems and glass paste. $28\,^3/_4 \times 17\,^3/_4$ in. (Museum Photo.)

The ornamentation on the back of the cross is lost. Compare with the cross of Charlemagne at Saint-Denis, also lost (cf. Bibliography, No. 196) but represented in a 15th-century painting (cf. Bibliography, No. 313, p. 267), and the cross of St Rupert at Bischofshofen (cf. Bibliography, No. 202, pp. 184 ff.). This cross comes from a monastery in the Luxembourg Ardennes. It is dated by Boeckler to the second quarter of the 9th century (cf. Bibliography, No. 573, p. 40), in the time of Louis the Pious (813-840).

312. Merovingian Art. *Crosier of St Germanus.* Second half of the 7th century. Treasury of the church of Saint-Marcel, Delémont. Gold, silver, filigree work and red stones on a wooden support. Height $46\,^7/_8$ in. Diameter 1 in. (Photo De Bellet, Geneva.)

St Germanus (died in 677) was abbot of the Grandval monastery. (Cf. Bibliography, No. 313, p. 265.) His crosier may be compared with the Oviedo casket (cf. 314) and the Enger reliquary (cf. ibid., p. 316). Probably local workmanship.

313. Merovingian Art. *Belt, Fragment.* Second half of the 7th century. Prähistorische Staatssammlung, Munich. Silver-plated iron. (Photo Elisabeth Römmelt, Munich.)

This belt comes from Feldmoching, near Munich. It is typically Bavarian in its workmanship.

314. Asturian Art. *Casket, detail: Lid.* Second half of the 8th century. Cámara Santa, Oviedo Cathedral. Gold, enamels, agates, almandines, stones. $6\,^1/_8 \times 3\,^7/_8$ in. (Photo Enric Gras, Barcelona.)

This reliquary is similar to that of King Alfonso III (866-910) in Astorga Cathedral and to the casket of San Isidro of Leon in the Archaeological Museum, Madrid. The inscription, showing it to have been a present from Fruela and Nunilo made in 948, reads as follows: 'SUSCEPTUM PLACIDE MANEAT HOC IN HO(NO)RE D(E)I QUOD † OFFERUNT FAMULI XRI FROILA ET NUNILO COGNOMENTO SCEMENA HOC OPUS PERFECTUM ET CONCESSUM EST SCI SALVATORI OVETENSIS QUISQUIS AUFERRE HOC DONARIA N(O)S(TR)A PRESUMSERI FULMINE DIVINO INTEREAT IPSE OPERATUM EST ERA DCCCCXLVIII.'

315. Italian Art. **CIVIDALE (?).** *Reliquary.* 9th century. Cathedral Treasury, Cividale. Embossed silver gilt on a wooden core; on the lid, medieval stones and cameos. Height $7\,^3/_4$, length $8\,^5/_8$ in, thickness 5 in. (Photo Scala.)

Similar to another reliquary from Cividale, so perhaps made at the same place. For the question of the pseudo-cameos, see the Teuderigus reliquary at Saint-Maurice (cf. Bibliography, No. 313, p. 268), that of Utrecht (cf. 317) and the cameos on the Cross of Desiderius at Brescia.

316. *Crown of the Virgin, detail: Cameo.* 8th century. Cathedral Treasury, Essen. Almandine. Height of the cameo, $^3/_4$ of an inch. (Photo Liselotte Witzel, Essen.)

According to Hans Wentzel (cf. Bibliography, No. 609, pp. 303-320), the style of this cameo recalls the Lombard coins of Romuald I (662-682) and Romuald II (706-731).

317. Carolingian Art. *Cover, Gospel Book of Lebuinus, detail: Cameo.* 8th century. Archiepiscopal Museum, Utrecht. Grey and white glass on red ground. Size of the cameo, $1\,^{11}/_{16} \times 1\,^1/_8$ in. (Photo Hans Sibbelee, Utrecht.)

The cameo of the Lebuinus Gospels has as its pendant a woman's head. (Cf. Germania, 1933, plate 14, fig. 4.) Its technique is identical to that of the pseudo-cameos of Saint-Maurice and Brescia. (Cf. 315.)

318. Merovingian Art. *Epitaph of St Cumian.* Time of Liutprand (713-744). Abbey of San Colombano, Bobbio. Stone. (Photo Studio Fagnola, Bobbio.)

319. Italian Art. *Cross decorated with Scrollwork.* About 827. Parish Church, Pieve di Budrio. Marble. $78\,^3/_4 \times 59\,^1/_8$ in. (Photo Villani e Figli, Bologna.)

The cross is carved on both sides. On the front is the donor's inscription: 'INDI NO RENOVA CRUX TEMPORIBU DOM VITALE EPSC.' *Vitalis was bishop of Bologna (789-844).*

320. Carolingian and Romanesque Art. *'Throne of Dagobert.'* About 800. Cabinet des Médailles, Bibliothèque Nationale, Paris. Gilt bronze. Height $53\,^1/_4$ in. (Arts of Mankind Photo.)

Restored for Napoleon, who made use of it in 1804. Already referred to as the 'Throne of Dagobert' by Abbot Suger of Saint-Denis in the 12th century, who had it refurbished. Comes from the treasury of Saint-Denis.

321. Carolingian Art. **AACHEN, Palatine Chapel.** *Tribune, Railing, detail.* (Cf. 204 for another detail.) Early 9th century. In situ. Bronze. (Arts of Mankind Photo.)

322. Carolingian Art, School of Tours. *Liturgical Fan (Flabellum).* About 875. L. Carrand Collection, Museo Nazionale, Florence. Ivory, wood, miniatures on vellum. Length $9\,^1/_2$ in; with the handle, $30\,^3/_4$ in. (Photo Alinari, Florence.)

At the top of the handle is an inscription: 'IOHEL ME SCAE FECIT IN HONORE MARIAE.' *Johel, the donor, may possibly be Abbot Gelo of Cunault, near Tours. Count Vivian maintained good relations with Cunault. On the handle are six reliefs representing scenes from Virgil's Eclogues; lines 8-10 of the Fourth Eclogue are quoted as referring to the birth of Christ. The miniatures on the fan recall the miniatures of the School of Tours. Same style as the Areobindus Diptych representing Paradise, in the Louvre. (Cf. 218.)*

From Tours? Noirmoutier? Saint-Philbert of Tournus? (Cf. 217, 324.)

323. Carolingian (West Frankish) Art. *'Casket of Charlemagne' ('Écrin de Charlemagne').* Drawing of the reli-

quary destroyed during the French Revolution. Third quarter of the 9th century. Recueil Le, 38 c, Cabinet des Estampes, Bibliothèque Nationale, Paris. The reliquary was made of silver gilt, inlaid with stones, pearls, gems and one intaglio. Coloured drawing executed after the original in 1791 by Etienne Eloi de la Barre. Size of the drawing, $22\,^1/_8 \times 14\,^1/_2$ in. (After Joseph Guibert, *Les Dessins du cabinet Peiresc au Cabinet des Estampes de la Bibliothèque Nationale*, Paris, 1910, plate IX.)

The form of the reliquary imitates a church façade. It was probably given to Saint-Denis by Charles the Bald and placed on the altar. The base is Gothic. (Cf. 234.)

324. Carolingian Art. *Liturgical Fan (Flabellum), detail.* (Cf. 217, 322.) Museo Nazionale, Florence. (Photo Alinari, Florence.)

325. Carolingian (West Frankish) Art. *Reliquary of St Stephen, side.* Mid-9th century. Weltliche Schatzkammer, Kunsthistorisches Museum, Vienna. Gold and silver gilt on a wooden core, with precious stones and pearls. $12\,^5/_8 \times 9\,^1/_2 \times 3\,^1/_8$ in. (Museum Photo.)

The top of the reliquary dates from the 15th century; the back part was restored in 1827. For the cabochons, see the cover of the Psalter of Charles the Bald. (Cf. 232.) This reliquary is assigned to the Palace School of Charlemagne by Usener. (Cf. Bibliography, No. 573, p. 37 ff.) Together with the Coronation Gospel Book and the sword of Charlemagne, it belongs to the old treasure of the Holy Roman Empire.

326. Carolingian Art. **TUOTILO.** *Book Cover: The Ascension.* (Cf. 241 for the other cover.) About 900. Stiftsbibliothek, St Gall. Ivory, with silver gilt frame and precious stones. Overall height, $15\,^5/_8$ in. Height of the ivory, $12\,^5/_8$ in. (Library Photo, Gebrüder Zumbühl, St Gall.)

327. **ROME.** *Plan of Old St Peter's.* 4th century. (After Otto Doppelfeld, *More romano. Die beiden karolingischen Domgrundrisse von Köln,* in *Kölner Domblatt* [Cologne, VIII, 1954], plan III, p. 51.)

Simplified plan of the basilica of St Peter's, Rome, erected about 330 by Constantine the Great over the Vatican cemetery—from the plan drawn up by Tiberio Alfarano before the demolition (beginning in 1506) of Old St Peter's. (Cf. Bibliography, No. 255, p. 180.) This was an occidented church; that is, the sanctuary was at the west end, the entrance at the east end.

328. FULDA. *Plan of the Abbey Church (2nd state).* (After Otto Doppelfeld, *More romano. Die beiden karolingischen Domgrundrisse von Köln,* in *Kölner Domblatt* [Cologne, VIII, 1954], plan III, p. 51.)

The many texts relating to the successive constructions of the Fulda abbey are cited in a recently published volume on pre-Romanesque churches. (Cf. Bibliography, No. 599, pp. 84-89.) The second Fulda church, built by Abbot Ratgar (791-819), imitated Old St Peter's of Rome in its occidentation, its plan with a large transept and its dimensions. Probably it already had a counter-apse at the east end, which in 948 was entirely rebuilt (or, possibly, then built for the first time). The words more romano used in the monastery chronicle to characterize these occidented churches prove that the notion of placing the altar at the west end in newly erected churches throughout the Frankish kingdom was part of the reform of the liturgy, in imitation of Roman usage, which was decided on by Pepin and carried out by Charlemagne. The double-apse plan (that is, an apse at each end of the church) was probably devised in an attempt to reconcile the innovations of the reform with the older usages. The plan had precedents in Early Christian churches similar in design to certain 5th-century basilicas in North Africa.

329. ST GALL. *Plan of the Abbey Church. (Cf. 34, 342.)* (After Otto Doppelfeld, *More romano. Die beiden karolingischen Domgrundrisse von Köln,* in *Kölner Domblatt* [Cologne, VIII, 1954], plan III, p. 51.)

330. SAINT-MAURICE. *Abbey of Saint-Maurice d'Agaune, Plan of the Monastery Church.* (After Louis Blondel, cf. Bibliography, Nos. 62, 63.)

Between the late 4th and the 8th century, four churches were successively rebuilt or enlarged at Saint-Maurice d'Agaune (canton of the Valais, Switzerland), at the foot of the crag where St Maurice and his companions had suffered martyrdom. Like the earlier churches, the late 8th-century basilica has been thoroughly excavated and studied by Louis Blondel. (Cf. Bibliography, No. 62, pp. 28-29, and No. 63, pp. 287-288). This large basilica, destroyed by the Saracens about 940, had a choir at each end, each with a confessio surrounded by an annular ambulatory in imitation of those in Roman churches. (Cf. 355.) The west choir, raised well above the level of the nave, seems to have been the larger. (Cf. Bibliography, No. 313, p. 338.)

331. ALET. *Plan of the former Cathedral of Saint-Pierre.* (After Jean Hubert,

L'Art préroman [Paris, Éditions d'Art et d'Histoire, 1938], fig. 57, p. 66.)

The town of Alet, near Saint-Servan-sur-Mer in Brittany, was liberated from the Vikings in 936. The Cathedral of St Peter, rebuilt shortly afterwards, is now in ruins. It has been studied by Monsignor Duchesne (cf. Bibliography, No. 167, pp. 1-10) and René Couffon (cf. Bibliography, No. 129, pp. 36-37).

332-333. COLOGNE. *Plan of the Cathedral (7th and 6th states).* (After Otto Doppelfeld, *More romano. Die beiden karolingischen Domgrundrisse von Köln,* in *Kölner Domblatt* [Cologne, VIII, 1954], plan III, p. 51.)

After the Second World War, excavations of Cologne Cathedral were carried out under particularly difficult conditions but with remarkable success by Otto Doppelfeld. Through the successive reconstructions of this large cathedral two quite distinct states can be discerned in the Carolingian era, that of the sixth period (early 9th century) and that of the seventh period (c. 870). Among Otto Doppelfeld's many studies devoted to the history of Cologne Cathedral, I would draw particular attention to the article cited above. Indeed, the grouping here of Figs. 327-333 has been dictated by his findings. In spite of all the evidence, some students have refused to admit that the Carolingian practice of building occidented churches was due to the imitation of the liturgical usages obtaining in Rome. I think I have confirmed the truth of Otto Doppelfeld's views on this subject by showing that in France, and particularly in the South of France, the number of Carolingian and early Romanesque churches built on the double-apse plan was nearly as great as in Germany. (Cf. Bibliography, No. 312, pp. 163-170.)

334. AACHEN. *Overall Plan of the 1911 Excavations.* (After Paul Clemen, *Fouilles et explorations dans l'enceinte du palais impérial carolingien et de la cathédrale d'Aix-la-Chapelle,* in *Revue de l'art chrétien* [LXII, 1912], p. 219.)

Cf. 335 ff. We give here the general plan of the excavations of the Aachen palace and chapel published at the beginning of the century by that highly competent archaeologist Paul Clemen. The excavations made since then, which owe much to the cathedral architect, Felix Kreusch, have added chiefly to our knowledge of the substructure of the atrium and the approaches to the chapel. (Cf. 365 and also Bibliography, No. 599, p. 16.)

335. AACHEN. *Palace, Reconstruction of the Modular Grid.* (After a plan drawn up by Robert Vassas, chief architect

of the Monuments Historiques, and published here for the first time.)

It has been recently shown by the French architect and archaeologist Robert Vassas that the proportions and layout of the Aachen palace were governed by a very simple modular plan, based very probably on a fairly tight-knit grid similar to the one which regulated the plan of the Germigny church. (Cf. 367.) But the modular data applied at Aachen called for a much higher degree of architectural skill than the use of a simple grid plan (Cf. 334.) This was the point that Robert Vassas wanted to make.

336 A and B. LORSCH. *Plan and Elevation of the First Abbey.* (After Friedrich Behn, *Kloster Lorsch* [Mainz, E. Schneider Verlag, 1949], plate 1.)

The Lorsch plans given here (Figs. 336-338) are based on those published by Friedrich Behn. The first monastery of Lorsch was founded in 763, and its first abbot was Chrodegang, bishop of Metz. Excavations made in 1882, 1910 and 1932-1933 revealed the ground plan of this small monastery, the first prior to the St Gall plan to show a perfectly regular arrangement of the monastery buildings and church around a cloister.

337 A and B. 338. LORSCH. *Elevation and Plan of the Second Abbey. Abbey Gateway, detail.* (After Friedrich Behn, *Kloster Lorsch* [Mainz, E. Schneider Verlag, 1949], p. 17, fig. 4 and plate 6.)

Cf. 336 A and B. A second monastery was built on a more suitable site at a distance of about 2,300 feet from the first. The new buildings and church were built in part by Abbot Heinrich (778-784). (Cf. 55-56.)

339-341. SAINT-RIQUIER. *Two views of the Monastery from 17th-century Engravings and Excavation Plan.* (Photo Bibliothèque Nationale, Paris. After Paul Petau, *De Nithardo Caroli Magni nepote ac tota ejusdem Nithardi presepia breve syntagma* [Paris, 1613], and after Jean Mabillon, *Acta sanctorum ordinis sancti Benedicti, I, Saeculum, IV* [Paris, 1676]. Excavation plan reproduced after Georges Durand.)

(Cf. 2.) The miniature painting illustrating the lost manuscript of the Chronicon Centulense written by the monk Hariulf (died 1143) was reproduced by both Paul Petau and Jean Mabillon. The painting gave a schematic view of the monastery built by Angilbert in the late 8th century on a triangular plan intended to symbolize the Holy Trinity. On two sides of the triangle were covered walks connecting the three churches. Within the trian-

gular area stood the monastery buildings (not represented by the painter). This layout, which I had inferred from a study of the documentary evidence (cf. Bibliography, No. 525, pp. 293-309), has been confirmed by the excavations made by Honoré Bernard, who has brought to light the foundations of the Carolingian church on a circular plan dedicated to the Virgin Mary. (Cf. 364.)

342. **SAINT-GALL.** *Plan for a projected reconstruction of the Abbey, detail. (Cf. 34, 329.)* Stiftsbibliothek, St Gall. (After Library photo of the manuscript plan, Gebrüder Zumbühl, St Gall.)

343. **METZ.** *Plan of the Ancient Cathedral Complex.* (After Jean Hubert, *La Vie commune des clercs et l'archéologie,* in *La vita comune del clero nei secoli XI e XII,* in *Atti della Settimana di studio, Mendola, sett. 1959* [Milan, Società editrice Vita e Pensiero, 1962], Fig. 1 top.)

About 754 Chrodegang, bishop of Metz, drew up a rule imposing on his cathedral clergy a common way of life based on that of the monks. Between 755 and 816 this vita canonica *or regular life was gradually imposed on the clergy of cathedral churches throughout the Frankish kingdom by a series of capitularies and conciliar decrees. To house the new 'canons' it was necessary to build 'chapters' comprising meeting halls and oratories. An old plan shows the layout of the chapter buildings at Metz as they existed in the 18th century, after a series of reconstructions and restorations. All the texts concerning the ancient cathedral complex at Metz have been brought together and commented on by Pierre Marot. (Cf. Bibliography, No. 15, pp. 152 ff.)*

344. **LYONS.** *Plan of the Ancient Cathedral Complex.* (After Jean Hubert, *La Vie commune des clercs et l'archéologie,* in *La vita comune del clero nei secoli XI e XII,* in *Atti della Settimana di studio, Mendola, sett. 1959* [Milan, Società editrice Vita e Pensiero, 1962], Fig. 1 top.)

The chronology proposed for the various churches of this cathedral group following the excavations of 1935 proved to be inaccurate; I have revised and rectified it. (Cf. Bibliography, No. 300, pp. 52-53.) The apse of the old cathedral of Saint-Étienne was brought to light in 1892. The sanctuary of the cathedral of Saint-Jean, cleared in 1935, does not go back to the Merovingian period but only to the beginning of the 9th century. The mosaic pavement does not date from Early Christian times; it is a 12th-century work.

345. **AUXERRE.** *Plan of the Church of Saint-Germain.* (After Jean Hubert, *L'Art préroman* [Paris, Éditions d'Art et d'Histoire, 1938], Fig. 41, p. 59.)

Shown on the plan is the crypt built between 841 and 859; it still exists. The east rotunda was rebuilt in the 14th century at the same time as the choir and transept of the upper church. The 11th-century nave and the westwork consecrated in 865 were both demolished in 1811. The original form of the church is known from an 18th-century plan preserved in the archives of the Yonne department under the number H 1035. (Cf. 48, 50, 361.)

346. **HILDESHEIM.** *Plan of the Cathedral.* (After *Vorromanische Kirchenbauten. Katalog der Denkmäler bis zum Ausgang der Ottonen* [Munich, Prestel Verlag, 1966], Fig. p. 117.)

From the plan drawn up by Herr Bohland. The east rotunda dates from the time of Louis the Pious.

347. **CORVEY.** *Plan of the Abbey Church. (Cf. 52, 360.)* (After *Vorromanische Kirchenbauten. Katalog der Denkmäler bis zum Ausgang der Ottonen* [Munich, Prestel Verlag, 1966], Fig. p. 55.)

348. **FLAVIGNY.** *Abbey Church, Plan of the Crypt.* (After Georges Jouven, *Fouilles des cryptes et de l'abbatiale Saint-Pierre de Flavigny,* in *Monuments historiques de la France* [No. 1, January-March 1960], Fig. 17, p. 20.)

The translation from Mont-Auxois to the monastery of Flavigny, which took place in 864, probably gave rise to the construction of the crypt of the abbey church. The excavations and researches of Georges Jouven, chief architect of the Monuments Historiques, *have brought to light part of this Carolingian crypt: the substructure of the east rotunda. The crypt, which was on a level with the nave, and the upper choir were both almost entirely rebuilt in the 11th and 12th centuries, but the main structure and layout of the 9th-century church were respected.*

349. **SAINT-PHILBERT-DE-GRAND-LIEU.** *Abbey Church, Plan of the Choir and the Crypt. (Cf. 46-47.)* (After Jean Hubert, *L'Art préroman* [Paris, Éditions d'Art et d'Histoire, 1938], Fig. 44, p. 59.)

350. **MÜSTAIR.** *Plan of the Johanneskirche (Church of St John). (Cf. 20-21.)* (After L. Birchler, *Zur karolingischen Architekturen und Malereien in Münster Müstair,* in *Art du haut Moyen-Age dans la région alpine,* Proceedings of the 3rd International

Congress for the Study of the Early Middle Ages [Lausanne, 1954], p. 173.)

351. **HÖCHST-AM-MAIN.** *Plan of the Church of St Justinus.* (After *Vorromanische Kirchenbauten. Katalog der Denkmäler bis zum Ausgang der Ottonen* [Munich, Prestel Verlag, 1966], Fig. p. 124.)

From the plan drawn up by Becker and Stiehl. The church was built by Otgar, archbishop of Mainz (826-847), to receive the relics of St Justin brought from Rome.

352. **CHUR.** *Plan of the Church of St Lucius or Luzius discovered under the south aisle of the cathedral choir.* (After *Vorromanische Kirchenbauten. Katalog der Denkmäler bis zum Ausgang der Ottonen* [Munich, Prestel Verlag, 1966], Fig. p. 51.)

From the plan drawn up by Sulser. The relics of St Lucius were brought to Chur about 820.

353. **RAVENNA.** *Sant'Apollinare Nuovo, Plan of the Crypt.* (After Paolo Verzone, *L'architettura religiosa dell' alto medio evo nell'Italia settentrionale* [Milan, Officine grafiche Esperia, 1942], Fig. 67, p. 125.)

In the opinion of Paolo Verzone, the confessio *imitating those in Roman churches was built about 856 inside the 6th-century apse to house the body of St Apollinaris, which had been transferred inside the city of Ravenna by Bishop John VIII.*

354. **SENS.** *Church of Saint-Pierre-le-Vif, Plan of the Crypt.* (After Jean Hubert, *L'Art préroman* [Paris, Éditions d'Art et d'Histoire, 1938], Fig. 45, p. 59.)

The church and buildings of the abbey of Saint-Pierre-le-Vif, founded in the 7th century in the east suburb of the town of Sens, were demolished during the French Revolution. Their layout is known from a 17th-century plan preserved in the Archives Nationales. I have shown that the two-storeyed rotunda which formed an outwork on the east side of the sanctuary may, in part at least, go back to the time of Abbot Samson (920-940).

355. **SAINT-MAURICE.** *Plan of the East End of the Abbey Church.* (After Louis Blondel, *La Reconstruction du chœur oriental de la basilique d'Agaune au Xe siècle,* in *Vallesia* [V, 1950], p. 175, Fig. 4.)

This ambulatory with radiating chapels was built for the east sanctuary of the monastery church after it had been wrecked by the Saracens about 940. (Cf. 330.)

356. **CLERMONT-FERRAND.** *Cathedral, Plan of the Crypt.* (After May Vieillard-Troiekouroff, *La cathédrale de Clermont du Vᵉ au XIIIᵉ siècle*, in *Cahiers archéologiques: Fin de l'Antiquité et Moyen-Age* [Paris, 1960, XI], Fig. 8, p. 210.)

Madame Vieillard-Troiekouroff was the first to publish an accurate plan of Clermont Cathedral, consecrated in 946. This plan, reproduced here, shows the same irregularities of design as the similar plan of the east end of the Saint-Maurice church. (Cf. 355.)

357. **RAVENNA.** *Sant'Apollinare in Classe, Plan of the Crypt.* (After Paolo Verzone, *L'architettura religiosa dell'alto medio evo nell'Italia settentrionale* [Milan, Officine grafiche Esperia, 1942], Fig. 56, p. 123.)

A typical example of the layout of an early 9th-century confessio, imitating those of Roman churches, in the apse of a 6th-century church. Paolo Verzone has pointed out that there is no documentary evidence to indicate the exact date of this important modification of the original plan.

358. **BOLOGNA.** *Plan of the Church of San Stefano.* (After Paolo Verzone, *L'architettura religiosa dell'alto medio evo nell'Italia settentrionale* [Milan, Officine grafiche Esperia, 1942], Fig. 54, p. 122.)

Excavations made in 1914 cleared the foundations of this interesting church, of complex design. Paolo Verzone has compared its chevet to that of Corvey. (Cf. 347.)

359. **SOISSONS.** *Abbey Church of Saint-Médard, Plan of the Crypts.* (After Maurice Berry, in *Centre international d'études romanes*, II [Paris, 1959], Fig. p. 12.)

The wide, elbowed ambulatory permitted pilgrims and worshippers to circulate freely round the confessio. The rooms with niches on the east side of the ambulatory were privileged burial places and oratories. (Cf. 45, 249.)

360. **CORVEY.** *Cross-Section of the Abbey Church.* *(Cf. 52-54, 347.)* (After Ludorf, Esterhmes, Claussen and Kreusch in *Vorrömanische Kirchenbauten. Katalog der Denkmäler bis zum Ausgang der Ottonen* [Munich, Prestel Verlag, 1966], Fig. p. 55.)

361. **AUXERRE.** *Abbey Church of Saint-Germain, Elevation of the Westwork.* (Photo Bibliothèque Nationale, Paris. After Dom Plancher, Bibliothèque Nationale, Cabinet des Manuscrits, Collection de Bourgogne, III, fol. 104.)

The westwork of Saint-Germain was consecrated in 865, restored after a fire that ravaged it in 1075, and demolished in 1820; its plan figures on the overall plan of the church. (Cf. 345.) A drawing accompanying Dom Plancher's description of the westwork shows the interior elevation of this imposing structure, whose proportions and design are comparable to those of the Corvey westwork.

362. **REIMS.** *Plan of the Carolingian Cathedral.* (After Jean Hubert, *L'Architecture religieuse du haut Moyen-Age en France*, with plans, notices and bibliography [Paris, Imprimerie Nationale, 1952], plate XI, Fig. 33.)

The costly excavations carried out in Reims cathedral from 1919 to 1930 were not mapped and documented with the scientific precision which one is entitled to expect nowadays of such archaeological investigations. As a result, they have given rise to contradictory interpretations. Our own, shown on the plan by a uniform brown shading, has this merit: it is the simplest interpretation that can be proposed, and it seems to be in keeping with the building practices of the Carolingian period. It was in 816 that Archbishop Ebbo decided to rebuild the cathedral on a larger plan. Though helped and seconded by Louis the Pious, he had not yet finished the work when he left the see of Reims in 841. Hincmar, his successor, covered the church with a lead roof. He installed stained-glass windows and had the ceilings frescoed. The dedication ceremony took place in the new cathedral in 862. The main sanctuary, dedicated to the Saviour, was at the west end; it stood over a vaulted storey, or crypta, which was demolished under Archbishop Adalberon in 976 to make way for a tower and a new façade.

363. **MINDEN.** *Plan of the Cathedral.* (After *Kunstchronik* [Munich, September 1953], fasc. 9, plate 9, p. 259.)

Plan published by Dr Thümmler. The central part of the choir goes back to about the year 800, while the nave and westwork were not finished till about 952.

364. **SAINT-RIQUIER.** *Excavation Plan of the Church of Notre-Dame.* (After Honoré Bernard, *Premières fouilles à Saint-Riquier*, in *Karl der Grosse, Karolingische Kunst*, III [Düsseldorf, Verlag L. Schwann, 1965], Fig. 1, p. 370.)

The excavations of Honoré Bernard at Saint-Riquier have cleared the foundations of the round church of Notre-Dame, which undoubtedly goes back to the last years of the 8th century this is the period when the monastery was built by Abbot Angilbert, who received substantial subsidies from Charlemagne for this purpose. The radiating chapels of Notre-Dame shown on the old view of Saint-Riquier never in fact existed, and this is one proof of the very schematic character of the picture, which some archaeologists have rashly assumed to be as accurate as a photograph. A comparison of the round church revealed here by excavations with the Palatine Chapel at Aachen is highly instructive. (Cf. 365). The two churches were built within a few years of each other. They are similar enough in some details, and different enough in others, to show the richness of invention of which the Frankish architects were already capable. Neither church betrays the least trace of Byzantine or Ravennate influence. (Cf. 2, 339-341.)

365. **AACHEN.** *Plan of the Palatine Chapel.* *(Cf. 35, 334, 364.)* (After *Vorrömanische Kirchenbauten. Katalog der Denkmäler bis zum Ausgang der Ottonen* [Munich, Prestel Verlag, 1966], figure facing p. 16.)

366. **BENEVENTO.** *Plan of Santa Sofia.* (After Luigi Crema, *Kunstchronik. Monatsschrift für Kunstwissenschaft, Museumswesen und Denkmalpflege* [VIII, 1955], fasc. 5, Nuremberg, plate 10b, p. 129.)

Arechis, son-in-law of Desiderius, king of the Lombards, finished building the church of Santa Sofia at Benevento about 768. Standing close to his residence, it was a palace oratory where nuns continually prayed, as at Santa Maria di Cividale, and where a quantity of relics were housed. The present church, rebuilt after an earthquake, is a rotunda. Excavations carried out in 1954 by the regional superintendent of monuments, the architect Rusconi, brought to light the original plan of this 8th-century edifice dedicated to the Holy Wisdom. This plan, published by Luigi Crema, was viewed with surprise and even incredulity by a certain number of archaeologists. In studying it, I myself soon detected a layout based on an equilateral triangle, like that of the French church of Planès (Pyrénées-Orientales), which is no less unusual. But it was the sculptor Claude Abeille, who is responsible for the drawings in this book, who succeeded in working out the geometric figure which determined the curious sharp-angled recesses on either side of the church. It is the famous star design whose survival since late antiquity has been studied by Armen Khatchatrian in Armenia and in Islamic art (cf. Arts asiatiques, II [Paris, 1955],

pp. 137-144, and Cahiers archéologiques, VI [Paris, 1952], p. 91 ff.). The discovery of the Benevento ground plan opens up a new line of research, for Byzantine influence seems to have been at work here.

367. **GERMIGNY-DES-PRÉS.** *Plan of the Church.* (After the excavation plan of 1930 drawn up by the architect M. Fournier and Jean Hubert.)

Cf. Bibliography, No. 125, p. 542. The grid applied to a small part of the plan could have been extended to cover the whole church, for the dimensions of all the walls and all the supports were strictly regulated by it. What is even more remarkable, the main lines of the elevation were regulated by the same grid, with equal strictness. The Germigny church formed a perfect cube, and every element of it corresponded to a regular division of that cube. (Cf. 42, 373.)

368. **MILAN.** *San Satiro, Plan of the Pietà Chapel. (Cf. 44.)* (After Gino Chierici, 'La chiesa di S. Satiro a Milano, e alcune considerazioni sull'architettura preromanica in Lombardia,' L'Arte [Milan, XX, 1942], Fig. 7, p. 27.)

369. **NEVERS.** *Plan of the Baptistery found under the Cathedral.* (After A. Khatchatrian, *Les Baptistères paléochrétiens*, with plans, notices and bibliography [Paris, 1961], Fig. 336, p. 50.)

Excavated in 1947-50, the baptistery of Nevers was at first attributed to the 6th century. But a careful comparison of its plan with that of other baptisteries of the same type dating to the 5th-7th centuries (e.g., Novara, Lomello, Como) reveals at Nevers a more advanced design hardly compatible with so early a date.

It seems more reasonable to assume that the Nevers baptistery was built in the time of Charlemagne for the occidented cathedral which stood nearby. The whole question of its dating, however, must remain open pending the results of the excavations now in progress.

370. **SETTIMO VITTONE.** *Plan of the Church of San Lorenzo and its Baptistery.* (After Paolo Verzone, *L'architettura religiosa dell'alto medio evo nell'Italia settentrionale* [Milan, Officine grafiche Esperia, 1942], Fig. 61, p. 132.)

The plan of this small church and baptistery in the valley of Aosta (about 40 miles north of Turin) was published by Paolo Verzone, who dates their original construction to the very early Middle Ages; some parts, however, as he points out, were rebuilt in the

11th century. The cruciform church is entirely vaulted.

371. **BARDOLINO.** *Plan of the Church of San Zeno.* (After Paolo Verzone, *L'architettura religiosa dell'alto medio evo nell'Italia settentrionale* [Milan, Officine grafiche Esperia, 1942], Fig. 60, p. 130.)

The plan of Bardolino (on Lake Garda, near Verona) was published by Paolo Verzone, who dates it to the last quarter of the 9th century. The whole church is vaulted.

372. **GERMIGNY-DES-PRÉS.** *Church Dome on Squinches.* (After Georges Bouet, in *Congrès archéologique* [Orléans, 1892].)

This drawing was made in the 19th century by Georges Bouet, to whom we owe a very accurate description of the Germigny church before it was demolished and incorrectly reconstructed in 1867-1876. The square bays over the four corners of the church were covered with domes on squinches. (Cf. 367, 373.) The domes were mistakenly assumed to be an Islamic element. This type of building goes back at least to the Late Empire, and the dome on squinches is known to have been common in the West from that time on (e.g, the 5th-century baptistery of Soter in Naples). The dome on squinches at Germigny is carried on three sides by wall-arches (formerets) similar to those of the semidome of Saint-Laurent at Grenoble. (Cf. Bibliography, No. 313, p. 112.)

373. **GERMIGNY-DES-PRÉS.** *Schematic View of the Church showing the Different Levels of the Vaulting.* (After Georges Bouet, in *Congrès archéologique* [Orléans, 1892].)

It seems likely that in its original form the church had a dome over the central square. But after it had been wrecked and burned by Norse raiders, and then rebuilt, no trace of a central dome remained. (Cf. 42, 367, 372.)

374. **AIGUILHE (Le Puy).** *Oratory of Saint-Michel: Cross-Section.* (After a plan by Jean Hubert.)

Built originally on a quatrefoil plan, the little church lost one of its apses when a short nave was added to it in the 12th century. On the central vault are some highly interesting paintings of the Carolingian period. (Cf. Bibliography, No. 356, pp. 86-90.)

In the time of Bishop Godescalc (936-962), Turanus, dean of the chapter, had this oratory built overlooking the town of Le Puy, 'on a rock which until then even the nimblest could scale only with great difficulty.'

375. **SAINT-DENIS.** *Plan of the Former Abbey Church.* (Photo Direction de l'Architecture, Archives photographiques. After an unpublished plan by Jules Formigé.)

In the case of large churches which in the course of many centuries have been rebuilt several times, the foundations are apt to confront even the most methodical excavator with well-nigh insoluble problems. It was my privilege to follow closely some of the difficult excavations carried out at Saint-Denis by Jules Formigé, following those of S. M. Crosby; and while I do not entirely agree with any of the proposed reconstructions of the earlier churches, I am happy to be able to publish here—and I do so with grateful acknowledgment—the overall plan of the Saint-Denis excavations which Jules Formigé kindly made over to me a few months before his death in 1960, and which he himself was given no time to evaluate and analyse. The Carolingian church of Saint-Denis, which had followed two earlier churches, was consecrated on 24 February 775; the dedication of the east oratory took place on 1 November 832. Before the rebuilding carried out by Suger (abbot from 1122 to 1151), there had been some extensive remodelling in the 11th century. In 869 the monastery was girdled with a fortified defensive wall, of wood and stone, whose position is known in part from documents; on the east side it coincided with the medieval enclosure wall. I have elsewhere published a plan of this wall. (Cf. Bibliography, No. 300, Fig. 76.)

376. *Map of Charlemagne's Empire at the Beginning of the 9th Century.* (After Louis Halphen, *Charlemagne et l'Empire carolingien* [Paris, Albin Michel, 1947], L'Évolution de l'Humanité series, XXXIII, map 1.)

377. *Map of Europe in the mid-10th Century.* (After F. Schrader, *Atlas de géographie historique* [Paris, Hachette, 1896], map 20.)

378. *Map showing the Partition of Western Europe made by the Treaty of Verdun in 843.* (After F. Schrader, *Atlas de géographie historique* [Paris, Hachette, 1896], map 20.)

379. *Map of the Areas covered by the Norse Incursions.* (After W. Vogel, *Die Normannen und das fränkische Reich bis zur Gründung der Normandie* [Heidelberg, 1906], inset map.)

380. *Map of the Religions of the 9th and 10th Centuries.* (After F. Schrader, *Atlas de géographie historique* [Paris, Hachette, 1896].)

Plans drawn by Claude ABEILLE, maps by Jacques PERSON.

Glossary-Index

AQUITAINE (AQUITANIA). One of the provinces of Gaul. Became an independent kingdom in 628 under Dagobert and remained so until 778 when Charlemagne gave it to Louis the Debonair, *p.* 33, 78, 101.

ARABS, *p.* 15, 32, 92.

ARCH. See DIAPHRAGM ARCH.

ARCHITRAVE. The lowest member of an entablature, a beam of wood or stone resting on columns, *p.* 9.

ARCS (LES). Town in Provence (Var), near Draguignan, *p.* 32.

AREA. Late Latin term for a funerary enclosure, *p.* 264.

AREOBINDUS. Consul of the East Roman Empire in 506, *fig.* 218, 219.

ARLES. City in south-eastern France (Bouches-du-Rhône), on the Rhône, ancient capital of the Kingdom of Provence and Arles, *p.* 66; *maps* 376, 378.

ARLES-SUR-TECH. Town in south-western France (Pyrénées-Orientales), 30 miles south-west of Perpignan, *p.* 62.

ARN (died 821). Bishop (785), then archbishop of Salzburg (798-821) and abbot of Saint-Amand, *p.* 124, 127, 181.

ARNALDUS. A prominent man of Orléans and court dignitary under Louis the Pious, who commissioned the St Gauzelin Gospel Book (second quarter of the 9th century) from the Tours scriptorium.

ARNULF (died 899). A natural son of Carloman who became King of Germania (887) and Emperor of the West (896-899), *p.* 256; *fig.* 238, 239.

ARRAS. Town in northern France (Pas-de-Calais) repeatedly devastated by the Northmen. The abbey of Saint-Vaast was built in the 7th century over the tomb of the first bishop of Arras, *p.* 163; *fig.* 151; *maps* 377, 379.

ASHBURNHAM PENTATEUCH. Another name for the Tours Pentateuch, a famous illuminated manuscript stolen from the Tours library in the 19th century by Count Libri, who sold it to the English bibliophile the Earl of Ashburnham (1797-1878). After a campaign led by the French scholar Léopold Delisle, it was returned to the Bibliothèque Nationale in Paris, *p.* 98, 141.

ATRIUM. The open court in front of a basilica, surrounded by porticoes, *p.* 2, 8, 42, 45, 62, 294; *fig.* 334, 337 B, 342.

AUGUSTINE (St). Bishop of Hippo (396-430) in North Africa, *p.* 98.

AUGUSTINE (St). Apostle of England and first bishop of Canterbury (596-605), *p.* 84.

AULA. Inner courtyard of a palace, *p.* 46.

AUNEAU. Town in north-central France (Eure-et-Loir), 15 miles east of Chartres, *p.* 66.

AUSTRIA, *p.* 29.

AUTUN. City in central France (Saône-et-Loire), *fig.* 61, 63, 119; *maps* 377, 379.

AUXERRE. City in north-central France (Yonne), on the river Yonne, with the abbey of Saint-Germain, built over the tomb of St Germanus, *p.* 6, 9-11, 46, 50, 62-64, 66, 67, 207, 264; *fig.* 5-8, 48-50, 248, 252, 253, 345, 361; *maps* 376-378.

AVARS. A nomadic people who settled in Lower Austria in the second half of the 6th century, *p.* 207.

AVIGNON. City in south-eastern France (Vaucluse), on the lower Rhône. After the partition of the Carolingian empire, it formed part of the Kingdom of Burgundy, *p.* 32.

BAMBERG. City in West Germany (Bavaria), 40 miles north of Nuremberg, *p.* 127, 251; *fig.* 121, 122; *map* 377.

BARBARIANS. Term applied by the Romans to all peoples foreign to them. Today it is used to designate the Germanic peoples who invaded the Roman Empire from the 4th to the 6th century, *p.* 53, 74, 102, 163, 171, 187, 233.

BARBERINI. Patrician family of Florence, then of Rome, who were active art patrons and collectors, *p.* 174, 233.

BARDOLINO. Town in northern Italy, on the east side of Lake Garda, 15 miles north of Verona, *fig.* 371; *map* 377.

BASEL. City in north-western Switzerland, on the Rhine, *p.* 37.

BASIL I. Byzantine emperor (867-886), *p.* 143.

BATHSHEBA. Wife of Uriah the Hittite. David committed adultery with her and caused her husband's murder. She was the mother of Solomon (2 Samuel), *p.* 251.

BAVARIA. The largest state in the Federal Republic of Germany, capital Munich, *p.* 171, 181, 184, 210.

BAYON. Town in north-eastern France (Meurthe-et-Moselle), on the Moselle about 15 miles south-west of Lunéville, *p.* 32.

BEAUVAIS. Cathedral town in northern France, with ancient church of Notre-Dame de la Basse-Œuvre, rebuilt between 949 and 988, *p.* 39, 50; *fig.* 57; *maps* 376-379.

BELGIUM, *p.* 54, 209.

BENEDICT OF ANIANE (St) (died 821). Founded the abbey of Aniane near Montpellier about 782 and drew up a Rule for the reform of the Frankish monasteries, *p.* 4, 78.

BENEDICT OF NURSIA (St) (480-543). Founder of the Benedictine Order, *p.* 2.

BENEVENTO. Town in south Italy (Campania), north-east of Naples. Capital of a duchy from 571 to 1033, *p.* 92; *fig.* 366; *maps* 376-378.

BERENGER (BERENGARIUS). Scribe at the abbey of Regensburg, *p.* 147, 156, 256.

BERENGER I (died 924). Son of Evrard, Marquis of Friuli, and Gisela, daughter of Louis the Pious. King of Italy (888-924) and emperor of the West (915-924), *p.* 215.

BERLIN, *p.* 209, 213, 224, 229, 232, 233, 238; *map* 377.

BERNARD (St) (1090-1153). Founder of the Cistercian Order, *p.* 117.

BERNARD (Honoré). Contemporary French archaeologist, *p.* 1.

BERNE. Capital of Switzerland, on the river Aar, *p.* 174; *map* 377.

BEZALEEL. Chief architect of the tabernacle and a cunning workman (Exodus XXXI), *p.* 81.

BISCHOFSHOFEN. Town in Austria, on the Salzach, 20 miles south-east of Hallein, *p.* 209.

BLOIS. City in north-central France (Loir-et-Cher), on the Loire, *map* 377. Gospels, *p.* 121; *fig.* 110, 292.

BLONDEL (Louis) (1885-1967). Swiss archaeologist, *p.* 50.

BOBBIO. Town in central Italy (Emilia), 30 miles south-east of Pavia. The monastery founded here in 612 by St Columban became an important centre of studies, *p.* 75; *map* 377.

BOETHIUS (Anicius Manlius Severinus) (c. 470-524). Roman philosopher, poet and statesman. Served as minister to Theodoric, who put him to death on a charge of conspiracy, *p.* 127; *fig.* 117-118.

BOLOGNA. City in north-central Italy, 40 miles west of Ravenna, *p.* 219; *fig.* 358; *map* 377.

BOLZANO. City in north-eastern Italy (Alto Adige), 30 miles north of Trento, *p.* 19, 31.

BONIFACE (St) (c. 680-755). English Benedictine missionary, bishop of Mainz and apostle of Germany, *p.* 61, 192.

BORDEAUX. City in south-western France (Gironde), on the Garonne, *p.* 32; *maps* 376, 378.

BOSCOREALE. Town in southern Italy (Campania), 35 miles south-east of Vesuvius, *p.* 103.

BOUSTROPHEDON. Ancient Greek mode of writing alternate lines in opposite directions, one line from left to right, the next from right to left, *p.* 141.

BRESCIA. City in northern Italy (Lombardy), 60 miles east of Milan. Formed part of the Lombard kingdom, then conquered by Charlemagne in 774. Basilica of San Salvatore, ancient church of a monastery founded in 753 by Aistolf, king of the Lombards, *p.* 16, 19, 92, 215, 217; *fig.* 15-17, 203, 258, 259, 263, 274; *map* 377.

BRITISH ISLES. *p.* 3, 15, 71, 74, 78, 163, 181, 192, 210, 213, 263.

BRITTANY. Peninsular region of north-west France, capital Rennes, *p.* 199; *fig.* 183-185; *maps* 376, 378.

BRÖNSTEDT (Johannes), *p.* 210.

BRUNSWICK (BRAUNSCHWEIG). City in West Germany (Lower Saxony), 45 miles east of Hanover, *p.* 238.

BRUSSELS. *p.* 92, 220; *fig.* 200-201; *map* 377.

BUDRIO. Locality in north-central Italy (Emilia-Romagna), 12 miles from Bologna, *p.* 32, 219.

BURGUNDY. Region of varying limits in eastern Gaul and pre-revolutionary France, included in the Middle Kingdom of Lothair I at the Treaty of Verdun (843), *p.* 213; *maps* 376-378.

BYZANTIUM. See CONSTANTINOPLE.

CAMBRAI. City in northern France (Nord), on the Escaut (Schelde), *p.* 181, 184; *map* 377.

CANTERBURY. City in south-east England (Kent), 50 miles south-east of London, *p.* 84, 161, 202; *maps* 376-378.

CAPETIANS. Dynasty of French kings founded by Hugh Capet (987), *p.* 5.

CAPITAL. Head or uppermost member of a column, supporting the architrave or the springing of an arch, *p.* 11, 19, 35, 37, 63, 274.

CAPUA. City in southern Italy (Campania), in a bend of the Volturno, 22 miles north of Naples, *p.* 192.

CAROLINGIANS. Second line of Frankish kings (751-987), *p.* 4, 15, 28, 39, 42, 71, 79, 102, 103, 111, 117, 121, 143, 156, 184, 202, 207.

CARPENTRAS. Town in south-eastern France (Vaucluse), 16 miles north-east of Avignon, *p.* 32.

CASTELLANI (Augusto) (1829-1914). Italian goldsmith and art lover whose collection is preserved in the Museo Nazionale di Villa Giulia, Rome, *p.* 213, 217.

CASTELSEPRIO. Village in north Italy (Lombardy), on the river Olona, 18 miles north of Milan. In the church of Santa Maria Foris Portas a large sequence of medieval wall paintings was discovered in 1944, *p.* 16, 19, 27, 92, 101, 174; *fig.* 13, 14; *map* 377.

CATALONIA (Spain), *p.* 265.

CATTANEO (Raffaele) (1861-1889). Italian archaeologist, *p.* 29.

CAVA (CAVA DEI TIRRENI). Town in southern Italy (Campania), 30 miles south-east of Naples, *p.* 192.

CELESTINE GOSPELS. *p.* 121; *fig.* 108.

CENTULA. Ancient name of the abbey of Saint-Riquier. See SAINT-RIQUIER.

CHALON-SUR-SAONE. City in east-central France (Saône-et-Loire), on the Saône, 38 miles north of Mâcon, *p.* 66.

CHANCEL SLABS. See CLOSURE SLABS.

CHARLEMAGNE (742-814). Eldest son of Pepin the Short, king of the Franks in 768 with his brother Carloman, then alone from 771. Crowned emperor in 800 at Rome by Pope Leo III, *p.* XI, XII, 1, 2, 4-6, 11, 14, 15, 23, 31, 32, 35, 39, 45, 46, 50, 57, 61, 64, 68, 74, 75, 78, 79, 81, 84, 92, 95, 101, 103, 105, 121, 124, 127, 130, 132, 143, 156, 158, 160, 161, 184, 192, 207, 209, 213, 223, 224, 229, 233-235, 239, 251, 254, 256, 279; *fig.* 64, 65, 206, 234, 237, 323. Gospel book of, see Coronation Gospels. Palace School of, *p.* 223, 224, 229, 232-235, 239, 251.

CHARLES II THE BALD. King of France (840-877), crowned emperor in Rome on December 25, 875, *p.* 5, 28, 66, 68, 101, 102, 120, 121, 127, 137, 141-143, 146-148, 156, 163, 168, 169, 239, 241, 247, 251, 256. Book of Hours, *p.* 143, 247. First Bible of, *p.* 137, 141, 146, 164; *fig.* 128, 129. Second Bible of, *p.* 163, 164, 167, 168; *fig.* 149-150. Psalter of, *p.* 143, 156, 174, 216, 247, 251, 256, 259; *fig.* 134-136, 230-232.

CHARLES III THE SIMPLE (879-929). Son of Louis II. King of France in opposition to Odo, 893-898; sole king, 898-923, *p.* 256.

CHARTRES. City in north-central France (Eure-et-Loir), on a hill overlooking the river Eure, *p.* 37, 66.

CHEMINOT. Locality in north-eastern France (Moselle), near Metz, with a royal villa given to the abbey of Saint-Arnoul of Metz in 783, *p.* 28.

CHEVET. The entire east end of a church, from the altar to the apse, *p.* 15, 26, 68.

CHRODEGANG (St) (c. 712-766). Bishop of Metz (742-766) and reformer of the cathedral clergy, for whom about 754 he drew up a Rule similar to that of the monastic orders but less strict, *p.* XI, 39.

CHRYSOSTOM (St John) (c. 344-407). Father of the Greek Church and patriarch of Constantinople (398-403), *p.* 181; *fig.* 166.

CHUR. Town in eastern Switzerland, capital of the canton of the Grisons (Graubünden), on the river Plessur, *p.* 23, 54, 212; *fig.* 352; *maps* 376-378.

CIAMPINI (Giovanni Giustino). Italian archaeologist (1633-1698), *p.* 11.

CIBORIUM. High canopy covering the altar, *p.* 2, 28, 31, 209, 256, 259, 277; *fig.* 238, 239, 270, 271.

CIMIEZ. Ancient town in France (Alpes-Maritimes), on the Riviera, now part of Nice, *p.* 31.

CINI (Vittorio) (born 1885). Italian industrialist, financier and collector. Established the Giorgio Cini Foundation in Venice in memory of his son, *p*. 247.

CIVIDALE DEL FRIULI. Town in north-east Italy (Venezia Giulia), 12 miles from Udine. Capital of the first Lombard duchy in Italy; then a Frankish duchy. Famous for the church of Santa Maria in Valle, called the Tempietto, *p*. 19, 21, 37, 74, 217; *map* 377.

CLERMONT-FERRAND. City in south-central France (Puy-de-Dôme), *fig*. 356; *maps* 376-378.

CLIPEUS. A large round shield, *p*. 35.

CLOSURE SLABS. Ornamental stone slabs closing off a tomb or the altar of a church, *p*. 19, 28, 31-33; *fig*. 24-28, 266, 267.

CLUNY. Town in east-central France (Saône-et-Loire), 14 miles north-west of Mâcon, with a famous Benedictine abbey founded in 910 by Duke William of Aquitaine, *p*. 1.

COBURG. City in West Germany (Bavaria), 70 miles north of Nuremburg, *p*. 238.

CODEX MILLENARIUS, *p*. 181.

COLOGNE. City in West Germany (North Rhine-Westphalia), on the Rhine, *p*. 57, 192, 229, 238; *fig*. 182, 309, 332, 333; *maps* 376-378.

COLUMBAN (St) (c. 540-615). Irish monk, founder of the abbey of Luxeuil *p*. 171.

CONFESSIO. Crypt where a saint or martyr was buried, *p*. 9, 53, 54, 68, 266; *fig*. 50.

CONQUES. Town in south-western France (Aveyron), 22 miles north-west of Rodez. Abbey of Sainte-Foy, famous from Carolingian times as a pilgrimage centre, *p*. XII, 266.

CONRAD OF AARGAU (Count). Uncle of Charles the Bald, *p*. 66, 264.

CONSTANCE (Lake). The Bodensee, lying between Germany, Switzerland and Austria, *p*. 27.

CONSTANCE (KONSTANZ). City in West Germany (Baden-Württemberg), on the south side of Lake Constance, *p*. 173.

CONSTANTINE THE GREAT (c. 285-337). Roman emperor (306-377). In 330 he transferred the seat of government from Rome to Constantinople, *p*. 27.

CONSTANTINOPLE (BYZANTIUM). Capital of the East Roman Empire, built from 324 to 330 by Constantine the Great on the site of the ancient Byzantium. Present-day Istanbul, *p*. 19, 31, 46, 94, 223, 266; *map* 377.

CORBIE. Small town in northern France (Somme), 15 miles east of Amiens, *p*. 64, 78, 135, 142, 161, 181, 229, 239, 241, 256, 259; *maps* 376-379.

CORONATION GOSPELS, *p*. 92, 98, 120; *fig*. 79-81.

CORVEY. Benedictine abbey founded in 882 by Adalhard, in West Germany (Hesse), near Höxter, on the Weser, *p*. 50, 63, 64, 267; *fig*. 51-54, 347, 360; *map* 377.

COSMAS INDICOPLEUSTES. Alexandrian merchant and traveller who became a monk on Mount Sinai (c. 548) where he wrote a *Topographia christiana* in Greek, *p*. 174.

COTTON (Sir Robert Bruce) (1575-1631). English archaeologist, historian and collector, *p*. 84.

COUNTERAPSE. Apse opposite the main apse of a church, *p*. 58, 62.

CUNAULT. Town on the Loire (Maine-et-Loire), 8 miles west of Saumur. Benedictine monastery given by Charles the Bald to Count Vivian in 845, *p*. 239.

CURULE CHAIR. Seat appropriated in ancient Rome to the use of consuls, senators and other high dignitaries, *p*. 35, 224.

CUTBERCHT or CUTHBRECHT. Scribe and illuminator who worked at Salzburg (9th century), *p*. 181. Gospels, *p*. 181, 210.

DAGOBERT I. Son of Clotaire II and king of the Franks (629-639), *p*. 209, 224; *fig*. 320.

DAGULF. Frankish scribe of the Palace School of Charlemagne (8th century), *p*. 78, 229; Psalter, *p*. 78, 229, 232; *fig*. 208.

DAMON. Character in Virgil's eighth *Eclogue*, *p*. 239.

DANUBE. River of central Europe (1,725 miles long) flowing from the Black Forest to the Black Sea, *p*. 192.

DARMSTADT. City in West Germany (Hesse), 18 miles south of Frankfurt, on the edge of the Odenwald, *p*. 156, 233; *map* 377.

DAVID (1015-c. 975 B.C.). Second king of Israel, father of Solomon, *p*. 134, 137, 161, 174, 229, 251; *fig*. 157.

DÉER (Jószef) (born 1905). Hungarian historian, *p*. 233.

DELÉMONT. Town in north-western Switzerland (canton of Berne), 30 miles south-west of Basel, *p*. 213; *map* 377.

DEMETRIUS PRESBYTER. Name figuring at the beginning of St Luke in the Coronation Gospels of Charlemagne (early 9th century), *p*. 92, 101, 117, 121.

DESIDERIUS (?-after 774). King of the Lombards, crowned in 757 by Pope Stephen II. Taken prisoner in 774 by Charlemagne, he died at Corbie or Liège, *p*. 75, 78, 215, 251.

DIAPHRAGM ARCH. Bracing arch surmounted by a wall carrying a timber roof, *p*. 66, 67.

DIJON. City in eastern France (Côte-d'Or), capital of Burgundy. Abbey church of Saint-Bénigne rebuilt about 871-880, *p*. 63, 68; *fig*. 60; *maps* 376-379.

DIONYSIUS THE AREOPAGITE (St). Athenian bishop and martyr (1st century), *p*. 256.

DIOSCORIDES (Pedanius). Greek physician of the 1st century A.D., born in Cilicia (Asia Minor), author of *De Materia Medica*. A 6th-century manuscript of this work is preserved in the Nationalbibliothek, Vienna, *p*. 94, 173.

DISENTIS. Town in eastern Switzerland (Grisons), 40 miles south-west of Chur. Benedictine abbey of the 7th century, *p*. 23, 24.

DOME ON SQUINCHES. A dome built over a square base and resting on arches or corbelling carried across each of the four corners, *p*. 66; *fig*. 372.

DOME WITH SPINDLE-SHAPED SEGMENTS, *p*. 66.

DONATUS (Aelius). Latin grammarian of the 4th century A.D. who wrote a commentary on Virgil and was the teacher of St Jerome, *p*. 187.

DOUBLE-APSE PLAN. A type of church with an apse at each end, *p*. 57.

DROGO. A natural son of Charlemagne, who became bishop of Metz in 823 and died in 855, *p.* 158, 160, 161, 233. Sacramentary, *p.* 158, 160, 181, 234; *fig.* 145-148, 214, 215, 298-301.

DÜSSELDORF. City in West Germany (North Rhine-Westphalia), on the Rhine, 21 miles north-west of Cologne, *p.* 121; *map* 377.

EBBO (775-851). Foster-brother of Louis the Pious and archbishop of Reims (816-845), *p.* 92, 98, 101, 102, 105, 117, 120-122, 132, 156, 158, 160. Gospels, *p.* 92, 98, 105, 109, 120; *fig.* 92-97, 242, 285-289.

ECHTERNACH (ECHTERN). Abbey founded in 698 by St Willibrord, on the German frontier of the Duchy of Luxembourg, *p.* 164, 181; *map* 377.

'ÉCRIN DE CHARLEMAGNE,' *p.* 239, 254; *fig.* 234.

EGYPT, *p.* 199.

EIGIL (died 822). Abbot of Fulda (790-819), *p.* 35.

EINHARD or EGINHARD (c. 775-840). Author of the *Life of Charlemagne*, *p.* 32, 35, 63, 81, 101, 224. Reliquary, *p.* 224; *fig.* 29.

ELIGIUS or ELOI (St) (c. 588-660). Goldsmith of Limoges, who became master of the mint under Clotaire II and Dagobert and bishop of Noyon (641), *p.* 224.

ELLWANGEN. Town in West Germany (Württemberg Baden), on the Jagst, 10 miles north of Aalen, *p.* 260; *fig.* 240; *map* 377.

EMILIA. Region of northern Italy between Tuscany and Lombardy, *p.* 32.

ENGER. Town in West Germany (Westphalia), 5 miles north-east of Herford. Abbey church with the tomb of Widukind, *map* 377. Reliquary, *p.* 209, 213; *fig.* 193.

ENGLAND, *p.* 75, 84, 199, 202, 210, 222.

EPERNAY. Town in northern France (Marne), on the Marne, 18 miles south of Reims, *p.* 102; *map* 377.

ERIGENA (John Scotus) (c. 833-c. 880). Irish-Scottish philosopher and theologian, who taught at the Palace School of Charles the Bald. Translator of Dionysius the Areopagite, *p.* 163.

ERIN, *p.* 163.

ERMENTRUDE (died 869). Daughter of Odo (Eudes), Count of Orléans, and wife of Charles the Bald, *p.* 163.

ERMOLDUS NIGELLUS. 9th-century author of a poem on Louis the Pious and of epistles to King Pepin, *p.* 6.

ESCAUT. See SCHELDE.

ESCORIAL (The). Royal palace and monastery in Spain (New Castile), 30 miles north-west of Madrid at the foot of the Sierra de Guadarrama, *p.* 47.

ESSEN. City in West Germany (Ruhr), 30 miles north of Cologne, *p.* 217, 266; *map* 377.

ESTOUBLON. Town in Provence (Basses-Alpes), 12 miles south-west of Digne, *fig.* 268; *map* 377.

EUDES. See ODO.

EUDOCIA (EUDOKIA INGERINA). Mistress of the Byzantine emperor Michael III, she married the emperor Basil I in 866, *p.* 143.

EUSEBIUS OF CAESAREA (c. 267-338). Father of the Greek Church, bishop of Caesarea in Palestine (314-338) and author of an important *History of the Church*, *p.* 75.

FAUSTA. Lady of the 8th century who commissioned a Gospel Book from the scribe Gundohinus (754), *p.* 71.

FELDMOCHING. Town in West Germany (Bavaria), 3 miles north of Munich, *map* 377.

FERKIL. See VIRGIL (St).

FLABELLUM. Fan or fly-whisk used in religious ceremonies, *p.* 238; *fig.* 217, 322, 324.

FLAVIGNY. Benedictine abbey of Saint-Pierre founded in 720, near Flavigny-sur-Ozerain, 6 miles south-east of Les Laumes (Côte-d'Or) in Burgundy, *p.* 63, 68, 135; *fig.* 348; *map* 377.

FLEURY-SUR-LOIRE. Former name of the abbey of Saint-Benoît-sur-Loire, near Orléans, *p.* 121, 192, 202, 247; *fig.* 179, 186, 308; *map* 377.

FLORENCE, *p.* 229, 232, 233, 238; *fig.* 217; *map* 377.

FLORUS OF LYONS (died c. 860). Writer and poet who taught in the cathedral school of Lyons, *p.* 6.

FOLCHARD. Monk and scribe of St Gall (second half of the 9th century). Psalter, *p.* 174; *fig.* 165.

FONTENELLE. Benedictine abbey in Normandy founded in 649 by St Wandrille, near Saint-Wandrille-Rançon (Seine-Maritime), 38 miles from Jumièges, *p.* 42, 63.

FORMERET. See WALL-ARCH.

FORMIGÉ (Jules) (1879-1960). French architect and archaeologist, *fig.* 375.

FOY (St). Female martyr venerated at Figeac, then at Conques, *p.* XII, 266.

FRAMEGAUD. Scribe of Reims who gave asylum in Paris to Ebbo when the latter was pursued by Louis the Pious, *p.* 102.

FRANCE, *p.* 23, 28, 62, 117, 143, 216, 222, 224.

FRANCIS II. King of France (1559-1560). Gospels, *fig.* 152, 153.

FRANCO-INSULAR or FRANCO-SAXON SCHOOL. School of miniature painters localized in northern France, *p.* 163, 164, 167, 171, 181, 184, 192.

FRANKS, *p.* 6, 15, 39, 61, 74, 75, 94, 98, 101, 207, 239, 264, 265.

FRANKFURT (FRANKFURT AM MAIN). City in West Germany (Hesse), *p.* 39, 158, 235.

FREIBURG IM BREISGAU. City in West Germany (Baden), on the edge of the Black Forest, *p.* 246, 247; *map* 377.

FREISING. City in West Germany (Bavaria), 20 miles north-east of Munich, *p.* 181, 192; *fig.* 180; *map* 377.

FRÉJUS. Town on the French Riviera (Var), 3 miles from Saint-Raphaël, *p.* 32.

FRIDUGISUS. English monk, abbot of Saint-Martin at Tours (807-834), *p.* 127.

FRUELA II. King of Léon (923-925), *p.* 215.

FUCULPHUS. Monk who ordered a Gospel Book from the scribe Gundohinus (754), *p.* 71.

FULDA. City in West Germany (Hesse), 70 miles north-east of Frankfurt. Famous abbey founded in 744, *p.* XII, 42, 57, 58, 61, 62, 121, 192; *fig.* 177, 178, 328; *maps* 376-378.

GABORIT-CHOPIN (Danielle). Contemporary French archaeologist, *p.* XII, 11.

GAEA (GAIA). The oldest of the Greek divinities, the Earth-Mother, the eldest born of Chaos, who formed the sky, seas and mountains, *p.* 251.

GAETA. City in central Italy, on the Mediterranean, 50 miles north-west of Naples, *maps* 376, 378.

GALL or GALLUS (St). Founder of the abbey of St Gall (Switzerland), died about 646, *p.* 171.

GALLIA CHRISTIANA. A chronological list of the archbishops, bishops and abbots of Gaul and France, compiled by two brothers, Scévole and Louis de Sainte-Marthe and by the two sons of Louis (4 vols., 1656), and considerably expanded by later compilers, *p.* 264.

GALLUS (Gaius Cornelius) (69-26 B.C.). Latin poet, who established the elegy as one of the main forms of Latin poetry, *p.* 239.

GARGANO. Promontory in southern Italy (Apulia), culminating in Monte Calvo (3,460 ft), *p.* 267.

GARONNE. River in south-western France, *p.* 265.

GAUDIOSUS. Bookseller in Rome (8th century), *p.* 187.

GAUL. Ancient region south and west of the Rhine, east of the Pyrenees and north of the Alps, *p.* 3, 5, 11, 15, 19, 26, 28, 29, 32, 33, 35, 39, 47, 54, 57, 61, 64, 66, 77, 103, 161, 181, 184, 187, 192, 264-267.

GAUZELIN (St) (died 962). Bishop of Toul, *p.* 130; *fig.* 120, 189.

GELLONE. Abbey founded in 804 by Duke William of Aquitaine near Aniane, in southern France. Known today as Saint-Guilhem-le-Désert (Hérault), *map* 377. Sacramentary, *p.* 78, 135, 161.

GELO. Abbot of Cunault, successor of Hilbold (c. 855), *p.* 238.

GENEVA, *p.* 47, *maps* 376, 378.

GENOELSELDEREN or GENOLS-EL-DEREN. Locality in Belgium (Limburg), 4 miles east of Tongres, *p.* 84, 220; *fig.* 200-201; *map* 377.

GEORGE OF AMIENS (c. 769-799). Bishop of Ostia, then of Amiens. Translator into Latin of a Universal Chronicle, *p.* 78, 92.

GERMANIA. In early medieval Europe, the region just west of the Rhine, covering north-eastern France and part of Belgium and Holland, *p.* 39, 57, 61, 161, 187.

GERMANUS (St). Born at Auxerre (c. 389), studied in Rome and became *dux* of his native town. Made bishop of Auxerre (418) and died at Ravenna (448), *p.* 10, 66, 264; *fig.* 312.

GERMANY, *p.* 28, 29, 54, 63, 199, 202, 213.

GERMIGNY-DES-PRÉS. Village in central France (Loiret), near the Loire, 20 miles east of Orléans and 4 miles from the former abbey of Saint-Benoît-sur-Loire (Fleury), *p.* 5, 11, 12, 14, 15, 46, 64, 66-68, 192, 265; *fig.* 10, 11, 40-43, 251, 255-257, 367, 372, 373; *maps* 376-378.

GIBEON (Pool of). Joab, commanding David's servant, encountered Abner at the pool of Gibeon and defeated him (2 Samuel II. 12-17). The actual site north-west of Jerusalem is a matter of controversy, *p.* 251.

GILES (St), *p.* 251.

GISLEMAR. Archbishop of Reims (808-816), *p.* 101.

GISULF I (died 611). Nephew of Alboin, king of the Lombards, and duke of Friuli, *p.* 74.

GLONS. Town in Belgium, 9 miles north of Liège, *fig.* 271; *map* 377.

GODESCALC. Frankish lord who ordered a Gospel Book for Charlemagne (before 783), *p.* 75. Gospels, *p.* 75, 78, 81, 84, 88; *fig.* 64, 65.

GOLDEN PSALTER OF ST GALL, *p.* 174.

GOLDSCHMIDT (Adolf) (1863-1944). German archaeologist, *p.* 224, 233, 234, 238, 247.

GOSPEL BOOK. Book containing the Gospel texts for all the masses of the year. See individual entries.

GOTHS. A Germanic people dwelling originally in Scandinavia and on the lower Vistula—the only one to achieve a successful synthesis of Roman and Germanic elements. Early divided into two groups: Ostrogoths and Visigoths (East Goths and West Goths), *p.* 15, 192.

GOZBERT. Abbot of St Gall (816-837), *p.* 42.

GRABAR (André) (born 1896). French archaeologist, *p.* 12.

GREECE, *p.* 2, 71, 174.

GREGORY I THE GREAT (St). Pope (590-604), *p.* 37, 155, 233.

GREGORY III (St). Pope (731-741), *p.* 53.

GREGORY IV. Pope (827-844), *fig.* 178.

GREGORY OF NAZIANZEN (St) (c. 330-c. 390). Father of the Greek Church. Friend of St Basil, bishop of Sasima (372), of Nazianzen (374), then of Constantinople (378-381). Orator and theologian, *p.* 21, 143; *fig.* 143.

GRENOBLE. City in south-eastern France (Isère), capital of Dauphiné, *p.* 15.

GUNDOHINUS. Frankish scribe (8th century) whose copy of the Gospels marks the beginning of Carolingian book painting, *p.* 71, 74. Gospels, *p.* 71, 74; *fig.* 61-63.

GUSSAGO. Town in north Italy (Lombardy), 6 miles from Brescia, *fig.* 36; *map* 377.

HAECPERTUS. Germanic scribe of the *Physiologus latinus*, *p.* 117.

HALBERSTADT. City in East Germany, 30 miles south-west of Magdeburg at the foot of the Harz mountains, *p.* 247.

HAMBURG. City in West Germany, on the estuary of the Elbe, *p.* 247; *maps* 376, 378.

HARRACH. Family of Austrian nobles who were active art patrons and collectors, *p.* 229, 232.

HAUTVILLERS. Town in north-eastern France (Marne), 4 miles north of Épernay. Abbey founded in 660, *p.* 102, 105, 120, 121, 160, 174; *fig.* 84-105, 242, 290; *map* 377.

HEIRICUS or ERIC (841-c. 877). Monk of Saint-Germain of Auxerre, annalist and poet, one of the authors of the *Gesta pontificum Autisiodorensium* (history of the bishops of Auxerre), *p.* 64, 264.

HENRY II (St) (973-1024). Holy Roman emperor (1002-1024), *p.* 251; *fig.* 229.

HERIBALD (St) (died 857). Bishop of Auxerre (829-857), *p.* 10.

HERIBERT (St) (died 1021). Born at Worms (970), chancellor of Otto III, archbishop of Cologne (999) and chancellor of the Empire (998-1002) *p.* 238.

HILBOLD or HILBOD. Abbot of Saint-Philbert-de-Grand-Lieu (846), *p.* 238.

HILDEGARDE (died 783). Daughter of the Count of Swabia and wife of Charlemagne, *p.* 75.

MEDITERRANEAN SEA, *p.* 15, 265, 266.

MELIBOEUS. In Virgil's first *Eclogue*, a dispossessed farmer driven into exile; in the seventh, the narrator of a singing contest, *p.* 239.

MELUN. City in northern France (Seine-et-Marne), on the Seine, 30 miles south-east of Paris, *p.* 39.

MEROVINGIANS. First dynasty of Frankish kings (c. 500-751), *p.* 5, 74.

METZ. City in north-eastern France (Moselle), *p.* XI, 28, 39, 41, 122, 123, 158, 160, 161, 168, 207, 229, 233-235, 238, 239, 251; *fig.* 24, 145-148, 224, 266, 297-301, 343; *maps* 376-378. Sacramentary, *p.* 147, 148, 156; *fig.* 140-143.

MEUSE (MAAS). River flowing from north-eastern France through Belgium and Holland to the North Sea (575 miles long), *p.* 156, 184; *fig.* 144.

MICHAEL. Archangel and chief of the heavenly spirits, *p.* 229, 233, 267; *fig.* 212.

MICY. Abbey founded in the late 5th century by St Mesmin between the Loire and the Loiret, 4 miles west of Orléans, *p.* 192.

MIDDLE EAST. The region from Egypt and Turkey to Iran, *p.* 78, 181.

MILAN. Capital of Lombardy (northern Italy), *p.* 16, 92, 217, 222, 229, 241, 246, 251, 267; *maps* 376-378. Sant' Ambrogio (altar), *p.* 209, 217, 241, 246, 251, 254, 256; *fig.* 188, 220-224. Sant'Ambrogio (closure slab), *fig.* 28. Santa Maria d'Aurona, *fig.* 262. San Satiro, *p.* 6, 11; *fig.* 9, 44, 368. Ivory diptych, *p.* 222, 229; *fig.* 202.

MINDEN. Town in West Germany (north Rhine-Westphalia), on the Weser, 20 miles north-east of Bielefeld, *fig.* 363; *map* 377.

MISSUS DOMINICUS. Personal envoy of the king sent out to supervise provincial administration, *p.* 33, 39.

MONDSEE. Benedictine abbey on the north shore of the Mondsee (Austria), 24 miles east of Salzburg, *p.* 181. Psalter, *p.* 184.

MONTESQUIOU-FEZENSAC (Count Blaise de) (born 1888). French archaeologist and collector, *p.* 35.

MONTPELLIER. City in southern France (Hérault), *p.* 265.

MONZA. City in northern Italy (Lombardy), 10 miles north of Milan, *p.* 75, 174, 213, 215, 246; *fig.* 194, 225; *map* 377.

MOORS. Mixed Arab and Berber conquerors of Spain (8th century), *p.* 265.

MOSAICS, *p.* 11, 12, 14, 15, 27, 71, 105, 160, 192, 217, 266; *fig.* 10, 11, 12.

MOSES. The great Hebrew prophet and lawgiver who led the Israelites from Egypt to Canaan, *p.* 134, 135.

MOUTIER-GRANDVAL (in German MÜNSTER). Town in north-western Switzerland (canton of Berne), 30 miles south-west of Basel. Abbey founded about 640 by St Germanus of Trier, *map* 377. Bible, *p.* 134, 136, 137, 146; *fig.* 123, 125.

MUIZEN. Town in Belgium (Brabant), 3 miles south-east of Malines, *p.* 209.

MUNICH. City in West Germany, capital of Bavaria, on the Isar, *p.* 143, 215, 229, 247, 251, 256; *fig.* 195, 229; *map* 377.

MÜSTAIL. Village in eastern Switzerland (Grisons), *p.* 23.

MÜSTAIR. Village in eastern Switzerland (Grisons), near the Italian frontier. Three-apsed church of St John (Johanneskirche) with wall paintings: some, discovered in 1894, were detached and placed in the Landesmuseum, Zurich, in 1909; the rest, discovered in 1947, remain *in situ*, *p.* 16, 23, 26, 27; *fig.* 20-23, 260, 261, 275, 350; *map* 377.

NAIN. Small town in Palestine, 10 miles south-east of Nazareth, the scene of Christ's raising of the widow's son (Luke VII : 12), *p.* 259.

NANCY. City in north-eastern France (Meurthe-et-Moselle), former capital of the duchy of Lorraine, *fig.* 189; *map* 377.

NAPLES, *p.* 192, 217; *maps* 376, 378.

NARBONNE. City in southern France (Aude), near the Mediterranean, *p.* 224, 232; *fig.* 209; *maps* 376-378.

NARTHEX. Church vestibule leading to the nave, *p.* 9, 66.

NATHAN. Old Testament prophet and counsellor of David, *p.* 155, 251.

NATURNO. Village in northen Italy (Alto Adige), near Val Venosta, 30 miles north-west of Bolzano, *p.* 181.

NEON. Bishop of Ravenna (451-460), *p.* 229.

NEVERS. City in central France (Nièvre), at the confluence of the Nièvre and the Loire, *p.* 229; *map* 377. Gospels, *fig.* 111, 369.

NICE. City on the French Riviera (Alpes-Maritimes), *p.* 31; *maps* 376, 378.

NIELLO. Process of decorating metal with incised designs filled with black enamel, *p.* 210, 217.

NÎMES. City in southern France (Gard), *fig.* 32, 272; *map* 377.

NIVELLES. Town in Belgium (Brabant), 20 miles south of Brussels, *p.* 54.

NORDENFALK (Carl) (born 1907). Chief curator of painting and sculpture at the Nationalmuseum, Stockholm, *p.* 256.

NORTHMEN or NORSEMEN. Viking raiders from Scandinavia who devastated the towns and monasteries on the coasts and rivers of the British Isles and France during the 9th and 10th centuries, *p.* 1, 39, 209, 263-265, 267; *map* 379.

NORWAY, *p.* 209.

NUREMBERG. City in West Germany (Bavaria), capital of Franconia, *p.* 209; *map* 377.

OCEANUS. Son of Uranus and Gaea, personification of the sea and especially of the great outer sea believed to encircle the earth, *p.* 251.

ODO or EUDES (c. 860-898). Eldest son of Robert the Strong, count of Paris and king of France (888-898), *p.* 256.

OLDENBURG. City in West Germany (Lower Saxony), on the Hunte, 28 miles north-west of Bremen, *p.* 213.

OLYBRIUS (Anicius). Roman patrician, consul (464) and emperor of the West (472). Father of Juliana Anicia, *p.* 94.

ORLÉANS. City in central France (Loiret), on the Loire, *p.* 67, 192, 267; *map* 377.

OSIMO. Town in central Italy (Marche), 5 miles west of Ancona, *p.* 217.

OSTIA. Ancient Roman town at the mouth of the Tiber, a busy seaport. It stood about 3 miles from present-day Ostia, *fig.* 243, 247; *map* 377.

OTOLTUS. Priest and calligrapher working at Salzburg (9th century), *p.* 181.

OTTO III (980-1002). German king (983-1002) and Holy Roman emperor (996-1002), *p.* 92.

OTTONIAN ART. The art of Germany under the reigns of the Saxon kings (919-1024), taking its name from the three Ottos, *p.* XII, 16, 27, 46, 202, 233.

OVIEDO. City in north-western Spain, capital of the Asturias, *p.* 215, 216; *fig.* 196; *map* 377.

OXFORD. County town of Oxfordshire, England, on the Thames 60 miles west of London, *p.* 105, 229, 232; *fig.* 207; *map* 377.

PALEMON. Shepherd in Virgil's third *Eclogue, p.* 239.

PALERMO. City and port on the north-west coast of Sicily, *p.* 222; *maps* 376, 378.

PAN. Greek pastoral god of fertility, worshipped chiefly in Arcadia, *p.* 239.

PARENZO (POREC). Town in Yugoslavia, on the Istrian peninsula 50 miles south-east of Trieste, *p.* 15.

PARIS, *p.* 102, 229, 238, 239, 247, 263.

PARMA. City in north-central Italy (Emilia Romagna), about 80 miles south-east of Milan, *p.* 75.

PASCAL I. Pope (817-824), *p.* 12, 217; *fig.* 198.

PAUL (St). Apostle of the Gentiles, the first great Christian missionary and theologian, martyred at Rome (c. A.D. 67), *p.* 137, 174; *fig.* 161.

PAUL I. Pope (757-767), *p.* 54

PAUL THE DEACON or PAUL WAR-NEFRIED (720-799). Lombard priest, historian and poet. After the fall of the Lombard kingdom, he took refuge at the court of Charlemagne in Aachen, *p.* 74.

PAVIA. City in northern Italy (Lombardy), 20 miles south of Milan, *p.* 75, 217; *maps* 376, 378.

PEIRESC (Nicolas-Claude Fabri de) (1580-1637). French archaeologist and collector, *p.* 11.

PEPIN (777-810). Second son of Charlemagne and king of Italy (781-810), *p.* 92.

PEPIN THE SHORT (c. 715-768). Younger son of Charles Martel, mayor of the palace (741-751) and king of the Franks (751-768), *p.* XI, XII, 15, 50, 61, 71, 74, 75, 181, 192.

PERICOPES OF HENRY II. A book of pericopes contained passages from the Gospels arranged for use on the consecutive Sundays of the church year, *fig.* 229.

PETER (St). Proselytizer, vicar of Christ on earth, martyred at Rome (67?), *p.* 259; *fig.* 239.

PETER (PETRUS). Abbot of Hautvillers (first half of the 9th century), under whom the abbey scriptorium produced its finest work, *p.* 102, 105.

PHILBERT or PHILIBERT (St) (died c. 684). Son of a bishop of Aire (Pas-de-Calais), abbot of Rebais near Meaux (c. 654), founded the abbeys of Jumièges (Normandy) and Noirmoutier (Vendée), *p.* 68, 239.

'PHYSIOLOGUS LATINUS.' Translation of a 2nd-century Alexandrian treatise on animals, *p.* 112, 113, 117; *fig.* 92, 100.

PIPPIN. See PEPIN.

POLYCARP (St) (c. 69-155). One of the Fathers of the Church, disciple of John the Evangelist and bishop of Smyrna, *p.* 256.

PONTHION. Town in northern France (Marne), 7 miles east of Vitry-le-François, *p.* 74.

PONTIUS (PONS). Early Christian martyr whose tomb is venerated at Cimiez, now part of Nice (French Riviera), *p.* 31.

PROPHETS (Four Major). Isaiah, Jeremiah, Ezekiel and Daniel, *fig.* 186.

PROU (Maurice) (1861-1930). French historian and archaeologist, *p.* 29.

PRUDENTIUS (Aurelius Clemens) (348-c. 415). Christian poet, author of hymns and polemical poems, and creator of the allegorical poem, *p.* 174, 187; *fig.* 162, 174, 175, 303.

PRÜM. Town in West Germany (Rhine Palatinate), 45 miles north-west of Trier. Gospels, *p.* 146.

PSALMIST (The). Name traditionally given to David, *p.* 251.

RABANUS MAURUS or HRABANUS MAURUS (784-856). A pupil of Alcuin (802), head of the Fulda school (815), abbot of Fulda (822-842) and archbishop of Mainz (847-856). A man of encyclopaedic learning and a voluminous writer, *p.* 192; *fig.* 178.

RAINAUD. Abbot of Marmoutier (first half of the 9th century) who ordered a Sacramentary from the School of Tours, *p.* 130.

RAMBONA. Town in central Italy (Marche), on the river Potenza, 3 miles west of Pollenza, *p.* 219.

RAMWOLD. Abbot of St Emmeram at Regensburg (975-1001), *p.* 256.

RASTEDE. Town in West Germany (Lower Saxony), 7 miles north of Oldenburg, *p.* 213.

RATCHIS (c. 702-c. 760). Duke of Friuli and king of the Lombards (744-749), he abdicated in favour of his brother Aistolf and became a monk at Monte Cassino, *p.* 74.

RATGAR. Abbot of Fulda (794-817), *p.* 61.

RATPODUS. Archbishop of Trier (883-914), *p.* 247.

RAVENNA. City in north-eastern Italy (Emilia), in ancient times an Adriatic seaport, now 7 miles inland, *p.* 19, 28, 32, 54, 74, 75, 92, 136, 143, 181, 209, 223, 224, 229; *fig.* 270, 353, 357; *maps* 376-378.

REGENSBURG. City in West Germany (Bavaria), on the upper Danube, 55 miles south-east of Nuremberg, *p.* 5, 39, 147, 256; *fig.* 106, 137-139, 235; *maps* 376-378.

REGINA. Concubine of Charlemagne, mother of Drogo in 807, *p.* 158.

REICHENAU. Famous Benedictine abbey founded in 724 by St Pirmin on an island in Lake Constance (south Germany), *p.* 181, 245, 246.

REIMS. City in north-eastern France (Marne), *p.* 8, 32, 39, 58, 63, 66, 92, 101-103, 111-113, 117, 121, 124, 132, 137, 141, 146, 148, 156, 160, 167, 168, 192, 207, 229, 239, 256, 263; *fig.* 107, 172, 173, 237, 285-289, 292, 362; *maps* 376-379.

REIMS (School of). Name given to various monastic scriptoria in Champagne in the time of Ebbo, archbishop of Reims (816-845). The abbey of Hautvillers (Marne) was its centre, *p.* 92, 94, 98, 101, 103, 105, 112, 117, 120-123, 127, 130, 137, 155, 156, 160, 174, 234, 239, 241.

RHINE. River of Western Europe (820 miles long), *p.* 33, 209; *fig.* 66-68, 72-76, 78.

RHINELAND, *p.* 57, 192.

RHONE. River in Switzerland and France (500 miles long), *p.* 66, 265.

RICHARIUS or RIQUIER (St) (died c. 645). First abbot of Centula, *p.* 2, 3.

RICHER. Monk and chronicler of Saint-Remi at Reims. Studied under Gerbert after 966, died after 998. His *Historiae*, in four books, contains the annals of the kingdom from 883 to 995, *p.* 263.

After the death of Jean PORCHER, the documentation concerning his chapter was completed by Dominique BOZO.

Maps

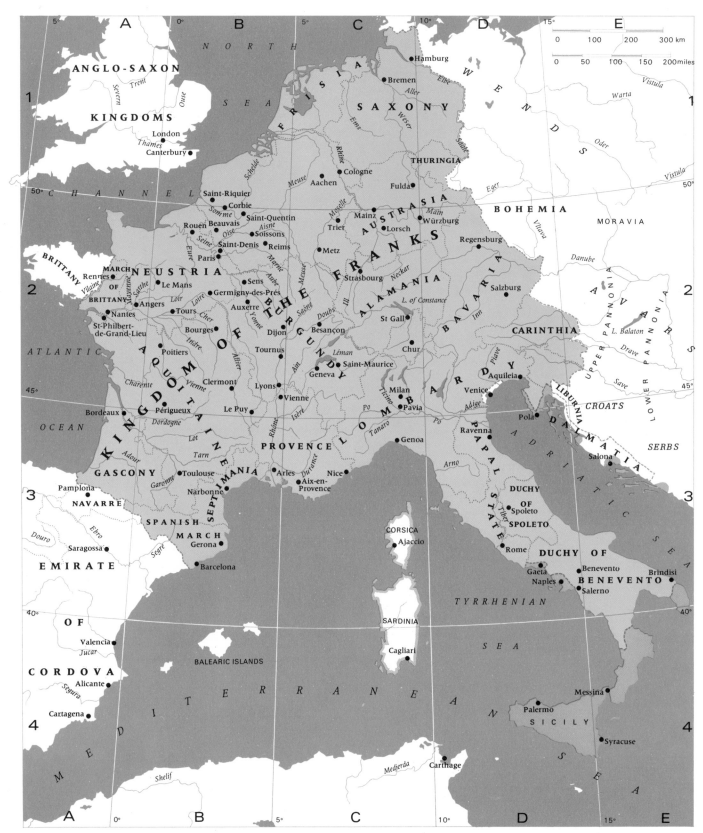

A 5° **B** 0° 5° **C** 10° **D** 15° **E**

NORTH

ANGLO-SAXON

1 *Severn* *Trent* *Ouse* *SEA* *FRISIA* **SAXONY** *Elbe* ● Hamburg

● Bremen *Aller*

W E N D S *Warta* *Vistula* 1

KINGDOMS *Ems* *Weser* *Oder* *Vistula*

Rhine ● Cologne **THURINGIA** *Saale* *Eger* *Vltava* 50°

● London *Thames* ● Canterbury 50° **BOHEMIA** **MORAVIA**

CHANNEL ● Saint-Riquier *Somme* ● Corbie *Meuse* Aachen ● ● Fulda

● Rouen ● Beauvais ● Saint-Quentin *Aisne* ● Mainz ● Würzburg **A U S T R A S I A** Regensburg ● *Danube*

Seine ● Soissons *Oise* ● Trier ● Lorsch

Eure ● Paris ● Reims ● Metz *Moselle* **F R A N K S** *Vltava*

BRITTANY **MARCH** ● Rennes **NEUSTRIA** ● Sens ● Germigny-des-Prés *Marne* *Aube* ● Strasbourg *Neckar* **A L A M A N I A** ● Salzburg **A V A R S**

2 **OF** *Vilaine* ● Le Mans *Sarthe* *Loir* *Mayenne* **T H E** *Yonne* *Saône* ● Auxerre ● St Gall **B A V A R I A** **CARINTHIA** *UPPER PANNONIA* *L. Balaton* 2

BRITTANY ● Angers ● Tours *Cher* *Loire* ● Dijon *Doubs* *Ill* *L. of Constance* *Inn* *LOWER PANNONIA* *Drave*

● Nantes ● Bourges *Indre* ● Besançon ● Chur *Save*

● St-Philbert-de-Grand-Lieu **K** ● Poitiers *Vienne* ● Tournus **B U R G U N D Y** ● Saint-Maurice **L** ● Aquileia **LIBURNIA** **CROATS**

ATLANTIC **I** *Allier* *Léman* ● Geneva **O** ● Milan ● Venice *Piave* 45°

45° *Charente* **N** ● Clermont ● Lyons *Ain* **M** ● Pavia **D** ● Pola **D A L M A T I A** **SERBS**

● Bordeaux **G** ● Périgueux *Dordogne* *Vienne* ● Vienne *Isère* **B** *Po* **A** ● Ravenna *Adige* **A D R I A T I C**

OCEAN **D** ● Le Puy *Lot* *Rhône* **R** ● Genoa **R** **P** **S E A**

O **P R O V E N C E** *Tanaro* *Po* **A**

GASCONY *Tarn* ● Toulouse **SEPTIMANIA** ● Arles ● Nice *Arno* **P** **L** 3

3 ● Pamplona *Garonne* ● Narbonne ● Aix-en-Provence **CORSICA** *Tiber* **DUCHY** **S** **I**

NAVARRE **SPANISH** ● Ajaccio **OF** **A** **Y**

Douro **MARCH** ● Gerona ● Spoleto

Ebro ● Saragossa *Segre* **SPOLETO** *Tiber*

EMIRATE ● Barcelona ● Rome **DUCHY OF**

● Gaeta ● Benevento ● Brindisi

OF *TYRRHENIAN* ● Naples **BENEVENTO**

40° ● Salerno 40°

SARDINIA

CORDOVA ● Valencia *Jucar* *SEA*

● Cagliari

BALEARIC ISLANDS ● Messina

Segura ● Alicante ● Palermo

4 *MEDITERRANEAN* **SICILY** 4

● Cartagena ● Syracuse

Shelif *Medjerda* ● Carthage *SEA*

A 0° **B** 5° **C** 10° **D** 15° **E**

0 100 200 300 km

0 50 100 150 200 miles

376 – THE EMPIRE OF CHARLEMAGNE AT THE BEGINNING OF THE 9TH CENTURY.

THE EMPIRE OF CHARLEMAGNE AT THE BEGINNING OF THE 9th CENTURY
PARTITION OF THE TREATY OF VERDUN IN 843

Aachen	C 1	Naples	D 3
Aix-en-Provence	C 3	Narbonne	B 3
Ajaccio	C 3	Nice	C 3
Alicante	A 4	Palermo	D 4
Angers	A 2	Pamplona	A 3
Aquileia	D 2	Paris	B 2
Arles	B 3	Pavia	C 2
Auxerre	B 2	Périgueux	B 2
Barcelona	B 3	Poitiers	B 2
Beauvais	B 2	Pola	D 3
Benevento	D 3	Puy (Le)	B 2
Besançon	C 2	Ravenna	D 3
Bordeaux	A 3	Regensburg	D 2
Bourges	B 2	Reims	B 2
Bremen	C 1	Rennes	A 2
Brindisi	E 3	Rome	D 3
Cagliari	C 4	Rouen	B 2
Canterbury	B 1	Saint-Denis	B 2
Carthage	D 4	Saint Gall	C 2
Cartagena	A 4	Saint-Maurice	C 2
Chur	C 2	Saint-Philbert-de-	
Clermont	B 2	Grand-Lieu	A 2
Cologne	C 1	Saint-Quentin	B 2
Corbie	B 2	Saint-Riquier	B 1
Dijon	B 2	Salerno	D 3
Fulda	C 1	Salona	E 3
Gaeta	D 3	Salzburg	D 2
Geneva	C 2	Saragossa	A 3
Genoa	C 3	Sens	B 2
Germigny-des-Prés	B 2	Soissons	B 2
Gerona	B 3	Spoleto	D 3
Hamburg	C 1	Strasbourg	C 2
London	A 1	Syracuse	E 4
Lorsch	C 2	Toulouse	B 3
Lyons	B 2	Tournus	B 2
Mainz	C 2	Tours	B 2
Mans (Le)	B 2	Trier	C 2
Messina	E 4	Valencia	A 4
Metz	C 2	Venice	D 2
Milan	C 2	Vienne	B 2
Nantes	A 2	Würzburg	C 2